D0538551

Performance

Texts and Contexts

Carol Simpson Stern
Northwestern University

Bruce Henderson
Ithaca College

Longman
New York & London

Performance: Texts and Contexts

Longman, 10 Bank Street, White Plains, N.Y. 10606

Associated companies:
Longman Group Ltd., London
Longman Cheshire Pty., Melbourne
Longman Paul Pty., Auckland
Copp Clark Pitman, Toronto

Acquisitions editor: Kathleen Schurawich
Sponsoring editor: Gordon T. R. Anderson
Development editor: Virginia L. Blanford
Production editor: Halley Gatenby
Cover design and illustration: Kevin C. Kall
Production supervisor: Anne P. Armeny
Copyright acknowledgments begin on page 557.

Library of Congress Cataloging-in-Publication Data

Stern, Carol Simpson.
 Performance : texts and contexts / Carol Simpson Stern,
 Bruce Henderson.
 p. cm.
 Includes bibliographical references and index.
 ISBN 0-8013-0787-2
 1. Oral interpretation. 2. Folklore—Performance. 3. Performance
art. I. Henderson, Bruce. II. Title.
PN4145.S74 1992
808.5'4—dc20 92-27332
 CIP

1 2 3 4 5 6 7 8 9 10-HA-9695949392

To J. Allyson Stern
and
In Memory of Richard Pollack

Contents

Preface
A Guide for the Instructor

THE PURPOSE OF THE BOOK

Performance: Texts and Contexts addresses the shift from the oral interpretation of literature to performance studies as a broader field of study. It is designed to be used in a variety of courses typically taught in such departments as speech communication and theater as well as in English; anthropology; and inter- and cross-disciplinary programs in the humanities, the arts, and the social sciences. As Clifford Geertz and others have suggested, there has been a blurring of traditional disciplinary lines, and performance has become one of the principal sites where fields that were previously regarded as separate and autonomous now meet in dialogue.

We envision this textbook as one that will offer both students and instructors avenues for engagement as performers and directors, as well as students of performance, whether in the role of critic, ethnographer, or historian. We typically write from the perspective of active performers with the assumption that participation in the various acts of performance provides essential experiences for all who would study performance. At the same time, we are also aware that, particularly at the advanced level, many courses are less concerned with the development of performance skills per se and much more centered on performance as a field of knowledge and as a way of knowing, and our hope is that this textbook will be of use in such courses as well.

If the textbook can be said to have a particular perspective it is the postmodern openness to pluralistic methods of study and constructions of meaning. Readers will recognize the influence of a wide range of thinkers, writers, and performers. We are indebted to the interpretive social sciences of Victor Turner, Erving Goffman, and Clifford Geertz; to the literary critical approaches represented by such contemporary writers as Henry Louis Gates, Jr., Sandra Gilbert, and Susan Gubar; to the recently rediscovered dialogism of Mikhail Bakhtin and the many varieties of poststructuralism loosely (and sometimes arguably) classified

as "deconstruction"; to the avant-garde developments of performance art, ranging from futurism and Dada to Whoopi Goldberg and Spalding Gray; and to the scholarship of RoseLee Goldberg. We also draw from those scholars working squarely within the field of performance studies, such as Dwight Conquergood, Leland Roloff, and Richard Schechner. We have found our own dialogue with these thinkers exciting and so have our students—and we hope you and your students do also.

AUDIENCE

This textbook is aimed at students who have had some experience with performance studies, either through an introductory course or through other practical experience, and who are now prepared to examine performance as a multifaceted phenomenon. Although the book may have some success with introductory students, depending on the students, the instructor, and the context itself, our assumption is that those students using this book will have done some performing, typically in a course that may be called something like Introduction to Oral Interpretation, Introduction to the Performance of Literature, or Introduction to Performance Studies. We further assume that most students encountering this book will have some familiarity with the basic terms of literary analysis, such as plot and character in drama; point of view and style in prose fiction; and persona, imagery, and prosody in poetry. In those instances in which an introductory course has omitted consideration of basic terms or concepts, we also assume that the instructor can recognize such gaps and supplement the text with this introductory material.

In addition to some elementary performance experience and some understanding of terms of analysis, we also assume that students approaching a course in which this book will be used will also have an enthusiasm for performance and a desire to expand the range of what might profitably be studied under that name. Students whose exposure to performance has been restricted to oral interpretation or theater may at first be surprised to look at their family narratives, public ceremonies, and everyday lives as modes of performance. However, we have found that they take to such an approach almost immediately. Similarly, although forays into performance art in university classes have been fairly recent, we have found students receptive, in fact eager, to engage in these experimental forms. They offer an additional means for the advanced student to experience imaging, media arts, the construction of improvisatory texts, and work with masks and personal texts. We also encourage the instructor to find ways of weaving local performance events, whether cultural, literary, or aesthetic in orientation, into class discussions, exercises, and assignments.

USING THIS TEXTBOOK

There are probably as many different ways of using this textbook as there are instructors and students. We do not advise trying to use the entire book in a single course, either semester or quarter length. Quite frankly, performance studies has

expanded too far to permit such a scope within a single, more in-depth second or third course: it is a pleasure to have so much at the banquet, but we do not advise that you fill your students' plates to the point at which no single dish becomes palatable.

The three-part division of the text suggests several natural organizations for courses. We recommend beginning any course with the introductory material in part I. From there on, each instructor will find some useful combination of parts and chapters, depending on the emphasis of a specific course. Part II, "Cultural Performance," could easily be the basis of a course in itself, moving from personal narrative to folklore and folk narrative through more elaborate public and cultural contexts. Such a course might include such performance assignments as the personal narrative, an ethnographic experience (as collector and/or performer), the traditional folk tale (perhaps narrowed to genre, nationality, or other classification), or a performance based on materials gathered through participation in public ritual. The adventurous instructor may even involve the class in a collective experience in which the participant-observer role yields a multivocal performance experience. Papers might very well be structured along such kinds of assignments as contrasts between oral and literary cultures, intertextual relationships between folkloric and other kinds of texts (personal, literary, historical), or ethnographic descriptions and analyses. Writing assignments that blend scholarly research with personal experiences of cultural performance often yield exciting and unforeseen results.

Another approach might be to focus primarily on part III, "Literary Performance." In a second course in the performance of literature, a course typically predicated on a genre-based approach in the introductory course, part III might be used to cut across genres and to focus on what we present as a developmental approach to the performing self, from play to variations on self to a more studied view of the body to the many meanings and contexts of dialogue and the dialogic. Instructors may wish to guide students through a range of particular genres: play seems to be a natural starting point for poetry, as might the linguistic, historical, and psychological approaches to self; similarly, a unit on prose fiction might begin with the self, move to the body, and end with dialogue; drama would also profit from the close study of self and other provided by the chapters on self and dialogue. We would also point out that virtually every chapter in part III contains selections from two or three of the traditional genres of literature as well as nonfiction selections; if instructors choose to structure the course around genre-based units, we encourage them to draw from various chapters for examples and selections for analysis and performance.

Advanced courses in the performance of literature are often based on the exclusive study of a single genre. We believe the book may be profitably used in such courses as well, particularly in courses in poetry and prose fiction. Using the chapters named in the previous paragraph as the organizing principles for semester- or quarter-length courses in poetry or prose fiction, instructors may then choose supplementary texts, either through one of the anthologies in the bibliographies or through a thematic, historical, or other plan of selection; in courses beyond the beginning level, we have found that most instructors prefer to isolate particular texts or kinds of texts in any case. A course in poetry might

use the chapters on play, self, and body as theoretical background and then focus on twentieth-century American poetry, poetry written by women, or even as specialized a focus as the sonnet. Similarly, a course devoted to prose fiction might use self, body, and dialogue as principles and look at the short story, metafiction, or literary fairy tale. Again, writing assignments will vary widely, depending on the particular goals set by each instructor, but a play-centered analysis of a text might focus on implicit and explicit "rules" (or conventions); another assignment might focus on in-depth exploration of one of the psychological or sociopolitical frameworks. Similarly, the material on body and that on dialogue present natural foci for analysis.

Still another set of possibilities lies in crossing the boundaries of the parts of the book to construct courses that focus on some aspect of the performance process or experience common to cultural performance, literary performance, and performance art. For example, play is important to all three performance contexts, and a course might use the book to explore its different contours in each. Similarly, the self is constituted in ways that are complexly similar and quite different in different performance contexts: the self in personal narrative might be connected to the lyric, dramatic, and epic voices in poetry and fiction and to culturally situated and aesthetically framed versions of self in performance art. A course in narrative performance might begin with the lengthy consideration of oral narrative in part II, proceed to the discussion of narrative selves in part III, and conclude with the performance artist as self-conscious postmodern storyteller.

We have devoted the least amount of space to part IV, "Performance Art," for a number of reasons. Even in the most pluralistic course, instructors will find only so much time to treat the range of topics available. Performance art is an important development whose history, as the discussion in part IV, chapter 13, suggests, reaches back to virtually all the revolutions in art and society in this century. Nonetheless, most instructors will probably choose to restrict their use of performance art in a second or third undergraduate course to one or two assignments or experiments in the form. It may be that a course in cultural performance will end with the intersection of culture and performance art or that a course in literary performance will conclude with a multimedia aesthetics of performance art. Thus, part IV may prove a brief but useful introduction to the phenomenon, building on such familiar and recognizable figures as Spalding Gray and Whoopi Goldberg, whose performances are readily available on videotape, but it is not intended as the source for an independent course in performance art.

SOURCES OF PERFORMANCE MATERIALS AND SUGGESTED FURTHER READINGS

We have provided two kinds of bibliographies: the first, called Sources of Performance Material, lists anthologies and important single sources for performance texts (included at the end of parts II, III, and IV); the second, called

For Further Reading, lists a selection of supplementary theoretical texts related to materials discussed in each chapter (included at the end of each chapter). It is our experience that individual instructors, once they are beyond an introductory level, prefer to choose their own texts for analysis. Our assumption is that anyone teaching an advanced course will have either favorite texts or a particular focus, genre-based, historical, or thematic, and will choose supplementary texts accordingly. We have provided a number of sources of material for parts II and IV because finding oral-centered texts in print (oral histories and personal narratives in particular) and performance art texts is still a fairly difficult task. In part III, we have emphasized anthologies that range from traditional introductions to genre, historical surveys of literary texts, and recent anthologies based on multicultural concerns. Where possible, we have cited paperback texts that should be easily available. We have also sought to provide a good cross section of multicultural sources.

For Further Reading provides a selective list of critical and theoretical sources for the topics discussed in each chapter. Keeping in mind the undergraduate student, we selected sources accessible for sophomores, juniors, and seniors or those that would be accessible with the assistance of an instructor. Such sources are of particular value for the course that stresses research and writing about texts in performance. We also selected titles that will be useful to the instructors who are seeking a richer bibliography of scholarship on the topics treated in the book. In some cases it is necessary to look at the bibliographies in several chapters in those cases where the subject matter is distributed throughout the book. We have also chosen not to include in For Further Reading any of the material in Works Cited.

What is most important, from our perspective, is that each instructor use the textbook as an instrument for serving his or her goals, interests, and needs—and those of his or her students. A textbook is only as valuable as the instructor who uses it, and we encourage you to think of this book as a point of entry for you and your students' own "dialogic engagement," to use Dwight Conquergood's term, with text, context, and performance.

ACKNOWLEDGMENTS

We wish to thank the following individuals for their help and support in writing this book: The late Gordon T. R. Anderson of Longman, whose vision guided us in the early stages of this project. It is a particular point of sadness to us that "Tren" did not live to see this project to its conclusion. Beverly Whitaker Long, University of North Carolina, who first suggested this project to us and later reviewed our manuscript. Ronald J. Pelias, the author of an introductory text on performance studies, who helped launch us on this venture. The editorial staff at Longman for all their fine work, particularly David Fox, Kathleen Schurawich, Halley Gatenby, Virginia Blanford and Elsa van Bergen. Alan Shefsky, Northwestern University, for his invaluable assistance and patience in the often thankless task of preparing the manuscript. Our colleagues at Northwestern University and

Ithaca College, whose many words of advice and encouragement kept us going throughout the process. In particular, our thanks to Elizabeth Threnhauser and Cynthia Seel, two doctoral students at the time, who read certain chapters, giving us helpful responses. Our colleagues and friends elsewhere, whose responses to the manuscript and whose general feedback were invaluable. In particular, we wish to thank the reviewers of the manuscript, whose comments have proven most helpful:

Linda Park-Fuller, Southwest Missouri State University
Elizabeth Fine, Virginia Polytechnic Institute and State University
John Anderson, Emerson College
Phyllis Carlin, University of Northern Iowa
Ronald Pelias, Southern Illinois University
Della Pollock, University of North Carolina, Chapel Hill

Faculty of the Department of Interpretation/Performance Studies, who as colleagues and teachers shaped much of our thinking about performance: Wallace A. Bacon, emeritus, and Leland H. Roloff, emeritus. Lilla A. Heston and Robert S. Breen were sources of inspiration to us and we deeply regret that they are not with us. To our families, particularly our parents, we express our deepest thanks for their constant encouragement on this and other projects over the years. And finally, Carol Simpson Stern thanks her husband, J. Allyson Stern, for all his help and encouragement and, in particular, for prodding her on with this project, giving her the freshness of his insights, the bluntness of his criticism, and the gift of his love.

PART I
An Overview

CHAPTER 1

Performance Studies: Some Definitions

The term *performance* incorporates a whole field of human activity. It embraces a verbal act in everyday life or a staged play, a rite of invective played in urban streets, a performance in the Western traditions of high art, or a work of performance art. It includes cultural performances, such as personal narratives or folk and fairy tales, or more communal forms of ceremony—the National Democratic Convention, an evensong vigil march for people with AIDS, Mardi Gras, or a bullfight. It also includes literary performance, the celebration of individual genius, and conformity to Western definitions of art. In all cases a *performance act, interactional* in nature and involving *symbolic forms* and *live bodies,* provides a way to constitute meaning and to affirm individual and cultural values.

This book examines *cultural* and *literary performance* as well as *performance art,* devoting a part to each. These categories are not mutually exclusive. Performances included in all three parts are aesthetically pleasing; that is, they are sensitive to art and beauty. It is equally true that literary performance and performance art are aspects of culture. However, a division of our subject into the three categories will assist you in making important distinctions between different kinds of performance on the basis of texts and contexts.

Part II focuses on cultural performance, from the personal narrative to the public display, including verbal art and public performances that use other media, such as masks, music, visuals, and so forth, in addition to language. This kind of performance in everyday life draws on both oral and written traditions. The texts for performance are more oral-centered than print-centered, even when a literary text captures a part of the performance experience. Part III, on literary performance, examines performances from texts of literature of all kinds, including riddles, puns, nonsense verses, poems, plays, novels, and essays. Part IV, on performance art, examines works of performance artists that mingle words, sculpture, visual displays, media art, music, and dance, combining "high" and

"low" art in new ways. This contemporary movement is best understood in the context of twentieth-century avant-garde works.

As performers, you will be studying expressive texts throughout this book, many raising ethical issues. Performance excites emotion; it can arouse us to action; it can be ecstatic, therapeutic, confrontational, and instructive. It is a daring act. Plato found it so powerful that he wanted to banish its practitioners from the Republic. Our experience with performers, students, and professionals has shown that it is an energizing activity, often heady and intoxicating. It can also be cruel and hard. It raises ethical questions, often in the context of power relationships. There are moral implications for performers when they act, which we will discuss. One of the ways we can come to understand performance is to engage in it actively while learning how to describe and evaluate it.

THE ROLES WE PLAY

A person presenting a role in ordinary life or an individual oral storyteller involved in discourse are examples of everyday life performances. The casual exchange between two acquaintances upon meeting in the street—one asks the other, "How are you?" and the other answers "Fine" although in fact feeling awful—is one example of role playing. The questioner affects the role of someone interested in the other's welfare; the respondent replies with a banal phrase suggesting health when he or she is ill. They are simply two people going through the ordinary conventions of good manners, and they use the convention to preserve the social fabric and protect their own identities. Both are assuming a *role,* and as such, both are *performers* of a social convention. The lively storyteller can be highly animated, impersonating the various characters in his or her story, capturing their mannerisms, tone of voice, and gestures and exaggerating some of them for comic effects. This teller, too, is performing in everyday life.

In *The Presentation of Self in Everyday Life,* the sociologist Erving Goffman explores the analogy between the organization of experience in everyday life executed by an ordinary social being with the organization of experience performed by an actor when he or she plays a role in a play. Goffman points to numerous examples of the presentation of self in everyday life. Some of the performances involve relatively uncomplicated enactments of either a natural or social function, such as a mother showing her child how to bathe himself or a girl in animated conversation mimicking her pesty little brother. His analysis shows how each performer is playing a role: in the first example the mother is demonstrating how to wash; she is imitating her own natural behavior when she bathes, reflecting on it, and using the performance of it to show another, through imitation, how to enact the role. In the second, the animated girl imitates her brother's whining voice, using his exact words and capturing his inflections. She speaks the lines of her brother as if they were direct discourse. It is almost as if she is an actress playing several parts—her own and that of her brother. Think about the variety of roles you play in the course of a day. Are some more theatrical than others? Do you sometimes feel as though you are "onstage" while you go about the ordinary business of life?

In his later book, *Frame Analysis,* Goffman extends his comparison of role playing in life to role playing in the theater, using language drawn from the visual arts and the study of film. He examines numerous *strips* of human activity. By strips, he means arbitrarily selected slices of ongoing human behaviors, or activities. The activity may be real or imagined, but by treating it as if it were a slice of film that can be edited, Goffman identifies a cluster of occurrences that can serve as the starting point for his analysis.

He introduces the term *frame* to organize experience and adds the concept of *laminations* (thin layers of covering), which are set on frames to assist us in interpreting experience rightly and answering the question, What does it mean? In Part II, we will talk more about the concept of framing, but for now think about the relationship of a picture frame to the scene, painting, or photograph it surrounds. The fact that the pictorial scene is framed heightens your understanding of what is inside the frame and what is outside. It literally places physical boundaries around something. A frame, like brackets, signals what is to be attended to and what should be excluded, not attended to. The concept of frame helps us explain what something means in everyday life, in which the frame is often invisible although a boundary is present. Once this invisible boundary is recognized—once we identify the frame—it enables us to define participants, their roles, and the sense of meaning that is to be given to the events and roles included in it. By framing performances from everyday life, we place the performance event in the foreground, making it easier to analyze it as a performance.

Goffman's Concept of *Frame*: An Example

You should be able to describe numerous examples of people performing everyday roles. In fact, a quick analysis of your teachers' behavior in your most recent classes will give you rich material. Think of the kinds of clues that suggest that your teachers are playing at being teachers. Think how they enter the classroom, the fanfare with which they approach the front of the room or invite you to place your chairs in a circular configuration, the way in which the lights are turned on, or the way they shifted from who they were when walking casually to class and the persona they assume in class. Think of these enactments as presentations and performances in everyday life.

You can probably even supply numerous examples of how a teacher dropped the part, let the frame slip, as Goffman might say. Can you think of instances when some personal mannerism of your teacher draws a great deal of attention to itself, marring the teacher's attempt to perform a teacherly role? From your point of view, you are watching a nervous trait. You recognize what Goffman would call the *frame slippage*—namely, that this action of the teacher's is not meant to be part of the role of teacher. You, the observer, can easily and simultaneously not attend to the nervous mannerism and attend to the role as teacher. For now, we want you to consider this kind of presentation or performance as falling at one end of our performance continuum.

When humans perform roles, whether the role of the liar, the con artist, the teacher, the ridiculed outcast, or any others they assume in ordinary life, they are doing more than merely sharing information or executing an act that has an

efficacious purpose. The behavior is not merely *informational,* offered for the purpose of sharing information or intended to produce a set effect; it is also *performative,* serving ends that go beyond the substance of the exchange. The roles are adorned; they are playful, inventive, and entertaining. They are expressive of a complex range of emotions and attitudes. As *performative modes,* they involve sequences of actions—both gestural and verbal—that an actor might use when playing the role of a character in a play or that may be used by a performer in a public ceremony. However, there are very important ways in which the performance act in everyday life is distinctly different from that of a performer in a play, ritual, or public ceremony. Close observation of performance behaviors helps us to recognize cues that separate a performance from an everyday occurrence. This book explores these differences, analyzing the various kinds of performances that are a part of our continuum and showing how they influence your cultural performances and literary performances as well as performance art.

Sartre's Example of the Role of the Waiter and the Flirt

The playwright and philosopher Jean-Paul Sartre offers a detailed commentary in his book *Being and Nothingness* about the roles humans play. He intricately describes the behaviors of the waiter and the flirt, showing how both play at being something other than what they are. Later in this book we will discuss issues surrounding the construction of gender and you will probably see ways in which Sartre's use of the stereotype of the flirt is somewhat offensive. Many might argue that Sartre willfully chooses to see this woman's behavior as flirtatious and crafted to fulfill male expectations. For now, however, we will forgive him his antifeminist viewpoint and consider how he treats the two roles.

Sartre's waiter approaches the customer in a French café with a movement that is "quick and forward . . . a little too rapid" (101). Sartre observes that he affects a kind of charm just as soon as he comes into the sightlines of the customer he plans to serve. He smiles and turns solicitously toward the customer from whom he plans to take the order, and turns smartly away when the order is completed, having exchanged the proper number of pleasantries to keep the customer happy. When he returns with the tray, he is "trying to imitate in his walk the inflexible stiffness of some kind of automaton while carrying his tray with the recklessness of a tight-rope-walker by putting it in a perpetually unstable, perpetually broken equilibrium which he perpetually re-establishes by a light movement of the arm and hand. All his behavior seems to us a game" (101). In other words, through gestural and verbal language, the person signals that he is a waiter; to be a waiter he must play the role of the waiter.

Now let us examine Sartre's description of the flirt:

> Take the example of a woman who has consented to go out with a particular man for the first time. She knows very well the intentions which the man who is speaking to her cherishes regarding her. She knows also that it will be necessary sooner or later for her to make a decision.

But she does not want to realize the urgency; she concerns herself only with what is respectful and discreet in the attitude of her companion. She does not apprehend this conduct as an attempt to achieve what we call "the first approach"; that is, she does not want to see possibilities of temporal development which his conduct presents. She restricts this behavior to what is in the present; she does not wish to read in the phrases which he addresses to her anything other than their explicit meaning. If he says to her, "I find you so attractive!" she disarms this phrase of its sexual background; she attaches to the conversation and to the behavior of the speaker, the immediate meanings, which she imagines as objective qualities. The man who is speaking to her appears to her sincere and respectful as the table is round or square, as the wall coloring is blue or gray. The qualities thus attached to the person she is listening to are in this way fixed in a permanence like that of things. . . . This is because she does not quite know what she wants. She is profoundly aware of the desire which she inspires, but the desire cruel and naked would humiliate and horrify her. Yet she would find no charm in a respect which would be only respect. In order to satisfy her, there must be a feeling which is addressed wholly to her *personality—i.e.,* to her full freedom—and which would be a recognition of her freedom. But at the same time this feeling must be wholly desire; that is, it must address itself to her body as object. This time then she refuses to apprehend the desire for what it is; she does not even give it a name; she recognizes it only to the extent that it transcends itself toward admiration, esteem, respect and that it is wholly absorbed in the more refined forms which it produces, to the extent of no longer figuring anymore as a sort of warmth and density. But then suppose he takes her hand. This act of her companion risks changing the situation by calling for an immediate decision. To leave the hand there is to consent in herself to flirt, to engage herself. To withdraw it is to break the troubled and unstable harmony which gives the hour its charm. The aim is to postpone the moment of decision as long as possible. We know what happens next; the young woman leaves her hand there, but she *does not notice* that she is leaving it. She does not notice because it happens by chance that she is at this moment all intellect. She draws her companion up to the most lofty regions of sentimental speculation; she speaks of Life, of her life, she shows herself in her essential aspect—a personality, a consciousness. And during this time the divorce of the body from the soul is accomplished; the hand rests inert between the warm hands of her companion—neither consenting nor resisting—a thing. (96–97)

In analyzing this woman's act, Sartre notes that she has "disarmed the actions of her companion by reducing them to being only what they are" (97). She permits herself to enjoy his attentions by pretending that they are something other than they are. While she is actually aroused by his attentions, she *acts* as if her body is a passive object to which things happen. Sartre claims that she is playing on

a double property of all human beings, namely, that we are at one and the same time a *body fact* and a *transcendence.* On the one hand, the young woman carrying on the lofty conversation with the young man, seemingly not heeding at all the implications of where his hand is placed, is denying the body fact that the young man is holding her hand. The woman is willing to consider that her transcendent self is her identity. On the other hand, she is also very much the woman who is permitting her hand to be held, who is treating it as an object. These actions are part of the self she is denying while she negotiates her other role in which her hand is just an object.

Sartre calls her a flirt and describes her condition as one of bad faith, *mal foi,* arguing that it is inescapable. We as humans are at all times not what we are. Or put another way, the woman in our example is doing something that is not herself and yet at the same time it is not not-herself. The flirt in her is a part she consciously disowns while she relishes playing it. She would say the flirt is not herself. Yet, while saying this, she knows that it is also not not-herself; it does, in fact, have a relationship to herself. Sartre concludes, "We have to deal with human reality as a being which is what it is not and which is not what it is" (100). This idea has important implications for students of performance.

Richard Schechner, an avant-garde director in New York of the The Performance Group in the 1960s and 1970s as well as a scholar of performance, offers another concrete instance of this phenomenon of "not-I" and yet "not not-I." It explains the evolution of the actor's process of moving from being the "I" (or me), the individual who will play a role learned from a script, to the state the actor inhabits during the theatrical moment of playing a character when the I and not-I fuse. He discusses the actor Laurence Olivier playing Hamlet. Olivier knows that he is not Hamlet, and yet he is not not-Hamlet. In *Between Theater and Anthropology,* Schechner says that this kind of *double negativity* (in grammar, a double negative transforms the statement being denied into a positive affirmation) provides a condition in which "choice and virtuality remain activated" (110). An understanding of this double negativity and the inherent contradiction embedded in the human condition usefully contributes to our understanding of role playing. Role playing in life is informed by role playing in drama, and we will continue to examine this interplay as we explore the field of performance study.

Think about roles you have acted, perhaps on stage or in class. Can you describe this condition of double negativity, examining how it influenced your own performance? Can you recall moments when you seem to have become the character in the role, and yet at the same time you are aware that you are not the character? Can you think of occasions when a part you played on stage seems to spill over into life, so that you hear yourself echoing a theatrical moment from a play, and yet now you have taken on this character, making it an aspect of your everyday self? But, again, you also know the way in which it is not you. These kinds of moments are rich in potential. They give you an opportunity to extend yourself and act in ways that may be unfamiliar or uncharacteristic. In these kinds of moments, you often feel a rich sense of possibility while you select one set of roles to play and reject others latent in you. Think about these kinds of experiences in the light of Schechner's comments.

Returning then to Sartre's example, we see that a study of the woman's actions, the *kinesics* of her body, the verbal utterances, and the context all tell us that she is playing at being something she is not. She is performing the role of the flirt. *Kinesics* is the science of bodily motion in relation to speech. In the case of the flirt, our understanding of the interplay of gesture with speech in performance helps us to interpret accurately the woman's motives and character.

SCHOLARLY DEFINITIONS OF PERFORMANCE

A number of scholars of performance have attempted to define *performance* and *performers.* In his book *Between Theater and Anthropology,* Schechner defines performance as *restored behavior,* or "twice-behaved behavior" (36). Drawing on Goffman's ideas in *Frame Analysis,* Schechner thinks of restored behavior as living behavior treated as a film director treats a strip of film. Performance is restored behavior that is always reflexive and repeatable, although the repetition will never be the same. This view of performance also considers restored behavior to be symbolic and multivocal, something that is always subject to revision and that can be treated by the performers as though it is something outside of themselves. It can be thought of as a *strip* of experience to be edited. The social self, according to Schechner, is a role or set of roles. A performer is someone who can "act in/as another" (36). Consequently, for Schechner performance is not a first-time behavior but one that is "twice-performed." Even if the performance seems to be entirely improvisational, Schechner would still argue that the performer draws on behaviors experienced in other contexts, molding and shaping them. In this sense, even the improvisational behaviors are "twice-performed."

Victor Turner writes of performance from the perspective of an anthropologist and ethnographer. He views performance as an essential aspect of experience. Through performance, one can both live through primary social processes and reflect back on them, investing them with meaning.

In *From Ritual to Theatre,* Turner offers a very helpful explanation of the etymology of the word *performance.* It is derived from the Old French word *parfournir,* meaning "to complete" or "to carry out thoroughly" (13). Drawing on a theatrical term, he defines performance as "the proper finale of an experience" (13). A performance completes, or thoroughly carries out, social processes. Turner compares Western theater to ritual behavior and social dramas, likening theater to what he calls the third phase of a social drama, the phase of redressive measures. This is a phase in which meaning is given to social events through a process of restoration of the past. Turner argues that theater has within it aspects of the judicial social process. He states that theater investigates, interrogates, and involves judgment and punishment; in short, it enacts a kind of law-in-action, while at the same time it relies on ritual, mystery, and even the supernatural. In these regards it performs a religious or quasi-religious function.

Through the performance of rituals, social dramas, and theater, Turner believes that actors discover other ways of understanding reality. When he examines performance from this perspective, he is able to compare the state of

arousal, heightened activity and emotion, a consciousness of dramatic time (rather than routinized time), and a sense of living through the performance while also reliving past experience, all of which are conditions in rituals and social dramas and all of which are characteristic of Western drama from the Greeks to the present. One of Turner's important contributions to social anthropology is his concept of the social drama, which he invented to enable him to describe and analyze social life cross-culturally. In part II, chapter 4, the concept will be fully examined, but for now it is important to recognize that human activity can be studied by reference to Western performance traditions, specifically, to the Western tradition of tragedy, which Aristotle writes about in the *Poetics.* More important, Turner argues that cultures forge meaning and communicate through performances. Performances are symbolic constructs that manifest themselves in a diverse range of behaviors, including rituals, trials, cockfights, wars, and a whole host of activities that are performed frequently in the social life of a culture. Performance scholars draw on Johan Huizinga's definition of man as *homo ludens,* man the player, and speak of *homo performans,* the man who performs. They thus draw attention to the fact that performance and mimicry are fundamental to a definition of a human being. They can be traced to the origins of humans and can be found in children, from their earliest stages of infancy onward.

Another fertile influence on the study of performance is the work of Kenneth Burke. His dramatistic approach to literature carries important implications for performers because it requires that literature be understood as equipment for living. Burke is primarily concerned with an examination of human motives in acts, and he considers language, thoughts, feelings, and deeds as modes of action. He interrogates literature through his five dramaturgical questions. Later, he adds a sixth term to his analysis, making it hexadic. He invites the performer to think of literature as a symbolic act by its author, deriving from a situation in life actually experienced by the author. Beyond formalistic inquiries into texts, Burke's system brings rhetoric and ethics, as well as an examination of motives, into the analysis of literature. Questions about the verbal act encountered in literature lead to a consideration of terms, the grammar, which are necessary to describe an action.

Burke's pentad, introduced in *A Grammar of Motives,* provides the principles for the discovery of motive. He identifies these principles as *act, scene, agent, agency,* and *purpose.* Later he adds *attitude.* To explain fully the motive behind an act, one must know what the act that took place is, be it a deed, thought, or feeling. One must name the *scene,* the situation in which the act occurred, or its background. One must know who performed the act, its *agent,* and what kind of person this is. In addition, one must know what kind of means or instruments were used to perform the act, what its *agency* is. And, too, one has to know for what purpose or reason the act is performed. Finally, one must know not only the instruments or agency used to execute an act but also in what manner or attitude it was carried out.

Burke's interest in the relationship between drama and life and his thorough-going development of his dramatistic approach rests on his belief that the relationship between life and theater is literal, not merely figurative. Students of performance have found his approach useful in probing the motivation of the

narrative or character voice in literature. You are probably familiar with the questions he asks of a text: who is speaking, where, when, through what act, for what purpose, and with what bent of mind? Asking these questions of a literary text, such as Jane Austen's *Pride and Prejudice* or Robert Frost's poem "Stopping by Woods on a Snowy Evening," can assist you in developing the roles of the character or narrator. You might want to discuss specifically how Burke's six questions are helpful.

Many scholars, including Goffman, Turner, and Schechner, have used Burke's dramatistic approach to illuminate ordinary social interactions and human behavior. They have recognized that although there are many theatrical elements in ordinary life behaviors, we can differentiate among the kind of performance behaviors characteristic of the actor in a play, the bullfighter in a ring, a shaman in a ritualistic healing, a communicant at an altar, Sartre's flirt, and a person telling a story. Because all of these situations belong in the category of performances, can we usefully discriminate among these kinds of activity, or are we saying that all of life is a performance? Scholars answer this question in different ways.

We have been considering very inclusive definitions of the term *performance.* Later we will see that a number of scholars find it useful to think about human behavior and performances in comparison with animal ritualistic behaviors. As scholars refine and limit the definition, they begin to introduce ideas about performers' intentions, whether or not they self-consciously reflect on the role at the time of enacting it. Considerations about the repeatability of the act and the actors' intention are also matters of interest to scholars of performance. In drawing these distinctions, they demonstrate ways in which it cannot be said that all of life is a performance.

In *The Presentation of Self in Everyday Life,* Goffman examines human interaction in social situations. He defines interaction as the "reciprocal influence of individuals upon one another's actions when in one another's immediate physical presence" (15). He defines a performance as "all the activity of a given participant on a given occasion which serves to influence in any way any of the other participants" (15). The audience in these interactions includes observers or coparticipants.

This definition of performance and audience is surely one of the broadest we will encounter. As students of performance, we may be guided by an examination of how social creatures navigate and perform in these everyday situations as we set out to grasp the contours of a role and consider the kind of behaviors that can be brought into play in performance. However, we know that institutionalized performances are significantly different from ordinary life, not the least because the activities are repeatable in a way dissimilar to that in which a hostess can again and again summon up the cliché of welcome at a cocktail party. One of the ways we distinguish between the hostess in life's welcome from the welcome executed by the hostess in T. S. Eliot's *The Cocktail Party* is that in the staged play the agent of the performance, the actress, knows that she is at once a real person who happens to be playing a part, an actress acting a role of a character, the character of the hostess. She also knows that she is acting in response to and with the characters and actors on the stage

as well as the audience. Also characteristic of her performance is an intensi-fied order of activity, projected considerably beyond the proportions of her behaviors as a hostess in life.

In the everyday life situation, or what Goffman would call a *strip of behavior,* he appeals to the frame to assist him in analyzing just exactly how the hostess's particular greeting in a particular situation is experienced. He cautions his audience against naively employing terms like *real* to describe the hostess's behavior. Part of his suspicion of the term *real* grows from his awareness of how many levels of illusion, fabrication, and deception color our day-to-day conduct. He comes to disbelieve that a real self exists, or if it does exist, he declares it to be unknowable. Such a view of reality and make-believe, of making and faking, suggests that performers of drama can draw a line of clear demarcation between the self they conceal and the self they play with the assistance of masks, lines, and costumes that are not their own. One of the consequences of Goffman's use of the theatrical metaphor to describe everyday behaviors is that he comes to see all role playing as very like the role playing onstage, and as such, he is preoccu-pied with how the defensive, deceptive trickery of life's roles and our view of life become so enmeshed that the individual cannot separate them.

Think about some of the everyday roles you play versus some stage roles you have acted. Do you agree with Goffman that almost all of everyday perfor-mance is more "act" than "real"—that there is something fundamentally insincere or inauthentic about almost everything that humans do? Or do you view the question differently, finding a coherent self that may manifest itself in very different roles and yet still maintain a central core? We will be discussing the individual self and multiple selves more fully in part III.

Bruce Wilshire in a book called *Role Playing and Identity* offers an extensive phenomenological critique of the metaphor of the drama as it applies to life. Phenomenology is a philosophy that grounds experience in consciousness and explores people's relationship to the world in which they live from this basic building block. Wilshire's purpose is to show how an actor "speaks himself" through a fiction, and in the course of his demonstration, Wilshire shows in what respects offstage life is similar to onstage life and to what extent it is profoundly different. Wilshire's phenomenological interpretation of role playing and identity argues that theater is an art of imitation that reveals imagination, whereas offstage role playing is a part of an ethical process by which the individual creates the self.

Wilshire is interested in the comparison of the social interactions of a cocktail party as an example of theaterlike behavior offstage in contrast to family behav-iors, which are probably, he maintains, the least theaterlike of everyday social behaviors. Goffman's examples of social interactions are generally drawn from the workplace and usually focus on public arenas. He discusses numerous fantastic con tricks. A memorable one is Virginia Woolf's role in the *Dreadnought Hoax,* in which she and some friends pass themselves off as a royal party containing two Abyssinian princes and are received by the admiral of a British flagship and invited to tea. Goffman does not often examine the social interactions of a family at home, and consequently, the examples he chooses tend to confirm a view that everyday life behaviors are marked by duplicity and provide layer upon layer

of facades, making it almost impossible to recognize an individual's identity and self. In fact, he reminds us that Robert Ezra Park writes, in *Race and Culture,* that the first meaning of the word *person* is *mask* and that it is in these everyday roles that we know one another. In saying this, Park attempts to show how our social selves are more masks than selves, more dramatic than lifelike.

Wilshire, in constrast, fully recognizes how theaterlike human activity is, but he sees it as the base on which we create identity. He grants that conduct at an urban cocktail party is very theaterlike. The more nearly the time span in life devoted to activity as "character" approximates the definiteness of the time span in theater allotted to character, the more nearly will the offstage behavior be theaterlike. In this regard, the cocktail party lasts for a relatively fixed time span of several hours, in which conversation, makeup, dress, and decor are developed to their highest. Because the guests are relatively unfamiliar with one anothers' true selves, it is easier for them to project an ideal image and not be inhibited by what others know about them. In the cocktail party, distancing and idealization enable the individuals to behave more like characters that actors portray in a staged play.

In *Frame Analysis,* when Goffman defines performance in the restricted theatrical sense, he calls it

> that arrangement which transforms an individual into a stage performer, the latter, in turn, being an object that can be looked at in the round and at length without offense, and looked to for engaging behavior, by persons in an "audience" role. . . . A line is ordinarily maintained between a staging area where the performance proper occurs and an audience region where the watchers are located. The central understanding is that the audience has neither the right nor the obligation to participate directly in the dramatic action occurring on the stage, although it may express appreciation throughout in a manner that can be treated as not occurring by the beings which the stage performers present onstage. At certain junctures the audience can openly give applause to the performers, receiving bows or the equivalent in return. And a special condition obtains in regard to number of participants: the performance as such is very little dependent on either the size of the cast or the size of the audience, although there are maxima set by the physical facts of sight and sound transmission. (124–25)

Goffman distinguishes performances according to their purity, which he measures by the degree of exclusiveness of attention they claim from their audience. Whether the audience pays, comes by invitation for no fee, or is drawn into the event by chance helps us to determine how exclusively an audience member's presence is involved in the performance. By this requirement plays, musical appearances, and nightclub acts are pure because they cannot take place without an audience and they lay full claim to the audience's attention, even though the audience may not pay attention to part of the performance.

Moving from pure performances toward more impure forms, Goffman cites contests presented for viewing since they take place in a sports ring or grounds rather than a stage; they require an audience and a take at the gate; and the players must act as though something beyond entertainment were at stake, although most frequently it is not the outcome of the contest that drives them. We all know that the degree of attention of spectators at a sport varies widely, from almost total attention (championship tennis) to very little watching.

Descending further down his ladder of impure performance types, Goffman includes personal ceremonies, such as weddings and funerals, at which the watchers are typically witnesses and guests who have come by invitation and pay no fee. Lower yet is the lecture or public briefing. The most impure form is work performance, in which people on the street watch construction workers or TV cameras shoot on-the-spot coverage of so-called news. In both these cases, the workers are unconcerned about the audience, but the onlookers treat the activity as though it were a performance.

CATEGORIES OF PERFORMANCE

We have just discussed Goffman's performance continuum with the most impure forms at one end and the purest at the other. Two other performance continuums may assist you in thinking about categories of performance. Figure 1.1 arranges performative events along a continuum from the individual to the collective. Figure 1.2 places performances drawn from ordinary, everyday experiences at one end and those drawn from the extraordinary at the other. Figure 1.2

FIGURE 1.1 Performance Continuum

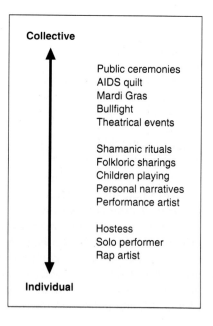

Collective

Public ceremonies
AIDS quilt
Mardi Gras
Bullfight
Theatrical events

Shamanic rituals
Folkloric sharings
Children playing
Personal narratives
Performance artist

Hostess
Solo performer
Rap artist

Individual

FIGURE 1.2 Performance Continuum

also uses various kinds of crosshatching to show you the ways in which cultural, aesthetic, and hybrid performances are classified. Literary performance, discussed in part III of this book, is a subset of the category we call aesthetic, using the term as it is defined by Western traditions of art. Look at figure 1.1 and figure 1.2, noticing the range of performance activities. These linear diagrams are in some ways inadequate to depict a very fluid process, that is, performance. The movement from the individual to the collective or from everyday life experiences to extraordinary experiences can be gradual or stark. Try to think of examples of different kinds of performance activities and consider where you would place them on these grids. What problems do you confront? As you read through this book, you may want to come back and consult these figures, considering how you would classify different performances by performance artists, for instance.

It is helpful to consider the functions served by performance when trying to determine what category of performance it best fits. Religious, political, aesthetic, psychological, and cultural performances can be distinguished from one another, while at the same time, some performance events serve multiple functions. For instance, a performance of Harvey Fierstein's *Torch Song Trilogy* can be seen as representative of a Broadway hit, highly theatricalized, highly artificial, a consciously constructed and enacted play. In this sense it is an aesthetic performance; its purpose is to be artistically pleasing, to be contemplated, to entertain and instruct. It is a work of art as defined by Western traditions of art. It has a literary text, and had we included it in this book, we could have placed it in part III, on literary performance.

Fierstein's play can also be seen as a cultural, ritual performance that brings members of the homosexual community together and permits a bonding and sense of cohesion to be solidified, buttressing this community and defining, in part, its identity and power. In this case, the purpose of the production is social and

polemical, and it is serving as a reinforcing cultural event for a marginal community. Through the rite of participation in this production, as actor or audience, homosexual identity is constructed and celebrated. In this regard, the audience is seen to be comprised of multiple constituencies who experience the production in significantly different ways. Had we chosen to analyze the work in this manner, the fact that it rests on a play text would have been subordinated to other issues, allowing us to discuss it in part II, on cultural performance.

This is another example of how performances can overlap categorical boundaries. In the Soviet Union before its breakup, a production like Jonas Jurisac's *Macbeth* permitted Jurisac, a dissident political activist, to subvert the party's Marxist interpretation of history and introduce his own subversive political statement, masked in a seemingly acceptable form. In both this case and Fierstein's, depending on how we frame the performance or how we describe its context, we see that it can function in different ways and be placed in different parts of our book.

Similarly, some of the work of performance artists like Robbie McCauley relates more closely to the practices examined in part II than it does to the practices of actors working with the kinds of texts considered in part III. All parts of this book examine performance—all involve actors or performers, texts and contexts, and audiences—and yet there are important differences among the approaches a performer takes to these different kinds of performance activities. For these and other pedagogical reasons, we chose this particular organizational structure for the book.

Notice that as we move toward the more collective end of the continuum, we find theatrical events, a bullfight, Mardi Gras, the AIDS quilt project, and public ceremonies. Can you appeal to the function of the performance in order to make finer discriminations? Do Mardi Gras and a staged play serve the same ends? Think again about the individual end of our performance continuum, the end where the performative activity often seems more like an ordinary life event than a highly organized, artificial one. Can you see how conversationalists who embed stories and roles in their discourse belong at this end? As the performance community enlarges to include more than one central or privileged performer in a performance event—distinguishing for now between the performer and the audience beyond the performer—we can place a performance of verbal art, or folklore, in our continuum. In each of these cases, a community of individuals engage in the performance event as participants and the boundary between performance and audience is blurred.

ELEMENTS OF PERFORMANCE: PERFORMER, TEXT, AUDIENCE, AND CONTEXT

Performative events require a *performer,* a *text,* an *audience,* and a *context.* At the base of all definitions of the performer is a performer who is a human, whose instrument is his or her own body. We prefer to refer to this person as a performer rather than an actor in order to have a broader term than the one that typically

refers to performers in the world of theater. Our term includes everyday role-players, performers who read aloud, interpreters, and actors. Sometimes we will use the words *actor* and *performer* interchangeably, but you need to remember the reason for the broader term. The performer lies at the intersection between text and context. The text can be literary or oral or gestural, but it must be essentially repeatable. Most commonly *text* refers to the book, play, or verbal transcription that the performer performs. It also can be expanded to include the ceremonies and rituals featured in a performance event. In its broadest sense, it can refer to a whole methodological field of meaning. For now, we are discussing its narrower sense. The audience can be as small as one, the performer, or as large as thousands, as in the Roman colosseum or at a modern rock concert. The context assists in clarifying the meaning of the performance by reference to essential events. *Context* includes the social, political, historical, psychological, and aesthetic factors that shape the way we understand the text. We will be discussing each of these elements in greater depth both in this chapter and throughout the book.

Let us consider the concept of text. Traditionally performers of oral interpretation and actors for the stage drew their texts from the literary canon, focusing on the "performance" or "reading aloud" of passages from novels, poems, plays, nonfiction, and occasionally essays. Students of oral interpretation, namely, students studying literature through the medium of performance, liken themselves in some ways to Homeric rhapsodes, reciters of Homer's epics, described in Plato's *Ion*. These ancient reciters valued the power of the spoken word. Orality predated literacy and infused a power in the spoken word that in some ways has been diminished in the age of literacy and postliteracy. Oral texts, therefore, as much as written ones, became the scripts for performance. Text, in this sense of the word, refers to the blueprint, usually written but not necessarily so, that is taken up by the performer or performers and enacted during the performance event.

We are using the word *text* in preference to *literature* or *dramatic play* because we want to include the breadth of performance materials embraced by the term. The term *text*, for our purposes, includes transcriptions of oral materials, be they folk tales, personal narratives, epics, or other forms of verbal art, as well as printed ones such as novels, plays, poems, and so forth. The text in performance is distinct from the performance event because the text simply provides a blueprint, some words, from which the performance will take its impetus; but the performance event includes the embodying or enacting of the text, and this enactment is a collaborative endeavor involving performer, text, director, other performers, and audience for its realization.

A performance may take as its starting point a literary or oral text, but the performance event reflects a realization of the text's interplay with bodies, directors, performers, and production concepts that gives the performance event its substance. A performance event based on an oral text also transcends the text, involving the active engagement of the performer's body and self interpreting the material while realizing it. We will discuss at great length alternative performance events based on the same text and we will also examine the way a performer and audience constitute a performance event. Our point now is that the text is

only a blueprint or script for performance. Further, the kinds of texts utilized in aesthetic and cultural performances vary, and we will be looking at personal texts; folk texts; sociocultural texts; aesthetic texts; and something called a *found* text, which often forms the basis for performance art.

There is another, even broader meaning of *text,* which we will discuss later. This use treats the word as if it were a methodological field, or a field of meanings, which assist us in understanding how works speak to works, texts to texts. For now, we are using *text* in a narrower sense, but later you will see how this expanded meaning functions.

Audience is another constitutive element of a performance event. Some critics have disputed whether it is accurate to consider the performer an audience member to his or her own performance, but we consider such disputes misguided. Any performer recognizes the way in which the self of the performer differs from the role of the character being performed. A performer also knows experientially the way in which one also knows, while immersed in what is called the *flow* of performance, that one is a performer. In other words, one distinguishes between the role one is in the midst of performing and the self-as-agent that is responsive to reactions. *Flow,* a term used by Mihaly Csikszentmihalyi, refers to the sense of being carried away, moved by forces beyond one's own control, quite the opposite of reflexivity, which also governs performance (38, 53–54).

All of you have probably experienced the sensation while performing of realizing that you have dropped a line or that distractions such as bright stage lights or street noises are interfering with your concentration and performance. Experienced performers constantly monitor their performance while in the midst of it, adjusting the performance and the role to accommodate the audience and the idealized version of the performance. A performer can also function as audience although an actor cannot stand in relation to his or her act as a painter to his or her painting. An actor, unlike the painter, is the instrument of his or her own art. The actor's body is his or her instrument, and so it is impossible for the actor to stand back and view the performance or work of art as a static object, whereas a painter can. It is true that repeated rehearsals allow a performer to ''monitor'' performance even while enacting it—and that this monitoring function can be understood as the performer-as-audience—but performers' inability to experience completely the performance as if they were outside of it does distinguish their role from that of the audience member, who is not the performer.

Further factors that help account for a performer's ability to function as an audience member to his or her own performance lie in the richness of a performative event during the preperformance and postperformance occurrences. In preperformance, the performer engages in improvisational activities, warm-ups, staged readings, and rehearsals, all the time evolving the performance, which is itself a mutable, constantly changing form. The performer uses bodily memory as well as cognitive faculties during this preperformance stage, through performance, and on into the postperformance experiences. In all stages, we can consider the performer as an audience of one, even in those performative events that are rehearsed and played for oneself but never shown to another. When the actor is performing, the actor is also recalling effects achieved during rehearsals,

warm-ups, and postperformance experiences from other performances. To the extent that performers are aware of these other experiences, it is as though they are being audience to their own performance act while in the very midst of acting.

The context of a performance event is defined by those factors, largely external to the performance itself, that help to answer these questions, What is going on in this performative experience? or What does it mean? When trying to differentiate between text and context, it is useful to think of their boundaries as elastic and likely to blur. Context is comprised of those events immediately available to the audience that are compatible with one kind of understanding of the performance event and incompatible with another. (In fashioning this definition, we are indebted to Goffman's useful definition of context in *Frame Analysis.*)

For example, if you were trying to analyze context in the theatrical tour de force, *Richard III,* performed by the Royal Shakespeare Company (RSC) in 1986 and starring Antony Sher as Richard, you would draw on other productions of Shakespeare's *Richard III* and almost certainly on Laurence Olivier's production, in which Richard's hunchback informed the way the actor carried his limb and affected a hunch throughout the entire production. In the RSC's production, the director exaggerated the handicap even further, making Anthony Sher appear like an arachnid, darting about the stage on a pair of hand irons typically worn by paraplegics or victims of multiple sclerosis. The wooden canes riveted to the wrist with steel bands enabled Sher to spring from place to place with an extraordinary and grotesque athleticism while eliciting the combination of repulsion and pity that often accompanies our reaction to a seriously handicapped individual. Of course, the choice to play Richard as nearly paraplegic was flagrantly anachronistic; it seemed to defy common sense and historical sense. How could a man who cried, "A horse! A horse! my kingdom for a horse!" be a paraplegic? Yet theatrically it was galvanizing and wildly successful.

In appealing to context to help illuminate this production, one would draw on not only the production history of *Richard III* but also on the biographical history of Anthony Sher as a performer and the shaping influence that rock music has on his personal performance style. Only an understanding of his immersion in rock music can rightly inform an audience's understanding of how context—the context of rock music and popular culture in the 1960s and 1970s—contributes to the RSC's production. In this instance, the events pertinent to the context cross time, draw from the musical world and the contemporary age of rock music, and also mingle high and low culture. If the text of the performance alone were the subject of analysis, of course we would attend to the written text of Shakespeare's play and also to the performance event for which the text is only a blueprint, as it unfolded as an ever-changing performance reality. And insofar as the event is theatrical, Western, traditional, and very much from the literary canon, it would be natural to consider these aspects of the event as intrinsic to it. The contextual events, however, lie outside the frame of the performance event and shape our understanding of it.

In our definition of context we are arguing that events that are immediately available to the audience and illuminate directorial choices and acting styles within the performance should be included, whereas all else is irrelevant to a consideration of context.

If you were to examine the converse of our definition of *context* and ask yourself what kinds of events would be excluded from it in the example of *Richard III*, you will understand that you should exclude immediately available events that would be incompatible with your understanding of the play. Can you think of events that are not, rightly speaking, features of the context of this particular performance event? Can you see how the analysis that we are suggesting requires that something inherent in the performance bear a relationship to the world of rock music? Other than martial music—the heralding of trumpets— the production we are discussing had no music; certainly, it had no rock music. The play was by Shakespeare and it was costumed in something that purported to be historical, period costuming. The inclusion of a discussion of the rock musical and music is only part of the context and not the text of this particular performance, if we grant that it is intrinsic to the performance event, and yet was not within the narrow boundaries of the performance event itself. In this case the production of the play itself and its visual and kinesthetic images are illuminated by reference to a context that lies temporally and spatially outside of the play as it was performed for a number of seasons at the Barbican Theater in London. In addition, it is only because the production itself suggested an intermingling of high and low culture that it is relevant to include pop culture and rock music as part of the context of this performance.

A set of legitimate events to be included in context would be those that contribute to the occasion of the production or performance event. We shall refine our definition of context to say that it refers to events, institutions, or factors that are immediately available and that assist us in answering the question, What does this performance event mean? They might include an appeal to the institutions that give rise to art, the patrons that support it, the people who attend it, and the temporal-spatial dimensions granted to it, both literally and figuratively. Here, you can see that the events included in the frame of context are broadening. Qualities intrinsic to either the production or the play are part of text. The institutional framework, which helps us understand the performance event, and modes of production—how it is advertised, mounted, and so on—are contextual features. Such matters as the cultural definitions of art, the political factors that define it, the ideology that bears on it, and economic factors that provide its underpinnings all properly belong to context. These contextual matters may be largely external to textual boundaries and to the performance event, but frequently they are deeply connected, and boundaries between texts and contexts blur.

ORIGINS OF HUMAN PERFORMANCE

Performance theorists have been intrigued by people's tendencies to imitate. As we mentioned earlier, they have often looked to the behavior of animals to assist their understanding of human performance modes. Charles Darwin argued that animal behaviors are connected through evolution to human behavior. You may have read some of Konrad Lorenz's behavioristic studies of wolves, Jane Lawick Goodall's studies of the ceremonial greetings of chimpanzees, or more recent

studies of the behavior of seals and whales. All point to the capacity of animals to display themselves in patterned actions, which others in their group mimic. Some talk of instinctual behaviors such as the triumphal dance of geese; the mating dance of swans; or the wolves' combat, in which the defeated wolf bares its neck to its attacker in symbol of surrender, bringing the fight to conclusion without death and validating the superior territorial claim of the male wolf who is victorious. The ethnologists describing these animal behaviors consider them performances and remark on their instinctual character. These animal performance rites serve as prototypes for human celebratory and theatrical performances. These animal behaviors are all marked by

1. A gathering of bands, some members being featured participants whereas the rest act like an audience or witnesses, only occasionally joining in, although the roles often shift
2. Behavior that seems to entertain as well as serve efficacious purposes, be it to mate, to eat, to fight, or to mark territory
3. A diversion of aggressive behavior into more playful behaviors
4. A marking off of a natural space to be used for the duration of the ceremonial behavior
5. Rhythmic behavior, often including drumming and dancing and accompanied by vocalization
6. A pattern of movement, which Schechner calls *gathering, performing,* and *dispersing*

Can you see how these animal behaviors relate to theatrical behavior and concepts, such as sacred space, the theater, the audience, and the structure of performative events—with a clear beginning, middle, and end—and to preperformance, performance, and postperformance behaviors? Many cultural performances, ranging from parades, political marches, and funeral processions to graduation and wedding processions, are tightly connected to the structure of gathering, performing, and dispersing found in animal rites. Performance theorists like Turner in *On the Edge of the Bush,* Schechner, Henry Louis Gates, Jr., and Gregory Bateson write about the ways in which these animal performances are like and unlike people's performative acts. They examine how natural ceremonial spaces utilized by animals are transformed into cultural, ritual, and theatrical spaces by human communities, each with its own implications on performance modes.

Can you think of examples of human performances that mimic animal behaviors? Are you familiar with strutting and display, which often accompany dance routines, or playing the dozens, in which competitors vie with one another for attention, exhibiting themselves in ways that resemble the mating dances of geese? Discuss other examples in which human rituals seem to be closely related to instinctual animal behaviors.

Turner was intrigued by the possibility of discovering a psychogenic and neurogenic basis for what he called *communitas,* a kind of human interrelatedness achieved during one of the stages of the ritual process. We will discuss it at greater length in part II. Turner's interests in neuroscience and certain states of heightened

activity, which are often referred to as flow, as well as the sense of whole-ness and mystery so often attendant with mythic consciousness are highly speculative. However, it is fascinating, and it does hold promise for explaining the features of ritual that animals and humans share through the similarity of brain structure.

Instinctive animal behavior is different from human performances, which share some of the same animal characteristics of patterning, heightened intensity, display, and spatial and temporal marking. In part III we will explore the relation-ship between play and performance, and you will see how Bateson's study of animals contributed to his understanding of play and how in turn it influenced performance theorists. We also turn to the subject of animal ritualistic behavior to remind you that although our spectrum of performance activity runs from the individual to the collective and from everyday life to institutionalized perfor-mances, the continuum also implies that human performance is something separate from animal behavior. In important ways it is. On the one hand, we simply do not have a sufficient understanding of the evolutionary chain or the brain to attempt a scientific explanation of performance. On the other hand, few have inquired into human performance behaviors without reference to both nature and the animal world. Aristotle grounded drama in a human's instinct to mime. Paleolithic cave art and prehistoric deer-hunting performances provide evidence that play and performance are simultaneously present not only in infant behavior but also in the origins of humankind.

Aristotle also stated that the function of the aesthetic performance is to please and instruct. We should add that the pleasure and instruction so imparted by this kind of imitation are achieved in accordance with how the culture defines art. This is not the place for a lengthy discussion of what is art. The qualities of art are not intrinsic to the object—that is, they do not lie within the object, making it inherently art. Rather the qualities of what we call art are constructed though a process of negotiation involving the artist, artwork, audience, and culture. This is to say that art in Western culture is art because our traditions have defined certain objects or acts as artistic.

When Andy Warhol focused his camera on a sleeping body for more than eight hours, the film made from this experiment, entitled *Sleep,* was called art. The natural human sleeping figure lacks intrinsic artistic qualities, but the work was declared to be art because it was framed in a film, which was called an art film and viewed by an audience who treated the sleeping body not as a natural figure sleeping but as an art object. Warhol, through a process of negotiation and cultural conditioning, established himself as the artist and made his film an artwork. The act of delineating miles of a natural landscape and calling it art is another phenomenon with which some of you may be familiar. Again, it is not that the natural object is suddenly other than a natural object, with natural beauty or ugliness; rather it is that the delineation of it as art has, for a while, made it so. Consequently, we are defining aesthetic performances in part by their function, and we are saying that this function is something that is negotiated among the artist, the work, and the public.

DIFFERENCES BETWEEN THEATER
AND EVERYDAY LIFE PERFORMANCE

Performance scholars stress the differences between theatrical elements of role playing in everyday life and the playing of roles by actors. One difference is that the everyday life performer very often has no fixed text. Social clichés may seem scripted; we know how to ask about the weather or how someone is feeling, but these banal social conventions cover only a few sequenced utterances. The phrasing can vary; it is not sustained over an extended length of time, even when mastered by the most gifted conversationalist. Much of the discourse is improvised and, aside from the shortest, is rarely repeated exactly from one performative situation in life to another. Theatrical events also are based on improvisation, and some have no set text, but the bulk of Western theatrical art does have a text and makes only limited use of improvisation.

Another theaterlike characteristic of everyday performance is the repeatability of the sequence of activity that constitutes the everyday role. However, if you as a performer practice observing and then "performing" a strip of everyday life experience, you will quickly discover important differences between how repeatable the sequence is in the two kinds of activity. Performance of literature binds you to a text that is unchanging even though you only use it as a blueprint for your performance, which does change. The actor usually prepares a role by repeating the text on numerous occasions in rehearsal, memorizing it for the final public run. The actor of a literary text learns a character's role, and no matter how empathic the actor becomes with the character in the literary text, the role of the character is quite clearly separable from the person of the actor.

In the everyday life performance experience, a person often repeats a personal story or a joke, retelling it again and again in a manner not too dissimilar to that of the actor rehearsing a set text. But in life, generally, the story is being recalled from memory, not from a written text. Nor is it necessary that each telling try to replicate exactly the sequence of words, gestures, and so on that constitute the story. In fact, much of the richness of the everyday life role lies in its variety and its ability to appropriate new elements and accommodate change. In addition, very often the everyday life role is not so clearly separable from the person who plays it. The performer of the literary text is usually in the realm of make-believe. Turner and Schechner describe this realm by saying that the actors are in the subjunctive mode, the mode of *as if,* and their behavior is playful in the way that imagined and make-believe behaviors are put on. The actors playing the as-if role know that the role is not their own. However, in everyday life, the performer is not so clearly separated from the role.

Another important distinction between an actor's performance and everyday performance is that the former is highly self-conscious and is played for an audience who generally must remain a passive witness of the event rather than an overt, unpredictable interrupter of the part. Although recent theatrical performances do depend on audience participation—some, like street theater or happenings, actually use audience members as players—for the most part an actor's role will

be performed for and to an audience, will assume the convention of the fourth wall, and will be performed in a specified space for a relatively fixed interval of time. Furthermore, the actor or performer *intends* to perform, and this element of *intentionality* further distinguishes the performances from those of the waiter or flirt. The waiter and flirt do not consciously intend to be doing something other than what they are doing, executing a job or engaging in a social situation. Neither intends to play a role in which the audience must sharply appreciate that the role is put on, that the player is not the character, and that the performance belongs in the domain of the imaginary and should not be confused with real life.

Finally, the actor has a trained body and voice and draws on some of the stocks of the trade such as makeup, costume, or lights to enhance the playacting, treating the instrumentality of the performance—namely, the body, voice, movement, and so forth—as something that must be trained and refined to be effective. The actor and performer of art in Western culture draw on native talent and acquire through training and rehearsal the techniques of an art form. The everyday life performance, such as personal narratives and folk tales, also involves training, practice, repetition, and rehearsal. When you encounter a seasoned storyteller or jokester in social situations, you can tell that that performer has told the tale many times before, perfecting the delivery and timing. But less accomplished storytelling or everyday roles also take place, and these performances are more "artless."

In this regard, although all humans are performers, not all are accomplished actors. All of you can perform, not necessarily finally in order to be actors but rather in order to heighten your understanding and abilities in the performative modes. The experience of performing itself is a way of knowing, of learning about yourself and your culture and of understanding verbal texts that originated in oral culture and only recently became set in script, then print, and finally computer print. Performances teach you the experimental power of language and involve you actively in a process of creation through performance.

Therefore, when we define the performer of theatrical performances, we mean that the performer (1) intends to perform; (2) performs for an audience; (3) performs in a space specifically designated for performance, with fixed boundaries; (4) uses his or her body as an instrument of the performance, often training it rigorously to be able to execute the movements and vocalizations required by the performance; and (5) performs for a fixed and relatively stable length of time. As you can see, for each of these items the behavior of the performer in this theatrical performance is noticeably different in degree, but not in kind, from the performance behavior of the individual in everyday life.

Many everyday life performances do not involve intentionality as we have defined it. Part of the intention is not to be seen to be performing. Both kinds of performances involve others who are audience members, but the behavior of the audience, so to speak, in the everyday life interaction is far more unpredictable than the behavior of the audience of theatrical performances. The spatial and temporal features of performance in everyday life and in the theater are also often dissimilar. The everyday life performance is often very brief and very fluid and can be enacted in numerous spaces, many of which do not have

boundaries as fixed as those that characterize theatrical performances. The playing space for the ensemble is generally sharply delineated. Usually the audience does not cross into the sacred space of the performers. This is often not the case in everyday life performance, whether in the workplace, the drawing room, or outside. The performance takes place in any space inhabited by the individual. There is a sense of who is "onstage" and who is not, and the everyday performer's "space" will be respected, but the barriers and boundaries of the performance space are often fluid. In theatrical performance, the requirements of space are far more rigid and specific. Similarly, the period of hours generally set aside for a theatrical performance also places more rigorous requirements of attention on both the audience and the performer. The concentration of the performer is markedly more intense than that of the performer in everyday life. The audience's ability to not attend to much of the performance in everyday life is greater than in a theatrical performance, where the audience can certainly elect not to come or to doze off, but the requirement of the performer is to hold attention as much as possible. Although the performer in everyday life who focuses his or her performances on only one other individual may well achieve a higher level of attention, that performer also faces a greater likelihood of interruption. In theatrical performance this risk is diminished.

CEREMONIAL PERFORMANCE

If we now consider another kind of performance drawn from the collective end of our performative continuum, namely, public, cultural, ceremonial performances, we will see that a different set of criteria apply to define the performer and the performance. The performer in Mardi Gras, a bullfight, an ERA march, or a healing ritual can be defined as someone whose performance is intentional. These public ceremonies are designed to feature public display and exhibition, and the participants are consciously aware that they are part of something that intends to be seen as performance, even the performer who seems most like an ordinary person in everyday life; for example, the straggler in an ERA demonstration, wearing her feminist T-shirt and walking with the march, is conscious that she is taking part in a collective event, giving a different intentionality to her actions, which otherwise might be interchangeable with walking down the street in a T-shirt. In this case, however, she does employ a costume and she utilizes a number of other rhetorical signs to signal that she is a player in a ceremony and that her behavior is to be seen as such. In the case of the Mardi Gras, there are different levels of performers, from the performer who is simply the partygoer, come to be festive and uninhibited, and the performer elaborately decked out in a costume, acting the harlequin. Both performers intend to perform, but again, the nature of the intentionality varies in degree. These cultural performances also involve an audience, but often the boundaries between audience and participants are blurred, whereas in theatrical performance, the lines of demarcation and the distribution of roles are more precise.

Also, the cultural ceremonies occur in designated places. Again, as the event becomes larger, involving both larger numbers and vaster spaces—for example,

Mardi Gras versus the wrestling match—the terrain of the performance and the boundaries between performing and nonperforming areas are less clear. The wrestling ring and sports arena are not unlike theatrical spaces. But the streets of an entire city, even though they are marked off for the large performance, blur at the outer margins. Similarly, the time of the beginning, middle, and end of the performances might become more obscure. In cultural performances, the bodies of the performers are their instruments, but the degree of training of the body as instrument is most rigorous for those figures who are privileged in the performance—for example, the bullfighter or the harlequin—whereas the participant performers probably alter their behavior and train their bodies very little for the event.

The duration of the event is another criterion that often distinguishes the cultural performance from the theatrical one. The time spanned in cultural events varies widely, from the sports match, usually roughly equivalent to the length of the typical play, to the Mardi Gras, which may go on for days.

Finally, the functions of cultural performances differ from theatrical performances. The latter, with their heightened aesthetic qualities, need to be understood in the context of the late eighteenth-century understanding of the word *aesthetic* in Western art. These theatrical conventions and narrow definitions of aesthetic depend on the public's acquiescence in a negotiated definition of what constitutes art. In Greco-Roman, Euroamerican traditions of art, art is something set apart from ordinary living and working. It is a product of leisure; its modes of production make it largely a middle-class or upper-class phenomenon; and generally it is not given utilitarian value but rather is valued for its purported beauty and for the pleasure it arouses.

Cultural performances, in contrast, particularly those of the public kind we are now considering, may involve aesthetic aspects—decoration, adornment, display, and beauty—but these properties are put at the service of the culture, and the ceremony is designed principally to reinforce cultural values and to solidify social organization or stimulate political action, rather than principally to please and entertain. The relationship between the performers in the collective performances is one that blurs the boundaries between privileged performers and participant performers and involves the collectivity as a whole more actively than in most of the aesthetic performances we are considering. In other words, it is the function of the performance that sets it apart.

PERFORMANCE ART

Performance art is very recent, having its origins in futurist and dadaist performances beginning in 1909 and coming into its own with the name of performance art in the late 1960s. Performance art mingles elements from popular entertainment with elements of so-called "high art." It emphasizes a visual image, often also drawing on the visual arts, sculpture, media art, and dance, as well as on theater. Currently it is thriving in many cities across the United States, although for about a decade it was most visible in New York and California. Many

of you may not have seen any performance art; others will be familiar with such figures as Spalding Gray, Karen Finley, Eleanor Antin, Judy Chicago, and others.

We classify performance art as a hybrid, on the basis of both its function and the texts it uses. Performance art can serve predominantly aesthetic ends, or it can function to produce social and political change. Its texts can be loosely improvisatory, relying on environments and chance and other elements of indeterminacy as well as on so-called *found* objects, or it can derive from tightly scripted works typical of literature. In part IV we will inquire more closely into this hybrid form of performance, showing both its sociocultural functions and its aesthetic performance features.

We think you will find this mode of performance challenging, and many of you may find it a useful way to enlarge your performance vocabulary, strengthening your sense of how to manipulate your body and the image in performance. One particularly appealing facet of performance art is that is allows performers to develop their own scripts, often relying heavily on the principle of collage, and make their own statements. Feminist performers and various ethnic performers have found this a powerful tool in producing social change. Often performance art takes the form of an intervention and challenges prevailing values and institutions.

SOME ETHICAL CONSIDERATIONS

Finally, let us say a little more about some of the ethical dilemmas that may confront you as performers in cultural and literary performances and performance art. As performers of cultural materials, you will be trying to grasp the point of view of others. They may be so-called common folk or they may be representatives of different minority cultures and ethnic groups. Often you may be working with intercultural texts. Some cultural materials call on you to acquire the perspective of people marginalized in our society. Whereas much Western theatrical art employs a convention that asks the *audience* to be sufficiently distanced from the material to observe it without becoming actively caught up in it, in some performance of cultural materials you are trying to close this distance and give yourself over to the experiences of others, no matter how hard or messy the task may be. Those writers, like James Joyce, who hold that the highest aesthetic emotion that art should excite is static do not want art to excite erotic desire, for example, because they maintain that too much desire distorts the perspective of the viewer, marring the artistic experience. In cultural performance and in some forms of theatrical performance (e.g., Brecht's theater) and performance art, this idea about aesthetic distance is inappropriate, if not downright counterproductive. This kind of performance wants to produce social change. Some of it wants to violate or challenge certain assumptions about performance, aesthetics, and techniques. In these cases, it is more important to achieve cultural understanding than to respect artistic conventions. You will want to discuss the purposes of performance. Why are we doing cultural and literary performances? Within the various categories, what are the performers' goals?

Performers who try to take cultural performances to public arenas may well subject themselves to very hostile audiences. Some of the hostility stems from the beliefs of some viewers that the performer has transgressed and invaded the privacy of others in impermissible ways. Think about the arguments of some blacks who claim that only a black person can know black experience; consequently, they condemn the outsider who presumes on a culture he or she does not know. Similarly, some feminists resent men who take over their material. How are you going to engage responsibly in this criticism and involve yourself in the task of cultural performance? You cannot do so without having to address questions of your own motives as well as questions that are ideological and political in nature. We will be discussing these kinds of questions in connection with the various texts and performances throughout the book. You may find that they arise in your classroom in the course of your performances.

Dwight Conquergood, an ethnographer who has studied Lao and Hmong refugees in Chicago, outlined what he called "four ethical pitfalls, performative stances towards the other that are morally problematic" (4): "The Custodian's Rip-off," "The Enthusiast's Infatuation," "The Skeptic's Cop-out," and "The Curator's Exhibitionism." In the center, he charted the fifth performative stance, naming it "Dialogical Performance" and identifying it as genuinely moral. He represented the stances with a moral graph, reproduced in figure 1.3. The vertical axis is the pull between identity and difference; the horizontal axis is

FIGURE 1.3 Moral Mapping of Performative Stances Towards the Other

SOURCE: Dwight Conquergood, "Performing as a Moral Act: Ethical Dimensions of the Ethnography of Performance," *Literature in Performance,* April, 1985: 5. Ed. by Mary Frances Hopkins. Published by Interpretation Division, Speech Communication Association. Reprinted by Permission.

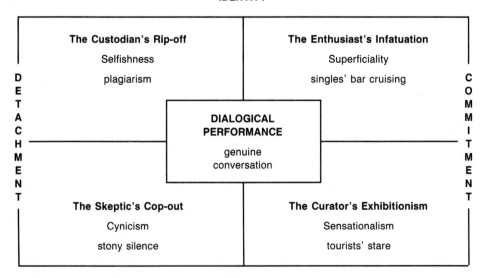

the pull between detachment and commitment. The center represents the goal of a morally centered performance, one that is dynamic and dialogical, holding the poles in balance.

Look at the brief descriptors Conquergood provides for each of his morally delinquent stances. Can you flesh out the diagram, pointing to illustrations of the four performance stances described? The custodian's stance is marked by acquisitiveness and detachment, so much so that Conquergood likens this unambiguous relationship to a theft or rape. The enthusiast's infatuation is marred by excesses of an opposite kind: being too quick and facile at achieving an identification with the other. The enthusiast trivializes the experience of the other, glossing over important differences in the zeal to generalize. The skeptic is imprisoned by detachment and difference. Standing back and scoffing at the other, the skeptic boldly pronounces that he or she stands above and outside the phenomenon being studied, too pure and too detached to engage in it. Conquergood condemns this skeptic as a moral coward, afraid to risk the encounter with the other. The curator's exhibitionism reveals itself in exoticism and romantic notions of the noble savage. So convinced of difference is the curator that his or her performances resemble picture postcards or tourist souvenirs or mute, staring museum exhibitions that deny humanity to the subjects.

The dialogical stance that Conquergood celebrates is one that

> struggles to bring together different voices, world views, value systems, and beliefs so that they can have a conversation with one another. The aim of dialogical performance is to bring self and other together so that they can question, debate, and challenge one another. It is a kind of performance that resists conclusions, it is intensely committed to keeping the dialogue between performer and text open and ongoing. Dialogical understanding does not end with empathy. There is always enough appreciation for difference so that the text can interrogate, rather than dissolve into, the performer. . . . Dialogical performance is a way of having intimate conversation with other people and other cultures. Instead of speaking about them, one speaks to and with them. (9, 10)

Literary performance and performance art raise some other ethical issues, and they also involve some of the same problems discussed earlier. When you begin selecting texts for performance and take on characteristics of others not like yourself, you will begin to see some of the personal and ethical questions the material may pose, depending on the composition of the class and the cluster of issues explored in the material. We have seen classes in which students performed from the Bible, selecting passages in which they deeply believe. Others in the class challenged some of these performances, claiming that they were homophobic or antifeminist or in violation of other religious beliefs deeply held in the class. Often discussion follows in which students question whether the performer ought to have selected the material. Students have vigorously accused the performer and questioned the belief system behind the performance. In these cases, performers must be humble and sensitive to their own prejudices and

beliefs. Discuss among yourselves some performances you have seen that raised ethical questions for you.

In part IV you will discover that performance art can explore very raw veins of feeling. Not only do lively issues involving pornography and censorship often attend this art form, but it also poses questions involving ownership of property and conventional ideas about plagiarism.

Throughout the course of this book, while you as performers engage different texts and different people who lie behind these texts, keep Conquergood's moral diagram and these other issues in mind. Think about your own performance stance and whether or not you think this explanation of the dangers performers encounter when grappling with the material of others is just.

CONCLUSION

So far we have been comparing everyday performances with theatrical ones, and we have been considering how drama illuminates life and, conversely, how life influences drama. Our performance continuum has everyday life and relatively private, individual performances on one end and collective, highly organized public performances—be they plays, sports matches, or public ceremonies—on the other. We have differentiated between performances whose texts are socio-cultural from those that are either personal or aesthetic, and in making this distinction, we have appealed to the function of the performance. We have also acknowledged that the study of performance behaviors has commonly examined the connective tissue between ritual and theater and that a study of rituals in cultures has often led to comparisons between human ritualistic behavior and that of animals.

To conclude, then, throughout this book you will be examining different kinds of performance events, either cultural, literary, or performance art. You will be looking at these performance events from a dual perspective: as a potential performer of the performance event and as a student of the event. As a performer, you will be interested in performing various texts to which we introduce you and others you select yourself. As a student of performance studies, you will become conversant with the meaning imparted by performative behaviors. You will learn to analyze them, considering the functions they serve, the belief systems on which they rest, the vocabulary by which they can be described, and the pleasures they can afford. We will introduce you to the different kinds of performance by an appeal to the developmental model as it applies to the individual in society. From the point of view of this developmental model, performance begins in play, moves to the construction of selves, includes the other through dialogue, and finally acquires the roundedness and fullness of voice as it is experienced in the most advanced stage of the development of the performing self. Consequently, within each unit, we have organized the discussion around these stages in the developmental process, whose end product is a performing self in a community of others.

WORKS CITED

Bateson, Gregory. *Steps to an Ecology of Mind.* New York: Ballantine, 1972.

Burke, Kenneth. *A Grammar of Motives.* 1945. Berkeley: U of California P, 1969.

Conquergood, Dwight. "Performing as a Moral Act: Ethical Dimensions of the Ethnography of Performance." *Literature in Performance* 5.2 (1985): 1–13.

Csikszentmihalyi, Mihaly. *Beyond Boredom and Anxiety.* San Francisco: Jossey-Bass, 1975.

Fierstein, Harvey. *Torch Song Trilogy.* New York: Gay P of New York, 1979.

Gates, Henry Louis, Jr. *The Signifying Monkey: A Theory of African-American Literary Criticism.* New York: Oxford, 1988.

Goffman, Erving. *Frame Analysis.* 1974. Boston: Northeastern UP, 1986.

———. *The Presentation of Self in Everyday Life.* 1959. Woodstock: Overlook, 1973.

Park, Robert Ezra. *Race and Culture.* Glencoe, IL: Free, 1950.

Sartre, Jean-Paul. *Being and Nothingness.* 1956. Trans. Hazel E. Barnes. New York: Quokka, 1978.

Schechner, Richard. *Between Theater and Anthropology.* Philadelphia: U of Pennsylvania P, 1985.

Turner, Victor. *From Ritual to Theatre: The Human Seriousness of Play.* New York: PAJ Publications, 1982.

———. *On the Edge of the Bush: Anthropology as Experience.* Tucson: U of Arizona P, 1985.

Wilshire, Bruce. *Role Playing and Identity: The Limits of Theatre as Metaphor.* Bloomington: Indiana UP, 1982.

FOR FURTHER READING

The Graff, Pelias, Strine, and Thompson citations below provide background information about the disciplines of interpretation and performance studies. In addition, the journal *Text and Performance Quarterly (TPQ),* published by Speech Communication Association, is an invaluable resource of writings in these fields.

Barthes, Roland. "From Work to Text." *Textual Strategies: Perspectives in Post-Structuralist Criticism.* Ed. J. V. Harari. Ithaca: Cornell UP, 1979.

Geertz, Clifford. *The Interpretation of Cultures.* New York: Basic, 1973.

Goffman, Erving. *Forms of Talk.* Philadelphia: U of Pennsylvania P, 1981.

Graff, Gerald. *Professing Literature: An Institutional History.* Chicago: U of Chicago P, 1987.

Huizinga, Johan. *Homo Ludens.* 1938. New York: Harper, 1970.

Pelias, Ronald J., and James VanOosting. "A Paradigm for Performance Studies." *The Quarterly Journal of Speech* 73 (1987): 219–31.

Strine, Mary Susan, Beverly Whitaker Long, and Mary Frances HopKins. "Research in Interpretation and Performance Studies: Trends, Issues, Priorities." *Speech Communication: Essays to Commemorate the 75th Anniversary of the Speech Communication Association.* Ed. Gerald M. Phillips and Julia T. Wood. Carbondale and Edwardsville: Southern Illinois UP, 1990. 181–204.

Thompson, David W., ed. *Performance of Literature in Historical Perspectives.* Lanham: UP of America, 1983.

Turner, Victor W. *Dramas, Fields, and Metaphors.* Ithaca: Cornell UP, 1974.

Turner, Victor W., and E. M. Bruner. *The Anthropology of Experience.* Urbana: U of Illinois P, 1986.

PART II
Cultural Performance

CHAPTER 2

The Personal Narrative and the Performance of Ethnography

Our exploration of cultural performance will begin with an examination of personal narratives and the problems involved in collecting and performing them. All of us routinely tell stories in ordinary conversations with our friends, peers, or family members as well as larger, more impersonal audiences. These stories— known as *personal narratives*—are spoken in social discourse and originate in an oral medium. They are part of an act of communication and an example of theatricality in everyday life. Constituted in a communal process, they tell about personal, lived experience in a way that assists in the construction of identity, reinforces or challenges private and public belief systems and values, and either resists or reinforces the dominant cultural practices of the community in which the narrative event occurs. The personal narrative very often gives the teller as well as the hearer a sense of value, cohesion, and empowerment.

In these personal narratives, we speak about ourselves and our experiences and how these experiences affect us. We tell these stories to others, the listeners or collaborators, often at the instigation of a group who call on us to tell about ourselves not only because our stories are relevant to ourselves but also because they are desired by the listener, who finds in the telling what Kenneth Burke referred to as "equipment for living." These narratives are also one of the ways in which we perform culture, and in this respect they reveal cultural practices and invite us to view them as a part of both social and political processes.

To understand fully this narrative practice, we must examine the particular, concrete relationships between performer and audience and text and context in the material, *situated* moment of performance. We must also consider the problems of collecting materials for performance and the research issues involved in collecting. The writer Zora Neale Hurston has an appealing way of defining *research.* In *Dust Tracks on a Road,* she refers to it as "formalized curiosity. It is poking and prying with a purpose" (127). An important component of

research is also what one of our colleagues, Lee Roloff, called "the me-search in the research." We search to discover things about ourselves at the same time as we learn about the subject of our study. When you begin to collect personal narratives and perform them you will discover how your own role as a collector, a researcher, bears on your performances.

We said that you need to understand the "material, situated" moment of performance. By situated, we mean that the personal narrative occurs in a specific local setting and in a particular historical time. Both the regional place and the historical moment function as constitutive elements in the social practice of personal narrative. The narrated events in the story are site specific, but the tellings of the story are not necessarily at the same site at all tellings; in fact, usually they are not. We use the word *material* to point to the textures, human properties, worldly objects, and historically rooted moment of the telling, whether the first telling or subsequent ones.

Try to think about situations in which you have participated in the production of a personal narrative. What are the kinds of stories you tell? What kinds of events structure them? What is your relationship as the speaker to the story you tell? What kind of circumstances and personal interactions between members of a group permit the production of a story? How does the social context shape what can and cannot be told? To help start your thinking about this kind of informal, oral production of stories, let us look at the recollections of one of the authors, Carol Simpson Stern, of a personal narrative and the context in which it occurred. We will also look at other kinds of personal narratives before offering a fuller definition of the term.

Personal narratives are rooted in everyday experience, some very familiar, some seemingly extraordinary. The experiences range from those that seem incidental and of little importance to those that are considered to be highly important and dramatic. Although there is a basis in fact for personal narratives, there is also a healthy component of invention. The personal narrative always describes something that has happened and it shows the relevance of this happening, both to the individual speaker (or speakers), who relates the story in the first person, and to the group that listens to it. It tries to leave the impression that the account is "true" and rooted in an actual incident that happened to the speaker, but the very process of reporting during the narration is a form of mediation interposed between the speaker, who speaks in the present, and the narrated event that has happened as a fact in the real world in a different temporal moment in the past. To understand these narratives we have to recognize both the social process that gives rise to them and the ways in which the speakers function simultaneously to express their individuality while also speaking as a social person, conveying collective values. You will see how the participants in personal narrative can be understood as performers of culture.

A PERSONAL NARRATIVE FROM
EVERYDAY LIFE—AN EXAMPLE

Let us turn now to our example. Stern traveled to Haiti in the mid-1960s. While on vacation with her husband, both were arrested when they drove late at night

too close to the presidential palace of Duvalier. They did not know that there was a curfew prohibiting driving on the palace grounds after 6:00 P.M. Several weeks earlier there had been a little-publicized episode involving students who had tried to bomb the palace. They had been arrested and a curfew was imposed. It was a time of considerable social unrest in Haiti, and there were rumors that the U.S. Central Intelligence Agency (CIA) was losing patience with Duvalier's regime and was perhaps instigating plots to overthrow him.

Stern and her husband, in the company of two friends and driving in a car that also contained a Haitian tour guide whom one of their friends had hired, were arrested on the grounds of the palace. They were held in a barracks for several hours, interrogated at gunpoint, and eventually released with the understanding that they had to remain in the country for 10 days and that they would be subject to police surveillance. The episode itself at the time was terrifying. As it unfolded, they were bewildered to find themselves growing accustomed to living in a virtual police state. Within a matter of days, they had actually co-opted one of the pair of palace guards assigned to watch them, members of the Tonton Macoutes, and were taken to many tourist spots by the guards, who began to act like extremely knowledgeable tour guides. You can imagine that upon safely returning to the United States, they were eager to tell their story.

Now safe and with the events sufficiently behind them, Stern and her husband recounted their personal narrative in their living room to her sister and husband. Animated by the attention given them by their kin, each interrupted the other, vying for authorship of the story and embellishing details in ways that had not occurred to them before the performative moment of this personal narrative.

We cannot here recount the narrative in its various forms because, of course, it lived in oral tellings and was never recorded. The story grew incrementally; it became part of their repertory of personal stories that they would tell again and again, sometimes initiated by themselves, at other times in response to a request. In subsequent tellings, some of the versions led others to take off from the story, offering their own narratives and deflecting the story in such a way that the group interactions were no longer directed toward the events in Haiti but rather became a kind of contest in which certain individuals challenged the story and its meaning to try to displace the narrative and advance social change. This illustration suffers from the fact that you are not confronting the performative moment in its immediacy, and consequently much is lost. Later in this chapter we will discuss how to go about studying this kind of performative phenomenon, and the contextual features of the story as well as its performative dimensions will become clearer.

This example of the Sterns' personal narrative concerns something extraordinary that has happened to the tellers. In this case, it is difficult to attribute the telling to either person; both originally shaped the story in a kind of collaboration; both were also markedly influenced by the social company they kept. They told the story to family members, members who shared their zeal for travel and excitement, and also members that openly acknowledged their love of "hearing stories." They had planned to come together socially for the purpose of sharing personal tales of their trip. The story was originally told in their home, an intimate, domestic setting. It was set in ordinary conversational language. The

event was communal in the sense that it involved the interactions of a group of family members who saw themselves as part of a cohesive social unit.

At the time they constructed their telling, distance and time had separated them from the immediacy of the events, from the fear aroused by being arrested in a foreign country and subjected to the force wielded by the police. The two principal speakers and tellers of the story can be seen as performers of themselves, their sense of who they are, how they function, and how they came to make sense of the frightening circumstances in which they found themselves. They can also be seen as conveyors of collective, social selves and participants in the processes of culture. In some later tellings, when the story was more distributed among interacting listeners not sharing the same cultural values, the narrative began to function differently. The participants were empowered in competing ways. The story functioned less as a sharing of an individual event and more as an object to be critiqued, appropriated, and constructed for different social and political ends. Although the Sterns still had a fair share of control over the narrative, whether the story would actually be told or not was always constrained by numerous cultural, social, and personal values and attitudes.

Each of the shapers of the personal story prided themselves on their storytelling abilities, but each was also needing to talk about a personal experience rooted in fact. The experience had been frightening and had called into question many of their assumptions about themselves and how they would react under pressure. Each had strong views about which details should be included in the story, how each of them were to be represented, and how much they actually wished to confess. And, too, the expectation and prodding of their family members propelled the story forward.

It is important to note two observations drawn from this example. First, the story was told in ordinary conversation. However, the way in which it was told, the language used, the kind of structuring that was given to the events, reflected the speakers' familiarity with print culture and the form narratives take when they become the stuff of literature. Their story arose in an oral circumstance and it was conveyed in social discourse, but it bore the marks of a literate culture, and the technologies of print are one of the contextual features that will help us understand this kind of personal narrative.

We will have more to say about the contrast between cultures that are predominantly oral and rely on oral traditions as their principal means of communication and those that use the technologies of writing and print or, later, electronics and how these radically different communication practices shape perception and constitute meaning. When we talk of an *orally centered culture,* we refer to one in which meaningful action is primarily shaped by oral, not written, modes of communication. We do not mean that the culture is one in which writing and reading do not take place. In orally centered cultures, performance is valued above talk and the exchange of ideas. In print-centered cultures, often performance is minimized and meaning is derived from reference to authoritative texts. In orally centered cultures, the actual doing of something gives rise to meaning and enables the doer to retain status. It is in face-to-face, interpersonal exchanges that meaning arises most often in the orally centered

culture. In a *print centered culture,* meaning more often is impersonal, deriving from written records, not enactments in speech. You need to keep this distinction in mind throughout this section of the book.

Second, you will remember from this chapter's opening that we described personal narratives as social and communal. Now you can see that in this form of oral telling, it is often difficult to identify one person as the originator of the tale. The process is a collective one, involving a number of people who coax a speaker or several speakers to start a story. As the story begins to live in the oral traditions, control over it is diffuse. In this illustration there is not one teller but two speakers weaving a tale in collaboration, prodded on by other family members. In some of the later versions, the processes of constructing the narrative began to subvert many of its original meanings, and other voices became as prominent as, if not more prominent than, those of the original tellers.

When you start observing, collecting, and performing personal narratives, you will discover that it is often useful to analyze them, not so much as tales told by a solo speaker, holding so-called authorial power over the narration, but as tales deriving from a collective process in that several principal players build the oral account of an event that happened to them while others in the group, interjecting their own experiences and texts, contribute to the account materially and help to constitute it. For example, think about some of the family stories you have heard in your home. You will probably remember many that were prompted by some reference to a clever antic of yours when you were a child, to a misadventure you had, or to a scary occurrence that happened to you. Others originate when a family member wants to tell a story about another relative, recalling how that person acted in a situation that the personal narrative relates to the present. Both these kinds of stories construct social cohesion and perpetuate the social unit of the family. Personal narratives that feature a family story are usually repeated many times until they become so familiar that other family members begin to pitch in with recollections of some detail that has been reported before. The reporting of these stories are often very animated: the speaker mimics his or her own gestures and speech and those of others who figure in the story. Listeners interrupt, often interjecting an experience of their own or correcting or modifying or amplifying the event that is being related. The stories are woven from memories and experiences of the past and desires that relate to dreams and hopes that exist in the present as well as in the past.

Think about the highly performative nature of these oral narratives. In many ways the speaker can be compared to an actor and director, presenting the past event almost as though it were framed as a play text to be staged. In other cases, the telling is very informal and seemingly unshaped. The theatrical dimensions are less apparent but very much there.

When a tale seems to be a weaving of a number of voices, expressing different cultural orientations, different regional and historical linguistic features, and connecting different kinds of texts, it is referred to as *intertextual.* Some intertextual texts combine elements from formal fictional genres, such as the novel, with colloquial speech and perhaps folk elements. An examination of these multiple voices helps us to understand the tale. Some of the family narratives

are told by family members in gatherings of different generations of the family. These stories often illustrate how multiple voices conveying many perspectives and embodying different cultural values and beliefs combine to create what we call a *dialogic,* open-ended form. This dialogue of different voices, speaking simultaneously, not trying to resolve a question with one answer, but trying to play against and with each other to make an open-ended meaning, is a performative process that presents intercultural dynamics. Different views of the world are offered simultaneously by the social selves who are present, each representing collective values as well as their own personal ones.

In the light of the discussion in the previous chapter, you can see how some of Goffman's concepts of framing and frame slippage inform our understanding of personal narrative. In the example of the Sterns' personal narrative, in the social context of ordinary, social conversation, one of the participants called for "a story," thus keying the narrative and setting the stage for the animated personal tale that the husband began to relate. Within seconds, the wife was chiming in, trying to set the beginning of the story in a different place. She wanted to include her visit to the home of a missionary and her determination to witness what she called "authentic voodoo" in the back mountains of Haiti. This episode had preceded the drive to the palace. For her it was important; it featured her and her background in anthropology; of course, it also reflected all sorts of values that she may not necessarily have intended to reveal. The account also attempted to present itself as though it were an accurate account of just exactly what happened. At times, when the two tellers were offering conflicting versions of various moments, the narrative frame threatened to slip. The tellers, whether consciously or not, were drawing on whole traditions of travel literature as they converted the events that had happened to them into an adventure story of sorts. You may recognize their fascination with the romantic accounts of journeys toward the "heart of darkness" in the depths of the African continent written by Joseph Conrad and others, which affected the way the Sterns constructed their tale.

In the opening pages of this chapter, we stated that the personal narrative assists in the construction of identity, reinforces or challenges private and public belief systems and values, and either resists or reinforces the dominant cultural practices of the community in which the narrative event occurs. Can you see how the example of the personal narrative of the Sterns can be analyzed for its contextual features? Such an analysis will reveal how dominant American cultural values, about property, power and submission, travel, and quest, to cite just a few, figure in the construction of meaning.

It is important to recognize that the term *dominant culture* is reductive. Culture is not monolithic. It is comprised of numerous subcultures whose voices play and compete with one another, using different dialects and idioms, expressing different attitudes and beliefs, negotiating with one another in an open-ended, creative dialogue. However, although culture is a fluid process, it is also possible to denote the set of beliefs, values, ideologies, and customs that gain ascendancy during certain temporal periods and within certain spatial regions. In this sense we can speak of dominant culture in the United States in the latter

part of the twentieth century as white, mainstream, rooted in Western culture, predominantly Christian, and committed to the ideals of democracy and a free economic marketplace.

It is equally true that actually there are numerous subcultures jostling to shape American culture and make their voices heard. Although these subcultures are subordinated in an hierarchical arrangement of power that gives greater value to the dominant culture, they are also very much present, albeit perhaps less visible and very often less likely to be represented in the homogenized images of culture reflected on television or in print. Remember that the subordination of one culture to another comments as much on relationships of politics and power and ideology as it does on the actual interplay of multiple voices and subcultures in lived experience.

The Sterns' narrative, first told in the late 1960s, reflects a liberal political bias, a commitment to democracy, a condemnation of dictatorship, and a condemnation of Duvalier and the CIA. In short, in this respect the narrative reinforces the liberal political values of the academic community in which the speakers were trained. The narrative was not one that resisted Western culture's dominant view of Haiti and its dictatorship, nor did it seriously criticize Western consumer culture and its preoccupation with commodities. Here we could talk of the ways in which the tourist industry and the commodification of culture affected the tale. Later versions of the story began to enter more contested spaces, and on these occasions the performative event revealed how this cultural practice of the personal narrative can participate in the displacement or subversion of existent cultural values and give rise to new emergent meanings and contribute to social change and personal empowerment.

To determine how this personal narrative constructs identity, we need to consider the way the authors used the voicing of the story to sort out their complicated relationship to the circumstances they found themselves in and the way in which the circumstances challenged their ideas about themselves, who they were, whether they were brave or cowardly, foolhardy, or trivial. All of these kinds of questions, many of them ethical, some of them involving the authors' representations of themselves, came into play in the fluid, processual unfolding of the story, starting with its first occurrence and evolving throughout its many repetitions—repetitions full of important variations.

You undoubtedly can think of numerous other kinds of personal tales, ranging from family stories about relatives, in which the tale is couched in the form of a personal narrative with the speaker vividly recalling an encounter with another family member, to heroic accounts of victories in war. Other tales are spun from such simple, everyday events as a ruined dinner, a frustrating argument at work, or a quarrel. Others can derive from a rap session or conversation during a coffee break or a sharing of life stories by women's groups, groups of Jewish refugees, or other groups representing minority cultures. We will be analyzing examples later in this chapter. You may want to use class time to perform your own personal narratives, observing how the group dynamic and the context participates in the performative event.

These kind of tellings can also be related to literary narratives of the sort you find in fiction. However, a series of literary conventions come into play when a personal narrative is cast in the form of a novel or short story. The transposition of the medium from orality to print, from verbal social discourse to written narrative and aestheticized language, reconfigures and reshapes the kernel event in real or imagined life that was part of the impetus for the original telling. In part III we examine a number of literary texts that use personal narratives. You may want to consider the relationships between the oral tellings discussed in this chapter and the more aestheticized versions found in fiction.

This chapter considers personal narratives found in ordinary conversation or in the form of transcriptions from oral traditions. These transcriptions may be ethnographic description or oral tellings. The latter are often gathered in oral histories. Personal narratives can also be written in the first person in autobiographies in which the authorial intention is to set down a personal narrative in a style of language as close to a verbatim record of an actual oral telling as the autobiographer working in a literary genre can accomplish. They can also be recorded on tape or captured on videotape.

We are asking you to examine the performative dimensions of the personal narrative from your perspective as a student who will be attempting to perform this species of cultural performance and as a student engaged in ethnography, whose own encounter with and collection of personal narratives raise methodological questions.

ETHNOGRAPHY AND THE ROLE
OF THE ETHNOGRAPHER

An ethnographer tries to understand culture from the standpoint of the participant observer. This act involves imagination, and the task is significantly different if you are studying a culture with which you identify than if you are studying a more remote one. James Clifford describes the act of ethnographic description as "a form of personal and collective self-fashioning" (9). The ethnographer's relationship to the subject under study is mixed. The ethnographer stands within culture while trying to look at it. He or she is always moving between a global perspective and a local one. In selecting a manner in which to report about another culture and navigate between different cultural practices, different political systems, and different institutions, the ethnographer has to settle on a strategy or multiple strategies by which to represent the other culture and the multiplicity of voices that are comprised in it.

Some scholars of ethnography describe this struggle to find a satisfactory way to represent the identity of another culture as one that is "mixed, relational, and inventive"(Clifford 10). They mean that ethnography is not offered from one fixed perspective, in which an outsider writes about the culture of insiders, but rather the account must reckon with the hybrid of outsider/insider and how the two are implicated in each other. It is *relational* in that it believes that culture is subject to multiple interpretations in play with one another rather than subject

to one comprehensive account of its meaning. It is *inventive* in that the ethnographer uses myth, collage, representations, metaphors, and an entire array of diverse kinds of writing practices to produce the account, which itself is a fabrication, an invention, more than an accurate, factual account of another culture, as though such an account could take a fixed form. We will be talking about how the student of personal narratives is involved in an ethnographic practice and the place of performance in this approach.

THE PERSONAL NARRATIVE: AN EXTENDED DEFINITION

Kristin M. Langellier's ideas about personal narrative have importantly informed our thinking in this chapter. She describes the personal narrative as follows: "called the prototypical discourse unit . . . and a paradigm of human communication, the personal narrative is part of the study of everyday life, particularly performance in everyday life and the culture of everyday talk" (243). The personal narrative is a story text, but it can be distinguished from some written literature and from oral forms such as folk tales, legends, myths, and epics in that it originates in oral performance; the events it narrates are initially site specific, although the site of subsequent tellings vary; and it is drawn from the speakers' own personal experience. It constructs a narrative of speakers speaking to others, usually in their own peer group, although we saw that the audience can be described more broadly. It is also set in a context, and its contextual features are a part of the process by which it is understood.

The speech in which the tales are told can be casual, informal, and in dialect, or it can be much more formal and tutored, aspiring to a condition closer to the speech captured in print literature. The personal narrative recounts something that has happened in the past experience of the speaker or speakers, but it mingles fact with invention and relates the happening to the context that evokes the telling.

William Labov in *Language in the Inner City,* and Labov and Joshua Waletsky in an essay in a collection entitled *Essays in the Verbal and Visual Arts,* as well as other scholars, argue that the personal narrative enacted as a performative event serves both *referential* and *evaluative* functions. By referential, they mean that the arrangement of the details in the spoken story attempts linguistically to refer to or match or approximate the linear chronology of the events that happened in experience, and the construction of a complete or whole story will involve several temporal periods in life and can be analyzed to conform to a sense of beginning, middle, and end. By evaluative, they mean the reason the narrative has been told, referring not only to the way in which elements internal to the story demonstrate the worthiness of the teller but also to ways in which elements embedded in the context that gives rise to the story contribute to its meaning. Evaluative functions on the part of the speaker are reflected in the ways in which the story is rearranged to serve his or her personal interests. Evaluative functions inherent in the social context that gives rise to the personal narrative reflect ways in which others in the narrative context and culture conspire to reshape the narrative telling.

When we talk about the referential features of the story text, we are examining features of the story emerging through personal narrative almost as though it were more literary than oral and as though it can be treated as a text that can be cut out of ordinary conversation and viewed as a discrete object. It can usefully be seen in these terms. The oral story can benefit by being analyzed in reference to its structure and narrative devices. However, it is essential also to examine the processes of interaction and the performative dimensions of the narrative event. Also, the oral story may not actually have any closure, and yet it still has enough of the features of narrative for us to call it such.

Therefore, in thinking about personal narratives, we can analyze them in relationship to the narrative that unfolds, in its referential and evaluative features, looking at it as though it were a story text. When we examine the story text set in context, we must examine the relationship between the events narrated within the story text and the event of the narration itself. The event of the narration occurs in the present. It involves the occasion that gives rise to the narrative, the interactions among the participants, and the relationships among the participants. How familiar are the participants with one another? Do they share similar beliefs and attitudes or are they more appropriately regarded as members from different subcultures and economic classes, more separate than alike? Numerous contextual features related to the site where the telling occurs, to the time of its occurrence, to events contiguous in space, or to the purposes for which the story was generated are all a part of our analysis of the narrative event.

The distinction between events narrated within the story text and the event of the narration itself is an important one. It enables us to see that the events narrated in the story text refer, at some level, to actual happenings situated in a different time period and purported to be external to the story itself. The event of, or fact of, the actual narration itself refers to the performative event in the present from which the story text emerges.

Mikhail Bakhtin expresses the distinction between narrated events and narrative events in the following way:

> . . . Before us are two events—the event that is narrated in the work and the event of the narration itself (we ourselves participate in the latter, as listeners or readers); these events take place in different times (which are marked by different durations as well) and in different places, but at the same time these two events are indissolubly united in a single but complex event that we might call the work in the totality of all its events, including the external material givenness of the work, and its text, and the world represented in the text, and the author-creator and the listener or reader. . . . (255)

Can you see how this distinction helps us to understand the complex dynamic, crossing time and place and showing the interdependence between author-creator and audience, that occurs in the performance of personal narrative?

The personal narrative is a good starting place to examine cultural performance because it values the personal voice of real, everyday people, but people

whose voices are often ignored or silenced. The dominant communication modes that are studied in our society involve print or the secondary orality of electronic media. Unfortunately, oral voices and the performative events that ground them are undervalued. One of the exciting dimensions of working with these personal narratives is that they offer you a way to empower voices that too frequently have not been heard. At the same time they allow you to interpret these cultural processes, seeing them as ways to constitute knowledge, construct identity, and negotiate the forces of invention and tradition, reinforcing some cultural values while subverting others. An exploration of personal narrative grounds us firmly in storytelling traditions and communal processes that are rooted in everyday life—in the quotidian, in informal settings, and in language practices found in ordinary conversation.

THE PERSONAL NARRATIVE AS A LIMINAL FORM OF PERFORMANCE PRACTICE

Personal narratives are liminal in their form. The term *limen* refers to a threshold or a border. Something is liminal when it is at or near the threshold, in a state of being betwixt and between, neither one thing nor the other, but best understood in relation to the states that bound it. In Western thought we often speak and think of things in terms of oppositional pairs, or binary oppositions. Orality/literacy is a binary pair; so, too, is public/private, everyday reality/imaginative worlds, and so forth. However, personal narratives are conceptually best understood not so much in reference to any one term in a binary opposition but as a hybrid, living in a liminal zone that blurs the boundaries that traditionally separate the two terms in a binary opposition.

Rejecting a species of classification that involves sharp lines of demarcation and clear boundaries, many scholars of the personal narrative are seeking to open up a new space, this space between, and discover how it operates. They describe personal narratives as a kind of cultural performance that inhabits a liminal zone, in respect to its medium and its spatial dimension and in regard to other domains. It is betwixt and between two kinds of discourse, the discourse of everyday life and ordinary conversation and the discourse of print, in which the narrative is transcribed and recorded or in which the teller actually shapes the personal narrative to its print medium, setting the narrative in a written text that might take the form of autobiography, journal, letters, or essay. The kind of personal narrative that is found in the novel, such as Mark Twain's *Huckleberry Finn,* is a form we are not considering in this chapter. However, it is useful for you to think about the fictional varieties of personal narrative in order to compare them with those of cultural performance.

The personal narrative is also liminal in that it lies between two spatial regions, the private and the public. The private space is intimate and often domestic, and the community involved in the making of the personal narrative includes those engaged in the narrative, either as producers of it or as those to whom it is addressed. We see this in the Sterns' narrative, set in the living room;

in the family narrative, which very often emerges during dinnertime and at the dinner table; or in women's stories, set in the kitchen over the sink or stove. The audience may include the interloper, someone who was not anticipated and may not even be known to the teller or tellers, but in any case the performance sphere is private, often actually an enclosed space; or if the space is more open, the ability of the participants to see and hear constrains the scale of the telling, affecting the style of the delivery and its acoustical and gestural dimensions. At the other end of the spectrum, we could consider the narrative, like evangelical testimony, that emerges in a large public space, such as parks, fairgrounds, or festivals.

A personal narrative that occurs in the kitchen, with a woman teller recounting an episode that has recently happened to her and to her friend—with her friend constantly interrupting the narrative either to embellish it or to ask that some part of it be reframed or retold, or interjecting her own experience into the account—is an example of a personal narrative that is told orally, in private space (namely, the kitchen in the home), to an audience of a single friend—a friend who actually may be better described as a coproducer of the story or at least as an important collaborator in the construction of the telling. In contrast, the personal narrative that is found in an autobiography—later in this chapter we will look at Zora Neale Hurston's *Dust Tracks on a Road* for an example—inhabits a public space. It begins in private but it is written to be read by an audience that is absent when the writer actually sets down the life history, and it extends far beyond the group of people that any single person can hope to know personally, embracing all those who read the book.

The personal narrative also involves an interesting interplay between fact and invention. As we have seen, the referential events in the story text have the appearance of being rooted in the actual experience of the real person who shares the personal narrative (or its coproducers). However, the fact of the narrative event itself, the performative moment situated in a particular place at a particular time and related to many larger contexts, always complicates the nature of the relationship between the discursive act of narrating and anything that lies outside of it.

In the case of the Sterns' narration, it is a fact that the Sterns were arrested in the 1960s in Haiti, but what really is the importance of this fact? Their coproduced account took many liberties with facts, and anyway, the fact that they chose to select this fact of arrest from all the other life facts they have experienced says more about what they choose to draw attention to, and mark, in a story that presumably will cast them in a favorable light than it says about the fact of the arrest. They have repressed or suppressed many facts of existence when they chose to shape the personal narrative on this fact. Their story is a blend of fact and fiction. It is not uncommon for storytellers to become confused about whether there is actually any kernel of truth in their stories or whether they have actually invented the facts or constructed a story that has only the loosest connection to fact.

The narrative event itself is one that is mediated. The words of the discourse in which the story takes hold interpose themselves between the tellers of the

so-called factual story and the facts in life. Because the medium of the telling is a form of representation and what we called self-fashioning and invention, the relationship between fact and invention in personal narratives is problematic. Nonetheless, it helps us to understand some of the ways in which personal narratives make meaning and have value if we consider their liminal position between the world of actual happenings to real people and the world of invented things and people that may have no actual counterpart in real life.

We have also seen how the personal narrative can be more like ordinary conversation and everyday life, with a very informal, rambling kind of structure, whereas in other cases, such as the personal narrative embedded in evangelical testimony, it may have more formal features, performed more like a ritual than like an ordinary strip of everyday talk.

The personal narrative gives us an opportunity to explore and perform the stories of ordinary people like ourselves as well as people whose voices and performances are not as often taught as those in traditional literary or historical studies. Let us move to a consideration of how we are going to find, examine, and perform these narratives, involving us in matters of ethnographic description.

ETHNOGRAPHIC DESCRIPTION, FIELDWORK, AND PERSONAL NARRATIVE

As researchers and performers of oral materials, you need to think about how you are going to collect, if necessary transcribe, and interpret them. This process assumes that you can identify such narratives when you encounter them (we will talk more about this later). You are probably going to engage in fieldwork to collect your materials. We want to offer some guidelines to help you execute your fieldwork responsibly and to enable you to make sense of what you gather, either in a written account or in a performance.

For now, we will consider some of the problems you will encounter as a gatherer of oral narratives from everyday conversation, or what we denote as social discourse. You can search for examples of personal narratives in autobiographies, oral histories, journals, and so on, and we will be analyzing several examples later in this chapter. In this section, however, we are largely concerned with how you go about locating and describing personal narratives that occur in everyday life and are transmitted orally, and it is this activity that places you in the traditions of ethnography. Of course, you will also be drawing on this material in later chapters when you will again be acting as researchers engaged in ethnographic fieldwork.

This book embraces the ethnographic tradition of the interpretive social sciences as practiced by scholars like James Clifford, Clifford Geertz, and Paul Rabinow and William Sullivan. They view culture and performance as *processual,* not *static:* culture is fluid. Its meanings are not determinate or fixed, but they are emergent. The cultural process is dynamic, and the researcher of the process at once stands within it and outside of it. This double position reflects itself in all that the researcher does.

In reaction against the ethnographic practices of early anthropologists such as Margaret Mead and Bronislaw Malinowski, the recent school of thought requires that ethnographers openly acknowledge their own participant role in relation to the account they are rendering. Rather than subscribing to a set of beliefs that assumes that the ethnographer is a disinterested participant observer, setting down as objective an account as possible of a culture different from that of the ethnographer, the interpretive position acknowledges that ethnographic description is subjective. Ethnographers are asked to address openly matters of their own motives, their biases, their involvement in their own culture, and the institutions that make their work possible—including not only the economics of their study but also their assumptions about knowledge, culture, power, religion, and so on, which inform their very decision to study and write about, even perform, another culture.

One of the first matters you will need to address is where you should go to observe your own role and the role of others in the construction of personal narratives. This topic involves not only a judgment about the sites of this kind of performance, namely, where it is likely to be found, but also judgments about yourself.

On the matter of sites, we know from the definition of the phenomenon that personal narratives can be situated in informal, conversational modes of communication that take place in intimate domestic settings, such as the kitchen or the living room, or in informal social gatherings in gardens, parks, alleys, or streets; or they can move into still more public institutional spaces like the recreational spaces in libraries, schools, or churches. As we work toward the outer limits of the spaces in which personal narratives can thrive, we include such public situations as an evangelical testimonial pronounced in an open, public space—for example, Reverend Billy Graham or Jesse Jackson addressing very large crowds in front of the White House in Washington, DC, or in Central Park in New York City, as well as in numerous civic locations about the country—in which the speaker invokes a personal narrative as part of a larger rhetorical strategy.

Personal narratives can take the form of storytelling, participating in the formal traditions of storytellers that evolved around a campfire. They can be mounted by professional storytellers who perform their tales in regional or national festivals. They can also be found wherever there is a storytelling community. You can see that there are numerous possible sites from which to choose when selecting the place to gather the personal narrative.

We could also gather the tellings from television, but if we do so, we need to be mindful of the distinction between the perspective of the viewer of television that derived from a visit to a television studio in which so-called "live television" is being mounted and the perspective of the viewer who simply watched the telling on the television at home. Because personal narratives are a form of communication and communication depends on its medium, be it oral, print, or electronic, it is important to understand how the technologies of the various kinds of media and media systems affect the way in which the story can be told. The story that

has been shaped for television is very different from the oral story told in the television studio, whether as a part of live television or as a bit of off-camera talk.

Let us turn now to some thoughts about yourself and your own relationship to this project. Try calling forth from memory your own experiences of personal narratives, either from the perspective of the originator of the narrative—whether it is constructed by you alone or by you in conjunction with others—or from the perspective of an audience. Think about the kind of narrative you want to study. Do you want to look at family narratives or personal narratives shared in the dormitories; or do you want to give voice to the narratives of groups that have largely been excluded from study, in part because they are considered marginal in relationship to the dominant culture?

If you choose to focus on the narratives of a marginal group, you need to think about your own belief system and your political values. Are you interested politically in a group you plan to study? It may be that you are a member of a group that has been marginalized and you want both to explore further your own relationship to this group as well as give it voice and advance the study of it. Or it may be that you are not a member of the particular group whose personal narrative you are going to seek out, but you have an interest in learning about the group and this assignment will give you such an occasion. In both cases, you are asking questions about yourself in the course of selecting the site for your fieldwork, and the answers you give will assist you when you enter the field. You are also involving yourself in questions of cultural politics. By cultural politics, we refer to social and political forces that influence what elements of a culture are promoted and what are suppressed or left out. Cultural politics give us clues as to why a person favors certain events in the narrative and why others are ignored.

To flesh out how this segment of the fieldworker's experience is at once shaped by the subject you are choosing to study and also shapes it, let us provide some illustrations. Imagine that you are a woman and that you are committed to a feminist agenda. By feminist, we mean a commitment to study women's achievement from a woman's perspective. You are probably offering the feminist perspective either to complement the dominant patriarchal account, which is incomplete when it stands alone, or to modify or replace it. Obviously, your political convictions will influence the way you go about this assignment. Having decided to gather these personal narratives to complement or redress the accounts offered by those who hold power, you will use an approach that replaces the lens of a patriarchal, postcapitalist society with the lens of a feminist who may wish to redistribute power, engage the narratives of a group that has been marginalized, and give voice to those who have been often ignored.

The feminist perspective wants to move beyond the society in which historically men have been accorded more value than women. Feminism revises the historical record that has been shaped by the male fabricators of the culture. The historical record shows that men have for long periods of time treated women as subservient, not deserving of holding property or having a vote. Patriarchal society accorded women the status of an object whose value has been based on how they have been viewed from a male perspective.

As the ethnographer who is going to gather these personal narratives of women, you may well not want to prejudge their nature. In fact, very often, you want to avoid interjecting too much of yourself into the project insofar as one of your objectives is to encounter something other than yourself and your own projections. However, as an ethnographer it is important to acknowledge the complexity of forces that are informing your project. Your stance as a feminist is an important element of your work. In this case, once you decide that you want to gather the personal narratives of women, not only will you have decided the site of your fieldwork but also you will start to recognize the ways in which your gender and certain political judgments you have made are influencing your work.

We could equally well have offered examples of an African-American student, either male or female, deciding to probe personal narratives to give voice to this marginalized group. Again, your motive will influence your choice of narratives. It is likely that you will use gender as a criterion for the selection of your stories if you have decided that you want to pursue this project from the perspective of an African-American woman who wants to capture the voices and stories of women of color. By *gender* we refer to the culturally constructed definitions of role based on culturally held views of sexuality. In contrast, quite different criteria will be used if you are not interested in the gender of either the speakers or of the subjects of the stories they tell.

Recently, because of the writings of such African-American women as Alice Walker in *The Color Purple,* Toni Morrison in *Sula,* and Maya Angelou in *I Know Why the Caged Bird Sings,* to mention just a few of their works, there has been considerable interest among black writers in constructing the tradition of writing by black women. Much of this interest has focused on discovering hitherto neglected fictive writings of black women, and because the lack of this tradition has been so notable, it is an important political act to bring attention to these writings. However, it is interesting that the most energetic work in this area has been devoted to discovering written, literary texts, and the vital contribution that blacks have made to the oral traditions are for the moment not being given as much attention.

Choosing to seek out the African-American woman's personal narrative is likely to draw the student to the domestic arena, the church, or a neighborhood or community where she is readily accepted and can mingle with the women who will give voice to these kinds of narratives. However, if a male African-American student was also interested in exploring personal narratives in black culture, he might well be committed to giving dignity to the black male. If so, he would look in somewhat different sites for the personal narratives and might choose to gather tales rendered by men.

Clearly, in all these examples, the student has numerous choices, and there is no necessary reason why a person of color would not want to ignore both race and gender when deciding what kinds of narratives to collect; but this, too, is a choice. It is also worth noting that very often a fieldworker selects a site with a series of expectations that are later radically altered once fieldwork begins. You could decide to seek personal narratives of African-American mothers—and therefore choose to go to a playground, high school, home for unwed mothers,

or streets where women gather with young children—only later to change the focus of your gathering, perhaps abandoning the decision to search for narratives of mothers and replacing it with another focus depending on the personal narratives you actually encounter.

Another example is the student who decides to draw on the personal narratives recounted at home, in fraternity and sorority gatherings, in dormitories, or in the gathering spots to which students go when they complete their studies at the end of the evening. Can you see that the students' choice of subject matter in all these examples bears an important relationship to who they are and their own relationship to the material they want to examine?

Ethnographers also need to think about the purpose of the research and the form the final ethnographic description might take. These questions force the researcher to attend to the research context. The activity is not value neutral but rather laden with beliefs and obligations, a number of them seemingly contradictory, which the researchers must negotiate to discharge responsibly their role as interpretive ethnographers.

The ethnographer can choose to give meaning to the material described in a number of ways. Bear in mind that as students in this class you are serving as researchers at the wish of your instructor as well as at your own wish. Nonetheless, the setting you find yourself in, namely, your institution and classroom; the educational constraints that shape this project; and the unequal distribution of authority between yourself and your teacher are all factors that affect your ethnographic work. Consider the multiple institutions that shape our discursive practices and the ways in which issues of dominance and subordination and of power, as well as of belief systems, might affect the way we come to understand the personal narrative.

The new interpretive ethnography conceives of the ethnographer as a producer of texts, either written, filmic, or oral. The act of rendering ethnographic description is itself a performance. In this case, the metaphor of performance is being used to give authority to the work and also to acknowledge that the account is a construction and that it must be understood as such. It does not stand as a definitive or decisive ethnographic work but as a work that must be followed by other productions, giving voice to other assumptions. Finally it is the interplay of these multiple voices that will move ethnography toward its goal.

The goal of ethnographic description of performance traditions is not an objective understanding of another unknown or little-known culture and its performative practices. Rather, it is a subjective understanding, derived from a variety of voices, of the ethnographer's desire to experience and interpret other cultures. The ethnographer relies on a methodology of participant observation, which acknowledges that the researcher of the culture is *implicated* in the subject about which he or she writes. To be implicated means to be involved or entangled in something. We often hear people talk of being implicated in a crime. Ethnographers are drawn to this kind of illicit word, a dangerous word, to describe the nature of their complicity, their entanglement, in their project—to try to grapple subjectively with knowledge about another culture. They use this word to describe the kind of twisted involvement that entangles them.

The researcher does not subscribe to the belief that he or she is a neutral observer of the culture of the exotic, unknown "other," recording and transcribing rituals, customs, beliefs, kinships systems, political systems, and institutions with the intention of enriching his or her own culture by preserving the best features of the endangered culture. Such a view of the ethnographer's role was common in the late nineteenth and early twentieth centuries, when many anthropologists began to travel to Africa, Asia, or the South Pacific to do their work. The expansion of trade and the spread of empire took many Westerners to lands far from home, where Western culture encountered other cultures, usually non-Western, and frequently, at the time, referred to as "primitive."

The ethnographers of the late twentieth century are painfully aware of how imperialistic objectives shaped Western writing about other, exotic cultures. These ethnographers have chosen the word *implicate* to draw attention to the complex relationship between individuals within the culture that is the subject of study and those outside of it who come to study it. Most anthropologists writing today no longer speak of "primitive cultures," nor does anthropology continue to study only very distant, and usually exotic, cultures far from home. Today, it is not necessary to travel to countries beyond one's own for ethnographic study. It is becoming increasingly common to study subcultures within our own society, on these shores, as well as to travel to other countries.

As ethnographers studying a form of narrative that traditionally has been undervalued and understudied in institutions of learning, you may find yourself raising ideological and political questions in a more overt way than you are aware of when you study and perform written texts. Many of the written texts you have studied come from the Western literary tradition. They have already withstood the test of time and have been given a recognized position in our culture, where they are valued as literary, aesthetic texts, whose importance to our traditions has been historically well demonstrated. These texts are equally products of social and political values, but very often the ideological assumptions underlying them are not addressed because the dominant culture subscribes to the ideology that gives value to them. When you work with texts that are marginal, the political implications of the study become more obvious.

You will discover that you may raise questions of ideology in the course of studying and performing personal narratives. By ideology, we refer to values, beliefs, and feelings that inform our critical judgments and assist us in understanding our role as political beings and how they affect our relationship to certain kinds of projects. The study of cultural processes inevitably forces us to consider our values and the institutions and cultural practices that shape how we conceptualize knowledge. In the search to discover and share personal narratives, you should recognize the vital role this performative phenomenon plays.

We have discussed how you might go about identifying the sites in which you will collect personal narratives; we have encouraged you to be sensitive to your own role in the project you are performing and to assess your own motives as well as institutional forces that might influence your study. You will be an ethnographer collecting from the oral traditions, and we have stressed your own role as participant observer, interacting with the community where you hope

to collect the personal narratives of others or attempting to collect, record, and document gatherings in which you will be involved in the construction of the personal narrative.

If your plan is to observe some of the sites in which you figure, such as your home, your dormitory lounge, and so on, you need to acknowledge the problems posed by the fact that you have a privileged position in the community in which the story will emerge. You know that you are watching for a certain kind of narrative. For example, you might ask a classmate to videotape you in your home in the hope that the family dinner might well be conducive to the making of a personal narrative. You need to consider how many occasions should be taped and whether or not you will tell the others what you are doing. Are you hoping to capture yourself or others in the midst of a personal narrative that arises in the course of the evening, or do you actually have a personal narrative in mind that you have delivered earlier and are hoping to find an opportunity to reintroduce? In the latter case, you certainly can consciously push the evening toward the moment of the telling, but you will only partially be able to influence the actual oral and performative event, no matter how much you might have planned to shape it. You might also choose to take a tape recorder with you, either concealed or not, in the hopes of recording the story text of such an event. You may plan to match this with a video record or simply to rely on the transcription.

As you can see, the process of doing ethnographic fieldwork raises numerous ethical issues. Many ethnographers acknowledge the tensions that arise between their desire to develop the trust of the group they are studying and their desire to gather material. Sometimes these two objectives cannot be easily reconciled. Studs Terkel, in *Working,* writes about the guilt he feels because he has trespassed on the privacy of strangers in the course of gathering their oral life histories. However, his experience has taught him that people want to tell these stories; indeed, they need to release them, almost as a kind of healing, and also to give themselves dignity. On balance, he prefers to tell his stories and use his tape recorder, which is sometimes compromising. You will experience similar kinds of moral dilemmas. The best course seems to be to confront them and incorporate them in your project. Don't hesitate to raise these kinds of issues in class and in your work.

In part I, we showed you Conquergood's chart of abusive performative stances. Think now about his descriptions of various ethical dilemmas in the light of your attempts to collect and perform personal narratives. Are some of the performers in your class guilty of exhibitionistically taking over material of others that is very private? Can you detect moments in your own performances when your egoism and narcissism have distorted the personal narratives? Do you think that some of the performers exploited the people whose works they were performing?

When thinking about ethical problems posed by collecting and performing the materials of others, you must consider the rights of informants. If you have collected materials under the promise of confidentiality, you must preserve that confidentiality. If people allow you to videotape them, so you can later perform

their stories, you need to decide whether or not you are obligated to tell them what you are doing and to what purpose you plan to put the findings. For those of you who plan to publish your findings or perform them for paying audiences, you need to consult books on ethnographic research methods and learn about informed consent, protection of confidentiality, and copyright law. In our list of suggested readings we indicate some books that will be helpful.

Typically, ethnographic fieldworkers immerse themselves in the culture they are studying, often living on the site for periods ranging from a number of months to many years. The amount of material gathered is often vast. Many ethnographers conduct intensive interviews, taping many, many hours of speech and filming for long stretches of time. Ethnographers go into the field with many preconceptions about what they are studying, but they often try to suppress these preconceptions, collecting in a seemingly haphazard fashion and waiting until the conclusion of the fieldwork to sort and arrange what has been gathered, seeking a way to describe it.

In later chapters we will be discussing some of the inventive new ways in which ethnographers are writing and presenting their subject, and the implications of using performance as a tool to assist your own understanding of a culture will become clearer. So, too, will the range of possible ways in which you might assemble your findings, giving space to the voices of others as much as to your own. But for now, we are simply reminding you that the gathering you will be engaged in will be rather modest, even if you spend a good part of the term doing fieldwork and collecting your personal narratives. You need to be respectful of the kind of careful research that goes into ethnographic fieldwork and what the ethnographer Clifford Geertz, in *The Interpretation of Cultures,* calls "thick description" (6–10).

Geertz's Thick Description

In a Geertzian thick description of a cultural practice, the ethnographer employs two kinds of descriptive techniques. One consists of a wealth of finely observed particulars drawn from fieldwork; the other generalizes and synthesizes, looking at the meanings of the particular against larger organizing phenomena that begin to address how the particulars of the cultural practice relate to larger contextual features. As the ethnographer moves between these two planes, one particular, the other generalizing, he or she also constantly moves between considerations of what such a practice seems to mean in the eyes of those who perform in it and how it relates to practices familiar to the ethnographer, drawn from his or her culture.

Geertz offers an excellent example of thick description in his analysis of a Balinese cockfight. As he describes the cockfight, he moves outward to relate it to other Balinese symbols. He finds he has to discuss feathers, blood, crowds, money, status rivalries, hierarchical structures, and numerous other Balinese experiences, finally interpreting the fight by reflecting on what it says about the Balinese and their culture. Geertz characterizes his method of describing cultural forms as one of taking a collectively sustained symbolic structure, that

is, the cockfight, and treating it as if it were a means of "saying something of something" ("Deep Play" 235).

As you gather and collect personal narratives, particularly if you were to gather narratives of a stable, tight community (e.g., freshmen at your school), not only will you begin to see how your description will account for the particulars of the ritual that gives rise to the stories but soon you will move to the larger, synoptic plane, where you will start offering an analysis of the event in the light of your knowledge of institutions, power relationships, belief systems, and so on, which the participants in the narrative share by virtue of living in our culture. You will want to think further about these kinds of issues.

One final methodological matter that relates to your role as an ethnographer of performance is the question of how to render spoken language in written form and how to record the performative dimensions of the rendering. Many scholars have written on this question, setting forth methods of transcription and in some cases developing systems of notation similar to Labanotation, which is used to record dance by capturing the visual dimensions resulting from the movement of the body in space. It is a system of notation often relied on by choreographers.

TRANSCRIBING PERFORMANCE INTO PRINT AND PERFORMING ETHNOGRAPHY

Transcribing spoken English in written form requires you to capture the nonstandard, vernacular dialects that many speakers of personal tales employ. Richard Bauman, a noted folklorist, talks about his practice of transcribing speech in his book *Story, Performance, and Event.* He reflects particularly on his experiences in gathering stories in West Texas. He attempts to capture features of local pronunciation, using words like "sumbitch" and "hunnerd," which refer to *some bitch* and *a hundred.* He also employs conventions for representing oral speech in language, citing as examples the words "gonna" and "bout" for *going to* and *about* (x).

As you listen to spoken English and think about transcribing it to preserve its expressive qualities rather than its exact linguistic features, you will see some of the problems involved in developing a written record. You will also notice that transcriptions of nonstandard English often play into a series of negative stereotypes, reflecting pejoratively on the speakers. You need to remember that the ethnographer is not trying to perpetuate negative stereotypes. Quite the contrary, the transcription is seeking to convey the expressive quality of speech in all its richness and irregularity. The force of a print-oriented culture and the prevalence of a series of learned conventions about standard English make the print version of dialect initially look different. Frequently, it is the fact that the experience is different that causes others to scorn it and treat those who are different in a demeaning way.

Often informants express discomfort when they read transcriptions of their speech. In part, this reflects their sense that their speech is different, that it is not "educated," that it is not the kind of speech you normally read in books.

In many cases, the informants will have little interest, or maybe even ability, to read your record of their talk. To them, you are the outsider and your record of their talk, flattened into the conventions of print, may seem laughable or dead. We mention some of these aspects to remind you of the difficulties involved in transcription and to emphasize that the goal is to capture the richness of actual speech and oral narratives.

Various methods are employed to present the performance of oral texts in a publishable form, many too complex to study here. But the problems confronting the transcriber of performance events are important to consider. We are assuming that there will be increasing reliance on video and film to document performance practices, but of course, this visual medium also distorts, often causing scholars to seek a print equivalent. Elizabeth Fine, in *The Folklore Text: From Performance to Print,* offers a detailed description of a method of transcription that you may want to consult.

In describing problems related to constructing a performance-centered text of a performance event, Fine describes two components of the account. One is a *report* of it written by the ethnographer, describing the performance's aesthetic field; providing information about the participants, the event, and the performance tradition that grounds the event; and commenting on the performance. It also comments on untranslatable features of the event. The other component offers a *record* of the performance in a print medium, developing systems of notation that can capture the linguistic, paralinguistic, and kinesic features of the event. Linguistic features include the words in which the text is spoken and matters of grammar, syntax, and punctuation.

Linguists recording vocalized utterances will transcribe *phonemes,* defined as the minimal recognizable unit of sound; *morphemes,* defined as minimal units of meaning; and *words. Paralinguistic* features include such matters as pause, stress, chanted phrases, intonation, and so forth. The *kinesic* features involve gesture, movement, dance, and so on. *Kinesics* refers to the study of bodily movement. In performance-centered records, it is common to consider not only the bodily movement of the participants but also their relationships to one another in space (*proxemics*) and their relationships to significant objects, such as costumes, props, or musical instruments, employed in their performances (*the artifacts of the performance*). The goal in these kinds of transcriptions is to provide a score, or a blueprint, that can better guarantee that a performance can be re-created from it that will approximate the performance event under study. Fine also discusses records of performance executed in video, film, or audio, but she reserves the word *text,* to describe the print record of a performance event. The record, according to Fine, tries to repeat, or say again, the "signals constituting the live performance" (95).

Although you do not want to litter the pages of your transcriptions with so many elements that it becomes almost unreadable, you will want to experiment with typeface and various markings to indicate whether the speaker is shouting, whether speakers are talking simultaneously, and whether the speech is so garbled that it cannot be understood. You can use descriptive passages set off in parenthesis to indicate some of the nonverbal dimensions of the performance.

You might want to comment on the tempo of speech, the cadences, and inflection. You might also refer to matters related to touch and smell insofar as they are essential elements contributing to the meaning of the performance. Often performers punctuate their speech with a puff on a cigarette, accompanied by a protracted pause. Or some routines require a response in the form of touch, stamping, or slapping. It could be important to account for how these systems of information contribute to the event. Finally, performing the narratives to your classmates is another means of partially capturing the ephemeral event of the personal narrative in its original site.

The performance of ethnography brings with it a number of problems. Performers can rely on empathy, their ability to feel with another person, and observation to assist them in realizing a full-bodied version of a performance event. But we can never completely know another, and we need to be careful not to diminish the experience of others through our own representation of it. As you will see when you study a number of the examples in this chapter, the performance of these texts raises sensitive issues for the performer. How does a man's body perform a woman's experience? What happens when a white person performs black dialect and experience? What are the kinds of things we learn about ourselves and each other through performance?

The performance of ethnography is a superior way of understanding a performance event than appealing to a written record of it. At least the performance captures, albeit with some distortion, many of the nonverbal features of the event. It also captures its interactive elements. If you try a group performance of personal narrative, you can experience the kind of tensions that exist among the speakers. You can experience the ways in which these narratives function as dynamic communicative processes, assisting individuals in asserting the identity of the self. It is worth noting that in recent years not only have scholars of folklore moved away from the study of texts to embrace the study of performance but so, too, have sociologists and anthropologists. For those of you interested in learning more about how to translate performance into print and into forms of re-presentation of ephemeral performances, you will want to look at the writings of Dennis Tedlock, Dell Hymes, Barre Toelken and Tocheeni Scott, Elizabeth Fine, Richard Bauman and Dwight Conquergood.

A PERSONAL NARRATIVE TOLD BY A SOLDIER IN VIETNAM AND RECORDED BY A JOURNALIST

Let us turn now to some examples of personal narratives that can be found in books. We assume that many of you will be gathering your own personal narratives from the sites in which they are produced. However, we want to acquaint you with some of the characteristics of this kind of story, and to this end we need to offer examples that have been set down in writing so that we can all look at the same text. We are looking now at narratives that have been recorded in works of nonfiction. As you read the examples, try to perform them, speaking aloud and developing a bodily feel for how the language affects your gestures

and how the words seem to be shaped for an audience. You will want to move about and experiment with different ways of performing this material. You may want to use tapes and media as you experiment to do justice to the context in which the narrative is embedded.

Our first example is drawn from Michael Herr's book *Dispatches,* published in 1971. Herr is a war correspondent who chose to go to Vietnam in 1967 when he was 27 years old in order to cover the war. In his book, he offers us some useful information about his own relationship to his subject.

> Talk about impersonating an identity, about locking into a role, about irony: I went to cover the war and the war covered me; an old story, unless of course you've never heard it. I went there behind the crude but serious belief that you had to be able to look at anything, serious because I acted on it and went, crude because I didn't know, it took the war to teach it, that you were as responsible for everything you saw as you were for everything you did. The problem was that you didn't always know what you were seeing until later, maybe years later, that a lot of it never made it in at all, it just stayed stored there in your eyes. Time and information, rock and roll, life itself, the information isn't frozen, you are. (20)

Think about the context in which the narrative is placed. Herr has chosen to go to Vietnam to report on the war; he also has chosen to rely on his own first-person account to achieve a kind of authenticity. He wants to hear real stories; he wants to actually look at the war from a particular site and in a particular time. He wants to be in Saigon, Danang, and Khe Sang. However, he also realizes that the war is acting on him. And we, in reading his book, are always conscious of how the account of the war, of what happened, is filtered through his personal experience and also through the medium of language, which he uses to render his account. As he states, you don't always know what you have seen until later, and some of what your eyes took in is never recorded. So we, in reading the narrative, need to think about how these various contextual features and the liminal nature of the form itself help us to understand it.

Consider one of the brief personal narratives Herr includes. The selection begins with his own account, which is folded around the brief personal narrative of the soldier, whom he refers to as "the kid." At the time of the narrative, Herr is packed into a truck moving in convoy from Phu Bai toward Hue:

> Everyone else in the truck had that wild haunted going-West look that said it was perfectly correct to be here where the fighting would be the worst, where you wouldn't have half of what you needed, where it was colder than Nam ever got. On their helmets and flak jackets they'd written the names of old operations, of girlfriends, their war names (FAR FROM FEARLESS, MICKEY'S MONKEY, AVENGER V., SHORT TIME SAFETY MOE), their fantasies (BORN TO LOSE, BORN TO RAISE HELL, BORN TO KILL, BORN TO DIE), their ongoing information (HELL

SUCKS, TIME IS ON MY SIDE, JUST YOU AND ME GOD—RIGHT). One kid called to me, "Hey man! You want a story, man? Here man, write this: I'm up there on 881, this was May, I'm just up there walkin' the ridgeline like a movie star and this Zip jumps up smack into me, lays his AK-47 fucking right *into* me, only he's so *amazed* at my *cool* I got my whole clip off 'fore he knew how to thank me for it. Grease one." After twenty kilometers of this, in spite of the black roiling sky ahead, we could see smoke coming up from the far side of the river, from the Citadel of Hue. (74)

Try performing this narrative. Read it aloud, a number of times, searching for the right voice and inflection to capture the tone of the two speakers, Herr and the kid. You will also want to play with the way you speak the labels written on the helmets. Think about what effects you could use were you to perform this material in class. Would you use costume; a boom-box; a set; or some signs, maps, and so on to try to make the story site, Vietnam during the war, more immediate to the class? In your relationship to your performance, you may want to imagine yourself as an ethnographer who has collected this narrative. You have collected this narrative from a book, but the purpose of your research has been to give voice to personal narratives, to voices that are often not heard or not relied on or given space in mainstream writing. In this case, the oral narrative of the kid, the narrative that is set off in quotation marks—signaling that it is direct discourse and that the words on the page are the words that were spoken— is the narrative that is closest to capturing the ordinary speech event of the kid. Of course, the reporter's account is also part of a larger personal narrative, a narrative that takes the form of war stories.

Both the narrative of Herr and the narrative of the kid can be regarded as liminal. On the one hand, the kid's unsought, shouted tale of his killing is a kind of boasting. He is shouting from one truck to another. His words have a public feel to them. They are designed to be heard by other "grunts," the term Herr uses to describe the soldiers, as well as by Herr. On the other hand, Herr, as a war correspondent who has chosen to nestle the kid's tale in his own account, has revealed that this is a kind of story that is personal and situational, and that it is also told with the assumption of a kind of private and intimate relationship between the kid and the journalist.

The kid asks him whether he wants a story, and in saying this, the kid signals that he is seeking to have his story become very public. Indeed, now that it is found in Herr's published book, his story has been heard by a very large public of book readers. But the kid cannot confidently know that his tale will be directly quoted. It is probably fair to infer that numerous soldiers tried to cry their stories out to anyone who would listen, in part because of a fear that they are not and will not be heard.

On still another level, you, as the collector of the personal narrative, may not fully trust Herr. How do we know that a kid actually shouted those words and not some others? How do we know that Herr did not simply choose to invent the words he quotes? We cannot really know whether Herr's direct quote of a

story transmitted orally is true, and this, too, is something we have to take into account when we try to understand whether the soldier's voice is being heard in this narrative.

The kid's narrative is liminal in relation to the public/private distinction, to oral/literary traditions, and to the fact/invention polarity. Are there other ways in which this personal narrative can be said to be liminal?

Another set of issues you may wish to explore in relationship to this story is *intertextuality*. What are the texts that are at play here? You have the text of the correspondent, who is familiar with the way in which the media construct and promulgate stories and who also has his own idea of the kind of on-site, personal telling he wishes to give to his subject. The quoted passage in which Herr is reflecting on what it means to be a war correspondent and what kind of person chooses to do this work shows us how one of the texts here is contextual and relates to the way in which the Vietnam war was displayed on nightly television as well as in the daily newspapers.

Another set of texts emerges when we consider the labels on the helmets of the soldiers. The soldiers are "repping," that is, representing themselves, through these labels. The vivid, colloquial language and the brevity of the label telegraphs who these men are and what they have known. Some of the labels sound like the titles of blockbusting films. They convey that the bearers of them have been saturated in the world of electronic communication. They know the sound bite; they have seen numerous war films night after night on television reenacting the battles of World War II, particularly those played out in the Asian theater of war. They also know that cameramen from the various networks are in the field and there is the possibility that the names emblazoned on their helmets will be captured on camera and aired on television.

You also have the text spoken by the kid, in which he uses expressions like "grease them" meaning "kill them," and carrying some of the connotations of the current saying "waste them." He uses a kind of lingo that is rooted in military training and the specific talk of American soldiers in Vietnam, where references to the battle site, Hill 881, and the weaponry, the AK-47 and the clip of machine-gun ammunition, identify him as part of this subculture. We also see the collision of East and West and the stereotyping of the two cultures in the account. A Viet Cong is referred to as a "Zip"; elsewhere the term is "gook." Each term reinforces an ideology and dehumanizes the enemy while reflecting racial prejudice on the part of the speaker.

Finally, how does the personal narrative of the kid framed in the larger narrative of Herr serve to shape identity, give voice to those who are in some sense marginal, and subvert or support the values of the dominant culture? These questions are complicated and multilayered. Think about the kind of self-image and self-representation that both Herr and the kid are forging. Do the two narratives support or subvert cultural values? You need to sort out the various texts that are woven together in this *heteroglossic* text of many voices. You are seeing too small a portion of Herr's entire account to conclude anything with confidence about his politics and attitude toward the war. Were you to read the whole account and consider it against the context of how it would read in 1969,

when it was copyrighted; how it would read in 1977, when it was published; and how it would be seen after the victory of the United States in the Gulf war in 1991, you would see how you can come to terms with the beliefs and political values contained in the story.

You might want to compare this text with those reporting oral histories of black veterans or accounts of the war from the perspective of the Vietnamese or the Viet Cong in order to see how they are alike and how they are different. Herr's account is written from the perspective of the critics of the war in the late 1960s. He writes with cynicism about Lyndon Johnson's account of the war, the domino theory informing American foreign policy during this era, the gross misreporting of casualties, and so on.

Another recently published book, *Bloods: An Oral History of the Vietnam War by Black Veterans,* offers an account of the oral histories of 20 black veterans. Wallace Terry, the black author of the book, was a correspondent for *Time* magazine in 1967 and he, like Herr, went to Vietnam to gather his story. In the preface to his book, he reports that he was originally asked to do a story on the role of the black soldier in Vietnam. At the time, Martin Luther King, Jr., and Muhammed Ali were denouncing the war in Vietnam. Terry reported that most of the blacks fighting in Vietnam supported the war effort. Later, in the 1980s, Terry, funded in large part by the Ford Foundation, tracked down black veterans, interviewed them, and set forth their histories. The stories vary but they support the argument that the black soldier in Vietnam, unlike his white counterpart, was fighting a battle on two fronts, against Vietnam and against racism. The oral histories in *Bloods* are brutal, wrenching, and graphic, but they also reflect on Terry and his project. They are gathered through lengthy interviews and then written to conform to a model that incorporates the responses of the interviewees to a fixed set of questions.

The oral histories, many taking the form of the personal narrative, tell us as much about the medium in which they are told as about the events that happened. You may want to select material from this collection for study and performance in class. You will find it useful to examine it in the terms of the concepts we have introduced.

You also may want to consider Herr's oral narrative in relationship to the story text and the referential and evaluative features embedded in the narrative. In this case, can you see that there are two story texts and two sets of events that exist in the world of the narration? Herr's narration tells about an incident in real life, when he encountered the kid and heard the kid's story. The kid's story narrates an episode in which he "greased," or killed, a Vietnamese soldier. Both narratives are simple in their structure, recounting a plot, the thing that happened, and featuring it for reasons of evaluation. The evaluative features of Herr's account force us to inquire into the motives that led both Herr and the kid to tell their story. Why did he choose to report the episode with the kid? Why did he include the kid's own story as a part of his own?

Finally, there are two ways in which we can analyze the narrative event, as opposed to the event that is narrated within the story. One involves our relationship to the narrative event as a silent reader of Herr's book; the other

involves an examination of the way in which Herr frames the narrative event of the kid's story. The first kind of narrative event raises contextual questions involving politics, culture, and history. Herr's book is published in 1977, when the United States is still actively struggling with the defeat it experienced in the war. The Vietnam war memorial has not yet been built; veterans of the war are ashamed, and those who control the medium of film are not yet ready to introduce another set of war films, this time to depict a war that we lost. Why is Herr offering his own account at this time? Why are we reading it, either then or now? Answers to these questions force us to put the event in history and to treat it as one of the book's presentations to a public. The narrative event of the kid's telling, filtered through the frame provided by Herr, makes us conjecture about how the kid feels about himself and the war, his relationship to the media, and other such factors, all of which reflect his attitude and his evaluation of the actual incident, the killing, that lies at the center of his story.

By performing this personal narrative to an audience, you are engaged in an act of discovery about another person's reality and experiences. The response of the audience, in this case, your class, will open up the text for still greater exploration, giving voice to another set of contextual elements that are important to an understanding of this kind of cultural performance.

PERSONAL NARRATIVE OF ZORA NEALE HURSTON IN THE FORM OF AUTOBIOGRAPHY

Let us turn to a personal narrative in Zora Neale Hurston's autobiography, *Dust Tracks on a Road.* Hurston is one of the most important black women writers of the twentieth century. She wrote her autobiography between 1939 and 1942, after having written three published novels and two books of folklore. She was one of the leading figures in the Harlem Renaissance in the 1920s, along with Langston Hughes. She sponsored concerts during the 1920s and early 1930s that brought black spiritualists and Haitian dancers to the New York stage. While the white public was coming to understand and idolize the singer Marian Anderson and the actor Paul Robeson, Hurston was seeking black performers who would share their cultural traditions, particularly spirituals and ritual dances, in a manner more faithful to their roots than the sanitized, albeit marvelous, productions of Anderson and Robeson. When Hurston's book was in press, substantial portions were revised to eliminate her criticism of the United States and its relationship to Japan. The bombing of Pearl Harbor stirred up a nationalistic passion that would not tolerate her criticism.

Growing up in Eatonville, Florida, Hurston attended graduate school at Columbia University in the late 1920s, studying under Franz Boas, one of the leading American anthropologists. Her book *Mules and Men* is one of the richest sources of black folk tales in print. She was a flamboyant, headstrong woman, stubborn in her independence and committed, above all else, to her role as a writer. For Hurston, her role was first and foremost to be a writer, and only secondarily to speak as a black writer.

During her lifetime, Hurston resisted being circumscribed by her race. Her work was often sponsored by white patrons as well as black leaders, and her fieldwork in the rural south was undertaken during the Great Depression. Some of her writing was supported by the WPA's (Works Progress Administration) Federal Writers' Project. She knew she was being asked to write in order to enhance the reputation of her race, but she often resisted the insistence that came from whites and blacks that she speak for her race and support the idea of racial solidarity. She was too much of a free spirit to bow to these kinds of demands. Although there were periods when she was the darling of New York intellectual circles, there were also periods both during her lifetime and afterward, when she fell from favor and her work was ignored. Her autobiography has occasioned a lot of controversy, in part because the book withholds so much of her own personal feelings from her public and in part because many of her opinions, particularly on matters of race and politics, so often seem conservative or even regressive. Time does not permit us to explore this matter here, but for those of you who find yourself drawn to this writer, you will want to read her writing and the commentary it has provoked.

Look now at one of the most vivid of the personal narratives Hurston includes in *Dust Tracks on a Road*. This passage occurs after the death of her mother. Her father quickly remarries; the many children who were sent to relatives upon the death of her mother are now called back to their father's new home. Sarah, Hurston's older sister, has been her father's favorite. When she returns to the new home, her criticism of her father's remarriage reaches her stepmother's ears. Her stepmother, enraged, demands that her father beat Sarah with a buggy whip. Hurston's narrative begins by recounting her rage against this act of injustice and the permanent damage it did to the relationship between her sister, who later ran off and got married, and her father.

As for me, looking on, it made a tiger out of me. It did not matter so much to me that Sarah was Papa's favorite. I got my joys in other ways, and so, did not miss his petting. I do not think that I ever really wanted it. It made me miserable to see Sarah look like that. And six years later I paid the score off in a small way. It was on a Monday morning, six years after Sarah's heartbreak, that my stepmother threatened to beat me for my impudence, after vainly trying to get Papa to undertake the job. I guess that the memory of the time that he had struck Sarah at his wife's demand, influenced Papa and saved me. I do not think that she considered that a changed man might be in front of her. I do not think that she thought that I would resist in the presence of my father after all that had happened and had shown his lack of will. I do not think that she even thought that she could whip me if I resisted. She did think, if she thought at all, that all she had to do was to start on me, and Papa would be forced to jump in and finish up the job to her satisfaction in order to stay in her good graces. Old memories of her power over him told her to assert herself, and she pitched in. She called me a sassy, impudent heifer, announced that she was going to take me

down a buttonhole lower, and threw a bottle at my head. The bottle came sailing slowly through the air and missed me easily. She never should have missed.

The primeval in me leaped to life. Ha! This was the very corn I wanted to grind. Fight! Not having to put up with what she did to us through Papa! Direct action and everything up to me. I looked at her hard. And like everybody else's enemy, her looks, her smells, her sounds were all mixed up with her doings, and she deserved punishment for them as well as her acts. The feelings of all those six years were pressing inside me like steam under a valve. I didn't have any thoughts to speak of. Just the fierce instinct of flesh on flesh—me kicking and beating on her pudgy self—those two ugly false teeth in front—her dead on the floor—grinning like a dead dog in the sun. Consequences be damned! If I died, let me die with my hands soaked in her blood. I wanted her blood, and plenty of it. That is the way I went into the fight, and that is the way I fought it.

She had the advantage of me in weight, that was all. It did not seem to do her a bit of good. Maybe she did not have the guts, and certainly she underestimated mine. She gave way before my first rush and found herself pinned against the wall, with my fists pounding at her face without pity. She scratched and clawed at me, but I felt nothing at all. In a few seconds, she gave up. I could see her face when she realized that I meant to kill her. She spat on my dress, then, and did what she could to cover up from my renewed fury. She had given up fighting except for trying to spit in my face, and I did not intend for her to get away.

She yelled for Papa, but that was no good. Papa was disturbed, no doubt of it, but he wept and fiddled in the door and asked me to stop, while her head was traveling between my fist and the wall, and I wished that my fist had weighed a ton. She tried to do something. She pulled my hair and scratched at me. But I had come up fighting with boys. Hair-pulling didn't worry me.

She screamed that she was going to get Papa's pistol and kill me. She tried to get across the room to the dresser drawer, but I knew I couldn't let that happen. So the fight got hotter. A friend of hers who weighed over two hundred pounds lived across the street. She heard the rumpus and came running. I visualized that she would try to grab me, and I realized that my stepmother would get her chance. So I grabbed my stepmother by the collar and dragged her to a hatchet against the wall and managed to get hold of it. As Mrs. G. waddled through the living-room door, I hollered to her to get back, and let fly with that hatchet with all that my right arm would do. It struck the wall too close to her head to make her happy. She reeled around and rolled down those front steps yelling that I had gone crazy. But she never came back and the fight went on. I was so mad when I saw my adversary sagging to the

floor I didn't know what to do. I began to scream with rage. I had not beaten more than two years out of her yet. I made up my mind to stomp her, but at last Papa came to, and pulled me away.

I had a scratch on my neck and two or three on my arms, but that was all. I was not at all pacified. She owed me four more years. Besides there was her spit on the front of her dress. I promised myself to pay her for the old and the new too, the first chance I got. Years later, after I had graduated from Barnard and I was doing research, I found out where she was. I drove twenty miles to finish the job, only to find out that she was a chronic invalid. She had an incurable sore on her neck. I couldn't tackle her under such circumstances, so I turned back, all frustrated inside. All I could do was to wish that she had a lot more neck to rot. (73–76)

This narrative was written on the eve of World War II, when segregation was very much alive in the United States and when the United States was about to go to war against Japan. At the very moment when the book is published in 1942, we were about to witness the internment of Japanese-Americans, another set of people of color, in the United States. Hurston is urged to write her autobiography both by her publishers and by a largely white set of patrons as well as by leaders of the black literary community. Remember, also, that she has been an anthropologist, studying the folklore of the rural black community in Eatonville, Florida. She was born in this small city, one that was entirely black. She must consider how she is going to present this account of her personal history. In a very real sense, her readership is largely white. If you think of these contextual considerations as you try to perform this selection, you will begin to sense some of the constraints under which she writes and appreciate the raw courage she displays in revealing this story, reveling in the particulars of the scene set in Jacksonville, Florida, the rural south by her account.

The story text itself is about a fight prompted by Hurston's desire to avenge the wrongs her father has inflicted on her sister at the orders of her stepmother; but more important, it is her attempt to prove her own identity, who she is in this new household of her father's, ruled over by the dominating stepmother.

The kernel of fact in the story is the fight that occurred when she was perhaps 15 or 16 years old. We do not learn her age in this passage, and the book itself is riddled with incorrect facts, misstatements, and outright lies, but it seems that she is roughly this age. The rest of the narrative is a rich mixture of fact and invention, and certainly we are in no position to affix reliably which is which. Nor in the personal narrative does it much matter. What does matter is that we believe in the narrative, believe in it insofar as we believe that the story tells about an incident in real life, which Hurston uses to mark her coming of age. She is a child in the house of her stepmother living there under the authority of her stepmother, and she is expected to be obedient. Her tale also reveals that she sees herself as reversing the tables on her stepmother. The woman who had her sister wrongly whipped, causing a permanent breach between Sarah and her

father, is now herself whipped by her stepdaughter. Not only does Hurston, in turn, act as mother of her stepmother, teaching her stepmother a lesson, but also the beating leads to a different relationship between Hurston and her father.

The referential material in the story relates the incidents narrated to actual incidents experienced by Hurston. The evaluative elements involve why she tells this story; how she feels about the actions she narrates; and how she expects the listeners of her story, in this case us, a reading audience, to respond. Can you say why Hurston tells this story? Can you place the story in certain storytelling traditions? How does she seem to feel about her role in this fight, which she so colorfully describes?

Probably many of you recognize a certain kind of truth in this tale. Haven't you either told stories yourself or heard others tell of a fight brought about to prove the storyteller's own worth? In literature, this kind of story is often found in novels that tell about the coming of age or of the righting of a gross injustice. In James Joyce's *A Portrait of an Artist as a Young Man,* one of the most memorable scenes occurs when Stephen, the young protagonist, marches to the office of the rector to complain of the "pandying," the beating, that was meted out in the classroom by Father Dolan, who struck Stephen's hands in full view of the whole class for a wrong for which he bore no fault. Other fight stories are found in boy's books and in tales like Mark Twain's *Huckleberry Finn.*

In literature it is less usual to read about girls fighting with girls, and it is even more unusual to find accounts of a girl physically fighting with her mother, but it is not unusual to hear such accounts in everyday life, when individuals are sharing their stories with their peers. In this case, often the speaker is seeking confirmation and validation from her friends to whom she tells the story. The story often has very vivid details, details of the kind we find in Hurston's account. She tells us vividly of the names her stepmother calls her, for example, "sassy, impudent heifer." This name brings with it all the references to a cow's hide and to "a hiding," a thrashing, that have been a part of Hurston's life. Raised in a large family, with numerous brothers, and priding herself on her toughness, dismissing many of the numerous "lickings" she received both in school and at home, Hurston makes herself larger than life, indomitable, someone who does not want to be "messed with" by anyone and yet someone who badly needs the love of her father.

Hurston grew up in an oral tradition in which "playing the dozens" is a rich cultural practice of signification. This mode of discourse, which employs an elaborate string of *tropes,* relies on humor and playfully flings insults about one's family members. Tropes are figures of speech such as similes and metaphors. In this instance, the tropes are repeated with variation, in an almost formulaic fashion. Playing the dozens has its own particular rules and rituals. The speaker revels in hurling invectives, reviling all the past ancestors of family members and then hurling abuse on all the relatives to come for generations into the future. Each turn in the exchange usually opens with an insult, with the speaker uttering "your mama is a . . ." followed by name-calling.

Hurston writes about the ways in which Southerners, whether black or white, are raised on similes and invectives. In *Dust Tracks on a Road,* she describes

this practice: "It is an everyday affair to hear somebody called a mullet-headed, mule-eared, wall-eyed, hog-nosed, 'gator-faced, shad-mouthed . . . razor-legged, box-ankled, shovel-footed, unmated so and so!" (98). Can you see that this list of insulting adjectives used to describe someone, very often one's mother, constitutes a series of tropes? In the narrative passage we are looking at, Hurston draws on her imagination and spirit of play as she freely improvises on the theme of the fight. She makes liberal use of amimal imagery: she is a "tiger," a "heifer," and a creature who wants to draw blood. When she speaks of her stepmother, she likens her to a "dead dog in the sun," comparing her ugly, false front teeth to the fangs of a dog. Her narrative is highly theatrical, and her improvisational stitching of words to relive the battle for her audience, blow for blow, spit for spit, is all part of the pleasure of her narrative. It also connects her to traditions that reach beyond the personal and invoke collective meanings.

In her use of indirect discourse, for instance, when she tells us that her stepmother called her "sassy," we see that she echoes oral, black vernacular speech. Her own language of narration has a folk quality to it, but it also respects the traditions of standard English. Hurston actually locates herself somewhere between these two kinds of speech, and in so doing, she practices what is called "double-voiced talk" by writers such as William Labov, or Henry Louis Gates, Jr., in *The Signifying Monkey: A Theory of African-American Literary Criticism.* This double voice allows her to revise and comment on both traditions, clearing away a space for a new kind of speech that captures her unique, personal experience as well as her experience as part of a larger community of black people living in white America. Her use of double-voiced discourse is one of the ways she manipulates her own image of herself so that it is one satisfactory to her but also impressive to whites.

Hurston's vivid account relishes the particular details of the fight. She wants to describe the blows she delivers and the "pudgy," ridiculous aspect of her wicked stepmother as she falls under Hurston's blows. Of course, the account shows Hurston's familiarity with the Cinderella legends. All the material about a daughter's struggle with a stepmother is a part of the fabric of this story. When you think about intertextual relationships within this narrative, you should consider fairy stories such as Cinderella as well as folk traditions in which brawls and fights figure importantly to define the social structure and positions of authority in tightly constructed communities.

Hurston's story requires her to amplify and enlarge the significance of her actions, setting them in grand traditions. In part this is actually a function of the degree to which she probably felt helpless and displaced at this stage of her life. Her family had been dispersed after the death of her mother. She never really had a permanent home again. The death of her mother propels her into adulthood far sooner than she was ready. She has to make her home with relatives, work as a domestic servant, or travel as a lady's maid to an actress in a touring company after her mother's death and her father's remarriage. Part of the function of her narrative is to come to terms with her father. Another of its purposes is to be true to the memory of her mother and to give voice to her's mother's experiences. During her mother's lifetime, her father was a figure she idolized. His womanizing

and irresponsibility were largely kept from her when her mother was alive and he was carrying out his ministerial functions in the Baptist church. Hurston comes to realize that her father needed her mother's sense of purposefulness and propriety in order to stand tall. After her mother's death, the household falls into disarray. Her father seems to lose his spirit, and traits that in the past contributed to his style are now part of his undoing. Hurston's narrative is part of her project to defeat her stepmother and restore the power of her mother.

This personal narrative is probably the most complex one we have examined in this chapter in relationship to both the speaker's identity and how the story does and does not subvert cultural meanings. Clearly, Hurston's relationship to her own image of herself is something she values dearly. She sees herself as a free spirit, feisty, independent, not to be messed with, a creature subject to rages and passions, and a person in touch with the "primeval" and also a part of a community.

She is expressing personal values within her narrative, but she is also asserting cultural values that involve community values and that speak to her role not simply as a woman and daughter but as a black person, drawing on the black vernacular, oral traditions and existing and writing in a segregated society. She says nothing overtly about these latter dimensions, but can you see that she uses her text to speak to another text, one about the relationships between blacks and whites in America? At this level, she very deliberately celebrates figures of speech distinctive to southern cultural practice and she revels in playing the dozens to assert her and her people's self-worth. Although the reference to the largely white world of Columbia University, near as it is to Harlem, is very brief, it carries a lot of baggage, forcing us to think about her relationship to the white society and inviting us to think more deeply about why she devotes most of her auto-biography, and this narrative, to events rooted in the rural South and a community that is self-contained and largely peopled by her own people, with only a few white characters figuring in her story.

We detect some of the difficulty Hurston has in finding a story that can hold together who she is when we consider the sentence about her studies at Barnard, a largely white, prestigious institution of higher learning, set against most of the descriptive passage in which she depicts herself as part of the Negro community in Jacksonville, where all the neighbors know one another and one another's stories. When Hurston talks about the two worlds, the world of her past in the rural South and the world of Columbia University, she uses entirely different vocabularies. Columbia is a world where she does "research." Now she refers to her stepmother as a "chronic invalid." She tells us that much of her frustration lies in the fact that she cannot complete the incomplete beating of her stepmother. In adulthood she has lost her ability to try to compensate for her feelings of inadequacy and to act out her rage and sense of injustice by physically assaulting a woman. The beating was extraordinary even when it happened. That is part of the reason it lends itself to being told in the form of a story. But equally as important in this narrative telling is the fact that coming of age forces us to be responsible for our acts, and in being responsible, we forfeit some of the freedom of our youth.

In Hurston's case, her appetite to do harm to her stepmother is very great indeed. The woman has cost her both her sister and the sense of a harmonious home, where her sister was her father's favorite. Ultimately, Hurston's stepmother is not the fit target for her anger and feelings of helplessness. They reach far beyond anything this single woman can or cannot do. Hurston directs her fury at her stepmother, who is the outsider, rather than fully reckon with the feelings she has about her father and the way he has permitted himself to be emasculated by the stepmother. Or it may be not that the stepmother has successfully succeeded in making him dance to her tune, but rather she has used the children to try to get back at him.

We cannot fully know the complexities of all these relationships, but we can see that the story provides a vehicle for the speaker to explore some of them, repressing some details while exaggerating others. The result is that Hurston gains power through her words and her telling. Her power comes through presenting an image of herself that she likes and by undercutting some of the cultural beliefs and attitudes that have fettered her while at the same time she tells a story that mainstream society admires.

This chapter has provided examples of personal narratives and introduced the tools of ethnographic fieldwork to help you to collect and perform them. The practice of the personal narrative is grounded in everyday life. As performers, one of the challenges to you when you re-present your narratives is to find ways in which your presentation can capture the diverse voices and contexts in which these narratives rest.

In your performances of personal narratives you will want to continue examining what these stories mean, what values they perpetuate, what values they create, and how they can justly be said to be carriers of culture and shapers of identity.

WORKS CITED

Angelou, Maya. *I Know Why the Caged Bird Sings.* New York: Random, 1972.

Bakhtin, Mikhail M. *The Dialogic Imagination: Four Essays by M. M. Bakhtin.* Ed. Michael Holquist. Trans. Caryl Emerson and Michael Holquist. Austin: U of Texas P, 1981.

Bauman, Richard. *Story, Performance, and Event: Contextual Studies of Oral Narrative.* Cambridge: Cambridge UP, 1986.

Burke, Kenneth. "Literature as Equipment for Living." *Philosophy of Literary Form: Studies in Symbolic Action.* Berkeley: U of California P, 1973.

Clifford, James. *The Predicament of Culture: Twentieth-Century Ethnography, Literature and Art.* Cambridge: Harvard UP, 1988.

Fine, Elizabeth C. *The Folklore Text: From Performance to Print.* Bloomington: Indiana UP, 1984.

Gates, Henry Louis, Jr. *The Signifying Monkey: A Theory of African-American Literary Criticism.* New York: Oxford UP, 1988.

Geertz, Clifford. "Deep Play: Notes on the Balinese Cockfight." *Interpretive Social Science: A Second Look.* Ed. Paul Rabinow and William M. Sullivan. Berkeley: U of California P, 1987. 195–240.

————. "Thick Description: Toward an Interpretive Theory of Culture." *The Interpretation of Cultures*. New York: Basic, 1973.

Herr, Michael. *Dispatches*. New York: Knopf, 1977.

Hurston, Zora Neale. *Dust Tracks on a Road: An Autobiography*. Philadelphia: Lippincott, 1942. Reprinted with a foreword by Maya Angelou. Ed. Henry Louis Gates, Jr. New York: Harper, 1991.

————. *Mules and Men*. Philadelphia: Lippincott, 1935.

Hymes, Dell. "Breakthrough into Performance." *Folklore: Communication and Performance*. Ed. Dan Ben-Amos and Kenneth Goldstein. The Hague: Mouton, 1975. 11–74.

Labov, William. *Language in the Inner City*. Philadelphia: U of Pennsylvania P, 1972.

Labov, William, and Joshua Waletsky. "Narrative Analysis: Oral Versions of Personal Experience." *Essays in the Verbal and Visual Arts*. Ed. J. Helms. Seattle: U of Washington, 1967. 12–44.

Langellier, Kristin M. "Personal Narratives: Perspectives on Theory and Research." *Text and Performance Quarterly* 9 (1989): 243–76.

Morrison, Toni. *Sula*. New York: Bantam, 1973.

Rabinow, Paul, and William M. Sullivan, eds. *Interpretive Social Science: A Second Look*. 1979. Berkeley: U of California P, 1987.

Tedlock, Dennis. *Finding the Center: Narrative Poetry of the Zuni Indians*. Trans. Dennis Tedlock. 1972. Lincoln: U of Nebraska P, 1978.

Terkel, Studs. *Working: People Talk about What They Do All Day and How They Feel about What They Do*. New York: Pantheon, 1972.

Terry, Wallace. *Bloods: An Oral History of the Vietnam War by Black Veterans*. New York: Ballantine, 1984.

Toelken, Barre, and Tacheeni Scott. "Poetic Retranslation and the 'Pretty Languages' of Yellowman." *Traditional American Indian Literatures: Texts and Interpretations*. Ed. Karl Kroeber. Lincoln: U of Nebraska P, 1981. 65–116.

Walker, Alice. *The Color Purple*. New York: Washington Square P, 1982.

FOR FURTHER READING

Baldwin, K. "Woof! A Word on Women's Roles in Family Storytelling." *Women's Folklore, Women's Culture*. Ed. Rosan A. Jordan and Susan J. Kalčik. Philadelphia: U of Pennsylvania P, 1985. 149–62.

Clifford, James, and George E. Marcus, eds. *Writing Culture: The Poetics and Politics of Ethnography*. Berkeley: U of California P, 1986.

De Certeau, Michel. *Heterologies: Discourse on the Other*. Minneapolis: U of Minnesota P, 1986.

————. *The Practice of Everyday Life*. Trans. Steven Rendell. Berkeley: U of California P, 1984.

Fisher, Walter R. *Human Communication as Narration: Toward a Philosophy of Reason, Value, and Action*. Columbia: U of South Carolina, 1987.

Jackson, Bruce. *Fieldwork*. Urbana: U of Illinois P, 1987.

Lionnet, Françoise. *Autobiographical Voices: Race, Gender, Self-Portraiture*. Ithaca: Cornell UP, 1989.

Shapiro, Michael J. *The Politics of Representation: Writing Practices in Biography, Photography, and Policy Analysis*. Madison: U of Wisconsin P, 1988.

Spradley, James P. *The Ethnographic Interview*. New York: Holt, 1979.

Stanton, Donna C. *The Female Autograph: Theory and Practice of Autobiography from the Tenth to the Twentieth Century*. Chicago: U of Chicago P, 1987.

Van Maanen, John. *Tales of the Field: On Writing Ethnography*. Chicago: U of Chicago P, 1988.

Zeitlin, Steven, Amy J. Kotkin, and Holly Cutting Baker. *Celebration of American Family Folklore: Tales and Traditions from the Smithsonian Collection*. New York: Pantheon, 1982.

The Folk Tale and the Folklore of Display Events

Chapter 2 considered personal narratives and showed how they embodied cultural practices drawn from everyday life, enabling us to see how people in society assert their individuality, their own character, and often share their life story. These personal stories tell of hardships as well as triumphs, often speaking of psychic scarring or how difficult it is simply to cope, to get through a day.

In this chapter we are interested in folklore, folk communities, and collective cultural experience more than in the individual person and the shaping of individual identity. Communities as well as individuals give expression to their way of life. They maintain their ties to the remembered past to be able to project their collective values into the future.

FOLKLORE AND COLLECTIVE CULTURAL EXPERIENCE

The various genres of folklore and its performance explore the performative traditions of "the folk." These performances are sites of cultural memory. Folk are people, but people of a certain kind. *Folklore* refers to traditional items of knowledge that emerge in recurring performances for the purpose of entertainment and instruction. Folk stories are constantly being told by word of mouth and passed around, taking on new characteristics. Variation and repetition are so much a part of this kind of lore that it is difficult to talk meaningfully about any one tale in isolation. The tale is part of a larger fabric, which is constantly evolving but which remains the property of the various communities that participate in it.

Folk refers to kin in a closely knit family structure or people knitted together in traditional communities that are local and bounded and in some sense remote

from a more modern and amorphous social structure. The brothers Jacob and Wilhelm Grimm discuss the *Märchen,* the Indo-European "wonder tale." It is a fictive tale located in an unspecified time and place. The tale involves heroes, tasks, magic, and rewards and treats family relationships rather than drawing on the heroic traditions of the court. In this respect, the folk tale can be distinguished from legends or sagas, which draw on heroic traditions and historical fact and are told as if they were true stories. These indigenous folk tales, tales of native speakers, also rely on plots in which natural law is transcended and magic or supernatural forces often figure prominently.

Folk communities are usually small and homogeneous; that is, the people are more like each other than different, sharing similar backgrounds, belief systems, and values. At the simplest level a "folk" community is a small group of people who interact with one another and have in common at least one set of beliefs. The language of the folk tale is immersed in vernacular speech. *Vernacular* refers to a kind of native speech nearer to oral language and dialect than to grammatically correct standard English.

Scholars of folklore are embroiled in arguments about what constitutes folklore, whether it must be defined in reference to traditions, folk, or small groups. For our purposes, we will look at folklore as a kind of performance practice in which the tale emerges in a specific time and place and shows the markings of this time and place, no matter how far it has traveled and how much further it will go. It is received by the group members and passed on with an attitude of trust. The participants may distrust the report of what has happened, but they seriously believe that the narrator has a right to tell them the story and ask them to think about it in relation to how they make sense of the world and how they will act.

Traditional Tales

When American folklorists were searching for materials, they often collected lore from Appalachia, reviving the tradition of the Jack tale. "Jack and the Beanstalk" belongs to this tradition. It is a tale that has its origins in Europe but migrated to this country, where it became invested with details of local color and specificity that wrench it from the community in which it originated and breathe fresh life into it in another land. The story is adjusted to meet local conditions and beliefs. Similarly, we might have cited the Grimm fairy tales and the numerous transmutations of these folk tales as they are gathered from different regions of the world.

The Cinderella story, which has hundreds of versions recorded from the oral traditions, was reported to have been heard in Naples in the 1500s but now appears to have had a much more ancient form. Alan Dundes reports in *Cinderella: A Folklore Casebook* that scholars have identified a Chinese version, dating some 700 years earlier yet sharing the familiar elements of the tale.

In the kernel Cinderella tale, a young girl is mistreated; she is forced to do menial tasks at home; she meets a prince, who is moved by her beauty; she is identified by means of her slipper; and she marries the prince, living happily ever after. In the media version of Cinderella made by Walt Disney, we can see how

greatly the character of the heroine is altered when the story is designed for a mass market. In earlier versions of the tale, Cinderella is strong-willed and rather vindictive. She certainly does not raise a finger to stop her wicked stepsisters from slicing off their toes in an effort to pass the shoe test and win the prince. In Disney's version Cinderella is passive and whining. Whereas in earlier versions she had been resourceful, making her own ball gown with her hands, thread, and needle, in Disney's versions the dressmaking is left to the mice. Poor Cinderella is utterly helpless, just waiting for the prince to rescue her. Such is the way in which folk tales are transformed, recast to suit the particular site of their appearance and the needs of the audience.

The storytellers from whom the Grimm brothers collected were very often women. The brothers claimed to be recording the tales as they actually heard them, but we know now that they took many liberties in the process of transcription, embellishing the story and changing its features. By modern standards of transcription, this practice is unacceptable. Today, a chief objective is to capture the tale in as nearly an accurate form as can be recorded in language. The tales the Grimms gathered were called "old wives' tales" and "granny tales." Interestingly, the early versions of these folk tales told by women often subvert conventional values, vesting power and authority in women, not men. It is the wise old woman or, later, the good fairy or the wicked stepmother who wields power in these tales. Very often the male figures who would typically exemplify power are the ones who are described as foolish. However, when these tales were taken over by men and entered into the written tradition, the female characters were diminished and the males became more powerful. As the tales were edited and reedited during the past two centuries, the women in the stories were accorded less and less importance: wise women were turned into fairy princesses. The rough crone of the folk tale became the bejeweled fairy queen, complete with wand and a court of lesser fairies. Ultimately we have the silly, useless, passive Cinderella of Disney's creation.

Folk tales have this unique quality of being able to subvert traditional values and become invested with new meanings, meanings given to them by the people who tell them. Joel Chandler Harris's Uncle Remus tales of Brer Fox and Brer Rabbit take on a significance quite independent of what was originally intended when they are retold from the porch of a house of black folks in Eatonville, Florida, recounted in Zora Neale Hurston's *Mules and Men*. Alison Lurie, in *Don't Tell the Grown-Ups,* comments on the meaning that "Jack the Giant Killer" holds today:

> [It] can be seen as a lesson about how to deal with the big, stupid, mean, and ugly people you are going to meet in life, a more useful lesson than that taught by video games. Jack doesn't zap the giant with a laser gun, because in real life when you meet a bully or an armed mugger or a boss who wants to push you around you probably won't have a laser gun. What Jack does is to defeat the giant by using his intelligence and powers of invention. (25)

In both these examples, the folk tale can be seen to play an active role in social affairs, helping to maintain social communities and preserve their

continuity. The process is dynamic, blending tradition and innovation while maintaining the coherence of the community. It is also essential to remember that the tale originates in the spoken version generated by an individual in a particular place and situation who chooses to tell it. The performance will feature distinctive traces idiosyncratic to the teller and in part a function of what the audience interjects into the telling.

Folk stories are full of low humor, violence, and sexuality. Psychologists argue that these stories provide us with important lessons for living. They often reveal conflicting motives for an action, showing us that mothers have both a dark and a light side. The wicked stepmother and the good mother are often, in life, dual aspects of a single person. Upon hearing stories of this sort, a child and an adult can voyeuristically live through the emotions experienced by the characters while at the same time learning how to make moral choices and how to cope. Some of our deepest fears are enacted in stories, but the stories also provide information about how to survive these kinds of tests and ordeals and pass on to a better state. Think how many stories, such as "Hansel and Gretel," "Sleeping Beauty," or "Little Red Riding Hood," have their beginnings in a leave-taking, a departure from one family, and conclude with the establishment of another family in which the protagonist can procreate and live happily ever after. Typically, the folk tale, scholars say, traces the maturation process of the child through to the emergence into adulthood and parenthood. In this respect, the tale deals with the growth of individual personality within a larger, communal context.

The hero of the *Märchen* is usually isolated from his family for much of the plot. The family is depicted as full of tension. Stepparents or wicked parents or siblings abound in these tales. Within the story text, the hero is often an only child. He is usually marked as stupid or lazy, and he is usually driven out of his home at the beginning of the tale. Once isolated and alone, in an environment that seems sealed off, the hero is tested in all sorts of ways. Throughout his journey, he seeks advice; he is commanded to execute all sorts of difficult tasks; very often he is subjected to extreme tests of his strength and willpower; often, too, he is forced to set out into the world alone. He makes progress through the advice, gifts, and assistance provided him by others whom he meets along the way.

In these tales, the hero is usually closer to the world of animals and nature than to human society. Because the hero is stripped of home and sent forth alone, he has a kind of freedom that enables him to enter into new relationships, unfettered by ties to family or loved ones. These tales feature the double aspect of experience. The hero is at once stupid and lazy, but he emerges as smarter, more successful, and more energetic than his lesser siblings or his parents. Animals are fierce and dangerous, yet they also offer help and safety. The protagonist begins as the lowliest of creatures in the social order and often emerges at the top.

Can you see how the elements of the story construct an image of the individual as hero, enabling the protagonist to confront conflicting aspects of his personality and knitting together unconscious desires that are unrelated to the conscious desires of the ego? Freud argues that the ego, the *I*, the self, is grounded in reality and struggles to satisfy the imperatives of what Freud called the *superego*, the repository of moral strictures imposed by society and internalized in the individual, while also driven by the instinctual drives of the

id, the unconscious. From Freud's perspective, folk tales offer symbolic versions of sexual processes.

Another psychological perspective, offered by C. G. Jung, interprets the *Märchen* as a tale that embodies an *archetypal* theory of personality, residing in a larger matrix of collective forms known as the collective unconscious. In this Jungian interpretation of folk tales, the tale is a psychological manifestation of instincts, or an *archetype,* as Jung names it. These archetypes predate culture; they are innate properties of the mind, relating the individual to collective, impersonal forms. Later, in part III, on literary performance, you will read more about psychological interpretations of self and literature.

The performance of the folk tale, rooted in a specific community and transmitted in face-to-face oral communication and the larger performance events of public festivals and displays, can be arranged along a continuum. At one end is the fairly private, local, particular, face-to-face interactions of an oral community, offering the tale to one another. At the other end is the public sphere of community festivals or museum exhibitions or such televised transmissions as Calaveras County's jumping frog competitions in which the folkloric performance appropriates the social structures of the larger community, inverting them and vesting power back in the community in a process of social transformation.

Campus Lore

You can probably think of numerous folk stories that arise on campus and are transmitted in face-to-face transactions, and very often the story becomes the catalyst for others to add their own variations on its theme. There is a rich vein of stories circulating among college students and attending to well-known motifs. There are stories about the impossible examination, the student who cheats and has falsified his or her grade transcript, the professor who is involved in some scandal, or a whole set of stories about the library.

At the university attended by the authors, stories always abounded about the "sinking library." A new library was built on campus, resting on sand that had been carried by barges from Indiana to Illinois and used to extend the Northwestern University campus into Lake Michigan. Once the new library was built, rumors began to circulate that it was sinking. It was said that the books were too heavy, and the design faulty, and year by year it was disappearing into the sand. Stories of this kind exist all over the United States. They are always humorous and subversive. The students telling the stories are seemingly reveling in the hope that the books will sink, the tower of learning will fall, and they will be liberated from the weight of these traditions. The story always includes features that are specific to the physical environment in which the story occurs, but the theme of the folk tale is one that is widely distributed, occurring in folk tales all over this country and abroad, and flourishing for many decades.

Folklorists study stories that surround fatal fraternity initiations, student suicides or violent deaths, artful examination takers, grotesque pranks, and the like. One tale Carol Simpson Stern heard retold at the University of Chicago involved a very difficult doctoral examination, which was spread over four days.

It was rumored that more than half the students taking it failed every year. A student's graduation and probably his or her future career depended on a successful score on the exam. Often students spent several years doing nothing but studying for the exam. Usually the questions were intricate, calling on the student to trace the history of intellectual thought in the answer. The tale that was constantly told celebrated the actions of one student who went into the four-day exam and read one of the questions, which was supposed to take eight hours to answer. The reports about the exact nature of the question were always changing, but what remained constant was that the question marched out the names of all the most esoteric philosophers, from Plato and Aristotle to Kant, Heidegger, and Hegel, and asked the student to trace the development of their thinking from the classical era to the present, discussing in particular the precise nature of the philosophical questions posed by these thinkers. The student was reported to have read the question, brooded, and then written a three-word answer. Asked to generalize about all philosophical questions, he had stated that philosophers asked themselves "Why?" and answered "Why Not?" The rumor claimed that he had received distinction for this answer.

Think about campus lore that you are aware of. Reflect on how the tradition of the story contributes to the particular version you know. What do these kinds of stories say about us? What do they mean? Think also about the way in which the story is performed. Where did you hear it? Who was telling it? In what ways is the story directly connected to a particular local site and time? Are these kinds of stories generally told by speakers who are quite accomplished performers of stories? Throughout this chapter you will be looking at different examples of folk lore and learning how to interpret them.

The Fourth of July Fair: Folkloric Elements in a Public Celebration

For an example of a form of lore drawn from the very public end of our continuum of folkloric performance, let us consider a contemporary, local community's celebration of an annual Fourth of July fair. You probably can draw on your own experience of such a fair in a community in which you have lived. We are describing the annual fair in Little Compton, Rhode Island, a community dating back to the colonial period preceding the American Revolution. Third generation descendants of settlers who came on the Mayflower are buried in the local churchyard. The central green in Little Compton, triangular in shape, is graced with a white, wooden-steepled United Congregationalist church, set alongside the old cemetery, with another, newer cemetery across the street. On another side, there is a grocery store, local restaurant, and real estate office. Opposite the point of the triangular green are several historical houses, backed by a large, open field. At the adjacent corner is a playing field and a set of municipal buildings, including the fire department.

The community has its own historical society and in numerous ways the landscape of this town bears the marks of the community. It visibly clings to traditional values, trying to preserve the historical flavor of many of the old

homes, trying to restrict the kind of signs local business people use so that the town can keep its clean, traditional, church-minded look. We are remarking on these features because all are part of the folklore the community chooses to preserve and pass on. There are a constant struggle and constructive dialogue in this community among the forces that are trying to hold onto the past, those that are trying to move beyond it, and those that are betwixt and between. The annual fair enacts this drama.

The Little Compton Fourth of July fair always features picnics on the town green, spreading out to the school grounds and open fields. The fair hosts an antique auction, bake sale, vended food, and parade. Often there is a circus act, with a high diver diving into a bucket. And there are rides in air balloons, sponsored by the local real estate agency. The organizers of the fair and the people who participate in it—in this case a community blending summer visitors, or tourists, with the "regulars," the year-long dwellers in the community—reenact the larger social structures of the society of which they are a part. At the same time the people, the folk, set themselves up as the makers of this larger social order, putting their community's mark on almost every aspect of the fair.

At the fair, the summer people are a principal audience of the event. Conspicuous consumers, they attend the fair, in part for its so-called local color, a color provided by the fair's commitment to American history, by the visible evidence of the local people's contribution to the fair, and by its obvious sense of festivity and play. The summer visitors come together in what is for them a festive occasion. Eating, drinking, reveling, dancing, and participating in the barter of the auction and in the excitement of raffles, these visitors enrich the coffers of the local people, particularly the enterprising organizers of the fair. It also makes the summer people feel more a part of the community. From their perspective, they are bringing their trade to the local vendors, and there are reciprocal benefits for both parties to the transaction because they are interconnected in their economic as well as social lives.

Most of these organizers are local business or church people. The fair mixes values of the marketplace with philanthropic values. The regulars, too, have an investment in the fair. For one thing, the wealthy, business segment of the year-round community organizes the fair for commercial reasons—it is good for business. It brings a brisk trade to the community. One segment of the Little Compton regulars comprises the "Brahmins," the old-line families who trace their ancestry to the Daughters of the American Revolution and the Colonial Dames. These people are active in local government, holding office and acting as the pillars of the community. Many have considerable wealth, and they reenact themselves and their values through expansive philanthropic gestures. Some are running the thrift shop, selling second-hand clothes, many worn only once and bearing designer labels, for the benefit of the poor. Often there is a "story" that is told about the clothes as the shopkeeper shows them to a potential customer. The lore about the clothes may refer to their original owner or to a very fashionable family that supposedly owned them and wore them to some society event written up in the Newport newspapers. Stern remembers purchasing a red plaid man's shirt, and upon buying it, being told with considerable relish that it had belonged to one of the local townsmen, who had died in it.

These good works give the people of the thrift shop a sense of value and worth. The activity spawns numerous parties and social gatherings. Many of the participants also serve as members of the Garden Club, another avocation that gives its participants an opportunity to enforce ideas of social class, preserve and augment the beautiful homes and gardens of Little Compton and neighboring communities, and act as preservationists and protectors of the ecological balance.

Another segment of the Little Compton community comprises the Portuguese farmers, many of whom are now owners of businesses on the pier and harbor. They are fishermen, landowners, and business people. Some of them are impatient with the old traditions. To gain an economic advantage, they want better schools and different zoning laws. Often the fights among the townspeople are fierce. The fair affords an occasion to come together for common purposes, minimizing, for the time, deep differences. The process is one in which the participants enact cultural values, perpetuating them, and participating in an ongoing tradition that is continuous, while at the same time they appropriate elements of social transformation into their ceremonies, mingling innovation with tradition and contributing to change.

Yearly the people of Little Compton put themselves at the center of the community's social structures, presenting a way of looking at the world that appears to be importantly theirs. In doing so, the Little Compton community offers another way of viewing societal structures alongside the view that in this contemporary and largely heterogeneous postmodern America, individuals and communities increasingly lose their differentiation and local color and rootedness. The practice of the fair itself is a performative ritual in which the participants forge their meaning and regain a vital part of their sense of control over the culture in which they live.

Can you see how in the studying of this kind of performative event you will use some of the tools of ethnographic fieldwork described chapter 2? Remember to consider that as the ethnographer of this Fourth of July fair, you are trying to offer an account both for and about the people of Little Compton. In writing the passage above, Stern stands as an outsider, a relative of summer people who have retired and become regulars in Little Compton. The account is heavily flavored by the perspective that Stern brings to it. To do justice to the ethnographic obligation of describing the fair, our final product would include photographs and written transcriptions of the voices of the participants and planners. We would also include reproductions of the flyers and advertisements that accompany the fair as well as of the ledgers and records, which render it from another angle. The account would feature a number of the local landmarks, including the relics of native American graves, the woods where Benjamin Church, the Indian fighter, did battle with King Philip and Queen Awashonk. It would show how local lore surrounding these sites manifests itself in the festivities of the fair.

The ideal ethnography is one that places the voices of the "other" and the voice of the describer in play with each other. It strives to respect the differences that exist within and between cultures. It is a self-reflexive process that wants to construct a dialogue among the participants, respecting their differences and

wary of imposing too normative a reading on any of the perspectives that are at play. Ideally, Stern's account should capture the voices of many of the "other" groups, competing to be heard.

THE FOLK TALE: A DEFINITION

Julius Lester, in *Black Folktales,* writes that "folktales are stories that give people a way of communicating with each other about each other—their fears, their hopes, their dreams, their fantasies, giving their explanations of why the world is the way it is. It is in stories like these that a child learns who his parents are and who he will become" (vii). The folk tale has a homespun and intimate quality. The folk, people seen as a collectivity, a community, share their inheritance, their traditions, with one another for the purpose usually of constituting the social order or bringing about a transformation of it.

The folk society in which the story emerges is usually homogeneous, covering a small area of space, and involving face-to-face interactions. One of the key features of the folk tale is the degree to which it is rooted in a specific, localized place. The community may be rural or urban, but the tale affixes meaning to very particular parts of the local landscape in which the story is set. The tale can originate in face-to-face tellings in a quite private sphere and then be extended across larger temporal and spatial planes, opening itself up to a more public sphere and being shared in festivals or in mediated forms of communication such as television.

The folk tale is a kind of lore or local wisdom. This lore draws on the figure of the trickster and speaks in terms of superstition, rhymes, games, jokes, and proverbs. In folklore, magic figures prominently as it offers its explanation of the world. We will be commenting more on the figure of the trickster later in this chapter. Lore is also a kind of learning; it is instructional. People use it to teach one another about themselves and their past and to enforce a set of values and beliefs. Consequently, we often think of folklore as a means to perform and transform tradition, passing traditions on from one generation to the next and actually constructing the tradition through the process of its performance. Folklore is also used to transmit values and truths that are often suppressed in the mainstream culture. It can give voice to violence, hate, greed, sexuality, and other emotions that are considered dangerous by society but must be acknowledged through some socially acceptable form in order for people to maintain their sanity and balance and function.

Earlier, we looked at the personal narrative in its oral contexts and spoke of it as a personal story in which individuals try to make sense of their lives. The folk story resembles the personal narrative in many respects, but it is distinguished from it in that it tells about something that has happened or been imagined from the perspective of a social community passing on collective wisdom. The personal narrative emphasizes the person as an individual existing within society. The folk story emphasizes the social and collective self, subordinating personal values and experience to the experiences of the group.

Lester states that children use folk stories to learn about their parents and themselves. Both folk stories and fairy tales are among the most subversive kinds of stories. They originate in oral traditions and are told by people who are seemingly unimportant in an institutional sense; in other words, they are children or marginalized people, people who have not fully grown up or who exist largely at the margins of society. These kinds of stories employ disguise to shield the ways in which they undermine or reverse the larger society's values and institutions. The stories support the rights of the disadvantaged members of society. Usually the story has no respect for law and order. People of power, counts and kings, are fooled by master tricksters. We see that the emperor has no clothes. When this kind of lore begins to enter the mainstream and be set down in books, generally the books are met with an outcry of condemnation.

Lewis Carroll's *Alice's Adventures in Wonderland* and Mark Twain's *The Adventures of Tom Sawyer* created quite a storm when some educators proposed introducing them to children in schools. Why? Because they struck the public and parents as books that undermined society's rules and regulations and its sense of propriety. Alice was hardly the image of a quiet, demure, nineteenth-century Victorian girl. The courts of the Queen of Hearts and the Red Queen can be interpreted as parodies of the court of Queen Victoria. Humpty-Dumpty parodies the teacher, the professor, who is so full of readings and interpretations of literary texts. Alison Lurie, in *Don't Tell the Grown-ups: Subversive Children's Literature,* reminds us that Humpty-Dumpty proudly proclaims that he can explain all the poems that have been invented and many that have not yet been invented. She recalls that Carroll's poem about the Walrus and the Carpenter is also interpreted as a caricature of Benjamin Disraeli and William Gladstone, two of Queen Victoria's ministers from rival political parties. The illustrations of the Walrus and the Carpenter are clues to this allegorical reading. The illustrator, Sir John Tenniel, pictured the Walrus in the elegant dress of Beau Brummel, the dandified Disraeli, and Gladstone is pictured in untidy clothes. Lurie reminds us that Tom Sawyer is a liar, a cheat, a bully, a fraud, and a bad boy who smokes. He is rewarded with a pot of gold and the beautiful Becky Thatcher. In these kinds of stories, the rich and powerful are often childless. They are tricked by people of no social station. All is topsy-turvy. Kings are fools and beggars are kings.

Richard Bauman, a leading American folklorist and performance theorist, describes folklore "as practice" in his essay "American Folklore Studies and Social Transformation: A Performance-Centered Perspective." He describes social life as something that is "communicatively constituted, produced and reproduced by communicative practice." Folklore, from his perspective, is a communicative means used by social actors "in the accomplishment of social life" (177). In this respect, one studies the performance of folklore not only to examine the text of the folk tale but also to consider how the communal process and social interactions give rise to the tale, assist in its transmission, and relate to the artistry and performance skills of its teller. In addition, one studies how folklore functions to share collective meanings and values and how the cultural community prepares for and participates in the fabrication of folklore.

Other scholars of folklore stress that it projects the values of a community into the future; validates the culture in which it is situated, justifying its rituals and institutions; offers instruction, of both a practical and moral kind; and provides a means of exercising social control, enforcing conformity to social practices. Together, these functions serve to perpetuate culture.

Let us turn now to a consideration of a folk rhyme as a kind of artistic verbal performance, enacted by interactants in face-to-face exchanges in such a way that the boundary between participant and audience is blurred. This kind of performance is a form of play, governed by rules that prescribe an order of taking turns.

THE CHILDREN'S RHYME, PERFORMED IN A SCHOOLYARD

Think about some of the rhymes you have heard children chanting in the playground as they transmit their folklore. Lurie quotes a rhyme sung by children in a schoolyard as they jump rope.

> Fudge, fudge, tell the judge,
> Mama has a baby.
> It's a boy, full of joy,
> Papa's going crazy.
> Wrap it up in toilet paper,
> Send it down the elevator. (3)

This is the kind of lore children pass on to one another in the playground. On one level, the simple rhyme seems cruel; on another it can be seen as a means by which children can speak about the forbidden and can express things they are not supposed to speak about, or even feel, at home. This rhyme is part of children's culture. The schoolchildren chanting it are enacting a tribal rite. Discipline and punishment are a part of children's worlds.

Children rely on magic and superstition and jokes to navigate their reality. Lurie notes that words often seem to hold magical properties for them. In the early stages of language acquisition, a child is effusively rewarded when he or she first utters a real, as opposed to a nonsense, word. To name things seems almost wondrous for a child. Initially, it can produce instant gratification. Children living in a world with adults quickly discover how the choice of a word can bring rewards or punishment. As they struggle to learn the difference between literal and figurative speech, they experience considerable discomfort.

Jokes and riddles show us how powerfully children fear being made to look stupid. Many such jokes hinge on a child's ability to recognize a simile or metaphor. Riddles are designed to make the questioner appear intelligent and in control and to leave the questioned one at a loss. For example, in the riddle

about the Big Indian and the Little Indian, the Big Indian says, "You are my son, but I am not your father; who am I?" and the answer is "I am your mother." We are so conditioned by lore about gender, which makes us think a Big Indian, or a chief, must be a man, that the child is often stumped and fails to give the obvious answer. Of course, the way in which the riddle is told is significant here. The teller has opened by describing the Big Indian and Little Indian seated on a horse. The narrator has probably inflected the opening and theatricalized it, suggesting the image of an Indian chief, male, riding with the child. The child who answers correctly feels the pleasure of having been able to satisfy the questioner; the child who fails enhances the importance and seeming power of the questioner. Jokes and riddles of this sort are necessary to children's culture. They give children a sense of control over a world in which, in many ways, they have very little control.

Look back at the rhyme quoted previously. It complains about the birth of a new baby. Here it is no happy event. The singers of the rhyme imaginatively set their case before a tribunal, a judge, investing him or her with all the authority that resides in such figures. As they put their case before the judge, they are calling for a ruling that will do away with the child, either by flushing it down the toilet or sending it down an elevator shaft. There is something quite sinister about the latter detail, but also something very local. The schoolyard in which the rhyme is spawned reminds us of principals, other authority figures, marching in lines to and from class, and going up and down elevators—but always rigidly regimented. But here the children turn the forces of authority to their own advantage. At home, the lawgivers are their parents; in society, the lawgivers are their teachers, the schools, and then the larger figures of law and the courts in the society. But here, the children by a trick of rhyme diminish the judge to something that rhymes with fudge, a chocolate, sugary sweet.

The announcement of the baby's birth is sung out, but we quickly learn that this bundle of joy is driving its father "crazy." This line balances simultaneously two possible readings. The father can be both "crazy" with joy, meaning he is "wild" about having the child, or he has been transformed into a kind of madman, a lunatic who has been driven out of his mind by the news of the child. This ability of the line to carry two opposite meanings simultaneously is characteristic of nursery rhymes and folklore. It enables the fashioner of the language to express deeply ambivalent states of mind. The inherent contradiction in the language need not be resolved, nor is it often resolved in life.

The children have made the arrival of the child something that is both wanted and unwanted. They talk about its gender, that it is a "boy" child, and a source of joy—and at one level, the children feel this; however, at another level, the new sibling is resented. In taunting tones, emphasized by the swinging of the jump rope, the children call for the child to be destroyed. In so doing, they vicariously experience an impulse that is forbidden to them in reality. Although the words used in the song are simple in their diction, they also resonate, commenting on one another in ways that cannot be explained by the grammar or syntax of the rhyme.

"Fudge, fudge, tell the judge" does not make clear sense in English. Why are the singers invoking "fudge"? Is "fudge" supposed to refer to someone, as the syntax of the line would suggest, or is the passage elliptical and is "fudge" being used as an expletive, offering parasyntactic commentary on the entire situation? In this interpretation, we have a situation in which Mama has "fudged it," or botched it by having the baby. The judge, somehow, is connected to this "fudging," by virtue of the fact that except for one letter in the alphabet, *f* in place of *j*, this person sounds just like the word that refers to the utter muddle and mess of the affair. At this level of symbolic values, can you also see that it is not an accident that the verse is talking about brownish-colored messes and hopes that the child will be smeared with feces and put down the toilet?

Writing on children's fantasies about birth, Freud noted that often the child imagines that a mother gives birth through her anus or that the baby is expelled from the stomach through the navel. His observations help us to understand why the children jeer that the baby should be flushed down the toilet. In a complex figure of speech, the text mingles the act of birth with the act of destruction. The singers of the song wish that the mother's baby had been delivered in the toilet.

The rhyme chanted is guttural and bawdy, expressing the obscene in barely disguised language. It offers a kind of bad bathroom joke as it expresses the mixed feelings children have about the arrival of a new sibling. Lore such as this lets children ventilate ideas and emotions that would very often be punished if they were expressed more openly in the situations in life that give rise to these feelings.

Notice that this is not a single child's complaint, but rather it belongs to the culture of schoolchildren and it thrives not in the classroom but in the open air of the playground. The children are performing a task as they chant. The swinging of the jump rope gains in its force, almost whipping the jumpers into words and actions, and each swing of the rope is like a blow of a whip. The chanters use this rope to reverse roles and themselves act as judges and disciplinarians who mete out punishment to the erring parents and to the unwanted child. These contextual features further reveal how the performers are both embedded within a culture and engaged in the process of commenting on it. The ideas the chant expresses are very real and quite serious, but the venue is playful.

Often folk stories and fairy tales are criticized for the violence and lawlessness they promote. And yet within the tale these means are put to good ends and we discover that it is the important people who are often truly corrupt, violent, and lawless. You saw an example of this kind of inversion at work in Hurston's tale of her fight with her stepmother. She is, indeed, an adolescent girl who should be thoroughly ashamed of her conduct. Girls are taught not to fight; parents teach their children never to raise their hand against them. Girls are not supposed to spit, and it is rude and ill bred to reveal our animal instincts. Hurston's tale, a personal narrative that has many folkloric overtones, inverts all these teachings, winning us over to her side. She looks at her world from the position of the disadvantaged. She is the child, looking up, seeing more than she should see. From her unique position as child, weak and disadvantaged, we see the flaws in her

father and stepmother. Her tale tells us that life is not really as it is described to be in the antiseptic teachings of adults, who are trying to discipline and control children to bring order to civilization and govern social relationships.

"KEEP ON STEPPING" AS SET DOWN AND TOLD BY JULIUS LESTER IN *BLACK FOLKTALES*

Let us look at one of the black folk tales as written and performed by Julius Lester. Lester cannot remember the source for the story, although he knows it exists in other printed versions. The following version is his telling of the tale, presumably sometime in the late 1960s, in preparation for the publication of his book. Read the story aloud; perform it; and think about the context of the 1960s, the civil rights movement, and how it enriches your understanding of why this tale, growing out of the days of slavery, is still being told. The reference to High John alludes to the folk hero High John the Conqueror, also known as trickster John or Jack, who was a slave in Mississippi.

Keep on Stepping

You know, white folks are something else. Always been like they are now. Just don't want to let a nigger be a man. Somehow they figure if you become a man, they ain't one no longer.

Back during slavery time, there was a black man by the name of Dave. He was slaving on a plantation somewhere in Tennessee. One day he was out working in the field, and he saw ol' massa and ol' missy's two children out in a boat, screaming. They'd lost the oars, and the boat was out of control, spinning around, and they were about to be thrown into the water.

Now if Dave had been a field nigger like High John, he would've swum out there and tipped the boat over. Dave wasn't like that. He'd probably been working in the sun too long and couldn't think straight. Anyway, he ran to the big house and told massa and missy.

Ol' missy hollered out, "Somebody save my children! I ain't never gon' have no more, and them the only two I got."

So Dave ran down to the river, jumped in, and saved the two children. Well, ol' massa and missy was mighty happy, and massa told Dave, "Well, nigger, if you make a good crop this year and fill up the barn and work 'till the crops are laid by next year, I'll give you your freedom."

That's what I mean about white folks. He couldn't give Dave his freedom just because he'd saved the children. Uh-uh. Dave had to save the children, plus do all the plowing and planting and hoeing the next year; then, if he did all that, he'd get his freedom. Dave was free all the time. Just didn't know how to enforce it.

Anyway, Dave worked like a champ to make a good crop that year. He made such a good crop that it not only filled the barn, but half the

house, too. So, after the crops were laid by the next summer, massa called Dave in the house.

"Well, Dave. I'm a man of my word. You're a free nigger today. I sho' hate to get rid of a good nigger like you, but I promised."

So he gave Dave one of his old suits of clothes and a few other things. The children were crying, and ol' missy was crying, and ol' massa was kinda sniffing himself. But Dave tied the clothes in a bundle and put 'em on the end of a stick, and took off down the road, walking real slow.

Ol' massa called out after him. "Dave! The children love you."

"Yassuh," Dave called back.

"Dave, I love you."

"Yassuh."

"And missy, she like you."

"Yassuh."

"But remember, Dave. You still a nigger."

As long as Dave was in sight, massa was standing there on the porch, hollering, "Dave! The children love you. I love you, and missy, she like you. But, remember, Dave! You still a nigger!"

Dave would holler back, "Yassuh," but he kept right on stepping until he got to Canada. Even though massa had let Dave's body go free, he still wanted to keep him a slave by yelling, "Remember, you still a nigger."

You ain't free long as you let somebody else tell you who you are. We got black people today walking around in slavery 'cause they let white folks tell 'em who they are. But you be like Dave. Just keep on stepping, children, when you know you're right. Don't matter what they yell after you. Just keep on stepping. (153–57)

Immediately, we recognize that this folk story addresses the relationships between blacks and whites, slaves and free, the rural South and the urban North. In the 1930s when Hurston was gathering folk tales, she talked about the difficulty of collecting them. Noting that the Negro people were historically underprivileged and shy, she pointed out that often the best tellers of lore would be reluctant to share their lore, their soul, to outsiders. She also commented on a characteristic of Negroes, saying that

. . . in spite of his open-faced laughter, his seeming acquiescence, [he] is particularly evasive. You see we are a polite people and we do not say to our questioner, "Get out of here!" We smile and tell him or her something that satisfies the white person because, knowing so little about us, he doesn't know what he is missing. The Indian resists curiosity by a stony silence. The Negro offers a feather-bed resistance. . . .

The theory behind our tactics: "The white man is always trying to know into somebody else's business. All right, I'll set something outside the door of my mind for him to play with and handle. He can read

my writing but he sho' can't read my mind. I'll put this play toy in his hand, and he will seize it and go away. Then I'll say my say and sing my song." (18–19)

Consider Lester's tale in the context of these words of Hurston's. Who is the audience of Lester's tale? Is it a tale to be shared among blacks, is it for a white audience, or is it for a mixed audience? What clues in the tale and in the context help you to answer this question?

At the opening, the speaker confides that he is going to share a private kind of knowledge about whites, a knowledge that blacks know and that whites probably do not want to acknowledge. In this respect, he is talking to black people who may know the experience of slavery or certainly have heard about it. He is also speaking to whites, not within the frame of the lore itself, but through the implied audience, external to the story, reaching beyond the community that shares the special knowledge of the white people's ways and declares itself to whites. Lester's introduction to his volume of tales helps us to recognize this point. He says that he tells these stories again, not as they were told over one hundred years ago, but as he wants to tell them now, in the wake of the civil rights movement, because they have meaning now.

Look at the dialogue between Massa and Dave. As Massa is shouting out to Dave, saying that he "loves him" and missy "likes him"—note the different verb here—but reminding Dave that whether he is free or not, he will always be a "nigger," Dave's responses are always the same: "Yassuh." With each "Yassuh" we realize how much more meaning this word withholds than it shares. Outwardly, it reflects the polite, smiling Negro, telling his master what his master demands to hear and what power has enforced. Behind the word is a completely different set of meanings and a different self. The real self, hidden behind the words but shining forth to those who can see behind language, is an independent soul who cannot be dominated or corrupted by those holding power and privilege. Massa is a white man who "sho' can't read" the mind of Dave. Dave's words seem to sustain the power structure and social relationships as they are organized during the age of slavery. However, actually they subvert them. As he keeps answering with "Yassuh," he walks away and keeps on walking, all the way to Canada, where slavery does not exist as a social institution.

In this tale, it is Massa who appears foolish and enslaved. Trying to appear masterful by reminding the slave of his power over the slave's body—and also asserting his power over his wife, Missy, who can only "like," not "love," Dave—we actually see Massa as henpecked by his wife and children. He is trapped by his domesticity and stuck in his home while his slave walks away. Equally important, he uses words stupidly. He shouts them, acting as though they actually state what he means, whereas in fact they are hypocritical. The slave, in contrast, never pretends that his words mean what they say. In the 1960s, when Lester retells this folk tale, he addresses it as much to his own community as to whites. It empowers the free black man by showing that he is always free, no matter if his body is owned by someone else and no matter if he is always being

watched by others who are trying to force him to conform to their ways. It also enables him to remind the black man not to be an Uncle Tom but to remember his own heritage and dignity.

THE TRICKSTER AND THE PLACE
OF LAUGHTER IN FOLKLORE

There is a rich tradition, both oral and written, concerning the trickster. You have encountered this figure in stories like the Jack tales in which Jack uses wit and good luck rather than physical strength to overcome his enemies. In the cycle of Jack tales, poverty is generally the occasion that sends Jack on the road in search of a job and worldly goods. He encounters numerous misadventures, often involving witches and animals and threats of dire misfortune, but he always turns the tables and outwits those who threaten him, usually by a combination of cunning and good luck. The tales typically end with his return home after he has defeated his enemies and acquired the material wealth he needs to stock his cupboard.

During the mid-1930s these Jack tales were collected by Richard Chase in the Beech Mountain area of Watauga County, North Carolina. They were published in 1943 in *The Jack Tales,* and subsequently many have been made available on excellent recordings. The tales are much older, and originated in Europe. When they resurfaced in North Carolina, they not only were carried through word-of-mouth traditions of local people but also became a part of the professional repertory of accomplished storytellers. Each of these tellers brought his or her own personal history as well as distinctive performance style and features to the performances. If you study the performances of professional storytellers, consider not only the particular performance competence but also the individual cast the teller gives to the tale. The latter is very much a function of the person of the teller and his or her interactions with the audience. As storytelling is professionalized, it undergoes transmutations reflective of the greater distance between the teller and the audience. Taken out of an intimate context, the more polished version of the professional tale undergoes marked changes. Some of you may want to look at multiple versions of the same tale and at performance-centered descriptions of professional storytellers in order to understand this dynamic.

The trickster is a figure who employs deceit, pranks, tricks, and jokes and intentionally manipulates the situation so that other persons have a false or misleading sense of what is going on, consequently inducing them to act in a way that brings humiliation, discomfort, or pain.

You are all familiar with the traditions of the practical joker and the jokes he or she plays on the victim. In most of these tales, the practical joker is a trickster, disarming the audience and playing a prank. Tales spun from practical jokes always construct the situation so that it sounds as though it actually occurred. Very often, the tellers either employ the first person, depicting themselves as the trickster, or they tell the story in the third person, but add authenticity by asserting

that either they knew the trickster or they were there during the trick. These kinds of stories depend for their effect on the audience's belief that they actually happened, even if they did not.

The figure of the trickster is familiar in folklore and in carnival. Mikhail Bakhtin writes on carnival, tricksters, and laughter. He shows how the world of carnival, a festivity designed to invoke and maintain joy, inverts the normal hierarchical order, turning everything upside down and inviting laughter. The laughter destabilizes authority, not permitting any one view of the world to hold sway. It gives expression to multiple voices and multiple ways of seeing the world, liberating people through the socially acceptable mechanism of laughter. Laughter is an aggressive behavior. It both bonds the individuals laughing and raises conflict. Someone is being laughed at. Laughter creates a we/they opposition, and yet its infectious qualities sustain a state of ambivalence. Rival groups can often laugh together; it is simply that they are not laughing at the same thing. The laughter is releasing psychic energy, which is, in part, a function of the repressive environment civilization places on humans.

In the world of carnival, the normal political, religious, and economic order is inverted and power is displaced to those who are the lowest in the social order. This theme of inversion is carried out in numerous aspects of the festivity. The image of the carnival is often the wheel of fortune, which more recently found its expression in the Ferris wheel. All sorts of acrobatic feats and whirling devices are featured at fairs. Even the human body participates in the rite of inversion. Performers dress up in overly elaborate costumes, with wide bottoms, and then perform cartwheels as they parade, bringing the heads of the clowns and masqueraders to the lowest vertical end of the axis, making them nearly touch the ground, while their bottoms and widespread legs fly high in the air. Thus power is displaced. The high are low and the low are high.

In these antics, usually the clown or the populace is king for the day, and those holding real power play the fool. These powerful inversions also affect the rite of eating. Many of the games and feasts are not adorned by a wealth of rich food but offer pigs' bladders, the pope's nose, or actual excrement as the just fare for those who have abused their powers.

We are citing these features of carnival because they are also found in the performance of folklore, and many of their qualities are invested in the figure of the trickster. As you explore performances of folklore and as you perform the character of the trickster, think about how the trickster manipulates the story, deceiving others, lying, and yet winning the approval of the audience, returning the world of the story to a good end, and punishing those who are shown to be undeserving.

The tales of the trickster depend, as does all folklore, on the audience's prior knowledge of many of the elements of the tale and also common referents to matters external to the actual lore being performed. Much of the delight that emerges from folkloric performance comes from the fact that we know the broad outlines of the kind of story we are hearing or participating in. We are also joined to others in the community in which the lore is shared because we share other kinds of knowledge and experiences that contribute to reinforcing the community.

It is this sharing of prior knowledge and common referents that provide the ground, or the basis, for the performance of a tale. We are sure you can think of socially strained situations, in which you are with a group of people who are largely strangers and with whom, at least initially, you have little in common. This is not fertile ground for folktales. It is unlikely that they would arise as long as the situation remained as alienating. You have to know the conventions of the lore in order for it to be performed.

THE FOLK LEGEND: CONVERSATION BETWEEN PEOPLE SWAPPING LEGENDS

Linda Degh and Adam Vazsonyi provide a transcript of a 1962 performance of folk legends in their essay "Legend and Belief." On the evening of the recording, eight adult women, four elderly men, and two young men were in the living room of a peasant cottage. The women were spinning hemp; the men were smoking. The tape recorder was placed in another room and the microphone was concealed under a shawl. Only the hostess knew it was there. The following is a description of the people and a transcription of a segment of the tape:

> Besides Mr. K, the twenty-two-year-old male proponent of the main legend, there were two principal contributors: Mr. A, a thirty-year-old man, and Mrs. Sz, a fifty-eight-year-old woman. The other contributors were Mr. E., the host; Mrs. E, the hostess; Mrs. F, R, and S, three elderly women; and Mr. T, an old man. Also present were two men and three women who did not take part in the conversation. [There is also a Mr. F, whom the authors do not acknowledge in this headnote.]

MR. K. Now listen to this, folks. In M. there is a woman. She is hundred and four years old. An old woman of hundred and four years. If anyone would shake hands with her would get three thousand forints.

MR. E. I have heard four thousand.

MR. T. What? Four thousand? You don't say!

MR. K. Sure. Whoever would shake hands with her. I mean, take her hand.

MR. T. What the hell! Why not? For four thousand?

MR. K. She cannot die until someone shakes hands with her.

MR. T. This is a joke.

MR. E. She is a witch.

MRS. S. Oh no . . .

MRS. F. This is the truth. Everybody knows about it.

MR. T. Why shake hands with her? What for?

MR. A. She cannot get rid of her power. She cannot die until someone takes over, do you understand, uncle? But no one wants it.

MR. T. Her power?

MRS. E. And her sins. She is a sinner.

MR. K. My father tells me that he would be willing to take her hand and squeeze it. But it had to be only the two of them. No one else can be present. Only the one who will do the handshaking and the old woman. And the fence around her orchard is something peculiar. No one on this earth has seen anything like this . . .

MRS. S. Oh come on . . . what can be so peculiar?

MR. K. Just listen to this: that orchard is full of apples and if one would reach out for one, I mean someone would pick up an apple from under the tree, his hand would shrink. One could not pick up the apple with one's hand. No one ever guards that orchard. No one takes care of their horse. They turn it loose, nothing on earth . . . I was . . .

MR. F. God protect us!

MRS. R. I have heard it too, but I am not sure about it.

MRS. E. God would not let this happen. I wonder . . .

MRS. S. Who is it?

MR. K. [*to Mr. A*] You know them, why don't you speak up?

MR. A. Of course. She lives close by the Catholic Church.

MR. E. On the corner, next to the cemetery?

MR. K. That's right. And you know about her son? She has a son, a handsome young man.

MR. A. He doesn't get a wife, no matter how handsome he is.

MR. K. He cannot marry, neither can her daughter. No one wants her daughter.

MRS. F. No, because of her mother. The witch.

MRS. S. I don't believe this.

MR. T. I do, I do . . . This is a good excuse for the boys. Is it not more sensible to stay a bachelor? [*He laughs.*] Smart fellow, didn't let himself to get pushed around.

MRS. SZ. Don't talk rot, old man. There were others like this. There was a man. But he is dead now. He lived somewhere close to these people. They say he was on his deathbed for very long, maybe for two weeks . . .

MRS. E. [*whispers*] He was tortured by the devil . . .

MR. T. O.K., haven't you ever heard about people who were dying away slowly? The teacher's mother had cancer . . .

MRS. SZ. . . . but he was tortured so much that the down comforter flew up from his body into the air, in the house, then, high up into the attic and again down. As if it would have been smashed into the middle of the room, onto the floor. Of course, they did not know what it was about. The one was there, who went to see the sick,

grabbed it and put it on the bed. As soon as it was on it, the puff jumped away again.

MRS. F. He got it I am sure, his sin or what, his power was taken over by the one who picked up the puff and put it on his bed.

MRS. SZ. The man could not die before that.

MR. T. All right, all right. You were saying they got to shake hands. How does the puff know that? This is all a big—big stuff of nonsense.

MR. K. Of course they have to touch hands until they get even with him.

MRS. SZ. Yes, yes, but nobody wanted his hand, no one went near to him. This is why the puff flew down the floor. As it was there, they had to put it back on its place. There was no other way.

MRS. S. How in God's name can a puff fly up to the attic?

MR. T. They were dreaming.

MR. A. But who would shake hands with a woman like this? Anyone would be scared.

MR. E. I wouldn't dare.

MR. A. She looks awful. She is only skin and bones. Only her big eyes. Her hand like a skeleton, only the skin keeps her together not to fall apart. She can't take a step all day, at night she still is not in her bed.

MR. T. Where is she?

MR. A. Who knows? They carry her all around.

MRS. S. People talk so much of these things, one is confused what to believe of it.

MR. T. Talk, talk, too much waste of time. I have never seen anything, you can take my word on that.

MRS. E. Who carried her around?

MR. E. The devil, the evil one. Her partner.

MR. K. That's why she can't die and rest in peace.

MRS. SZ. They carry her all over. Those are dragged to the middle of the Tisza [*river*], into the willows, the thickets, on the top of the houses, over hills and valleys, ditches and bushes, they drag those everywhere.

MR. K. Well, of course, these have to go, to settle with the devils. This is real truth, Aunt Emmy.

MR. T. How you can lie!

MRS. R. Maybe those things happened to our ancestors. Not today. Wasn't that one of your father's stories?

MR. K. You can visit and see for yourself. I am not making this up.

MR. A. Now listen to this. Do you know who was the one who told this to me? The man who built the house of the B's, over in E. I don't know whether you know the man. The name is M. Do you know the M. boys?

MR. E. Why, sure.

MRS. E. Aren't we related? We baptized one of the boys.

MR. A. Well, they've called them to finish up the house, the house of the old woman. They offered some eight thousand forints for the finishing and the painting of the house from the inside and the outside. And they didn't dare do it. Such an easy job for so much.

MR. T. What a dope.

MR. A. If you don't believe, why the hell don't you do the job? For that money?

MR. T. I have no time for fooling around. (104–07)

Read this conversation aloud. Try to perform it. You will probably want to assign a character part to each student, so that one student performs Mr. T's lines, another Mr. A's, and so on. Think about the attitudes toward belief of the various participants in the conversation. If you work with this selection in group performance, observe how you relate to one another as you play roles that involve you in ordinary conversation. What impulses do you have to interrupt one another? What clues do the lines give you about the age, background, and relationships among the speakers? Why do you think this particular story is told and retold? This conversation occurred in the 1960s. Could it equally well arise today? Why? Why not? Do you think it was unethical to employ a concealed microphone? Let us think now about how legends function and what characterizes this kind of folk narrative.

Scholars of folklore often quarrel about what constitutes a genre, whether a tale is a myth or legend or folk tale, and so on. We are less interested in what constitutes the formal mode of the tale because a tale, initially site specific and authored by one or several people, spreads across vast geographical terrains, constantly evolving and acquiring a mixture of characteristics that makes generic distinctions wobbly.

In the past, the legend was distinguished from the *Märchen* by virtue of the fact that it told of the narrator's ancestors, bringing glory to them, or of historical events, such as battles, explaining their significance to the local community that shared in the lore. Thus legends were tied to empirical facts and historical reality and therefore were true, whereas the *Märchen* was fictional and clearly known to be a lie. In addition, it was typically believed that the legend, or saga, involved belief. These past ideas about the legend were largely developed not by studying the living, collective event of the performance of legend but by analyzing written texts of the tale as though they were unified stories best illuminated by techniques of literary criticism. Many recent studies of folklore are attending to its performative dimensions and significantly altering how we understand these forms.

Many scholars thought that the narrated events of the legend were factually untrue; in other words, they were invented and could not be verified by reference to objective facts in the world. However, the story was always presented in a simple account that acted as though the events were true. The narrators would

typically state that the tale had been reported by someone they knew well, who knew the information firsthand. They would add that they were passing the tale on, exactly as recounted, thereby reinforcing the impression that the narrator's role was to explain more than to create. Or the narrators would claim to know of the events by virtue of having participated directly in them or having witnessed them, so they had to be true. Another characteristic of the genre was that the audience also acted as though it believed the imaginary events reported in the legend.

In the segment quoted earlier, the tale is collectively performed, so much so that it is somewhat misleading to act as though there is a single author or narrator of the legend. There are at least three principal tellers; there are two versions of the tale and then a third one that confirms the first two. The tales are coperformed, with the same people acting as listeners and tellers, switching roles constantly in the ordinary flow of conversation. The audience for the legend represent a whole range of attitudes about whether they do or do not believe the events described.

Think about legends you have heard, such as the report that flying saucers have been seen to land on a desert in Texas; that unidentified flying objects have been sighted, bearing men from Mars; that an old house is haunted; or that the Loch Ness monster has again been seen. By the old definitions of legends, the people sharing these kinds of lore assert their unquestionable belief in, say, the sighting of flying saucers, and the story excites belief, although it is also known that the visit is imagined or invented and did not really take place.

Many scholars assert that the events in the legend cannot have happened but rather are the formation of the "fabulating gift of the people" (a statement made by C. W. von Sydow, qtd. in Degh 94). However, Degh and Vazsonyi question these assertions on the basis of their own research. They argue that we cannot know or demonstrate objectively that the speakers and listeners of legends actually treat their so-called "belief" in the narrated events of the story they hear as an "objective truth." Nor can we say with certainty that some of the events reported in legends did not, in fact, really happen. Again, as when we discussed the personal narrative, it seems more accurate to say that the legend is constructed so that it seems as if its narrated events can be validated by reference to events external to the story and rooted in fact. Actually, the study of folklore and legends raises questions about whether or not the narrated events are always imagined and untrue, although believed.

Degh and Vazsonyi believe that the essential aspect of the legend does not depend on whether the narrated events are objectively untrue nor on whether the participants of the story and the story itself suggest that the hearers believe what they are being told is true, whether it is true or not. Rather, what is essential is that the legend is a story that always states something and that it makes its case and calls for the expression of opinion on the question of truth and belief. It is also important to recognize differences that emerge in the nature of the performative event when it is shared with a group that includes only believers, a group of doubters and believers, or a group of all doubters who are caught up in the questions the legend poses.

According to Degh and Vazsonyi, there are two ways in which we can think about belief. In the first, belief refers to faith, or religiously held belief. This kind of belief asserts the existence of spiritual beings whose existence cannot be empirically validated but are attested to through an act of faith. In the second, we believe in the attitude of belief but not necessarily that the existences asserted by the attitude of belief actually exist. Instead of feeling reverence and awe and sometimes fear of the beings that faith asserts, those holding an attitude of belief may feel that the figures "believed in" are objects of ridicule, scorn, or parody. In this case, it is not important whether the beings asserted actually exist or not. Rather, what is important is that those who speak about them have the attitude of belief. Such is very much the case in the legend spun above.

Let us examine how belief works in this legend. While doing so, remember the context of the event, noting that it arose in ordinary conversation, initiated by someone who wanted to share an old legend. It also involves the shared knowledge of a number of the participants. Legends typically flourish where there is a common ground of beliefs, values, customs, and institutions to support the lore and where its elements are familiar. In this case, not only do the three principal tellers know about the old woman, but also elderly Mrs. F chimes in, asserting that everyone knows the old woman is a witch. Mrs. R also says she has heard about the story. The people sharing the story also share common ideas about marriage, courtship, private property, and the church. Their assumptions about these institutions need little explanation, but the legend testifies to the power of their cultural practices to shape so much of their everyday behavior and beliefs. Can you analyze the various comments by the participants to reveal what they say about the culture and the community in which the tale is shared?

Returning now to the question of belief, we look more closely at the attitudes expressed about witches. Mr. E insists the old woman is a witch. Mrs. E believes the old woman is a sinner. Believing in Christian values, Mrs. E believes that this old woman exists, but she believes she is evil and that God, also a force that exists for her, will protect her from the evil old woman. Mrs. F also believes she is a witch. Mr. A supports Mr. K in his story, insisting that the old woman is a witch and stating that he has heard independently about her from a man, M, who was asked to paint the old woman's house. He is eager to assist his uncle, Mr. T, in understanding why it is that no one wants to shake her hand. Mrs. S thinks the story is a ruse. She is a doubter, unwilling to believe the woman is a witch but willing to admit that she finds the reports confusing. Mr. T wants to resist the story and reaches for other, more rational explanations of the old woman's power. But at the end, he, too, refuses to offer to do the work on her house, despite the lure of 8,000 forints.

We have not been given information about the personalities of the participants in the collective performance of this legend, nor do we know their class, economic status, jobs, or even the precise nature of their relationships to one another. To understand properly the role of the folk legend in the performance of culture, we would need to know these facts. However, before we leave this legend, let us comment on some of the sociopolitical ramifications of the lore.

This kind of lore is deeply rooted in social reality. The reactions to this kind of story, in fact, the very way it is built, differ depending on age, gender, race, and class, to name just a few of the elements that will affect the lore. Because performance of the lore enforces traditions and introduces change, the lore often functions to make social units more cohesive, to give them solidity. In part, this is achieved by boundary drawing and by scapegoating.

In the legend we looked at, the age of the old woman—an unnaturally old age, 104—causes conflict within society. The tale makes her a scapegoat. She is said to be a witch; she is invested with supernatural powers and a whole array of superstitions and myths surrounds her. The apples in her garden—a variant of the garden of Eden—are dangerous. Those who eat them are said to shrink. Her house is polluted. The fence that encloses it is seen as a wall that should keep her apart from her neighbors, and yet we see that she cannot be held within walls. Her poison and powers spread. Those who touch her are contaminated. She occasions all sorts of fears, but most of the fear has little to do with her. The fear derives from the community's difficulty in dealing with aging, death, disease, and the helplessness that comes with aging.

During the Inquisition, women were tortured mercilessly and condemned as witches by the Catholic church. It was not that these women were, in fact, witches. The turmoil in society caused by the upheaval of moving from a feudal society to more centralized models of government and the collision of rival religious values threatened the powers of the church, powers only recently acquired. One of the means the relatively weak institution used to aggrandize itself was to solidify the recently strengthened religious communities by rallying them around a common cause, in this case the attack on pagans, or nonbelievers, who were said to be witches. Peasant women were one of the most dependent and vulnerable members of the feudal society. The collective fear of those who held power became translated into witchcraft beliefs. The creation of the social stereotype of the witch led the church to elaborate its standard of official orthodoxy by which witches could be judged as heretics and burned. At the same time, in the folk culture, witchcraft continued to function as a folk religion. In the New World, the Puritans used witch-hunts and burnings as a way to enforce their own religious beliefs.

In this legend, as it is retold in a peasant community in 1960, we see how ideas about witches trouble the social order. The community seeks a natural explanation for the phenomenon of the too-old woman who will not die. Although some of the citizenry in this community practice religion, many of the others are nonbelievers. It is uncertain whether the community, if asked, would say that it or any part of it actually believes in witches. Modern belief in medicine and the troubling phenomenon of living to a great old age threaten the social glue that holds the community together. The people are fearful of the childlike dependence that comes with old age. The community appears to pride itself on its Christian values and sense of goodwill toward other people, but at the same time, it comprises individuals who do not want to take care of one another unless it is to their mutual advantage. It is not clear whether it is to anyone's advantage to have to care indefinitely for aging people whose bodies, like their

houses, are weakening. This particular legend enforces a number of social and communal norms, giving the individuals in the society an acceptable way of expressing their fears, discharging their hostility, and cementing their bonds with one another in the process.

AN EXAMPLE OF AN URBAN LEGEND, TRANSMITTED ORALLY BUT ALSO CARRIED IN THE PRESS

The previous example of lore came from a peasant community and dealt with witches. There are also numerous stories that circulate in cities and acquire a very large audience because they also circulate through the media. These performance events move us further along the performance continuum, fanning out from a performance that is more private and involves a quite homogeneous audience and transmission by word of mouth as well as by print. As the continuum expands, it includes performance that is mediated through the information channels of popular culture, the press and television.

Jan Harold Brunvand has been studying and collecting urban stories for a number of years. He summarizes these stories, discussing their sources and certain contextual features in four books: The *Vanishing Hitchhiker, The Choking Doberman, The Mexican Pet: More "New" Urban Legends and Some Old Favorites,* and *Curses, Broiled Again.* Let us look at one of his tales, told in several versions in *The Mexican Pet.*

Brunvand classifies the tale as an animal story, connecting it to the folklore traditions involving good animals that are misunderstood and killed and bad animals that destroy good people. He first encountered the story in the press in 1981. Once he began collecting variants of the tale, he discovered it had wide circulation for a number of years and its roots could be traced to animal stories dating back hundreds of years in Wales. Even more ancient ancestors for the story can be found in rural witchcraft lore, in which a supernatural intruder, possibly a neighbor, is injured, usually in the hands or fingers. Again, please read the story aloud and perform it.

The Choking Doberman

A woman came home from a shopping trip, loaded with parcels, and she found her Doberman pinscher lying in the hall gagging and choking. She dropped her packages and tried to clear the dog's throat, but without success; so she picked up her pet, rushed back to her car, and sped to the veterinarian.

The vet took one look at the wheezing watchdog and said that he'd probably have to operate in order to remove whatever was blocking the dog's windpipe. He said that the owner should go home and wait for his call. The Doberman continued to choke and gag in a most pitiful manner, growing weaker by the minute.

The woman drove directly back home, and as soon as she got out of her car she heard her telephone ringing ["ringing off the hook!" people

say when they tell this story]. She opened her front door and grabbed the phone; it was the vet, highly excited. "Listen carefully," he said in a tone of great urgency. "I want you to hang up the phone when I tell you to; then don't say a word, but turn around and run straight out of the door again. Go to a neighbor's and wait for the police to arrive; I've called them. *Now!* Don't say a word and don't hesitate, just get right out of there!"

The woman was greatly alarmed at the vet's message and his manner, but she was also very impressed. So she wasted no time in following the orders, and in a few minutes a police car came screaming up. The police explained that the vet had found two fingers stuck in her dog's throat ["two *human* fingers," storytellers often say], and he figured that someone must have been trying to break into her home when the Doberman caught him. He might still be there. The police searched the place and found a man in her bedroom closet, cowering back in a corner in a state of shock. He was trying desperately to stop the flow of blood from his right hand, from which two fingers had been neatly nipped off. (41–42)

Brunvand states that this story has been in circulation for several years. He asserts that the event is entirely fictional but that it is always framed by the speaker so that it is attributed to a friend of a friend of the narrator's source, who actually was the owner of the dog and the subject of the story. The story belongs to the tradition of "scare" stories. It also depends on the theme of the intruder in the house, a theme common to many stories spawned in cities and reflecting a common urban fear of crime.

According to Brunvand, the Doberman pinscher legend gains some of its seeming believability because it is commonly thought that Dobermans are vicious and unpredictable dogs. Their reputation as guard dogs is widely known, but it is also common to fear that the dog may turn on its owner or resort to extreme forms of cruelty in the practice of its role as a guardian of property. Can you also see that this kind of story thrives in communities where property holds value? If it were to be told in a community that is poor, underprivileged, and by and large without property, it is likely that its tone would change and the story would become mocking. It would mock the way the police officer and veterinarian are depicted and would show the woman to be foolish, inept, and gullible. It might even make a hero of the robber. Brunvand observes that the tellers of this story are usually white and that it is not unusual for them to describe the intruder as either black or Chicano.

There are a number of traditional points of variation that differentiate one telling of the tale from another. Very often the details regarding the name of the veterinarian and the city in which the story happened are changed, giving the story a local base in any number of communities. The number of fingers found in the mouth of the dog varies; so, too, does the place where the intruder is found. Sometimes it is a closet, basement, or cabana, or he even might have fled the apartment, only to be found by the police in some local hospital. Another standard

feature is the important message, conveyed over the telephone. The dialogue is frequently varied. Other elements subject to variation are the age and vocation of the dog owner, the nature of the surgical procedure, and the breed and pedigree of the dog.

Brunvand offers another version of the tale, this time sent to him in 1983 by an economist at the Centre for Urban and Regional Development Studies at Newcastle University in England.

> The following story was told to a group of friends and myself on June 1st during the run-up to our recent general election. The storyteller, who works as a social worker, had spent many evenings campaigning for the Labour Party. He claimed to have heard of an incident which had happened during the previous week in North Shields and told it as a cautionary tale to others of us involved in canvassing. The gist of the tale was as follows:
>
> A North Shields woman had returned home from work to find her pet dog lying seriously ill in her hallway. She rushed the dog to a local vet who performed an immediate tracheotomy. The horrific outcome of the operation was the discovery of a pair of human fingers lodged in the unfortunate dog's throat. The human victim of the incident was assumed to be an electioneer pushing leaflets through letterboxes. Not surprisingly, no such mutilated campaigner had been known to have turned up at any local hospitals. (43–44)

Brunvand reports that versions involving "fingers-in-the-mailslot" also occur in the United States. The marks of these guard dog attack stories are the theme of injury or mutilation of the hand and the theme of a helpful animal that is misunderstood. They have their roots in very ancient lore. The folk tale of the good animal that is misunderstood by its lordly owner and blamed for the death of a child, when in fact the dog has saved the child from a wolf that the dog has killed, is a common one. Stories about horrible things being delivered through mailboxes—including letter bombs—and severed fingers are also common to many tales. We cannot fully trace this legend to its roots here, but it provides an example of the ground of tradition, which provides a base for the tale, and shows how variations of the same tale are significantly different.

In this case, the first version uses a good deal of direct quotation. We are given the words of the vet. The story also adds lively descriptive detail about the dog's pitiful condition. In the first version, the vet emerges as one of the tale's heroes. The real hero, of course, is the dog. In the second version, the economist who sends the account is probably doing so because he has read Brunvand's book on the legend. He provides information about the socioeconomic class of the storyteller and about her and his role as canvasers in a general election. He uses no direct quotations. He comments on the story, drawing attention to the fact that, naturally, he does not believe it.

You might want to use class time to perform both versions of the tale, apportioning lines to different members of the class and deciding how you will

place yourself during the performative event. Can you see how such an exercise draws attention to the interactions among the participants of the tale and provides quite different characters for them, ranging from the vet to the dog's owner to the police officer? Also notice how the storyteller, the speaker who frames the tale in each version, draws attention to a privileged position. The teller knows more than those to whom he or she speaks. The teller gains some stature just by virtue of claiming to know someone who knows the person involved in the scary event. The teller appears more knowing than the characters described, a fact that also increases his or her self-importance.

Finally, notice that the story could not undergo all these transformations if its audience members, as well as the participants, were not thoroughly conversant with this kind of tale. In the last chapter, we talked a little about the ground of experience, which funds tales and which must be acknowledged by ethnographers describing a performance text. In this case, the aesthetic field and the ground of belief necessary for the story to survive involve the traditions of tales about severed limbs and good animals misunderstood by their owners. The stories are also framed as stories, and thus the speech is set off from ordinary life and the characters are highlighted. It is also important to note that these Doberman stories appear in newspapers or on nightly television. You have probably seen a variant of the animal story on television. Think about the ways in which the mediation of television alters the story and also how it serves to spark the viewers to tell more stories, this time taking off from the TV version. In this manner, these kinds of tales circulate widely in pop culture.

"NO NAME WOMAN" RETOLD BY MAXINE HONG KINGSTON

Maxine Hong Kingston's *The Woman Warrior: Memoirs of a Girlhood among Ghosts* opens with an account of a story told to her by her mother. Kingston was raised in California, the child of Chinese parents who had emigrated to the United States to build a new life. She writes about the "stories to grow up on" told to her by her mother and other family members. She tells how they confused her, making it difficult to distinguish what was in them that derived from Chinese traditions and what was made up out of the peculiarities of one's own childhood—poverty, family, and family lore.

Kingston's opening story offers an excellent example of another kind of folk tale, one passed on by one member of a family to another for the purpose of instruction and the creation of social cohesion. The tale provides cohesion for the social unit that creates it—in this case a family of Chinese-Americans who first emigrated to the United States in 1924. It also enforces conformity to the values of a subculture struggling to gain acceptance in a dominant culture that is very different. It is a part of Kingston's strategy of self-portraiture. Confronted with the difficulty of finding a voice or many voices that can express her dilemma as a Chinese-American woman, marginalized by multiple dominant cultures, Kingston fabricates her account from many threads, many stories, and uses the interplay of these stories to draw a picture of herself.

When she was still a child, Kingston was taught the story of Fa Mu Lan, a girl who took her father's place in battle. For much of her life, the pertinence of the story of a woman warrior was not clear to her. She was being raised in the United States by a mother who was also telling her stories that suggested that as a woman she was unwanted and likely to grow up as a wife and slave. But it was also her mother who had taught her about Fa Mu Lan. Now read the folk story drawn from this latter tradition, which opens Kingston's book.

"You must not tell anyone," my mother said, "what I am about to tell you. In China your father had a sister who killed herself. She jumped into the family well. We say that your father has all brothers because it is as if she had never been born.

"In 1924 just a few days after our village celebrated seventeen hurry-up weddings—to make sure that every young man who went 'out on the road' would responsibly come home—your father and his brothers and your grandfather and his brothers and your aunt's new husband sailed for America, the Gold Mountain. It was your grandfather's last trip. Those lucky enough to get contracts waved goodbye from the decks. They fed and guarded the stowaways and helped them off in Cuba, New York, Bali, Hawaii. 'We'll meet in California next year,' they said. All of them sent money home.

"I remember looking at your aunt one day when she and I were dressing; I had not noticed before that she had such a protruding melon of a stomach. But I did not think, 'She's pregnant,' until she began to look like other pregnant women, her shirt pulling and the white tops of her black pants showing. She could not have been pregnant, you see, because her husband had been gone for years. No one said anything. We did not discuss it. In early summer she was ready to have a child, long after the time when it could have been possible.

"The village had also been counting. On the night the baby was to be born the villagers raided our house. Some were crying. Like a great saw, teeth strung with lights, files of people walked zigzag across our land, tearing the rice. Their lanterns doubled in the disturbed black water, which drained away through the broken bunds. As the villagers closed in, we could see that some of them, probably men and women we knew well, wore white masks. The people with long hair hung it over their faces. Women with short hair made it stand up on end. Some had tied white bands around their foreheads, arms, and legs.

"At first they threw mud and rocks at the house. Then they threw eggs and began slaughtering our stock. We could hear the animals scream their deaths—the roosters, the pigs, a last great roar from the ox. Familiar wild heads flared in our night windows; the villagers encircled us. Some of the faces stopped to peer at us, their eyes rushing like searchlights. The hands flattened against the panes, framed heads, and left prints.

"The villagers broke in the front and the back doors at the same time, even though we had not locked the doors against them. Their knives

dripped with the blood of our animals. They smeared blood on the doors and walls. One woman swung a chicken, whose throat she had slit, splattering blood in red arcs about her. We stood together in the middle of our house, in the family hall with the pictures and the tables of the ancestors around us, and looked straight ahead.

"At that time the house had only two wings. When the men came back, we would build two more to enclose our courtyard and a third one to begin a second courtyard. The villagers pushed through both wings, even your grandparents' rooms, to find your aunt's, which was also mine until the men returned. From this room a new wing for one of the younger families would grow. They ripped up her clothes and shoes and broke her combs, grinding them underfoot. They tore her work from the loom. They scattered the cooking fire and rolled the new weaving in it. We could hear them in the kitchen breaking our bowls and banging the pots. They overturned the great waist-high earthenware jugs; duck eggs, pickled fruits, vegetables burst out and mixed in acrid torrents. The old woman from the next field swept a broom through the air and loosed the spirits-of-the-broom over our heads. 'Pig.' 'Ghost.' 'Pig,' they sobbed and scolded while they ruined our house.

"When they left, they took sugar and oranges to bless themselves. They cut pieces from the dead animals. Some of them took bowls that were not broken and clothes that were not torn. Afterward we swept up the rice and sewed it back up into sacks. But the smells from the spilled preserves lasted. Your aunt gave birth in the pigsty that night. The next morning when I went for the water, I found her and the baby plugging up the family well.

"Don't let your father know that I told you. He denies her. Now that you have started to menstruate, what happened to her could happen to you. Don't humiliate us. You wouldn't like to be forgotten as if you had never been born. The villagers are watchful." (3–5)

Do you notice how many elements of this story resemble some of the features of the legend about the 104-year-old woman? The aunt is treated as though she is a pariah, an outcast. The story is a ghost story, of sorts. The aunt, who has committed suicide as a result of adultery and who has an illegitimate child, functions as a ghost, haunting the memory of the mother who tells the story and plaguing the memory of Kingston. Within the frame of the story, the villagers threaten the mother and the aunt with the spirits of the broom. The story is rooted in a very specific region in China, in the village from which the Kingstons descend. It expresses powerful taboos, or prohibitions. A woman must not commit adultery. Such acts can bring about fierce retaliation and punishment, leading the victim to seek suicide rather than the disgrace and severe hardships facing a social outcast. The will of the community prevails, both in China and in the United States. The mother tells Kingston this story for educational purposes, as a warning to her to preserve her virginity. But her mother is also telling her a story that her father does not want her to hear. Kingston's mother partially escapes the authority of

her husband as she tells the tale; however, she also shapes the tale to express a moral lesson that both she and her husband want to teach to their daughter. Animal imagery figures prominently in the story. Birth is connected to water, to a downward thrust, to the well. However, as in the schoolyard jump-rope taunt, all these images are inverted so that water, wells, and earth serve to drown and give a grave to the baby.

Kingston comments on the story her mother told her and the lore it perpetuated, remarking on the numerous distortions in the story. Drawing on Chinese traditions to inform her interpretation of her mother's tale, she fashions a very different tale of this no-name woman. She denies that her aunt could have been some romantic figure, sacrificing all for her adultery. Under Chinese custom women did not choose their mates. They were told whom to marry and were then put out of their own homes to live instead in the home of their husband's family. In this case, then, something was already seriously wrong. The aunt must have been abandoned by her husband's family and returned in disgrace to her own parents. Further, because it was a time of famine, food was very scarce, and it is likely that the aunt would have been eating apart from the family, in isolation. We can see from the details in the mother's story that food figures very prominently. The mother's story expresses anger at the villagers for their wanton cruelty, but it suppresses information about the famine and it probably misleads by stating that she witnessed the villagers' raid.

In Kingston's remaking of her mother's story, she also suggests that the raid of the villagers, which led to her aunt's decision to kill herself rather than bring further shame to the family, is a pale punishment beside the punishment dealt out by Kingston's father and family, who have banned the name of the dead aunt. The villagers punished the aunt because they saw her ways as a threat to their social order, their customs, and the local economy. Kingston's parents were equally as inhibited by community values when they came to the United States. Their insistence that their daughter not bring any shame on them and that she remember who she is and that she is beholden to a husband for her status directly relates to public values.

There is much that can be said about this folk story and the other fabrications that Kingston creates. This kind of folk story is a family story, but it is different from the personal narratives cited in chapter 2. Here, we see the child as an inheritor of a multiplicity of voices, all of which contribute to identity, not as an individual but as a representative of a larger social unit, in this case the family and the community. We are joined to others, and we are more like them than different. It is this communal definition of a collective self, rather than a portrait of highly individualized selves, that is the domain of folklore.

The aunt's father, brother, and husband are said to have gone "out on the road." They have been given wealth and have embarked on travels and Western ways. It is the lot of women to be the conservers of tradition and continue the customs of the non-Westernized China. When you examine the lore about Kingston's aunt, you can see how it is critical to account for what is left out, what is ignored, as much as for what is included when you attempt to interpret its meaning.

FOLKLORIC ELEMENTS IN DISPLAY
EVENTS SUCH AS COMMUNITY FESTIVALS
AND COMMUNITY CELEBRATION

Let us conclude this chapter by considering folkloric elements in display events. As you will remember, the continuum of performances ranges from those that are executed in isolated, largely private arenas to those that are richly mediated; transmitted to vast publics through the media; or played out in large ceremonies, such as parades, circuses, and amusement parks, where large segments of the population perform in the event. It also ranges from those that are performed for an audience of one or for small groups to those that are mounted in highly theatricalized spaces, where the performers and audience are separated by large distances, the audience being largely passive while the performers are active and onstage. Still another form of relationship involves intimate interactions, in everyday contexts, where both the interactants actively engage themselves in the performance, whether it be the sharing of a personal narrative or the spinning of ghost stories.

At the far end of this continuum in which the boundary between performers and audiences is increasingly blurred, is the public display event, in which whole communities design fairs, museum exhibits, parades, or boat regattas. In these events, we can differentiate between the organizers and those that execute their plans and the publics who are necessary participants in the event, although at various degrees or distance in relationship to it. The performance events mirror the processes by which social communities differentiate themselves, breaking up into smaller units and reorganizing themselves to function in an increasingly complex, technologically sophisticated world. They also reveal ways in which diverse parts of a community come together and interject their individual, local stamp on an institution that reaches far beyond the community, embracing national borders.

At the opening of the chapter, we showed an example of a local fair celebrating the Fourth of July in Little Compton. Now let us look a little more closely at some features of these kinds of events, incorporating some of the knowledge we have gained about folklore in this chapter.

These folkloric display events are often related to the seasons in nature or to a particular festivity that the community celebrates. Examples of festivities tied to the seasons and what are called "first fruits" are Thanksgiving, the taking in of the harvest, and May Day, which ushers in spring. Halloween parties, held always in the fall and tied to the autumnal season through such rites as ducking for apples and carving pumpkins are other examples of display events situated in a specific locale and connected to a time of year. Citizens also declare days of national celebration that are marked by their date and generally commemorate an event of national significance, such as Declaration Day or Martin Luther King's birthday. The festivities that surround these cyclical, calendrical celebrations can be seen as part of a folk culture, but in this case, the meaning of the word *folk* has been considerably enlarged. The community performing its culture through these celebrations draws on many of the elements common to

less elaborate folk sharings. The display event is marked by feasting, drinking, revelry, dancing, games, auctions, barters, dance, music, noise, games, and parades as well as a whole body of lore, shared in face-to-face tellings, which are also integral to these events.

You can certainly see how these kinds of performances can be analyzed in reference to numerous frames, using Goffman's approach. One frame treats the event in a historical context, drawing attention to the history of the local people; to a chronology of events linked to the historical event being commemorated; and to the history of ancestry, especially in relation to persons who are closely connected to the event in history being celebrated. Another frame encompasses the events that are featured in the display as fictional. This frame signals to us that some of the stories being shared are made up; they are part of the folklore of the kind we have been examining in this chapter. This lore is, in part, indigenous to the community in which the celebration occurs, but it is also drawn from cultures external to the event, and much comes through information systems such as television. Other elements are framed by a rhetorical strategy; in other words, the event must be understood not in relation to history or fiction but to a strategy of persuasion, which molds its material to produce a very particular outcome, often a political act of patriotism or the purchase of a commodity or the giving of a philanthropic gift.

Think about some of the folkloric display events that take place on campus. You could include "stepping" or "blocking," which is a common performance tradition among African-American sororities and fraternities; marches sponsored by women's groups to "Take Back the Night" in protest against rape and other violent crimes; the football parade and festivities preceding the games; or May Day rites, which often occur in spring, often as a prelude to graduation. We are going to be considering rituals and public ceremonies in the next two chapters, but before closing this one, we want to remind you that embedded in these large-scale, quite public performances are many folkloric features more commonly found in interactions between small groups. The performances of these large-scale displays are a further way in which we perform culture and culture performs us.

WORKS CITED

Bauman, Richard. "American Folklore Studies and Social Transformation: A Performance-Centered Perspective." *Text and Performance Quarterly* 9 (1989): 175–84.

Brunvand, Jan Harold. *The Choking Doberman: And Other "New" Urban Legends.* New York: Norton, 1984.

———. *Curses, Broiled Again.* New York: Norton, 1989.

———. *The Mexican Pet: More "New" Urban Legends and Some Old Favorites.* New York: Norton, 1986.

———. *The Vanishing Hitchhiker: American Urban Legends and Their Meanings.* New York: Norton, 1981.

Chase, Richard. *The Jack Tales.* Boston: Houghton, 1943.

Degh, Linda, and Andrew Vazsonyi. "Legend and Belief." *Folklore Genres.* Ed. Dan Ben-Amos. Austin: U of Texas P, 1976. 93–123.

Dundes, Alan, ed. *Cinderella: A Folklore Casebook*. New York: Garland, 1982.

Hurston, Zora Neale. *Mules and Men*. Philadelphia: Lippincott, 1935.

Kingston, Maxine Hong. *The Woman Warrior: Memoirs of a Girlhood Among Ghosts*. New York: Knopf, 1986.

Lester, Julius. "Keep on Stepping." *Black Folktales*. New York: Grove Weidenfeld, 1969. 153–57.

Lurie, Alison. *Don't Tell the Grown-Ups*. Boston: Little, 1990.

FOR FURTHER READING

Abrahams, Roger. *Deep Down in the Jungle . . . : Negro Narrative Folklore from the Streets of Philadelphia*. 2nd ed. Chicago: Aldine, 1970.

Bauman, Richard, and J. Sherzer, eds. *Explorations in the Ethnography of Speaking*. 2nd ed. London: Cambridge UP, 1989.

Ben-Amos, Dan, ed. *Folklore Genres*. Austin: U of Texas P, 1976.

Ben-Amos, Dan, and Kenneth Goldstein, eds. *Folklore: Communication and Performance*. The Hague: Mouton, 1975.

Bettelheim, Bruno. *The Uses of Enchantment: The Meaning and Importance of Fairy Tales*. New York: Knopf, 1976.

Dorson, Richard M., ed. *Buying the Wind: Regional Folklore in the United States*. Chicago: U of Chicago P, 1964.

———. *Handbook of American Folklore*. Bloomington: Indiana UP, 1983.

Dundes, Alan, ed. *Sacred Narrative: Readings on the Theory of Myth*. Berkeley: U of California P, 1984.

———. *The Study of Folklore*. Englewood Cliffs: Prentice, 1965.

Finnegan, Ruth. *Literacy and Orality: Studies in the Technology of Communication*. Oxford: Blackwell, 1988.

———. *Oral Traditions and the Verbal Arts: A Guide to Research Practices*. London: Routledge, 1992.

Gumperz, J. J., and Dell Hymes, eds. *Directions in Sociolinguistics: The Ethnography of Communication*. New York: Holt, 1972.

Jordan, Rosan A., and Susan J. Kalčik, eds. *Women's Folklore, Women's Culture*. Philadelphia: U of Pennsylvania P, 1985.

Ong, Walter J. *Orality and Literacy: The Technologizing of the Word*. London: Methuen, 1982.

Sebeok, Thomas A., ed. *Myth: A Symposium*. Bloomington: Indiana UP, 1985. [See "The Structuralist Study of Myth" by Claude Lévi-Strauss (50–66) and "The Eclipse of Solar Mythology" by Richard M. Dorson (15–38).]

Thompson, Stith. *The Folktale*. 1946. Berkeley: U of California P, 1977.

Zipes, Jack. *Fairy Tales and the Art of Subversion: The Classical Genre for Children and the Process of Civilization*. New York: Methuen, 1983.

CHAPTER **4**

Social Drama and Ritual

Chapter 3 considered how groups construct folklore as part of the process of performing culture. This chapter examines social dramas and ritual activity to show how each functions as an enactment of self and society, providing a mirror for culture and presenting collective knowledge. We will also place this kind of activity along our performance continuum.

SOCIAL DRAMA

In Victor Turner's anthropological work studying the Ndembu, a Central African tribe, he identified a minimal unit of social processes—the *social drama*—to analyze how people handle conflict and restore order. He wrote that "social dramas occur at all levels of social organization, from state to family." They arise out of conflict situations, be it a quarrel between husband and wife, parent and child, rival groups in a community, or regions threatening to secede from the state. They mount to a climax and toward resolution through a series of conventionalized, repetitive patterns of social action enacted by members of the community involved in the conflict. They are public occasions in which a crisis emerges and is resolved. They are marked by a high level of ritual activity.

According to Turner, social dramas progress in an orderly fashion, moving through four stages: *breach, crisis, redress,* and *resolution* or *deterioration.* As the drama unfolds and mounts, the behavior and symbolic activity of the group become increasingly agitated. The drama begins with a breach in the collective life of the community. Usually it occurs when one of the members perceives a rift occasioned by someone else's violation of a custom and draws attention to it, involving others in the community in the quarrel. People begin to align themselves according to how they view the threat. As the groups agitate and

quarrel, the situation becomes more complicated and mounts to a crisis. The participants become emotionally caught up in the mood and the atmosphere and events threaten the social fabric. During the redressive stage, the people begin to be drawn into ritual activity, looking to authority figures to restore order to the community. The ritual activity invokes public ceremonies and appeals to authority figures and traditional institutions, like the church or state, or less formal substitutes for authority to adjudicate the quarrel. Redress is offered to the community for the wrong committed by some of its members, and order is restored. When these means succeed, resolution is achieved in the form of restoration of the old social order prior to the breach. If the means invoked cannot restore equilibrium, either through restoration or transformation, the drama ends in a state of deterioration, with varying degrees of breakdown in the social order marking its conclusion.

Turner uses the metaphor of the social drama to describe a pattern of social behavior and symbolic activity in society. He compares the behavior in life to the structure of drama, an artistic form derived from ritual practices. He argues that social dramas match the plot and structure of plays, leading to a *denouement* and resolution. They are marked by ritual activity, particularly in their third phase. He and other contemporary scholars of performance analyze rites of passage, shamanic rituals of healing, hunting rituals, and juridical processes as forms of social drama. By observing the processes of social drama and performing from texts that capture them, you will better understand the relationship between ritual and social dramas in everyday public life and the forms they take in Western theatrical productions of drama, chamber theatre, or other literary forms.

Social Drama Drawn from *Number Our Days*

Barbara Myerhoff's book *Number Our Days* pursues her anthropological interests in the country of her own birth, studying a community of elderly Jewish people, many of them immigrants from Eastern Europe and survivors of the Holocaust, in which Hitler's Germany destroyed more than 6 million Jews.

Number Our Days is a study of aging and ethnicity. It explores the question of what it means to be a Jew. It is about the people of the Aliyah Senior Citizens' Center, a cross between a day-care center and a halfway house. It provides a detailed account of many contextual factors that assist Myerhoff in interpreting the performance of the particular social drama.

The center, located in Southern California, is sponsored by a philanthropic Jewish organization. Its mission is to bring people together in a community emphasizing secular Judaism, enabling them to cope with the problems of aging. Most of the members of the center are cut off from their family members, who live elsewhere in the United States. Their children have been assimilated into American culture, shedding their ethnic identity. The aging parents cling fiercely to their pride and autonomy, not wishing to be a burden on their successful children.

Many of the center's members grew up in Yiddish-speaking villages known as *shtetls* in Eastern Europe. During the nineteenth century more than half the

world's Jewry was confined in these areas, regularly terrorized by outbreaks of anti-Semitism initiated by government officials. Living within reach of Czarist Russia, life was precarious in these settlements, giving rise to a rich cultural tradition. The musical *Fiddler on the Roof* offers a popularized version of the *shtetl* culture. The folk culture is based, in part, on a shared sacred history of religion, which Jews date back many thousands of years to God's Covenant with His chosen people. Folk customs and practices and two shared languages, Yiddish and Hebrew, further contribute to the cohesion of this community and the richness of ritual activity.

The pogroms of the late nineteenth century drove many of the Jews out of the *shtetls* to the cities. Later, many emigrated to the United States in search of a new life. In the 1930s many Jews came to the flourishing Jewish community in Southern California. In the late 1950s urban renewal displaced as many as 6,000 of the elderly Jews, driving them out of the community, and leaving the others to hang on. The acute shortage of housing as a result of the development has resulted in no further growth in this aging community. Many described the upheaval in the 1950s as a "second Holocaust." When people die, there is no one to replace them. Consequently the person's fear of his or her own death is greatly increased because it carries with it the death of a community.

Myerhoff lived two years, 1973–74 and 1975–76, with the people of the center. Thereafter, she returned on a number of occasions spread over another two years. She also developed a film based on her fieldwork, *Number Our Days,* which won an Academy Award for Best Short Documentary in 1977.

Can you already see how this community provides a fertile ground for study of the social drama? The people in the center are desperately trying to cling to their collective past and their customs. They are also living in a world that is rapidly being transformed. Some members are being pressured by family members and others to give up the old customs and the old ways and adapt to change. Then, too, there is a whole array of aggravations and tensions growing out of the process of aging and the attendant diminution of bodily and mental functions as well as the fear of dying.

Myerhoff's verbatim transcriptions of the members' speech coupled with her descriptions of their activities help us to witness and interpret the enactment of a social drama. A social drama begins with a breach of norms. This social drama begins when Kominsky, an outsider, is elected president of the center. His status as an outsider is important in the sequence of events that unfolds. Kominsky had been recently hired to teach in the center. He has prestigious connections to the outside world. He appears glamorous and more religious than the members of the community. He brings a fresh vision and draws new members, raising people's hopes for a period of renewal. All these factors are important in understanding how the breach erupted, built to crisis, and was redressed through the expulsion of Kominsky from the community. The insiders were devoted to indigenous styles and norms that are a unique aspect of the folk culture that had grown up in this center community, which more nearly matched the homogeneous quality of stable villages than it did the culture of a heterogeneous and changing society.

Myerhoff describes one of the moments that marks the breach as follows:

At his [Kominsky] first meeting as acting president, he announced that he meant to have things proceed in a more orderly fashion than usual. "We got serious business here. We can't *daven* [literally, pray] over little things. This Center has its life at stake, so you will excuse me if I rush, because our affairs are urgent." He called for the minutes to be read from the previous meeting. This was the secretary's, Sonya's, opportunity to shine. She had worked especially hard at her minutes, recopying them and checking spelling to please the new president with his modern standards. She stood to read them in a bold, proud voice. Kominsky reprimanded the people for applauding, "Minutes is supposed to be an objective record, not a performance. Sonya, you will learn, you gotta keep out the interpretations, like saying that Sofie wore a new sweater from her daughter in Hawaii at the last meeting. That's not business. No more flowery phrases, please. You'll learn, we'll all help you."

Sonya was angry. "But she did have a new sweater. Everyone here saw that. Why is that not part of the record?"

"It's not about Center affairs," he countered.

"Certainly it is. She wore it to the Center. We all saw it." People nodded.

"Never mind, Sonya," replied Kominsky. "You'll learn to do it, very easy."

"Don't argue with our president, Sonya," shouted Jake. "What he says makes a lot of sense. When you talked about the last meeting, you wrote, 'It's a lovely discussion we had.' It was what I call a fight. You should name it the right way. Do like he tells you. Be objective."

"Don't tell me I don't know the difference between a discussion and a fight, Jake," she answered. "It's very simple. Whenever you are around, you make the fight from a discussion."

Rachel came in with her comments. "The minutes didn't mention that Sofie paid for the cake and coffee at the last meeting. It should go in the record, because this was a lovely thing for her to do."

"Please, please!" Kominsky's wonderful smile flashed across his face as he banged the gavel on the table. "Rachel, Sonya, Jacob, sha. This is just what we should not be doing. More order, please. Now we go on with reading the correspondence."

Rachel raised her hand and shyly announced that she had a letter from her grandson in Switzerland. "He writes it very big and dark so that I could read it easily. Isn't that a thoughtful boy? 'Dear Grandma,'" she began.

"Rucheleh," interrupted Kominsky gently, "this here is not what we mean by correspondence."

"I know what is correspondence, Mr. President. This is a letter and I am reading it for the members and so it goes into the minutes. Sofie read a letter last time, nobody objected."

"These are supposed to be letters about the affairs of the Center. Just like I said to Sonya, we don't include everything, only our business.

Otherwise we never get anything done. Please, Rucheleh, you read it to me afterward. I would like to hear it.''

The meeting bumped along until a motion was proposed and seconded. ''I make another second,'' said Itzak. ''I also,'' said Max. Kominsky pounded the table. ''We say 'second' because it means what it says, 'second.' Not three and four times.''

''But you don't write down that I am in favor of it, if I don't second,'' shouted Max.

''We don't have to have everyone's name,'' Kominsky tried to persuade them. ''That's why we have a vote. No names.''

The motion was passed with one second and once more everyone clapped. Again Kominsky stopped the proceedings to explain that applause was not appropriate. ''You will all learn to do these things a better way than you are used to. You have practiced all these things by yourself. That's fine, but if you want people not to think you are greenhorns, you got to learn to follow the rules that everyone uses when they have a business meeting. Otherwise it is not legal. That was good enough for the old days, but now we take on bigger things.''

''Mr. President,'' answered Basha, ''please don't *hok* my *tchynik* [literally, knock my tea kettle; don't bother me with trivia] on this. I was in the union many years. I was one of the big ones in the Emma Lazarus Club. We were the first woman's libbers in America. A lot of history we made there. Please, I know what a meeting is.''

Loyal Olga stood and pleaded with everyone to cooperate with ''our learned president, who has much to teach us, if we can find the patience with each other getting started in the new ways he brings here.''

After this the meeting proceeded with unusual smoothness and speed. The old people were outside on the boardwalk much sooner than usual. The ordinary high level of energy that was so characteristic of their gathering was conspicuously absent. (122–25)

This passage marks the opening of the schism that threatens the community. Kominsky is an outsider jostling with the insiders. Initially, they are proud of him. After all, they have elected him to office. Many of them welcome the vitality and expertise that he offers. And they welcome his concern for them and their center. But immediately we see him trying to introduce new ways to the community. He wishes to run the meeting as a business meeting, following *Robert's Rules of Order,* rules that regulate how motions are made, how they are formulated, who can move and second them, and so on. He comes from a bourgeois community that values the efficiency afforded by such codes. Like the others, he values freedom and democracy, but he wants it to operate efficiently.

Kominsky is a religious man who shares many Jewish values with the community. He has a respect for the Talmud and Talmudic (Old Testament) scholarship and exegesis. As Myerhoff points out, the center people value talk. It is a way to express sociability. They also enjoy probing questions and a good quarrel. Center people call this kind of talk, which pierces to the heart of a

question, "talking *tachlis*." Kominsky refers to it when he reminds the center members that they are here for "serious business," not to talk a matter to death. The center members see talk and meetings as a way to gain attention and to compete with one another. This jockeying for status by virtue of one's cleverness does not necessarily value results. In some ways everyone in the group is right, but the strains emerging in the meeting have the potential to build to a crisis.

The breach in the social order would not have come about if Kominsky were less of a leader or if he had not been placed in a position of importance by the community. His ability to deviate from the group's norms of behavior is in part a function of his status as an outsider, but it also depends on the fact that he has much in common with the insiders. We see evidence of the traits that initially made the center folk care for him. When Rachel misunderstands his call for the reading of the center's correspondence and reads her letter from her grandson, Kominsky gently corrects her, but he also tells her she can read the letter to him later. He cares about her, referring to her affectionately by a diminutive version of her name. Nonetheless, he does not want her to read the letter during the meeting.

Try performing this segment. It invites you to speak in dialect and simulate, if you can, the sound of Yiddish speech. The language in the passage is richly expressive. The people are outspoken, set in their opinions, and not ones to settle for authority. If you passed these lines around in class or enacted the scene, did you discover that each of the characters is delineated quite completely despite the fact that we have only a handful of lines from each? They are colorful people and their commitment to the act of naming themselves, sharing their narratives, and competing for attention help to accentuate their humanity. Basha proudly speaks her personal narrative, her life story, of her role in the Emma Lazarus Club. Jake is quick to join forces with Kominsky and also to urge Sonya to take "objective" minutes. Rachel comes to Sonya's side, urging that Sofie's "lovely" act of paying for the cake and coffee at the last meeting should also be recorded in the minutes.

The center members' unusual silence as they leave the meeting signals that the breach has occurred. Myerhoff reports the subsequent growing number of occasions on which Kominsky violates the center's norms, antagonizing more of the members. A high point is reached when he cancels an outing to a liberal temple because he disapproves of the temple's tolerance of a group of homosexuals. The members of the center are outraged at the insult to their members and to the Jews of the temple. The question of the insult is far more important to them than a conservative interpretation of the scripture's views about homosexuality.

Myerhoff shows how the breach mounts to a crisis, marked by a heightened intensity of feeling and increased ritual behaviors. After the episode with the temple, Sadie invents a little rhyming song about him, sharing it with the other members. Her singing of the song is part of her cry for moderation. She names the source of some of the fault. By converting the unpleasant situation into a little ditty, rhyming in couplets and offering its homespun advice, Sadie conceals some of the depths of the hostilities while at the same time she calls on the group to help effect a cure.

It's true that somewhere, sometimes, somehow
 things go wrong.
It's hard for us to know just where we do and
 where we do not go along.

As far as I can see, the situation here is such:
Maybe our Reb Kominsky is doing now too much.

We all here know he always tries to do his best.
But maybe now it's time he thought about a
 little rest. (127–28)

The final act that settles the breach occurs when Kominsky accepts, in the members' behalf, a package of holiday foods for the next Passover season donated by a Jewish organization. The fiercely proud center members feel humiliated, arguing that they are people who give, not receive, charity.

As the breach turns to crisis there are numerous attempts on the part of center members to teach Kominsky their ways and to urge him to make amends. The crisis occurs at the public ceremony installing Kominsky as president. This occasion, which might have used ceremonial definitions of identity to reinforce Kominsky's role and bring about reconciliation with the members, actually results in his expulsion. Look at Myerhoff's depiction of these final two stages in the social drama.

The installation of officers took place a few weeks after Kominsky's outburst at Itzak [he had criticized him as treasurer for not keeping proper accounting records]. It was a grand and expensive affair with flowers, refreshments, dignitaries, and a couple of surprises that Kominsky had arranged. On his own, he had invited a Hasidic rabbi to make a speech at the installation. The rabbi was a fervent man, extremely Orthodox, and a member of a proselytizing Hasidic sect. Kominsky had recently renewed his acquaintance with the rabbi, seeking consolation and guidance concerning his growing conflicts with the Center people. In the course of their contacts, Kominsky had had a kind of conversion experience, a renewal of his faith; this appeared not to be widely known among the members. The rabbi's presence caused a stir. He was a large, stern man with a full, square beard and wild black and white eyebrows that were prominent even under his black wide-brimmed, fur-trimmed hat. His powerful frame was covered from chin to ankle by a black gabardine caftan, traditional Hasidic attire. After the officers had been installed, the rabbi began his speech in Yiddish, telling the people there how fortunate they were to have a man like Kominsky take an interest in them, since without him they would be forgotten and neglected. He likened Kominsky to a tzaddik, a Hasidic holy man, who had come to bring them back to the proper observance of their religion. He continued, saying that Kominsky had recently realized his mission among them.

Dramatically he announced that Kominsky would begin this work by establishing a Kosher kitchen at the Center.

This news was received in momentary silence. Then people broke into excited side conversations. "Kosher? What for? None of us keep kosher at home. We left this behind when we came to America." And that was true. Unfortunately the rabbi and Kominsky had selected one of the least meaningful religious symbols of Judaism to resurrect people's identification with Judaism. The custom of keeping Kosher had been abandoned by many even before they left the Old Country. Only Kominsky was really observant. Center members were willing to overlook this in him, but certainly would not let it be foisted upon them. Despite their surprise and annoyance, the members were loathe to be overtly rude to the rabbi and they allowed him to continue his speech without speaking up. He went on to talk about the plight of Soviet Jews, a subject of widespread and grave concern. "Our hearts and our work must be with those who want to emigrate, those who are *true* followers of Moses. *They* are the Jews who must be saved," he said.

This was too much for Basha. "Do you suggest that the Jews who are not observant should be left behind? Kominsky, you agree with him in this?"

Kominsky stood up, cleared his throat, but couldn't find words. He seemed unwilling to disagree with the rabbi, but he was obviously distressed by the implications of his remarks.

Basha had no patience with this temporizing. "No, this won't be any good. Which one of us leaving Russia would qualify by such standards? None of us would be here now if only the observant escaped the pogroms. I can't go along. With God, without God, with kosher, without kosher, a Jew is a Jew." It was clear that most people agreed with her, and the din mounted quickly. The rabbi scowled at the group, nodded to Kominsky, and abruptly left. Abe took the microphone and insisted the ceremony be completed.

The next day the Center officers and the board of directors met and agreed that Kominsky would be asked to resign his office. The installation could have been an occasion for reconciliation. It was a ripe moment, when differences might have been glossed, unaffiliated individuals and disgruntled factions drawn together in a ceremony that emphasized their common goals and destinies and drew attention to the need for solidarity in the face of external threats. Instead, it provided the basis for the members' final repudiation of Kominsky. There was no possibility of reconciliation after the rabbi's blunder, evidently supported—or at least not rejected—by Kominsky. Everyone agreed that Moshe would make a good president. (136–38)

This passage shows both the enactment of the crisis and the unfolding of the final stage, in which reconciliation is achieved and the social unit regains it equilibrium. The resolution is accomplished by expelling Kominsky and making

some changes within the community. Itzak refused to be treasurer; the loyal Olga did not return to the center for a month. One of the functions of ritualistic behavior is that it balances contradiction, letting the members negotiate changes in their status while still preserving the basic core of cultural beliefs largely unchanged.

For the center people, the politics of their business meetings are more important than the actual conduct of business. They use politics to gain visibility, to assert their self-worth, and to affirm their station within the community. These peoples' need for attention is particularly keen. They are aging people of limited means, facing the prospect of not only their own death but also the death of the cultural legacy they carried with them from the pogroms of Eastern Europe and from their status as survivors of the Holocaust. Through the resistance of the people to the power and actions of their leader, Kominsky, they powerfully reassert their own collective identity. Before his arrival and rapid ascent to a position of leadership, activity in the center had been dwindling. Upon his arrival, there is a resurgence of energy and some of its methods of outreach do succeed. But most important, as Sofie and Rachel and, later, Basha challenge and defy Kominsky, they gain allies and the group's sense of its own values is kindled.

Consider also the ceremonial and ritualistic aspect of the social drama Myerhoff recounts. Rituals, both sacred and profane, abound in the narrative. There is the conflict between various sects of the Jewish religion, each carrying with it its own set of rituals, prayers, and observances. Rules regarding eating habits and cleanliness, whether a house is kosher or not, are prescribed by Judaism. Such ritual practices separate the clean from the unclean, and in so doing food laws are used not so much for dietary and health reasons as for cementing collective identity. These sets of taboos reenforce boundaries and preserve the social unit.

Other ritual behaviors are in evidence during both the business meeting and the ceremony of the installation. Ritual activity, with its formulaic elements, its ceremonial garb, its invocations to authority, and its numerous precise regulations, dictating how the ceremony is to be accomplished, assists in preserving and maintaining tradition while being sufficiently pliable to incorporate change.

Kominsky tries to perpetuate the discipline of surveillance, a discipline that regiments people, keeping them under the eye of the regulator, in this case, the president of the center and the Law book he invokes, *Robert's Rules of Order.* Under the guise of democracy, a certain kind of lawmaking and civil regulation develops that increasingly restricts the freedom of the very citizenry who believe they are free. In the meeting, Kominsky tries to rule certain material out of order. He uses rules to restrict speech and limit the number of people who can be honored in this civic function. He puts himself and his set of disciplinary regulations against the will of the center's membership. They, too, are products of democracy and they, too, celebrate the right to life, liberty, and the pursuit of property. But they require a forum that permits them to talk, to quarrel, and to quibble, ungoverned by rules designed only to produce efficiency and to minimize individuality. Rules can turn people into machines; they can limit our

freedom. These tensions are part of the source of the friction and social drama that Myerhoff describes.

The ceremony of the installation has many ritualistic elements. With its pomp, its ceremonial costumes, and its expectation that people will honor the occasion with an attitude of high seriousness as well as festivity, it is designed to effect the transformation of the man, Kominsky, who had served as president-elect into the man who can serve as president. Such a ceremony must accomplish this transformation and return the man to the community from which he has come, complete with his new status. In the center's social drama the ceremonial function of the installation is unable to produce its desired end. But such is the stuff of ceremony that it is susceptible to alteration and change. In this instance, the ceremony is inverted. Kominsky's installation results in his expulsion. The authority that should have rested in the rabbi is challenged by the center members, also participants in and witnesses of the ceremony. The installation ceremony enacts redressive measures through the expulsion of the outsider, which reestablishes the claims of the center and its commitment to do philanthropic work, support world Jewry, and assert its ethnic identity.

Go back now and read the account a number of times. Divide it into parts and perform it in class, passing the roles around so that members of the class can put themselves in the roles of several of the characters. Experiment with the way you handle the commentary provided by Myerhoff, the frame narrator of the social drama. If you were to mount a more elaborate production of the script, you would use costume and stage the selection. You will discover that some of the activity is more patterned, precise, and ceremonial than other portions. There are also snippets of personal narratives interjected into this material. The rhyming song can be related to some of the folklore you studied in chapter 3.

Think about the kind of responses this material elicits from you as you perform it. Does it awaken memories you have, either of religious rites in which you have participated or in life stories of kin, Jewish or of another ethnic origin, that you have heard? How do you respond to the dialect? Are there ways in which gender and age help you to understand the perspective of the speakers and how they relate to one another? You will want to think of these and other performance-related matters more after you have read the following discussion and experimented with this selection in class. Some of you may want to improvise your own social dramas, drawing on experiences that have happened to you or about which you have read or seen that can fit the definition of a social drama.

Having looked at this one example of a social drama, let us now discuss the meaning of such dramas and ritual behavior in theoretical terms.

RITUAL BEHAVIOR

Ritual behavior is marked by repetitive social action that usually arises out of conflict and marks periods of transition, when an individual in society moves from one socially designated position of status to another, transforming himself or herself into a different person in the process.

Arnold van Gennep, an anthropologist, defined *rites of passage* as ''rites which accompany every change of place, state, social position, and age.'' The individual or group undergoing the rite of passage is referred to as the *ritual subject.* The two *states* between which the ritual subject moves, the past state and the one that is to come, are both stable social orders in which an individual or group is expected to behave in conformity to a set of customary norms and ethical standards that govern people of similar social position in the society. The transitional phase through which the ritual subject passes in order to accomplish the rite of passage is characterized as *liminal,* a betwixt and between zone of the sort we described in chapter 3. Gennep believed that all rites of passage are marked by three phases: *separation, margin* (or *limen*), and *aggregation.* Later, Turner develops the concept of the social drama and divides Gennep's *liminal* stage into two stages, *crisis* and *redress.*

In Gennep's model of the stages in rites of passage, the first phase marks the separation or detachment of the ritual subject from a set of cultural conditions and a social structure that had governed during the state that preceded the rite of passage. The second phase is liminal. The ritual subject moves through a cultural realm that has neither the characteristics of the state that has been left behind nor the characteristics of the coming state. During this marginal or liminal phase, the characteristics of the ritual subject are ambiguous. The systems of classification that normally locate people's states and positions in society do not obtain. People are suspended in a state where neither law nor custom nor convention adequately captures their status. The qualities they possess are indeterminate and ambiguous.

The shaman's initiation ceremony in many cultures is a good example of one of the kinds of rites of passage that Gennep and other anthropologists have studied. Shamans have practiced their healings in different cultures for thousands of years. In *Shamanic Voices: A Survey of Visionary Narratives,* Joan Halifax, a medical anthropologist, traces the word *shaman* to its prehistoric roots in ''Vedic *sram,* meaning 'to heat oneself or practice austerities' '' (3).

The rites that prepare shamans for their role are usually situated in caves or mountain tops. In Native American cultures the healer is often forced to enter a dark pit. The initiate generally fasts before entering the ritual space of the visionary pit, cave, or mountaintop. An elder brings food as the initiate remains in the ritual site for periods of time ranging from several days to months. During this period of almost complete isolation, the initiate begins to hear voices and to have hallucinogenic experiences, often entering a trance. It is during this phase that the initiate may learn of his or her calling as a shaman. The stories spawned by these rites report of near-death or out-of-body experiences. The initiate talks of having died, been dismembered, and then resurrected. This physical and psychological encounter with extreme states of being, with what many call ''death,'' leaves the shaman peculiarly ready to assist others with experiences of illness and dying. Turner notes that frequently liminality is compared to ''death, to being in the womb, to invisibility, to darkness, to bisexuality, to the wilderness, and to an eclipse of the sun'' (*The Ritual Process* 95).

The third phase in Gennep's model, aggregation, marks the consummation of the passage in the reaggregation or reincorporation into the state. In this final

stage, the ritual subject has achieved an alteration in status, a change in social position. As the subject reenters the stable cultural community, the subject is governed by the norms the culture has dictated for the particular social position entered into by the subject.

The shaman's initiation often begins during the culture's puberty rite, which involves an adolescent boy in a ritual that transforms him from boy to adult. In those cases in which the adolescent comes to understand his dreams and visions as expressing a shamanistic calling, he also emerges into adulthood in the status of a shaman. Think about a rite of passage drawn from your own experience and contemporary American culture. Can you see how the rite can be divided into these stages?

A wedding, baptism, confirmation or bar mitzvah, and graduation are only a few examples of familiar modern rites of passage. These rituals take place around thresholds, or *limens.* The physical space in which the ritual takes place is marked. The temporal dimension is also fixed and durational. However, at the heart of many rituals, secular time and sacred time intersect. Sacred time is reversible, repeatable, and capable of being recovered. It transcends ordinary time and history. The rite itself is liminal, betwixt and between spatial and temporal zones, and divided into stages that enable the individual to effect the transformation in status thorough the ritual process.

Usually these kinds of ceremonies are marked by dancing, feasting, spectacle, and formulaic expressions. They involve an interaction between members of the community and the specific individual or individuals who have been set apart from the group for a part of the journey that accomplishes an alteration in their social status. The participants enacting the ritual often awaken memories of earlier experiences, thereby releasing them. The capacity for ritual to release stored experiences often grows out of what scholars call "bodily memory." The body, through gestures or dancing, awakens its own memory of earlier experiences. It begins to express images and gestures from a different time, when the body knew its reality differently, for example, from the perspective of a child. In trance or ecstatic dance, dancers take on different bodies, with old men acting like children; healthy men simulating decrepitude; men assuming the roles of women and vice versa; and many other bodies hurling themselves frenetically about, almost as if crazed. These kinds of transformations often occur in moments of heightened ritual activity. Part of our interest in ritual is for its performative features.

This explanation of the three stages of ritual is abstract. Let us turn now to some examples. You may want to supply your own, particularly the kind of performative behaviors that are exhibited in ritual and the contextual and performative features necessary to an understanding of it.

A Wedding Ceremony

A wedding ceremony, and the events leading up to it and bringing it to conclusion, is an example of the way in which ritual acts as a reflecting mirror for society, allowing the members and the couple involved to become aware of themselves and their relationships to one another as the self of the wedding couple moves

through a change in social station, ultimately assuming the role of married couple. The reflecting qualities of the ceremony are twofold. First, it reflects images of the participants in relationship to their world, which helps the group and the ritual subjects achieve self-awareness. Second, it provides an occasion for self-reflexivity, reflecting back on the selves that acted as the surface of a mirror. The guests, family members, and ritual subjects all assist in the ceremony, which permits them to speak their various stories, display themselves, and negotiate this precarious rite of passage. The ritual requires participants who can stand as witnesses to the event as well as interpreters of it.

The wedding is, by its very nature, a ceremony of collective identity, defining the self in relationship to the group. It is based on shared beliefs. It is highly theatrical and sensual, relying on visual images, costumes, sound, movement, and touch to move the senses and emotions of the participants, bringing about a condition of belief that derives more from the doing of the ceremony than from a critical understanding of it. It involves an orderly chain of events, repetitive words and behaviors, precise and predictable occurrences, a dramatic presentation, and considerable formality. All of these features of ritual assist in explaining how it functions as a ceremony, offering continuity through change to its participants.

Gennep's three stages of ritual can be applied to the wedding ceremony. The first stage is the time of separation, which begins when the immediate families of the two ritual subjects begin to set them apart from their peer group, treating them as an engaged couple and involving them in the arrangements for the wedding ceremony. This time of preparation is marked by a heightened level of interaction.

During the marginal or liminal phase, a number of performative events take place that mark the ambiguous status of the engaged pair. This phase may begin with an engagement party. Later, friends of the groom may host stag parties, through which a male community bonds to mark the end of bachelorhood and the beginning of the man's emergence into husbandhood. Friends or relatives of the bride throw showers for her, providing her with numerous goods for the new marital household she will enter. These gatherings, too, are part of the rite of passage. They are a part of the transitional period for the ritual subjects, marking the end of one kind of relationship with other people and the beginning of a new status as "married person." If the ceremony is religious, the couple is often instructed by the church about the sacred significance of the union. Once the new status is finally achieved, through the consummation of the marriage ceremony in the bridal bed, the woman no longer comes together with friends and family as a single woman. She is a married woman with important obligations and affiliations to her mate. By virtue of her status as a married woman, her relationship with family and friends alters.

The marginal phase is full of ritual activity. After the stage of preparation for the wedding—and very often this stage protracts itself for over a year—there is the wedding ceremony itself. It customarily begins with a rehearsal of the wedding by members of the wedding party, followed by a rehearsal dinner. Then there is the wedding ceremony itself, officiated over by members of the clergy or of the court and attended by the couple, their extended families, and guests. During this liminal stage, the woman is bride; the husband, groom. Vows are

shared during the ceremony. Through the pronouncement of vows, a set of words fixed by law (and very often, also by the church), the couple enter a new state, leaving behind them their single status and becoming parts of the marital unit. The ceremony is followed by feasting; the eating of a wedding cake; dancing; the throwing of the bride's bouquet and maybe her garter; and the departure of the married couple to their marital bed, leaving the guests to finish their festivities and return home to the world of everyday living. For the bride and groom, the marriage is not complete until it has been consummated through the sexual act. The occasion of the honeymoon creates the opportunity for the marriage to be consummated, giving the couple time to be alone with each other and apart from the larger social unit for some fixed period of time before they reenter the social world of everyday living, no longer as "bride and groom" but as a "married couple."

The third phase of aggregation occurs once the man and woman reenter the social world as a married couple. They have completed the rite of passage marked by a change in their social status. The change in status may occur at a religious level as well as a level of civil law. The ceremony alters the sociopolitical, economic and perhaps religious status of the individuals.

In the ritual, the ritual subjects must leave behind one state, enter another, and then move back into the social fabric, altered by virtue of the ritual that has transformed them. The participants and officiators in the ceremony also have their roles. The officiators act as agents to effect change in the ritual subject. They must assist in bringing about the ritual transformation and then return themselves to the community and their ordinary roles. The participants in the ceremony, its witnesses and audience, also participate in the event, assisting the individuals through the ceremony and accepting them back into their midst at the end.

Rituals occur in periods of crisis. They are cultural performances in which the participants undergo a change of status. Very often the individual's courage and character, inventiveness, and resourcefulness are tested during the ritual. Rituals occur within special time periods and in particular places. In the case of the wedding, the date is always set and subsequently celebrated by rituals of renewal in the form of yearly anniversaries. Weddings take place in churches or synagogues or other religious sites, in offices of a justice of the peace, or in other spaces with fixed boundaries designated for the ceremony. Fixed rules, traditions, and strategies accompany them.

Can you describe some of the rules, traditions, and strategies that govern weddings, graduation, or funerals? Think about some of these ceremonies that you have attended and consider them as examples of cultural performances, in which the three phases of the rite of passage assist you in understanding the nature of the performance process.

"All the World's a Stage": A Metaphor That Compares Life with the Theater

Many contemporary critics are interested in exploring the relationships between rituals such as the one described above and theater. In pursuing the points of similarity and difference between the kind of heightened theatrical experience

that occurs in life during rites of passage and the kind that is found in Western drama and artistic performances, beginning with the birth of Western tragedy, some of these critics have drawn on Turner's discussion of the social drama to help them understand the role of ritual during times of conflict.

So far we have referred to rituals in contemporary society with which you are all familiar. Can you see how concepts drawn from the study of Western drama assist us in thinking about these kinds of performances? The metaphor that states that "all the world's a stage" allows us to think about the ways in which figures in life assume roles and function like the protagonist of a play. In the wedding, the priest or rabbi or judge, whoever is performing the wedding ceremony, functions as an agent of action transforming the identity of the principal players, in this case the bride and groom. Similarly, in the shamanistic healing ritual, the shaman plays a priestlike role—uttering words, offering sacrifices, and calling on spirits and deities—to rid the sick of the source of physical illness through transformations involving magical and spiritual powers. The bride and groom or the sick person is the protagonist of the social drama.

The seemingly spontaneous events that mark people's behaviors in society during times of stress and conflict share other characteristics with Western drama. Let us consider how space and time as well as text and spectacle are treated in both forms.

In Western drama, the play, such as Shakespeare's *Macbeth,* is set in a fixed space, usually a stage. In rituals performed in society the space is similarly set apart from ordinary space and designated as a kind of "sacred space," a space suitable for the liminal transformation that lies at the heart of the ritual ceremony. For example, the wedding is conducted in a church, before an altar, or in a judge's chambers. The space is well prescribed, allowing set places for the ritual subjects, the officials, and the spectators.

The social dramas in life also seem to enter their own temporal period, set apart from ordinary life and divided into phases, much as a drama is enacted during times designated for the sharing in the event. The drama, too, divides itself into acts and scenes and moves through a beginning, middle, and end, with a plot that advances toward its climax and resolution after it has become sufficiently complicated.

Also, the ritual activity taking place during a social drama has a text, in much the same way that a play relates to its text. In the ritual activity in life, the text is uttered, often in the form of prayer, chant, song, magic words, or call and response. Part of the text is entirely formulaic and repeatable, but there are also improvised texts. In *Macbeth,* not only is there a play text written in words, which serves as a blueprint for performance, but ritual is enacted within the play itself, beginning with the witches' greeting to Macbeth and later very much extended in the chant they repeat again and again over their broth: "Double, double, toil and trouble/Fire burn and cauldron bubble (IV.1:10–11; 20–21; 35–36). Macbeth fears the prophecy of the witches. Throughout the play, their magical words are repeated, precisely following the formulaic pattern of ritual words. Finally, of course, the actor performing in *Macbeth* commits the words of the part to memory, rehearsing them again and again both prior to the public performance

and during it. In this respect, an actor's body and mind are committed to a ritual act during the performance of the play. The actor experiences many of the states of mind of ritual subjects.

We can also compare social dramas to theatrical ones in regard to their treatment of visual elements, that is, costumes, props, sets, and so forth. The participants in these ritual performances often wear costumes particular to the occasion. The physical environment is adorned, or furnished; dancing, singing, music, feasting, and other forms of revelry take place. Social dramas find their dramatic counterpart in Western theater, not only within the drama text itself but also in the institution of theater and theatergoing; an evening of theater is a social event, often preceded or followed by dinner and broken up into intermissions, when the audience mingles in the lobby, enjoying refreshments.

This metaphor that draws an analogy between theater and ritual is useful up to a point, but it is also important to recognize some essential distinctions that are less easy to grasp when we depend on the analogy. Art is not life. Cultural systems define what a people will agree is art. Cultural definitions of art, rather than properties innate to the object, enable us to know what is to be considered art and what is not. These definitions, which are in constant flux, identify the particular features that are comprised in beauty and ugliness. Some Western definitions of art set the art object apart from the ordinary, utilitarian object, drawing a distinction between efficacy and entertainment. Other definitions are less comfortable with the efficacy/entertainment polarity, arguing that many things considered to be art are every bit as much efficacious as entertaining.

This argument rests on the idea that ordinary objects in everyday life are defined as serving functional (efficacious) purposes more important than their aesthetic features. They are designed to assist humans in the conduct of life, and the objects that have largely efficacious ends are designed to be able to produce a desired effect or result. For example, a drug by definition must be capable of producing a fixed result, relieving a symptom if not curing it. An art object, however, comprises many features that have little to do with efficacy and a good deal to do with entertainment. Art does serve efficacious purposes. It is considered to be psychologically therapeutic, enabling us to experience catharsis and cleanse ourselves. However, much of what a culture calls art is understood in relationship to matters of beauty and pleasure. The particular pleasure and pain inflicted by art is usually very different from the physical pain and pleasure derived from life. Although we are considering the ways in which it is useful to compare art or theater and life, do not lose sight of the important distinctions between them.

Performers in a play enact ritualistic behaviors. Some actors undergo experiences very similar to ecstatic or trance behaviors typical of many rituals practiced in society. Many actors have described moments of intense heightened activity experienced onstage. However, when actors achieve ritualistic moments of trance or ecstasy in the midst of a performance, we need to distinguish between what they are experiencing as agents of the action in the play and what they are experiencing as the characters they are playing in the drama. It is possible to analyze the actors' trance or ecstatic experience in the role as agent of action and compare it to ritualistic behaviors in society. This will involve us in

considering the actors' behavior in relation to the other actors and the audience and explaining the phenomenon as one of the rituals engaged in by members of the theater community. We will consider the sociology of art worlds and the use of ritual to define status within the community and in relationship to audience members, who are part of the larger community. This analysis of the ritual behavior of actors is significantly different from an analysis of whether the plots of Western drama draw on ritual for their subject. Numerous plays have plots that mirror the cycles of nature and involve birth, death, and renewal. They use the concepts of ritual time.

The *Liminal Phase* and *Communitas*

In *From Ritual to Theatre: The Human Seriousness of Play,* Turner describes rituals practiced in everyday life as liminal experiences. He defines ritual as "a transformative self-immolation of order as presently constituted," stating that it requires a "reordering" of a social situation (83–84). Rituals are part of the fundamental process by which cultures produce history. They enable people to step out of time temporarily, out of the chain of events, and during this period of disruption, to set events in new directions. You can see how this principle operates if you think of the personal history of the bride and groom prior to marriage, when their lives are traveling in one set of directions, different for each of the two individuals, set against their personal histories after the ritual of marriage. Now their lives are set in new directions, working toward different goals.

Ritual experience, according to Turner, is marked by its communal nature. During the liminal period of the ritual, the individuals escape the normal social order and its constraints, entering a phase in which social status is temporarily laid aside and the participants mingle as social equals, bonding in a spirit of *communitas,* which affirms universal characteristics of humanity and the individual's worth. Turner describes the state: "It is almost everywhere held to be sacred or 'holy,' possibly because it transgresses or dissolves the norms that govern structured and institutionalized relationships and is accompanied by experiences of unprecedented potency" (*The Ritual Process* 128). Later, the individual returns to the world of time and social differentiation, where communitas no longer exists. However, it is because of the existence of communitas at the heart of the ceremony that all the humiliations that have separated the members of the group are now mended.

In the rituals that Turner studied in cultures that had not undergone industrialization, the experience was often quasi-religious, marked by a sense of timelessness and wholeness. In the modern world, according to Turner, life is too fragmented to achieve any lasting wholeness. Consequently, performances of the kind that we call aesthetic, such as Western theater, simulate many features of ritual but without the hope of the kind of transcendent experience and social cohesion present in preindustrial societies.

Turner's studies about ritual and the social drama led him to expand on Gennep's idea about the three phases in rites of passage, breaking the liminal phase into two stages, namely, crisis and redress. His schemata is a useful one for an

understanding of ritual performance, particularly from the perspective of the student of performance. You saw it operating in Myerhoff's analysis of the social drama at the center.

THE FOUR STAGES OF THE SOCIAL DRAMA:
BREACH, CRISIS, REDRESS, AND *REINTEGRATION*
OR *RECOGNITION OF SCHISM*

Turner considers ritual to be one of the primary means by which cultures can change themselves, taking their history in different directions. He builds on Gennep's three phases in rites of passage to develop his analysis of social dramas, classifying them into four stages:

> These I label: breach, crisis, redress, and *either* reintegration *or* recognition of schism. Social dramas occur within groups bounded by shared values and interests . . . having a real or alleged common history Whether it is a large affair, like the Dreyfuss Case or Watergate, or a struggle for village headmanship, a social drama first manifests itself as the breach of a norm, the infraction of a rule of morality, law, custom or etiquette in some public arena. This breach may be deliberately, even calculatedly, contrived by a person or party disposed to demonstrate or challenge entrenched authority. . . . (69–70)

During the phase of crisis the community involves itself in a period of intense argument and debate, leading to increasingly antagonistic forces, dividing the group, and causing people to regroup into parties representing different "sides." As tensions mount, behaviors become markedly more aggressive, often involving threats of violence and even violence itself. *Redressive* measures consist of various kinds of machinery brought into play to mend, or patch up, quarrels and restore the social fabric. This *redressive* machinery includes juridical processes, that is, courts of law; ritual means provided by religious institutions, for example, confession; and artistic performances, such as drama, dance, storytelling, and so on. Such redressive measures probe a community's weaknesses; portray its conflicts; assess the behavior of the leaders, often calling them to account; and suggest remedies. When art functions as the means of redress, it does not offer the restoration of the old order, or the condition before the breach, so much as it offers a method of transformation that will enable society to go forward and move beyond the rift.

In the Myerhoff example, the redressive machinery involved the installation of Kominsky and his subsequent expulsion, brought about during a meeting of the center's leadership pursuant to their election of a new leader. Turner is intrigued with the numerous kinds of performative rituals that are enacted to produce a stable culture. Can you see that a trial—such as the Watergate trials and the subsequent resignation of President Nixon or the trial of the Chicago Seven following the riots at the National Democratic Convention—is a richly

textured performative event in which the role playing takes on a very public character, and numerous customs, beliefs, and codes of law are used to restore the social order?

PERFORMING RITUALS

These theories about ritual and social drama assist you in identifying such events and analyzing them. In the performance of ritual activity and portions of social dramas you will achieve a kind of knowing through doing.

Many think it is dangerous and unwise to perform sacred ceremonies from other cultures in an attempt to enact ethnography or to know the nature of the other through performances of their rites. This thinking is based on the experiences of Turner and other anthropologists who have themselves experimented with these kinds of performances and have had their students practice them as a part of fieldwork. Our view on this matter is less rigid. We agree that it is unlikely that an American reenacting a voodoo ceremony or a Buddhist ceremony can actually attain the state of belief of those who participate in the ceremonies as a part of their living belief system. However, performances of these ceremonies do afford a more bodily encounter with the kind of experience that lies at the heart of ritual. You may not be able to know the experiences of religious transcendence of peoples from another culture, but the attempt to step into and feel with and through the body as it undergoes such rituals can add dimensions of understanding that cannot be provided by critical, nonperformative means. The encounter can open you up to your own religious systems as well as illuminate parts of the experience of others.

You may want to experiment in class with enacting rituals of sacred ceremonies different from your own religious beliefs. What do these experiences show you, both from the perspective of a student performing in one and from the perspective of an audience member?

The rest of this chapter introduces you to ritual performances of Native Americans and a Vietnamese shaman to give you an opportunity to explore another culture's customs and practices and also to heighten your awareness of what ritual means through the performance of it.

Witchcraft and Sorcery

Chapter 3 looked at a legend constructed by members of a peasant community about a 104-year-old woman who was said to be a witch. It also alluded to a number of *Märchen* and fairy tales in which witches figured prominently. This chapter considers witchcraft, its lore and its rites, from the perspective of a student of ritual and culture.

Witchcraft, Magic, and Oracles among the Azande of the Anglo-Egyptian Sudan, written by E. E. Evans-Pritchard, a leading anthropologist, offers one of the best descriptions of witchcraft, but it has also given rise to a lively controversy about whether witches can be distinguished from sorcerers on the basis of innate

(given in nature) versus acquired (learned) characteristics. It is commonly thought that witches and sorcerers aggressively use magic or other supernatural techniques to do harm to others. It is also believed that accusations of witchcraft and fears about it generally occur between persons occupying certain statuses and not others, and that these statuses involve them in competition for items in scarce supply such as power, food, economic goods, affection, and prestige. Further, these in-group rivalries often occur where open conflict and competition are not sanctioned.

Witchcraft very often offers people a practical solution to vexing, often insoluble problems. Many scholars think it is best understood as a moral code, which recognizes that within societies, particularly small, homogeneous ones in which there is little centralized or formal authority, there are many occasions when the ill feeling or hostility of one of the members of the group threatens the well-being of the whole. Witchcraft is very responsive to human values. Its machinery—witches, witch doctors, cures, medicines, magical utterances, and curses—all relate very closely to human emotions and bear on the kind of value humans place on one another in their society.

Witchcraft offers an explanation for human misfortunes. It permits members of a group to project their feelings of hostility and guilt on another, the witch, while denying their own responsibility for emotions dangerous to the health of the whole. It invests the "witch" with all sorts of dark powers and evil possibilities; at the same time it gives rise to shamans, diviners, and witch doctors and the institutionalization of curing remedies. In the Americas, it is typically the shaman, priest, or perhaps diviner who is turned to as a specialist to counteract the supernatural forces of the witch. Through witchcraft, a society can elevate some of its members to the status of a witch, consequently enabling itself to expel unwanted people from its midst. At the same time, others in the group accrue special powers as they are identified as possessing powers and cures that can bring health to the community. Many anthropological studies have revealed that very often one community's witch is another community's witch doctor; even within one society, the same person can function as both witch and witch doctor.

In a recent study, *Witchcraft and Sorcery of the American Native Peoples,* Deward E. Walker, Jr., has provided one of the most comprehensive anthropological investigations of witchcraft and sorcery in the Americas. Walker concludes that it is premature to speak with confidence about definitions of witchcraft that would contain universal, generalizing truth. Rather, he offers a working definition that enables him to talk about witchcraft cross-culturally.

Walker defines witchcraft as "the aggressive use of supernatural techniques" (3). By "supernatural" he refers to an explanation of causality that is empirically nondemonstrable. He notes that in-group suspicions and accusations about witchcraft and the supernatural result from displaced tensions stemming from in-group competition. He also argues that witchcraft and sorcery must be understood through an analysis of the neocolonial struggles for survival of groups in greater Euroamerican society.

Native American contact with Euroamerican people often resulted in various degrees of acculturation on the part of the Native American. We see evidence

of this in the frequency with which Native American religious practices assimilated elements of Christianity, mingling calls on Christ with calls on animal spirits. Very often the result of missionary work was to produce a conversion to Catholicism by Native Americans while their religion was pushed underground or practiced by those holding the lowest social position in the community. Walker argues that if you are fully to understand witchcraft and sorcery, you must understand the total existential condition of the society under study, particularly concentrating on ethnic, economic, political, and acculturational factors in the intergroup and intragroup competition. Often sibling rivalry or competition between father and son, mother and daughter, or uncle and nephew may account for the widely held belief in the Americas that "cannibalistic sacrifice of a close relative is required for witchcraft or sorcery initiation" (4). He also notes that witchcraft and sorcery techniques commonly reflect conventional, culturally patterned fears and frustrations. The techniques of witchcraft, such as using dolls resembling the victim or impersonating the victim's behavior, are highly patterned and predictable.

We cannot expect you to be experts in witchcraft and sorcery and knowledgeable about numerous Native American tribes and American cults who practice witchcraft. We are interested in these practices because they show us more broadly important aspects of this cultural system and a ritual activity. Let us turn now to an account of a performance of a *Cese•ko* cited in Louise Spindler's ethnographic account, "Great Lakes: Menomini," in Walker's *Witchcraft and Sorcery of the American Native Peoples*.

> A description of the performance of *Cese•ko* in 1851 is given by a visitor (Hoffman 1896:146, quoted from Hiram Calkins in *Collections of the Historical Society of Wisconsin for 1851*, Vol. 1,1955):
>
> "He is always called upon, far and near, in cases of sickness, or in the absence of relatives, to foretell whether the sickness will prove fatal or whether the friends will return in safety, and at what time. He is also consulted by the Indians when they go out to hunt the bear, to foretell whether success will crown their efforts. Before performing these services, he is always paid by the Indians with such articles as they have, which generally consist of tobacco, steeltraps, kettles, broadcloth, calico, and a variety of other commodities. He usually performs after dark, in a wigwam just large enough to admit of his standing erect. This lodge or wigwam is tightly covered with mats, so as to entirely exclude all light and the prying curiosity of all outsiders. Having no light within the lodge, the acts and utterances of the medicine man or conjurer are regarded as mysterious, and credulously received by the wondering crowd surrounding the tent. He first prepares himself in his family wigwam by stripping off his clothing. Then he emerges singing, and the Indians outside join him in the sun with their drums, and accompany him to the lodge, which he enters alone. Upon entering, the lodge commences shaking violently, which is supposed by the Indians outside to be caused by the spirits. The shaking of the lodge produces a great

noise by the rattling of balls and deers' hoofs fastened to the poles of the lodge at the top, and at the same time three voices are distinctly heard intermingled with this noise. One is a very hoarse voice, which the Indians are made to believe is that of the Great Spirit; another is a very fine voice, represented to be that of a Small Spirit; while the third is that of the medicine man himself. He pretends that the Great Spirit converses in a very heavy voice to the lesser spirit, unintelligibly to the conjurer, and the lesser spirit interprets it to him, and he communicates the intelligence to his brethren without. The ceremony lasts about three hours, when he comes out in a high state of perspiration, supposed by the superstitious Indians to be produced by mental excitement." (45)

Perform this narrative describing a ceremony involving a Menomini medicine man. Try to visualize the ritual being described, but at the same time be aware of the point of view of the visitor who tells the account. How does his attitude toward the Indians and the beliefs of the medicine man affect his account? Do you notice how he talks of the "credulous" ways in which the Indians receive the acts the medicine man wondrously enacts in the darkened tent? Notice also how he interprets the beliefs of the Indians, stating that they will interpret the "shaking" of the medicine man as something caused by the supernatural, by spirits. Do you sense his tone of disbelief when he reports the way in which the medicine man tells of the spirit conversation to the other Indians? He calls the other Indians "superstitious," and he describes the three voices that are heard coming out of the lodge. Throughout his account, the visitor seems to be describing the performance as though it were an elaborate piece of artifice, in which the medicine man cons the other Indians.

Before reading another account of a part of this Menomini performance and system of belief by a different informant, take a moment to notice the ritual elements in the description above. The *Cese•ko,* or jugglers, as they are sometimes called, work in a special lodge of "jugglery" when they consult the spirits to cure the sick. Spindler writes that the small birchbark lodge sways from side to side, or shakes, while the medicine man listens to the winds and the spirit voices, whom he interprets through another medium. In the preceding passage, we see that the wigwam is the lodge of the juggler. It is the site of the performance. The performance of the ritual is prepared for in several ways.

The medicine man is summoned by the people for a case of illness. We could say that this ritual is enacted in a moment of crisis. It has been precipitated by a stage of separation in which someone has fallen ill, and therefore been taken apart from the rest of the group, and the group senses a kind of separation of itself from itself as it experiences the threat posed by the illness. The medicine man, like Kominksy in the Myerhoff account, is an outsider, a specialist, whose powers are needed to assist the group through its crisis. He is paid for his services and we learn that he is considered to have powers of prophecy and is consulted before hunting expeditions about the probable success of the hunt.

The ritual is situated in the wigwam, or lodge, with the community members outside of it. The ceremony takes place at night. The matter of illumination, or

rather, the lack of it, is important. Enshrouded in darkness, the techniques of the medicine man are concealed and the atmosphere is conducive to making vulnerable men and women responsive to the forces of nature and the supernatural.

The ritual involves ceremonial costume. The medicine man sheds his ordinary clothing and enters into the most intense phase of the ritual activity. Note that this phase is ushered in with drumming and it appears that the ceremony begins when there is sunlight; however, after three hours the medicine man is in darkness, in which he conducts his craft. There is rhythmic drumming accompanied by singing as the Indians and the medicine man move toward the wigwam. The ceremony is heating up.

Once the medicine man enters the lodge alone, he is in the most liminal phase of the ritual. He is at once in the lodge at a fixed moment of durational time and also unseen and surrounded by sounds—the three voices, one being his own, and the noises produced by the rattling balls and deer hoofs that are tied to poles at the top of the lodge. According to the report, the medicine man is unable to understand the wisdom of the Great Spirit and must rely on the Small Spirit to speak to the Great Spirit and translate the voice to him, which he in turn translates to the other Menomini. Traditionally, the *Cese·ko* is said to rely on a turtle to act as his medium and interpret the words of the Small and Great Spirits. When this account ends, the medicine man has emerged from the tent, bathed in perspiration, giving visual evidence to the other Menomini of his prowess and of his struggle with the spirit voices. This particular informant does not go on with the account, so we have not properly reached the conclusion of the ceremony.

Several contextual features are necessary to our understanding of this account, written in the mid-1860s and reported by Hoffman to the Bureau of American Ethnology in 1892–93. The Menomini Indians, members of the Central Alkonkian tribe, inhabited territory in northeast central Wisconsin, an area of the country that is heavily forested. In aboriginal times, the Indians formed a hunting, fishing, and gathering society, living in relative isolation near the Wolf River and Lake Michigan. They were part of a larger culture, spreading throughout eastern and central United States and Canada. Spindler describes the ''core'' culture as one characterized by

> . . . the family hunting group with patrilineal extended family and a high degree of socio-political autonomy; girl's seclusion at puberty with menstrual taboos connected with hunting luck; an extreme fear of famine; divination; respecting observances toward game animals (especially the bear); emphasis upon the boy's first kill; shamanistic practices and guardian spirit complex; the importance of dreams and ''power''; the shaking tent rite for curing or finding lost objects through the medium of the turtle; the use of the sweathouse for magico-religious purposes and curing; the trickster cycle and reference to skeleton beings in folklore; the spring feast of thanksgiving; mild mother-in-law, son-in-law avoidances; the naming feast for the child; marriages arranged by the parents. (40–41)

The Menomini lived in a fairly stable fashion, assimilating some practices from the Sioux and Iroquois Indians, over a very long period of time. Spindler has discovered descriptions of the tribe dating from the late 1600s by fur traders and Jesuits. The passage we are studying dates to the mid-nineteenth century, when the practices of the tribe are being described for government records. At this time, there is considerable contact between the Native Americans and the Euroamericans who govern the United States. The missionaries and historians describing the Native Americans typically treat the jugglers as sorcerers, but there is good reason to believe that the craft practiced in the ceremony you are reading about forms a part of the religious beliefs of the Native Americans and that the *Cese·ko* was one of the healers in the culture.

The practices of the *Cese·ko* need to be understood in the context of the worldview held by the Menomini. This worldview, or cosmology, refers to a network of concepts that explains the universe, relating its ways to nature and man. In the cosmology of the Menomini, the earth is an island floating in an ocean and dividing the universe into two realms, one high, above the ocean; the other low, under it. These realms are governed by a hierarchy of spirits, from lesser to greater, and divided into two warring poles.

The highest order involves the gods of war; beneath them are War Eagles and the White Swan; and beneath them birds of all species, chief of which is the Bald Eagle. These are the supernatural deities reigning over the higher sphere. In the underworld, the evil world, there is another hierarchy, this time descending, describing the evil forces that threaten the Menomini. Chief among these is the Great White Bear, the main source of evil. The world is peopled with creatures from all spheres, natural and supernatural—men, animals, and hobgoblins.

Within the Menomini society, certain men and women have been designated as technicians of the sacred and healers. These people, by means of witches' bundles, turtles, and other items, can help the people of the tribe to better their lives. Stories about the cosmology (we usually refer to these kinds of stories as myths) help the people describe their own reality to themselves, accounting for it in a way that makes it easier to cope.

You may find yourself initially marveling at the myths and folklore of the Menomini cosmology and their cultural practices. Some of you may be extremely skeptical, thinking about these beliefs as though they are quite alien. Try to put yourself in the position of an outsider to your own culture and beliefs. Can you see how many of our own practices can appear outlandish, fabricated, and strange?

Just to cite one example, can you see how the so-called "talking cure" practiced in our culture by psychiatrists, psychoanalysts, and psychologists trained in the schools of Freud and his descendants might strike an outsider as very little different from the cures of witch doctors? Similarly, from the perspective of the Western medical model, the practices of faith healers or medicine men are considered to be largely lacking in scientific value. Consequently, the Western doctor will be unlikely to consider these methods as useful in the curing of illness. However, as you know, other schools of medicine, such as the holistic medicine movement in this country or herbal medicine, deviate significantly from the model

of scientific medicine, relying instead on other systems of belief to assist in curing. You may want to use class time to discuss some of your own cultural practices from the perspective of an outsider. Of course, immersed as we are in our own culture, we are probably blind to some of its most significant features, taking it so much for granted as we do. Nonetheless, the exercise is valuable.

Consider another account of this ceremony, this time reported to Spindler in the period 1947–60 in the context of her ethnographic work with the Menomini. This account is offered by a female, whom Spindler describes as a lower-status, acculturated woman informant. Spindler means that this woman, who lives on the Menomini reservation, has been baptized a Catholic and has one Catholic parent; but she has been denied access to the groups belonging to the Catholic church and has also found little in common with the lower-status white women near the reservation, whose social station more nearly matches her own. This account was offered in response to Spindler's question "Did you hear much about witchcraft?"

. . . My great grandmother had a tent and people that was hard to doctor, she'd shake that tent and bring animals in and make them talk. She swallowed regular bone with a hole in the middle and spit it up. After she swallowed it, I could hear them rattle. She used whiskey to get them down. Maybe they wouldn't poison her then. Some were bone, some were copper. Sick people come; she doctored all over the reservation. One old lady just died; she lived to be real old. J. [medicine man] used to go to her; he called her "aunt." She went to New York, Chicago, Milwaukee. She used Indian herbs she said mother earth planted for her. She was the biggest witch on the reservation. She used to sing a song and put a sheet out and serpents would come up and lay on it. She cut up and used hearts. I knew the song she used to sing. She used to use Indian rouge made of gold and rub it on her cheeks. You can't get it now. I had it but gave it away. I had a finger of an old Indian chief, grated up for luck. I was afraid to use it; I give it up.

Big M. [grandmother] earned her bag by fasting. She earnt her own. She laid in a hammock with the sun for ten days without eatin' and had her hand up like this. The bag was a gift. She made a bag of medicines. She went to work and got parts from serpents. She had so much power! She got bones from children buried; I seen them. At night she would talk to her bag and disappear. I cried; she scared me. She could turn into anything—dog or anything. When someone got her mad, she turned into a turkey and made lots of noise and she'd witch them and fight and they wouldn't live, or cripple them and make them sick. She turned into a cat. Sometimes she was comin', there'd be a fire comin'. She's pass me out so she could go. I can cure anyone's sickness. When she died, she said, "Here's a seed, eat it and dream of medicine I know." When someone's sick I know what's wrong. Then I go out and pick the right medicine. She said I would know what she knowed. She felt bad about fasting; her sons didn't fast. When she died, her daughter took the bag;

I was too young. Her daughter went blind after that; she couldn't handle it. Her daughters burnt it up. (69–70)

In this autobiographical narrative, the speaker describes some of the ritual activities said to have been engaged in by her great-grandmother. You can see that the processes of increased acculturation and contact with twentieth- as well as nineteenth-century white culture have left strong traces on this tale. Spindler notes that the men on the reservation, almost without exception, would not talk to her or other researchers about witchcraft. Spindler believes this refusal to be a result of their immersion in the mainstream culture. They would lose dignity and perhaps be ridiculed were they to speak about witchcraft as though it were something in which they believed. It was women with the least to lose who would talk about witches, embellishing their stories and detailing the techniques of the practice. You might want to think of this woman's account in connection with the folk tale told by Kingston's mother, in chapter 3. In both cases, the women, away from their husbands, risked telling stories that otherwise they would have suppressed.

This speaker describes how her great-grandmother practiced her craft as a witch on the reservation. She, too, like the *Cese·ko* in the earlier account, has her ritual paraphernalia. It includes the witches' bundle, a bundle that contains witches' potions and often is reported to hold the entire hide of a bear or other animal parts. In this account the bag contains medicines, but the witch is also said to possess all sorts of transformative and supernatural properties, far more than are described as attending the juggler in the earlier account.

Her great-grandmother uses a tent for parts of her ritual, but she also spreads her magic out in front of people, particularly when she is on the circuit, and she uses serpents in her rite. Can you see how her practices have shaped themselves to serve as a commodity? They are something she sells, and she selects details from what is probably her ancestral heritage and features them to satisfy her audience. The audience, according to this storyteller, are probably tourists as well as Native Indians in need of healing.

This story of her great-grandmother is richly textured and functions at a number of levels. It refers to the rituals through which her great-grandmother discovered her vocation as a healer. She mentions a period of fasting wherein the witch is prepared for her role. The details that describe the ways in which she came by her witch's bag and the power and status this bag conferred on her are typical of descriptions of the initiation rite that leads to the status of shamans, witches, or sorcerers. The final details in the account are also typical of stories about healings. Some people are marked for their status as healers. It is not entirely clear by what process a community ascribes the identity of healer on some persons and not others, but it is common to have reports of healers who lose their powers and others of persons receiving a call to fulfill a vocation that they cannot meet. In this case, we learn that the witch's daughter does not meet the test of the witch's bag. She inherits it but then becomes blind. Later the magical bag is destroyed by burning. Fire and light figure prominently in these ceremonies. In the first account the juggler emerges from the tent hot and sweating, giving bodily

and visual testimony to the physical struggles he has enacted with the supernatural spirits. Throughout this account, the speaker brags of her relative's great power. It is clear the great-grandmother has derived status of a kind through her performances. The speaker also tries to gain approval and some status by telling this story. She confides that she, too, has gifts with medicine, but she is reluctant to make too much of it.

Again, in this account, the ritual activity is highly theatrical, involving costume, words, a set, sounds, touch, and visual spectacle. Many of its techniques are designed to create a sense of wonderment as much as to effect a cure. We are told that healings take place but without much convincing detail. We are made more aware of the reputation M has gained and how her story has been shared and passed on than we are made to believe that her cures are efficacious. We do know that people came to see M and that M earned a livelihood through this role.

The Shaman

Walker generalizes about the use of shamans in the Americas:

> Resorting to a shaman usually follows unsuccessful efforts by the victim to remedy the effects of an accident, illness, or protracted behavioral disorder. Counteracting witchcraft or sorcery commonly includes ritual removal of the curse, sometimes with a protracted ritual struggle, ritual assistance of close friends and relatives, and often elaborate dramatizations of the spirits believed to be involved in the curse and its remedies. Spirits of dead relatives, telary spirits, and even Christian gods are commonly invoked. Although widely used to combat witchcraft or sorcery attacks, shamans are also widely feared as potential witches or sorcerers. In some cases . . . the shaman also uses his power punitively against those who violate approved norms. In most American groups, the assistance of shamans is viewed as a dangerous but necessary risk. (5–6)

Other accounts of shamans celebrate their traditions as part of ecstatic religious practices. These accounts proffer the rich myths that have been constructed from visionary experiences of the shamans, offering them as a way to share the wonderment of the creation. Milton's *Paradise Lost* is an elaborately extended version of the Genesis myth and the story of the fall of man based on Christian theology and the Bible. You may want to gather texts of shamanic quests and share them in class. Because we think you are probably familiar with these texts as they emerge in Western literary traditions, we decided to conclude this chapter with an account from a third-world culture told by a refugee. It is the contemporary account of the practices of a Hmong shaman as set down in poetic form (influenced by Dennis Tedlock's methods of translation) by Dwight Conquergood in *I Am A Shaman: A Hmong Life Story with Ethnographic Commentary*. There is also an award-winning documentary film, *Between Two Worlds: The Hmong Shaman in America,* based on Conquergood's fieldwork. It provides a visual record of the shamanic performances and their context.

Here is the way to shake for having children
From the time I became a shaman until now
I have helped four or five women
Women who are barren

The first time you shake
You shake to build the bridge to the sky
So that the baby can come to the earth

The shaman brings the bridge into the bed of the husband and wife
He puts the bridge inside all the pockets of the clothes
Of the husband and wife

He sends his shaman-spirit with a baby-carrier up to the heaven
To bring the baby to the earth
And give to the husband and wife

And then the shaman turns another way
To see if the wife has a bad spirit
Which comes to her and makes her barren

You shake to cut the web of the evil spirit
So that it cannot afflict the wife anymore
After that she will get pregnant

Then you will know what kind of spirits are good
And what kind are bad
You make a fence between the two

Then you speak softly to the good spirits
And promise them an animal offering
They are happy with your vow

Then you will know what kind of animal
And what color of animal
Will make the fence around the evil spirits
And make them afraid

Sometimes you use a red male dog
 Or a chicken with curled feathers
 Or a black sheep
After that the woman will get a baby
SO THIS IS THE WAY THE SHAMAN SHAKES FOR HAVING CHILDREN

Thus my master taught me
If the big spirit who lives between the sky and earth
Comes to the wife and makes her barren
Then she cannot get pregnant

You take this animal to make a fence
And shelter the wife from the evil spirit

You take a cat
And a black dog
 With white around the muzzle
 And white markings above both eyes
And a red chicken
One you kill
One you keep

Take a sheep to make a fence at the crossroads in the sky
Where the three ways of the spirits meet
You cut the web of the evil spirit
After that she will get pregnant

When the woman gets pregnant
Then the family promises you payment
But you must take care of her
Until the baby is born

When the baby is born
And the shaman sees with his eyes
You must go back and shake again

You take the same animal as before
To make the fence
The shaman says
 "It is finished
 Do not come back anymore"

After that you must take care of the baby for three years
If he has a headache
 Or a stomachache
 Any problem
You must shake again
You have to take care of him

You shake to build the bridge to the sky for the baby
You must pull the white ropes over the door across the roof
To the bench of the shaman's altar
Then you sit in the parent's bed

After that the baby can find his way
To his father and mother
Then he has parents

When the baby is about three years old
Then the Shaman comes and shakes for the last time
He cuts the web again

He says, "For the rest of your life
 Child, do not bother the spirits

Spirits, do not bother the child"
So the spirits do not have the way to come to the child anymore

If you cannot help the first baby
It is hard to save the following babies
Sometimes your chanting works
Sometimes it does not work

If the parents have good luck
Then you can help
But if they have bad fate
Then you cannot help
SO THIS IS THE WAY YOU SHAKE FOR CHILDREN (10–14)

Conquergood set this narrative down in the form of a written epic poem from the words of Paja Thao, which were translated for him by Xa Thao. In determining how to put these words transmitted orally into a print form that would be true to the expressive qualities of the speech, Conquergood drew on the writings of Tedlock about cross-cultural translation and decided to use typography and stanzaic divisions in the manner of Western poetic conventions. The effect is to produce a text to be performed in a manner that achieves an equivalent of the shaman's nonliterate speech as understood and interpreted by a Westerner.

Can you see how this text, more than the two previous accounts, has no voice mediating the experience of the shaman? In the Hoffman account quoted by Spindler and the autobiographical telling of the contemporary Native American, there is a narrator who frames the account of the ritual practice and filters it through his or her own interpretive lens. In each of the other two accounts, the narrator tells about the practice, choosing words that will describe it; however, very often the words go beyond description to offer an evaluation of the account. In this case, Conquergood has heard a narrative account from a shaman that he has set down as if it were Paja Thao speaking. His words are conveyed to us directly, with no interpretive comment. However, Thao himself is constantly explaining his practice as he tells about it, and his explanation is partially shaped by his understanding of the expectations of the audience to whom he is telling the tale, namely, an ethnographer who is his friend but also an outsider.

In the passage quoted above can you see how it is important to Thao to preserve the Hmong culture? He feels this need particularly keenly now that he lives in a world so very far away from the farming villages in Southeast Asia. The situation is further complicated by the fact that his flight from his homeland was necessitated by the victory of the Viet Cong during the Vietnamese war, the defeat of the United States, and the collapse of Laos. The Hmong were hired mercenaries, recruited by the United States during the war. Before the war, they were a minority people in their own country. Their role as American collaborators made them hated and feared enemies in their own country and, at best, neglected and uncelebrated heroes in ours.

Conquergood's ethnographic practice attempts to capture the voice of others as much as possible. He wants to feature the voice of the shaman and render

him sympathetically. Conquergood follows the tradition of other scholars who produce person-centered ethnographies. The intention is to capture dialogue, the voices of people speaking to one another. In this case, it is Thao's voice that asks to be heard in its own right, not translated into a generalizable category but preserved in its uniqueness.

Conquergood's book, *I Am a Shaman,* opens with an epigraph quoting Xiong Hu, a leader of the Chicago Hmong community. Hu tells about the importance of the shaman in Hmong culture.

> In the beginning there was a bad God who sent the demon of death down to earth to bring misery and sickness. God sent a shaman to earth with "equipment" and he healed the people. The demon of death turned him into a pig and he had to leave, but he left his ritual objects and taught the people how to be a shaman and how to heal. Follow his ways. He was the original healer." (n.p.)

Paja Thao is a Hmong refugee from the mountains of Laos. He fled his farm and escaped from Laos in 1975. He spent eight years in a refugee camp in Thailand before coming to the United States. The narrative recounted above was told to Conquergood in August 1984, within six months of Thao's arrival in the United States. He was about 49 years old, a married man, and the father of 11 children. At the time of the narrative, he was living in the Uptown neighborhood of Chicago.

Thao's account is offered with eloquent simplicity, narrating the calling of the shaman and telling of his important role as a preserver and transmitter of Hmong culture. In portions not included here, Thao sets forth elements of Hmong cosmology and narrates one of the origin myths, telling how the god Saub proclaimed the way of the shaman. According to Thao, he became a shaman not by an act of his own will but because his spirits guided him to this path.

According to Hmong cosmology the body is the site of multiple souls. The body is considered healthy if the "life-souls are centered in the body, cooperating interdependently and living together harmoniously as a group. Sickness is explained by the isolation and separation of one or more of these souls from the community of the body. Disease, depression, and death result from diffusion, dispersal, and loss of souls" (44). The culture of the Hmong celebrates inter-connectedness and community rather than individuality, as in Western culture. The shaman, therefore, is not only performing the rites of soul-calling to restore health to the members of the community; he is also paving the way for a healthy body politic by healing its members.

The cultural beliefs of the Hmong assert the primacy of a spiritual world. Not only is the universe rich in spirits, so, too, is the natural world. The animals in nature are viewed by and large as good, and their spirits commune regularly with more distant spirits. Conquergood reminds his readers that whereas the Western world may label the Hmong "preliterate" and "undeveloped" technologically and "unscientific," thus emphasizing the absences in their culture, the Hmong might equally well look at contemporary American culture and find it deficient, labeling it, as Conquergood states, " 'pre-spiritual' and 'undeveloped' in terms of human relationships" (46).

As you can see from Thao's words, he enters into a trance state, shaking in order to assist in the rite of healing or birthing. Notice that this act of healing, or actually producing fertility, is not simply a rite to cure one woman or assist her in delivery, but he is assuring the health of the community through his important role as an overseer of procreation and a preserver of infant life. His elevated status in the community is, in part, marked by extraordinary capacities that he can execute with his body. When his body enacts the "shaking ceremony," it stands in for the body of other members of the community, and, through a transformative process, assures its and his own health.

The shaman puts on a veil when he enters the shaking state, and from his own report in an earlier segment, he says, "All the shamans see nothing while they wear the veil and shake/When you close your eyes, darkness/When you open your eyes/You see only the smoke of the incense" (6). During this trance state, or out-of-body consciousness, the shaman is able to cross the threshold that separates the physical from the supernatural world, carrying spirits back and forth between the two. His behavior during the trance state has many of the qualities that anthropologists and theologians have described when they write about ecstatic religions, sacred time and space, and liminal ritual activity. The shaman re-creates the culture's myths of the sacred past, investing them with presence during each ritual occurrence. Conquergood, echoing the words of Mircea Eliade in *Myth and Reality,* says that each performance of the shaman offers a breakthrough into the world of the sacred. In Conquergood's words, "whether the sickness abates or lingers, the shaman's real accomplishment in every performance is that she or he *establishes the world*" (*I Am a Shaman* 50).

The procedures Thao follows in the ritual he described are very precisely set down, adhering to a particular order and indicating the many times he enters the "shaking" state in order to create a pathway to permit the baby's spirit in the sky to travel into and be received by the woman, thus enabling her to bear a child. He describes the series of movements he makes—"And then the shaman turns another way/To see if the wife has a bad spirit"—as he executes the ritual of shaking as it has been passed down to him, largely through word of mouth and the practice of other shamans.

Conquergood's analysis of shamanic performances emphasizes the ways in which ritual utterances are actual doings of something, not just sayings. In ritual, many words are invested with transformative power so that the actual speaking of the word makes what it speaks about happen. In ritual, the community is made to believe that it is actually witnessing wondrous events through having them named and presented. Conquergood expands on his explanation of the efficacious power of language—that it does what it speaks—and draws attention to the dramaturgical elements, the staging, of the shamanic performance.

In a recent book Conquergood writes:

> A Hmong shamanic performance is an intricate assemblage of dynam-
> ically orchestrated image and action. Every performance is loaded and
> layered with incandescent palimpsests, multiple exposures, super-
> imposed doublings. The restoration of behavior occurs simultaneously

on at least four levels: Hmong shamans (1) re-present the patient's affliction, (2) reenact their own initiatory crisis, (3) relive the myth of Shee Yee ("*Siv Yis*" in Hmong), the first shaman, in the context of refugee diaspora and relocation in the West, (4) reconstitute their displaced tradition of healing within this contested space of domination and struggle. ("Performance Theory" 44)

Part of the series of ritual acts Thao performs includes speaking to the spirits in order to learn the kind of animal, dog, chicken, or sheep, that must be used to protect the good spirits and the kind that must be sacrificed to drive away the evil ones. He continues to narrate the series of ritual acts he will undertake once the woman becomes pregnant, bears the child, and cares for it during its first three years. As in the other accounts of shamans that we have read, Thao receives payment for his services. He openly talks about the possibility of failure, attributing it to a higher fate. He acknowledges that if he has difficulty in facilitating the first birth, it is likely that subsequent ones also will be difficult or will not occur. His account also shows us the repetitive nature of the ceremony. Parts of it are repeated, with variation, across a number of years. The relationship between the shaman and the husband and wife in this account is marked by trust. He comes to their bed, and the ceremony, involving domesticated animals, is practiced in their home.

CONCLUSION

All the rituals we have examined show how the body of the ritual subject is a site of memory, power, and meaning. The way the body is represented in the ceremony mirrors cultural practices and beliefs, ranging from the religious to ideas about beauty and ugliness, fear and comfort, gender, age, kinship, relationship to the animal world and to the universe, and so on. In part III we devote a chapter to the representation of the body, discussing how it inscribes sex, race, and gender. For now, as performers of some of these rituals, think about how you use your body and what the body conveys in the ceremony.

These rituals employ movement, sometimes extremely agitated movement, and stillness. The ritual subject experiences out-of-body states. The elements of water, fire, air, and earth are placed in intimate relationship to the ritual subject. Objects are invested with magical or supernatural properties and are used as symbols of power, both otherworldly and worldly. Sometimes the healer is naked, drenched in bodily fluids; in other cases, such as voodoo ceremonies, the ritual participants cover their bodies with oils. Pigmentation is applied to the body, and symbolic values are given to different colors. Costumes are worn. Part of the power of the healers derives from their ability to know, to master, the intricate details of the mysteries they enact. Often the healer is not only a charismatic person but also a person of considerable physical prowess.

Shamanic practices enable a community to differentiate people in the social order on the basis of certain abilities, some probably natural, some acquired. These

practices are one of the ways of distributing power and authority, cementing relationships and dependencies among members of a community and providing mechanisms for the expulsion of deviants or their advancement to positions of considerable personal and communal power.

Think about the place of belief in these rituals, belief by both the participants and the practitioners and also by those whose participation takes the form of observation of, rather than performance in, the ceremony. All of our examples show the dynamic processes of ritual and its capacity to negotiate a place for itself, even when some of its symbols and belief systems seem threatened. Several of the accounts reflect deep suspicion of the event on the part of the narrator. In most, we saw that the participants stood in different relationships to what was revealed, some more willing assistants in the rite than others. A characteristic of ritual performance such as shamanic healing is that it provides the community with an explanation of life events, many of them extreme in form such as death and illness, giving the participants a way of understanding them that is compatible with their belief system. Far more important than whether the healer can or cannot cure someone is the fact that he or she can produce an explanation of life experiences that can be believed. It is this explanatory function of ritual, combined with its ability to instill belief through its often awesome manipulation of technique, symbol, mask, visual display, sound, and movement, that affords it the power it contains.

In your class performance you will probably also experience very different levels of belief as you attempt to feel into and incorporate in your body some of the bodily language and speech of these ritual events. Discuss your responses to these materials, exploring in particular the elements that are the most dangerous or the most difficult to approximate and those that are more easily accommodated. There may be considerable disagreements among you about your emotional and cognitive responses to these performances. Keep using these discussions to explore the ways in which the ritual subjects represent themselves through ritual performances and also how your ritualistic expression grows out of facets of today's society.

As performers, talk about the kinds of memory or experiences you called on to help you realize your part. How did movement, costume, patterned speech, and the use of ritual objects help or hinder you as a performer? Were you initially uncomfortable taking on parts in some sense so distant from your own frame of experience? How did you overcome your own feelings of discomfort? What elements in the ritual drew you into the activity? How does dance, rhythmic drumming, sound, costume, and patterned movement help you as a performer? If you attempt to reach an out-of-body experience, either through any of the materials here or in other contexts, can you describe your state of mind and its physical manifestations? How did these rituals manipulate space? If possible, watch the films we cited in this chapter so that you can better appreciate the visual dimensions and the spectacle of these rites as well as the relationships among the participants.

Finally, think about the material in part I concerning the ethical obligations of the ethnographer and the performer of cultural practices. What kinds of ethical

questions were raised in the context of performances in class? Discuss them and their implications. In particular, go back to the question of whether or not we can perform another culture's sacred rituals and discuss your responses to it based on your reading of this chapter and performances in class.

This chapter opened with a description of a social drama and a wedding ceremony, both drawn from cultural performances in contemporary America. We assumed that these two ritualistic events would be more immediately accessible to you because they feature cultural practices that are familiar even if they do not come from your own ethnic background. We moved to rituals as presented in earlier historical times and by people considered to be less advantaged by contemporary mainstream values. Did your encounter with these other ritual subjects, filtered through quite different lenses, assist you in seeing the participants not so much as representatives of other cultures but as unique individuals, grounded in history, representing themselves, and giving voice to something you want to hear and know?

The social dramas and ritual activities considered in this chapter are collective events, but very often we focused on the central performers such as the ritual initiate or the shaman. In the next chapter we will look at more public ceremonies in which performance is widely distributed among many participants, much more so than in the examples in this chapter. We call this last category of cultural performances public ceremonies.

WORKS CITED

Conquergood, Dwight. *Between Two Worlds: The Hmong Shaman in America.* Prod. Dwight Conquergood and Taggart Siegel. Written and narrated by Dwight Conquergood. Siegel Productions, Chicago, 1985, and Third World Newsreel, New York, 1985.

———. *I Am a Shaman: A Hmong Life Story with Ethnographic Commentary.* Southeast Asian Refugee Studies. Occasional Papers 8. Center for Urban and Regional Affairs. Minneapolis: U of Minnesota, 1989.

———. "Performance Theory, Hmong Shamans, and Cultural Politics." *Critical Theory and Performance.* Ed. Janelle G. Reilelt and Joseph R. Roach. Ann Arbor: U of Michigan P, 1992. 41–64.

Eliade, Mircea M. *Myth and Reality.* Trans. W. R. Trask. New York: Harper, 1963.

Evans-Pritchard, E. E. *Witchcraft, Oracles and Magic among the Azande of the Anglo-Egyptian Sudan.* Oxford: Clarendon, 1937.

Gennep, Arnold van. *The Rites of Passage.* 1909. London: Routledge, 1960.

Halifax, Joan. *Shamanic Voices: A Survey of Visionary Narratives.* New York: Dutton, 1979.

Myerhoff, Barbara. *Number Our Days.* New York: Dutton, 1978.

———. *Number Our Days.* Dir. and prod. Lynne Littman. KCET, Community Television of Southern California, Los Angeles, 1977.

Spindler, Louise. "Great Lakes: Menomini." Walker 39–74.

Tedlock, Dennis. *The Spoken Word and the Work of Interpretation.* Philadelphia: U of Pennsylvania P, 1983.

Turner, Victor. *The Forest of Symbols: Aspects of Ndembu Ritual.* Ithaca: Cornell UP, 1967.

———. *The Ritual Process: Structure and Anti-Structure.* Chicago: Aldine, 1969.

————. *From Ritual to Theatre: The Human Seriousness of Play.* New York: Performing Arts Journal Publications, 1982.

Walker, Deward E., Jr. "Introduction." *Witchcraft and Sorcery of the American Native Peoples.* Moscow: U of Idaho P, 1989.

FOR FURTHER READING

Bell, Catherine. *Ritual Theory, Ritual Practice.* Oxford: Oxford UP, 1992.

Benamou, Michel, and C. Caramello. *Performance in Postmodern Culture.* Madison: Coda, 1977.

Conquergood, Dwight. "Health Theatre in a Hmong Refugee Camp." *TDR: Journal of Performance Studies* 32(1988): 174–208.

Douglas, Mary. *Purity and Danger: An Analysis of the Concepts of Pollution and Taboo.* London: Routledge, 1966.

Geertz, Clifford. *Local Knowledge: Further Essays in Interpretive Anthropology.* New York: Basic, 1983.

Hall, Edward T. *Beyond Culture.* New York: Anchor, 1976.

Lévi-Strauss, Claude. *The Savage Mind.* Chicago: U of Chicago P, 1963.

Moore, Sally Falk, and Barbara Myerhoff, eds. *Secular Ritual.* Amsterdam: Van Gorcum, 1977.

Schechner, Richard, and Willa Appel, eds. *By Means of Performance: Intercultural Studies of Theatre and Ritual.* Cambridge: Cambridge UP, 1990.

Taussig, Michael. *Shamanism, Colonialism, and the Wild Man: A Study in Terror and Healing.* Chicago: U of Chicago P, 1987.

Williams, Raymond. *Culture and Society, 1780–1950.* New York: Harper, 1966.

Public Ceremonies:
The Spectacle of the Scaffold,
Mardi Gras, a Bullfight,
and ACT UP and the
AIDS Name Project

Public celebrations, such as a public execution, Mardi Gras, a bullfight, or the making and sharing of the AIDS quilt, take us further along our spectrum of performance to events that are conducted on a large scale, involving numerous performers, dissolving many of the distinctions between performers and audience, and constructing meaning for large communities of people. These ceremonies are situated in time and place and rooted in the historical moment. They communicate ideas, beliefs, and symbols, enabling people to negotiate their relationships with one another and with communal values that are shared to greater and lesser degrees by the various participants. Through these celebrations, cultures commemorate themselves, mark peak periods in the life of the community or in the social life of individuals, and provide an occasion for a celebration of shared values, while also offering ample potential for innovation and, occasionally, revolution. The forces of invention and repetition compete with each other in public ceremonies. You will want to observe these ceremonies, thinking about how the old and the new jostle alongside each other, coexisting in a dynamic interplay that keeps the festivity alive.

Public ceremonies take place in the streets or in indoor places, seemingly presented to the eyes of all. However, we need to remember that the concept of a public space itself must be understood in context. What is public does not mean that everyone participates in it or that participation in it is equal. The idea of public carries with it the ideology of openness and democracy, but often there is competition for control in these so-called public, or open, spaces, and the events that occur in them are subject to multiple and often conflicting interpretations.

These ceremonies are *polyvocal.* Very often there is simultaneously a public explanation of the ceremonies' meaning as well as numerous private explanations, many of which do not conform to the public explanation. These celebrations

involve a complex web of interrelationships. They provide a site for the making of cultural meaning. Again, the meanings conveyed are best understood as processual and emergent rather than fixed. Frequently, the participants in the celebration will only partially understand its larger significance. Many of the forces unleashed in these ceremonies are deeply rooted, psychologically, sociologically, and politically.

In earlier chapters we have usually been able to offer a written description of the performances, including a verbal text as well as an account of some of its performative features. Despite the limitations of these kinds of transcriptions, in most cases they can function as a blueprint for your performances.

In this chapter, we cannot offer you a blueprint of Mardi Gras or a bullfight or the other ceremonies we discuss. If you have participated in these kinds of ceremonies, draw on your memories of them to flesh out our descriptions. Otherwise, rely on written descriptions that you have encountered in the popular press and in books, as well as visual ones on television and film. We will describe some examples of these public ceremonies and focus on certain performance features, such as the traditions of carnival and the use of masks and costumes, to give you an opportunity to reproduce elements of the ceremony in a way that will increase your understanding of it, introduce new styles of performance, and narrow the distance between yourself and the event under study through the act of performance itself.

To *stand in* (take on the part of another as if you were the other) for other people from your own culture and other subcultures through performance is to step into the space that ordinarily separates speaking and performing subjects, partially filling it with your bodily enactment of performances executed by the others. This method of standing-in does not allow you actually to fuse yourself with others, knowing their experience with the same immediacy that they know it. However, it does allow you to employ empathy, nonverbal language, gesture, and the instrumentality of your own body to try to experience partially an order of experience that can otherwise be known only cognitively or by talking about it rather than trying to do it. It also increases your self-reflexivity. Once you have attempted to stand in for other performative selves, the experiences you acquire provide you with material to reflect back on the way in which you knew and understood the external phenomenon before you tried to ''be'' it. You will want to discuss these experiences in class, exploring the ways in which performance can be seen as a kind of bodily knowing.

The French philosopher Michel Foucault, in *Discipline and Punish: The Birth of the Prison,* offers a composite account of a public ceremony, showing how it is a product of a whole system of political, social, and biological factors. He is interested in the ways in which people wield power and the instrumentalities that help them maintain it. His book contrasts the worldview of the Middle Ages with that of the post-Enlightenment. In his analysis of power and how it manifests itself, he compares the public execution under France's *l'ancien régime* of a king-killer, a regicide, to the system of punishment in modern times, in which discipline is enacted not through blows and tortures applied directly to the body of the offender but through a system of observation. This system of surveillance,

complete with prisons; forced labor; fixed regimens of behavior governing dress, exercise, forced work, solitary confinement, and so forth, makes up our present system of penal justice, according to Foucault.

Foucault refers to this system of penal justice as being based on the philosophy of the penitentiary panopticon. The panopticon was a cylindrical architectural structure with a high tower designed in the mid-nineteenth century by Jeremy Bentham. Its design permits all cells to be seen into from a point of observation high in a tower above the many tiers, segmented into cells, that make up the structure. This segmented building enables those who hold power to witness those they imprisoned, controlling utterly all matters of their conduct, not by vicious physical punishments inflicted on the body, but by treating them as animals to be set apart, ordered, and controlled through watching. It is a system that makes everyone subject to it visible, whereas the watcher is invisible, unverifiable, and consequently omnipresent in the mind of the imprisoned.

Foucault argues that this system of penalty is the natural outgrowth of modern economic, sociological, and political forces. The introduction of new systems of government, appropriate to theories of democracy, industrialization, and the redistribution of power, taking it out of the hands of a monarch and placing it in the hands of the people, required new penal systems. Foucault is particularly interested in ways in which the physical body becomes a site of power in society and participates in its own social construction. His book is a rich source of descriptive material on society's ceremonies of power. The scenes of public execution, the training exercises conducted by the modern military, the regimens that govern the conduct of prisoners, all provide examples of human ceremonial occasions that can be analyzed in performative terms. His description of the spectacle of the scaffold offers a useful beginning for our discussion of public ceremonies.

THE SPECTACLE OF THE SCAFFOLD

Today, the public spectacle of punishment in the Western world has almost died out. There is a controversy currently over whether or not the courts should permit executions to be shown on television, but the very fact that this issue is now being raised is proof of the extent to which we have moved away from the practice of public executions that was common in Europe from the Middle Ages to the mid-eighteenth century and the Enlightenment.

Punishment is now largely a hidden process. Foucault argues that it has been replaced by a visual spectacle in the courts, a far more tepid and civilized affair, in which the judge puts on ceremonial robes; the jury of one's peers take their seats dressed in "respectable" but ordinary clothes; and the accused, represented by a lawyer, an officer of the court, sits behind a table, facing the judge, and looking very much like an ordinary person seated at a business meeting. The spectators, or those witnessing the trial, sit in orderly rows, watching passively, forbidden to speak or read by the rules of the court. The courtroom has its ceremonial regalia—the seal of the United States and the U.S. flag—and there is

still a visible display of force by the officers of the court, who bear arms concealed under their uniforms, but the entire display is one that minimizes the accused's physical vulnerability to those who hold power. What is at stake is the conditions under which the accused, if found guilty, will have to live. It is his or her "freedom" that will be taken away, and perhaps even life, but the ceremony does much to mask this reality.

Now look at what Foucault describes as the "gloomy festival of punishment":

On 2 March 1757 Damiens the regicide was condemned 'to make the *amende honorable* [a solemn confession made by the condemned man before the door of a church] before the main door of the Church of Paris', where he was to be 'taken and conveyed in a cart, wearing nothing but a shirt, holding a torch of burning wax weighing two pounds'; then, 'in the said cart, to the Place de Grève, where, on a scaffold that will be erected there, the flesh will be torn from his breasts, arms, thighs and calves with red-hot pincers, his right hand, holding the knife with which he committed the said parricide, burnt with sulphur, and, on those places where the flesh will be torn away, poured molten lead, boiling oil, burning resin, wax and sulphur melted together and then his body drawn and quartered by four horses and his limbs and body consumed by fire, reduced to ashes and his ashes thrown to the winds'. . . .

'Finally he was quartered,' recounts the *Gazette d'Amsterdam* of 1 April 1757. 'This last operation was very long, because the horses used were not accustomed to drawing; consequently, instead of four, six were needed; and when that did not suffice, they were forced, in order to cut off the wretch's thighs, to sever the sinews and hack at the joints . . .

'It is said that, though he was always a great swearer, no blasphemy escaped his lips; but the excessive pain made him utter horrible cries, and he often repeated: "My God, have pity on me! Jesus, help me!" The spectators were all edified by the solicitude of the parish priest of St. Paul's who despite his great age did not spare himself in offering consolation to the patient.'

Bouton, an officer of the watch, left us his account: 'The sulphur was lit, but the flame was so poor that only the top skin of the hand was burnt, and that only slightly. Then the executioner, his sleeves rolled up, took the steel pincers, which had been especially made for the occasion, and which were about a foot and a half long, and pulled first at the calf of the right leg, then at the thigh, and from there at the two fleshy parts of the right arm; then at the breasts. Though a strong, sturdy fellow, this executioner found it so difficult to tear away the pieces of flesh that he set about the same spot two or three times, twisting the pincers as he did so, and what he took away formed at each part a wound about the size of a six-pound crown piece.

'After these tearings with the pincers, Damiens, who cried out profusely, though without swearing, raised his head and looked at

himself; the same executioner dipped an iron spoon in the pot containing the boiling potion, which he poured liberally over each wound. Then the ropes that were to be harnessed to the horses were attached with cords to the patient's body; the horses were then harnessed and placed alongside the arms and legs, one at each limb.

'Monsieur Le Breton, the clerk of the court, went up to the patient several times and asked him if he had anything to say. He said he had not; at each torment, he cried out, as the damned in hell are supposed to cry out, ''Pardon, my God! Pardon, Lord.'' Despite all this pain, he raised his head from time to time and looked at himself boldly. The cords had been tied so tightly by the men who pulled the ends that they caused him indescribable pain. Monsieur Le Breton went up to him again and asked him if he had anything to say; he said no. Several confessors went up to him and spoke to him at length; he willingly kissed the crucifix that was held out to him; he opened his lips and repeated: ''Pardon, Lord.''

'The horses tugged hard, each pulling straight on a limb, each horse held by an executioner. After a quarter of an hour, the same ceremony was repeated and finally, after several attempts, the direction of the horses had to be changed, thus: those at the arms were made to pull towards the head, those at the thighs towards the arms, which broke the arms at the joints. This was repeated several times without success. He raised his head and looked at himself. Two more horses had to be added to those harnessed to the thighs, which made six horses in all. Without success.

'Finally, the executioner, Samson, said to Monsieur Le Breton that there was no way or hope of succeeding, and told him to ask their Lordships if they wished him to have the prisoner cut into pieces. Monsieur Le Breton, who had come down from the town, ordered that renewed efforts be made, and this was done; but the horses gave up and one of those harnessed to the thighs fell to the ground. The confessors returned and spoke to him again. He said to them (I heard him): ''Kiss me, gentlemen.'' The parish priest of St. Paul's did not dare to, so Monsieur de Marsilly slipped under the rope holding the left arm and kissed him on the forehead. The executioners gathered round and Damiens told them not to swear, to carry out their task and that he did not think ill of them; he begged them to pray to God for him, and asked the parish priest of St. Paul's to pray for him at the first mass.

'After two or three attempts, the executioner Samson and he who had used the pincers each drew out a knife from his pocket and cut the body at the thighs instead of severing the legs at the joints; the four horses gave a tug and carried off the two thighs after them, namely, that of the right side first, the other following; then the same was done to the arms, the shoulders, the arm-pits and the four limbs; the flesh had to be cut almost to the bone, the horses pulling hard carried off the right arm first and the other afterwards.

'When the four limbs had been pulled away, the confessors came to speak to him; but his executioner told them that he was dead, though the truth was that I saw the man move, his lower jaw moving from side to side as if he were talking. One of the executioners even said shortly afterwards that when they had lifted the trunk to throw it on the stake, he was still alive. The four limbs were untied from the ropes and thrown on the stake set up in the enclosure in line with the scaffold, then the trunk and the rest were covered with logs and faggots, and fire was put to the straw mixed with this wood.

'. . . In accordance with the decree, the whole was reduced to ashes. The last piece to be found in the embers was still burning at half-past ten in the evening. The pieces of flesh and the trunk had taken about four hours to burn. The officers of whom I was one, as also was my son, and a detachment of archers remained in the square until nearly eleven o'clock.

'There were those who made something of the fact that a dog had lain the day before on the grass where the fire had been, had been chased away several times, and had always returned. But it is not difficult to understand that an animal found this place warmer than elsewhere.' . . . (3–6)

In this grisly and disturbing account woven from historical records, the body of Damiens is visually displayed in the square. Look at the ritual and theatrical elements in this public ceremony. Damiens is tortured, dismembered, assisted by a confessor, killed, burned, and displayed for public viewing. The ceremony is held in a public square and opens with a ceremonial procession, the body, naked but for a shirt, borne by a cart to the site of execution. Before being taken to the site of execution, the condemned man has been forced to make a verbal confession of his crimes before the church doors, in full view of the public. By this means those who control what Foucault calls the ''political technology of the body'' have effectively forced the accused himself to sanction the punishment about to be enacted upon him. Through ritual utterance, Damiens admits his guilt, asking God to grant mercy upon his soul. Foucault argues that a whole system of meanings devolve on this ''soul'' once it is constructed in this manner. It is left to a higher force to judge its fate, thus making the practices of law more acceptable. That is, if we make a mistake with the body, we can fall back on the soul.

The performers in this ceremony include Damiens, the accused king-killer; the executioner; the priests; the clerks of the court; and the spectators. The last bear witness to this spectacle. Their role is to assist in the enforcement of the king's code, which requires the death of Damiens. The public shares responsibility for the act of wrong. Part of this shared guilt takes the form of the cost imposed on the public of having to witness a punishment as harsh as this one. Then, too, the spectators have the potential not only to reinforce the actions of the executioners but also to disrupt them. In reading the accounts, can you point to portions that suggest that the executioners and others assisting in the ceremony are

concerned about the response of the spectators to their acts? Discuss some of this evidence.

The composite account Foucault weaves together carefully enumerates the precise tortures that are to be inflicted on the displayed body of the criminal. The drawing and quartering is supposed to be effected by the horses; only when this method fails can the executioner literally hack the body into pieces. Consequently, we also see how this kind of ceremony has not only elements of visual display—a kind of staging of its own, principal performers, and costume appropriate to the roles that are being enacted—but also a set of ceremonial objects, such as the instruments of torture, the knife Damiens is said to have used to kill the king, and the heavy torch. These ceremonial objects are needed to accomplish the literal objective of killing the accused as well as to exhibit themselves as emblems of power. Most important, the human body itself is displayed almost as an *icon,* reflecting to the society its own social, political, religious, and economic system, which is figuratively written on it. *Icons* are visual representations, or images, of figures. Very often in Eastern Orthodox religions, *icons* show representations of saints or Mary and Jesus. Iconographers study the symbolic meanings behind the icon. Today we use the word, *iconoclast* to describe someone who shatters images or rebels against society's so-called "sacred" ideas. Foucault suggests that the body functions as an icon. In thinking about performance of the body, you will find this concept useful.

Foucault describes the process by which the body reveals the relationships of power:

> If torture was so strongly embedded in legal practice, it was because it revealed truth and showed the operation of power. It assured the articulation of the written on the oral, the secret on the public, the procedure of investigation on the operation of the confession; it made it possible to reproduce the crime on the visible body of the criminal; in the same horror, the crime had to be manifested and annulled. It also made the body of the condemned man the place where the vengeance of the sovereign was applied, the anchoring point for a manifestation of power, an opportunity of affirming the dissymmetry of forces. (55)

In such a public display, it is impossible not to feel the shared horror experienced by the man who must die and those who must inflict the punishment. The law of the time drew clear lines of demarcation between those empowered to enact the king's law and preserve the regal body of the monarch (thought to rule by divine right) and those who stood accused. However, the law had also set in place a live, theatrical ceremony in which error could occur. One of the risks inherent in such ceremonies is that the people will cease to act as audience, reinforcing the law they see enacted, and instead will turn into accusers of those who hold power out of their pity for the accused or outrage at the sheer display of monarchical power exhibited by the public execution. During the French

Revolution executions of this sort were turned against those that practiced them. The revolutionaries destroyed the guillotine.

The spectacle of the scaffold forces the public to confront issues of guilt and shame. What is at stake as the public watches such pain inflicted on a man is the life of that body as much as the life of a spiritual soul believed to reside in the single individual. So much pain is meted out because the crime of the accused is believed to be so dastardly. This system of penal justice uses the symbolism of this ceremony to assert the power of the king. It is a ceremony that uses violence and physical pain in order to eliminate it. It does not shy away from the violence that is involved in punishment, but it does use it as a deterrent to others and, more important, as a way of visibly displaying to the public the enormous power of the monarch.

The protracted nature of the torture fuels the appetite of the spectators. Throughout the prolonged agony, which the spectators watch, moment by moment, cry by cry, the spectators have the opportunity to engage themselves directly in the activity, trying to determine the guilt or innocence of the accused man measured by the exact manner in which he responds to the torture. Numerous accounts of public executions reveal the ghoulish ways in which the crowds hang on to the words and sounds generated by the suffering of the condemned man. The plight of the accused is so extreme that one of the elements that contributes to the spectacle of this ritual is the very ambiguity of the noises emitted by the dying man. Do they show courage, and does this expression of courage suggest innocence? Or are they the sounds of a hardened criminal, deceitful to the core? Gossip and gallows humor thrive during rituals of this kind, further cementing communal relationships and shared values or providing the basis for conflict.

It is because Damiens has been accused of regicide that his punishment is so extreme. He has committed the crime that carries the greatest potential threat to order and to those who hold power, and for this wrong, a system of law has devised the most elaborate instruments of torture and punishment. Foucault analyzes the economic, political, and theological institutions of the time, showing how they shape and are shaped by ideas about the physical properties of the body. In his analysis of penal systems, he is able to show how in modern times "Physical pain, the pain of the body itself, is no longer the constituent element of the penalty. From being an art of unbearable sensations punishment has become an economy of suspended rights" (11).

Consider how this spectacle of the scaffold exemplifies the power and techniques of performance, which make it such a potent instrument of culture. It can also be understood against the background of Western theatrical presentations. Foucault describes classical civilization as one of spectacle. Reflecting on the temples, theaters, and circuses of antiquity, he writes that the problem for the architects and makers of ritual and theater was to enable a multitude of people to inspect and watch a small number of objects. These older forms depended on public life, the intensity of festivals like the Bacchanalia (with its festive orgies and rites in honor of the god of wine), and their sensuous properties. Foucault laments the passing away of these ritual manifestations of spectacular power and expresses his fears about our segmented, individuated, almost bloodless

politics of incarceration. The contemporary dramatist Caryl Churchill attests to the raw theatricality of Foucault's subject in her play *Softcops.*

A number of other scholars whose works we have discussed also worry about the loss of ritual power, magic, mystery, and wonderment in our culture's performances. Think about public ceremonial displays of power that are practiced in American public life. Which ones come to mind? Are you thinking about marches or demonstrations against capital punishment? What kinds of images and symbols are evoked on these occasions? Some of you may be thinking about such ceremonies as the national Democratic and Republican conventions, when our political parties identify their candidates for the highest office in the land; or Martin Luther King's march on Washington, DC, on the eve of civil rights legislation; or the marches and demonstrations during the 1960s, 1970s, and 1980s for peace, the Equal Rights Amendment, Nuclear Disarmament, or pro-life. All of these examples are drawn from the political arena, and all involve deliberate rhetorical strategies to direct the end toward which the ritual strives.

Discuss some of these kinds of public ceremonies, comparing them to the spectacle of the scaffold described above. Consider their theatrical dimensions and their use of ritual. Also consider the relationships among the participants. Are the boundaries between spectators and performers quite pronounced, or are they blurred? What use is made of ritual objects, lighting, costume, props, space, and movement? How are the multitude of bodies involved in such presentations orchestrated or patterned?

Turn now to a consideration of another kind of public ceremony, Mardi Gras. It has all the markings of a tribal ritual: dance, movement, costume, song, chanting, festive eating and drinking, body paint, masks, and a wealth of *olfactory* (refers to the sense of smell) and tactile stimuli. More than any other festivity of mass culture in America today, this ceremony embodies ritual activity of the sort we saw described in the last chapter but on a large scale, involving massive numbers of people.

MARDI GRAS AT NEW ORLEANS

An excellent example of carnival is found in the yearly springtime festivities celebrated in New Orleans. Mardi Gras (meaning ''Fat Tuesday'') actually refers only to the final day of the celebration, which stretches from twelfth night, January 6, to the first day of the Christian religious season of Lent, the Tuesday before Ash Wednesday. The festivities build to a height over the weekend, culminating in parades and gatherings on Fat Tuesday involving tens of thousands of people, decked out in costumes, to share in the several parades that are part of the "grande finale," to use a stage metaphor.

These celebrations have been going on for many hundreds of years. Coming to the New World through the immigration of French Catholic colonialists during the eighteenth century, Mardi Gras has continued to be celebrated annually, marking the transition from winter to spring. It is sufficiently supple and pliable to have changed in many ways since it was first introduced in this country,

negotiating the tensions within the community in this Gulf city in the South, and continuing to be a meaningful and vital ceremony.

The events occurring during Mardi Gras range from the very private to the very public. They also can be analyzed in reference to class and ethnic distinctions. The carnival balls, particularly the Comus (the god of festive mirth, related to Bacchus) ball, are part of the upper-class social season. The organizers of these balls are drawn from the upper-class, white elite, usually restricted to persons of Anglo-French extraction. Jews and Italians, until quite recently, were excluded from membership. Curiously enough, these fashionable, elite balls invite guests not to have them join in the dance but to have them witness a tableau, followed by the entrance of the queen, who is a debutante, and her court. The queen is greeted by the king. There is a grand march and perhaps a ceremonial presentation of last year's queen and certain prominent guests. Members of the krewes (the organizations that sponsor the dance) are masked and serve as male dancers. They dance with only a limited number of invited female guests, who are referred to as *call-outs*. These are the women who are "coming out" during the social season.

The entire ball, from its beginning tableau—which presents a drama of royalty, a court with attendant lords and ladies—to its parade and dance, enforces a strict hierarchical set of relationships. Those holding economic and social power and prestige quite literally "lord" it over the guests, who stand as lowly spectators to the ceremony, paralleling the groundlings in the street outside who come to watch the public displays of floats exhibiting the king and queen of Mardi Gras. At one level Mardi Gras helps define social status, reinforces the power and prestige of the upper class, and maintains its conservative political and cultural agenda. On this public level, the ceremony is very print-centered. It is texted and there is less room for freedom and invention in the representations: the images of high society must look just right.

On another level, played in marginal places, Mardi Gras is an invitation to dream. The kind of play it involves does not ask that you be either this or that; you can be both. At this level, characteristics associated with orally centered culture are prevalent. Innovation and *bricolage,* anthropologist Claude Lévi-Strauss's term for makeshift construction, abound. The participants use all manner of found materials to dress up their costumes. Meanings are not fixed but are relative and must be determined by reference to the circumstances. When you compare the costumes of the elitists in their role taking to the costumes fashioned by the outsiders—blacks, Creoles, Indians, and ordinary whites—this comparison becomes clear. In this double-faced aspect, Mardi Gras exemplifies the kind of dialogic structures, both/and, that Bakhtin describes.

Other neighborhood-based organizations, such as the Zulu Social Aid and Pleasure Club and the Black Indian Tribes, lead their own set of parades and balls in the neighborhoods and "unfashionable" parts of New Orleans. These groups sponsor neighborhood parades that parody the white-dominated carnival traditions. Their parades follow informal routes, moving from bar to bar in the French Quarter, making their own music.

Until very recently the Zulu parade included

numerous stops at saloons and funeral parlours in black neighborhoods. King Zulu and his court would arrive from the river on a barge and there would be rudimentary floats. Zulu members are decked out in ''African'' garb—which includes grass skirts, spears and shields—and their faces are blackened with white makeup used to heighten certain parts of the face, especially the eyes. They also wear long black underwear and black ''woolly wigs.'' For throws they toss (or in recent years hand out) highly sought after coconuts. (De Caro and Ireland 63)

The throwing game is one of the institutions of Mardi Gras. It entails giving coins or trinkets, or *throws,* to the crowd as a gesture of largesse. The Zulu rituals play on and parody the white physical stereotype of blacks and their African ancestry; at the same time they parody the white elite social structure, with its monarchical fantasies of courts, royal power, and generous displays of wealth. The Native American and black ethnic identities are asserted in these festivities, which parallel the mainstream, public face of Mardi Gras, mocking and making ridiculous its sense of social position.

In addition, other excluded groups—including whites who do not belong to the social elite and women who are denied membership in the krewes—simply appropriate the symbols of the groups that hold power, throwing their own balls and mounting their own parades in numerous middle-class suburbs throughout the city. It is this capacity of Mardi Gras to innovate and adapt, to play, which accounts for its presence and success as a thriving form of celebration.

The so-called audience of Mardi Gras is also mixed. The occasion often leads to intimate family reunions, with family members disbursed about the country returning for a host of parties and intimate get-togethers held in the home. It also brings strangers, tourists, to New Orleans. Most of these people have no roots in the community and many have little experience of the cultural richness and diversity displayed during the week. Rather, they come to eat, vacation, party, and witness the parades. And of course, there are the New Orleaners themselves, some of whom try to divorce themselves from the festivities and others who stand as onlookers in a manner not unlike that of the tourist. It is important to note that although we referred to these participants as its ''audience,'' they actually function more as groundlings in Renaissance theater. They are in the pit, in the streets, running after the floats and gathering remnants for souvenirs; barhopping and dancing in the streets; gawking in the streets, sometimes wearing stilts in order to watch the floats. In this kind of ceremony the division between performers and spectators is blurred. In a very real sense all are performing.

The Gulf port cities themselves, Mobile and New Orleans, were frontier cities, facilitating commerce and trade and serving as a site for cultural exchanges between the recently arrived white French colonists and the Amerindian cultures native to the area. New Orleans became a gathering point for slaveholders and slaves, both free and unfree, fleeing from the Caribbean colonies and the black

resistance there from the time of the French Revolution in 1789 onward for nearly another century. In *Carnival, American Style: Mardi Gras at New Orleans and Mobile,* Samuel Kinser argues that "African tribal cultures, however adulterated or suppressed by the old Spanish-French or new Anglo-American slavery, nevertheless found in New Orleans' social miscellany good chances for survival" (xiv).

The annual seasonal festivity displays what Kinser calls "festively feathered human animals." It offers an example of the rites of carnival, in which the world order is reversed and inverted through a series of playful and inventive parades, games, and symbols. Nonetheless, as richly dense as the festival material is in offering the culture a mirror of itself and an opportunity to escape temporarily the pressures of ordinary life, it is also, according to Kinser, a deeply ambivalent ceremony. It has double sites, one representing the public face of the central city at play, the other entering darker, more suppressed realms, enacted alongside the official face of the parade but situated in neighborhoods and more forbidden zones, and reflecting our society's stratification and racial barriers. We should note here that Kinser takes issue with Caro and Ireland's contention that the festivity as a whole fuses the two opposite worldviews it contains.

According to Kinser,

> Playful as it is, richly inventive as it has been, Carnival at New Orleans and Mobile conserves the black-white barriers which can be observed nearly everywhere in American society and which developed with force in the slave society of this southern area's first century and a half of existence. The double role of marginality, inviting and forbidding movement across frontiers, has special meaning in these circumstances, for it is etched in black and white. The rituals all make reference, consciously or unconsciously to race relations. (xix–xx)

De Caro and Ireland argue, "Carnival symbolically mediates between two opposing social ideals: that of kingship, aristocracy and class hierarchy on the one hand; that of equality on the other" (65). They believe that the carnival's atmosphere of goodwill eases the social tensions produced in a city with a history of struggle over political, social, and cultural dominance. Kinser's explanation more fully grasps the conflict embedded in Mardi Gras and its polyvalent nature. The controversy in 1992 over the city's decision to open membership in the krewes to those discriminated against on the basis of sex and race almost caused the cancellation of Mardi Gras. The krewes refused to accommodate the law and finally the city relaxed the law rather than face the economic losses that would have resulted from the cancellation. This episode suggests that Kinser's analysis is more correct.

Kinser's analysis of Mardi Gras operates on three levels: from the perspective of a participant observer, describing ritual behavior in the manner of anthropologists or ethnographers of performance; from the perspective of a sociologist, exploring the connections among economic class, social status, and cultural standards; and from the perspective of a semiologist, analyzing codes and signs

(gestural, visual, and acoustical) to interpret cultural activity. *Semiotics* refers to the study of signs and the relationships between *signifiers* (words, pictorial representations, or acoustical systems) and *signified,* the referents lying outside the system of signs to which the sign refers. Kinser draws on history, sociology, and semiotics to make sense of the complex web of meanings unfolded through this ceremony. Ultimately, he discusses the ways in which Mardi Gras takes on different meanings when interpreted by the people of the neighborhoods, the popular public, the elite groups, and the official organs that govern its representation.

This textbook has not asked you to analyze performative behaviors in terms of semiotics because we do not believe that the expressive behaviors found in these rituals can be systematically analyzed in reference to any system of codes, no matter how complex. The idea of a code assumes that by its use the meaning of any sign becomes completely clear and can be exactly replicated and transmitted. It assumes that a sign can be deciphered and decoded, exhaustively explaining its meaning, with nothing left over. Our experience with the dynamic and expressive aspects of ritual and aesthetic experience make us doubtful that it can be reduced to a science. Nonetheless, the Kinser book on Mardi Gras is an invaluable tool for the student of performance, and we are greatly indebted in this chapter to his enumeration of the rich variety of the festivity and his sociopolitical and historical analysis of it.

Some of you may know about Mardi Gras only through bits you have seen of it on television news or have read about in journalistic reports or novels. Others may have gone to New Orleans during Mardi Gras or participated in other carnivals in the Caribbean, South America, or London. We will examine some of its features, based on Kinser's account, and offer some concepts to explain this kind of public performance ceremony and how it functions. Our other objective is to offer you the experience of performing some of the ritual behavior, including masking and clowning, that is typical of these large-scale public festivities.

Mardi Gras as Carnival

In chapter 3 we discussed Mikhail Bakhtin's concept of carnival in connection with the trickster and folkloric practices. In *Rabelais and His World,* Bakhtin describes carnival as an indispensable component of folk culture, marked by *heteroglossia.* Writing about the boisterous carnivals of the Renaissance and its immediate ancestors, the folk celebrations in the Middle Ages that surrounded ecclesiastical holidays officially sanctioned by the church, Bakhtin discusses the two faces of these celebrations, one official, one unsanctioned and populous. The multivocality entailed in heteroglossia, which we discussed earlier, reveals the dialogic relationships between person and person and the discrepancies between official authority and its constructions of reality and a richer, polyvocal reality that the official ideology suppresses. Bakhtin views the marketplace as a public center for the common people in which subversive behaviors flourish and compete against the official order and ideology, providing a speech that is "free, gay, and frank" (195). It provides a forum in which authoritative structures can be parodied and resisted through popular festive images that are socially

acceptable. Laughter, parody, and satire are the tools of carnival. During some of the historically most restrictive eras, such as the Reformation or Stalinist Russia, those in authority have attempted to censor laughter, fearing its subversive power and banning those writers who used it.

Carnival gives to unofficial cultures, those we have referred to as marginal or lower strata, a mechanism to resist and unmask the authoritarian ideology and word. Bakhtin compares the period of revolutionary fervor in 1530, when the French novelist and physician Rabelais wrote, to the Russian Revolution of his own time. In Rabelais's time, the old medieval order was overthrown and replaced by new Renaissance principles. Rabelais's writings showed the struggle for power between the medieval church and state, with its official governance, and the unofficial, unsanctioned, corrosive behaviors of carnival. In Bakhtin's time, tsarist, authoritarian Russia was toppled by the Communist revolution of 1917 and its attendant restructuring of society, leading up to the Stalinist repressions in the 1930s through World War II. For Bakhtin, both he and Rabelais shared a common project, to use their writings and parodic, dialogic forms to resist authoritative ideologies.

Bakhtin's understanding of the ways of carnival enables him to grasp how a change in the social order can be brought about and how the new can confront the old, playing out the challenge in festival spaces that are uniquely capable of being double-voiced, of simultaneously conveying two often contradictory impulses within the same behaviors. He refers to these spaces as "open," permitting frank exchanges and free expression between people familiar with each other, provided they understand the rhetorical forms and images through which this exchange can take place. The carnival laughter of medieval and early Renaissance lower-strata culture celebrates the wholeness of being in all its ambivalence, utopianism, and antidogmatic character.

Bakhtin vividly describes some of the most typical clowning behavior, with which we are all familiar, showing how it was used by Rabelais to criticize the social order. Let us consider how some of these aspects of folk culture are realized in Mardi Gras. Bakhtin notes that carnival culture runs parallel to forms of official celebrations. The carnival feast of fools contrasts with the high culture's celebrations of kings. Carnival pageantry and language are full of bawdy curses, abuses, and charlatans and mountebanks, as well as the themes of billingsgate, in which disease is closely tied to the lower regions of the body. Feasts, with animal slaughter and dismemberment, exist side by side with images of birth, fertility, and regeneration. Games and fortune-telling abound. Carnival produces a culture in which social differentiation is minimal, and all are permitted to display themselves. People participate side by side, with no one individual featured in the limelight; rather, the performance is of collective identity.

The boundaries that separate people from the world are constantly erased in carnival behaviors. The orifices of the mouth, vagina, and anus become the sites whereby humans engorge and disgorge themselves, devouring the world of which they are a part. Because boundaries are transgressed in so many of the rites of carnival, the visual display and imagery constantly draw attention to these threshold places. Bakhtin describes the grotesque body that is inscribed in carnival:

The grotesque body has no façade, no impenetrable surface, neither has it any expressive features. It represents either the fertile depths or the convexities of procreation and conception. It swallows and generates, gives and takes.

Such a body . . . is never clearly differentiated from the world but is transferred, merged, and fused with it. It contains . . . new unknown spheres. It acquires cosmic dimensions, while the cosmos acquires a bodily nature. Cosmic elements are transformed into the gay form of the body that grows, procreates, and is victorious. (339)

Commenting further on the imagery of carnival and the downward thrust of so much of its movement and gestural language, Bakhtin refers both to the way in which festive movement is directed in literal space and to the metaphorical meaning of an image.

Mardi Gras occurs on a set calendar date, thereby giving a seeming authority to those who set calendars and the law the calendar reflects, whether the law of church or state or the law of nature, revealed in the cyclical pattern of seasons. It is also licensed by those who hold authority, and its parades and festivities are marked as official ceremonies of a festive nature, seemingly suggesting the degree of power that rests in those that set the date. However, as Bakhtin and other scholars note, the actual people who hold power in carnival are the common people and a force resting in them that predates the systems of authority vested in the officials that actually cause them to license the carnival.

You can probably understand this mechanism if you think about the yearly reports of rowdiness, sometimes vandalism and violence, that occur during spring vacation, when college students in droves drive to New Orleans to participate in Mardi Gras or to Fort Lauderdale. Municipal authorities and businesses often discuss banning the festivities, not granting them a license because of the disruption of order they occasion. Nonetheless, the festivities continue to be licensed, in large part because authorities recognize that they must bow to the unbridled forces that are unleashed at this time.

The festivity itself, set at a particular time and typically restricted to a week of heightened activity, allows students and the populace to release themselves from the tensions that college or high school life or work enforce, allowing them to revel and express a set of forces that predate the rise of municipalities. Therefore, it is not so much that these Mardi Gras parades honor the self-serving interests of business communities and civic governments than that they honor an older, more lawless, instinctual impulse of people marginalized in the present system, giving them an opportunity to ventilate their feelings and express their resistance to forces that dominate them. Inherent in such carnivals are revolutionary impulses. In a dynamic way, these ceremonies hold out the possibility of social change while they are also a mechanism that perpetuates the social order.

Numerous parades occur at Mardi Gras. They consist of floats, elaborately decorated and drawn by tractors. The float's visual display is developed around a theme drawn from a fairy tale, fantasy, or history. The official Mardi Gras parade is led by a throne resting atop of the first float, bearing the king of the krewe.

The king, who has been selected by the members of the sponsoring agency, carries a scepter, a symbol of royal authority, and waves to the crowd. Those riding on the floats wear masks, a matter about which we will have more to say. High school and military bands accompany the parade, providing music, pomp, and circumstance. At night, huge traditional torches, called flambeaux, are carried by lower-class blacks to light the central floats. Again, the symbolism is obvious. The lower order serves the aristocratic elite. The aristocracy displays itself in all its glory and largesse, throwing favors to the crowds, the people of lower social orders who are deemed to be privileged just to look at the royalty they serve.

Notice how folkloric elements of the kind we discussed in chapter 3 are utilized in the drama played out on the floats. The very playing field of the drama emphasizes ideas about high and low, royalty and commoners, aristocratic privilege and common life. The floats, mounted on tractors, once were drawn by horses. They move high above the heads of the people. The common people, also performers in this celebration, are for the most part at ground level. Some stand on the balconies of private homes abutting the streets where the parade passes, but there is also a hierarchical symbolism played out at this level. Those tourists and city dwellers able to watch the parade from their balconies, porches, or windows are drawn from the middle class, living in more affluent quarters that enable them to be placed on a higher plane than the floats. Nonetheless, the floats attract the eye, compelling the watchers to look down on them and thus continuing to exercise a kind of dominance.

An important implication of Mardi Gras in the light of Bakhtin's concept of carnival is that it illustrates the ways in which performative behaviors of print cultures differ from those of orally centered cultures. The more print oriented culture seeks a performance style that in its culmination simulates what Kinser calls the Visionary Word. Its highest aspiration is to reach some abstract, mystical height, realized in the visual display of the mystery of the biblical word. Orally oriented cultures, in contrast, are associated with what we will call lower-strata performance, in which the supernatural emerges directly out of "The body's down-flowing, gravity-centered kinetic feel. 'Getting real low': the rock-and-roll dancer and Jerry Lee Lewis offer another formula for the way this culture aims at unifying reality from the bottom up rather than from the head down" (Kinser 171). This bodily mode of invention is best acquired by a performer by immersing oneself in improvisation, considering jazz languages, or kinetically entering into the performance by doing it. Kinser cites how one of the bands that gathered in the neighborhoods during Mardi Gras tried to learn the Indian chants played by another group, the Wild Magnolias. "Willie Lee" Turbinton, the band leader, describes his experience: "They came out and started doing their thing. . . . So we just kind of started jamming. And it was so hip and natural that, you know, when you strike a groove musically with somebody, it's almost like knowing 'em. You pass up the barriers of getting to know somebody" (172).

Can you see how trying to learn some kinds of roles may be better achieved by simply trying to enter into it, picking up its rhythms, imitating its sounds, and seeing where it takes your body, than by trying to observe it, trying to learn the steps and the music? This chapter invites you to engage in some of the

performances you see in this kind of ceremony by simply entering into them kinetically and building out from there.

Try this kind of approach in class, letting the group establish a rhythm and attempt to build it toward a frenetic display, in which members are invited to strut forward and perform, almost as a jazz player would offer a riff, and others are forced to compete. Try to preserve a sensuous, continuous, group-centered flow while you try this exercise. You are primarily interested in developing a call-and-response pattern of the sort prevalent in African cultures. The call may elicit a response in the form of a gesture; a thumping of feet; or a movement of the head, torso, hand, or foot. All the movements of the separate individuals are connected by a tie to a central axis (a collectively determined point), which integrates all the separate movements of the participants into a complex creation of a overriding rhythm.

Observe the kind of rivalries that come into play. Note how tension is built and dispelled. How does this kind of performance control the overflow of kinetic energy it unleashes? Can you see how it could lead to violence? Can you see how the performance you constructed relates to jazz, break-dancing, or gospel preaching? Contrast this kind of performance with the more literate-centered performances that also figure in Mardi Gras. The marching in the parades, the tableaux of Elizabethan court life, and the entering and leave-taking from balls all place you in linear forms of performance quite different from the continuous, circular flow constructed in the above exercise. You will want to discuss these performances once you enact them, looking at them from your perspective as a participant as well as one who observes.

Consider how parts of Mardi Gras have been appropriated by other festival makers in the United States. Many of you surely noticed how the parades at halftime in national football stadiums borrow from Mardi Gras. You should also think about the kind of cross-pollination that occurs between ceremonial occasions. You see Disneyland realizations of make-believe kingdoms afloat in the midst of Mardi Gras; you see them converted into entire Disneyland-type theme parks across the country.

MASKS

The large public ceremonies discussed in this chapter feature masks. Many of the participants disguise themselves by putting on costumes and, in particular, by hiding their faces through the use of a mask or makeup. Masks are often used in rituals, and we could have selected examples in the last chapter to show you how these devices operate. However, masks are even more theatrical and more central in these large display events. They project a visual image in a large space and they enhance the role the performer executes, actually enlarging its dimensions and exaggerating its movements, again in a manner that is appropriate to the spatial dimensions of these ceremonies.

Masks are material objects with very specific textures, materials, tactile properties, color, size, and form. They also function as symbols; that is, they

project a meaning not through what they overtly say but through a set of associations that take us beneath their surface meaning to another complex of meanings. Symbolic meanings derive from the resemblance of the object to other objects related to it; from conventions that relate the object to a set of traditions; and from a set of associations called forth by the object, some collective, some personal. Very often there is a personal significance invested in the choice of the materials from which the mask is made and a personal story. Unless we are familiar with the specific time and place the mask was made, we will probably not be able to understand the ways in which the historical time and indigenous materials contributed to its meaning. Nonetheless, masks also function at a more general level of meaning, which we can grasp. Think about the chain of associations and resemblances that help you unravel the meaning of one of the symbolic elements drawn from either Mardi Gras or from the description of the display of the scaffold.

Generally masks as well as other ritual artifacts function symbolically. These ritual objects are said to be "culturally encoded," with meanings specific to the situation in which they occurred and the people who used them. Common adjectives describing the multifaceted ways in which masks function are *multivocal, multivalent,* and *polysemous.* In other words, they speak in many voices (*polyphonic* is another term), they simultaneously convey different meanings and values, and they are open-ended and susceptible to many explanations of their meaning. To begin to unravel the mask's function as a material object with symbolic meanings, it is necessary not only to know its material makeup, and its maker if possible, but also who wears it, when, and in what position.

Many of you have probably looked at masks from other cultures in archaeological or anthropological museums. Try to remember the rich diversity of masks and their extravagant collage of materials and figures. *Celebration: Studies in Festivity and Ritual,* edited by Victor Turner, contains numerous illustrations of masks and other ritual objects from celebration rites collected by the Smithsonian Institute in Washington, DC. The initiation mask used by the Yaka people in southwestern Zaire shows a woman in childbirth, assisted by a midwife standing behind her. The face of the initiate who wears this mask is also partially covered by a white eye mask. Other masks, many times the actual size of the head, are marked by huge eye openings, protruding and elongated papier-mâché noses, and other features dramatically reshaping the contours of the human face.

Try making masks for yourself. You can use simple or complex materials, but the objective is to fashion two masks, one expressing a public face for yourself, another offering a more private face. Try putting on the mask and improvising a performance that involves speech, movement, and your masks. It may be that you will want your performance to speak the story of the mask; or you may build the performance around some myth with which you are familiar, designing a mask that represents the mythic figures. Or you may want to model one of the masks on one of the figures associated with Mardi Gras, such as the king or queen or pierrot, the clown. In any case, present a solo performance in your mask; then attempt to perform a group ritual in masks. In this case, use masks that connect you in a system of shared beliefs.

What happened to you as a performer in a mask? How did you feel? Can you discuss the differences between your performances when you wore the public and the private masks? Did you find yourself seeking other objects and costumes to make you feel more comfortable in your performance? How did your interactions with the other performers alter when you played a role in a mask? Can you see how the materials out of which you made the mask as well as the personal history you invested in it help account for its meaning?

Masks allow you to act out private fantasies and assume roles that you would not ordinarily permit yourself in life. As one interviewee reported to scholars of Mardi Gras,

> You use the costume as a disguise, so that nobody knows you're John Doe—you're Bozo the Clown, or you're [a] He-Man, and you can take on those characteristics. . . . If you're inhibited, you can flash people on Mardi Gras and nobody knows who you are and you've turned yourself around and become something you have not allowed yourself to do before. It's a good outlet for open expression. (De Caro and Ireland 59)

Another account tells of a masker who played Lucifer in the Devil Band in the Trinidad Carnival:

> "When the moment comes for me to take up that mask, and I take the mask and put it on, I become a different being entirely. I never feel as if I'm human at all. All I see in front of me is devils! Real!" His oversized head mask portrayed a gloating mien, sported small horns, was encircled by a bearded ruff fanning out from the shoulders, and was topped by a crown, while he carried a fork and flapped wings six feet in length. Associated with him in the Devil Band was the Beast, whose dragon's head mask exhibited movable ears, eyes, and tongue, and emitted flames and smoke through its mouth, until the burning of a masquerader's face brought that display to an end. (Dorson 39)

In many cultures in which people frequently disguise themselves, the mask is usually described in relationship to supernatural powers. It may be that in the modern world and even in the public face of the Mardi Gras ceremony, the participants have forgotten or never knew the supernatural properties associated with masks. Nonetheless, the act of putting on masks and pretending to be someone else is an oddly unsettling and often disturbing ritual. Momentarily the masker feels liberated and uninhibited and, often, peculiarly susceptible to fantasy, dreams, or excited behavior.

Much of our own sense of individual identity is related to our physical self, unadorned and adorned. How we look, what we weigh, and how our features appear to us are all very significant in constructing our image of ourselves. We may not be mirror-gazers, although many of us are, but we can see our image reflected back to us in mirrors or on the surface of water or on panes of glass,

and we also see our appearance reflected back to us in how others, particularly those with whom we are very close to emotionally, look at us and respond. The face, and particularly the eyes, is a sensitive register of feeling. We often look at each other because we want to know how we are being responded to, and we can often see this in the faces of others. In short, age, sex, and physical size as well as numerous other physical attributes are intimately involved in people's depictions of themselves. Often in society changes in our status are marked by changes in dress and other changes in appearance. To change the way we look, by putting on makeup, dieting, costuming ourselves, or masking ourselves, we can change the way we behave.

Masks, then, can transform us. Considering the extent to which our sense of private identity is tied to our body, it is not difficult to understand why as important a disguise of our body as a mask can be exhilarating as well as a little frightening. The putting on of a mask and the bodily experience of the mask often provide us with one of the chief ways of coming to know ourselves. When we cover our face, not letting others see it and at the same time showing a different kind of face to others, we derive two immediate advantages. We can fancifully step out of our sense of private identity, escaping those aspects of ourselves that are normally unavoidable, and at the same time we are free to take on the behaviors of the character depicted on our mask. In many of the kinds of ritual ceremonies we are looking at in this chapter, the mask belongs to someone whom the person wearing it could never be. Common people wear the masks of kings. Others put on the face of one of the physical manifestations of a god. You can step into the mask of someone who is dead or lived only in imagination.

Masks have been used for numerous purposes. Aristocratic women wore masks in the courts of England to preserve their complexions, sparing them from the sun and dirt. Masks were worn because they allowed for concealment, enabling the aristocrats to carry out their sexual dalliances in full view of the public. In carnival and other festivals, masks are used to invert the social order. In Brazil's carnival, the slum-dwellers wear the masks of Portuguese royalty and the elite put on the costumes and masks of bandits and prostitutes. Masks can be used to effect cure; they can function to assert the social order. The circumstances that govern the wearing of the mask, who can put it on and when and who can take it off, are connected to the social meaning enforced by masks.

As you experiment with various masks and as you study public celebrations that employ masks, continue to think about how they function as material objects, as symbolic objects, as objects that construct identity and assist in self-discovery, and as kinetic instruments, compelling you to gesture, move, speak, and visually display yourself in different ways.

EFFICACY AND ENTERTAINMENT

A number of scholars of theater and anthropology attempt to distinguish between ritual and theater on the basis of the degree to which actual transformation occurs in the performers, as opposed to the audience. Already, you can see that this

distinction is dubious. In a very real sense much of performance in everyday life blurs the boundaries between participants and audience. Similarly, it is difficult to measure the degree to which an actual rather than a figurative transformation occurs in these two forms. Further, there has not been enough research delving into ritual performance from the perspective of the performers' experiences to know with certainty the kind of belief that does or does not exist during rituals. Richard Schechner has discussed the relationship between ritual and theater that places the elements in a richer interplay with each other.

The view that contrasts ritual and entertainment argues that in Western theater, for the most part, excluding some experimental and avant-garde forms, the audience is passively entertained while the performers undergo the transformation of playing a role. However, in playing a role, the performer knows the difference between the role and life, and therefore the transformation is one put on for an audience, to occasion an act of belief in them, whereas the actors know who they are and who they are not. The audience, however, is asked to believe in the illusion of theater. This is quite different from actually thinking that the illusion *is* reality.

Schechner discusses this distinction in terms of the ratio between efficacy and entertainment in various dramas in everyday life and for the stage. His chart, contrasting efficacy and entertainment, or ritual and theater, shows the ways in which the two actually relate to each other (see Figure 5.1). He argues that whether we call something ritual or theater depends on the context and function of a specific performance and the blend of efficacious versus entertainment elements. Those traits characteristic of efficacy usually accompany events we call ritual. Those that are listed under entertainment are those that we traditionally describe as theater. Nonetheless, Schechner argues that the perspective you take on the event can alter your description of it. A more complete

FIGURE 5.1

SOURCE: Richard Schechner, *Performance Theory: Revised and Expanded Edition,* 120. Copyright 1988, Routledge, Chapman, and Hall, Inc. Reprinted by permission.

Efficacy Ritual	Entertainment Theater
results	fun
link to an absent other	only for those here
symbolic time	emphasis now
performer possessed, in trance	performer knows what s/he's doing
audience participates	audience watches
audience believes	audience appreciates
criticism discouraged	criticism flourishes
collective creativity	individual creativity

analysis suggests that efficacy and entertainment function less as a bipolar pair and more as part of a continuum.

Can you apply the chart to some of the ritual behaviors we looked at in earlier chapters? Particularly, think about how the elements line themselves up in a shamanic performance? Now think about the ways in which they mingle across the categories in the group-concocted narrative of the 104-year-old "witch." In the shamanic narrative or the unfolding of the social drama, can you see in what ways the audience is invited to "believe" rather than "appreciate" the ritual? Consider also the different perspectives on time in the liminal space of the ritual as opposed to the present time of a staging of *Macbeth*.

We can also try to distribute these elements in an analysis of public cere-monies. Can you see how the ritual elements of Mardi Gras will gain more influence if we look at the neighborhood, parallel, improvisational courts, games, and wildmen rather than the officially sanctioned parades in the fashionable quarters of New Orleans? In the neighborhood performances we see the carni-valesque face of Mardi Gras. Meaning is more emergent, and a both/and reality of orally centered culture is clustered. However, if you think about the way Mardi Gras is presented on television and through officially sanctioned accounts in the mass media, the event takes on more of the elements of entertainment. In the latter case, the audience does not believe that the performers are possessed or in trance; rather they believe the illusion of possession or trance. If you were actually to be caught up yourself in the frenzied rite, you might more appropriately talk of yourself as having been possessed, intoxicated, or transformed into another state.

Let us look at another example of a public ceremony—this time a bullfight—to understand how the elements of efficacy and entertainment mingle. We have deliberately chosen a ceremony that is banned in the United States and one that invests its central moment with emotions of high seriousness, almost religious in character. This example, more than the other two, permits us to inquire into the ways in which performers and audience are and are not transfigured in the moment the bull is killed.

DEATH IN THE AFTERNOON: A BULLFIGHT

The bullfight (corrida de toros) is another public ceremony enacted in public spaces (plaza de toros) but more transformative than either of the two ceremonies we have studied: execution and Mardi Gras. The bullfight demonstrates the ways in which the elements of ritual and theater mingle within the same overarching performative event. Hemingway defines the bullfight: "The bullfight is not a sport in the Anglo-Saxon sense of the word, that is, it is not an equal contest or an attempt at an equal contest between a bull and a man. Rather it is a tragedy; the death of the bull, which is played, more or less well, by the bull and the man involved and in which there is danger for the man but certain death for the animal" (16).

Ernest Hemingway, the American expatriate novelist and journalist, wrote about the bullfight in the 1930s as an *aficionado* of the ritual. The aficionado

is a lover of the bullfight who sees it as a ceremony involving a sense of tragedy and the ritual of a fight. In this context, the killing of the horses in the ring, a practice considered brutal by many, is unimportant against the backdrop of the drama. You may want to consider how you would approach the festival of the bullfight were you its ethnographer today.

In his novel *The Sun Also Rises,* Hemingway presents the bullfight as the only "pure" moment in an otherwise decadent civilization. It acts as a moment of test and moment of truth in the novel. In *Death in the Afternoon,* Hemingway writes as an American journalist, acquainting Americans with the traditions of the Spanish bullfight. Hemingway studied the bullfight for more than seven years, witnessing the killing of as many as 1,500 bulls, according to him. We are drawing on Hemingway's text for our example because it offers an excellent analysis of many of the meanings of the ritual; at the same time, it does so from the perspective of a writer hungry for meaning, looking at the rite with romantic longings; hoping to understand a ritual that knows and defines courage, life, and death; and giving them a dignity that the slaughter in the killing fields of modern World War I did not confer.

He studied the bullfight because he wanted to know death, look it in the eye, and account for how an act has consequences. He wanted to learn to understand "the real thing, the sequence of motion and fact which made the emotion and which would be valid in a year or in ten years or, with luck and if you stated it purely enough, always . . ." (2). He thought the only place he could actually see life and death, violent death, once the war was over was in the bullring, and so he went to Spain to see the fights and write about them.

Hemingway is part of the "lost generation." He sees in the bullfight some of the values that are lost and needed. He uses a metaphor from drama to describe it. For him, the bullfight is a *tragedy* centered in the bull and in the man; everything else is incidental. He is using tragedy in an Aristotelian sense, referring to a drama of high seriousness, involving death and bringing about a *catharsis,* a purging of the emotions of pity and fear, in the spectators. You will want to contextualize this description, recognizing that it is a part of a tradition that longs for ritual experience, mystification, and transformation, feeling a deep dissatisfaction with the absence of such rituals in Western life. It also involves a very masculine fantasy, extolling physical prowess and reveling in blood lust. Some of the other scholars whom we have been citing, Turner and Schechner, to name two, join their voices in the lament for the loss of ritual in the modern Western world. We hope this example of the bullfight will assist you in understanding the imaginative representation of ritual that figures in much present-day thinking.

The bullfights Hemingway describes take place in Spain in the month of August. We stated earlier that public ceremonies are presented in public spaces. The structure of these designated places and the rules that govern them are contextual features that shape our understanding of the ceremony. In the bullfight, the public space it dominates is the entire city, reaching out to the roadways that bring tourists and outsiders into town for the occasion. Its most "sacred space" is the circular bullring, but it covers a much broader terrain. During the bullfight season, the streets of the towns are redefined by the civic authorities, who

cooperate with the organizers of the bullfight. Streets are marked off, and ordinary traffic is interrupted to accommodate the crowds that come to Pamplona or other towns and cities for this occasion.

The seasonal calendar as well as a *diurnal* (activities that take place daily) calendar establish the temporal space occupied by the fight. The bullfights coincide with national religious festivals, opening during the festivities of the saints' day of the town. In this respect, the bullfight can be compared with Mardi Gras. Bullfights occur annually, beginning on Easter Sunday and continuing through November. The fight itself occurs late on Sunday afternoons, with the time of the killing set at 5 or 5:30 P.M., when the ring is half in shadow, half in light, a liminal zone optimal for the enactment of the ritual transformations, involving death, that are played out in this festivity.

The bullfighter first sees the bulls early in the afternoon of the fight during the *apartado,* when the bulls are sorted and brought to the pens they will be kept in until they actually enter the bullring. This activity generally involves only the matadors, the bullring management, the authorities, and a few friends. The number of spectators of this part of the event is kept down by setting prices high. The owners of the bulls fear that the bulls may become overexcited by the crowd at this time and so fight less well later. This time of selection serves as a "warm-up," or part of the rehearsal process for the actual public performance in the amphitheater. The world of the bullfight is a temporary world, a world that interrupts the ordinary time and space of everyday life, interjecting an alternative world contained in its own kind of spaces and times and with its own set of special rules.

The ritual of the bullfight is a kind of cultural play in which fundamental values about life and death and dignity are asserted. It has been related to the gladiatorial combats of the Romans. The ritual, as the other rituals we have looked at, involves repetition (tradition) and innovation. The precise rules that govern the running of the bulls, the costuming of the matador, the placing of the banderillas (3-foot wooden shafts with harpoon-pointed ends), the movements of the veronica and the scarlet muleta (capes), and the killing of the bull are passed on by those knowledgeable and experienced in the art of the bullfight. Part of the danger of the fight grows out of the inherent tension between a rule-prescribed activity and the lawless element of chance, which together with art and skill determines who is victor, the fighter or the bull. Many activities, such as the sorting, running of the bulls, and general carousing, all lead up to the fight itself. Within the ring, the ceremony is opened by the president, who is greeted with trumpet fanfares and men mounted on horseback, dressed in the garb of the time of Philip II. This opening trumpetry is followed by the parade (*paseo*) of the bullfighters. Finally, upon a wave of the president's hand, the gate is opened that admits the bull, and the fight begins.

At one level the bullfight can be seen as a terrifying game in which the risks are of the extreme kind that mortals can know. The principal players must adhere to the rules as they compete in a rite that tests their prowess; courage; tenacity; and in the case of the man, qualities of fair play. The fight is also a test of something spiritual, beyond the physical. The death of the animal body is part of the rite

(either the matador's or the bull's), but equally important are the ideas the ceremony constructs about the "spirit" of both the man and the animal. At the same time, the ritual tries to contain the forces it unleashes.

The spectators play an active role in this cultural game of bullfight. Among their many roles is that of adjudicator. Some members become expert in the rules, watching for "false moves" or "false plays" and booing the matador if he breaks the rules or evades them, risking less of himself than is expected if he is to be judged worthy of the game and the attention of the spectator. According to Hemingway, the true *aficionado* does not want to see a bullfight in which the horse wears protective covering, concealing the wounds. Rather, they prefer "to see the horses with no protection worn so that all the wounds may be seen and death given rather than suffering caused by something designed to allow the horses to suffer while their suffering is spared the spectator" (12).

The bullfighter is assisted in the ring by five or six men. Three are on foot and place the banderillas; two, the picadors, are on horseback. Just as in our example of the public execution, the spectacle of the bullfight itself makes room for responses from the viewers, even such responses as total disruption of the event. To understand this rite, we must also look at it from the perspective of the audience as participant. In this regard, the distinction between whether the bullfight is "ritual," and therefore efficacious, or "entertainment," and therefore theater, becomes more complex.

There are different kinds of spectators to this festival. The rite also functions as a "test" of the audience's mettle, character, and courage. In the United States the bullfight is against the law. The public view of the fight is that it is barbaric and cruel. Here, there is no audience or spectator for the event. Without a communally shared system of beliefs that can sustain the bullfight, the ceremony cannot take place. Hemingway has much to say about this subject. We ban the bullfight, and in most parts of this country dog-fighting and cock-fighting are also banned, although they frequently take place. However, we do not ban the boxing match, in which two humans are pitted against each other for the purpose of knocking one of them unconscious. Death can occur in the boxing ring, as can permanent brain damage.

The American public can watch Muhammed Ali on television talk shows and see the brutal results of the hammering he took. Once the boxing champion of the world, a specimen of physical fitness taken to near perfection, now the man's movements are slow and his speech is blurred and rambling. But the American dream of success, the Horatio Alger story, is still sufficiently powerful to motivate the public to justify the fierceness of the physical combat, seeing it as a way out for disadvantaged minorities, with only their fists to carry them to a different social level. And other explanations obtain. The appetite for a fight, a real one, no punches barred, continues to grow in our society, where so much of our behavior is ordered and regulated. A rite such as a boxing match is one of the few places that legitimizes feelings of hostility, focusing them and giving them an outlet. We can cheer our heroes and boo the losers without loss to ourselves.

An analysis of social attitudes and beliefs helps us to understand why a bullfight is too cruel to convert into sport and yet a human fight is not. Both

are blood sports, but with important differences. Part of the differences lie in economic factors and the class structure, whether the society is agrarian or industrialized. Both involve culturally constructed ideas about competition and fair competition. What appetites draw the public to these two kinds of events? To answer, you need to analyze the composition of the audience, on the basis of money, class, expertise in the act being performed, gender, and other factors. All will help you understand the kind of social interactions encouraged by the festivity and why it flourishes or disappears. Think also about the belief system or worldview that underlies these two kinds of festivities. How do they contribute to the ways in which the rules are structured and the performers are "coached" to execute their roles?

Look finally at the performances enacted by the principals in the rite. Hemingway describes the kind of ultimate moment in the bullring, when bull and matador are nearly matched, both in superb physical condition, both examples of courage, and both expert and experienced in the struggle. In these cases, Hemingway talks of the "genius" and "artistry" of the matador. He describes one such matador, a man known to be erratic and capable of cowardice if the bull is one in whom he has no confidence and yet one who can reach supreme heights.

> [Then he] can do things which all bullfighters do in a way they have never been done before and sometimes standing absolutely straight with his feet still, planted as though he were a tree, with the arrogance and grace that gypsies have and of which all other arrogance and grace seems an imitation, moves the cape spread full as the pulling jib of a yacht before the bull's muzzle so slowly that the art of bullfighting, which is only kept from being one of the major arts because it is impermanent, in the arrogant slowness of his veronicas becomes, for the seeming minutes that they endure, permanent. That is the worst sort of flowery writing, but it is necessary to try to give the feeling, and to some one who has never seen it a simple statement of the method does not convey the feeling. Any one who has seen bullfights can skip such flowerishness and read the facts which are much more difficult to isolate and state. The fact is that the gypsy, Cagancho, can sometimes, through the marvellous wrists that he has, perform the usual movements of bullfighting so slowly that they become, to old-time bullfighting, as the slow motion picture is to the ordinary motion picture. It is as though a diver could control his speed in the air and prolong the vision of a swan dive, which is a jerk in actual life, although in photographs it seems a long glide, to make it a long glide like the dives and leaps we sometimes take in dreams. Other bullfighters who have or have had this ability with their wrists are Juan Belmonte and, occasionally with the cape, Enrique Torres and Felix Rodriquez. (13–14)

This passage is interesting in the way in which Hemingway adopts two styles, one for the inexperienced spectator of the bullfight, the other for the aficionado.

This choice shows us the polyvalent and polyphonic nature of the voices that make up the spectators. Hemingway is addressing an audience of readers, but he is also reflecting, here and elsewhere in the book, on the different kinds of people that come to bullfights and the different ways the bullfight is orchestrated by those who produce and promote it. If we return now to the distinction between efficacy and entertainment, we can see how these different elements of the audience receive and contribute to the bullfight in different ways.

The inexperienced audience member is one kind of person who must be incorporated in this public ceremony if it is to succeed. It occurs on Spanish soil and it grows out of lengthy performance traditions of the Spaniards, going back perhaps to Roman games. However, many who see it are not practiced in its rituals. They do not want to see too much suffering or blood. The artifice of the display needs to convince some of the spectators that the matador is skilled at sleight-of-hand movements that will spare him any real risk. Likewise, some spectators will believe that the bull has already lived a long life and that it is not really cruel to kill it. Promoters and bullfighters who have become jaded by the commercial motives of the fight may well sacrifice elements of the so-called art of the ritual for easy thrills and entertainment. Hemingway describes these kinds of bullfights and corrupted matadors at length, but he also knows the importance of those elements of the ceremony that are unpredictable as well as those kinds of art that, when achieved, make the aficionado marvel at the purity of the form.

In our discussion of public ceremonies we have discussed the ways in which ritual behaviors are at once both rule-governed and also a product of the spirit of play and improvisation. In the passage quoted previously, you see evidence of the degree of adeptness the bullfighter has with his ritual objects, the veronica and the sword. You probably all have seen photographs or pictures of bullfighters and the ring, showing the gorgeous wealth of color and spectacle, from the dress of the matador and the garlands that bedeck the bull to the decorations all about the bullring and the corridor leading to it. These elements also contribute to the atmosphere of the ritual, creating a climate likely to produce belief in a mystical moment of perfection, achieved when matador and bull are one, caught in the throes of the bull's dying.

For those who achieve this level of belief, this is a pure example of ritual when it is defined as being efficacious. The killing of the bull, in this perfect moment, manifests the actual transformation of man and bull into something more than a mortal whose life is at risk and an animal that is being killed. Hemingway describes this moment: "The beauty of the moment of killing is that flash when man and bull form one figure as the sword goes all the way in, the man leaning after it, death uniting the two figures in the emotional, aesthetic and artistic climax of the fight" (247). The two transcend their material boundaries and express something indestructible about the nature of life and death. At the moment when the bullfighter becomes more than an ordinary man and the bull more than an animal, the actual act has transformed them in an efficacious manner. It has also transformed the spectator who participates at this level of belief in the rite. The spectator, too, feels exquisite tragedy at the sight of such extreme circumstances and leaves still under the spell of the joy felt at the moment of perfection.

It probably sounds as if we, like Hemingway, have fallen under the romantic spell of the bullfight, caught up in its lore and investing it with a quasi-religious set of meanings. These meanings are appropriate to "sacred" or "holy" spaces and the stuff of ritual sacrifice read about in Western plays and other places. We are describing this moment in this way because it appears that for the aficionado it attains this emotional and mystical intensity and is accompanied by a kind of belief that accompanies faith. At this level, the performance of the principals is more accurately described as being efficacious than entertaining. It is worth noting that the matador is trained through years of experience and testing in order to achieve the level of mastery demanded if the killing is to rise to the heights we are describing. Can you see how the patterning of every movement; the use of color; the excitement generated by enacting this rite in a large public space, confined within a circle and watched over by sun and crowds; and the presence of liquor, song, tale-telling, and communal bar crawling, all contribute to the effect? It also sounds, as you read Hemingway's accounts and listen to the reports of various bullfighters, that they overreach even their own desire for perfection in certain moments acted out at the heart of this ceremony. Here again, as in Mardi Gras and the scene of the execution, the intensity of the drama and the expansiveness of the ritual are important elements in creating the appearance of belief. It also appears that the believers are actively caught up in the festival. Many say they have been changed by it.

Others at the bullfight are not prepared to enter into it fully, giving themselves over to its potentially transforming power. These are the spectators who attend the festivity largely to be entertained. They are not familiar with the lore of the rite. For them, the veronica is a cape; it is not a replication of St. Veronica's napkin, the napkin she used to wipe the brow of Christ, bearing the cross to Calvary. They do not recognize that the bullfighter holds this cape with his two fingers at the corners in the same manner as the iconic representations of St. Veronica and her handkerchief. Once these ritual objects lose some of their specific and contingent meanings, their ability to effect a transformation, to act as "magical words"—when the mere saying of them or sight of them produces what they represent—no longer obtains. As in the case of Mardi Gras, the actual performance is multilayered and multivoiced, carrying with it many different levels of belief and commitment. The different views excited by the performance rub up against one another, enriching its meaning, generating new stories and new lore, producing some innovations in the ceremony, and assisting in its survival as a viable form. The ceremony provides a site for conflict while at the same time offering stability.

AIDS AND PUBLIC CEREMONIES:
ACT UP AND THE NAMES PROJECT

We will conclude our consideration of the public ceremony with responses to one of the most devastating and controversial of current issues, the AIDS crisis. AIDS not only has ravaged the bodies of thousands and thousands of people all

over the planet, but has also been devastating for various cultures, psychologically and politically. For example, studies have demonstrated an upsurge in violence against gay men and women since the beginning of the AIDS crisis. Certain kinds of racist jokes have become popular again. Many would argue that there is a double-edged tragedy here: because AIDS initially emerged in America among traditionally oppressed populations (i.e., gay men and people of color), larger institutions (such as the federal government) have not uniformly been as quick to respond in helpful ways to the crisis; similarly, because AIDS has understandably been the source of so much fear and suspicion, it has been the excuse for the return of violent homophobic and racist attitudes and behaviors.

The responses of the groups initially most affected by AIDS have been varied, reflecting the diversity of the ideologies, goals, and temperaments of the people. Two particular responses are especially relevant to the study of public ceremony: ACT UP and the NAMES Project. Although they are not affiliated organizationally, their membership overlaps to a certain extent. Both organizations use public ceremony as a way of raising consciousness and moving people to social change, but their tactics are quite different.

ACT UP, which stands for AIDS Coalition to Unleash Power, began in New York City in 1987. It began as and remains a politically radical coalition of people representing different populations and interests and committed to acts of civil disobedience and public intervention designed to dislodge what they see as the status quo's racist, sexist, and homophobic indifference to the AIDS crisis. One of the founders of ACT UP was Larry Kramer, a gay activist and writer, whose play *The Normal Heart* was a commercially successful indictment of the social response to AIDS.

ACT UP has used what might be termed a "guerilla theater" approach to civil disobedience, and it is no accident that many of its members are also in the forefront of the avant-garde in the visual arts, performance art, and writing. Many of their more public displays involve what are termed "interventions," attempts to "correct" what they see as oppressive, inaccurate, and reactionary statements about AIDS and about the various groups of people affected by it. For example, you may be familiar with the logo SILENCE = DEATH. This symbol began to appear all over New York City, on subways, buildings, and posters, as a way of intervening in the sometimes anonymous city landscape. The distinctive pink triangle made the the image stand out, and it carries historical and revolutionary significance. The pink triangle was the badge gay men were forced to wear in Nazi concentration camps. The use of it by ACT UP is a statement by them that AIDS is also a form of genocide, as was the Holocaust; at the same time, the pink triangle had been adopted by many gay activists as a symbol of pride and triumph over oppression. Its use as a central symbol of the struggle against AIDS widens the scope of its meaning: to wear it is not necessarily to announce one's sexuality; rather, it is now a way of announcing solidarity with and commitment to the fight against AIDS. In more recent years, the ACT UP logo has been produced in the form of peel-off stickers, which people have used to "intervene" in public places. For example, these stickers have been used to "critique" posters and advertisements that may be seen as promoting unsafe sex or "politically incorrect" ideologies.

In addition, many ACT UP members, both as individuals and collectively, have created visual and verbal installations, works of art displayed both in art galleries and in less aestheticized environments. These assemblages often involve the appropriation and recontextualization of public documents, statements, and artifacts, such as statements by Jesse Helms, Jerry Falwell, and William F. Buckley, conservative public figures whose antigay remarks were, by their recontextualization, deconstructed in the 1987 display "Let the Record Show . . ." presented at New York City's New Museum of Contemporary Art.

The size of ACT UP's membership has grown dramatically, and the organization has used its numbers to produce some powerful and controversial public ceremonies, ceremonies that carry so much performative weight that ACT UP was awarded an Obie a few years ago, an award given for off-Broadway achievement in performance. For example, ACT UP frequently stages "die-ins," eerie and painful representations of large groups of people pretending to be corpses in public places, places usually considered inappropriate sites for death and destruction. One example of such a site is the National Institutes of Health in Maryland, where much of the most institutionalized AIDS research is carried out. In protest of what ACT UP sees as elitist protocols in the testing of experimental drugs (i.e., that typically only white males have had access to such drug programs, ostensibly in the name of "pure" medical research), ACT UP staged a day of civil disobedience there.

Another, even more controversial act of civil disobedience was ACT UP's intervention (along with Wham!, Women's Health Action Mobilization) during a mass being served in St. Patrick's Cathedral in New York City. St. Patrick's, on New York's busy and affluent Fifth Avenue, is a particularly sensitive site for ACT UP's interventionist approach to civil disobedience. The Catholic church has traditionally held a public position that opposes homosexuality and any form of birth control other than abstention. John J. O'Connor, the cardinal who serves at St. Patrick's, has been a vocal opponent of any sex education and AIDS education in the New York City public schools that involves condom use. ACT UP has named O'Connor as one of the individuals they consider most responsible for the continued growth of AIDS among teenagers, poor people, and women. The teachings of the Catholic church forbid condom use for any reason (because it precludes procreation, which Catholic dogma says is the sole reason for sexual intercourse).

On a Sunday morning in December 1989, a group of over 4,000 protesters gathered outside St. Patrick's Cathedral to disturb vocally the mass being served inside. The number of protesters was itself a major statement; in addition, their placards and chants served to intervene with the service, to provide a counter ceremony to the one going on inside. ACT UP's ceremony was clearly designed to disturb the people worshipping inside the church, challenging them not to follow the prescribed ritual and the ideology underpinning it. However, ACT UP's demonstration went further than originally planned, and a handful of protesters (43 were finally arrested) entered the church and physically upset the service, including overturning the Host, the wafer that takes the place of the body of Christ in Christian communion. Although even among ACT UP members this final, extreme act of intervention remains controversial (some members claim that it

was acceptable, given the seriousness of the need to raise people's consciousness about the AIDS crisis), in general it seems that both the majority of ACT UP members and the popular press and general population feel that the actual act of disrupting and stopping the service went too far.

Stop and think about this issue for a minute. What do you think? When does a public ceremony of a revolutionary nature go too far? What is implied here is that public ceremony is fine as an instrument of radical social change only to the point at which it disrupts and impedes other public ceremonies. Is this so? Perhaps also adding to the complexity is the notion of contested space. St. Patrick's Cathedral, because it is a Catholic church, is not, strictly speaking, a public space; at the same time, O'Connor has used his position to attempt to influence public policies (as, indeed, is the right of all individuals): in some sense, the intervention at St. Patrick's may be seen as a questioning of the lines of division between public and private discourse and of the separation of church and state.

ACT UP's approach to public ceremony as a mode of social action remains controversial. Not the least of the controversy is the effectiveness of their approach in accomplishing their goals. To some more moderate sensibilities, such radical, even shocking tactics act to close minds rather than open them. To others, the need to shock, although in the short run upsetting and offensive, is part of the larger social process of change. If we see polyvocality as at the heart of much public ceremony, how do we regard ACT UP? Does ACT UP call for an opening of dialogue through its interventionist performances, or does it shut down dialogue through offense and the assumption of a set of ideologies as "politically correct"? This remains an open and much-debated question.

The NAMES Project has taken a more singular project as its goal, though a project with wide-ranging implications and involvements. In 1985, at a candlelight march commemorating the murder of San Francisco Mayor George Moscone and openly gay Supervisor Harvey Milk, Cleve Jones, a gay activist, was struck by the power of placards listing the names of those people who had died of AIDS (Ruskin 9). Soon thereafter he and a friend, Mike Smith, came up with the idea of establishing an ongoing memorial to those who had died in the epidemic, a memorial that would continue to grow, marking the epidemic's growth through time. This idea eventually became the NAMES Project, more commonly known as the AIDS quilt.

The tradition of the quilt as a public performance goes back decades, even centuries. The quilt as a form is particularly important to women's culture and is a place for women to work creatively and collaboratively. In our own country, the quilting circle was a popular way for women to socialize and to produce something of material and cultural value. In small towns, women from various generations and families would gather to stitch together designs, stories, and experiences on the canvas of the quilt. As is true with all collaborative art, the final product was something inclusive of but also larger than the work of the individuals. Each woman would leave her distinctive mark on the quilt, even if only in her specific way of stitching; yet there were consistency and coherence in the final object. Quite obviously, there were also products beyond the material as well: community, accomplishment, and solidarity. A quilt could become a site of at least

temporary harmony and reconciliation, a place where people's disagreements, their private wars, might be put aside in the name of something larger.

For these reasons, the quilt is an appropriate art form for the commemoration of those people who have died of AIDS. Though it began less with the strict goal of collaborative work, it has evolved into an activity that is extraordinarily collective and polyvocal. On the largest scale, the AIDS quilt stitches together the somewhat disparate lives and personalities of those people who have died of AIDS. To see the quilt in its "entirety" (which is a contradiction, as new panels continue to be contributed) is to be overwhelmed not only at its size but also at its diversity. Grandmothers are next to infants; drag queens, next to movie stars. There is something egalitarian about the quilt's scope and about its refusal to promote a style or quality of craft: the starkest, simplest panel rests next to the most glittery, sequined one, and the viewer is struck by the authenticity and power of each.

The production of the quilt panels is also a polyvocal, collective act. Various accounts testify to the diversity of processes involved in the designing and construction of individual panels. In some cases, an individual (often a surviving partner, parent, sibling, or close friend) makes a panel alone. More frequently, a number of different individuals, all close to the deceased in different ways, gather together and design and build the panel together. In some cases, the process is one of reconciliation of different aspects of the deceased person's life, a reconciliation that in some cases tragically did not occur during his or her lifetime. Because AIDS is an epidemic involving homophobia, sexism, and racism as well as a baffling virus, the healing effect for those who survive of working on the quilt can be immense. And in some cases, several panels are made for the same individual, each one reflecting a different person's perspective on the deceased. To what extent does the quilt thus function in ways parallel to the mask?

Display of the quilt has varied over the period of its evolution. When it was of a size that could feasibly be displayed as a whole, it nonetheless required large, often outdoor environments. The lawn outside the Capitol in Washington, DC, Central Park in New York City, and Navy Pier in Chicago are only a few of the large arenas in which is has been displayed. The fact that each of these sites is a public, sometimes politicized place adds to the sense of ceremony by providing a social, even rhetorical dimension to its display and to its messages. Moving through the quilt, negotiating it in all its minute detail and conceiving it in its almost global dimensions, involves the viewer in performative acts, acts that both consolidate the epidemic as a loss of tragic proportions and also intensify the sense of the loss of each individual voice, each individual life story.

In addition, the organizers have devised ways of involving the viewers in more overt participation and performance. For example, at some showings of the quilt, a blank panel has been provided for viewers to write a message, perhaps in memory of someone they have lost to the crisis or more generally in response to viewing the quilt. Another tradition that has developed is the reading of the names of people who have died of AIDS. Frequently the reading features the names of local or regional people who have died, often read by their families, friends, and lovers. Thus, the effect is both extraordinarily public and at the same time intensely private.

Other groups have used more extensive performances of literary and personal texts around the quilt. For example, members of the Speech Communication Association gathered at that group's annual conference with panels designed for members who have died; various people attending the memorial service performed literary and personal texts, sometimes about AIDS, sometimes selections that carried other, specific meaning either for the performer or for the person being memorialized. In a number of communities, December 1, World AIDS Day, has become a time and a place for performance that, in the spirit of the quilt, draws together those who are living with AIDS and those whose lives have been affected by it (at some level, all of us) for speeches, prayers, and performances commemorating individual and collective loss.

Let us look at just one panel to see the ways in which its design, construction, and display are highly individualized yet part of a larger, public ceremony. The excerpt is from *The Quilt: Stories from the NAMES Project,* written by Cindy Ruskin: it is one of literally hundreds of stories in that volume. Turn to the appendix and look at the illustrations of the quilt and the text that accompanies it (pages 438–439).

This panel is obviously a particularly theatrical and aestheticized, as Tom Biscotto was professionally and personally involved in both theater and art; it is natural and appropriate that his friends and family decided to remember him in ways that recalled his professional and personal forms of expression. But beyond the inherent theatricality of this individual, notice how each letter adds to the fabric of who he was and how the material, the style, and the content of the panel are themselves in a sense a performance of Biscotto's life, rendered by those who knew him. Look at the entire panel and also at its independent letters. There is a cohesiveness to it that reflects the collective experience (and that is aesthetically appropriate to a designer and technician), but there are also significant individuality and diversity in the panel's various parts. Just as Biscotto was not simply one single image at all times for all those who knew him, so his panel reflects the complexity of his life. Yet there is a wholeness to the panel, as well, just as there was a wholeness to the man.

The AIDS quilt is, in complex ways, an act of celebration, in that it celebrates the varied and often rich lives of those who have died of AIDS; at the same time, it is a profoundly rhetorical and political act as well, for it demonstrates the vastness of the loss and personalizes the loss. Its multiplicity of images and written texts (many of the panels include verbal statements, poems, song lyrics, and other texts) puts it squarely in the dialogic tradition of art, in which no one style, ideology, or life is privileged, or held up over the many other options. All that is excluded is indifference—and it is indifference that is criticized in that collective text created in the artifacts and ceremonies that make up the quilt.

ACT UP and the NAMES Project quilt share their origins in a grass-roots movement to create discourse, ceremony, and performance in response to the AIDS crisis. Their methods and approaches are different, and in some important ways, their goals are different (radical civil disobedience vs. commemoration), yet at the same time both see public display and public ceremony as forms of public discourse, as ways of working toward change. They are complementary rather than oppositional responses to the AIDS crisis, each with its own power.

CONCLUSION

The public ceremonies we have considered in this chapter are the most complex cultural performances we have examined. Turner's analysis of social drama could fruitfully illuminate some of these events, particularly the public execution, a society's redressive measure, or the construction of the AIDS quilt. The Mardi Gras festivities provide different social groups with different ways of asserting or subverting power. Not only can Mardi Gras be viewed as an occasion in a social drama, particularly, for instance, when recent laws against racism banned certain of the krewes from presenting their entertainments, but also it can be viewed as a patchwork of various initiation rites. For example, the debutante's balls are often used to introduce young women to society and a potential husband. You can also notice numerous elements of folklore woven into these public ceremonies, such as the reworkings of the Cinderella legend, often enacted on the floats of Mardi Gras. The events also afford participants with the raw material of personal narratives. In short, looked at from different perspectives, the public ceremonies examined in this chapter shed light on all the other forms of cultural performance we have considered in part II.

We chose to set these ceremonies apart for particular examination because they lie at the most public end of our performance spectrum, featuring very theatrical elements and in some cases drawing sharp lines of demarcation between spectators and participants, while in others blurring the boundaries. The dynamics that fuel these ceremonies combine traditional elements with innovation, making it possible for the participants both to conserve the past and to produce change. In some cases, notably Mardi Gras and the AIDS quilt, the ceremonies are sites of subversion where new values can be forged. Such ceremonies have the potential to construct meaning and produce change. They also enact cultural institutions.

The ceremonies and cultural performances we have considered in part I thrive in an oral medium. Their practices are transmitted through oral, written, and electronic means, but the site of the performance is live and the texts are largely nonliterary, although often artistic. In part III, we will introduce you to literary performances by using theories of play to help illuminate them. You will see many points of convergence between the kinds of performances we have studied in this part and the kinds studied later, but there are also a number of important differences in the performative modes.

WORKS CITED

Bakhtin, Mikhail. *Rabelais and His World.* Trans. Helene Iswolsky. Bloomington: Indiana UP, 1984.

Churchill, Caryl. *Softcops and fen.* London: Methuen, 1986.

De Caro, F. A. and Tom Ireland. "Every Man a King: Worldview, Social Tension and Carnival in New Orleans." *International Folklore Review* 6 (1988): 58–66.

Dorson, Richard M. "Material Components in Celebration." Turner, *Celebration* 33–57.

Foucault, Michel. *Discipline and Punish: The Birth of the Prison.* Trans. Alan Sheridan. New York: Vintage, 1979.

Hemingway, Ernest. *Death in the Afternoon.* New York: Scribner's, 1932.

Kinser, Samuel. *Carnival, American Style: Mardi Gras at New Orleans and Mobile.* Chicago: U of Chicago P, 1990.

Kramer, Larry. *The Normal Heart.* New York: New American Library, 1985.

Ruskin, Cindy. *The Quilt: Stories from the NAMES Project.* New York: Pocket, 1988.

Schechner, Richard. *Performance Theory: Revised and Expanded Edition.* New York: Routledge, 1988. First published as *Essays on Performance Theory.* New York: Drama Book Specialists, 1977.

Turner, Victor, ed. *Celebration: Studies in Festivity and Ritual.* Washington, DC: Smithsonian Institution P, 1982.

FOR FURTHER READING

Bettelheim, Judith. "Jamaican Jonkonnu and Related Caribbean Festivals." *Africa and the Caribbean.* Ed. Franklin Knight and Margaret Crahan. Baltimore: Johns Hopkins UP, 1979.

Bruner, Edward, and Victor Turner, eds. *The Anthropology of Experience.* Urbana: U of Illinois P, 1986.

Burke, Peter. *Popular Culture in Early Modern Europe.* London: T. Smith, 1978.

Chaney, David. *Fictions and Ceremonies: Representations of Popular Experience.* London: Edward Arnold, 1979.

Davis, Susan G. *Parades and Power: Street Theatre in Nineteenth-Century Philadelphia.* Philadelphia: Temple UP, 1986.

Drewal, Margaret Thompson. *Yoruba Ritual: Performers, Play, Agency.* Bloomington: Indiana UP, 1992.

Fine, Elizabeth C. "Stepping, Saluting, Cracking, and Freaking: The Cultural Politics of African-American Step Show." *The Drama Review (TDR)* 35.2 (1991): 39–59.

Foucault, Michel. *Archaeology of Knowledge.* Trans. A. M. Sheridan Smith. London: Harper Colophon, 1972.

Johnston, William M. *Celebrations: The Cult of Anniversaries in Europe and the United States Today.* New Brunswick: Transaction, 1991.

Kochman, Thomas, ed. *Rappin' and Stylin' Out: Communication in Urban Black America.* Urbana: U of Illinois P, 1972.

Ozouf, Mona. *Festivals and the French Revolution.* Cambridge: Harvard UP, 1988.

Rydell, Robert W. *All the World's a Fair: Visions of Empire at American International Expositions, 1876–1916.* Chicago: U of Chicago P, 1984.

Stallybrass, Peter, and Allon White. *The Politics and Poetics of Transgression.* Ithaca: Cornell UP, 1986.

Part II

SOURCES OF PERFORMANCE MATERIAL

Cisneros, Sandra. *Woman Hollering Creek and Other Stories.* New York: Vintage, 1991.

Erdoes, Richard, and Alfonso Ortiz, eds. *American Indian Myths and Legends.* New York: Pantheon, 1984.

Lesley, Craig. *Talking Leaves: Contemporary Native American Short Stories.* New York: Dell, 1991.

Lester, Julius. *Black Folktales.* New York: Grove, 1969.

Locke, Alan. *The New Negro.* New York: Atheneum, 1992.

Mellon, James. *Bullwhip Days: The Slaves Remember: An Oral History.* New York: Avon, 1988.

Personal Narratives Group, ed. *Interpreting Women's Lives: Feminist Theory and Personal Narrative.* Bloomington: Indiana UP, 1989.

Shuman, Amy. *The Uses of Oral and Written Texts by Urban Adolescents.* New York: Cambridge UP, 1990.

Stahl, Sandra K.D. "Personal Experience Stories." *Handbook of American Folklore.* Ed. Richard M. Dorson. Bloomington: Indiana UP, 1983. 268–76.

Terkel, Studs. *Race: How Blacks and Whites Think and Feel about the American Obsession.* New York: New P, 1992.

Terry, Wallace. *Bloods: An Oral History of the Vietnam War by Black Veterans.* New York: Ballantine, 1984.

Washington, Mary Helen. *Invented Lives: Narratives of Black Women 1860–1960.* New York: Doubleday, 1987.

PART III
Literary Performance

CHAPTER **6**

Play, Performance, and Literature

[maggie and milly and molly and may]

—e. e. cummings

maggie and milly and molly and may
went down to the beach(to play one day)

and maggie discovered a shell that sang
so sweetly she couldn't remember her troubles,and

milly befriended a stranded star
whose rays five languid fingers were;

and molly was chased by a horrible thing
which raced sideways while blowing bubbles:and

may came home with a smooth round stone
as small as a world and as large as alone.

For whatever we lose(like a you or a me)
it's always ourselves we find in the sea

 E. e. cummings's poem "maggie and milly and molly and may" is an invitation to play. Not only does it tell a story about play, but it also asks us as readers to play the game of poetry, to enter into the rules and conventions any performance of literature requires. Let us begin our consideration of play and literary performance by examining this poem, both for *what* it says about the nature of play and for *how* it says it—how it asks us, as performing readers (whether the performance is presented to an audience or sounded in our heads), to participate in its experience.

Consider the poem's content: what it says, at least on the surface, about play. Remember that what a poem's verbal statements say is only part of the whole experience of the poem. Although it is often useful to begin by examining what a poem says on its surface, we know that we cannot stop there, for the poem is more than a series of statements.

The poem "maggie and milly and molly and may" tells a straightforward and relatively simple story, almost as if a child had been asked to recount a day of summer play. Four girls, all linked by the *m* that begins their names go "down to the beach(to play one day)." The word "down" suggests physical direction, but it also invokes a return to the basic, elementary conditions of being a child: cummings has not specified the age of these four characters, but the whole tone of the poem suggests childhood; if they are not children, they are returning to the childlike state that we typically associate with play.

Once at the beach, each of the girls has her own, individual experience, an experience that becomes emblematic of her character. Let us consider the unique qualities of each girl's moment on the sand. Cummings begins with maggie, for whom the beach is a place to escape from whatever worries she might have had before she set off for the day: "and maggie discovered a shell that sang/so sweetly she couldn't remember her troubles." Most of us have listened to the song of the seashell, being almost hypnotized by its rhythms, which echo the ebb and flow of the waves as they crash and dance from shore out to sea as well as the almost preconscious voice of the lullabies sung to us as infants. It is easy to become lost in the daydream of such music and to lose all sense of self. Maggie removes herself from the "real" world, preferring the fantasy world of play. Hers is a solitary play, far from the other girls, in mind if not necessarily in body.

Milly, the second of the girls, moves beyond the world of the self and "befriends" another living creature: "a stranded star/whose rays five languid fingers were." The "star," in this case, is not an astronomical body but a starfish, washed up on the beach by the tide. Like all children, milly is learning to personify, acknowledge, and understand the existence of beings outside herself. For milly this encounter may be the beginning of seeing herself in the context of a world that both includes and subsumes herself: she is learning how to act in society. Milly, like most children, is egocentric enough to transform the starfish, perceptually, into something like herself, connected to her sense of being: its "rays" are "five languid fingers." We can almost see milly picking up the starfish; turning it over and over; and laying her hand on top of it, measuring its anatomy by the span of her own.

So far, cummings has created a world of happy and peaceful play; yet he knows that play, like every other human activity, is subject to dangers and ruptures. The third girl, molly, embodies these dangers: "and molly was chased by a horrible thing/which raced sideways while blowing bubbles." What is this "horrible thing"? Cummings does not tell us, preferring the ambiguity of the child's perception. We might infer that it is a sea-creature, perhaps a small crab or similar shellfish—one reader has even suggested that this "horrible thing" might be a little boy, adding a dimension of sexuality to the encounter. Why is it chasing molly? Perhaps she has poked the "thing," or intruded on its home. That it is

"blowing bubbles" suggests that molly has actually ventured into the water. She has taken the first step beyond the familiar landscape of the sand, away from solid ground, and learns that it is not without peril. Play involves taking risks, at times: molly must choose between the safety of her comfortable world and the allure of the unknown.

Finally, may "comes home," reminding us that all play ends, that time passes. She, like the other three girls, has had her own encounter with the world of nature and has taken possession of it: "a smooth round stone/as small as a world and as large as alone." It is interesting that of all four girls, may has chosen the phenomenon least alive in nature for her play; even maggie's shell no doubt held a living creature at some time. May's relationship with her object is, however, also the most sophisticated from a cognitive point of view: she is able to move farther than any of the other girls into the realm of symbol and metaphor and experience the stone as something imbued with more meaning than its surface physical characteristics might immediately suggest. For may, it is "as small as a world"; the ability to conceive of a "world" as small requires a leap of abstraction that is the beginning of a higher level of thinking than that evidenced by the others. Similarly, the contrasting simile, "as large as alone," bespeaks a poetic knowledge of matching size and emotion, of finding similarities in differences, the essence of metaphor itself.

Each of the four girls has had an experience on the beach, an experience best described as play, for there is no utilitarian or instrumental value to be carried away from their activity; the moment each has on the beach has its own authenticity and intrinsic worth. Although each child may have learned something (and cummings suggests that this is so, in the final stanza), what is foregrounded is the specific and particular experience when it occurs. It is also possible to see the four experiences as allegorical of a larger, more universal process of development: the four girls may be symbolic of the individual going through stages of development, from earliest sensual awareness of the world (maggie) through the awakening of symbolic interpretation (may).

Whether we wish to see the four girls as separate characters or as four aspects of the same individual (experienced at different points in life), cummings is clear that it is the union of "selves" that is the most important result of such play: "For whatever we lose (like a you or a me)/it's always ourselves we find in the sea." Play, even in the solitary dream play of a maggie, involves some giving up or giving over of individual self, particularly the self we present in "everyday" life, in order to achieve the harmony and coordination of roles and rules social play necessarily involves. In this giving up of a "you" or a "me" (our usual labels, distinguishing egos in familiar and comforting ways), we discover something larger—"ourselves," a communal, multiple sense of being. This is not unlike any child's game, in which roles off the playing field will typically need to be forgotten to make the game or dramatic story work. To play "house" or "school," children must sometimes forget that they are children and take on a different self in order to make the play work on its own terms, which may be either explicitly or implicitly known by all players. And the irony, of course, at least to cummings, is that in this loss, we have the opportunity to discover and rediscover much

about ourselves. Within the separated, set-off world of play, there is the possibility of transformation and union that may change us in some important, sometimes imperceptible ways when we pack up our shovels and pails, leave behind our befriended stars, and go home at night to our familiar beds.

So far we have analyzed the poem simply for what its "content" may tell us *about* cummings's concept of play. In some sense, we have told our own story of "maggie and milly and molly and may," a story that sees play as an important, perhaps *the* important lesson to be learned. Perhaps some of you will find other things to say about the content of this poem. The fact that you may feel the poem is about something rather different from (or in addition to) what we discussed is part of the "play" of interpretations. Although it is probably not wise to say that all interpretations carry the same weight or validity, many critics now believe that it is unlikely that there is such a thing as any one "correct" interpretation. Thus, the many ways of finding meaning in a poem (or any other work of literature) may be seen as akin to a game in which each reader finds reasons to justify his or her own particular "moves."

LITERARY ANALYSIS AS PLAY

At this point, you may think it odd to look at literary analysis as "play," the search for meaning as a kind of "scavenger hunt," with various rules for people who wish to play it in different ways. Yet, interestingly enough, a number of long-standing traditions view interpretation as just that. For example, the ancient Greeks held Hermes as the god of interpretation, the messenger god. It is probably no accident that Hermes was also the god of thieves as well as a "baby" god, who stole a herd of cattle while still in diapers. For the Greeks, the art of interpretation (from which we derive a modern word, *hermeneutics,* the study of ways of interpreting meaning) was a complex idea, tied to the seriousness of the arts of poetry and music (symbolized by the god Apollo, whom Hermes served) but also to the thievery of the child-god, whose swiftness and pleasure were important aspects of message carrying. It is easy to forget that "making meanings," the very stuff of interpreting, should be a pleasurable act.

Similarly, in the Yoruba tradition, there are also distinct gods connected to interpretation. One, Esu-Elegbara, is similar to Hermes, carrying meaning to human beings. Like Hermes, Esu is a trickster, a player, for whom interpretation is the highest game of all. Interestingly, in African-American traditions, according to Henry Louis Gates, Jr., the god Esu becomes the anthropomorphized figure "the signifying monkey." Can you see how the ways in which we try to derive meaning (looking for ideas and themes larger than the specific incidents of a work of literature) is like playing a complicated game, a game in which some-times we forget to remind ourselves of which set of rules we are playing by in a given reading?

A poem is an experience, an experience involving not simply the isolation of themes or extraction of ideas but also the engagement of the senses and the play of writer and reader, of competing voices, and of timing and rhythm—a game involving not just the intellect but the rest of the body as well. In this

way, the poet, in this case e. e. cummings, *plays*—plays with language, plays with the reader, plays with the whole world of the imagination. We need now to look at the ways in which this poem not only talks *about* play but also *performs* play. Indeed, for many readers, this sensual level is where the experience of the poem begins; few of us begin our reading of a poem by trying to figure out what it means. Instead, it is far more likely that at least during the first few readings, we are concerned with locating ourselves in the particular world of the poem, becoming comfortable sounding out the language, accommodating the poem's formal requirements, and determining whose voice or voices (and their accompanying identities) we are to inhabit. We suspect that for many readers, looking for meaning may come considerably later and, in all probability, can only come as a result of these more immediate concerns of experiencing the text.

So, without trying to generalize about all literature, or even about all poetry, how does cummings's poem ask us to play? How does cummings keep us in a state of gamesmanship in which we must keep up with him or "lose" the game? Are there "rules" we must obey in order to play with this poem? Are there places where we have choices about how to follow rules or which rules to follow (such as which direction we wish to move on a Trivial Pursuit board or which card to play in a game like Old Maid)?

Let us focus on the level of sound and form, the poetic levels that take us closest to our own childhood experiences of language and poetry. Jonathan Culler speaks of the "call of the phoneme," by which he means the very genuine pleasure by which sound (and the games we may play with it) draws us into both the production of language as performers and the experience of it as audiences (1).

What is the first thing we notice about sound in cummings's poem? It is probably the heavy concentration of *m* sounds in the first line. We have already noted that the repetition of *m* sounds (technically known as alliteration) draws the reader's attention sharply to the four girls as a unit. But the alliteration also has a simpler function, and that is to provide a kind of pleasure to the reader who is sounding out the line. The juxtaposition of the same consonants with different vowels allows the performer the pleasure of repetition (which is comforting and "special," in that such repetition does not typically occur in such close proximity in ordinary language) and also the surprise of variation in the different vowels. Note that phonetically, each girl's name is dominated by a different principal vowel. The combination of similarity and difference produces sensual and intellectual pleasure. This kind of repetition occurs elsewhere in the poem: in the second stanza, "sang/so sweetly"; the third stanza, "stranded star"; the fourth, "blowing bubbles." It is worth noting that cummings does not make an effort to hide this repetition (as do some poets) but rather seems to have intended just the opposite: to put the sounds so closely together that the reader cannot help but pay attention to them. This closeness adds to the childlike quality of the poem; it also may slow down the rate at which we read the poem (either orally or silently), thus encouraging us to enjoy the sound as sound rather than simply to rush through it in our quest for "meaning."

Perhaps the next level of sound we notice when we read the poem aloud a few times is the rhythm. Try reading the poem aloud a few more times. Read it first as if it were not verse, as if there were no divisions for line or stanza (it

may help to copy the poem in prose form). What do you notice? If your experience is at all similar to ours, you found yourself falling into patterns of rhythm, even though there were no specific typographical divisions to cue you. Now go back and read it aloud again, this time paying strict attention to the line and stanza divisions. Just to experiment, decide on how long a pause between lines should be and how long a pause between stanzas should be. The length itself does not matter, but the attempt to be consistent does. Do not worry about the sense of the poem at all for this reading; read the poem almost as if you were reading gibberish, though of course your recognition of the *syntax* (the relationships of words to one another in phrases and sentences) and the inescapable familiarity of words will make a purely nonsensical reading impossible. What do you find this time? Again, if your readings are like our own, you will find yourself falling into a musical pattern, a pattern you probably think you could extend almost indefinitely, no matter what words were inserted; this is how powerful cummings's establishment of rhythm is in the poem.

Now look at our scansion of the poem in Figure 6.1. There are many different ways of describing the rhythm in any poem, some of which may be familiar to you. As a rule of thumb, the best prosodic description (*prosody* is the word we use for the study of such patterns in poetry) is the one that tells us the most information. One of the first things we would probably do in trying to describe the rhythm of the poem is to count the number of syllables in each line, which can help us see a repeated pattern. This poem has a range of line lengths from 8 syllables to 13; 10 seems to be the average, though only 4 of the 12 lines contain 10 syllables. So at this primary level, we can say that cummings uses boundaries of 8 and 12 syllables per line but allows himself complete freedom within that range. This range, by the way, is typical of poetry in English, so cummings is adhering to a convention many readers might expect, although stretching it and allowing himself considerable room within it. This is probably as far as syllable counting alone will take us with the poem's rhythm.

The next aspect of rhythm we would probably turn to is that of counting stresses per line. A stress-based rhythm is the oldest form of rhythm in poetry composed in English. We hear four primary stresses in each line (you may find one more or less in particular instances, depending on how you speak the poem), a pattern that also invokes the old traditions of Anglo-Saxon poetry. This regularity of stresses per line begins to account more specifically for the rhythms we feel in the poem when we read it. Yet does it fully describe the complexity of your experience of the poem's rhythm simply to say that there are four stresses per line? That statement tells us very little about where cummings has placed the stresses, and the trickiness of the game depends a great deal on where they are located.

Looking at our scansion in Figure 6.1, you will notice markings that indicate stress and unstress (over the syllables). You are probably familiar with the concept of *feet* in poetry. It involves relative emphasis, intonation, and length (timing) of syllable. Some readers object to the opposition of syllables as either "stressed" or "unstressed," and from a linguistic point of view, their objections have some merit; many prefer a more complicated three- or four-level system. For the sake of brevity, at this point we will use the traditional two-level version.

Syllables	Stresses	Prosodic Features	Rhyme
10	4	maggie and milly and molly and may	a
9	4	went down to the beach(to play one day)	a
10	4	and maggie discovered a shell that sang	b
13	4	so sweetly she couldn't remember her troubles, and	c
9	4	milly befriended a stranded star	d
8	4	whose rays five languid fingers were;	d
11	4	and molly was chased by a horrible thing	b
10	4	which raced sideways while blowing bubbles: and	c
8	4	may came home with a smooth round stone	e
11	4	as small as a world and as large as alone.	e
12	4	For whatever we lose(like a you or a me)	f
10	4	it's always ourselves we find in the sea	f

--e. e. cummings

FIGURE 6.1

NOTES: Above lines:

 x = unstressed syllable
 / = stressed syllable
 | = foot division
 () = possible cross-stanzaic "foot"
 [] = no probable foot division

On lines:

 O = alliteration
 □ = assonance

You will also notice a taller vertical bar at various points in the poem; this bar divides the lines into feet, smaller units of rhythm. These divisions are not uniform and they are open to discussion, but we have put them there to bring the question of rhythm into an even more complicated light. If you look at the number of syllables in each unit and the order of stress and unstressed syllables, you will begin to see some patterns, though not as regular as the simple number of stresses per syllable.

How many syllables are there per foot? We find either two or three. Depending on how you stress specific syllables and where you make your divisions between feet (individual readers will vary with both), you will come up with a few more two-syllable (disyllabic) or three-syllable (trisyllabic) feet but with a fairly

equal distribution. Most of us would probably not say one kind of foot dominates. What about the order of stressed and unstressed syllables? Here there is more consistency. For the most part, the feet move from unstressed to stressed syllables. In a two-syllable foot this is called an *iamb;* in a three-syllable foot, an anapest. Again, in your own readings, you may disagree with where we have placed some stresses, but it is likely that you still find what we call a rising rhythm dominating.

Is it wholly accurate to go this extra step and say that cummings is writing in a regular, predictable "foot" system of prosody? Can we even go as far as to call it iamb-anapest, to indicate the two dominant feet, and to add tetrameter, to show that there are typically four of these rising units per line?

Here is where the game becomes a little trickier, for cummings has both lulled the reader into the dominant rhythm and pulled it away at critical moments in the poem. The first four lines follow a very predictable and consistent rhythm, with the exception of the opening foot of the poem, which traditionally may begin, as it does here, with a stressed syllable followed by an unstressed one, known as an *inverted foot.* But at the end of the second stanza, the reader is faced with a dilemma: what do we do with the "and" that concludes not only the line but the stanza as well? Do we stress it simply because there have been stresses at the end of every other line? From a purely formal standpoint, that choice would fulfill expectations. However, think about the relative weight you give the word *and* in everyday conversation. It is a conjunction, a linking word, and rarely requires special attention. Certainly at this point in the poem, it fulfills no special function in the meaning of the poem, other than to move us on to the next girl. Add to this the dilemma that the very next syllable must be stressed: "milly" must be pronounced with the stress on the first syllable. What do we do, both in trying to discern how this moment fits into the "rules" of cummings's prosodic system and also into the uttering of the words in performance?

One choice may be to place what most of us see as undue stress on the "and" to maintain the consistency of rhythm. Another, which we have chosen, is to leave the "and" unstressed, an extra syllable that is not properly part of any foot. For us, this is the rhythmic variation cummings places into the consistency of his adherence to his own "rising" rule of stress. Our decision will become even more complicated when we add the dimension of rhyme, but for now let's leave the rhythm as we have just described it.

We feel confident about this decision to stretch the rules of traditional prosody because when we come to the fourth stanza, "molly's" stanza, the regularity of rising rhythm breaks down completely. Try reading it aloud, paying no attention to our own markings. Do you hear or feel the same consistency of rhythm here that you have up until now? The first line maintains the rising rhythm, almost speeding it up by putting 3 anapests in an 11-syllable line, forcing us to speak the line quickly if we wish to maintain some sense of equivalence of lines. But the second line of the stanza has the awkward scuttle of the "horrible thing," in which "raced" and "sideways" are placed next to each other, forcing a disruption of the alternation of stress and unstress. In addition, we have the same dilemma as in stanza two, ending the stanza with the weak word "and," also followed by a name, "may" this time. In this stanza, cummings has used the variation of rhythm to echo the discomfort "molly" experiences: the beach is

not a harmonious place for her. Cummings has ventured away from strict adherence to the rules of this game to make a point. Because he has not maintained an absolutely consistent rhythm elsewhere, he can justify his variation on the reader's expectations at this point by the "violence" of the poem's content.

The answer to the question of whether using foot prosody to describe this poem is accurate or not is, to our minds, a compromise. Clearly, because cummings has chosen to move so frequently between the iamb and the anapest, he seems to be signaling us not to try to name the form by anything quite so specific as "iambic" or "anapestic" per se; "rising" seems as far as we can legitimately go. Similarly, to enforce a rising rhythm throughout, even at the sensitive moments we've noted, would be unnecessarily slavish and contrary to the directions the poem seems to want to take us. We believe that a modified and generously elastic use of the "rules" of foot prosody does allow us to observe and describe the rhythm we feel when we read the poem, but only with the knowledge that this poem's "game" is played with the greatest stretching of the rules most readers would probably allow. It is important to add that different readers will perceive the rhythm of the poem differently, depending on their own ear for sound and their familiarity with the conventions of the "game" of poetry.

The next level of sound we might notice is the poem's use of rhyme, specifically *end rhyme,* the pairing of identical vowels and final consonants in matched lines. The lines of course need not always be in succession, though they typically are in this poem. Each stanza consists of a pair of rhymed lines, which we can call a *couplet.* Cummings plays with our expectations about rhyme throughout this poem.

The first stanza rhymes perfectly: "may" and "day" have identical vowels, and there are no final consonants. The rhyme, combined with the establishment of rising rhythm, builds an expectation of regularity in readers, even though, if they are familiar with cummings's other poetry, they may have been prepared for no rhyme at all (cummings is best known for his free verse, which typically, though not by definition, makes little use of end rhyme). Just when we are ready to anticipate another "full" rhyme (that is what we call the kind of rhyme found in the first stanza), cummings immediately upsets our expectations in the second stanza: the final sounds in the lines are "sang" and "troubles,and." Even stretching our notion of rhyme to its limits, conceiving of it in critic Henri Meschonnic's words as the "echo from word to word" (93), we would find it difficult to hear or see these two words or phrases as rhymes (though the repetition of the vowel *a* in each of the words creates another effect, known as assonance). Cummings has established expectations only to disrupt them. We must interrupt our reading of the poem to search for rhyme partners for these two words. We find them, two stanzas later, with "thing" (an off-rhyme for "sang") and "bubbles:and." The rhyming of "troubles,and" and "bubbles:and" is a particularly playful strategy, as cummings not only has put two oddly matched words together ("troubles" and "bubbles," though in the poem both words are occasions for distress) but to make the rhyme "work," also has had to use typography and punctuation in extraordinary ways, drawing attention to his own performance.

He plays similar games with rhyme in the third stanza as well, where, "star" and "were" are paired; although in some dialects, the vowel in the two words may sound the same, for most speakers they are slightly different in placement.

Does cummings want us to adopt the same pronunciation for both vowels, perhaps adding a New England twist to "were," pronouncing it to rhyme with "star"? Or does he want the slight variation to remain, perhaps being even semantically functional in underscoring the differences between the starfish's rays and milly's fingers? Each reader will have to decide, and put the results of that decision into performance.

Having torn rhyme as far apart as he can, cummings returns to the full rhyme of stanza one in the last two stanzas, appropriate as a way of drawing the day (and the poem) to a close. Cummings plays with the metaphoric pairing of "stone" and "alone," giving us a phonetic equivalent of the simultaneity of metaphor. And the final rhyme, "me" and "sea," is quite similar to the pairing that opened the poem, in which the rhyme depended exclusively on the vowel; even consonants are repeated from the first stanza to this last one: from "may" to "me."

This lengthy discussion of the games cummings has played with the form of the poem may seem overtechnical to you. But think for a moment about some of the games you like best in real life. Doesn't your pleasure in them depend sometimes on the intricacy of the rules and on the variations you and the other players negotiate for your personal versions? The absolute fascination some players have with all the variants possible in Dungeons and Dragons is one example that comes to mind. For another example, consider poker, in which the dealer gets to establish what constitutes a wild card; the main rules are adhered to, but each dealer may choose a wild card, from aces and deuces to one-eyed jacks. Similarly, we know families who have special rules for such board games as Monopoly, Clue, or Trivial Pursuit; for example, in Monopoly, what happens to the Free Parking money. In one family it is traditional to begin the popular detective game Clue with one particular move: Miss Scarlet in the lounge with the knife. Although this rule is not standard (it is unwritten and not required for the game to take place), it adds to the pleasure of that group and does not impede the normal progress of the game as a whole. Though it may sound farfetched, this is not unlike what cummings has done with the form of "maggie and milly and molly and may." Although he does, for the most part, retain most of the traditional rules or conventions readers expect when they read a poem (such as a story, a consistent persona, fairly equal line lengths, etc.), he makes up some of his own rules, rules that the reader must discover in order to "play" the poem to its fullest.

Cummings stands as one of the most openly and consciously playful poets of this century. It is this kind of "playing" that is at the heart of much of the pleasure we derive from poetry: play that engages us with the heart, body, and breath of the poem, as well as with the intellect of its ideas and themes. Finally, we do not want to separate such technical considerations of form and sound from the "content"; they are inextricably linked. As Meschonnic says, "everything in language is the play of meaning, which is necessarily so, since nothing that is in language can fail to have an effect on meaning . . ." (93). So the rhymes, the rhythms, the typography, all of which we may be tempted to see as ornaments, are indeed critically tied to the full play of the poem; similarly, the process of deciding "what the poem is about," the act of interpreting, is also part of play, as we ourselves learn to listen to and speak the poem.

Think about how much more you know about the poem as a whole, having looked at some of these aspects of sound; the poem isn't quite so simple as you might have thought. You, as a performer, are now better equipped to make decisions (such as how much of a pause to take between lines and stanzas, if it is appropriate to take pauses at all, how heavily to weight rhymes, and how much to emphasize rhythmic patterns and deviations) about the performance than you were before. This, in turn, should make the act of rehearsing and performing the poem more of a pleasurable challenge than previously, even though your goal may not (and probably will not) be to make your audience fully conscious of all of the complexities of the technique and meaning of the poem. In a sense, your game as performer may be similar to that of cummings as writer: to understand the complexities of play undergirding the poem while maintaining a surface of sand castles and shells for the audience, who may only understand the deeper qualities of the poem in unconscious, inexpressible ways, just as the child understands his or her games in ways not always meant to be articulated. There are different ways of knowing, just as there are different ways of playing, but it is important to remember that playing *is* a way of knowing.

Wrestling as Play in D. H. Lawrence's *Women in Love*

Before we move on to discuss in more general terms what it means to say that literature is a form of play and to identify some specific ways in which writers and readers play in the literary experience, let's look at another text. This time we will look at a piece of prose fiction, a chapter from a novel, in which two adults use play in very serious and complicated ways, which may bring into question our assumptions about play as something unconnected with "real life." You will find this selection in the appendix (pages 439–47): it is the chapter "Gladiatorial" from D. H. Lawrence's novel *Women in Love*. This time do not attempt to read the entire selection aloud, though you may find yourself wanting to read some parts orally simply to experience the intense passion Lawrence creates. After you have read the selection once or twice, turn back here for our discussion of it.

Now that you have read "Gladiatorial," we are ready to look at the questions it raises about play. One critic has suggested that Lawrence is one of the writers least concerned with play, particularly with the act of literature *as* play. What do you think of this assertion? Certainly compared with the effervescence of cummings's "maggie and milly and molly and may," this scene of combat, with its dense, sometimes mystical prose, seems at quite a remove from the "lightness" we traditionally associate with play. Indeed, Lawrence's prose has often been criticized for the turgidity of its style: an overseriousness of purpose, to the point where the writing is almost entirely bereft of playfulness. Some critics who view Lawrence in a more positive light suggest that this high-seriousness is an expression of Lawrence's moral vision. As Diana Trilling writes, "He estimated, more accurately than any of his contemporaries, the social and moral cost of an increasingly dominant industrialism, and the price the modern 'free' spirit must pay for its assertion" (2).

Let us look specifically at "Gladiatorial." Even the title suggests a darker perspective on sport and play. Who were the gladiators? They were the warrior-sportsmen of ancient Rome, who battled each other in the public forum of the Colosseum, usually to the death. Their actions were viewed as entertainment by spectators yet were clearly of greater urgency to the actual participants. In what way are Birkin and Gerald "gladiators"? We as readers view them as fictive creations and, at some level, are conscious that whatever their fates, they are both figures in a story invented by Lawrence. The third-person narration is itself a technique that places some distance between us and the characters as "real people"; the intervention of the narrator reminds us of the "unreality" of the two men. Yet there is also a sense in which Birkin and Gerald are themselves aware of the fictiveness of their own experience. They are certainly not actually fighting to the death, and there is no stake, beyond their own sense of competitiveness, for which they are battling.

At the beginning of the chapter, Birkin has just returned from unsuccessfully proposing to Ursula Brangwen. He finds Gerald at home at Shortlands, "suspended motionless, in an agony of inertia, like a machine that is without power." The two men are at opposite ends of the spectrum: Birkin, agitated and frustrated; Gerald, drained of any sense of purpose or desire. Both are as far from the state of play as imaginable: Birkin is preoccupied with the world he has tried to create with Ursula, and Gerald is devoid of any creative or imaginative impulse.

The two men discuss the need for connection with "the right woman. . . . Failing that, an amusing man." Birkin's advice to Gerald (which we probably find peculiar today) is "You should try hitting something." From this rather animalistic suggestion, the two men negotiate their way to an appropriate form for the "hitting," beginning with boxing but discarding that for wrestling. Wrestling, particularly for the aesthetes of Lawrence's generation, carried more of a sense of artistry than did boxing. It goes back to Greco-Roman education, in fact, in which the training of the body was considered as important as the training of the mind. Wrestling involves more strategy and thought than boxing, which depends more on brute strength. The phrase *to wrestle* is often used as a metaphor for the play of the intellect with a controversial issue—a physicalization of the process of dialectic itself. In such a sport, Birkin, who is physically slighter than Gerald, would have as much chance of winning as the bulkier, heavier man; this would not be true with boxing.

The two men agree to wrestle, specifically to play at jiu-jitsu, a Japanese style of wrestling Birkin learned in Heidelberg, where he was a student at the university. The foreignness of the style of wrestling adds to its removal from everyday life. This is not the sparring of two miners, resolving a squabble in a pub, but two warriors searching for some kind of communion through the meeting of bodies and minds. Gerald, recognizing the ritual holiness of their endeavor, summons the butler and instructs him to bring food and drink and to leave the two of them alone for the rest of the night; in essence, Gerald is sealing the two men off from the outside world to allow them to explore the boundaries of self and other.

Lawrence describes the wrestling match in rhythmic, almost hypnotic terms, capturing the ebb and flow of the bodies as they seek a resolution of their separateness: "They stopped, they discussed methods, they practised grips and

throws, they became accustomed to each other, to each other's rhythm, they got a kind of mutual physical understanding.'' The men are complementary, not only physically but also spiritually: "It was as if Birkin's whole physical intelligence interpenetrated into Gerald's body, as if his fine, sublimated energy entered into the flesh of the fuller man, like some potency, casting a fine net, a prison, through the muscles into the very depths of Gerald's physical being.''

When the two men cease their wrestling, Birkin is the nominal victor, though he is "much more exhausted,'' no doubt because he put much more of himself into the experience. In fact, Lawrence describes him as "almost unconscious,'' then "half-conscious again, aware only of the strange tilting and sliding of the world.'' Play is ending, and the two are beginning their reentry into a world of failed romances, exploitative industrialism, and their own unending yearning for connection. As if to signal this change, they resume speech. Gerald, typically the less articulate of the two, tries at first to diminish Birkin's victory: "Of course . . . I didn't have to be rough—with you—I had to keep back—my force—'' but then concedes defeat; "I could have thrown you—using violence— . . . But you beat me right enough.'' Birkin seems almost unaware, less concerned with the sportsmanlike question of who won than with the spiritual quality of the experience, responding to Gerald's expression of surprise at Birkin's strength with the simple statement "For a moment,'' a recognition of the transience of play. A little later, Birkin summarizes in simple, almost aphoristic terms what this battle has "meant'': "One ought to wrestle and strive and be physically close. It makes one sane.'' It is important to note the very different attitudes toward play suggested by the two men's responses to the end of the wrestling match: Gerald defines play as contest, whereas Birkin sees it more as an engagement of the mind, spirit, and senses.

The two men dress, returning to their positions before the wrestling match: Gerald, the sensual, eats; Birkin, the spiritual, does not. Gerald puts on his caftan, a colorful, exotic robe from Bokhara. Birkin's mind wanders from the present scene and returns to thoughts of Ursula, and he tells Gerald about his proposal of marriage to her. He is now able to see Ursula's response not as a rejection but as her declaration of self—that she would not be "bullied into answering.'' This leads the two men into a more abstract discussion of love itself, Gerald declaring that he doubts he will ever love a woman and that this does not matter to him "so long as I feel I've *lived,* somehow—and I don't care how it is—but I want to feel that—.'' He struggles for words. Birkin, again the master of brevity and simplicity, says, "Fulfilled.'' Gerald resists this a little: "We-ell, perhaps it is, fulfilled; I don't use the same words as you.'' But Birkin is certain: "It is the same.''

Where do the two men end up? Has their wrestling match, sealed off from the outside, made any kind of impact on their lives beyond the game? Is this even important? The narrator suggests that the sport has not been simply a diversion to the two of them: "The wrestling had some deep meaning to them—an unfinished meaning.'' In their conversation after the wrestling match, both men affirm the value of the experience. Birkin emphasizes aesthetic benefits, a sense of harmony the two share; "mentally spiritually intimate, therefore we should be more or less physically intimate—it is more whole.'' He also remarks on Gerald's physical beauty; "that is enjoyable too. One should enjoy what is given.''

Gerald, in contrast, is less able to define what the experience has given him. He exclaims, "It's rather wonderful to me," and later says, "I can say this much, I feel better. It has certainly helped me." He then asks Birkin if this is the "Bruderschaft you wanted," to which Birkin cautiously answers, "Perhaps." Birkin sums up the experience by saying, "one feels freer and more open now—and that is what we want." The wrestling has liberated them, in the ways Trilling suggests the modern "free" spirit sought (1). Whether the change is temporary or simply the response at the moment remains ambiguous within the scope of the chapter (remember that the two men return to their own individual thoughts, needs, and habits almost as soon as they have remarked on the effects of the wrestling) and is certainly problematic within the novel as a whole, in which Gerald's lack of freedom brings about his downfall.

What, then, are we to make of Lawrence's use of play? It is certainly true that his sense of play is quite different from cummings's: at no point do we feel the self-conscious play through language and form that cummings brings to his seaside holiday. Play exists in the Lawrentian selection as a device of theme and plot, a scene, in some sense, in which the two men plumb the depths of identity and relationship. Lawrence himself does not seem to be a "player," beyond the play of invention of characters and dialogue; his own sense of self-seriousness is too dense for that. Although his novel talks about freedom and restraint as one of its major themes, Lawrence, as writer, stays rather firmly within the recognizable bounds of the realistic novel; his themes may involve issues of play, but his techniques do not. (You may find it instructive to compare Lawrence's discussion of wrestling in this selection with French philosopher Roland Barthes's essay "The World of Wrestling" in his book *Mythologies*.) For cummings, it is impossible to remove notions of play from any level of the poetic process and performance; for Lawrence, play needs to be discussed within the lives of the people who inhabit his fictive worlds, but it is a more mystical, less articulate, and even painful experience.

We have looked at two writers who may be plotted at almost opposite ends of a continuum: cummings, the artist as player, and Lawrence the artist who looks in on play but does not participate in it in a full way. We should make it clear that we intend no judgment here: cummings is no better a writer because of his immersion in play, nor is Lawrence deficient because he lacks the spirit of play in his own role as writer. Rather, they are simply two (among an infinite number) different ways of acting, of performing in the world we call literature.

We now move away from our close studies of these texts to some more general considerations of play and literary performance. We will begin by examining some definitions and theories of play, particularly as they apply to literature. We will then examine a number of specific elements of play in literature, focusing on how they influence and even shape our experiences as performers.

PLAY THEORY: HUIZINGA AND CAILLOIS

As our discussion of the two selections indicates, play is an important aspect of the literary performance and varies in its style, degree, and function from writer to writer (as well as from reader to reader and performer to performer, we might

add). We would hesitate to say that a writer such as D. H. Lawrence has no interest in literature as play; his very role as novelist, inventing stories and characters and words for them to say, is itself a form of play, no matter how deep and dark the content of the story. Similarly, do not let cummings's seeming simplicity of tone and technique fool you; there is as much craft and care in his day at the beach as in Lawrence's wrestling scene.

What, then, constitutes play in literature? This is a question critics and theorists have been asking for many centuries. We can trace fundamental questions of play and literature back as far as the Greeks, for whom drama was both an imitation of life (not unlike the child's make-believe game) and an opportunity for what they called catharsis: a cleansing or purging of the emotions through observing a dramatic tragedy. Both of these elements of play (imitation and pleasure, in that word's broadest sense) remain important today to most discussions of literature and play.

Yet the concept of play remains as elusive and disputed for students of literature as it does for students of culture. Let us return to one of the most popular definitions of play, not as an exclusive definition, but as a place to begin our own questioning. Johan Huizinga, the European historian, thought the relationship between play and poetry (the word he used to describe all of what we would consider to be literature) an essential and long-standing one: literature is a fundamental activity for *homo ludens,* the human being as player. In his discussion of play and poetry, he offered this definition of play: It is ''a free activity, standing quite consciously outside 'ordinary life' as being 'not serious' but at the same time absorbing the player intensively and utterly. It is an activity connected with no material interest, and no profit can be gained by it. It proceeds within its own proper boundaries of time and space according to fixed rules and in an orderly manner'' (13).

A number of contemporary theorists have taken issue with Huizinga's definition of play as being in some ways too narrow or limiting. For some, Huizinga's insistence on separating play from ''serious'' or ''real'' life is too simplistic and leads to tautological circles: if play is a human activity, it cannot be held entirely separate from life. Similarly, the question of to what extent rules must be a part of play remains open. For some theorists, there are forms of play either not bound or less bound (and the two are different in important ways) by rules. Finally, the question of utility is also controversial. Although most theorists would agree with Huizinga's notion of play as separate from ''material utility'' (i.e., the production of some thing or service necessary to the orderly maintenance of society), many theorists argue that for play to be valuable, it, like any other human activity, must have some kind of usefulness.

Some critics of Huizinga might go even further, arguing that his definition of play removes it from any sense of value or worth and robs it of its social, psychological, and political complexity. One only need look to the institutionalization of play in its various forms, they say, to see that the very qualities Huizinga sees as essential to play are violated time and time again: professional sports, the commerce of the performing arts, and the life-threatening controversy over novelist Salman Rushdie's *The Satanic Verses* (the writer's pungent satire of Islam has resulted in a call for his death by some religious Muslims). Perhaps one valid

response to such charges is that the institutionalizing of play activities in some respects pollutes them as "pure" play, that given a continuum of literary experiences, the ones closest to true play are not those required for a college literary course but rather those engaged in spontaneously. We know people who feel the need to apologize for the pleasure they take in reading popular novels by calling them "trash," perhaps under some standards an accurate evaluation of the books' worth but also a rationalization for participating in what they may see as less than "useful" activity.

Whatever flaws there may be in Huizinga's definition of play (and we encourage you to try to come up with your own definition as well), it remains today a dominant one. Other theorists, such as Gregory Bateson, have used different terminology and different disciplinary perspectives (e.g., Bateson's theory of "framing" and the double consciousness of "play" and "not-play"). One theorist who has expanded on many of Huizinga's basic concepts is Roger Caillois, who has written at great length about play and games. Two of Caillois's greatest contributions to the theory of play have been his expansion of its definition and his classification of types of play, beyond Huizinga's basic contest-oriented one. Caillois offers six essential qualities of play activity:

1. Free: in which playing is not obligatory; if it were, it would at once lose its attractive and joyous qualities as diversion;
2. Separate: circumscribed within limits of space and time, defined and fixed in advance;
3. Uncertain: the course of which cannot be determined, nor the result attained beforehand, and some latitude for innovations being left to the player's initiative;
4. Unproductive: creating neither goods, nor wealth, nor new elements of any kind; and, except for the exchange of property among the players, ending in a situation identical to that prevailing at the beginning of the game;
5. Governed by rules: under conventions that suspend ordinary laws, and for the moment establish new legislation, which alone count;
6. Make-believe: accompanied by a special awareness of a second reality or of a free unreality, as against real life. (9–10)

As you can see, many of Caillois's ideas are similar to Huizinga's overall definition. Caillois has in some cases qualified the element of play to make the definition clearer. Let us look briefly at each of these elements to see how they apply to literature and its performance from a writer's perspective, a reader's, or both.

Free

Is literature a nonobligatory activity? In its purest sense it is, though writers may speak of being possessed by the need to write (and professional writers certainly need to write in order to support themselves). But having said that, we believe that the act of writing a work of literature comes from the initiative of the writer.

How about the reader? As most of us have been forced to study literature from elementary school through college, it may be more difficult for us to see the experience of reading literature as wholly nonobligatory. And in school, it is probably not nonobligatory; it is probably also the least pleasurable site of reading we can imagine. Have you ever enjoyed a book that you read on your own, only to feel quite differently about it when you were subsequently required to read it for a class? We hope this does not suggest that courses in literary study should be done away with, only that some of the spirit of play needs to be reinjected into our way of studying them. The same is true for the performance of literature; the pleasure we may have taken as a child in speaking a nursery rhyme is quite different from the stiffness we may have felt in being required to learn "memory pieces" in school. Even when required to read or perform literature, it seems critical to us to try to reclaim the sense of freedom in the original experience.

Separate

It may seem less true of the silent reading of literature than of other forms of play (including oral performance of literature) that it is "circumscribed within limits of space and time," and it is true that in silent reading we often have much more choice about when and for how long we will read. Some readers will spend an entire day engrossed in a novel; others will use it as a way of relaxing before bedtime, making a novel last many months. What does seem to be true is that if we are really reading a work of literature fully, we do have a sense of separation from other activities; most of us find it difficult to expend the necessary psychic energy required to enter into a work of literature if we are also trying to watch television or to carry on a conversation. This sense of separation is much more clearly defined in the performance of literature: both performer and audience gather together in a specific place, whether classroom or theater or other space, at a specific time for the unique purpose of experiencing the work of literature through performance. Again, the amount of time may be more or less set (a class period or, in the case of a public performance, however long it takes, within mutually assumed reasonable limits), but there is a sense of the event as being time-bound, of existing in the time it takes for the performance to occur.

Uncertain

For some theorists who wish to apply Caillois's play theory to literature, the idea of uncertainty is the most difficult to account for. For them, there may be uncertainty for the writer as the work is being composed (i.e., the writer is uncertain of the exact words to be used or even of such seemingly more fixed elements as character and plot) and for the reader, who unless he or she "cheats," is likely to be uncertain of the outcome, but the theorists argue that there is little room for innovation or variation once a work is written, that a text becomes "frozen."

What do you think of this position? We would certainly agree that there is less uncertainty with a literary work than with some other kinds of play (such as a game of make-believe or even a game like hide-and-seek) but that there is

considerably more uncertainty in the play among writer, reader, and literary work than some critics might expect. The fixedness of the words in a work of literature ought not to be confused with the uncertainty of the experience that might result from either the writer's generation of language or the reader's reception of it. Think about a disagreement you and someone had about whether a particular work of literature was good or bad (using those words in whatever way you might have). Uncertainty was an important element there; however used we may be to accepting some evaluations or interpretations as "correct," most of us would probably agree that there is indeed room for latitude in coming to such judgments, as there is in interpreting the meaning of a literary work.

An example would be the controversy over Henry James's novella *The Turn of the Screw*. This novella is a variation of the nineteenth-century ghost story, but critics have argued over whether the ghosts in the story are "real" or the neurotic fantasy of the narrator. That there is indeed uncertainty about the ghosts, if not for some specific readers then for the larger critical community, is in fact what makes the novella "playful" for many; for some readers, their own uncertainty about whether they believe in the ghosts or not is what makes the work a continually satisfying experience. A performance of this work that either brings the ghosts clearly onstage or definitely says they are no more than the governess's own fantasies would prove disappointing to these readers.

Unproductive

We have already considered the issue of unproductivity, what Huizinga called the absence of "material utility." Again, we need to stress that the concept of unproductivity is, both for Huizinga and Caillois, tied up in the rather limited sense of material productivity. Certainly it is difficult to conceive of any human activity that does not produce something, even if it is only relaxation or momentary respite from the vicissitudes of ordinary life. So it is with play, and with literary play specifically. Although it is true that the commercialization of the sale of literature creates "goods" and "wealth," to use Caillois's words, only for the most mechanical writer is this probably the single or primary purpose.

What is true is that many writers would see the production of a psychological state in the reader or the political alteration of society as a primary part of their agenda as writers, just as we may read a work of literature in order to understand our own situation or to understand the world better. Given Huizinga's and Caillois's definitions, would these writers be outside the realm of play?

A similar situation obtains with the performance of literature. It is true that for many performers (and audiences), the self-enclosed experience of the literary work in performance is the goal. Yet for centuries literature has been performed for reasons that may be deemed by some as external to the literature itself. The drama of Bertolt Brecht, the fiction of Theodore Dreiser or Leo Tolstoy, the war poetry of Wilfred Owen and Siegfried Sassoon, to name only a few examples, had social and psychological utility as goals as much as any orator or pamphleteer. Yet at the same time, it is important not to forget the exceedingly funny comedy of many of Brecht's plays, the lyrical formalism of Owen's "Dulce et Decorum Est,"

or the incisive characterization of Anna Karenina or even the less adept portrait of Sister Carrie in Dreiser's novel of that name. Just as any work of literature is part of the world at large, so even the most openly and primarily rhetorical work contains elements of play.

Governed by Rules

For some theorists, this aspect of play presents the greatest problems in conceiving of literature as a form of play. Such theorists say that literature does not pay heed to any kind of rules. It is true that neither the writing nor the reading of literature typically makes use of rules in quite the same way as any game we might name. Yet it is probably a misunderstanding of how conventionalized literature functions to suggest that literature does not depend on rules.

Let us look at a few examples of how literature uses rules, for both writers and readers. Although we might disagree about them, most of us could probably come up with a number of rules of literature. A major rule of literature might be that we assume some kind of distance (biographical, psychological, or aesthetic) between the writer and the literary work and also between the literary work and the reader (or the audience in the case of performed literature). Thus, when we read a poem by Robert Frost or an essay by Jonathan Swift, we assume that there will be a distance between the writer and what is contained in the literary work written by Frost or Swift. Although we may infer some relationship between Frost and the speaker he created in such poems as ''The Road Not Taken'' or ''Mending Wall,'' one of the rules of literature requires that we assume at least some difference between the two figures (Frost and his poetic speaker). The same is true with Swift and his essay; although the essay as a form typically appears to move us closer to the writer's own voice and attitudes, we still keep our guard up—surely it would be an error in judgment to read Swift's classic essay ''A Modest Proposal,'' which argues for the eating of children as a solution to the famine in Ireland in the eighteenth century, as an accurate representation of Swift's own self. Therefore, this particular rule of literature, which we may call aesthetic distance, asks us to read literature in a certain way rather than in another.

What is truer in literature (and in all the arts for that matter) than in other kinds of play is that the players (in this case writers and readers) tend to break and stretch the rules more often than they might in a game of Clue or Monopoly. Continuing our example of aesthetic distance, we might look at what is for some readers an exception to the rule: autobiography. For some readers, there are assumptions that go along with autobiography that distinguish it from such other literary forms such as the novel or the play or even the lyric poem, that form of literature most typically associated with the writer's own sensibility. By definition, an autobiography is a narrative of the writer's own life. Thus, one of the secondary rules of literature might be that in the case of autobiography—although depending on our individual preferences or sensibilities as readers, we may be willing to allow some room for invention—we expect that the work has been written by the person whose life it purports to tell and also that it does not invent

"fact." If these two conditions are not met, if these rules are not followed, most readers will probably be uneasy about calling what emerges "autobiography."

It is the tension between the rule of aesthetic distance and what we have called the secondary rules (because they deal with specialized cases rather than universal givens) of autobiography that cause both pleasure and controversy for modern readers. For example, Gertrude Stein wrote a book entitled *The Autobiography of Alice B. Toklas.* Alice B. Toklas was Stein's lover of many years. Stein's decision to write from Toklas's perspective and call it autobiography was clearly a playful strategy. It forced the reader of the work to consider to what extent the reportage accurately expressed Toklas's "autobiography"; to consider what this interweaving of lives meant to the two women involved; and to question ideas of truth, fact, and self in literature and life. The openness with which Stein played with the rules of literature emphasized her own position as player.

Rules also vary depending on who the writer is and what expectations readers bring to the literary work in question. In the 1950s, the burlesque star Gypsy Rose Lee wrote *Gypsy: A Memoir.* Although Lee claimed to have written the entire work without a ghostwriter, this did not seem to be an issue. A good-natured self-promoter, Lee boasted of having a "talent for no talent." For most readers, the question of whether she had written every word or whether everything she recounted happened as she said it did seemed, if not irrelevant, comparably unimportant. The novelist John Steinbeck praised the book for its entertainment value, adding, "and I bet some of it is even true." The latter remark was not meant as a criticism of the book but rather an acknowledgment that the facts were not what really mattered in this autobiography.

Such was not the case with playwright Lillian Hellman, whose three memoirs, *An Unfinished Woman, Pentimento, and Scoundrel Time,* remain the source of heated debate. When the memoirs were published, Hellman was accused of not only embellishing material but also inventing incidents and even characters to make herself appear more heroic. The controversy became so serious that Hellman was engaged in a lawsuit with Mary McCarthy that was still unsettled at the time of Hellman's death. What "rule" allowed readers to look less circumspectly at Gypsy Rose Lee's fabrications but be outraged by Lillian Hellman's? Perhaps more than one rule. First, it is conceded that Lee's early life (which is the subject of *Gypsy: A Memoir*) was harsher than Lee portrayed it: her sister June Havoc's memoirs attest to the monstrosities of their mother. Thus, given Lee's later success, her softening of her early life might be seen as both a daughterly protection of her mother and as an act of self-redemption, making herself over without really hurting anyone. Second, as Lee was never regarded as a major or "serious" (there's that word again!) writer, her violation of the rule was less important.

Hellman, however, was and is considered to be a major American writer of this century, the only woman in its first 60 years to have serious and sustained commercial and critical success as a playwright. The subjects of her memoirs are growing up in New York and in the South, her experiences in Europe during the Nazi occupation, and her resistance to Joseph McCarthy's witch-hunt. One of her major themes is the courage it takes to be honest at all times. Thus, a breach of "honesty" in her own autobiographical writing may be seen by many readers as beyond what the stretching of the rules of the form may allow.

We hope it is clear by now that the acts of writing and reading literature do indeed involve rules, more usually called conventions, and that one difference between rules in literature and rules in some other forms of play is that, typically, literature both allows and even encourages a broader interpretation of and even tinkering with the rules, and that the rules tend to be less universal, more changeable, and in fact often more implicitly understood than overtly stated. Nonetheless, without these rules, the writing and reading of literature would be chaotic.

Are there rules for the performance of literature? Think about this question. What do you automatically assume about any performance of a work of literature that you are either about to prepare or about to be an audience for? For some, one rule might be fidelity to the literary text as written because improvisation of language is unacceptable. A second, perhaps more arguable, rule might be that in general a performer should never or rarely cut anything from the selection to be performed. A rule that has come under more scrutiny in recent years concerns the "humility" of the performer: the assumption that the performer's office is to serve the writer and literary work, not to present the self in any significant way in the performance (though, of course, it is impossible to erase the self completely from any performance). Have you been taught any of these rules, either explicitly or implicitly? Do you agree with them? Why or why not? Can you think of others or substitutes?

Make-believe

Our example of aesthetic distance speaks to the question of make-believe, just as the tensions provided for some readers by autobiography suggest the ways in which it is probably impossible to divorce play completely from "reality." It is a time-worn cliché that the wars of England are "won on the playing fields of Eton," suggesting that sport prepares its players for military service. Similarly, actors are often accused of being unable to distinguish between the theater and "real life," suggesting that they never step out of character or, conversely, that they never have a personality of their own. How do we resolve these kinds of observations with the quality of make-believe Caillois sees as characteristic of play?

Putting it simply we might say that play may operate on at least two levels: the "second reality" suggested by Caillois and a residue that carries into everyday life. It is not the existence of these two levels that causes problems but the confusion. The inability of the cowboy, around the turn of the century, to distinguish stage melodrama from real life, thus causing him to draw a pistol and aim at the villain is what may be called "underdistancing." Conversely, the old movie in which the actor playing Othello suspects his wife of infidelity and wants to strangle her is an example of a performer who is unable to make the necessary distinction. The play between make-believe and real life is at the center of what is arguably the greatest play in English, Shakespeare's *Hamlet,* in which the title character has a make-believe play that mirrors what he suspects were the events surrounding his father's death acted before his uncle, whom he suspects is the murderer.

Caillois suggests that the last two qualities of play—rules and make-believe— are related in important ways, and our examples attest to this assertion. Autobiography, a form often placed at the boundaries of literature and history (if the two

can indeed be separated), suggests that there are indeed border areas between play and real life, regions of what anthropologists call liminality, and that play and real life are spaces along a continuum rather than discretely drawn lines of demarcation.

We will now look at Caillois's other major contribution to play theory, his classification of games. On criticism of Huizinga's play theory is that it is heavily weighted toward play as contest or competition, and it ignores or diminishes any form of play that falls outside the scope of winning and losing. Caillois's classification of games triumphs over this dilemma, seeing the purposes and effects of games as more varied. We will consider where literature fits among these different kinds of games.

CAILLOIS'S CLASSIFICATION OF GAMES

We have considered at some length the ways in which Caillois expanded on Huizinga's definition of play, discussing also the specific ways in which literature and the performance of literature do and do not fit into these definitions. Caillois went even further by attempting to classify games according to two sets of variables: first, a continuum from what he calls *paidia* to *ludus* (we will explain these terms below) and, second, a particular dominant characteristic of a given game. Look at Figure 6.2, which depicts the categories and qualities of Caillois's system of classification. Caillois devised the chart to suggest the intersection of these two variables as descriptions of play (36).

Let us first consider what Caillois means by *paidia* and *ludus*. Each word suggests a degree of freedom or institutionalization that Caillois sees as distinctive in play. He chooses *paidia* to denote "the spontaneous manifestations of the

FIGURE 6.2 Classification of Games

SOURCE: Roger Caillois, *Man, Play, and Games,* trans. Meyer Barash (New York: Free, 1961). Reprinted with the permission of the publisher.

		AGÔN (Competition)	ALEA (Chance)	MIMICRY (Simulation)	ILINX (Vertigo)
PAIDIA ↑ Tumult Agitation Immoderate laughter		Racing Wrestling ⎫ not Etc. ⎬ regulated Athletics ⎭	Counting-out ryhmes Heads or tails	Children's initiations Games of illusion Tag, Arms Masks, Disguises	Children's "whirling" Horesback riding Swinging Waltzing
Kite-flying Solitaire Patience Crossword puzzles ↓ LUDUS		Boxing, Billiards Fencing, Checkers Football, Chess Contest, Sports in general	Betting Roulette Simple, complex, and continuing lotteries	 Theatre Spectacles in general	Volador Traveling carnivals Skiing Mountain climbing Tightrope walking

play instinct: a cat entangled in a ball of wool, a dog sniffing, and an infant laughing at his rattle . . .'' (27–28). Note that these examples are at the extreme end of the continuum; it is probably accurate to say that they suggest a developmental beginning in the human being, a phase out of which the child characteristically grows. In a sense, *paidia* may be seen as corresponding to what we have been calling pure play.

Ludus, in contrast, involves institutionalization of the play instinct originating in *paidia.* As Caillois's chart indicates, most formalized games may be seen as sitting far closer to *ludus* than to *paidia.* For Caillois, although *ludus* is a fact of civilization, it is neither a higher nor more desirable order of play than *paidia.* In fact, his discussion of *ludus* suggests that the opposite is the case:

> At the opposite extreme, this frolicsome and impulsive exuberance [*paidia*] is almost entirely absorbed or disciplined by a complementary, and in some respects inverse, tendency to its anarchic and capricious nature: there is a growing tendency to bind it with arbitrary, imperative, and purposely tedious conventions, to oppose it still more by ceaselessly practicing the most embarrassing chicanery upon it, in order to make it more uncertain of attaining its desired effect. (13)

Thus, keeping some of our earlier questions about freedom in mind, we can see that in Caillois's world, the classroom study of literature and performance is a manifestation of *ludus,* as opposed to the *paidia* of spontaneous occasions for reading and performing. It may also be useful to consider some writers (and readers, for that matter) as falling closer to one end of the *paidia-ludus* continuum: Cummings seems more engaged in *paidia,* Lawrence in *ludus.* We hasten to add that Caillois's validation of *paidia* over *ludus* is not one we necessarily wish to put forward as either representative of our position or a desired universal condition but, rather, that his continuum does seem a useful way of seeing the range of play, particularly in its games.

In counterpoint to this continuum, Caillois sets four principal categories for types of games, and we find these divisions especially useful in trying to see the different kinds of literary play we may encounter. We might add that Caillois proceeds to complicate matters by drawing ratios among these four categories, combinations of the dominant characteristics. For our purposes, we will empha-size the four individual categories, but as will become clearer in the second half of our discussion of play, most actual literary works combine two or more categories.

Agon (Contest)

This category is the most traditional of games and, as we observed, the one Huizinga saw as central to play in general. In a sense, it is possible to look at any literary text as a site for a contest between writer and reader. Whether it is a mystery writer inventing a murder and challenging the reader to second-guess the outcome or whether it is a poet invoking levels of symbolism that invite the reader to puzzle out ''meaning,'' there is a sense in which the writer somehow

throws down the gauntlet, sometimes in a friendly way, sometimes in what seems an almost hostile, "antireaderly" way. Peter Hutchinson in his book *Games Authors Play,* suggests some of the ways in which authors play with the reader: allusion, ambiguity, hoax, and red herrings (clues that throw the reader off) are only some of the "contests" he describes.

A few specific examples might clarify this concept of literary text as contest. Eudora Welty's story "Why I Live at the P.O." is a first-person narrative, told from the point of view of Sister, the beleaguered postmistress of a small town in Mississippi. Her story details the outrages practiced on her by her family, particularly by her sister Stella-Rondo, the family favorite.

Although its outlandishness may well tip off the more sophisticated reader fairly early on, the story tends to trick most readers, who feel great sympathy for Sister for awhile until details start to contradict one another, or we feel that Sister seems to embellish her tale to her own advantage. At some point, most readers catch on and enjoy Sister's unreliability as narrator. To do so is to enter into a conspiracy of sorts with the implied author; to miss the implied author's irony is, in a sense, to "lose" the game. It is certainly true that the game is one in which the desired effect is to have no losers; surely Welty would feel less satisfied to have readers feel eternally sorry for Sister.

A second example is some poets' use of actual puzzles in their poems. Both Lewis Carroll and Marianne Moore have used acronyms in their poems as a private puzzle. In his epilogue to *Through the Looking-Glass,* a novel based on the game of chess, by the way, Carroll presents a poem entitled "A Boat, Beneath a Sunny Sky." The first letter of each line of the poem combines to spell out the name Alice Pleasance Liddell, the actual child-reader to whom Carroll dedicated his books. Similarly, Marianne Moore in her poem "The Wood-Weasel" creates a reverse acronym, in which, again taking the first letter of each line starting with the last line of the poem and moving backward, we discover the name Hildegarde Watson, a close friend of Moore's and the owner of the coat described in the poem. Such games with the reader, although they do not present a tangible criterion of "winning" or "losing," do suggest a prize to those readers adept enough or informed enough to discover the added treasure. In general, though, it is probably more accurate to say that the contest of literature is not unlike the Caucus Race in Carroll's own *Alice's Adventures in Wonderland:* a race in which there may be many winners, each winning a different prize.

Alea (Chance)

The second category Caillois identifies is games of chance; he derives the name of this category from the Latin for a dice game: "I have borrowed it [*alea*] to designate . . . all games that are based on a decision independent of the player, an outcome over which he has no control, and in which winning is the result of fate rather than triumphing over an adversary" (17). Caillois sees *alea* as the opposite of *agon;* in *alea,* hard work and ingenuity count for nothing, and that is its very appeal. The popularity of lotteries and other forms of gambling attests to the power of such games.

We might ask ourselves how on earth a game of chance is relevant to literature. Literature might seem of all play activities to be the least in debt to chance. We may say that the very idea of an author suggests a conscious plan, the exercise of control over the variables involved in the literary work. Similarly, the audience's freedom to choose to read or not to read might also seem to work against chance as a part of the literary experience.

There is another way of looking at the issue, however. It is possible to conceive of language as itself an arbitrary set of signs, over which the human being has limited control; for instance, we do not invent new sounds (at least not at the level of the phoneme, the smallest unit of sound) but rather select from those already present in language. Similarly, once we move beyond the level of the individual sound we may see how language is, at least to some extent, a matter of chance. Although we certainly have more choices at the *lexical* (the level of words) and *syntactic* (the level of sentences) level than we do at the phonetic, we are still typically limited by established conventions and existing vocabularies. To exert complete control over language, we would have to invent our own. Even then, it is doubtful that we would be able to do so without some reference to our own history of language: what we are used to language being. Thus, at some level, language speaks (or writes) us as much as we write it. It is this lack of complete control that contributes to the sense of chance being involved in the composition and reading of literature.

It is also true that many writers speak of their literary works taking control over them, again suggesting that a certain amount of chance is involved at any level of literary experience. The ancient philosopher Plato saw this in religious terms: he believed that poetry was a form of divine madness, in which the gods spoke through the poet. This idea led Plato to believe that there was very little artistry in literature. Modern writers do not speak to this issue as well. In interview after interview we find authors confessing that a given character took over the process at some point, leading the author in directions that must be seen as beyond conscious or complete control.

This is not to suggest that we should see chance as the dominant feature of literary play. It can be, as for example, in the Dada movement, in which artists would cut up existing texts and pluck them out of a hat at random, making a new poem out of an old one. But even in the case of Dada, chance is at least somewhat dependent on the products of the human imagination.

Though chance might seem the most constraining of play forms, because it takes away much if not all choice from the players, oddly enough, games of chance are extremely popular (consider the success of gambling, legal and otherwise, as a big business in America). Caillois suggests that "games of chance would seem to be peculiarly human" (18), that such games correspond to the very human awareness of the role of destiny in life: "To await the decision of destiny passively and deliberately, to risk upon it wealth proportionate to the risk of losing, is an attitude that requires the possibility of foresight, vision, and speculation, for which objective and calculating reflection is needed" (18). So, chance does not exclude human consideration; rather, it stacks the odds against the player. Chance can in some ways absolve the player from the guilt that the idea of complete control

might carry; if we must trust to destiny, at least to some degree, we are relieved of some sense of responsibility.

Let us take the idea of chance one step further: to what degree is chance a factor in performance? We suppose most of us would like to deemphasize the role of chance—certainly we do not encourage performers simply to "trust to destiny." Conscious and careful preparation is a requisite in all good performances. But we also recognize that chance does play a role in performance: such variables as spontaneous inspiration, the mood of the audience, and the context of the performance overall (what has preceded, for example) may affect the shape the performance takes. It is not that these factors are completely out of the control of the performer; rather they may influence performance quality and reception in ways that cannot be anticipated. In some ways, this element of chance can add excitement (and also anxiety): many students, who have never performed before find that the unknown of how they, the text, the audience, and the context will all combine to create the performance adds a degree of play, a living presence to the experience of literature that they had not anticipated. So although chance is not enough to account for a performance, it should not be overlooked, either in the preparation of a performance or in the analysis of a performance that has taken place.

Mimicry

Mimicry is derived from the same root as the Greek word *mimesis,* which roughly translates into English as "imitation." As such, mimicry is fundamental both to play and to literature. Again, the Greeks provide some of the earliest discussion of the importance of this play element to literature: Aristotle's *Poetics* states that a tragedy is an imitation of an action of a certain quality (25). By this, he meant that tragedy (specifically, tragic drama) mirrored the activities of human life. He did not mean that tragedy simply documented life; rather, it selected from life incidents and perspectives and arranged them in an order that is consonant with the span of existence.

Similarly, the mimicry of everyday play rarely attempts to reproduce every detail of that which is being imitated. When children play house, they choose the largest, perhaps most symbolic aspects of day-to-day life and "live out" those moments or phases. So it is with literature: the *synecdoche,* the part that stands for the whole, is at the center of mimicry. This is true whatever the form of literature; a story or novel, no matter how long, cannot hope to capture every moment of the protagonist's existence, nor can even the most personal of lyric poems ever reflect every emotion or response felt. This is also true of nonfictional forms, which although they do attempt more of a documentation of actual lives, nonetheless must choose to include some aspects and exclude others. It is its very selectivity that gives mimicry its artistry.

Equally important is the concept of illusion. When we mimic anyone or anything, we are asking our audience to believe, even if it is only for a moment or with only a partial belief, that what they are seeing or hearing is "reality." The belief in the illusion may not be complete; that is, we may not give in entirely to the illusion. This partial belief need not be seen as a flaw, either in the writer,

the performer, or the audience. Sometimes, it is the tension between belief in the illusion and recognition of its temporary quality that makes a literary work or its performance pleasurable. In a work of literature, we may derive pleasure when we are able to infer a considerable distance between the implied author and the speaker or character, as in a poem like Robert Browning's ''My Last Duchess''—in which a Renaissance duke delivers a monologue suggesting that he has had his last wife murdered—or in a story like Eudora Welty's ''Why I Live at the P.O.,''—in which there is clearly quite a distance between the implied author and Sister, the narrator. Our belief in the characters is matched by our sense of complicity with the author and his or her implied judgment of the character. The function of mimicry is twofold, simultaneous belief and evaluation.

Yet we can and do take pleasure in those literary works that do seem to create a seamless illusion, in which we feel that a reality has been created for us, with little evidence of the author behind the work. It is probably true that the more sophisticated we become as readers and audiences, the less we are able to give in to illusion completely, but some works of literature take us farther than others, partly because of intention (some works aspire to greater illusion than others) and partly because of skill (some authors are simply better than others at creating illusion). The literary movement known as realism builds its philosophy on the desire to create utter illusion. Some kinds of literature lend themselves more readily to this kind of illusion than others. A playwright like Tennessee Williams in *A Streetcar Named Desire* or Edward Albee in *Who's Afraid of Virginia Woolf?* draw painfully real portraits of women and men together, and both use the realistic approach to make statements about the difficulty of separating reality from illusion—whether it can be done and what price is paid for doing so.

Think about mimicry and performance for a moment. Are you accustomed to praising those performances that seem to you to sustain most successfully the illusion of a reality? Or do you prefer those performances that remind you that they are performances, which allow or even require you to see through the imitated world or characters and glimpse the thinking, conscious performer? We would suggest that neither of these approaches to performance is by nature better than the other, that each simply may have a different set of goals, expectations, and effects. What is important is that the performer be aware and signal to the audience his or her own intentions, having thought through the reasons for these intentions. Mimicry may take many forms, from the most physically and psychologically detailed imaginable to one that exaggerates and lampoons, that caricatures for the purpose of social or political statement. It is up to the performer to determine how and why mimicry is important in a given context.

Ilinx (Vertigo)

Ilinx, or vertigo, is the last of Caillois's four principal types of play. *Vertigo* usually refers to a physical condition brought on by a fear of heights or motion; Caillois uses it to refer to a game that is ''an attempt to destroy momentarily the stability of perception and inflict a kind of voluptuous panic upon an otherwise lucid mind'' (23). Of the four types of games, Caillois suggests, ilinx is the one least

unique to the human being: it is common to observe animals taking great pleasure in such physical sensations. In humans, ilinx may be seen in such physical activities as certain kinds of dance, some sports, and even a child's twirling spin. When we take a ride on a roller coaster or walk through a haunted house or hall of mirrors in an amusement park, it is this sense of vertigo we seek. In some respects this form of play may be the most difficult to analyze. We can find psychological and social roots in the three others, but perhaps ilinx is a more physically based, instinctual variation on the game of chance, in which we give ourselves to external forces. Perhaps the vertigo we experience is pleasurable because we know it is temporary and artificial: it gives us the sensation of being endangered, of losing control over our own bodies, without the actual fear of the permanence of such a condition.

Does literature ever give us the experience of ilinx or vertigo? Consider the selection from Lawrence's *Women in Love* once more (pages 439–47). Read again the passages describing the wrestling. Do you feel yourself falling into any of the physicality of the actions described? If so, you may notice your own metabolism rising and falling, an actual reaction to the events being recounted. Now look back to cummings's poem. Remember that we asked you to read it once strictly for rhythm and other prosodic features. When we asked you to try to divorce the sense of the words and sentences and simply experience the sounds cummings orchestrated, in a way we were pushing you toward an experience of vertigo. Tongue twisters, in which the mouth must work at double time to keep up with the intricacies of the sound combinations, can leave us breathless, with our hearts pounding in our ears. Perhaps the supreme example of a story exploiting vertigo is Edgar Allan Poe's "The Tell-Tale Heart," in which the madman-narrator is so haunted by the imaginary beat of the heart of his murder victim that he finally confesses to the crime, so possessed is he by the vertigo of his aural hallucination. In this case, the vertigo is the downfall of the narrator, but much of the reader's or audience's pleasure resides in our own eerie experience of that heartbeat in the sound of the narrator's voice (whether we read the story silently or perform it or have it performed to us) and the vertigo it creates within us.

Because ilinx is the most immediately physical of Caillois's four types of play, it is the most immediately accessible aspect of play in performance. It is difficult to conceive of any performance that does not, at some level, engage performer and audience in the world of physical sensation; even the most internalized lyric poem tends to use language in a way that evokes a physical response. It is true here, as with the three other forms of play, that vertigo is emphasized more in some literary works and in some performances than in others; it is also true that some performers may choose to highlight the physicality of a text more than others. But at some level, unless a text is entirely static and inert (and, hence, "dead"), the impulse toward ilinx will be present.

CONCLUSION

We have presented Caillois's theory of play because it offers rich possibilities as a way of analyzing both literature and performance and as a place from which to embark on your own performances. The idea of rules and literature has proven

troublesome for some critics; others may find vertigo too violent a way of describing our physical responses to literature. We encourage you to think carefully and argumentatively about the issues raised and about other issues a play perspective brings to the whole business of literature and performance. For instance, it may be argued that a play perspective emphasizes the pleasurable aspects of literature and may deemphasize other important areas, such as social change and education.

In answer we might point to the group of contemporary critics and philosophers known as deconstructionists. Although their philosophy is too complex to elaborate on at this point, they are profoundly committed to the role of play in literature and in society in general. The very conditions of play we have examined, such as freedom to participate and uncertainty of outcome, to name only two, are essential to their outlook on the ways in which literature is connected to society. Similarly, a number of French feminist thinkers are attempting to describe and analyze what they call *l'écriture féminine,* which may be alternately treated as "feminine writing" or "writing-the-woman," a use of language they see as characteristic of women—less linear or bound by rational logic and more connected to the pleasure of the body as exemplified in discourse, a pleasure they call *jouissance,* sexual in its connotations. Although both the deconstructionists and the French feminists (many of whom borrow concepts from the psychoanalyst Jacques Lacan) remain controversial groups, they are challenging what they see as conventional definitions of language and literature and standard criteria for evaluation. They are passionately interested in what Victor Turner called "the human seriousness of play."

In our next chapter, we will turn from the theoretical issues of play and its components to a concrete discussion of three aspects of literary play, which cross and sometimes combine the categories discussed here: sound, sense, and nonsense.

WORKS CITED

Aristotle. *Aristotle Poetics.* Trans. Gerald F. Else. Ann Arbor: U of Michigan, 1970.

Barthes, Roland. *Mythologies.* 1952. Trans. Annette Lavers. New York: Hill & Wang, 1972.

Bateson, Gregory. *Steps to an Ecology of Mind.* San Francisco: Chandler, 1972.

Caillois, Roger. *Man, Play, and Games.* Trans. Meyer Barash. New York: Free, 1961.

Culler, Jonathan, ed. *On Puns: The Foundation of Letters.* Oxford: Blackwell, 1988.

Cummings, e. e. "maggie and molly and milly and may." *Complete Poems, 1913–1962.* New York: Harcourt, 1962. 682.

Gates, Henry Louis, Jr. *The Signifying Monkey: A Theory of African-American Literary Criticism.* New York: Oxford UP, 1988.

Huizinga, Johan. *Homo Ludens: A Study of the Play Element in Culture.* Boston: Beacon, 1955.

Hutchinson, Peter. *Games Authors Play.* London: Methuen, 1983.

Lawrence, D. H. "Gladiatorial" from *Women in Love.* In *The Portable D. H. Lawrence.* Ed. Diana Trilling. New York: Viking, 1947. 456–70.

Meschonnic, Henri. "Rhyme and Life." *Critical Inquiry* 15 (1988): 90–107.

Trilling, Diana. "Introduction." *The Portable D. H. Lawrence.* New York: Viking, 1947. 1–34.

FOR FURTHER READING

Auerbach, Erich. *Mimesis: The Representation of Reality in Western Literature.* Trans. Willard Trask. Princeton: Princeton UP, 1953.

Carse, James P. *Finite and Infinite Games.* New York: Free, 1986.

Guinness, Gerald, and Andrew Hurley. *Auctor Ludens: Essays on Play in Literature.* Philadelphia: J. Benjamin, 1986.

Messenger, Christian K. *Sport and the Spirit of Play in Contemporary American Fiction.* New York: Columbia UP, 1990.

Ong, Walter J. *Fighting for Life: Contest, Sexuality, and Consciousness.* Ithaca: Cornell UP, 1981.

CHAPTER 7

Language and Literary Play: Sound, Sense, and the Play of Literature

Hoopsa, boyoboy, hoopsa!

—James Joyce, *Ulysses*

This sentence begins the chapter known as "Oxen of the Sun" in James Joyce's twentieth-century novel *Ulysses*. It begins our chapter because it demonstrates the degree to which play is an important element in even some of the most complex and sophisticated literary works. Joyce's novel is considered one of the most playful works of literature ever written. It parallels the wandering of Odysseus, the trickster hero of Homer's epic poem, reset in Dublin on one day in June in the early part of this century.

About two-thirds of the way through the novel, just as some of the characters are about to descend into Nighttown—a dramatized burlesque of Hades, seen as a street of brothels and pubs—Joyce inserts a chapter that is a work of performance virtuosity. In "Oxen of the Sun," Joyce traces the history of the English language and English literature from its folk origins (in the sentence quoted above) through a parody of the style of medieval heroic epics through all the literary developments of style from Elizabethan England to the present day. The chapter ends in an explosion of contemporary, "popular" English—slang, cursing, and vulgarity—reducing language once more to the basest level of the senses, in essence ending the chapter where it began. In the midst of all of this, the plot moves forward as a group of interns and doctors await the birth of a baby in a maternity ward and go out to drink afterward.

Joyce is celebrating birth, sensuality, and language—he is, more than anything else, playing in this section. He demonstrates an awareness of the origins of human play in the experience of the child, whose first encounter with language is the joyful exclamation of the midwife, "Hoopsa, boyoboy, hoopsa!" Language is a vehicle for play, a way of playing. Although it is doubtful that a midwife or nurse

would actually toss a newborn child in the air, her language does so: the vertigo of which Caillois spoke and which we discussed in the last chapter are created here through language.

In chapter 6, we examined some theories of play and some vocabulary to describe what play is. We also considered some general ways in which literature and performance are profitably thought of as play. In this chapter, we will explore uses of language in literary play. We will divide our discussion into two main areas: sound and literary play and sense and literary play. Again, we hasten to add that these divisions are, at some level, arbitrary and artificial; as you will see, these categories intersect with each other at many points. We have decided to discuss the areas in the order listed because we believe they correspond to the development of the human being as a conscious performer of and audience for play. Sound (and its attendant pleasures) is the beginning place for the child, though it is important to recognize that some children have a wonderful feeling for the contradictions embodied in irony at an early age, earlier, in fact, than they might be able to articulate their pleasure in such acts (as in the world of nonsense, which has phonetic and semantic levels). Similarly, some of the most "adult" works of literature (such as some modern poetry by such writers as Gerard Manley Hopkins and Dylan Thomas) emphasize sound, sometimes deemphasizing "sense" almost completely. Throughout, we will be looking across the spectrum of age and cognitive development; sometimes it is the writer's use of a form of literary play more typically associated with another age group that adds to the work's meaning and achievement.

We turn first to the world of sound.

SOUND AND LITERARY PLAY

Our experience of rhythm precedes our entrance into the world external to our mothers. Even in the womb, we are engaged in the symbiotic rhythm of the beating of our mother's and later our own heart. Although we cannot name at a conscious level what we are experiencing, we need this pattern of rhythm to sustain our lives. In a sense, rhythm is itself the impulse that supports us from birth to death. A heart that is arhythmic is considered faulty.

What is rhythm? Definitions vary, but the most inclusive sense of rhythm would include any pattern of repetition and variation. We are accustomed to thinking of rhythm in terms of sounds and in terms of beats (as in music) or stress (as in language), though research suggests that rhythm cannot be reduced to one or two characteristics. Rhythm may be any set of characteristics that gives an experience (whether literary, musical, or even nonartistic) a sense of pattern, a sense of return and release. We often speak of the rhythm of the waves in the ocean or the rhythm of the seasons in the calendar. Rhythm is sometimes quite rigid; sometimes it is not. Some people prefer a highly structured sense of rhythm, both in their lives and in their art; others may enjoy the spontaneity that a certain degree of unpredictability (within their own, personal set of limits) may allow.

Rhythm, then, certainly includes the traditional rhythms we have been taught to assign to poetry (such as the foot and other prosodies discussed in relation to cummings's poem in chapter 6), but it may also include other elements beyond the level of pure sound; the pattern of having four girls in cummings's poem may very rightfully be considered rhythm. It builds an expectation in the reader (which it fulfilled), yet allows enough room for variation within each girl's experience. Rhythm also exists at the level of repeated words, parallel grammatical structures, patterns of images, and so forth. The mark of rhythmic excellence rarely rests in the writer's ability to establish a rhythm with no room for elasticity; rather, it is typically the tension between pattern and variation that creates the most satisfying, complicated sense of pleasure.

Where do children first take pleasure in the rhythms of literature? In lullabies, traditional and improvised, sung to them by their parents. Think back to any songs sung to you by your parents. Which ones do you remember? We recall "Rock-a-bye, Baby" and "Bye, Baby Bunting" and, probably like most of you, can sing these songs even now. But what we don't recall is the specificity of the content. Consider the content of each:

Rock-a bye, baby, on the tree top,
When the wind blows the cradle will rock;
When the bough breaks the cradle will fall,
And down will come baby, cradle, and all.

Bye, baby bunting,
Daddy's gone a-hunting,
Gone to find a rabbit skin
To wrap the baby bunting in.

Although as adults we find it fascinating to speculate on the origin and significance of such songs, we think you will agree with us that very few babies or small children will notice the specific content of the words; if they did, we imagine that these songs would create more nightmares than lull children to sleep. What soothes the child is the regularity of the sound and the familiar voice of the performer (usually a parent). It is the predictability of the rhythm, in this case, that is emphasized: if the singer misses a beat or gets out of rhythm, the child may very well notice.

The same is true of rhyme, that "echo from word to word" (Meschonnic 93), usually of specific individual phonemes or clusters of phonemes. In the lullabies quoted above, in addition to the felt regularity of rhythm, the child may take pleasure in the pairs of rhyming words, such as "top" and "rock" (not quite a full rhyme), "fall" and "all," "bunting" and "hunting," and "skin" and "in." As we develop as readers, we pay more attention to which words rhyme with which and to any semantic connections that emerge from such pairings, but at this stage it is simply the presence of the rhyme itself that gives pleasure. The *ilinx,* to use Caillois's term, is not vertigo here so much as stability.

As children begin to participate in literary performances, by chiming in with those who read to them or through play with other children, rhyme is a principal

source of pleasure, in great part because the child understands the rules of the game easily. For example, Bruce Henderson gave his nephew Dr. Seuss's *Green Eggs and Ham* as a birthday present a few years before he could read. Less than a month later, his mother called to report that this book was the nephew's favorite—he always wanted to shout out "I do not like green eggs and ham, I do not like them Sam I am," the refrain of the verse that is part of the verbal text of the book. The major reason for the child's enthusiasm was surely the degree of repetition in the two lines, both the identical repetition of "I do not like" at the beginning of each line (called *anaphora*) and the rhyming pairs "ham" and "Sam I am," which triples the rhyme through the internal rhyme of "sam" and "am" in the second line.

That rhyme is a principal source of pleasure remains true in those songs or poems we traditionally call nursery rhymes or Mother Goose rhymes. Tongue twisters are perhaps the most vivid examples of what Northrop Frye calls "babble," the pleasure of the human voice producing sound, divorced from what we think of as meaning. Verses like "Peter Piper picked a peck of pickled peppers" remain living texts not because they offer insights into any universal condition but because human beings (whether children or adults) continue to enjoy the dizzying race of keeping up with rhythm and the plosive *p* sounds.

At this point it is important to make a distinction between two principal uses of sound in poetry (and other forms of literature): between that form named by critic Dick Higgins as "sound poetry," on the one hand, and nonsense verse on the other (Higgins uses the phrase "nonsense poetry," but we prefer the more prevalent "verse" in this instance). It is easy to confuse the two but essential to separate them, as they evoke different performances and go after different effects from their audiences.

> Sound poetry is somewhat different from some kinds of nonsense poetry, since the category includes materials which have no correspondence with the normative world, which is not true of all sound poetry. That is, there may be considerable sense or logic in the acoustic structuring of a sound poem, while much of nonsense verse deliberately rejects logic or sense except in its own universe. In fact nonsense verse tropes upon the conceived contrast between what we know and what we are hearing. . . .
>
> In sound poetry, on the other hand, the sound generates its own sense through its patterns and by their reference to our experience. (42)

Which of Higgins's two categories would "Rock-a-bye, Baby," and "Bye, Baby Bunting" most easily fit into?

Gertrude Stein's *Susie Asado:* An Example of Sound Poetry

Let us look at a poem in which sound is arguably the primary determinant of pleasure for the reader (performer) and audience (listener). Again, it is important to remember that the point is not that this text is devoid of semantic

meaning (as we usually name it) but rather that sound is, for many readers, what is most important.

Susie Asado

Sweet sweet sweet sweet sweet tea.
 Susie Asado.
Sweet sweet sweet sweet sweet tea.
 Susie Asado.
Susie Asado which is a told tray sure.
A lean on the shoe this means slips slips hers.
When the ancient light grey is clean it is yellow, it is a silver seller.
This is a please this is a please there are the saids to jelly. These are
 the wets these say the sets to leave a crown to Incy.
Incy is short for incubus.
A pot. A pot is a beginning of a rare bit of trees. Trees tremble, the
 old vat are in bobbles, bobbles which shade and shove and render
 clean, render clean must.
 Drink pups.
Drink pups drink pups lease a sash hold, see it shine and a bobolink
 has pins. It shows a nail.
What is a nail. A nail is unison.
Sweet sweet sweet sweet sweet tea.

After reading this selection silently, go back and read it aloud. How would you describe the experience of trying to utter it? Frustrating? Amusing? Entertaining? Confusing? How did you go about trying to speak it? If you are like most readers, you began by trying to follow all the rules of English grammar and syntax you have learned (in many cases subconsciously) from the time you began to speak. You looked for the standard parts of the sentence (i.e., noun, verb, and so forth) and tried to construct sentences that moved as standard English ones do. If you are like many of us, you were comparatively successful at doing this, in a strictly formal way. Although Stein throws in unexpected words, her sentences sound more or less like sentences.

Did the performance process break down for you at any point? For some performers, it is impossible to make ''sense'' of this poem at all—it is so far removed from a world of reference (i.e., a system in which words refer to recognizable things, actions, and qualities in the world we experience) that to try to assert a ''meaning'' becomes an unattainable goal.

If most performers find themselves unable to come up with a paraphrasable summary of the situation of this poem, of what value is it? Does it help to know that some critics believe that Stein wrote this poem after viewing a flamenco dancer and that the poem was in some sense an attempt to capture what she saw and (perhaps more important) heard? For some performers, this knowledge will help locate their imagination in some kind of imitable world. As they utter the poem, they can project themselves into either the sensibility of the dancer or that of the audience. But having done that, to what extent are Stein's actual words

a useful example of "mimicry"; can you explain what dance actions "Incy is short for incubus" imitates? We confess that we are hard put to go that far. What might the performer do with this selection?

We have witnessed two performances of this text, each of which approaches the challenges of Stein's words in a different fashion. The first was a solo performance, given in the context of a longer two-person performance of works by Stein. The performer emphasized the vocal "music" of the poem, giving it a kind of improvisatory "swing," not unlike a jazz musician, taking the text of English sound and playing off in her own directions. There was very little physical movement in the performance (a few occasional hand gestures or bodily movements) but simply the encounter among voice, sound, and the language of Stein. The performance of the poem was not framed by any explanation of possible settings or contexts (such as the flamenco dancer) but was "pure" sound (though, obviously, the performance took on some of the resonances of the other Stein pieces).

The second performance of "Susie Asado" was also a portion of a longer performance, which was not exclusively made up of Stein material; in fact, "Susie Asado" was the only piece by Stein in the performance. The entire performance was entitled "Poetry in Motion: experiments in language and dance" and was a self-contained anthology of performances involving modern poetry and modern dance. As with the other performance of "Susie Asado," there was no spoken introduction of the poem or the performance. There was a printed program, which gave a little background to Stein and explained the possibility of the flamenco dance as the genesis of the poem. As is always the case with program notes, it is unlikely that all audience members read them or read them before observing the performance. The director and the choreographer saw the program notes as an extra opportunity to offer some information but realized that the performance would have to stand on its own.

The poem was chosen to begin the evening's performance, principally because it offers language in motion, without a connected referential situation or context. A temptation for the director and the choreographer was to take the flamenco dance as the medium of performance for the poem, but they resisted this temptation for the simple reason that they did not want to feel too tied to a literalization of the historical moment that perhaps gave rise to the poem.

Instead, they chose to bifurcate language and dance, in some sense respecting the division between the poet's voice, creating language, and the body's response to the poem. A solo reader at a lectern stood to one side of the stage, in front of the proscenium, deliberately separating himself from the world of the dancers. He used a microphone to amplify his voice, so that the sound would outweigh his physical presence. The decision was made not to leave him offstage but to allow him to be present, if minimized, as a human sensibility giving rise to the language the audience would hear.

In searching for a medium of dance that would serve analogously to the language, the director and the choreographer decided on tap dancing, for a number of reasons. First, tap is a uniquely American dance form and would suggest

Stein's own Americanness (despite her self-exile to Europe for much of her life); the director in particular felt the presence of an American voice in Stein's use of slang and rhythms. Second, and perhaps more important from a performance standpoint, tap is the most vividly rhythmic of the dance forms; unlike ballet or modern dance, tap actually produces sounds, mimicking the syncopated beat of an unorthodox metronome. Six dancers were selected for this piece, again, as an attempt to avoid the identification of one dancer with the dancer behind the poem's genesis. The dancers were all women and were all dressed in white, glittery outfits, not unlike show girls from a Las Vegas nightclub. The intended effect was slightly satiric and also slightly exotic.

The reader entered in darkness and was in position when the lights came up. As soon as he was in place, microphone in hand, the dancers entered, already tapping as they moved onstage in line. After a moment of silence, the reader and the dancers began their performance of the poem. During rehearsal, the director and the choreographer considered whether to try to score the speaking and dancing exactly (such scoring is possible through Labanotation, a notation system that allows a choreographer to mark exact movements and timings). They experimented with this kind of precision dancing but found that it tended to mechanize both the reader and the dancers, depriving the poem of the very free-spirited quality that drew them to it.

What finally emerged was choreography that echoed many of the rhythms of the poem but did not bind itself to the exact speech patterns of the reader. This was fortuitous, as the reader found he could never sustain quite the same rhythm or timing two performances in a row (if you look closely at the poem, you will understand why such rigidity was virtually impossible and probably undesirable). The reading and the dancing did not work as exact counterpoints to each other, but there was audibly and visually a relationship between the two. Some nights the reader felt he had to race to keep up with the pace of the dancers; other nights, he found himself trying a slightly different phrasing or rate, which he would then adapt to coincide at various points with the dance. This variation required the dancers, who didn't have the luxury of such improvisation because they were tapping together, to learn a rhythm in their heads, paying attention to the voice of the reader but also relying on the inner beat set by the director and choreographer.

It would have been interesting to ask audience members what they thought the poem, the dance, and the performance "were about." Each night the performance received an enthusiastic round of applause and was accompanied by laughter. What was clear is that most of the audience enjoyed the play of language, voice, and bodies, whether they were able to discern an underlying meaning to the poem or not. In this sense, they experienced "Susie Asado" as sound, typically not wondering about sense. It is possible to argue that they enjoyed the poem as nonsense, but that assumes that they were able to identify gaps in their expectations. Is "Susie Asado" more about sound or about nonsense? Both the performances we have described cared little about the sense or lack thereof in the poem; we would therefore argue that sound is what dominated. Another performer might devise a performance that highlighted the ways in

which the poem wreaks havoc with the expectations of sense readers bring to poems.

You have now read about two different performance approaches to the poem—one focusing on the solo voice, one on the divisions between voice and body, and both emphasizing sound and rhythm. Can you conceive of other performance approaches, either as a solo performer or as a group director or participant? Do your ideas focus on sound or on sense versus nonsense elements?

The House That Jack Built and *Visits to St. Elizabeths*

We will now consider how sound and sense intermingle, sometimes to contradict or confuse each other. We will begin by returning to the world of the nursery rhyme and to a modern poem that uses the rhythmic and syntactic frame of the nursery rhyme in subtle, often disturbing ways.

As children learn to read, they begin to participate in the processes of literary play in different ways. For one thing, they begin to recognize recurring patterns in the nursery rhymes they have had read to them. These patterns include the rhythms of sound we have alluded to, and also an understanding of language and other cognitive processes that nursery rhymes and other children's verses lead them through. Play still dominates over instruction, though the two become more and more blended, as preparation for the formal education of the child; using Caillois's distinction (see chapter 6), we might say that the mode of play begins to move from *paidia* to *ludus*.

This is not to say that the child is always conscious of the instructional purpose of such verses: the masking of education through the more purely playful elements accounts for much of the success of such poems in helping children learn. Indeed, some of the most painfully dull children's literature is that which addresses the child's educational needs overtly. Although the rhymes and literature for the growing child move more toward exploration of formal experiences and concepts, some sense of anarchy and subversion is still present.

This presence is perhaps nowhere more obvious than in the works of literature adults have fashioned by using children's nursery rhymes as their foundation. One example is the accumulative rhyme, that form in which the child learns that language is infinitely producible, that syntax allows the child the creation of sentences that need never end. Perhaps the most famous of these accumulative (or "list" verses) is "The House That Jack Built."

The House That Jack Built

This is the house that Jack built.

This is the malt
That lay in the house that Jack built.

This is the rat,
That ate the malt
That lay in the house that Jack built.

This is the cat,
That killed the rat,
That ate the malt
That lay in the house that Jack built.

This is the dog,
That worried the cat,
That killed the rat,
That ate the malt
That lay in the house that Jack built.

This is the cow with the crumpled horn,
That tossed the dog,
That worried the cat,
That killed the rat,
That ate the malt
That lay in the house that Jack built.

This is the maiden all forlorn,
That milked the cow with the crumpled horn,
That tossed the dog,
That worried the cat,
That killed the rat,
That ate the malt
That lay in the house that Jack built.

This is the man all tattered and torn,
That kissed the maiden all forlorn,
That milked the cow with the crumpled horn,
That tossed the dog,
That worried the cat,
That killed the rat,
That ate the malt
That lay in the house that Jack built.

This is the priest all shaven and shorn,
That married the man all tattered and torn,
That kissed the maiden all forlorn,
That milked the cow with the crumpled horn,
That tossed the dog,
That worried the cat,
That killed the rat,
That ate the malt
That lay in the house that Jack built.

This is the cock that crowed in the morn,
That waked the priest all shaven and shorn,
That married the man all tattered and torn,
That kissed the maiden all forlorn,

That milked the cow with the crumpled horn,
That tossed the dog,
That worried the cat,
That killed the rat,
That ate the malt
That lay in the house that Jack built.

This is the farmer sowing his corn,
That kept the cock that crowed in the morn,
That waked the priest all shaven and shorn,
That married the man all tattered and torn,
That kissed the maiden all forlorn,
That milked the cow with the crumpled horn,
That tossed the dog,
That worried the cat,
That killed the rat,
That ate the malt
That lay in the house that Jack built.

This is the horse and the hound and the horn,
That belonged to the farmer sowing his corn,
That kept the cock that crowed in the morn,
That waked the priest all shaven and shorn,
That married the man all tattered and torn,
That kissed the maiden all forlorn,
That milked the cow with the crumpled horn,
That tossed the dog,
That worried the cat,
That killed the rat,
That ate the malt
That lay in the house the Jack built.

A nursery rhyme like this is easy to produce from a grammatical point of view. Once the child has caught on to the game of adding on noun phrases beginning with "that" and to the secondary rule of transforming the phrase that has previously been a "This is" to a "That," followed by a new verb plus an old noun phrase, there is no reason the child cannot keep the poem going indefinitely. Thus, the child is learning a lesson in how language works in English, though it is highly doubtful that many children would be able to or care to verbalize this lesson.

What do they learn from participating in the content of the rhyme? They may learn something about concepts of hierarchy, biological and social. Only the least aware child would confuse where to place the "rat" and the "priest"; although the hierarchy does not proceed along strict lines up the chain of being, it does suggest movement away from the inanimate. Historically, it no doubt made sense to end with the farm scene, the source of the agricultural industry, which is the source of the malt that instigates the entire poem.

This nursery rhyme—which has evolved through the centuries through oral tradition, has been traced back to 1755 in English, and is supposed by many scholars to have begun life as a Hebrew chant (Opie and Opie, *Dictionary* 231)—possesses many of the rhythmic elements we noted in other poems: there is much end rhyme, which becomes more regular as the poem progresses (it is not found in the first few stanzas). The syntactic regularity of "This is" and "That" phrases creates a predictable sense of rhythm. It is easy for a group to speak this poem in unison, so ingrained are the phrasings and pauses. In addition to the educational aspects of the accumulative form (teaching the child the interdependence of the food chain), the expanding form of the poem sets up a challenge to the performer: to sustain the ever-lengthening stanzas. Bruce Henderson remembers taking a voice course in which the unit on breath control ended with a test in which each class member had to read each stanza in one breath only—the winners were those who got to the end.

This seemingly simple nursery rhyme provided Elizabeth Bishop with the formal scheme for "Visits to St. Elizabeths," her complex and haunting poem of tribute to Ezra Pound. Read the poem carefully, speaking it aloud, over and over, preparing yourself to perform it.

Visits to St. Elizabeths
[1950]

This is the house of Bedlam.

This is the man
that lies in the house of Bedlam.

This is the time
of the tragic man
that lies in the house of Bedlam.

This is a wristwatch
telling the time
of the talkative man
that lies in the house of Bedlam.

This is a sailor
wearing the watch
that tells the time
of the honored man
that lies in the house of Bedlam.

This is the roadstead all of board
reached by the sailor
wearing the watch
that tells the time
of the old, brave man
that lies in the house of Bedlam.

These are the years and the walls of the ward,
the winds and clouds of the sea of board

sailed by the sailor
wearing the watch
that tells the time
of the cranky man
that lies in the house of Bedlam.

This is a Jew in a newspaper hat
that dances weeping down the ward
over the creaking sea of board
beyond the sailor
winding his watch
that tells the time
of the cruel man
that lies in the house of Bedlam.

This is a world of books gone flat.
This is a Jew in a newspaper hat
that dances weeping down the ward
over the creaking sea of board
of the batty sailor
that winds his watch
that tells the time
of the busy man
that lies in the house of Bedlam.

This is a boy that pats the floor
to see if the world is there, is flat,
for the widowed Jew in the newspaper hat
that dances weeping down the ward
waltzing the length of a weaving board
by the silent sailor
that hears his watch
that ticks the time
of the tedious man
that lies in the house of Bedlam.

These are the years and the walls and the door
that shut on a boy that pats the floor
to feel if the world is there and flat.
This is a Jew in a newspaper hat
that dances joyfully down the ward
into the parting seas of board
past the staring sailor
that shakes his watch
that tells the time
of the poet, the man
that lies in the house of Bedlam.

This is the soldier home from the war.
These are the years and the walls and the door
that shut on a boy that pats the floor
to see if the world is round or flat.
This is a Jew in a newspaper hat
that dances carefully down the ward,
walking the plank of a coffin board
with the crazy sailor
that shows his watch
that tells the time
of the wretched man
that lies in the house of Bedlam.

Several readings have probably convinced you that this is the kind of poem that requires background information before it can be fully understood. The date, 1950, just below the title; the constantly recurring and ever-shifting references to the man who lives in the house of Bedlam; even the name of the asylum itself, as well as the knowledge that the poem records a number of visits to St. Elizabeths, all point to a historical personage at the center of the poem and suggest an autobiographical source for the speaker's incantation.

The speaker's attitude toward her subject is ambivalent. The poem teases us with the question, Who is this man that lives in the house of Bedlam? However, it is not until the penultimate stanza of the poem that we discover that the tragic inmate of St. Elizabeths is a poet. A closer examination of the varied adjectives used to describe this unnamed poet provides clues to his identity and to the occasion of the poem. He is at once described as "tragic," "talkative," "honored," "the old, brave man," "cranky," "cruel," "busy," "tedious," "the poet," and "wretched." Once we recognize that the inmate is a poet, the references to the times, the era, and the Jew gain heightened significance. The range of the poem's subject moves to matters much bigger than those contained in St. Elizabeths. The moral confusion caused by World War II and its devastating effects on culture become a part of the experience of the poem.

Some of you may have found the clues in the poem sufficient to identify the poet as Ezra Pound. The allusion to the poet would have been readily identified by most of the audience of the poem at the time it was written. Many readers today would not recognize the allusion, and this is a fact the performer must reckon with when deciding how to perform the poem to an audience. In any event, do not feel embarrassed if the allusion was unfamiliar to you. One of the problems a reader and a performer encounter when considering a poem with a historic dimension is how to treat its historical subject. We will return shortly to this question and others involving the poem and its performer's relationship to its audience and its historical context, at the time it was written and as it evolves through time. For now it is sufficient to acknowledge that this poem depends on knowledge that lies outside of it for its meaning.

Within the poem we have discovered a man and a paradox. How are we to reconcile the seeming incompatibility of Ezra Pound, the poet, and Ezra Pound,

the man? In terms of the poem, we are disquieted by the knowledge that the "tragic" man is also "cruel," that this "honored" man is also "wretched." Armed with the additional knowledge that this man is Pound, we can see that Bishop is troubled by the incongruities he embraces. How can this creative genius also be the ideological fanatic who championed Mussolini and reviled the Jews? What is the relationship between art and belief? Beauty and value? These are some of the deeper questions that the beguiling form of the nursery rhyme allows us to engage.

Those of you who were unfamiliar with the allusion to Pound probably recognized the clues in the poem that pointed to information that lies outside of it. Your problem is that you did not know who the man might be. References to meanings found outside of the poem itself are called *extrinsic* references. Meanings that can be found by reference to things that lie within the nature of the poem are called *intrinsic* meanings. An *allusion* is a covert, that is, indirect or implied, reference to things or people that are extrinsic to the poem. Equipped with the clues provided by the poem and a library, you would not find it difficult to discover the background information necessary to a full understanding of this poem.

In literature, an allusion often refers you to other literary sources as well as to historical personages or places. In this poem, it is the cumulative weight of the series of adjectives describing the poet and his circumstances that refers you beyond the world of the poem and its fictive portrayal of St. Elizabeths to the real world, the real lunatic asylum of that name, and the real poet, Ezra Pound. Through allusion, a poet can open rich veins of experience with a minimum of language. This poem's use of the nursery rhyme "The House That Jack Built" is a further example of allusion. Together, the allusions to the real man and to the nursery rhyme tease the reader into making connections between diverse worlds—the world of the real and the world of make-believe. In lunatic asylums these worlds are interpenetrating; has the modern age similarly lost its bearings? The poem does not answer this question, but it raises it, deliberately contriving to give the matter no resolution.

The poem is rooted in history and autobiography. It records Elizabeth Bishop's visits to Ezra Pound during the early years of his incarceration in St. Elizabeths, a federal asylum for the insane in Washington, DC, where Pound was imprisoned for 12 years, from 1946 to 1958. Elizabeth Bishop, a Pulitzer Prize-winning American poet, was one of many poets who visited Pound during his incarceration. In *Ezra Pound: The Solitary Volcano,* John Tytell lists the numerous poets who paid their pilgrimage at St. Elizabeths (299). Among some of the most notable were Thornton Wilder, Stephen Spender, Katherine Anne Porter, Langston Hughes, Archibald MacLeish, Robert Lowell, Marianne Moore, and of course Elizabeth Bishop.

Ezra Pound (1875–1972) is an American poet who became expatriated when a young man, living first in London and ultimately settling in Spain, where he lived with his wife throughout the 1930s and World War II. He discovered and nurtured many of the poets whom we now equate with modernity. A poet himself, he is best known for *Mauberley,* a dramatic monologue in the manner

of T. S. Eliot's "The Lovesong of J. Alfred Prufrock," which Pound published when he was 35, and for his obscure epic poems, written over a period of 40 years, *The Cantos* and *The Pisan Cantos*. He was the founder of a number of *avant-garde* poetic movements, most notably imagism and vorticism, and self-styled ambassador of culture and a literary entrepreneur. His remarkable role in the revisions and publication of Eliot's *The Waste Land* alone entitles him a secure place in the annals of literary history.

The stain on Pound's record—and many critics would choose a harsher word than *stain,* some wanting to obliterate the record entirely—was produced by his savage anti-Semitism. During the early years of World War II, beginning in 1941 when the Axis powers appeared to be likely victors of the war, Pound began a series of propaganda broadcasts for Radio Rome in which he extolled Mussolini; viciously attacked Churchill and Roosevelt, virtually calling for their assassinations; promulgated his economic theories of Social Credit; and raved about the "syphilis of capitalism" and the plots of bankers and financiers to destroy the West.

Pound had long been cantankerous, ornery, vituperative, and iconoclastic, but during the 1930s and early 1940s these traits hardened and became obsessional. Venomous and fanatic in his anti-Semitism, he denounced the United States and Britain and extolled fascism. In 1939 he traveled to America, seeking an audience with President Roosevelt in order to warn him to stay out of the war. Unsuccessful in this visit, he returned to Italy and his journalistic writing on what he called "usury economics." In 1941, needing money and eager for attention, he started the series of propaganda broadcasts that led to his indictment for violations of the treason statutes by the U.S. Department of Justice in 1943. In May 1945 the U.S. Army arrested Pound in Italy and imprisoned him for six months. He was then brought to the United States to stand trial for treason. He arrived here two days before the Nuremberg trials began, when the American appetite for retribution was at its height. Fearing that Pound might be sentenced to death, his attorney, with considerable assistance from the literary community, sought to commit Pound to St. Elizabeths on reasons of insanity in order to avoid the trial. Pound remained in St. Elizabeths until 1958 when his friends finally succeeded in having the treason charges dismissed and he was permitted to return to Italy.

Among the many ironic events in Pound's situation during those years is the conferral of the coveted Bollingen Prize in Poetry by the Library of Congress in 1949, at the same time that another branch of government, the Department of Justice, was still pursuing its charge of treason. In an encapsulated version, these were the circumstances at the time Elizabeth Bishop wrote her poem. Many years later, Pound recanted his anti-Semitism in a conversation with the Beat poet, Allen Ginsberg, who had written *Howl*. However, many critics remain suspicious of Pound's motives and unconvinced of his penitence. Today, some 40 years later, critics are still troubled by the moral dilemma raised by Pound's case, and it is not uncommon to find those who are unwilling to read him or include him in the community of poets or who, like the eminent critic Harold Bloom, must "close the door" on him (viii).

In the previous chapter we discussed play, the ludic impulse, and how rules operate within the context of play. Bishop's poem is an excellent example of how intricately patterned the nursery rhyme can be and how that pattern emphasizes subtle shifts of meaning, which without the force of pattern would probably not be felt. One example can be found in the shifting adjectives Bishop used to describe the man who lived in the house of Bedlam. In "The House That Jack Built" you probably noticed that the nursery rhyme never modifies or varies the nouns that describe the people, animals, and objects. Only the first line and one-half of each stanza introduce new subject matter and new words; all the other lines are repeated in exactly the form in which they are first introduced. This pattern is typical of oral ballads or ancient, traditional nursery rhymes, which were written to be spoken and remembered and which relied heavily on *mnemonic* devices in their construction. Mnemonic devices are rules and patterns that assist in memorization. Bishop's more sophisticated and literary rhyme deviates in slight but important ways from the more simple structure of the nursery rhyme.

In "The House That Jack Built" there are 12 stanzas and 78 lines. The poem's kernel 12 lines make up the final 12th stanza, which is comprised of the first lines of each preceding stanza with only the first word of each line changed from "this" to "that" and one additional word change in the final line. In Bishop's poem, however, there are also 12 stanzas and 78 lines. Of these 78 lines, 51 are different, and the remaining 27 lines are made up of exact repetitions of some of the 51 lines. Throughout her poem, Bishop varies the kernel 12 lines, which are found in her twelfth stanza, and as she does so, she makes fine nuances among the meanings we associate with "Bedlam," "the poet," "the time," "the wrist-watch," "the sailor," "the roadstead," "the ward," "the Jew," "the world," "the boy," "the door," and "the war." It is through these fine shadings of meaning, which acquire undue weight because of their position in a fixed form, that Bishop is able to portray the incongruities and morally vexatious matters inherent in Pound while retaining sympathy for the man and his strange breed of courage.

In your readings of the poem, and particularly if you rehearse the poem for a formal performance, you will discover that its rhythms and rhyme compel the speaker forward, and yet the rules that govern the promulgation of the lines are unremitting and seem to carry you in a sea of sound, reinforcing the atmosphere of prison that permeates the lunatic asylum. As the stanzas lengthen, the scope of the poem's subject broadens. The poem drives toward its final stanza of judgment in a manner that electrifies the audience while almost hypnotically compelling them to attend to the man, the madness, and the world.

Let us look a little more closely at the poem's formal structure to understand how Bishop achieves this extraordinary effect. The poem has 12 stanzas, each stanza incrementally increasing by one line. In this respect it is similar to "The House That Jack Built." Each stanza contains the same number of lines as the number of stanzas in the whole poem.

In Bishop's poem, the twelfth, and final, stanza contains 12 lines, and the last word of each line repeats the last word of the first line of each stanza in the poem in inverse order, with the exception that "wrist watch" is replaced by "watch" in all but the third stanza of the poem. In other words, if you read the

last stanza backward, starting with the last line, you discover that it repeats the last word, "Bedlam," of the first line of the poem. Likewise the penultimate line of the poem ends with "man," which is the last word of the first line of the second stanza. This pattern of repetition in inverse order continues through the second line of the twelfth stanza, where the last word, "door," corresponds with the last word of the first line of the preceding, eleventh, stanza. Only the first line of the twelfth stanza is new.

Each stanza is built in a similar fashion. The first line in each stanza is always new; the rest of the lines that follow always repeat most of the words of the line as it appears in the preceding stanza. In every instance, the terminal word in each line, with the exception of the terminal word in the first line, is always the same as the terminal word in the preceding stanza, beginning with the first line of the preceding stanza. In other words, all the lines except the first line in each stanza are culminated in the same exact word in the same order in every subsequent stanza.

So far we have looked at the formal organization of the stanza and the repetition of lines and words in the poem. Let us look now at other matters involving rhyme and rhythm that further restrict the freedom of language in this poem. Like "The House That Jack Built," this poem is also made up of two- and four-stress lines. It, too, lengthens the line midway through the poem and binds the lengthened line more tightly by introducing frequent alliterations within it.

In "The House That Jack Built," the four-stress line is introduced in the refrain and occurs regularly in the opening line of each stanza beginning with the sixth stanza, "This is the cow with the crumpled horn," and the phonetic k sound is repeated in "cow" and "crumpled." In "Visits to St. Elizabeths" the lengthened line first occurs in the opening line of the sixth stanza, "This is the roadstead all of board," and again the line has taken on two more stresses, giving it four stresses; however, the alliteration is less noticeable, occurring only in the terminal d sound of "roadstead" and "board." However, in the next stanza, the alliteration gains force when Bishop assonates both the long e sound and the w sound; "These are the years and the walls of the ward." In the same stanza where the line is lengthened, the pattern of rhyming terminal sounds also becomes more straitened. You probably observed earlier that the terminal words of the first line of each stanza are the following, in the order of their appearance: "Bedlam," "man," "time," "wristwatch," "sailor," "board," "ward," "hat," "flat," "floor," "door," and "war." Beginning with the sixth stanza, the following first lines of each subsequent stanza rhyme in pairs until the last three stanzas of the poem, where the last word of each opening line rhymes, that is, "floor," "door," and "war." Finally it is worth noting that the entire poem is written in words of no more than three syllables, and most are monosyllabic or disyllabic. "The House That Jack Built" uses only monosyllabic and disyllabic words.

We have spent a considerable amount of time discussing the formal elements of the structure of Bishop's poem. An analysis of these formal features is useful to you as performer, in part because they can heighten your awareness of some of the problems you must consider in preparing your performance. A poem of such simplicity, repetition, and density carries the danger of being read in a monotone. There is no way to resist the poem's structure or its rhymes, but you

can probably already see how necessary it is to put focus and weight on the key descriptive adjectives that shift throughout the poem and, once understood, clarify the speaker's emotional attitude toward her subject.

In a poem with such a potentially inflammatory subject, it would be easy to be reductive of the poem's meaning or to distort its emotional response to Pound. We have seen performances of this poem that featured its mechanistic elements, giving it a postmodern feeling, by treating the asylum as a place of regimentation. This performance constituted the poem's meaning in such a way that it was about the postindustrial world and automation as much as it was about Pound.

As discussed in chapter 1, the meaning of a performance is a function of the artist, medium, artwork, and audience. Meaning is constituted through a collaborative process in which the performer, author (in this case the performer and author are not the same), medium (the words of the text and the enacting body of the performer), and artwork (the lived event of the performer realizing the text), and audience (the audience in 1950, when the poem was written, and the audience today, when the poem is read or performed) together forge the meaning of the event. In the case of the performance we are describing, the performer's and the audience's relative unfamiliarity with the historical Pound combined with the performer's preoccupation with mechanistic aspects of culture led to a performance that fused the mechanical elements of the poem's formal structure with aspects of its theme to produce the effect we are describing. The performance worked because the audience and the performer were caught up in the poem's language and were only dimly familiar with Pound's life and work.

In a performance executed by Carol Simpson Stern, we found that, again, the audience—it was a university audience of people well versed in literature and our discipline—probably would not have recognized the allusion to Pound had they not been told of it. This performance tried to keep the poem a poet's poem. Its nursery rhyme elements; its fondness of sound, repetition, mythical enhancement, and language; and its subject, the poet Pound written about by another poet, all directed Stern toward her performance choices. Clearly, had the poem been performed in 1950 the performer would have had to make even more conscious choices about the poem's morality, for example, whether it would be found too offensive because of Pound's anti-Semitism or allegedly treasonable actions. Historically, the poem has also been set to music and performed as a round. Bishop, herself fond of music, collaborated in this event.

Let us consider the poem's thematic development just a little more. The stark opening one-line stanza of the poem sets the stage. Upon first hearing it we recognize its simple declarative value. St. Elizabeths is a federal asylum for the insane. It does contain locked wards to hold prisoners. In fact, initially Pound was in such a ward before being moved to an open floor in the hospital. But the word "Bedlam" immediately resonates with wider references. Many would recall Edgar, the fool "Tom" posing riddles to Gloucester and Lear on the heath in *King Lear* (I.ii.148). The *Oxford English Dictionary* tells us that in 1547 the Hospital of St. Mary of Bethlehem (Bedlam) in London was incorporated as a royal foundation for lunatics. Since the 1300s, when the hospital first accepted lunatics, *Bedlam* began to function metonymically for lunatics and madmen.

Metonymy is a figure of speech that refers to something in terms of one of its attributes. For example, as a figure of speech *White House* is understood to refer to the president with which it is associated. Metonymic figures of speech are developed from external principles of contiguity in space and time. Topics and verbal entities are connected by means of external contiguities in space and time. The chief mental operation in metonymy consists of combination and context. Hence the relationships between the two entities or words derive not from patterns of similarity, as in metaphor, but from temporal or spatial associations due to proximity. In metonymy, one rearranges and deletes parts of contiguous entities to create the figure of speech. In these figures of speech, a part of the entity figuratively substitutes for the whole. In this poem, Bedlam comes to function metonymically, referring not only to the hospital but also to lunatics. Then, through the process of amplification whereby a writer broadens the frame of reference for the denotative words used, Bedlam and lunatics embrace not only Pound but also the war and world of 1940–45.

Earlier we said the word "Bedlam" sets the stage for the poem. Our choice of the word "stage" was deliberate because another aspect of the connotations of this first line is that is calls up the stage, not only the stage of Shakespeare's plays but also a circumscribed space, a stage, in which Pound plays his part. Look carefully at the language and the metaphors in the poem and see if you can discover other evidence that supports the interpretation that "Bedlam" functions as a theatrical stage in this poem. Some of you probably also recall numerous literary allusions to Bedlam, particularly in the writings of confessional poets like Anne Sexton, the author of *To Bedlam and Part Way Back.* In literary imagination, the language of the lunatic has always been the language of the poet, or the wise fool. Shakespeare's likening of the lunatic to the lover and poet contributes to this poem in an especially pertinent way. Pound, the man, was exhibitionistic and bombastic. He liked to speak in slang and jingles. Probably most informed medical people today would agree with Pound's lawyers that although he could be called legally insane, he was not, in fact, actually insane. Nonetheless, that he was both a poet and alleged to be mad are facts that Bishop makes central to her poem.

Another motif that haunts the poem is time, both historical and mythical. The wristwatch is a mechanical device that measures *diachronic* time (linear time; clock time). But time's meaning, too, is amplified. Time refers to what occurs to this inhabitant of St. Elizabeths; it refers to a fixed unit of time, the number of years he is imprisoned and the number of years he broadcast his allegedly treasonous remarks. It grows to include an epoch, the time of World War II, and it also ticks the minutes. Mythically, time can be transcended. The sailor, boy, and Jew in the poem are particular people in Bedlam and universal types. Their journeys seem to traverse more than geographical boundaries. The boy's patting of the floor, to see whether the world is round or flat, is one of the most poignant lines in the poem. In it he becomes Columbus and all men who have attempted to challenge the limits of knowledge as well as the borders of their worlds. But the poignancy comes in our recognition that this boy's mind cannot function at the margins; to question the simple truths of the floor and the walls is testimony here to madness, not genius. Bishop's treatment of the sailor, the wanderer, also

unites him to Pound, a man who wrote his own epic odyssey in *The Cantos,* and also to the Greek mythical wanderer, to Odysseus.

Finally, we ought to confront the figure of the Jew. He is fashioned out of the very language used by Jew-baiters, and yet he is one of the most moving figures in the poem. In the literature of defamation, the stereotype of the Jew as usurer, as financier, and as controller of the newspapers and consequently the media and propaganda gave rise to the hideous tales of a Jewish conspiracy to take over the world. The transcripts of Pound's broadcasts and his letters reveal that this was one of the more odious stereotypes he used in his rantings. In the poem the newspaper is no longer an instrument of power but a decorative hat, which clothes the Jew in the garb of the carnival or the hood of the jester. But remember, jesters and fools are often wise.

The innocence of this Jew in his hat becomes even more pronounced. He is the widowed Jew, dancing, weeping, waltzing, and finally "walking the plank of a coffin board." This final image is one of the most harrowing in the poem. The image is childlike, uttered in words that carry a singsong tone, and yet like so many nursery rhymes, the language only thinly veils the fear just beneath its surface. Darkness, loneliness, the fear of domination, the need for stability, and the dread that grows out of our sense of our own mortality are all themes of nursery rhymes, and all are working here. This house is not secure. Even the walls of the ward, the hospital, and the prison cannot hold its inhabitants. The madness in this hospital has spilt over into the world, or rather the world's ills have ruined innocence and created evil. The Jew carries the weight of the history of the Holocaust, bigotry, and the plight of a wandering race. The Jew, the scapegoat of history, now unwittingly torments the anti-Semitic inhabitant of St. Elizabeths. Pound the poet is finally eclipsed by Pound the man, and that man is "wretched."

Bishop was asked by an interviewer to offer a prose comment on Pound the man. She responded by saying, "I think I've said all I want to in that poem. I admired his courage enormously; he proved his devotion to literature during those thirteen years" (Schwartz and Estess 301). This remark was made many years after the writing of the poem. In preparing your own performance of this poem, see whether your experience corresponds with hers. Continue to explore the ways in which she shades her response to Pound in the poem and keeps our sympathy for him at the same time as she records his excesses and deficiencies.

NONSENSE, SENSE, AND THE PLAY OF LITERATURE

The word *nonsense* suggests different qualities to different writers and thinkers. To some, *nonsense* is a purely logical term, the absence of *sense* in philosophical and mathematical problems or situations. To others, it suggests a worldview of incoherence and chaos, a nihilistic view of existence, in which there is no hope for order. A third use is one that puts *nonsense* in relation to *sense* and typically sees the pleasure of nonsense in the writer's and reader's acknowledgment of the gap between ordinary expectations of reality and the fiction presented in a work of literature.

Sound and sense typically interact in nonsense literature in conflicting ways. The effect is one of semantic confusion. Although language often moves in ways we are accustomed to hearing, the use of the sounds of language to create new words creates a semantic dissonance—we know we are hearing something that sounds familiar, but important levels of meaning are omitted or distorted. Some theorists have likened the language of nonsense literature to that of dream, in which the dreamer no longer has conscious control over language and the dreamscape is often unfamiliar and slightly "wrong": some elements are recognizable, but usually an element has been changed and cannot be translated into the dreamer's waking life.

Jabberwocky: A Nonsense Poem

One of the most famous examples of nonsense is Lewis Carroll's "Jabberwocky," from his novel *Through the Looking-Glass,* the second of the Alice books and the one in which Carroll plays the most with logical problems (he was a mathematician). In the looking-glass world, everything is reversed, including relationships between words and meaning. Alice reads the following poem:

'Twas brillig, and the slithy toves
 Did gyre and gimble in the wabe:
All mimsy were the borogoves,
 And the mome raths outgrabe.

"Beware the Jabberwock, my son!
 The jaws that bite, the claws that catch!
Beware the Jubjub bird, and shun
 The frumious Bandersnatch!

He took his vorpal sword in hand:
 Long time the manxome foe he sought—
So rested he by the Tumtum tree,
 And stood awhile in thought.

And, as if in uffish thought he stood,
 The Jabberwock, with eyes of flame,
Came whiffling through the tulgey wood,
 And burbled as it came!

One, two! One, two! And through and through
 The vorpal sword went snicker-snack!
He left it dead, and with its head
 He went galumphing back.

"And hast thou slain the Jabberwock?
 Come to my arms, my beamish boy!
O frabjous day! Callooh! Callay!"
 He chortled in his joy.

'Twas brillig, and the slithy toves
 Did gyre and gimble in the wabe:
All mimsy were the borogoves,
 And the mome raths outgrabe.

As you read the poem, were you able to make sense of it? If you can make it past the first stanza, you are usually able to proceed through the poem with some success. Yet even the first stanza, which seems to contain the densest amount of nonsense, is nonetheless perfectly acceptable from a grammatical standpoint. Are you able to recognize the grammatical category (noun, verb, adjective, and adverb) of each word, even when you don't know what the word means? Perhaps less so in the first stanza, but more so as the poem proceeds? The poem actually is very traditional, in that it tells a story of a heroic quest, a battle between a knight and a ferocious creature called the Jabberwock. What gives us pleasure is the juxtaposition of the traditional ballad form and situation with the absurd, invented words. As opposed to "Susie Asado," where the relationship between language and reference (between the words used and the thing described) seems tenuous and impressionistic, "Jabberwocky" seems as if its logic would be quite accessible if only we had the vocabulary necessary to translate the unfamiliar words. Again, this is not to suggest that "Jabberwocky" is a better piece of writing than "Susie Asado," only that its experience takes us on a wholly different journey as readers and audiences, one more overtly tied to conscious and conventional uses of language. You may wish to read Humpty Dumpty's explication of "Jabberwocky" from a later chapter in *Through the Looking-Glass,* which appears in the appendix (pages 447–54).

Although it is probably true that poetry (particularly modern poetry) tends to make far greater use of the sense/nonsense duality than do other forms of literature, there are many accomplished examples of nonsense in both prose fiction and drama. Modern novelists such as James Joyce, Vladimir Nabokov, Thomas Pynchon, and others have used the tenuousness of language as a bearer of meaning to great effect. Similarly, in drama, playwrights such as Antonin Artaud, Samuel Beckett, Arthur Kopit, and many earlier in the century who experimented with dadaism and expressionism take the verbal and visual language of performance and the stage to what seem to be the outer limits.

The Bald Soprano: A Nonsense Play

One of the most famous uses of nonsense in modern drama is Eugene Ionesco's play *The Bald Soprano.* The very title of the play suggests a contradiction in terms and a contradiction of expectations. We are accustomed to thinking of a soprano as a woman; at the same time, we are also accustomed to thinking of bald-ness as an exclusively (with very few exceptions) male condition. In the play, Ionesco raises the curtain on a typical English household and a typical English couple, Mr. and Mrs. Smith. Smith is close to a "universal" English name, so stereotyped as to rob the couple of any sense of individuality. Indeed, the Smiths

are matched with another couple, Mr. and Mrs. Martin, a name almost as lacking in character as Smith.

Indeed, it is difficult to say what exactly "happens" in *The Bald Soprano.* It is a play developed from the movement known as the Theatre of the Absurd, in which much of the action seems purely linguistic—the playwright using characters in order to play with words rather than to imitate an action from "real life." Though a number of outrageous events do happen in *The Bald Soprano,* the playwright seems less interested in the plot than in making the audience aware of different ways of playing with and in language.

Let us examine a scene from the play. Not much happens; so far, the Smiths have made a number of relatively self-obvious statements, such as "We've drunk the soup, and eaten the fish and chips," and uttered clichés about health, society, and life in general. We know that something odd is about to happen when Ionesco gives the following stage direction: "The clock strikes seven times. Silence. The clock strikes three times. Silence. The clock doesn't strike." First, when the clock strikes three times after having just struck seven, we know something is amiss, that time as we are used to perceiving it has exploded. Obviously, only readers will catch the joke of "The clock doesn't strike," reminding us that definition by the absence of an event is itself in some ways illogical and nonsensical.

The ensuing dialogue takes us even further into the world of nonsense, in which language, although retaining its syntactic and grammatical structure, no longer is able to communicate meaning between these two people:

MR. SMITH [*still reading his paper*]: Tsk, it says here that Bobby Watson died.

MRS. SMITH: My God, the poor man! When did he die?

MR. SMITH: Why do you pretend to be astonished? You know very well that he's been dead these past two years. Surely you remember that we attended his funeral a year and a half ago.

MRS. SMITH: Oh yes, of course I do remember. I remembered it right away, but I don't understand why you yourself were so surprised to see it in the paper.

MR. SMITH: It wasn't in the paper. It's been three years since his death was announced. I remembered it through an association of ideas.

MRS. SMITH: What a pity! He was so well preserved.

MR. SMITH: He was the handsomest corpse in Great Britain. He didn't look his age. Poor Bobby, he'd been dead for four years and he was still warm. A veritable living corpse. And how cheerful he was!

MRS. SMITH: Poor Bobby.

MR. SMITH: Which poor Bobby do you mean?

MRS. SMITH: It is his wife that I mean. She is called Bobby too, Bobby Watson. Since they both had the same name, you could never tell one from the other when you saw them together. It was only after his death that you could really tell which was which. And there are

still people today who confuse her with the deceased and offer their condolences to him. Do you know her?

MR. SMITH: I only met her once, by chance, at Bobby's burial.

MRS. SMITH: I've never seen her. Is she pretty?

MR. SMITH: She has regular features and yet one cannot say that she is pretty. She is too big and stout. Her features are not regular but still one can say that she is very pretty. She is a little too small and too thin. She's a voice teacher.

[*The clock strikes five times. A long silence.*]

MRS. SMITH: And when do they plan to be married, those two?

MR. SMITH: Next spring, at the latest.

MRS. SMITH: We shall have to go their wedding, I suppose.

MR. SMITH: We shall have to give them a wedding present. I wonder what?

MRS. SMITH: Why don't we give them one of the seven silver salvers that were given to us for our wedding and which have never been of any use to us? [*Silence.*]

MRS. SMITH: How sad for her to be left a widow so young.

MR. SMITH: Fortunately, they had no children.

MRS. SMITH: That was all they needed! Children! Poor woman, how could she have managed!

MR. SMITH: She's still young. She might very well remarry. She looks so well in mourning.

MRS. SMITH: But who would take care of the children? You know very well they have a boy and a girl. What are their names?

MR. SMITH: Bobby and Bobby like their parents. Bobby Watson's uncle, old Bobby Watson, is a rich man and very fond of the boy. He might very well pay for Bobby's education.

MRS. SMITH: That would be proper. And Bobby Watson's aunt, old Bobby Watson, might very well, in her turn, pay for the education of Bobby Watson, Bobby Watson's daughter. That way Bobby, Bobby Watson's mother, could remarry. Has she anyone in mind?

MR. SMITH: Yes, a cousin of Bobby Watson's.

MRS. SMITH: Who? Bobby Watson?

MR. SMITH: Which Bobby Watson do you mean?

MRS. SMITH: Why, Bobby Watson, the son of old Bobby Watson, the late Bobby Watson's other uncle.

MR. SMITH: No, it's not that one, it's someone else. It's Bobby Watson, the son of old Bobby Watson, the late Bobby Watson's aunt.

MRS. SMITH: Are you referring to Bobby Watson the commercial traveler?

MR. SMITH: All Bobby Watsons are commercial travelers.

MRS. SMITH: What a difficult trade! However, they do well at it.

MR. SMITH: Yes, when there's no competition.

MRS. SMITH: And when is there no competition?

MR. SMITH: On Tuesdays, Thursdays, and Tuesdays.

MRS. SMITH: Ah! Three days a week? And what does Bobby Watson do on those days?

MR. SMITH: He rests, he sleeps.

MRS. SMITH: But why doesn't he work those three days if there's no competition?

MR. SMITH: I don't know everything. I can't answer all your idiotic questions!

MRS. SMITH [*offended*]: Oh! Are you trying to humiliate me?

MR. SMITH [*all smiles*]: You know very well that I'm not.

MRS. SMITH: Men are all alike! You sit there all day long, a cigarette in your mouth, or you powder your nose and rouge your lips, fifty times a day, or else you drink like a fish.

MR. SMITH: But what would you say if you saw men acting like women do, smoking all day long, powdering, rouging their lips, drinking whisky?

MRS. SMITH: It's nothing to me! But if you're only saying that to annoy me . . . I don't care for that kind of joking, you know that very well!

[*She hurls the socks across the stage and shows her teeth. She gets up.*]

MR. SMITH [*also getting up and going towards his wife, tenderly*]: Oh, my little ducky daddles, what a little spitfire you are! You know that I only said it as a joke! [*He takes her by the waist and kisses her.*] What a ridiculous pair of old lovers we are! Come, let's put out the lights and go bye-byes.

Notice that from the first line, language becomes suspect: Mr. Smith's line "Tsk, it says here that Bobby Watson died" is immediately contradicted by the line, a few sentences later, "It wasn't in the paper. It's been three years since his death was announced. I remembered it through an association of ideas." The couple then proceed to go through a series of exchanges in which they realize that they are not talking about the same "Bobby Watson." In addition to everything else, we get pleasure from the repetition of the name Bobby Watson, which appears to refer to a number of different individuals, a reminder that language is not identical to the person it names, that in some ways language is inept, not allowing us to be as precise and specific as we think we are being at times. It is only through the cumbersome spelling out of details about "which Bobby Watson" they mean that the Smiths are able to come to some agreement. The play of language in this scene is the confusion language can create by pretending to refer to real people and things in the world and our pleasure in the recognition that it cannot ever wholly give us what it describes.

Nonsense literature can be a great challenge and a great pleasure for the performer (both the solo performer and the ensemble). It is a challenge because it frequently reverses our expectations of language, character, and action. We

must find a way of "playing" the language, deemphasizing our tendency to search for and make prominent the character's motives and interaction. At the same time, for the nonsense to have any impact, it must emerge from expectations of a context of sense. If in *The Bald Soprano* we do not believe in the possibility of a Mr. and Mrs. Smith, who might sit around and talk about trivial matters, the ensuing anarchy of language has no basis from which to leap.

Experiment with the nonsense literature, finding texts in the library. Keep in mind the continuum between sense and nonsense and also some of the distinctions between sound literature and nonsense literature. To what degree are they related? How are they different? What different demands do they make on the performer and on the audience?

The Pun and the Riddle: Sound and Sense as Puzzles

Two of the most common types of semantic play in literature are the pun and the riddle. The pun typically requires less intellectual work from its listener than does the riddle, though both require a kind of agile involvement of speaker and listener.

What is a pun? This question may be more difficult to answer than we might think, for the very notion of puns and punning is tied up in the ambiguity (some would say duplicity) of language itself. Without repetition and similarity, without the possibility of mistaking the meaning of language because of sounds, puns could not exist. A pun may be broadly defined as an instance in which a sequence of sounds may carry more than one meaning, both for speaker and listener (we should add reader, for there are purely visual puns). Usually, such plurality of meaning is intentional, the speaker wishing the listener to identify and acknowledge the ambiguity of meaning, but there is the phenomenon of *lapsus linguae,* or Freudian slip, in which a speaker's unconscious takes over. Similarly, some theorists would go so far as to call all rhymes a species of punning; the phonetic similarity in a rhyme draws attention to the repetition of language.

However we do define the pun, we know that it has been in evidence and of some controversy from the time of the Greeks, who gave it a special name in their rhetorical handbooks, *paronomasia.*

Punning has been held in variable esteem throughout the ages, and how an age responds to it may sometimes be seen as an indicator of critical taste. Shakespeare, for example, is one of the most accomplished punsters in English literature; indeed, one of the difficulties many contemporary readers find in his works is unraveling his sometimes archaic puns. Juxtapositions of words that communicated clear puns to Elizabethans have become obscure because language has changed over the centuries. To some critics, Shakespeare's puns are yet more proof of his genius. His ability to weave sounds together is a virtuoso feat, affirming his place as premier poet of the language. To others, his puns are a flaw in his achievement, a sign of a weakness, a tendency to resort to what these critics consider the too easily produced verbal play of the pun.

How do you feel about puns? We find that different people feel very differently. For example, Bruce Henderson grew up in a family in which his father

punned with almost incessant frequency; it was the rare family dinner that did not include several puns. The puns were, we might add, frequently what many call "groaners," named for the almost involuntary response they elicit from their audience. In fact, as Henderson grew older he engaged in a kind of verbal duel with his father, as a sign of adolescent sparring—a kind of "can you top this" effect. Yet he found when he entered college that his roommate not only did not wish to engage in this form of play but also was openly hostile to it. The standard pun gambit, "Did you take a shower? No, why, is one missing?" which plays on the meaning of *take* became the source of serious fighting. Although Henderson's roommate may have been an extreme exception, this incident suggests the radically different ways people respond to puns. To some, they are seen as the lowest of all humor, perhaps because they are often based less on intellectual invention and more (to some perspectives) on taking advantage of the natural limitations of sounds in language. Though we can produce a vast number of sounds, the frequency of homophones and homonyms makes the pun a comparatively easy mark.

For some, the very easiness of a pun may make it good or bad. If the pun seems effortless, this may mark it either as too simple or as agile. For others, the less distortion one has to impose on language to create the pun, the better it is. The rhymes Ogden Nash uses in many of his poems, and the everyday jokes that require the speaker and listener to stretch the boundaries of similarity are two examples of stretching language to its limits. Some of you may be familiar with the television game show "Concentration," based on picture rebuses, in which players must combine the words (or sounds) symbolized by the pictures to come up with the winning phrase. Some of the rebuses seem quite accessible: it is easy to discern what is intended by the combination of pictures and letters; others seem quite obscure. Some viewers might prefer the easily accessible ones; some, the more difficult.

Explore these issues with your friends and classmates. Ask them to tell you a good pun and a bad pun. Do not have them tell you which is which or why they consider one good and one bad. After you have heard both puns, write down your own response. Then ask your friend to reveal which was which and why? Do you agree or not? Why?

Literature is full of puns, most used for humorous purposes. At their worst, literary puns stick out of the fabric of the text, seeming self-indulgent and impeding the progress of the work: we come to a full halt, and focus only on the pun. A gratuitous literary pun seems to have been inserted into the literary text simply for the purpose of making a joke and not because the pun adds anything to the text as a whole. Although we may enjoy the individual moment of the pun, we typically feel the overall experience has been cheapened by its use.

But this criticism is by no means true of all or even most of the uses of the pun as literary play—far from it. Some of the greatest writers of all times have used puns as integral parts of their texts. Writers such as James Joyce, Vladimir Nabokov, Lewis Carroll, Robert Frost, Emily Dickinson, Langston Hughes, Anne Sexton, John Lennon, and Shakespeare have found puns to be profound links between sound and sense in their literary creations.

As an example of a serious, even religious use of the pun in literature, we might look briefly at John Donne's poem "A Hymne to God the Father." Donne was an Episcopalian minister in seventeenth-century London. He is a poet of incredible range and depth, able to move from the bawdiest of love poems to the loftiest of prayers. As you read his "Hymne," consider how his primary pun functions within the web of meaning the poem is creating.

A Hymne to God the Father

Wilt thou forgive that sinne where I begunne,
 Which is my sin, though it were done before?
Wilt thou forgive those sinnes, through which I runne,
 And do run still: though still I do deplore?
 When thou hast done, thou hast not done,
 For, I have more.

Wilt thou forgive that sinne by which I'have wonne
 Others to sinne? and, made my sinne their doore?
Wilt thou forgive that sinne which I did shunne
 A yeare, or two: but walled in, a score?
 When thou hast done, thou hast not done,
 For, I have more.

I have a sinne of feare, that when I have spunne
 My last thread, I shall perish on the shore;
Sweare by thy selfe, that at my death thy Sunne
 Shall shine as he shines now, and heretofore;
 And, having done that, Thou haste done,
 I have no more.

How many puns were you able to find in the poem? You may need to consult an edition with a glossary or footnotes to work out some of the religious references. Certainly one very important pun occurs in the last stanza, when the poet asks us to think of the word "sunne" in two different ways: first, as the sun, the star that gives us heat and light during the day; second as God's "son," Jesus Christ, who "shines" eternally for the poet and whose eternal light will lead the poet beyond death and into eternity, where he will "feare no more."

But there is a more primary pun throughout the poem. If you have not yet caught it, remind yourself of the name of the poet—John Donne. Now go back and reread the poem (read it aloud if you have not yet done so). How many times does the word "done" occur in the poem, and in what contexts? It occurs in each stanza, as part of the last two lines, which form a refrain. The repeated "When thou hast done, thou has not done,/For, I have more" plays on the poet's identity and on his acknowledgment of his own need to repent his sins before receiving God's grace. Thus, in the first two stanzas, the poet declares that even when God has accomplished what Donne has described, he has not "done,"

meaning "has not finished" but also "does not have the soul of John Donne." It is only in the final stanza of the poem that the poet, who has accepted Christ as his savior, can say "Thou haste done," meaning "God has completed his work" but also "God has my soul."

The double force of "done" as "finished" and "John Donne" adds to the personal relationship between the poem's speaker (who in this case seems virtually identical to some of the sense of the historical John Donne) and the deity. Without the pun, the poem is a pious and reverent declaration of faith; with the pun, it is an intellectual communion between one poet and another (i.e., Donne and God), in which language is a vehicle by which the lesser of the two (from his own perspective) shows how the repetition of sound in language permits him to give himself even more completely (by giving himself as "done"—"completed" and the one specific individual "John Donne") to the "Father."

As you continue to read literature, we encourage you to look for puns, whether you define the term quite narrowly or whether you welcome a broader feeling of the play of sound and sense. As a performer, how do you treat puns? Surely this must depend on the specific text in which it occurs and on your intent in emphasizing or deemphasizing the pun. In the Donne poem, what would you do with the puns? Would you speak the words that pun louder than other words, "pound them home," so to speak? Isolate them with pauses? Or would you simply speak them with the same weight and emphasis you give every other word? Would you treat the "done" pun differently from the "sonne" pun? Why or why not? On what are you basing your decisions in each case?

Depending on your perspective, the pun may be either pessimistic evidence of the limited ability of language to communicate messages with absolute certainty or a celebration of the possibilities of the same set of sounds to express simultaneously very different, yet oddly related, ideas. The pun is a hybrid of games of chance and contest: chance because the nature of sound in language has created the punning words or phrases and, to a large extent, removes control from the punster; contest because the punster plays a game with both language and audience, trying to outwit one and impress the other.

If the pun is typically held in ambivalent esteem by connoisseurs of literary play, the riddle is almost universally considered a high achievement of language and the mind. The riddle's history is as old as the pun's; indeed, the riddle and the pun are sometimes combined. Perhaps the most famous of ancient riddles is the riddle of the Sphinx in the myth of Oedipus. The Sphinx, a mythical creature half human and half beast, demanded all who passed by to answer her riddle. To give the wrong answer was to meet death. All who preceded Oedipus failed in their task. Only Oedipus, who ironically would meet his tragic destiny because of his inability to solve the riddle of his own life in time to avoid killing his father and marrying his mother, was able to solve this riddle: What walks on four legs in the morning, two legs in the afternoon, and three legs in the night? The answer, of course, was man—four legs as a baby (morning); two legs as an adult (afternoon); and with the help of a stick or cane, three legs in old age (night). Oedipus, by making the imaginative leap beyond the literal, was able to save his life and defeat the Sphinx.

The leap Oedipus made in solving the riddle of the Sphinx was what we would call metaphoric. Oedipus was able to move from the literal referents of the terms of the riddle (the times of day and the legs) to their metaphoric equivalents: the phases of life; "leg" meaning "physical support" rather than "human anatomical part." Not all riddles are metaphoric. Folklorists Robert Georges and Alan Dundes distinguish between literal and metaphorical riddles (98). A literal riddle might be something like this: "What sleeps in the day and walks at night?" the answer to which is spider. There is no metaphor involved here; spider is simply the answer that fits both conditions of the question. A metaphoric riddle would be that of the Sphinx or one such as the following popular example: "Twenty white horses on top of a red hill," the answer to which is teeth and gums. Here, it is necessary for the answerer to go through a process of drawing connections between the images in the riddle and possible referents (objects) outside their literal context.

So, although riddles need not be metaphorical, a great many of them are, and we suspect that those that provide the most pleasure involve metaphor in some way or another. The great philosopher Aristotle knew this. In his *Rhetoric* and *Poetics,* two works that set the foundation for literary criticism, he spoke of riddles as a source for good metaphors. Some traditions of riddles do not involve rational deduction but either require training in the specific answer (as in some forms of religious education, such as the Zen koan or the Catholic catechism) or simply have no answer (such as conundrums, shaggy dog stories, and the nonsensical riddles in Carroll's *Alice in Wonderland*).

The pleasure metaphoric riddles give, then, is in the teller's invention of a question that challenges the answerer to make the connections that will produce the desired answer. Contest is involved in riddling, though like many playful contests, it is one in which the happiest outcome is something less than an undefeated victory by the questioner. For example, if a riddle is so obscure, private, or confusing that the answerer not only cannot supply the correct answer but also does not understand the correct answer, surely the riddler gains little pleasure from this performance; implicit is a failure to come up with a fair challenge. The best riddles are those that offer a reasonable opportunity to figure out the intended response, so that even if the answerer fails to come up with the proper response, when he or she hears it, the natural reaction will be "Of course!"

How do riddles function in literature? Some critics would argue that the entire process of reading literature is akin to unraveling a riddle: as we search for meaning, we look for clues and draw connections. Reading a murder mystery is like answering a riddle but on a larger scale, depending less on the ability to think metaphorically than on the ability to move through the processes of inductive and deductive reasoning.

Craig Williamson, a scholar and translator of Old English riddles, eloquently describes the connection between riddles and the lived world:

The metaphor of riddles mirrors metamorphosis: all things shift in the body of nature and the mind of man. But the flow, the form and movement, remains. As the mind shifts, it shapes meaning. When is an

iceberg a witch-warrior? When it curses and slaughters ships. When is it a great mother? When transformed and lifted, it rains down. There is a primitive participation and synchronicity in this. Man charts the world and the world sings in images his uncharted spirit. The riddles are primitive flower and seed. To us they offer a world in which there is an eye (I) in every other, a charged world where as Walt Whitman says, there is ''God in every object.'' (4)

Williamson distinguishes between two traditions in literary riddles: the Latin and the Old English. In the Latin, he argues, the act of riddling is technical display more than anything else. Latin riddles solve themselves in their titles, making the act of figuring them out unnecessary. We can never be in that wonderfully tortured state of struggle with a Latin riddle poem as we are with an Old English riddle poem, which keeps us in a state of suspension as we read it; we go through some of the same processes of thinking and creating as did the poet.

Let us look at two brief examples of these Old English riddle poems. We give the answers below, but read through these poems a few times before you check the answers. After you read the riddles, try to think of one or more possible solutions. How did you come to your conclusions? What characteristics did you draw on to solve the riddles as you did? Try performing these riddle poems (and others) in class. Have different people perform the same riddles. How did their performances focus on different ways of solving the riddles? Is it possible to retain ambiguity in the performances, so that the riddle poem remains an interaction between teller and listener rather than a ''statement'' made by the riddler?

Read this riddle first:

On earth this warrior is strangely born
Of two dumb creatures, drawn gleaming
Into the world, bright and useful to men.
The scourge of warriors, the gift of foes,
It is tended, kept, covered by women—
Strong and savage, it serves well,
A gentle slave to firm masters
Who mind its measure and feed it fairly
With a careful hand. To these it brings
Warm blessings, to those who let it run
Wild it brings a grim reward.

Now read the following riddle. Notice that the riddler has chosen to impersonate one of the things (or beings) whose identity he is asking us to solve.

Shunning silence, my house is loud
While I am quiet: we are movement bound
By the Shaper's will. I am swifter,
Sometimes stronger—he is longer lasting,
Harder running. Sometimes I rest

While he rolls on. He is the house
That holds me living—alone I die.

The answer to the first riddle is fire; to the second, fish and river. Look back at the riddles now that you know the solutions. If you did not come up with these solutions, can you figure out why not? Can you see how the solutions do fit?

Some critics see riddling as the foundation of much modern poetry, particularly of that poetry generally considered "difficult" because it is obscure in referents or significance. Johan Huizinga, in particular, thought that modern poetry was moving more toward a riddling quality, and he did not see this as a negative quality at all but something that would involve the reader more actively in the making of meaning. Many theorists insist that it is necessary to divorce the author's intention from the meaning of a work of literature (often adding that an author's intention is usually impossible to obtain, anyway). In this case, the poem can be seen as a riddle with no definite or single answer.

Andrew Welsh, whose *Roots of Lyric: Primitive Poetry and Modern Poetics* draws fascinating links between oral traditional forms and twentieth-century literature, also sees the riddle as one of the primary literary forms tied to modern poetry. He suggests that one advantage of using the riddle as a way of understanding metaphor in poetry (and other literature, for that matter) is that it allows us to move away from the concept of metaphor and imagery as "visual pictures" created by language (which he believes is a limited and limiting view of metaphor) and toward the more complex, intellectual game that riddling suggests. What do you think? Are all metaphors and images "pictures"? We find Welsh's perspective a satisfying one, because it encourages us not only to use all our senses (sight, hearing, smell, taste, and touch) when we experience literature but also to use sense (thinking and imagination) when we work our way through a difficult passage, in which the language does not immediately reveal the object or experience being described or does not overtly draw the connections.

The riddling impulse in literature can certainly move beyond identification of images and metaphors. Indeed, our search to find meaning, to find reasons "why," in much modern literature is a kind of riddling. As we said, with the insistence by some critics on the disappearance of the author from the literary text, it is possible that all acts of reading can become acts of riddle solving and even riddle making. We speak of some people we know as "riddles"—we find it difficult to discern their motives and feelings. So it may be with literature—it is not always easy to figure out what the language is saying or why we think or feel that way about language. Perhaps what riddles teach us is that the process of looking for answers is as important as, if not more important than, finding one that will satisfy everyone. The answers are important but may remain elusive or changing. To us, this is part of what allows us to return to a literary text over and over. To solve the mystery of *Hamlet,* to use a cliché, is perhaps to have finished reading it, once and for all—in a way, killing it off. And yet just as soon as we think we have done so, someone else will come along with a different answer to the riddle.

LITERARY PLAY AND THE CONTEXTS
OF PERFORMANCE

We would like to conclude our chapters about play with a few thoughts about play in some of the larger contexts of literature and performance. Thus far, we have tended to look at play elements in individual works of literature, primarily poems, through such categories as the pun, the riddle, and so forth, isolating examples to demonstrate their presence, structure, and function within a given work. We have also raised questions a performer of these texts might need to address in realizing the text in performance, encouraging you to attempt a variety of approaches; we would add that we believe such pluralism is in keeping with the spirit of play.

But what of play in the larger contexts of literary performance? In what sense is all performance of literature an act of play? Certainly because it involves the assumption of the words, emotions, and experiences of those other than ourselves, there is always the element of what Caillois called *mimicry* or imitation. Athough theorists have argued and continue to argue about just who the performer is at any moment in a performance (some opt for a nearly complete identification between performer and the character in the work; others, for a more self-conscious stance as performer, as we will see in the next chapter), there is little doubt that the act of performing literature involves imitation.

Performance, as we have suggested earlier, also involves to some degree or another all three of the other main types of play outlined by Caillois: *contest,* as writer, performer, and audience work in coordination and sometimes friendly competition; *chance,* as performers always live in the present, which is dictated by what may happen at any given moment; and *ilinx,* or vertigo, the dizzying pleasure of speaking and acting, of being bodies and minds in motion (even if the motion is primarily a vocal and intellectual one).

We find play in some of what may seem the least likely places in literature and performance. To end the chapter, let us consider one more specific text and its performance.

Sweeney Todd, the Demon Barber of Fleet Street

In *Sweeney Todd, the Demon Barber of Fleet Street,* composer and lyricist Stephen Sondheim wrote (along with librettist Hugh Wheeler, who wrote the book for the play), what he called a "musical thriller," a musical play (almost an opera) derived from a legendary tale out of what the British called "penny dreadfuls," sensationalistic novels describing in intimate and gory detail melo-dramatic and lurid crimes. Such penny dreadfuls were quite popular in the nineteenth century and, in various forms, remain successful forms of entertain-ment today. (Have you ever seen *Nightmare on Elm Street* or one of the *Friday the Thirteenth* movies?)

Sondheim set out to create a work that would straddle both the passionate intensity of emotion and revenge in the legend of Sweeney Todd and a more modern, satiric perspective. To do so, he gave depth to the central male character, Sweeney Todd, and added a darkly humorous spin to Sweeney's partner in crime,

the devouringly named Mrs. Lovett. *Sweeney Todd* is a tale of revenge, of dark corners of human hunger and sexuality. Sweeney Todd was originally Benjamin Barker, an honest barber, banished to Australia on false charges by a wicked judge who had designs on Sweeney's beautiful young wife, Lucy. Many years later, under his new alias, Barker returns as Todd, recognized only by Mrs. Lovett, a baker, down on her luck.

The plot is intricate, and much of its pleasure derives from its intricacy, as Sondheim and Wheeler lead us and the characters on a merry chase. At the end of the first act, Todd is near despair, believing his plan for revenge will never be realized. He sings a magnificent song, "Epiphany," a title Sondheim must surely have meant to be taken ironically: if Todd's song is "epiphany," then it is an unholy epiphany indeed.

Enter Mrs. Lovett, who in most productions is made up with a garish wig and colorful face paint, like a devil-doll or cartoon. Her appearance seems quite intentionally surrealistic, as if those involved in the production are signaling to the audience not to take her or anything they see too seriously (though the points they wish to make are quite serious). Mrs. Lovett finishes listening to Todd's ravings, pauses, and dismisses them, asking what they are to do with the body of Pirelli, a barber who recognized Todd from previous days and whom Todd murdered after Pirelli tried to blackmail him. Todd tells Mrs. Lovett, that after dark, they'll take the body away and dispose of it.

Mrs. Lovett has other ideas, and what follows is what by all accounts is one of the most brilliant uses of play in a context that in real life would seem as far removed from play as imaginable: murder. Sondheim calls the musical number in which Mrs. Lovett reveals her plan to Todd "A Little Priest." If at all possible, try to listen to a recording of this or watch it on videotape (it has been filmed for television). Angela Lansbury's performance as Mrs. Lovett and Len Cariou's as Todd (on the audiotape) and George Hearn's (on the videotape) provide as dramatic examples as possible of the limits to which the play impulse may be taken.

MRS. LOVETT:
>Seems an awful waste . . .
>Such a nice plump frame
>Wot's-his-name
>Has . . .
>Had . . .
>Has . . .
>Nor it can't be traced.
>Business needs a lift—
>Debts to be erased—
>Think of it as thrift,
>As a gift . . .
>If you get my drift . . .

[*Todd stares into space*]
>No?

[*She sighs*]

> Seems an awful waste.
> I mean,
> With the price of meat what it is,
> When you get it,
> If you get it—

TODD [*Becoming aware*]: Ah!

MRS. LOVETT:

> Good, you got it.
> Take for instance,
> Mrs. Mooney and her pieshop.
> Business never better, using only
> Pussycats and toast.
> And a pussy's good for maybe six or
> Seven at the most.
> And I'm sure they can't compare
> As far as taste—

TODD:

Mrs. Lovett,	
What a charming notion,	MRS. LOVETT:
Eminently practical and yet	Well, it does seem a
Appropriate, as always.	Waste . . .
Mrs. Lovett	
How I've lived without you	It's an idea . . .
All these years I'll never know!	Think about it . . .
How delectable!	Lots of other gentlemen'll
Also undetectable.	Soon be coming for a shave
	Won't they?
	Think of
How choice!	All them
How rare!	Pies!

TODD:

> For what's the sound of the world out there?

MRS. LOVETT:

> What, Mr. Todd,
> What, Mr. Todd,
> What is that sound?

TODD:

> Those crunching noises pervading the air?

MRS. LOVETT:

> Yes, Mr. Todd,
> Yes, Mr. Todd,
> Yes, all around—

TODD:

It's man devouring man, my dear,	MRS. LOVETT:
And who are we	Then who are we
To deny it in here?	To deny it in here?

TODD: These are desperate times, Mrs. Lovett, and desperate measures are called for.

[*She goes to the counter and comes back with an imaginary pie*]

MRS. LOVETT: Here we are, hot from the oven.

[*She hands it to him*]

TODD: What is that?

MRS. LOVETT:
It's priest.
Have a little priest.

TODD:
Is it really good?

MRS. LOVETT:
Sir, it's too good,
At least.
Then again, they don't commit sins of the flesh,
So it's pretty fresh.

TODD [*looking at it*]:
Awful lot of fat.

MRS. LOVETT:
Only where it sat.

TODD:
Haven't you got poet
Or something like that?

MRS. LOVETT:
No, you see the trouble with poet
Is, how do you know it's
Deceased?
Try the priest.

TODD [*tasting it*]: Heavenly.

[*Mrs. Lovett giggles*]

Not as hearty as bishop, but not as bland as curate, either.

MRS. LOVETT: And good for business—always leaves you wanting more.
Trouble is, we only get it in Sundays. . . .

[*Todd chuckles. Mrs. Lovett presents another imaginary pie*]
Lawyer's rather nice.

TODD:
If it's for a price.

MRS. LOVETT:
 Order something else, though, to follow,
 Since no one should swallow
 It twice.

TODD:
 Anything that's lean.

MRS. LOVETT:
 Well, then, if you're British and loyal,
 You might enjoy Royal
 Marine.
[*Todd makes a face*]
 Anyway, it's clean.
 Though, of course, it tastes of wherever it's been.

TODD [*Looking past her at an imaginary oven*]:
 Is that squire
 On the fire?

MRS. LOVETT:
 Mercy no, sir,
 Look closer,
 You'll notice it's grocer.

TODD:
 Looks thicker,
 More like vicar.

MRS. LOVETT:
 No, it has to be grocer—it's green.

TODD:
 The history of the world, my love—

MRS. LOVETT:
 Save a lot of graves,
 Do a lot of relatives favors . . .

TODD:
 —is those below serving those up above.

MRS. LOVETT:
 Everybody shaves,
 So there should be plenty of flavors . . .

TODD:
 How gratifying for once to know—

BOTH:
 —that those above will serve those down below!

MRS. LOVETT:
 Now, let's see . . .
[*Surveying an imaginary tray of pies on the counter*]
 We've got tinker.

TODD [*Looking at it*]:
　　Something pinker.

MRS. LOVETT:
　　Tailor?

TODD [*Shaking his head*]:
　　Paler.

MRS. LOVETT:
　　Butler?

TODD:
　　Subtler.

MRS. LOVETT:
　　Potter?

TODD [*Feeling it*]:
　　Hotter.

MRS. LOVETT:
　　Locksmith?

[*Todd shrugs, defeated. Mrs. Lovett offers another imaginary pie*]
　　Lovely bit of clerk.

TODD:
　　Maybe for a lark . . .

MRS. LOVETT:
　　Then again, there's sweep
　　If you want it cheap
　　And you like it dark.
　　Try the financier.
　　Peak of his career.

TODD:
　　That looks pretty rank.

MRS. LOVETT:
　　Well he drank.
　　It's a bank
　　Cashier.
　　Last one really sold.

[*Feels it*]
　　Wasn't quite so old.

TODD:
　　Have you any Beadle?

MRS. LOVETT:
　　Next week, so I'm told.
　　Beadle isn't bad till you smell it
　　And notice how well it's
　　Been greased.
　　Stick to priest.

[*Offers another pie*]

 Now this may be a bit stringy, but then, of course, it's fiddle player.

TODD: This isn't fiddle player. It's piccolo player.

MRS. LOVETT: How can you tell?

TODD: It's piping hot.

[*Giggles*]

MRS. LOVETT [*snorts with glee*]: Then blow on it first.

[*He guffaws*]

TODD:
 The history of the world, my sweet—

MRS. LOVETT:
 Oh, Mr. Todd,
 Ooh, Mr. Todd,
 What does it tell?

TODD:
 —is who gets eaten and who gets to eat.

MRS. LOVETT:
 And, Mr. Todd,
 Too, Mr. Todd,
 Who gets to sell.

TODD:
 But fortunately, it's also clear—

TODD:	MRS. LOVETT:
That everybody	But everybody
Goes down well with beer.	Goes down well with beer.

MRS. LOVETT: Since marine doesn't appeal to you, how about rear admiral.

TODD: Too salty. I prefer general.

MRS. LOVETT: With or without his privates? "With" is extra.

[*Todd chortles*]

TODD: [*as Mrs. Lovett offers another pie*]:
 What is that?

MRS. LOVETT:
 It's fop.
 Finest in the shop.
 Or we have some shepherd's pie peppered
 With actual shepherd
 On top.
 And I've just begun.
 Here's the politician—so oily
 It's served with a doily—

[*Todd makes a face*]

 Have one.

TODD:

> Put it on a bun.

[*As she looks at him quizzically.*]

> Well, you never know if it's going to run.

MRS. LOVETT:

> Try the friar.
> Fried, it's drier.

TODD:

> No, the clergy is really
> Too coarse and too mealy.

MRS. LOVETT:

> Then actor—
> That's compacter,

TODD:

> Yes, and always arrives overdone.
> I'll come again when you
> Have judge on the menu . . .

MRS. LOVETT: Wait! True, we don't have Judge—yet—but would you settle for the next best thing?

TODD: What's that?

MRS. LOVETT: [*Handing him a butcher's cleaver*]: Executioner.

[*Todd roars, and then, picking up her wooden rolling pin, hands it to her*]

TODD:

> Have charity toward the world, my pet—

MRS. LOVETT:

> Yes, yes, I know, my love.

TODD:

> We'll take the customers that we can get.

MRS. LOVETT:

> High-born and low my love.

TODD:

> We'll not discriminate great from small.
> No, we'll serve anyone—
> Meaning anyone—

BOTH:

> And to anyone
> At all!

Even if you have not heard this selection sung, we are certain you can imagine how all of the elements of language play we have identified come together here. The imaginary bake shop in which Todd and Mrs. Lovett categorize all their pies by professions is as much a game of make-believe (at this moment in the play, though they will make it come true, bizarrely enough) as any child's fantasy; it

is also a comment on the economic class system of England during the Industrial Revolution, during which the play is set. Sondheim has used the playful game of listing professions (not entirely unlike the child's game of Rich Man, Poor Man, Beggar-man, Thief) to make a statement about history.

He uses language in deft and surprising ways. The movement from spoken to sung dialogue is also marked by the use of rhymes, emphasized all the more because they occur in such rapid succession. The shortness of the lines and the alternation between singers (approximating what the Greeks called *stichomythia*) remind us that we are not watching reality but two performers playing with the characters, the language, and the audiences. It is a pleasurable and audacious way for Sondheim to introduce the usually shocking and disgusting element of cannibalism into the play.

Mrs. Lovett and Todd play a verbal game, a rhyming contest that also reminds the audience of the playfulness of the theatrical performance. There is something of the verbal duel in the segment in which the two match wits by reducing their challenge and responses to single words; Mrs. Lovett offers a name, and Todd must respond with an adjective or adverb appropriate to both the name and to the world of food (such as ''potter'' and ''hotter''), the game ceasing only when Mrs. Lovett stumps Todd with the unrhymable ''locksmith.''

The selection and the play's act end with the pair's declaration ''we'll serve anyone—/Meaning anyone—/And to anyone/At all!'' The fortunes of Todd and Mrs. Lovett appear to be on the upswing at this point, and so there is a natural division. If taken completely seriously, such a conclusion to the act would be most troubling, suggesting that murder is an approved way of solving economic and emotional problems (not unlike Swift's ''A Modest Proposal,'' in which Swift suggests eating babies as a solution to the Irish famine); but Sondheim has built in enough cues to assure the audience that he is using the light-hearted duet, like something out of British music hall or American vaudeville, not as a serious suggestion of how to see justice served but as a way of combining the audience's and performer's pleasure at the ''routine'' (which when performed often involves mugging, or exaggerated facial gestures and bodily movements) with an underlying horror at what is being described. Sondheim, amazingly enough, substitutes play and horror for Aristotle's notion of catharsis (or purging of emotions) through tragedy's pity and horror. For those audiences insisting on a totally ''realistic'' approach (whatever ''realism'' finally means for them) to drama, ''A Little Priest'' is impossibly vile; for those who can negotiate play and ideology in the same context, it is an exhortation to join in the game.

WORKS CITED

Aristotle. *Aristotle Poetics.* Trans. Gerald F. Else. Ann Arbor: U of Michigan P, 1970.
———. *The Rhetoric of Aristotle.* Trans. Lane Cooper. New York: Appleton, 1932.
Bishop, Elizabeth. *The Complete Poems 1927–1979.* New York: Farrar, 1983. 133–35.
Bloom, Harold, ed. ''Editor's Note.'' *Ezra Pound.* New York: Chelsea House, 1987. vii–viii.

Carroll, Lewis. *Alice in Wonderland:* Authoritative Texts of *Alice's Adventures in Wonderland, Through the Looking-Glass, The Hunting of the Snark.* Ed. Donald J. Gray. New York: Norton, 1971.

Donne, John. "A Hymne to God the Father." *The Complete Poetry.* Ed. John T. Shawcross. New York: New York UP, 1968. 392.

Frye, Northrop. *Anatomy of Criticism: Four Essays.* Princeton: Princeton UP, 1957.

Georges, Robert, and Alan Dundes. "Towards a Structural Definition of the Riddle." *Analytic Essays in Folklore.* By Alan Dundes. The Hague: Mouton, 1975. 95–102.

Higgins, Dick. "Early Sound Poetry." *Literature in Performance* 5.2 (1985): 42–48.

"The House That Jack Built." *The Mother Goose Treasury.* Ed. and illus. Raymond Briggs. New York: Coward-McCann, 1966. 30–33.

Huizinga, Johan. *Homo Ludens: A Study of the Play Element in Culture.* Boston: Beacon, 1955.

Ionesco, Eugene. *The Bald Soprano. Four Plays.* New York: Grove, 1958. 7–43.

Meschonnic, Henri. "Rhyme and Life." *Critical Inquiry* 15 (1988): 90–107.

Opie, Iona, and Peter Opie, eds. *The Oxford Dictionary of Nursery Rhymes.* Oxford: Oxford UP, 1951.

———. *The Oxford Nursery Rhyme Book.* Oxford: Oxford UP, 1955.

Schwartz, Lloyd, and Sybil P. Estess, eds. *Elizabeth Bishop and Her Art.* Ann Arbor: U of Michigan P, 1983.

Dr. Seuss. *Green Eggs and Ham.* New York: Random, 1960.

Sexton, Anne. *To Bedlam and Part Way Back.* Boston: Houghton, 1960.

Sondheim, Stephen. "A Little Priest." *Sweeney Todd: The Demon Barber of Fleet Street.* New York: Revelation Music Publishing Corp./Rilting Music. A Tommy Valendo Publication, 1978, 1979.

Stein, Gertrude. "Susie Asado." In *Selected Writings.* Ed. Carl Van Vechten. New York: Random, 1946. 485.

Tytell, John. *Ezra Pound: The Solitary Volcano.* New York: Doubleday, 1987.

Welsh, Andrew. *Roots of Lyric: Primitive Poetry and Modern Poetics.* Princeton: Princeton UP, 1978.

Williamson, Craig, trans. *A Feast of Creatures: Anglo-Saxon Riddle-Songs.* Philadelphia: U of Pennsylvania P, 1982. 110, 144.

FOR FURTHER READING

Freud, Sigmund. *Jokes and Their Relation to the Unconscious.* New York: Norton, 1963.

Holland, Norman N. *Laughing: A Psychology of Humor.* Ithaca: Cornell UP, 1982.

Olson, Elder. *The Theory of Comedy.* Bloomington: Indiana UP, 1968.

Sewell, Elizabeth. *The Field of Nonsense.* London: Chatto & Windus, 1952.

Turco, Lewis. *The New Book of Forms: A Handbook of Poetics.* Hanover: UP of New England, 1986.

Williams, Miller. *Patterns of Poetry: An Encyclopedia of Forms.* Baton Rouge: Louisiana UP, 1986.

CHAPTER 8

Performance and the Self

Let us begin our discussion of the selves in literature by considering two poems, written roughly in the same historical period, by two New England poets, radically different in temperament, style, and life. First, consider a brief lyric by Emily Dickinson. As you read the poem to yourself, try to answer the question it poses in the first line: "Who are you?"—"you" being both the self in the poem and you the reader addressed by the poem.

> I'm Nobody! Who are you?
> Are you—Nobody—too?
> Then there's a pair of us!
> Don't tell! they'd banish us—you know!
>
> How dreary—to be—Somebody!
> How public—like a Frog—
> To tell your name—the livelong June—
> To an admiring Bog!

Where do you begin to answer the question that the poem asks of the reader. "Who are you?" This is a question of identity, not simply of identification; there is no simple answer to be puzzled out but a number of different possibilities.

THE LINGUISTIC SELF

We might begin with what we could call the linguistic self of the poem—that self created by the language. Of course, it is impossible ever wholly to divorce our perception of the language from the other contexts of the poem, but it can

sometimes be useful to approach analysis initially on the basis of what we can discern from the words and sentences in the text of the poem. What kind of self does the language give to us?

To begin with, this is a poem that presents a self in the very first word: "I'm." Although we can tell very little about the self at this point, it is worth noting that this poem, in its grammatical form, anyway, does not hide the presence of a conscious, speaking subject but rather makes that self's presence immediate. However, this presentation of self is immediately followed by a word that would seem to negate self: "Nobody!" Even at this early stage, as readers we must begin to sense the contradictions and complexities inherent in such a statement. In what way is it possible to say, "I'm Nobody!"? Is this not a paradoxical statement? Under what conditions might we find ourselves saying it?

We might make this statement in a number of situations, depending on context and our intended meaning. Imagine a situation in which your requests or suggestions are ignored by those around you. You might utter these words sarcastically, suggesting that you believe your sense of self has been diminished by the world around you, that others see you not as a subject but as a "nobody." Or a less sarcastic reading might be that of psychologically diminished or modest individuals who feel their self-worth or importance is indeed minimal.

In this text, however, the words that follow this opening statement of self give us clues to the rather idiosyncratic, even eccentric uses to which the self of this poem puts such a self-negating declaration. After the statement "I'm Nobody," the speaker immediately follows up with a direct address to the reader or audience of the poem: "Who are you?/Are you—Nobody—too?" This is neither a resentful lashing out against a rejecting world nor the impoverished neurotic cry of the lonely but rather an invitation to anyone who reads the poem to be "Nobody—too."

Yet how is it possible to be "Nobody" and to speak or write the words declaring this fact at the same time? Does not the linguistic act itself require the state of being someone, of having a self? The irony present in such a contradiction is both astonishing and yet, at some fundamental level, absolutely true—and this is part of the poem's achievement. To be able to make a statement such as "I'm Nobody!" requires some kind of consciousness capable of formulating sentences—"somebody." At the same time, "Nobody" is also a pun; language, strictly speaking, is an abstract phenomenon, and there is no necessary "body." In a sense, then, the self of the poem may be seen as a circular self-contradiction between the self as subject, the self as perceiving and speaking being, and the self as negation of self. Indeed, the remainder of the poem proceeds to take the diminution of self as a theme; even the complicity of "I" and "you" (the addressed reader) as a "pair of us" involves an admonition—"Don't tell! they'd banish us"—suggesting that it is only through this state of being "Nobody" that survival can take place.

Thus far we have looked exclusively at the poem in terms of the statements made by the language, keeping insofar as possible any other concepts of self not derived immediately from the words and sentences out of our consideration. We have done so not to suggest that other ways of viewing and constructing the self

in literature are unimportant or even less important but rather to approach the poem's presentation of self in ways that we suspect are most familiar to you. We have constructed a self in the poem from the language in some abstract sense, divorced from other possible contexts: the historical or biographical self of the poet; the psychological self we might find, based on the ideas of such thinkers as Freud and Jung; the sociopolitical self, as seen by those critics who base their ideologies in the works of Marx and other sociopolitical theorists; the gendered self, created by society's and culture's construction of sexuality, of what it means to be a woman or man.

OTHER SELVES: PSYCHOLOGICAL, SOCIOPOLITICAL, BODILY, HISTORICAL, AND INTERTEXTUAL

Let us consider some of the different selves this poem may present. Psychologically, this is a poem of containment, of using language and art as a way of simultaneously presenting and denying the ego, the conscious, perceiving subject of the poem. The contradictions we find in the language of the poem, in the ways in which its use of the "I am" form with a predicate that logically negates the essence of the "I am" construction, is also something of a psychological contradiction; perhaps it would be more accurate to say that psychologically there is a complexity that the self-paradoxical statement makes. Without being too glib in coming to conclusions about the self contained in the poem, we might hazard the interpretation that this self is someone at odds with herself, controlled by conflicting or competing desires and needs: on the one hand, the desire to present herself (we will use the feminine here simply to be consistent with the poet's identity—some readers may wish to argue for a genderless speaker) through the language of the poem, clearly addressing an unnamed listener or audience and wanting the company of that listener, wanting to be part of the world; on the other hand, a need to diminish her own public presence in the world by calling herself "Nobody." Psychologically, the poem may be seen as a contest between the speaker's desire for the ego fulfillment of the poetic situation and the fear of being turned into another kind of nonperson, a public "Frog," endlessly sounding out identity—"To tell your name—the livelong June"—to an audience that can or will never know anything authentic. How much more satisfying to restrict the presentation of self to the intimacy of the "pair of us" suggested by the poem.

It is perhaps a bit more difficult to discern a political self in this poem, which reminds us that these various perspectives on the self, these "lenses" through which we look, cannot all be applied with equal success to every text. Yet building on some of the aspects of the psychological self suggested above, we might see a political agenda in the poem's presentation of self. If a primary (perhaps the primary) opposition in the poem is between public and private, the political self of the poem is indeed something of a "Nobody," that self who has selected not to become involved with "things of the world" and, indeed, paints the public

realm as "an admiring Bog!" She is the disenfranchised woman in a patriarchal society, who has no outlet to pontificate to the public. The speaker of this poem resists the impact of society, for she sees it as transforming the freedom of "Nobody," which allows a curious kind of liberty, into a "Frog," croaking away in a meaningless repetition of sounds.

Our responses to the psychological and sociopolitical dimensions of the self in this poem may lead us to look at other perspectives on the self, related to these two larger categories. Certainly the sense of self as a physical body is important, if only in a negative way. Although language is itself an abstract system, it is also composed of physically concrete performances—the sounds we make when we speak, the marks we make when we write, and so on. Language, although in some ways bodiless, is also densely bodied. So it is with this poem. The self of this poem declares herself bodiless, yet the unfolding of words creates a body—and a body immediately recognizable to those familiar with other poems by Dickinson. The vocabulary, the rhythms, the odd use of dashes as punctuation, and the brevity of syntax are all as much a part of the self's body as Dickinson's characteristic image in a white dress with her hair tied back in a bun. That this poetic self denies the body, in fact throws it off, may well be tied to two other factors: her life (her personal history) and her gender, particularly as it was constructed in her moment in history.

When we move into the poem's self in history, we step over boundaries that may make some readers uncomfortable: we admit the poet into the world of the poem she has written. We do not necessarily have to say that the self in the poem is the same as the self known as Emily Dickinson, who lived in Amherst, Massachusetts, in the latter part of the nineteenth century and about whom we know some biographical facts; however, when we do look at the poem's self in historical and biographical perspectives, we do suggest that there is some important relationship between the two selves, the self in the poem and the self of Emily Dickinson. Indeed, today most critics would argue that some difference, no matter how slight, needs to be maintained between the self in the poem and the self of the poet. But a consideration of the historical and biographical self may shed some light on the poem.

Dickinson was, by all accounts, an eccentric and reclusive individual. Passionate about people, poetry, and the world around her, she nonetheless kept the world at more than an arm's length. Various biographers have speculated about the reasons for this reticence: some see a domineering father's influence; some see unrequited or disappointed love. It is outside the scope of our brief examination of the poem and of Dickinson to speculate with any certitude. What is important to recognize is that some critics wish to draw close connections between the historical Emily Dickinson and the self created in her poems, to see the sources for the poem's self in the life of the poet. Other critics will choose to ignore anything about the life of the writer in discussing the poem; still others will strike a middle ground, seeing the writer's life as one more factor to be considered in experiencing the work of literature.

More recently, critics have paid more attention to the ways in which the gendered self is constructed in literature. Such critics would focus on the ways

in which the gender of the poem's self affects the experience of the poem. In this poem, the gendered self may be seen either as the neuter self in the poem, which does not overtly reveal itself as female or male, or the female self of Emily Dickinson, who perhaps created this poem of self-presentation through self-negation out of her experience as a woman, particularly as a woman struggling to create art in a male-dominated world. If we see the self in this poem as neuter, we may understand this to be a strategy designed to not allow male critics or male listeners to disregard the poem on the basis of something as arbitrary as sex. It is also possible to see the naming of self as ''Nobody'' as an attack on those male critics (Dickinson's own ''mentor'' perhaps included) who would indeed diminish her to a state of being ''Nobody'' simply by virtue of her womanhood. Certainly other possible constructions of the gendered self are available.

We have a last comment on the varieties of self in this poem. We may also speak of an *intertextual* self, a self created out of other literary (and for that matter, other kinds of) selves. Some selves are more overtly and more densely intertextual than others. But even with this brief poem, we may see the presence of intertextual selves, pointing backward and forward in time. Looking backward, we may hear a resonance in naming the self ''Nobody.'' You may remember that in the *Odyssey,* Odysseus escapes from the Cyclops by calling himself ''Nobody'': he tricks the Cyclops with this name, and when he has blinded the Cyclops, the monster, enraged, can only declare that ''Nobody'' has hurt him. Although we cannot know if Dickinson had this reference in mind, the use of ''Nobody'' aligns the self in the poem with the tradition of trickster heroes and heroines, players with language and identity.

Another dimension of intertextuality arises when we as readers in the 1990s sense that Dickinson's play with nonidentity is picked up and developed by such contemporary writers as Sylvia Plath, Anne Sexton, and Adrienne Rich, to name only a few, who present equally troubled and questioning selves in their poems. Plath's poetry in particular may be seen as following along some of the same lines as this one: at one level, the poet revels egotistically in self, while using such poetic occasions to negate being. Plath took this strategy to its extreme personal end in a suicide that may have been designed not necessarily to kill herself but to allow herself to be discovered and saved. Again, although we do not wish to draw too simple or too concrete an analogy between these poetic strategies, there seems to be some ways in which the selves in this poem and the poems and careers of later poets read or speak to one another.

We have omitted one rather important self in the poem, named in the first line, the one who asked ''Who are you?'' Literature does not exist in a vacuum, in which the author writes language and that is the end of it. Most critics today see the need to include the reader in any theory of the literary experience. All poems ask us to be selves as we read, to be subjects in our own right. Dickinson's poem asks us in more overt ways than do many. It asks us to align ourselves with her, to be kindred selves with her, ''unpublic'' with her.

But in addition to the self the poem asks us to become, we bring our own set of complexities to the experience of the poem. It would be possible, and probably useful, to try to look at the variety of selves we carry with us when

we read the poem. To what degree does our own psychological state or sociopolitical ideology or historical life affect how we read this poem? Does our own gender as male or female influence the self we construct as we read the poem? How do all these factors become complicated or transformed when we move from the realm of the private, silent reading of this poem to a public, oral performance? Is it possible to perform this poem publicly? Why or why not? What does it do to the self in this poem to make it "public"?

"I Sing the Body Electric": An Example

As a contrast, let us now look at another poem, a poem that is in many respects at the other end of the spectrum from Dickinson's poem. Read the following selection from Walt Whitman's poem "I Sing the Body Electric" (the entire poem is in the appendix, pages 455–60). As you read these opening two sections of the poem, consider how different this self is from the self in "I'm Nobody." Using some of the categories for the self we examined with Dickinson's poem, think about what kind of self you would present in a performance of Whitman's.

I Sing the Body Electric
1

I sing the body electric,
The armies of those I love engirth me and I engirth them,
They will not let me off till I go with them, respond to them,
And discorrupt them, and charge them full with the charge of the soul.

Was it doubted that those who corrupt their own bodies conceal
 themselves?
And if those who defile the living are as bad as they who defile the
 dead?
And if the body does not do fully as much as the soul?
And if the body were not the soul, what is the soul?

2

The love of the body of man or woman balks account, the body
 itself balks account,
That of the male is perfect, and that of the female is perfect.

The expression of the face balks account,
But the expression of a well-made man appears not only in his face,
It is in his limbs and joints also, it is curiously in the joints of his
 hips and wrists,
It is in his walk, the carriage of his neck, the flex of his waist and
 knees, dress does not hide him,
The strong sweet quality he has strikes through the cotton and
 broadcloth,

To see him pass conveys as much as the best poem, perhaps more,
You linger to see his back, and the back of his neck and
 shoulder-side.

The sprawl and fulness of babes, the bosoms and heads of women,
 the folds of their dress, their style as we pass in the street, the
 contour of their shape downwards,
The swimmer naked in the swimming-bath, seen as he swims
 through the transparent green-shine, or lies with his face up and
 rolls silently to and fro in the heave of the water,
The bending forward and backward of rowers in row-boats, the
 horseman in his saddle,
Girls, mothers, housekeepers, in all their performances,
The group of laborers seated at noon-time with their open dinner
 kettles, and their wives waiting,
The female soothing a child, the farmer's daughter in the garden or
 cow-yard,
The young fellow hoeing corn, the sleigh-driver driving his six
 horses through the crowd,
The wrestle of wrestlers, two apprentice-boys, quite grown, lusty,
 good-natured, native-born, out on the vacant lot at sundown
 after work,
The coats and caps thrown down, the embrace of love and resistance,
The upper-hold and under-hold, the hair rumpled over and blinding
 the eyes;
The march of firemen in their own costumes, the play of masculine
 muscle through clean-setting trowsers and waist-straps,
The slow return from the fire, the pause when the bell strikes
 suddenly again, and the listening on the alert,
The natural, perfect, varied attitudes, the bent head, the curv'd
 neck and the counting;
Such-like I love—I loosen myself, pass freely, am at the mother's
 breast with the little child,
Swim with the swimmers, wrestle with wrestlers, march in line
 with the firemen, and pause, listen, count.

As you read the poem, did you try to sound it aloud? If so, you no doubt found that you needed to slow down, take more time getting through it than you did with Dickinson's poem. This points to a rather obvious feature of the self in this selection: the linguistic self is more expansive, if simply in the volume of language produced in the poem. Whereas the linguistic self in Dickinson's poem has great logical complexity in the paradoxical semantics of its statement of being, "I'm Nobody," the linguistic self in Whitman's poem is complex in the number of words and phrases it uses to present itself. Although this observation of difference in the quantity of language may seem obvious, it is an important

difference for the performer to acknowledge because the different uses of the amount of language suggest different ways of orienting the self to the world through language. For the self in the Dickinson poem, the least amount of language possible is what is desired, perhaps as if language could be trusted only so far in rendering self and experience for others. The self who wishes to remove herself from the public Bog will not wish to produce any more language than necessary.

The self in Dickinson's poem might very well point to the self in Whitman's poem as that "Frog," telling "your name—the livelong June." The self in Whitman's poem sees language as an occasion for rejoicing—and if you read through Whitman's works, you will see that this selection is representative of the expansiveness of voice found in most of his poetry. In his longest single poem, "Song of Myself," Whitman begins by stating, "I celebrate myself," which to some readers might suggest a kind of egotism quite different from the "I'm Nobody" of Dickinson's poem.

Yet what kind of psychological self do we find in the section from "I Sing the Body Electric" that we have just read? We just used the word "egotism" as a possible way of describing the selves in both of these poems. We have already discussed the curiously contradictory psychology of Dickinson's poem—what about the mind of the self in Whitman's?

In the first section of this poem, the speaking (or "singing") self begins by placing himself in an interdependent relationship with the rest of humanity: "The armies of those I love engirth me and I engirth them." He is not suggesting an idiosyncratic godliness but a universal sense of oneness: as a poet, he can speak for humanity by speaking as part of the large community of humanity. Thus, for all the fecundity of language in this selection, there is not the same degree of conscious reflection on the self as in Dickinson's poem. The self in Whitman seems less concerned with revealing the incidents or emotions of his life per se than with conjuring up the fullness of the "body electric," the human body in all its motion and variety. Certainly there is an undeniable concentration on the speaking self by virtue of its invitation to us to listen to his bardic incantation; if the speaking self of this poem did not believe in the quality of its own perceptions, there would be no reason to attend to so lengthy a catalogue of descriptions. Yet at the same time, it is easy, as reader and as performer, to lose (and loose) self in the long lists of section 2, to submerge self into the described bodies. This speaker not only sings the body electric but also is one with the body electric. Just as Dickinson's poem created a complex psychology of self-presentation and self-negation, so Whitman gives us a psychological speaker who is both subject and subjected, speaker of bodies and someone who is spoken by the bodies he celebrates.

This observation suggests another, rather apparent difference between the selves in the two poems, that is, the bodily self. Again, we pointed to the contradiction between the negation of body in Dickinson's poem and the presence of sounded or printed body in the production of a text in performance or book. In Whitman's poem, we have a self that is critically concerned, some would say obsessed, with the presence of, not the body, but bodies. The poem is not a negation of the spirit or soul but sees the body as a holy and sensual place, to

be accorded no less glory than the intellect or heart in the exultation of the human being. The self sees the body in such a multitude of ways and in a multitude of places: in sexuality, in work, in play, in children, and in water and on land. It is as if there is nowhere the body is not.

But just to keep the balance, we need to recognize that the bodies invoked in this poem, in all their fullness, are no more literally physical than the "nobodies" of Dickinson's poem. To return to the notion of the linguistic self, however much Whitman invokes the world of the physical in all its dimensions, we must remember that he does so through as abstract a medium, that of language, as does Dickinson; it is in the particular uses of language that Whitman creates a sense of the bodies as physically present.

Because the self in Whitman's poem is in love with the world of bodies and the world of the human, we feel the presence of a more fully engaged social self than we did in Dickinson's poem. Whitman went out into the world, even serving as paymaster in the Civil War. Even if we knew nothing of the life of the poet, the self in his poem clearly communicates a love of being in a social world, engaged with other humans, as opposed to the self in the Dickinson poem, who seems to desire the company of self and one other (or even *no* other).

As with Dickinson's poem, we can look to the historical self of the poet to understand the self in the poem. Whitman's life included his Civil War experiences, his passionate relationships with other men, which recent scholarship suggests may have been overtly homosexual. The poem's self celebrates the masculine body in open and fearless ways, both idealizing its beauty and concretizing its acts. An understanding of the historical self of the poet may offer us a reading of the poem that admits direct sexual experience of the male as well as of the female body as sources for the poem's vividness of detail and emotion. The poet's experience in the Civil War suggests a direct relationship with the social world of men, a relationship not found either in the text of Dickinson's poem or in the text of Dickinson's life. As a performer, what would be the difference for you between a reading that saw the bodies only as idealizations in the speaker's mind and one that was funded by a knowledge of the poet's own bodily and sexual experiences? Do you think it wrong or inappropriate to consider such elements in constructing a self for the performance of this poem? If so, why do you think it is incorrect? If you believe such knowledge is useful, how is it useful? Are there limits to its usefulness?

Obviously, the issue of the gendered self is involved in a poem that concentrates so much on the physical, especially on the masculine body. At least one critic has called much of Whitman's poetry "genderless," by which he means that nowhere in the poem does the poet make explicit the gender of the speaker. Do you agree that the poem is genderless in this selection or in the entire poem? If the poet has not overtly specified the gender of the speaking self, do you nonetheless have a sense of the perspective as more masculine or feminine? If so, can you describe what makes the poem seem more characteristic of one sex than the other? If you have no clear sense of the self as masculine or feminine, consider what it would mean, experientially, for the performer to present a self that is neither one sex nor the other. How would that affect the performer's

engagement of his or her own self with the self in the poem—as we all carry our gendered selves with us? How would that affect the presentation of the body in performance?

The selves in the two poems we have discussed raise some critical and difficult questions for the performer. Although Dickinson and Whitman offer what may be perhaps the most extremely dramatic oppositions of selfhood in their poems, the questions of identity suggested by "I'm Nobody" and "I Sing the Body Electric" are found, in one way or another, in virtually every literary text we read. We turn now to more detailed consideration of some of these categories of self in literature and performance.

THE SELF IN LITERATURE

Contemporary writer Kurt Vonnegut, Jr., asks the question "Who am I this time?" in his story of the small-town amateur actor who has no personality, no sense of self, other than that of whatever character he is playing, whether it be Stanley Kowalski in Tennessee Williams's *A Streetcar Named Desire* or Shakespeare's Romeo. Certainly the question of identity is one the performer immediately asks when approaching a text for performance; it is a human need to know "who" we are at any given moment, in life as in literature.

Yet as we know from our experiences in life, the answer to the question of identity is easier posed than solved, at least in any satisfying way. Stop for a moment and ask yourself the question "Who am I?" If you are like most people, you will answer initially by stating your name, a label given to you by someone else, usually your parents. But do not stop there—you have hardly begun to answer the question. Whether you believe in a self, a unified, singular sense of being, or in multiple selves (as many psychologists and philosophers do today) or even in a no-self, a negation of being, you know that you can describe and define yourself in a number of ways. On the one hand, there is a reliable, recognizable self, that person you present to the world on a daily basis; so recognizable is this self that people will remark, "You don't seem to be yourself today," when you act in ways they don't recognize. At the same time, we are also aware of the ways in which we refashion ourselves, depending on the context, not to fool people but simply to emphasize some part of ourselves that takes on greater importance in a given context.

Is there such a thing as *a* self, something irreducible, some element or essence that cannot be taken away from who you are and that defines you more profoundly than anything else you might say about yourself or others might say about you? This is a question that cannot be answered by a simple yes or no. We and psychologists and philosophers believe in some essential state of being we call the self, something that synthesizes all the facets of itself into one. However, speaking from a performance perspective, we also believe that we are complex enough to find it useful to consider aspects of the irreducible self in ourselves: we are psychological selves, sociopolitical selves, intertextual selves (selves created from other selves), historical selves, bodily selves, gendered selves,

and performing and performed selves. Keep asking yourself the question "Who am I?" Ask it until you can no longer come up with a new answer. We think you will be surprised at how many different ways you can define who you are. Of course, you are never (or only rarely) any of these selves independent of the others: it is virtually impossible to be only a psychological self, divorced from a bodily or political self. Do your selves ever war with one another? How does one self take priority over another at any given moment? Is one self more important to you than another?

Consider the development of the child: initially the child has no sense of self but feels itself to be one with the entire physical world. The first step toward individuality is the child's recognition of physical separation from the rest of the world. Similarly, the entire notion of individuality as a way of defining and giving boundaries to the self is a fairly recent concept; self-consciousness, according to many historians, is a product of a humanistic perspective, which places the human being at the center of the world.

All the questions of identity, of selfhood, complex as they are, become even more complex when we move into the sphere of literature and the literary performance. We now not only have to deal with our own identities as we experience life on a daily basis but also we must consider the identity of the writer of the text and of the selves the writer helps to create. A very linear approach to the literary process might suggest something along these lines: a writer creates a text, shaping language in a certain way toward a certain end. Depending on the writer and his or her aim, there may be a speaker in the text who either is identifiable as the writer or is an invention created by the writer (as in the characters in almost every play). The reader then processes this writer's text, essentially listening to the speaker (whether the speaker is the writer or someone else created by the writer); the voice heard in the silent reading is assumed to be that of the writer (whether the writer is speaking as self or as other). The reader as performer then takes the task of reproducing the self created by the writer in the text for an audience. In a way, the process is somewhat like an elaborate puzzle in which the performer's responsibility is to figure out what the writer's self is like and, insofar as possible, to submerge the performer's self in the language of the writer.

What do you think of this description of the process of performing literature? Does it capture your experience of how the various selves involved interact? Certainly there is something quite commonsensical about this approach. We are so accustomed to thinking of the writers as the source of the literary experience that we automatically defer to them. Although we may readily admit that in many if not most cases it is virtually impossible to discern what the writer's intention is, many of us are used to thinking that we should be aiming at a reconstruction of what we think the writer was trying to do. As we said, what emerges is an intellectual, sometimes exciting guessing game.

In the last few decades, many critics have radically departed from this sense of literary self based in the writer. Indeed, Michel Foucault and Roland Barthes, two of the most dynamic of these critics, wrote essays entitled "What Is an Author?" and "The Death of the Author," respectively, in which they argue

that the author does not exist—not in the way we are used to thinking of an author, as the ultimate source of experience or meaning for a literary text, as its point of origin, or as the repository of the repressed psyche that finds expression in the artwork. The romantic enshrinement of the author, which developed in the nineteenth century and continues in various forms today, has led in modernity to a vision in which the author is victim, in a sense, of his or her own biography, enslaved by what may be called the cult of the author. To use words like "victim" and "enslaved" may seem ironic here, but many contemporary critics would say that such an identification of the historical and biographical author with the "author" written by the text (the "I" as subject, either explicitly or implicitly presented in any text) confuses planes of existence and reality.

In other words, there is nothing antecedent to writing; the writing process is a linguistic act, and the only predicates to it are linguistic rules and the dictionary. The "I" in a sentence is a structuring device that keeps the writerly process unfolding. The thing that gives meaning to the text in this conception of literature—the site of the meaning of the writerly act—is the destination of the text, namely, the reader: not the personal reader who stands in history with a biography and a psychological self but rather the reader as "someone" who holds together all the traces by which the text is constituted. As Barthes says, "We know that to give writing its future, it is necessary to overthrow the myth: the birth of the reader must be at the cost of the death of the author" (148). In this sense, the reader is as much a "writer" as that being we call the writer or author. Again, the extreme version of this position proves as troubling for some readers as did the earlier, more author-centered one. For one thing, it can lead to a denial of what seems to some readers a fairly commonsensical thing: that there is an originating individual consciousness behind any work of art, any piece of discourse. Foucault and Barthes (and their followers) might respond by saying that the author, as traditionally conceived, is *not* originating: language precedes the individual, and that person we are accustomed to think of as the author no more creates the words, sentences, and larger units of language than does the reader. Further, the emphasis on text as a linguistic act can lead to a denial of the individual presence of either author or reader; both can finally be seen as functions of language, rather than the other way around.

We are in sympathy with both positions. Although we are not ready to call for the death of the authorial self, we agree that to place exclusive control of experience and meaning in the author's hands denies the very real role of the reader in the process. At the same time, it seems hopelessly one-sided to place all control or responsibility in the hands of the reader; the language must come from somewhere, and we wish to suggest, it does not come from a personless vacuum. Finally, that process of experience and meaning we call literature is one that must point back (*intends,* to use the philosophical term) both toward the writer and toward the reader. The selves we discover in literature are neither independent of the writers who shape the texts nor of the readers who experience them—and by experiencing reshape them. As cummings said in the poem discussed earlier, "whatever we lose(like a you or a me)/its always ourselves we find in the sea."

THE HISTORICAL SELF AND THE LITERARY SELF

We need to make a distinction between two broad categories of the self: the historical self and the literary self. We also hasten to add that there are important ways in which this division is arbitrary and artificial: as we will see, the two "selves" are not always (some would argue ever) mutually exclusive in reality. But just as a way of probing what the self is in literature, let us begin by suggesting that there is something or some person we can call the historical self.

The historical self is the person who exists and lives in history, in the unfolding physical and temporal world common to all of us. This is not to say that we all experience the world or any moment in it in a necessarily common way. Even something as seemingly objective as a date or a time of day is open to the subjectivity of the individual. But there is probably something we can all agree on as the historical life of people in time and space, even if we disagree radically on how to interpret such lives, places, and times. Thus, as we write these words, we are writing them as people in history. Although the words may themselves be open to subjective interpretation, few would dispute the factuality of the action itself.

So it is with literature and the historical self. If we go along with critics like Foucault who wish to argue against the primacy of the author, we at least need to acknowledge the existence of an originating writer, a subject who created the words. To go back to our two initial examples, although we do not want to attribute the source of all meaning in the poems to either Emily Dickinson or Walt Whitman, we do find it necessary to acknowledge their existence and to consider their role in the creation of the literary experiences we discover. Not to do so simply denies part of the process. There was an Emily Dickinson and a Walt Whitman who were responsible in some part for the literary experiences we have when we read the poems signed by them.

But this matter-of-fact statement raises a few difficult, to some degree unanswerable, questions about the selves in literature. First, what is the relationship between the historical self and the literary self—by which we mean the self contained in the work of literature? Second, to what degree is the biography—the life of the historical self—germane to the making of meaningful experience in the literary text? In some ways, these questions return to that of Vonnegut: "Who am I this time?"

These are difficult questions because the route to answering them is not cut-and-dried. How we answer depends on how we regard literature itself and where we wish to position the writer with respect to her or his work. In the nineteenth century, critics focused so heavily on the lives of the writers that many people felt the experience of the literature somehow got lost. Surely, most contemporary readers would agree that this is an excess to which none of us would wish to return. The lives of the writers can be fascinating and illuminating, and the twentieth-century zeal to know even the most intimate details of a writer's life continues unabated; nonetheless, these biographical explications are balanced by other approaches that concentrate on the literature.

Out of this dissatisfaction with the ways in which people talked about and analyzed literature (as opposed to the way people actually experienced it as

readers), a number of critics experimented with an approach that came to be called New Criticism (though there really was no tight sense of unity among these critics, whose perspectives varied widely). For these critics, the literary self—the self that could be discerned only through the reading of the literature, supposedly on its own terms, with no reference to the historical self of the writer (and often, with no reference to the historical context in which the poem was written or read)— was the only one that mattered in the "true" experience of literature. The literary self was similar to what we initially called the linguistic self; such critics tried to base their experience of and analysis of literature exclusively on what they perceived the language of the text to be doing.

Another method based on the literary approach that you may be most familiar with is the modal. It attempts to describe a work according to the voice in which the text is spoken and its relationship to the author and, in some cases, the audience. Initially defined by Aristotle, there are traditionally three modes. The first is the *lyric* mode, in which the author speaks directly in his or her own voice; recent critics, who have felt uncomfortable with a direct, one-on-one identification between the authorial self and the literary self, often modify this definition to suggest that the lyric mode is that which seems closest to the point of view of the author. In the second mode, the *dramatic,* the author speaks through a voice other than his or her own, typically by creating a named character or persona, whose situation is demonstrably not his or her own. Again, some critics would argue that however much a writer may attempt to mask or submerge self in the voice of another character, it is impossible ever wholly to escape some semblance of the lyric sensibility underpinning the text. The third mode, the *epic,* is typically viewed as a combination of the lyric and dramatic, in which the author sometimes speaks and the created characters sometimes speak. Because it is a hybrid of the two other modes, the epic involves the most sophisticated mediation of author and character and self and audience.

Sometimes modal critics assign speaker-audience relationships to the modes: the lyric mode is sometimes seen as having the most interior sensibility, in which no one is addressed directly; the dramatic may be seen as closing itself off from the reading or listening audience, though speaking to an equally dramatized audience of its own (which the reader or listener may imaginatively become). The relationship to the audience is perhaps the most variable characteristic; for some critics, it is not distinctive—a text may be lyric whether it addresses an audience directly or not, and it only becomes epic or dramatic when a voice demonstrably different or dissimilar from the writer's enters the text. For some critics, all texts are finally epic, moving between the historical self of the writer (one way of understanding lyric) and the always dramatic self in literature (so that the literary self is always at some important point of distance from that of the author).

Let us consider how these questions of mode might be applied to Dickinson's poem. From some perspectives, it would be useful to call this poem lyric in mode because it presents a single voice, a voice not characterized as necessarily distinct from that of the poet's. Neither has Dickinson given her speaker a name that differentiates it from her own identity, nor has she created a situation that

distances the speaker from the poet. If we pursue the issue beyond the single text of ''I'm Nobody!'' and look at the poem in light of other poems by Dickinson, we might also conclude that the speaker shares common attitudes and orientations toward the world with the speakers of other poems by this writer. At some level, we feel the presence of a consistent, unnamed sensibility, a sensibility not unlike that of the historical Dickinson. These lines of analysis might encourage us to consider the poem to be lyric.

Are there other elements in the poem that might make us want to consider it through other modalities? From some perspectives, the use of ''you'' to create a sense of direct address between speaker and reader or audience might push the poem beyond the meditative, often internally directed situation of the lyric mode. Remember that we said that the speaker-audience relationship was one of the most variable distinctions in modal analysis. But for some critics, the explicitness of the ''I-you'' relationship might push the poem further into the dramatic mode, a mode oriented toward dialogic, external interaction. For many of these critics, the speaker-audience relationship would be more important than the relatively undifferentiated status of the speaker, that is, the sense that the speaker seems comparatively unseparated from the poet herself. Other critics might argue that the creation of a fictive situation in which speaker and audience interact places the poem in a dramatic mode, no matter how close the poem's speaker may seem to the poet.

How might we translate some of these considerations into performance? Is it ever possible to give an entirely lyric performance of this poem, given that Dickinson is Dickinson and we are ourselves? From this perspective, is it possible to say that any performance of this poem will necessarily involve a distancing to the dramatic mode? At the same time, it might also be possible to argue that the more we feature our own experience of the poem, our own sense of ''Nobodiness,'' the closer we come to placing both poem and performance in the lyric mode. If what I am emphasizing is my own reticence, even within the imaginative frame of Dickinson's language, I might wish to call my performance lyric in modality.

It is less important for all readers to agree on one way of defining each of these modes and more important to be aware of how our varying definitions of them suggest very different ways of experiencing the selves in literature and theorizing about these experiences. Try applying these modal distinctions yourself to the two poems we read. In what way is it useful to try to describe the lyric modality of each? Can you see ways in which they are either dramatic or epic? How do your decisions about mode translate into the performance choices you make about the selves in these poems?

Although this concept of a literary self is as problematic a way of trying to define the self in literature as was the earlier biographical or historical approach, some benefits are produced by such attempts. Most of all, searching for the literary self in a text encourages readers to focus on the experience contained within the text rather than depending on the secondary material of biographers. The New Criticism made readers more attentive to language, structure, and detail. If you have ever written a close, detailed analysis of a speaker in a poem, a narrator

in a story, or a character in a play, you have followed in the New Criticism tradition. Certainly such an approach to understanding the self in literature helps the performer immensely: because we focus on the text, we are more able to find ways of enacting the text or some aspect of it.

What do you think might be some of the problems of this exclusively "literary" way of examining the self in a text? What is lost, omitted, or deemphasized? What assumptions about a text may be made if we follow only the New Criticism approach to the self?

For one thing, we may lose the ability to see the literary text as an experience that, like all other experiences, exists in history. There is a critical movement called Reception Theory or Reception Aesthetics, in which the historical context becomes the horizon against which any literary text is viewed. Take the Dickinson and the Whitman poems as examples. It is, of course, quite possible to read these poems with no reference to the points in history in which they were written, to the lives of the individuals who wrote them, or to the times during which we read them or those aspects of our lives we bring to them. We do not need to know nineteenth-century views about women as writers or about Emily Dickinson's own personal reticence in order to make a meaningful experience out of the poem; we can perform the poem simply by puzzling out its situation and tone from the language. Similarly with Whitman's poem: does a knowledge of the Civil War or of Whitman's homoerotic feelings inform how we experience the poem or, as performers, how we might fashion a self in a performance of it?

Without waffling on the issue, we believe the answer is simply that there are different kinds of performances of any text. You no doubt have seen the same text performed by a number of different people in a class. Each performance is different in some way from the others, though typically there are recognizable similarities simply because the same words are uttered (though they have meaning in different ways, depending on who is performing, don't they?). We would not call an ahistorical performance of either "I'm Nobody" or "I Sing the Body Electric" wrong or deficient because such a performance seeks to view the text in a certain way, focusing not on its historical context but on a linguistic and "literary" experience.

At the same time, if a performer chose to identify the speaker of "I'm Nobody" with Dickinson to the point of wearing a white dress and pulling her hair back in a recognizably Dickinsonian way (as did the actress Julie Harris in her theatrical performance, "The Belle of Amherst") or if a performer grew a beard to perform "I Sing the Body Electric," we would also not wish to call that performance wrong. We would see such a performance as emphasizing the historical relationship between writer and text, perhaps to the exclusion of other ways of viewing the self.

To extrapolate beyond these two texts for a moment, we might consider what would happen when a performer chooses to build a performing self on the historical life of the writer of a text, even when the writer has chosen to give the self in the literature an identity other than his or her own. Playwrights do this as a matter of course: rarely does a playwright literally include himself or

herself as a character in a play. By definition, the dramatic mode in literature involves building a mask through which to speak.

At the same time, a play is as much a text in history as is any other kind of literature and, therefore, is as open to consideration of the historical self of the playwright. A playwright like George Bernard Shaw makes his authorial presence felt in play after play, both in the style of his dialogue and in the ideas presented. In the 1950s, when his play *Pygmalion* was transformed into the musical comedy *My Fair Lady,* advertisements depicted Shaw as a puppeteer playing with marionettes fashioned after the characters Henry Higgins and Eliza Doolittle. The implication was that the historical Shaw was present in very noticeable ways in the characters; that is, the puppeteer was never wholly absent from the scene.

This relationship between the historical and philosophical self of Shaw and the selves of the characters in his plays was exploited in a recent revival of what many consider to be his masterpiece, *Heartbreak House.* Many critics have described the pivotal character of Captain Shotover as Shaw's mouthpiece, that character who most fully speaks for Shaw. In the revival, the actor Rex Harrison, who played Henry Higgins in the original production and subsequent film of *My Fair Lady,* played Captain Shotover. Some critics remarked that the casting of Harrison drew something of a triangle between Shaw, Higgins, and Shotover. It is even possible to argue that physically Harrison's performance recalled the historical Shaw.

What is probably true is that the more distance the writer consciously puts between his or her historical self and the selves created in his or her texts, the more disorienting a performance will be that ties the historical self to the self in the text. For example, many people, including the playwright, have often remarked on the affinity between Tennessee Williams and his female characters, such as Blanche DuBois in *A Streetcar Named Desire,* Alma Winemiller in *Summer and Smoke,* and others. It is possible to conceive of a performance that tries to draw this affinity closer in performance terms by casting a male actor to play one of these heroines, perhaps with reference to Williams's own historical presence and characteristics. Because Williams has intentionally placed a distance between himself and the characters by making them different from him in external ways (sex and specific life situation), the decision to place Williams in the character will remove the play from what most readers would recognize as the dramatic situation. To use modal terms, what might emerge is a lyric performance of a dramatic text. There is nothing inherently wrong with such an enterprise (indeed, it could prove exciting), but it is necessary to recognize that it does indeed cross conventional boundaries of an audience's expectations.

As you continue to study performance, you will find that the tension between the literary self and the historical self in texts will reappear, and you will find that various teachers and performers will hold very different positions on which ''I'' is the appropriate one for performance. Remember that what we are advocating is a continuum in which the purely linguistic self (which we have dubbed literary, to distinguish it from linguistic selves in nonliterary contexts) and the purely historical self are both abstractions, never wholly available to any reader or performer. We never perform absent history, yet we can also never

fully recover the historical self (if such a stable entity can really be said to exist) present at the writing of any text. Keep working to explore how different ways of seeing the self as linguistic and literary or historical push you to create very different kinds of performances.

LITERARY TEXTS AND THE PERFORMING SELF

The American literary critic Richard Poirier wrote a provocative volume of essays called *The Performing Self.* Poirier did not mean quite what we are used to thinking of as the performing self (i.e., you or me in the act of performing a text, whether written by us or not). He was referring to what he perceived as the impulse by many writers to perform in their works—to present themselves in a public act—rather than to send out a message or pass down information. For Poirier, Robert Frost was an exemplar of the poet as performing self, whether working in the lyric mode of such poems as "The Road Not Taken" or in more dramatic forms such as "Home Burial" or "Wild Grapes." Poirier examines how writers "compose" and "decompose" selves in time (and, sometimes, place) in the act of writing literature.

What do you think of this concept of the writer as performing self? How is it connected to our two poles of linguistic self and historical self? What does it mean to say that the writer is always engaged in an act of performance? Can you conceive of a situation or context or a particular writer that you do not think is "performing"? It is possible to say, if we banish the writer from his or her work (as the direct speaker or as the source of meaning), that all writers are nothing other than performers, actors speaking lines rather than playwrights or directors (to whom we sometimes attribute greater responsibility for meaning). What do you think of this position? To some, it is absurd, for they believe that finally we must acknowledge that writers are responsible for the creation of texts, at least from a linguistic standpoint; that is, they are the ones who choose words and place them in syntactic and rhetorical relationship to one another. Writers are performers, they argue, but of a special and different nature. For others, the relegation of writers to the level of all other kinds of performers is a reminder that language precedes the consciousnesses of individual writers—that language writes us, essentially—and that writers are finally no more (and no less) privileged than other kinds of performers.

Some writers are more interested than others in featuring the performing self in texts, either thematically or experientially. Writers like the contemporary poets Edward Field and Frank O'Hara make explicit the relationship between poetry and the movies, seeing the performance element in both, and both question the ultimate reality of each of these arts of performance. The play *Hamlet* is perhaps the greatest single text to question the relationship between performance and everyday life; some critics would argue that Hamlet's procrastination is an inability to perform—that when he says "readiness is all," he is finally coming to terms not only with mortality but also with the importance of performing his own life.

Comedians: An Example

Let us consider an excerpt from a play that is in some sense about nothing but the performing self, about how we come to be performers and the ethical and artistic choices we must confront as performers. The play is Trevor Griffiths's *Comedians;* the title refers to the class for comedians run by a Mr. Waters. The second act consists of the stand-up routines done by some of the pupils as a kind of public audition at a seedy English nightclub. We have included two selections from the play: the first is the stand-up routine of the most brilliant but most troubled student, Gethin Price; the second is the encounter between teacher (Waters) and student (Price) at the very end of the play, after Price has lost the competition and been rejected by audience and students alike. First, read Price's monologue in the appendix (pages 460–68).

Notice the ways in which Griffiths uses the theatricality of the situation to underscore questions of the performing self, for example, the whitening of the face "to deaden and mask" it. As Griffiths describes him, Price is "half clown, half this year's version of bovver boy." Price takes great pains to create a nonverbal impression of himself for the audience before he speaks a word, symbolized by his inability to play the violin and his subsequent destruction of it. His first words, according to Griffiths, are "to himself, not admitting the Audience's existence." Though standards in stand-up comedy are changing, it is generally true that an audience expects immediate and direct interaction with a comic, so Price is violating one of the cardinal rules. When he does acknowledge the audience, the audience is one of his own making, dummies who ignore him. He attempts to interact with them, carrying on a one-sided dialogue.

The content of the monologue is an odd admixture of stream-of-consciousness and bad, somewhat racist, smutty jokes (such as the play on "election" and the Chinese substitution of *l* for *r*). The audience in the nightclub (not the dummies, but the people listening to Price) and the audience of the play must wonder what Price wants us to make of such humor. Does he want us to think his jokes are actually funny, or is he criticizing standard forms of stand-up comedy? His last words, after he has completed the routine with the dummies, are "Still. I made the buggers laugh." Who, we all must ask, are the "buggers"— and are we to be included among them?

Price's rather distanced brand of stand-up comedy is eerie and certainly not traditional—though it is perhaps more familiar to us today in the work of such stand-up comics as Emo Phillips and Steven Wright and in the creations of performance artists, whose style it resembles (and about which we will have more to say in part IV). What is perhaps most disturbing is its dislocation of the performing self: Price is no Joan Rivers nor even an Andrew Dice Clay, who project consistent personae, stable selves we can always expect when we go to see them. Now read in the appendix the second scene from the play, the confrontation between Price and Waters.

Notice that there are ways in which Price and Waters are asking different questions about performance. Waters, admitting that Price was "brilliant" (his word), is nonetheless repelled by the performance because, in his words, "It was

ugly. It was drowning in hate. . . . You forget a thing called . . . the truth.'' Price's response is scornful: "What do you know about the *truth*, Mr. Waters,'' and he launches into a scabrous speech on the ugliness of comedy as a business and on Waters's own bankrupt values. Waters's own defense recalls his nightmarish visit to Buchenwald, one of the Nazi concentration camps, after the war and his horror, his inability to find humor, to joke anymore.

Waters sees Price's act as nothing but hate and says, "We've got to get deeper than hate.'' For Price, this alienating, bitter laughter is subversive, the only hope for expressing the self and maybe triumphing over such people as the Nazis. The two men part, uneasily, uncertain where they have come to and where they will go. Each is left with a vision of performance and of the performing self in society different from and irreconcilable with the other's.

A Performer's Struggle to Find a Performing Self: An Example

Let us end the chapter with an actual account of a performer struggling to find a performing self: Alec McCowen's performance of "St. Mark's Gospel.'' He describes the process of creating and rehearsing this one-man performance in his memoir, *Double Bill*. Read the excerpt from that book in the appendix (pages 468–74). McCowen describes in thoughtful and elaborate detail the various performance choices he had to make in confronting what must be one of the most challenging texts in all of Western literature. Notice the emphasis he places on "learning" in the performance process—not simply the learning or memorizing of lines but the analysis of the words and sentences of the text as well.

Deciding "How should it be done?'' became the central question McCowen confronted—not merely how to stage this performance but also who he was to be, who his performing self was. He toyed with historical versions of the self, considering being St. Mark himself. He attempted a literary self through the theatrical metaphors of the Hollywood reporter, ultimately discarding it because it "seemed unnecessarily gimmicky,'' what we might say at too far a remove from the literary or linguistic self created by the text. He finally opted for what we might call a "readerly" self in performance: "I would simply enter with my copy of St Mark, put it on the table, take off my jacket and tell the story—as if it had just been told to me.'' Though he would not use our terminology, we might say that McCowen combined historical, literary, linguistic, and performing selves in this decision; he gave the impression of being a listener, but who has told him the story (St. Mark, another preacher)? What mattered was his decision to locate himself as someone like Alec McCowen, taken over by the story of the Gospel itself. Clearly, he was not pretending to be the "historical Alec McCowen,'' for this was not the first time he had heard the story, nor was he simply a vessel through which the words passed, but an imaginatively created version of himself, placing himself in the position of the reader and listener and audience, filled with the excitement of story for the first time. He created a new performing self for this event, one he re-created each night in performance.

The excerpt is instructive for all performers, for it documents the personal experience of one of the most accomplished and gifted of contemporary actors in the process of discovery and creation; it also reminds us that performance is hard work and, although most of us would not admit it, at times dull work (learning lines and those other periods of monotony when nothing new seems to be coming). But finally for McCowen and, we hope, for you, the process of finding selves (linguistic, literary, historical, etc.) in performance is immensely rewarding. In the next chapters we will continue to explore various ways of understanding and knowing the selves of literature and performance. We will begin with the self as individual, the inner life of the self: the self in psychological context.

WORKS CITED

Barthes, Roland. "The Death of the Author." *Image, Music, Text.* Trans. Stephen Heath. New York: Hill & Wang, 1977. 142–48.

Dickinson, Emily. "[I'm Nobody! Who are You?]" *Poems.* Ed. Thomas H. Johnson. 3 vols. Cambridge, MA: Harvard UP, 1955. Vol. I. 206–07.

Foucault, Michel. "What Is an Author?" *Critical Theory since 1965.* Ed. Hazard Adams and Leroy Searle. Tallahassee: Florida State UP, 1986. 138–48.

Griffiths, Trevor. *Comedians.* New York: Grove, 1976.

McCowen, Alec. *Double Bill.* New York: Atheneum, 1980.

Poirier, Richard. *The Performing Self: Compositions and Decompositions in the Language of Contemporary Life.* New York: Oxford UP, 1971.

Vonnegut, Kurt. "Who am I This Time?" *Welcome to the Monkey House.* New York: Dell, 1968. 14–27.

Whitman, Walt. "I Sing the Body Electric." *Complete Poetry and Collected Prose.* New York: Library of America, 1982. 250–58.

FOR FURTHER READING

Supplementary bibliographies are found at the end of chapters 9, 10, and 11.

CHAPTER 9

The Self in Psychological Contexts

The development of the social sciences in the last century and a half has provided two divergent, though tangential ways of looking at the self in literature: the psychological, which emphasizes the development and orientation of the individual in the world, and the sociopolitical, which emphasizes the ways in which social forces and conditions shape the individual. Although the two different approaches can be mutually exclusive, depending on the critic who employs each perspective, there are often points of similarity. They may be seen as two ways of making sense of the life of the individual in the world, two ways that point in different directions: the psychological looking at the journey inward, the sociopolitical at the journey outward. Both perspectives offer rich opportunities for the examination of the historical and the literary self; indeed, the major thinkers in psychology and sociopolitical theory have often borrowed their examples from the world of literature and the literary self as a way of explaining theories they see operating in what we can call the historical world.

Different critics have used psychological and sociopolitical approaches to literature to very different ends, with different goals in mind. For some critics, the goal is to understand the author—the literary text becomes something akin to a dream or an analytic session for the psychological critic, a tract or public speech for the sociopolitical thinker. Such critics are often said to be focusing on extrinsic matters: matters of history and biography rather than the internal workings of the literary text itself.

Other critics emphasize the psychology or politics of the selves or subjects in a literary text. They ignore or deemphasize what is known about the life of the writer outside of the text and, in fact, are not particularly interested in what their analysis might suggest about the writer. They are interested exclusively in the world created within the text and the ways in which a psychological or sociopolitical perspective reveals the dynamics of what happens or what is said

in the text. Such critics, in contrast to our first group, are often referred to as intrinsic critics.

As our discussion of historical and literary selves suggests, sometimes the richest and most catalyzing reading of a literary text is one in which we move back and forth between the writer and the context in which the text was initially produced and our present-day experiencing of the selves within the text. Although we must be careful not to be inconsistent in our movement back and forth between the extrinsic and intrinsic understanding of the literary selves, sometimes a perception of one can fund a perception of the other.

An interest in the inner life of the selves in literature has always been important, but perhaps the most sophisticated and innovative uses of the psychological to study literature have been initiated by two twentieth-century psychiatrists, two men who worked closely together but parted company and ended their careers by forming very different philosophies of the self: Sigmund Freud and Carl Gustav Jung.

FREUDIAN AND JUNGIAN APPROACHES TO THE IDENTITY OF THE SELF

You are no doubt familiar with some of Freud's basic theories about the development of the *personality,* the term he and other psychologists most frequently use to cover the entire area we have been discussing as the self. His contributions to the psychology of personality have been many, and they remain consistently debated even today. Freud believed that personality is based on the pursuit of wishes and desires and that these wishes and desires are typically established in childhood, during that period (usually before the age of five) when the child is struggling to make sense of his or her sexuality. Out of this theory of development came Freud's most famous specific example: the Oedipus complex. Oedipus, as you may remember, was the king of Thebes in ancient Greece who killed his father and married his mother. Freud believed that the male child unconsciously lives out this fantasy, ending by transferring his usually benignly incestuous obsession with his mother to an identification with the male sexuality of his father.

That the male child experiences this process primarily through the unconscious brings us to Freud's second major contribution to the theory of psychology. Previous psychologists emphasized what we would generally call a conscious psychology. Freud changed this conscious approach to the psychology of the individual in a dramatic way: he posited the existence of what he initially called the *subconscious* and later changed to the *unconscious,* the latter term less hierarchical in nature.

What this theory did was to allow Freud considerably greater latitude in exploring the motivation of the individual; it suggested that there are forces and experiences not entirely knowable through the waking life of consciousness that may unlock the riddle of the self. A central goal of psychoanalysis, then, became the analyst's prodding of the subject's unconscious, often through the analysis

of dreams and the usually uninterrupted monologues of the subject, whose spoken memories of childhood and narratives of present-day experience allowed both analyst and subject greater access to the border regions of the self.

Freud saw the personality as tripartite: ego, id, and superego. The *ego* is the conscious, perceiving self, the part of ourselves that takes responsibility for action in the world. *Ego* comes from the Latin, meaning "I am." The ego is the center of the personality but not, as the existence of the unconscious suggests, the only important or influential part.

The *id,* which roughly translates as "thing," is the most basic, even primitive, part of the personality, the closest to the animalistic needs of the body as a sexual and physical entity. The child, when born, is closer to the id than to the ego. The id is the source of wants and needs, of wishes and desires; it is the hungry part of the self. All this may suggest that the id is always a negative element of the self—not at all. It is true that an id left to follow its own impulses is destructive, just as an infant who is allowed to indulge its every desire will not survive. But the id is also an important source of pleasure, a part of ourselves that allows for the spontaneity of play, for the experience of freedom.

The *superego,* as its name suggests, is "above" the ego, "above" consciousness. It is the superego that produces what we usually call the conscience, that part of ourselves that keeps a reign on the id, that censors action and speech (and conscious thought), that is aware of what society deems acceptable or unacceptable. It, too, must be kept in balance with the other two components of self; an overcontrolling superego robs the individual of personal expression and the courage to take risks and make difficult choices. At the same time, in Freudian theory, the superego is that part of the personality that makes it possible for the individual to function responsibly and successfully in society.

It is important to remember that Freud's theories are just that: theories, which can never be proven or disproven as scientific fact. Certainly there is much to criticize in Freudian psychology. For some, Freud's psychology is too tied to his own life and social biases to be entirely successful as a universal or general theory of the individual. Freud's emphasis on sex and sexuality as the basis of the individual's needs, desires, and personality seems obsessive to them. Similarly, many feminists in particular find sexism in Freud's emphasis on the experience of the male child as the central myth of the individual. They see his famous question, "What do women want?" as tantamount to an admission that his is a psychology of the male.

Having raised a few of these objections, we must nonetheless point out that so persuasive have Freud's ideas been that many of his terms have entered ordinary conversation: we often speak of the Oedipus complex (though the term *complex* is itself an invention of the psychologist Jung), the id, and the ego, among others. This is also true of his influence on the study of the personality or psychological self in literature. The connection between Freud's theory of the self and literature can be seen vividly in his own naming of the Oedipus complex: he turned to literary myth to describe his theory. Since the time of Freud, many critics and performers have found either his general theory of the unconscious and wish-fulfillment and the pleasure principle or his

tripartite self of ego, id, and superego to be useful ways of constructing the psychological self in literature.

One of the most famous is Ernest Jones, a psychologist who applied the Freudian notion of the Oedipus complex to the character of Hamlet in Shakespeare's tragedy. Jones saw in Hamlet an embodiment of the Oedipal complex, a man unconsciously obsessed with his mother's sexuality (by his repulsion at her remarriage to his uncle) and possessed by an inability to resolve his relationship with his father—both his actual father, whose ghost may be seen as a manifestation of this inability, and his evil stepfather (and uncle) Claudius, who murdered Hamlet's father, in a sense usurping Hamlet's own psychological need. When Laurence Olivier filmed the play in 1948, most critics pointed to the Jones/Freudian reading as the identifiable source of Olivier's character. Olivier himself in the film provided the audience with a clue, calling *Hamlet* "the story of a man who could not make up his mind." Some critics objected to what they saw as a reduction of the character to a neurotic diagnosis, claiming that the narrowly Freudian approach diminished much of the poetic and moral majesty of the play. For other critics, Olivier's approach was a daring and exciting attempt to see the classic character through the new knowledge of modern psychology, and the play became the story not only of a prince revenging himself against a villain but also of the individual "making up" himself psychologically, finding self through the mental action of deciding to avenge his father's death.

The concept of the self was equally, perhaps more, important to the Swiss psychoanalyst Carl Gustav Jung, who was a student of Freud but broke off and developed his own theories of the human mind and soul. Where Freud was most concerned with the personal unconscious of the individual, as a product of his or her own familial and sexual history, Jung was equally concerned with the individual's relationship to what he called the "collective unconscious" (to distinguish it from the "personal unconscious," which was the center of Freud's concern).

This collective unconscious is, according to Jung, the reservoir of the racial memory of humankind, that common source from which comes all categories of experience and action. In his writings, Jung described and analyzed these categories, which he called *archetypes*. Archetypes are patterns by which we live out our own personal myths. It is important to distinguish archetypes from *stereotypes*, with which they may easily become confused. An archetype is a pattern within which we live out our lives, though each individual will manifest it in a personal way. Thus, as we saw in part II, although many individuals will live out the archetype of the trickster, each individual will live out the archetype in a very different way. Homer's Odysseus and Warner Brothers' Bugs Bunny are both embodiments of the trickster archetype, but they would never be confused with each other. Odysseus lives out the trickster archetype to find his way back to the civilized world of Ithaka; Bugs Bunny is the arch anarchist, the trickster as plunderer of the Darwinian-capitalist system of Elmer Fudd and his garden of carrots.

A stereotype, in contrast, restricts how an individual person or experience is perceived and understood. Whereas an archetype allows us to see the recurring

patterns of being and behavior that link such seemingly disparate characters as Odysseus and Bugs Bunny, a stereotype keeps us from seeing with any depth or dimension the wholeness of the individual. Stereotypes are typically based on ignorance or limited experiences with a group of people, on which we too hastily base judgments or predictions about all members of any group. Stereotypes may select a single trait of an individual and suggest predictability for a whole group. Archetypes focus our understanding; stereotypes limit it.

For Jung, the purpose of psychological analysis, and the purpose of life itself, is the journey toward individuation, which Jung described as "the process of forming and specializing the individual nature; in particular, it is the development of the psychological individual as a differentiated being from the general, collective psychology" (259). It is the road to selfhood and "embraces our innermost, last, and incomparable uniqueness . . . becoming one's own self" (143). Jung was careful to distinguish individuation from egotism: the latter implies a negative form of selfishness, in which the individual cares only for the self, disregarding social or collective obligations. In contrast Jung acknowledges the collective nature of human existence and sees individuation as each individual's unique fulfillment of the self, a self that will live and act in society.

Jung believed that archetypes are inherited forms of experience, present in the collective unconscious possessed by every human being. He thought a number of archetypes were central to every personality: the persona; the shadow; the self; and either the anima or the animus, depending on the sex of the individual. As these particular archetypes of personality recur in much Jungian analysis of literature, we will briefly describe what each is in Jung's theories.

The *persona,* which is derived etymologically from the same roots as our words *person* and *personality,* refers to the public mask or role worn by each individual in daily life. The simplest example would be the occupation or social role we each play. Jung noted that we may easily have a number of different personae at any point in our lives, depending on the context: you may be a student as you read this, but when you put it down and go to a part-time job, you may assume a very different persona. Jung believed that personae could be both beneficial and dangerous. Obviously, it is necessary to assume a number of different personae; otherwise, it would be impossible for us to shift from one set of roles and expectations to another. At the same time, when we attach too much importance to any one persona or when we allow ourselves to identify personae as our only way of defining ourselves, we fall prey to what Jung called an *inflated persona* and lose integrity of personality.

Unlike Freud, Jung believed that a wholeness of personality is present in the individual from birth onward. This wholeness he named the archetype of the *self.* The process of individuation in life consists of finding and clarifying this self, learning to live as the whole person each one of us is. It is easy to confuse this concept of the self with Freud's concept of the ego, for both suggest the center of the personality. Indeed, both do provide the center for personality in the respective theories, but the ego for Freud was always conscious. Jung also believed in the ego but as a quite separate element of personality from the self; the self transcended consciousness, although it was not separate from it

in the way the superego is in Freud's theories. For Jung, the self is the center of order and experience.

The *shadow,* like the id, suggests something baser than the other elements of personality: that which is hidden, though part of the personality. For Jung, the shadow is the archetype through which individuals work out their relationship with their own sex. Like Freud's id, Jung's shadow is animalistic and ancient in its origins, the place of instinctive response. Many Jungians consider it to be one of the most powerful archetypes making up the personality. Although the rational response might be to cover up the shadow and try to deny that which seems dark and dangerous, Jungians believe that it is only through the acceptance of the shadow that we become whole. When the shadow is not acknowledged and accepted, the ego tends to fall apart, devoured by the unconscious.

Like Freud, Jung was interested in sexuality as a critical element in psychological development. He believed in the fundamental *androgyny* of the human being, that each individual possesses both masculine and feminine psychological qualities (distinguished from male and female biological traits). In defining the archetype of the soul as part of the personality, Jung wrote of a complementary relationship between the sex of an individual and the character of his or her soul. Jung argued that the more manly a man appeared or the more womanly a woman appeared, the more their souls would exhibit qualities of the other sex because no man is completely a man and no woman is completely a woman. That womanly part of the man Jung called the *anima;* the manly part of the woman, the *animus.* Jung wrote at some length about the anima and the animus. His theories of them continue to be controversial, in many of the ways Freud's theories of gender and sexuality continue to be controversial: they often verge on stereotyping the sexes. Feminists in particular have struggled with Jung's theory of the anima, which tends to reduce what is womanly to what they see as socially determined roles of maternity and to deny as feminine anything not overtly emotional or maternal. You may want to read Jung's own writings on archetypes and sexuality. He raises intriguing, if difficult to resolve, issues of gender and sexuality.

In addition to these central archetypes of the personality, Jung also developed a highly complex system of personality types based on two central ways of orienting the self to the world: *extroversion* and *introversion,* which are generally referred to as the two principal psychological attitudes. For Jung, extroversion and introversion represent different ways of orienting oneself to the world. Extroversion is an outward orientation, in which the individual is more concerned with the world without than with the world within. Introversion is simply the inverse: placing priority on the inner life. It is a matter of direction. It might be helpful to see each personality orientation as pointing a different way, though each suggests an equally valid journey.

In conjunction with these two broad categories of personality attitudes, Jung named four functions for the personality, each corresponding to a different way of treating experience, of performing psychological action: thinking, feeling, sensing, and intuiting. He considered thinking and feeling to be rational functions involving the making of judgments; sensing and intuiting he considered irrational

or nonrational. Jung believed that each one of us is dominated by one of these four functions and that we are also guided by what he called an auxiliary function as well. The auxiliary function is never from the same category, rational or irrational, as the dominant. Thus, a personality ruled by thinking would not have feeling as its auxiliary function but would instead be guided by either sensing or intuiting.

As you might imagine, Jung has had a considerable influence on literary criticism and analysis. His theory of archetypes and the collective unconscious in particular influenced such writers as James Joyce and Anaïs Nin as well as the confessional poets, including Theodore Roethke, Sylvia Plath, and Anne Sexton, and has given readers categories that prove helpful in understanding the larger, more universal meaning and context of an individual literary self's experience. Again, the danger is in naming the archetype and stopping there, as if the archetype itself carries the totality of the individual experience. Similarly, Jung's notion of anima and animus has been a great help to those critics who wish to explore the role of sexuality in the psychological self in literature, particularly for those readers who may instinctively feel the presence of a psychic or literary androgyny either in the relationship between the writer and characters or between various characters in a given text. For example, the French novelist Gustave Flaubert wrote, "Madame Bovary is myself, drawn from life," speaking of his most famous creation in the novel of the same name. On the one hand, one can certainly interpret his statement as suggesting an authorial, some might say patriarchal stance toward the character; on the other hand, a Jungian critic might be more intrigued by the suggestion of androgyny. In a sense, such a critic might argue, Flaubert is announcing Emma Bovary as a manifestation of his anima, a way of narrating his own relationship to that which is feminine in him.

Id, Ego, and Superego in Lawrence's *Women in Love*

Let us look at a few selections now to see how the psychological theories of Freud and Jung may prove helpful in understanding and performing these texts. We will begin with the "Gladiatorial" chapter from D. H. Lawrence's *Women in Love* in the appendix (pages 439–47). Reread the selection, and then let us consider what a Freudian approach to the text may tell us.

Of course, to gain the most insight possible into construction of the psychological selves in this selection, it would be necessary to look at it in light of the entire novel, in which Lawrence has developed these two characters in complex ways. We recommend Leo Bersani's discussion, using a highly Freudian approach, in his critical study, *A Future for Astyanax: Character and Desire in Literature,* in which he examines the ways in which the varieties and objects of desire motivate characters and, by extension, the writers who invent them, from the drama of Jean Racine to the present day. Bersani's analysis of Lawrence is a particularly intriguing example of how a critic can adapt a psychological concept or concern, in this case Freud's theory of sexual stages and fixations (oral, anal, phallic, and genital), as a way of understanding the self Lawrence constitutes in his fiction. Bersani's emphasis throughout his study is on the insight

such analyses of character and psychology provide into the writer's own development and situation. Bersani is less interested in the psychology of the writer from a biographical standpoint and more interested in seeing the development or character of the artist throughout a career.

Let us consider how some of Freud's central ideas help the performer create the various selves in the selection. We would probably want to differentiate between the performer in a group performance, whose stance might be that of one of the individual characters or the narrator, and the solo performer, who must somehow embody all the complex psychological relationships among characters, as filtered by the narrator, in this selection. Needless to say, whether the performer embodies one of the characters (say, Birkin) as part of a more theatricalized adaptation or takes the epic stance of all the selves, the more the performer understands the entire world of the text, the more intelligent will be his role in it.

One approach to the psychology of this text is to look at Birkin and Gerald and the narrator in terms of the Freudian division of ego, id, and superego. Although it is dangerous to become too schematic in such an analysis, it is useful to consider the narrator as a kind of superego for the entire scene, the distanced, superior part of the self, seeing from afar though not entirely disengaged from what is happening. Thinking of the narrator as the superego allows us to retain the narrator's presence within the drama of the encounter between Birkin and Gerald yet suggests the judgment and remove inherent in his role. If the narrator may be seen as a kind of superego, how might we apply the same set of terms to the two characters in the scene? We might think of Birkin as the ego of the scene: he is the conscious, striving, reasoning figure. A reading of the entire novel would support this description of him. He survives his quest for self, whereas Gerald does not. This is not to say that Birkin is not lacking in passion or sensuality or his own relationship with the id or superego; rather, within the world of the novel, he seems to be the conscious self that anchors the novel's ideas and concerns. He desires "Bruderschaft," brotherhood, suggesting that he desires a conscious relationship with the community of humankind.

Gerald, in contrast, is unable to transcend his own sensual and inarticulate desires. Even after the wrestling scene, Gerald proves less able than Birkin to resolve what the experience meant to him. He is able to respond to it in terms of the pleasure it gave him: "It's rather wonderful to me" and "I can say this much, I feel better." In some respects, Gerald represents the Freudian id, the more animalistic part of the self, that which desires without being able to analyze what or why it desires. Indeed, in some respects, Gerald's tragedy is the tragedy of the unrestrained id, and it leads him to his separation from society (represented by his isolation from Gudrun, the woman he loves) and his actual death. Gerald dies from exposure, freezing to death on a mountain, a victim of following nothing but his impulses toward the sensual.

Of course, no performer would stop by naming the narrator and the two characters as exemplars of the Freudian triad of ego, id, and superego. To do so is to rob Lawrence's novel of its psychological richness. Birkin's own engagement in the wrestling match indicates that he is not without his own

relationship to the id; similarly, throughout much of the novel, Gerald reaches, agonizingly and unsuccessfully, toward consciousness, toward understanding the world of the rational. The narrator, because he gives us insight into both of the characters, is not simply a distanced, unemotional superego. A Freudian analysis allows the performer to see which characteristics of each self are emphasized and to understand the personal self of each character. The solo performer stands in allegorical relationship to the psychological self Lawrence creates in his novel: the performer possesses ego, id, and superego, and his performance allows him to explore each of these areas through the three characters. One might argue that the single, integrated psychological self is that of Lawrence or of his narrator, who may be seen as containing the characters in the story he tells, and that Lawrence is himself working through his own conflicts among ego, id, and superego through the wrestling match or, indeed, through the entire novel.

The performer, of course, cannot play anything quite as abstract as ego or id, though from time to time writers have tried, usually unsuccessfully, to write in such schematic terms. The psychological perspective allows the performer to gain greater insight into character than might otherwise be the case. In this respect, the performer may combine the stance of the superego in his analysis of the text yet honor the immediacy of the ego and the id in his enactment of the scene.

Freudian critics might very well point to other elements in the selection as well, including the wrestling match as a way for the two men to work out unconscious homoerotic feelings toward each other—sexual and romantic emotions they, Gerald in particular, would feel unable to handle in conscious fashion. Similarly, the curiously close bond between love and death that Freud noted (as *eros* and *thanatos*) seems present in this warrior contest between the two men: wrestling is an act of love for them but also a symbolic way of killing each other and, perhaps, themselves.

Archetypes on the Beach: Cummings's "maggie and milly and molly and may"

Jungian critics would also find much in "Gladiatorial" to examine, seeing the warrior archetype as fundamental to an understanding and enactment of the selection, perhaps also seeing the selection as a comparison of two different individuals wrestling, physically and psychically, with the shadow archetype. But let us return to cummings's "maggie and milly and molly and may" to provide material for the application of some of Jung's theories to the literary text. How might Jung's theories help the performer with this poem?

The Jungian critic would see the entire poem as a study of the feminine as an archetype; it is surely a poem "about" what it means to move from girlhood to womanhood—for the poem binds the four girls together by their initial letter, *m,* which is connected to such words as *maiden, miss,* and *mother.* Jung names this the archetype of the *puella,* Latin for "young woman." Similarly, cummings keeps the overtly masculine out of the poem. The closest we may come to the

masculine might be in such images as the "horrible thing," which is perhaps, predatory, as we suggested earlier, a sign of the loss of innocence. Even the setting of the poem, a beach by the sea, is archetypically an image of boundaries between the conscious and the unconscious. In Jungian symbology, the sea is usually considered the feminine domain of the unconscious.

We do not need to work our way through the experiences of each of the girls on the beach. Each girl moves progressively from the sensual and instinctual world toward the rational and intellectual, further away from the "sea" of the unconscious to the "beach" of consciousness. Another way of describing it in Jungian terms might be to say that each individual girl demonstrates her personality type, attitude, and function in the course of the poem: maggie and may both seem introverted; milly and molly tend toward extroversion. We might even extend this line of analysis to ask which girl seems most thinking or feeling or sensing or intuiting. Again, there is danger in trying to make the poem and its characters fit too easily and simply into these categories, but they might help us to understand what kind of person each one of these girls is, and, in turn, might help us to enact a performance that will accommodate the range, variety, and balance of attitudes and functions of the personalities.

We may return to the question of wholeness: is cummings describing one self or many selves? cummings makes it clear that it is necessary to "lose" the "you" or the "me" in the sea to form the "ourselves" that is society, that is being with one another. To some readers, it may prove difficult, even impossible, to resolve a vision of this as a poem about individuation with cummings's celebration of collectivity in the division between "you" and "me" against "ourselves." What do you think? Remember that individuation means growing into the true self, not simply the egotism of isolation from all other people. In this way, it is only through this journey beyond self, through the unconscious realm of the sea and through the conscious return to the land, that we find the balance between self and society that Jung sees as the goal of life.

We have said that the poem explores the feminine through the figures of the four young girls and through the setting of sand and sea. A reasonable question might be, why the feminine? Why make these characters four young girls? Why not four young boys? Would the poem be the same experience for you if the sexes were reversed?

Some Jungian critics might argue that the presence of the four young girls suggests cummings's exploration of the anima, the soul as feminine. Recall that Jung believed in androgyny, the presence of the masculine and feminine in every individual, and that the name he gave to the feminine in the male was the anima; to the masculine in the female, the animus. For cummings, the poem might be a way of working out, either on a personal or collective level, the varieties of the feminine possible for the male, from the lyrical sensuality of maggie's encounter with sound to the poetic artistry of may's discovery of metaphor with the "smooth round stone." We have no way of knowing, of course, whether cummings was working out purely personal and private experiences with the feminine or whether he was attempting to make a statement about the feminine

as a universal experience for the male. Indeed, it would be reasonable to see the poem as an exploration not of the anima but of the feminine as a larger element of humanity, not simply the narrower contrasexual domain of the male.

Again, as with the Lawrence text, most performers will not be satisfied to stop at the point of classification of archetype in their enactment of the poem, though we would suggest that cummings's poem, by its very spareness and compactness, invites a more starkly psychological interpretation. Most performers will choose either to keep the four girls wholly separate in their minds or to synthesize them as one developing girl-woman. For some performers, the contrasexual relationship between male poet and feminine selves in the poem will be an important part of the performance experience; for others, cummings's sex will be less relevant, and the poem will speak more to the universal condition of what is "feminine" in the world (if such a category can even be said to exist, in any universal sense). It is doubtful that any performer will choose not to explore the psychology of sexuality and gender in this poem; to do so would simply be to ignore what is inescapably present, some would say conscious, in every moment of the poem.

For psychological critics, the literary text is not unlike a dream or a dream reshaped in the waking light of consciousness. Indeed, many writers intentionally strive for the quality of dream in their works. Samuel Taylor Coleridge, an English Romantic poet, claimed that "Kubla Khan," one of his most famous and most beautiful poems, was the result of an interrupted dream. Others, like the dramatist August Strindberg, one of whose works is called *A Dream Play,* attempted to use structures and images that reflected dream states and processes. In all cases, what was emphasized was the struggle of the psychological self to make conscious and understandable what emerged from the personal experience of the unconscious. Whether we use a Freudian model, which emphasizes the personality of the individual's psychology as a result of early familial and cultural experiences, or the Jungian model, which emphasizes the individual's relationship to the collective psychology, the movement tends to be toward an understanding of the inner experience of life.

A question you might reasonably be asking at this point is what difference any of this makes to the performance of either Lawrence's selection or cummings's poem? How will either a Freudian or a Jungian analysis of the text alter what happens in the performance? It is entirely possible that the difference between a Freudian or a Jungian analysis of the psychological self of a writer or characters will lead to no observable difference for the audience in the behavior of the performer in a performance of either of these texts. What will inevitably result, however, is a difference in the way the performer regards the selves who inhabit or are constructed by these texts; the inner lives of the performance must be different. And it is also possible that a psychological approach may lead to a performance that is experientially and behaviorally different from the audience's perspective, as well. It is possible, though not inevitable, that a Freudian performance may emphasize those elements of the performed self that appear most individualistic and idiosyncratic, bound to the personal history of the character or writer, and that a Jungian approach, with its special attention to the collective

unconscious, may attempt a performance that seems more universal, broader in its archetypal implications. Again, we wish to stress that our hypothetical characterizations of a Freudian or Jungian approach to the self in performance are not prescriptions, nor even predictions, but suggestions of how the differing approaches to the personality may exhibit themselves in performance. It is also possible that an audience might witness two performances virtually identical in their delivery and execution that have been funded from radically different perspectives.

This discussion is equally true of the differences between a psychological and a sociopolitical approach to the self in literature, though these two approaches differ even more radically in the way they see the self in the world than do the Freudian and Jungian versions of the psychological self. There are points of contact between psychological and sociopolitical approaches to the self, to be sure: neither ignores either the uniqueness of the individual nor the relationship between individual and society. It is more a matter of which each sees as more important and where each sees the origin and primary constituting force of the self.

PSYCHOLOGY AND THE PERFORMING SELF

We have focused primarily on textual or authorial selves in our discussion of the psychological contexts of literature in performance: those characters or personae who emerge either within the fictive world of the novel or poem (in the case of the two selections we have analyzed) or as projections of the personality of the author. We might do well to comment on psychology and the self of the performer.

Just as we can analyze, either from a Freudian or from a Jungian view (or from a number of other standpoints) the psychologies of characters and authors in a literary text for the purpose of creating a psyche-centered performance, so we can analyze the psychological dimensions of the performers themselves. All performance is, at some level, a psychological experience or journey, a way of exploring who we are in the process of participating in art. And although for some performers, the attraction of performance is the very appearance of escape from self—that is, the immersion of the performer into the identity of a character or persona other than his or her own—finally there is simply no way of completely divorcing the self of the performer from the selves created or evoked in performance. We always bring ourselves with us along the way.

How might Freudian and Jungian theories provide a way of perceiving the performer's experience? Perhaps the concept of the unconscious, common to both Freud and Jung (though first named as such by Jung), is the single most critical concept relevant here. Although performance can be and needs to be one of the most conscious of activities, there are aspects or moments of it that are undeniably tied to and are products of the unconscious. It is true that any good performer follows a conscious plan in creating a performance, from the selection of material to rehearsal to public performance. At the same time, almost every performer can attest to the ways in which the unconscious takes over at times as the primary source of creativity in the performance.

Let us consider one example. Bruce Henderson directed a production of "In the Region of Ice," a short story by Joyce Carol Oates. The story, which we will consider in more detail in chapter 12, concerns the relationship between a Catholic teaching nun and a young, brilliant, more than a bit mad, male Jewish student. The story plays out the psychological conflicts between teacher and student as well as the struggle within Sister Irene, the nun, to resolve her complex feelings about the student. Both teacher and student try to live almost entirely at the level of consciousness, the nun having elected her religious vocation as something of an escape from the complicated, messy emotional life of the family she fled, the student using the consciousness of literary study as a way of trying to stave off his inevitable descent into the depths of the psyche.

Oates tells the story through a third-person narrator, who is omniscient with respect to Sister Irene. The narrative technique is particularly useful in this story, as it both allows entry into the consciousness of Sister Irene and also provides a sensibility (the narrator) who is able to see deeper into Sister Irene than she can herself. We featured this duality of self through the casting of two performers, one to act as Narrator and one to act as Sister Irene.

To avoid oversimplification of the relationship, there was no cut-and-dried assignment of lines: however, in general, we restricted Sister Irene primarily to conscious thought, assigning the revelation of the unconscious to the narrator. Indeed, although these were the two principal functions of each of the characters, the blending of roles created a dialogic relationship between them that reflected the sophisticated psychology of Oates's story. There were moments when Sister Irene became acutely aware of something in her unconscious, and the surfacing of such material became a moment in which she took over the speech from the Narrator.

An incident in rehearsal demonstrated the often fortuitous relationship between rehearsal process and psychological creativity. After a few weeks of blocking and initial rehearsals, performers were asked to be off book (i.e., have their lines memorized). The two performers playing the Narrator and Sister Irene were responsible for much of the stage time and, therefore, had unenviable tasks of memorization. Nonetheless, both were ready to be off book at the first rehearsal for which it was requested.

The rehearsal sailed along smoothly, with both the Narrator and Sister Irene producing their lines with seemingly no problem. We got to the point, about two-thirds of the way through the story, when Sister Irene receives a desperate note from the student, who has been institutionalized. Sister Irene deduces from the Shakespearean references in the note that the student is considering suicide. In what is one of the first (and perhaps the last) unselfish acts of her life, one of the only moments when she stops acting out of rigidly prescribed codes of her role as teacher, Sister Irene goes to the home of the student's parents to try to warn them and to convince them that the student needs to be rescued.

At the moment when Sister Irene enters the Weinstein home, the actress playing her froze and simply could not remember the lines. It did not appear as if any external noise (physical distraction) had disturbed her or that she had

not done her homework; rather, it seemed as if something within her was keeping her (performer? character?) from entering the home and confronting the parents. For a minute or two, the rehearsal was in limbo, for we had agreed not to call for lines unless absolutely necessary.

Then, something unexpected and intriguing happened. The performer playing the Narrator took over Sister Irene's lines and role, without any direction from Henderson. Of course, a large part of what was going on was that as Narrator, she was onstage the entire time and knew almost all of the lines in the story by default—so many of her cues were tied to the other characters that she had unconsciously absorbed their lines. She was what we call a trouper, a performer who wants to keep the show going at all costs and is willing to pitch in. It would be a distortion of the process not to take these facts into account in looking at the experience.

At the same time, there was a psychological "rightness" to the Narrator's actions. Her proximity to Sister Irene was such that she, and only she, could step in for her—literally and psychologically. In a sense, it is possible to see the Narrator of the story as the figure who can speak to Weinstein's parents—not the recessive, coldly objective Sister Irene; the Narrator became the psychologically bold and risking side of Sister Irene. At first, the Narrator simply took over Sister Irene's lines in a stationary position, as if simply to keep the performance flowing until Sister Irene got back on track. But her natural exuberance and command of the stage made her move into the scene, perhaps to give the performers playing the parents a physical presence to which to respond.

An equally odd thing happened next. The actress playing Sister Irene, who was understandably distressed at her inability to find her own lines and who had sat down onstage to try to recover her performing self, began to recite the Narrator's lines from her isolated place onstage. For whatever reason, she could muster up the Narrator's objective language (in this scene) but not her own representation of inner life. In essence, what happened was an exchange of psychological selves: the Narrator became Sister Irene; Sister Irene narrated from a distance the actions and experiences in which she could not imagine herself participating.

The conclusion of this incident is that what happened, totally by accident, totally out of the sometimes clumsy business of learning lines and putting a performance on its feet for the first time, became a source of psychological revelation about the story and about the performer-performer and performer-character relationships. We chose to integrate what happened into the final version of the script. To some directors, the decision to make such a change might seem to violate the integrity of a script and production concept; to us, it seemed to be what Jung would call a moment of profound *synchronicity,* where seemingly unconnected events converge to create something of meaning, both in the context of the story and in the context of performance.

You might consider other ways in which the psychology of performance has led and can lead you to discoveries and choices about texts and performances. For example you might use Freud's theories of the components of personality (id, ego, and superego) as a way of conceiving the different levels of the

performance process: at what point does exploration of id seem most necessary; is there an analogue to the superego in the performance process (perhaps a director, at some level)?

Similarly, Jung's theories of archetypes and of the functions of personality might help you to explore yourself and others as performers. What archetypes might the performer enact? Which functions of personality seem most relevant to any particular aspect of rehearsal? Do some performers depend more on one personality type than another in the performance process?

A final area to consider is the performer's own development of a psychological life. While we have emphasized the ways in which the performer's study of psychology can prove useful in understanding character, it is critical to remember that performers learn about themselves through their contact with characters and personae in performance. Directly related to this is the performer's choice of materials. Consider some of the psychological factors that led you, whether you knew it or not at the time, to select specific literature for performance. To what degree does a text's psychological match with your own experiences, needs, and concerns become an important factor? Can you think of an instance in which the psychological congruence between you and a text actually helped you resolve a situation or problem you faced? Have you ever found yourself in the position of trying to perform a text that was so distant from either your experiences or your general psychological outlook that you were virtually unable to perform it? In our own performance work, we have sometimes discovered the psychological significance of a text only after we have performed it.

This seems especially true when performers work with literature that is highly symbolic and mythic in texture. For example, consider which fairy tales remain most memorable for you even today. If you were called on to tell a fairy tale to your class, which one would you pick? Without much reflection at all, most of us could name one or two fairy tales that are most powerful for us, though it is likely that we would not be able to say exactly why that particular fairy tale carries the most meaning. Psychologists such as the Freudian Bruno Bettelheim and the Jungian Marie-Louise von Franz have written extensively about the psychological power of specific fairy tales. They see these tales as narratives through which we explore our personal and social development, tales that speak to relationships with family, with bodies, with sexuality, and with the world. "Little Red Riding Hood" may appeal to one woman because it deals with feminine initiation into womanhood; "Jack and the Beanstalk" may appeal to a young man because, through it, he is able to overcome the "giants" in his own life. You may wish to consult some of their analyses to gain insight into your own relationship with whatever fairy tale seems to be "yours."

You may also be familiar with plays, films, and other texts that use fairy tales in intensely psychological ways. Stephen Sondheim and James Lapine's musical play *Into the Woods* takes Bettelheim's Freudian view of the fairy tale as a psychological narrative of sexual and personal growth as a point of departure; the play weaves a web of familiar tales ("Cinderella," "Jack and the Beanstalk," "Rapunzel," and "Little Red Riding Hood," to name a few) together to explore the psychological complexities of contemporary society. The British writer Angela

Carter wrote a volume called *The Bloody Chamber,* in which she draws on such tales as "Little Red Riding Hood," "Bluebeard," and "Puss in Boots" to comment on the psychosexual (as well as political) condition of women. You may know other such transformations of familiar tales, like fairy tales and myths, in which writers explore their deeper psychological significance.

Working through the issues that draw us to specific texts psychologically can be useful in trying to puzzle out problems or difficulties we encounter in the performance process. It can help to illuminate how and why we make the performance choices we do and to put them in perspective. It can even help us to understand why we may make choices that seem odd or eccentric for our audiences. For example, we remember once when a student in a course chose to perform the poem "The Mythical Journey" by Edwin Muir. The poem is allusive, reaching into dark corners of the unconscious for images of the interior landscape. The language is cerebral and spiritual. This student elected to do a rather athletic performance, in which the poem became a metaphor for the performer's celebration of the sensual and the corporeal. The performance puzzled most of the audience, for whom it was obscure at best. In the discussion that ensued, the performer, who in most instances is a scrupulously careful reader, was able to articulate a general discomfort with his body as a performing agent. He had typically selected poems that seemed to reside more in the head and voice than in the full body. He realized that his choice to turn the poem into a landscape of the body, although not invalid in helping him to grow as a performer, nonetheless probably distorted what most readers would see as the style of the poem. His need to work on questions of the body in performance was very real. His attraction to the poem in question was perhaps tied to its darkness: because his own relationship to his body was to some degree obscure and unconscious, he read the poem's use of private and dreamlike imagery as kinesthetic and bodily.

Such a psychological analysis of the performer's process in selecting the poem had a number of results, all of which were positive. First, the discussion allowed the performer to understand more clearly his motives in creating this performance; until the postperformance session, he could not have articulated the ways in which he had been overwhelmed by his own psychological discomfort with his body in performance. This revelation allowed him to make conscious choices for future performances of texts that would more directly and immediately take him in directions he felt he needed to move. Second, the discussion helped him and the class understand more fully the poem itself. The very fact that the performer's choices felt so wrong for the audience forced them to try to talk in very concrete and analytical ways about the style of the poem's language. The degree to which the poem itself played with the gap between linguistic consciousness and unconsciousness became more vivid as a result of the performance and the discussion of the performer's psychology.

We need to proceed with caution when moving into the realm of the performer's psychology. There can be a real danger in acting as amateur psychoanalyst concerning either the selection of material or performance choices. But as in the case described above, the work of an individual and the sensitivity and openness of those around him can lead to discoveries that are liberating and exciting.

You may also find it useful to read some of the writings of Leland H. Roloff (who has also written under the name Lee Zahner-Roloff), a teacher and a scholar of performance studies who is also a Jungian analyst. Roloff writes from the perspective of a practicing analyst for whom the performance of literature is a profound source of growth and healing. Roloff's work has been enormously influential in those who find Jungian perspectives valuable and compelling.

WORKS CITED

Bersani, Leo. *A Future for Astyanax: Character and Desire in Literature.* Boston: Little, 1976.

Bettelheim, Bruno. *The Uses of Enchantment: The Meaning and Importance of Fairy Tales.* New York: Knopf, 1976.

Carter, Angela. *The Bloody Chamber.* New York: Penguin, 1979.

Cummings, e. e. "maggie and molly and milly and may." *Complete Poems, 1913–1962.* New York: Harcourt, 1962. 682.

Flaubert, Gustave. *Madame Bovary.* Trans. and Introduction by Francis Steegmuller. New York: Modern Library, 1982. vii–xxix.

Franz, Marie-Louise von. *An Introduction to the Interpretation of Fairy Tales.* Zurich: Spring, 1973.

Freud, Sigmund. *The Basic Writings.* Trans. and ed. A. A. Brill. New York: Random, 1938.

Jones, Ernest. *Hamlet and Oedipus.* Garden City: Doubleday, 1949.

Jung, Carl Gustav. *The Basic Writings.* Ed. Violet Staub de Laszlo. New York: Modern Library, 1959.

Lawrence, D. H. "Gladiatorial" from *Women in Love.* In *The Portable D. H. Lawrence.* Ed. Diana Trilling. New York: Viking, 1947. 456–70.

Oates, Joyce Carol. "In the Region of Ice." *Where Are You Going, Where Have you Been? Stories of Young America.* New York: Fawcett, 1974. 57–77.

Olivier, Laurence, dir. *Hamlet.* Written by William Shakespeare. With Laurence Olivier, Jean Simmons, Eileen Herlie, Basil Sydney. A Two Cities Film, 1948.

Roloff, Leland H. "Performer, Performance, Performing—Towards a Psychologization of Theory." *Literature in Performance.* 3.2 (1983): 13–24.

———. *The Perception and Evocation of Literature.* Glenview: Scott, 1973.

———. "Social Despair in Adolescent Boys: Poetic Therapies and Metaphoric Diagnoses." *Journal of Social Psychology.* 127.3 (1987): 65–72.

Sondheim, Stephen, and James Lapine. *Into the Woods.* New York: Theatre Communications Group, 1987.

FOR FURTHER READING

Berman, Jeffrey. *The Talking Cure: Literary Representations of Psychoanalysis.* New York: New York UP, 1985.

Bodkin, Maud. *Archetypal Patterns in Poetry: Psychological Studies of Imagination.* London: Oxford UP, 1934.

Campbell, Joseph. *The Hero with a Thousand Faces.* Princeton: Princeton UP, 1949.

Hillman, James. *Re-visioning Psychology.* New York: Harper, 1975.

Kiell, N., ed. *Psychoanalysis, Psychology and Literature: A Bibliography.* 2nd ed. 2 vols. London: Scarecrow, 1982.

Knapp, Bettina L. *A Jungian Approach to Literature.* Carbondale: Southern Illinois UP, 1984.

Pratt, Annis (with Barbara White, Andrea Loewenstein, and Mary Wyer). *Archetypal Patterns in Women's Fiction.* Bloomington: Indiana UP, 1981.

Stevens, Anthony. *Archetypes: A Natural History of the Self.* New York: Morrow, 1982.

Vickery, John B., ed. *Myth and Literature: Contemporary Theory and Practice.* Lincoln: U of Nebraska P, 1969, 1966.

Winnicott, D. W. *Playing and Reality.* New York: Basic, 1971.

CHAPTER 10

The Self in Sociopolitical Contexts

Let us turn now to the sociopolitical realm of literature in performance. Performers and critics who emphasize this approach are more concerned with the ways in which the external life of society and politics operates and the role of the individual in society than with the creation or inner life of the individual self. As suggested earlier, both the psychological and sociopolitical approaches are concerned with the individual and society. For the psychological critic, society is important in shaping the individual, and for the sociopolitical critic, all the elements of an individual's personality are significant in shaping society; in each case, it is a matter of emphasis.

Just as there has always been an interest in the psychological self, even before a science of psychoanalysis arose, so performers and audiences of literature in Western civilization have been interested in its social values from the time of Aristotle, who cross-referenced his *Rhetoric* with his *Poetics;* through the Middle Ages, when the position of literature in a society governed by religion was considerably restricted and circumscribed; to the growth of literature as social criticism in the late nineteenth and twentieth centuries.

AUDRE LORDE'S "POWER": AN EXAMPLE

Before we begin a discussion of theories of sociopolitical selves, let us look at a poem that raises many of the central questions such an approach might pose. The poet is Audre Lorde, and she announces a political agenda in the title, "Power."

Power

The difference between poetry and rhetoric
is being
ready to kill

yourself
instead of your children.

I am trapped on a desert of raw gunshot wounds
and a dead child dragging his shattered black
face off the edge of my sleep
blood from his punctured cheeks and shoulders
is the only liquid for miles and my stomach
churns at the imagined taste while
my mouth splits into dry lips
without loyalty or reason
thirsting for the wetness of his blood
as it sinks into the whiteness
of the desert where I am lost
without imagery or magic
trying to make power out of hatred and destruction
trying to heal my dying son with kisses
only the sun will bleach his bones quicker.

The policeman who shot down a 10-year-old in Queens
stood over the boy with his cop shoes in childish blood
and a voice said, "Die you little motherfucker" and
there are tapes to prove that. At his trial
this policeman said in his own defense
"I didn't notice the size or nothing else
only the color." and
there are tapes to prove that, too.

Today that 37-year-old white man with 13 years of police forcing
has been set free
by 11 white men who said they were satisfied
justice had been done
and one black woman who said
"They convinced me" meaning
they had dragged her 4'10" black woman's frame
over the hot coals of four centuries of white male approval
until she let go the first real power she ever had
and lined her own womb with cement
to make a graveyard for our children.

I have not been able to touch the destruction within me.
But unless I learn to use
the difference between poetry and rhetoric
my power too will run corrupt as poisonous mold
or lie limp and useless as an unconnected wire
and one day I will take my teenaged plug
and connect it to the nearest socket
raping an 85-year-old white woman

who is somebody's mother
and as I beat her senseless and set a torch to her bed
a greek chorus will be singing in 3/4 time
"poor thing. She never hurt a soul. What beasts they are."

There are a number of different ways to approach this poem. Let us consider
how it addresses the whole issue of power, central to any discussion of society
and politics, and what questions it raises about the function and value of liter-
ature in society.

It is virtually impossible to separate this poem from the sociopolitical context
in which it was written. As Lorde said in an interview, the poem grew out of
her own rage at the actual incident documented in the poem, the killing of Clifford
Glover, a 10-year-old black child, by a New York City police officer. Lorde wrote
the poem as an alternative to following a murderous impulse herself: she recalls
pulling her car over to avoid the impulse to drive into the next person she saw
after hearing the news on the radio.

The poem, then, grows out of individual experience and perception, in some
respects the domain of psychology, but in a way that is unmistakably political.
The entire situation that gives rise to the individual artist's personal rage is that
of a society torn apart by racism and by the imbalance of power such racism
enforces. For Lorde, poetry becomes a way of taking social action, of creating
a discourse that could address her anger and her sense of loss without simply
destroying human life.

So she begins her consideration of power by drawing a distinction between
"poetry" and "rhetoric," two words that often sit in uneasy relationship to each
other. How does Lorde differentiate between them? She uses metaphor to suggest
a primary difference: poetry "is being/ready to kill/yourself/instead of your
children." What does this make rhetoric, then—a willingness to destroy one's
offspring, one's products? Lorde presents a metaphor, placing poetry in an analogous
relationship to suicide, and rhetoric to either murder or at least to a passive
willingness to see one's children killed. What does such an analogy mean? To what
degree is there a capacity for suicide in the act of poetry? We more traditionally
classify poetry as an act of creation, of self-expression, rather than self-extermination.
How, then, can poetry be viewed as a potential act of self-annihilation?

One possible way of reconciling the notion of poetry as a suicidal act is to
consider poetry as primarily expressive, rather than persuasive in intent, which
seems to be at the heart of Lorde's polarized use of these two terms. If the primary
function of poetry is for the poet to work through her own emotions and
responses through language, then there is a way in which poetry opens her up
and exposes her emotions to the level of consciousness. Such self-exposure could
conceivably be seen as a way of sacrificing herself—if the pain of such revelation
is intense enough. The act of writing a poem, then, is self-directed; its annihilative
power moves toward the interior of the soul rather than the exhortation to others
to act. What do you think of this as a way of conceiving of poetry? How is such
a view of poetry demonstrated by or contradicted by Lorde's own poem? Is the

allusion at the end of the poem to Greek tragedy, which usually carries a reference to sacrifice, relevant to Lorde's definition of poetry? How might a performance of the poem complicate the issue?

Similarly, rhetoric is here defined in an unusual way—as a willingness to kill or allow something to be killed. As we shall see later in this chapter, rhetoric is usually defined as an art of discovery and as an art of action. Its end is primarily seen as change, either of an audience's intellectual position or of their actions. Although at its most extreme (say, the rhetorical strategies of Hitler) rhetoric has the potential to destroy, by definition it is based in the ability of its audience to make choices. Lorde is clearly inviting us to rethink what each of these words means and what values we attribute to them. Let us consider in more detail what she seems to mean by the terms of her analogy.

Having set up this troubling analogy in the first stanza of the poem, Lorde proceeds to paint a nightmarish landscape of a world devoid of those elements that seem most integral to her vision of poetry: "the desert where I am lost/ without imagery or magic." Ironically (or perhaps not so ironically), she achieves her chilling, wrenching effects through these very elements, through the images of color, blood, the parched desert, and the bleached bones. She is invoking the art of poetry even as she explores what it means to lose it. In the next stanza she shifts dramatically from the interior world of the nightmare to the cold, seemingly "objective" world of the courtroom, a world dominated by testimony, by language used to persuade people to act as a group—the world we must infer she represents by the term "rhetoric." It is not a world of the imagination and magic; rather it is a world in which "facts," quasi-objective material, are given a privileged position denied to "poetry." We hear the testimony of the policeman who stands accused of the murder; Lorde reproduces his words, underlining their socially accepted status as "facts" by her refrain, "there are tapes to prove that."

In the fourth stanza she presents the conclusion of the jury, the audience for whom the courtroom rhetoric has been created. She very carefully uses as many statistics and numbers as she can here, such as the "37-year-old white man with 13 years of police forcing" and "11 white men . . . and one black woman," as well as the description of the "4'10" black woman's frame." Notice that she combines the wit and irony of poetry in the punning play of phrases like "police forcing"; whatever she may state, she clearly cannot wholly separate poetry from rhetoric.

The poem reaches its climax in the statement of the one black woman on the jury: "They convinced me." This sentence captures the irony and anger of Lorde's attitude toward rhetoric. In a sense, the juror's words are the ultimate praise one could bestow on a speaker—that persuasion has been successful. But it is clear from the words that follow that Lorde's assessment of the value of such rhetoric is scathing; she uses intensely imagistic language to describe what has happened—"they had dragged . . . over the hot coals . . . until she let go the first real power she ever had/and lined her own womb with cement/to make a graveyard for our children." Lorde is clearly indicting not only the black woman, whom she sees as abdicating her opportunity and her responsibility to resist such

persuasive attempts, but also the entire system of white male power that has led to this moment. In this one line is a compact expression of her distrust of the discourse of persuasion that privileges white male society.

Why, do you suppose, does Lorde return here to the language of poetry? Perhaps it is to follow her own advice to herself, advice she makes explicit in the final stanza: "to use/the difference between poetry and rhetoric." The alternative is to perpetuate the cycle of violence begun by the history of racism and slavery in this country. The images Lorde uses to describe her vision of what will happen if she simply continues to participate in that for which rhetoric stands in her eyes is horrific: the rape of an 85-year-old white woman by Lorde's "teenaged plug," her metaphor for a young black man, and Lorde's own torching of the white woman's bed. This vision is accompanied by the "greek chorus," mouthing racist clichés of sympathy for the white woman and stereotyping the black rapist and his mother, as Lorde imagines herself to be in this image. In the rote chanting of the chorus we have what is for Lorde the final corrupt, empty meaning of rhetoric—language used without authenticity of feeling, language used only to confirm the values of a murderous society.

Clearly, for Lorde, poetry is something better than rhetoric. For those of us used to viewing rhetoric as one of the central arts of communication, this is a troubling opening statement. What it forces us to do, though, is to call into question what rhetoric is, what rhetoric means to Lorde, to reconsider its status. Finally, it is impossible for us to divorce poetry and rhetoric to the extent that Lorde claims she wishes to do. Her poem is, at some important, crucial level, a rhetorical act: it attempts to persuade its audience that the racism of American society leads to inequities in power and justice. If we leave the poem unconvinced of Lorde's position, no doubt Lorde would not feel that she has succeeded completely in her goal. Poetry is finally a way of working through the deep, often painful emotions that would otherwise lead to the violence she has described in the poem; in some way, the suicide she mentions in the opening stanza may be seen as a willingness to kill the enraged part of self rather than take that rage to the streets and kill others. Perhaps she would even go so far as to say that she would be willing quite literally to kill herself rather than perform the kind of act she describes in the final stanza of the poem. But in the world of the poem, poetry becomes the alternative to either blind violence or inciting speech, an alternative to the white male traditions of language represented by traditional rhetoric. We may feel that Lorde has contrasted poetry and rhetoric in a way that is flawed, too easy an opposition, and that at some level she has demonstrated the contradictions in her position in the very act of writing a poem of such conviction, but the poem raises the issue of language as a source of power, both individual and social power, in ways that are dramatic and vivid—the poem invites the immediacy and urgency of performance.

In the remainder of the chapter, we will discuss two principal approaches to conceptualizing the sociopolitical self in the performance of literature. The first, which we call the rhetorical tradition, builds on traditions as old as the philosophy of Plato and Aristotle and continues into the present. It bases itself on a belief in the power of language to persuade audiences to social and political

action. We can speak of the rhetoric *in* a literary work (how characters go about persuading themselves and each other within the realm of a story or situation contained in the fictional world of the work) and we can speak of the rhetoric *of* a literary work (how a writer, similar to a public speaker, uses a work of literature to attempt change in an audience). The second approach we will discuss is a comparatively more recent development but an increasingly influential one: Marxist aesthetics, based on the teachings of Karl Marx and his followers, which propose and argue for a specific view of political power and change in society and which situate art (and literature as one particularly potent form of art) within that worldview. Both the rhetorical and Marxist traditions offer much to the performer of literature, who is increasingly called on to place his or her work in contexts larger than the classroom.

TRADITIONAL RHETORIC
AND THE PERFORMANCE OF LITERATURE

As we noted in our discussion of Lorde's poem "Power," the word *rhetoric* has been a central concept in the history of literature and performance. It goes back as far as the earliest treatises on literature in the Western tradition and continues today in courses and research in such departments as speech communication, English, history, politics, and theater. At various points in its history, rhetoric has meant different things to different people. For example, during that period coinciding with the fall of the Roman Empire, referred to as the Second Sophistic, rhetoric was synonymous with the ornamental use of language, with flowery, usually nonfunctional displays of speaking skill. Can you think of how you respond to the word *rhetoric* today? How have you heard it used?

The philosopher Aristotle conceived of rhetoric as an art corresponding to that form known as dialectic (the process of questioning associated with Plato and Socrates) and defined rhetoric as the art of discovering all the available means of persuasion in any given case. If rhetoric was to be considered an art, it was a particular kind of art for Aristotle: an art of discovery that involves choosing among options—considering all the possibilities, deciding what the implications of such decisions are, and only then coming to conclusions about what strategies to use.

Aristotle divided his art of rhetoric into three major kinds of what he called "artistic" proofs or appeals, the three main strategies by which speakers and writers might attempt to persuade their audience through analysis and creativity. Each of the three artistic appeals or proofs focuses on a different aspect of the persuasive process. Although they are obviously interdependent in actual instances of persuasion, they may be isolated for the purposes of analysis: *logos,* the use of reasoned language; *pathos,* the use of the audience's emotion or psychological state; and *ethos,* the audience's attribution of credibility and goodwill to the speaker. Each shares a concern with the relationship among speaker, message, and audience, with an acknowledgment that persuasion always involves an analysis and adaptation of the specific audience context in which it occurs. Let us take up each of these artistic proofs in turn.

Logos, the use of reasoned speech, is usually considered the foundation of argumentative discourse, typically the most universal way of effecting change in any audience. In traditional rhetorical systems, the advantage of focusing persuasion on logos is that reasoning, by definition, requires universal agreement on terms and processes: when we appeal to logic, we assume (sometimes to our own peril) that we are using strategies that we can assume our audience will consider something akin to scientific proof. Of course, as anyone who has tried to use reasoning with an audience knows, it is not as simple as it sounds: convincing your audience to accept the terms of your reasoning and to base its decisions on reasoning can sometimes be as difficult as discovering the reasoned arguments themselves.

Rhetoricians have traditionally based their appeals to logos on two principal kinds of strategies: inductive and deductive reasoning. *Inductive* reasoning refers to reasoning based on example, in which we move from specific instances to a general conclusion. If you say to your roommate, "You should take a course in performance studies. I took one with Professor X and I loved it," your roommate is likely to say, "Yes, but I don't know that I would enjoy the same courses you do, and besides Professor Y is teaching that class next semester." What your roommate is saying to you is that you have not provided enough examples to persuade him or her: your inductive reasoning has been relatively weak. However, if you say to your roommate, "You really should take a course in performance studies. I've taken five of them, with Professors X, Y, and Z, and three of the people down the hall have taken them and enjoyed them," your roommate may be persuaded far enough to investigate the courses. In this case, you have provided your roommate with at least enough information and enough examples to warrant the possibility of persuasion.

Deductive reasoning works in reverse fashion. It begins with general, universal statements and moves to specific conclusions. Typically, it uses some variation of what is called *syllogistic* form, based on philosophical and mathematical models of logic. A *syllogism* is a three-part proof, beginning with what is called the first (or major) premise, moving to a second (or minor) premise, and ending with a conclusion based on the interaction of the two premises. Perhaps the most famous syllogism is this:

Premise: All men are mortal.

Premise: Socrates is a man.

Conclusion: Socrates is a mortal.

Do you see the logical process involved? We begin with as universal a statement as is imaginable: who could doubt that all human beings are mortal (i.e., subject to death)? From there, we move to a second, in this case more specific but equally universal statement: Socrates (the famous Greek philosopher) is by definition a member of that class of beings known as men. Therefore, based on the truth of these two premises and on the relationship between the two, we can come to the conclusion that, as Socrates is a man, he is also mortal.

Aristotle noted that few speakers depend on the pure syllogism, either formally or intellectually, and that persuasion rarely centers around such scientific or abstract questions as are best served by the syllogism. Instead, speakers and writers tend to use what he named the *enthymeme* as an adaptation of the syllogism. The enthymeme has a number of characteristics: first, it tends to be based on possibility rather than certainty—as do most controversial issues, the subjects of persuasion; second, the enthymeme tends to omit one or more of the premises, assuming an implied knowledge or understanding by the audience of the unstated premise. Think about everyday persuasive conversation: how often do we simply make statements in which we assume our audience accepts our basic premises rather than spelling them out in detail each time?

Because human beings are, by definition, subjective creatures, logos is rarely sufficient to effect persuasion. Recognizing this, Aristotle identified pathos as a second important method of persuading people. He saw pathos as the single most effective way of effecting short-term persuasion, because our immediate response is often emotional or irrational. It is often only in the long term that the coolness of logic and reasoning has its full effect; similarly, the passion of the moment can burn out, and persuasion based exclusively on emotion may not withstand time.

Much of what Aristotle has had to say about emotion has been revised by what we have learned of psychology in the last century. Yet in terms of the public arena of human beings in groups, his attempts to describe the universals of human emotional experience are useful as a place to begin and a source of contrast to the reactions of individuals and groups quite different from the elite, almost exclusively male audience about which he was writing in the *Rhetoric.*

Aristotle's third artistic appeal or proof is ethos, which is harder to translate than the first two terms, *logos* and *pathos.* The literal translation of *ethos* is "character," and it usually carries the sense of "moral character." It refers to the audience's perception of the speaker as a moral agent, and according to Aristotle, was founded on two principal areas: *competence* and character. The first area, competence, refers to the audience's perception of the speaker's knowledge and credibility with regard to a subject, that is, whether the audience believes the speaker has the expertise to make his or her opinion worth listening to. The second area, character, is even more amorphous but perhaps, in many instances, more critical: character refers to an audience's perception of the speaker as someone honest, credible, and possessed of goodwill toward the audience. Is it possible to separate competence from character?

Today many celebrities have taken up social causes, such as AIDS, the Amazon rainforest, and drug and alcohol abuse. Many of these celebrities have enormous sincerity and commitment to the causes they serve. The audiences may very easily attribute a high degree of character to them: goodwill and honesty; what is less certain in many, though certainly not all cases, may be the amount of competence these celebrities have concerning the cause they espouse. How important, we may ask is it that they have anything approaching expertise regarding treatment and the politics of funding? Some might argue that at this level, competence is not terribly important. Others would argue that it is critically important, that

such celebrities need to understand the impact of their public persuasion. Can you think of examples? Can you think of examples of the reverse—instances in which an individual may possess great competence but little character? Which counts more for you, ultimately, competence or character?

Aristotle's system of artistic proofs is one of the bedrocks of traditional rhetorical theory and has important implications for the study and performance of literary texts. You may wish to read more extensively in Aristotle's *Rhetoric* to consider his analysis of emotions and the ages of humankind. You may also find the works of such other theorists as Cicero, Quintilian, and Longinus useful in studying the sociopolitical dimensions of literature in performance.

For performers, a consideration of the internal rhetoric of the text is very useful in building the characters in performance. Such an analysis not only helps fund the performer's sense of the characters' inner lives (the psychological dimension) but also helps make the politics of outer actions, verbal and physical, more identifiable. Thus, if you recall that we emphasized the inner lives of the characters in the selection from *Women in Love,* consider how a rhetorical analysis will help make the dialogue and the physical act of wrestling take on persuasive qualities for the two men.

We may also analyze what might be called the external rhetoric of a literary text, or what we earlier called the historical self or selves of a text. By this, we mean the persuasive strategies and, when we can identify them, either by inference or direct testimony, the intentions of the author in creating the text. In some respects, this can be a more disputable area of consideration: whereas some writers make their rhetorical goals quite explicit, others mask them or simply are silent. Indeed, in trying to situate texts rhetorically, some of our most intriguing and arguable work is trying to discern where the lines between the speaker's persuasive goals and the author's resides; in many, if not most cases, we can never come to a final answer.

Let us turn now from theory to a specific text and some individual performances of it. Our text will be William Shakespeare's history play *Henry V,* specifically act IV, scene iii, which contains one of the most famous examples of rhetorical speech in all of literature, the St. Crispin's Day speech. We will consider the scene first as an act of rhetoric within the world of the play, through the internal rhetoric of Henry V as character, situated in a dramatic and rhetorical moment; we will then consider the external rhetoric of the speech within Shakespeare's writings, career, and ideas. Finally, we will consider how two different performances of the speech from the play have emphasized different rhetorical goals, based on very different historical, social, and political contexts.

Traditional Rhetoric in *Henry V*

Henry V is the last play Shakespeare wrote in his sequence chronicling the life of King Henry V of England, which follows the monarch from his youthful adventures as Prince Hal through the heroic warrior of this final play. By the time we reach *Henry V,* Hal has become Henry and has foresworn his drinking

and womanizing; in a crucial moment, he denies his old friend Sir John Falstaff, the comic, carousing knight. In a sense, this act of denial is also an act of transformation of self, from the semiprivate individual, who may drink too much and take his position with less seriousness than he ought to, to the man who must stand as leader and symbol of an entire nation under siege.

This transformation is a rhetorical one, in the sense that in becoming Henry rather than Hal, the king must persuade his various audiences within the play that he warrants respect and loyalty, that he possesses the qualities of the head of state: he must convince his audiences to give him ethos. Henry helps build his ethos through action in a number of ways: first, he affects a different set of companions, he shows himself able to make decisions based on the pragmatics of war rather than on emotion per se, and he balances the difficult roles of leader and citizen. In a memorable sequence, he walks among the soldiers in disguise, engaging them in conversations that reveal their various attitudes toward him. He himself manipulates some of their attitudes in order to find out what weaknesses they perceive, what strengths they acknowledge, and so forth. He realizes that in the state of war, it is essential that he fight the battle not simply on the field but also in the minds and hearts of the men he must lead.

Perhaps the most stirring scene in the play is act IV, scene iii, on the verge of the St. Crispin's Day battle. It is included in the appendix (pages 475–79). The English are far outnumbered by the French, and the French arrogantly have called for a ransom or surrender to avoid annihilating the British. Henry's rhetorical goal, then, is to persuade his audience (the British soldiers) that their comparative lack of numbers does not doom them to destruction, either in the physical battle or in the annals of history. Read the following scene; as you do, consider how Henry uses the three major persuasive appeals, logos, pathos, and ethos, to win over his audience and to prove his point.

As you read this selection also consider the ways in which Henry's rhetoric shifts within the scene, as his audience changes from the British soldiers to Montjoy, the French emissary. Does Henry's essential message or rhetorical goal change, as well? How might your performance suggest shifting attitudes and strategies?

Let us work through this scene, examining the ways in which Henry responds to the rhetorical situation. The scene begins with a group of noblemen who are leading the soldiers in the battle and waiting for the king to return. Their main topic of conversation is the vastly disproportionate contrast between the French and the English armies; as Exeter says, "There's five to one. Besides, they are all fresh," meaning that the French soldiers are new to the battle, whereas the English must depend on the same group of soldiers who have already been fighting. The interchange between the noblemen on this subject sets the rhetorical problem for Henry: to convince the noblemen and the soldiers that the numbers are not as important as other qualities, such as courage, loyalty to country, and so forth. Henry's challenge involves logos, pathos, and ethos—logos because most people would assume that an army outnumbered fivefold would simply have no chance of winning; pathos because the possibility of death creates fear, sadness, and even frustration and anger, emotions that need to be addressed and

transformed if the English are to have any chance of winning; and ethos, finally, because Henry must somehow present himself as a leader and symbol, convincing the English army that he is a man worthy of their loyalty and obedience, a man they can trust and who possesses goodwill toward them.

Henry is clearly aware of this situation when he enters, and he picks up the mood of the audience, signaled by Westmoreland's wish that "we now had here/But one ten thousand of those men in England/That do no work today!" Henry responds by turning this concern with numbers around: "If we are marked to die, we are enough/To do our country loss; and if to live,/The fewer men, the greater share of honor." To which of the three areas of rhetorical appeal does this statement belong: logos, pathos, or ethos? We would argue that Henry invokes all three. The statement appeals to logos in its transformation of a few basic facts and assumptions about the situation: first, that the English army is smaller in number than the French; second, that a small number tends to be at a disadvantage in warfare (i.e., in the man-on-man combat of the historical period); third, that the numbers do not inevitably lead to a loss of the battle; finally, that whatever the outcome the size of the group can be an advantage—if the English lose the battle, at least fewer men will have died, and if they win, the glory will be greater because it will be divided among fewer participants; each will have a larger piece of the pie, so to speak.

Is this logic unassailable? Hardly. In response, one could argue that increasing the number of soldiers would raise the likelihood of a victory for the English, so that even if the triumph had to be spread among more soldiers, at least there would be a better chance of it occurring. Similarly, if there were more soldiers, it is possible that fewer men might be lost overall because there might be opportunity for greater force and for fewer tired soldiers in the battle. And one could also counter by saying that increasing the number of men need not dilute the glory but could increase it, in that even more of the men of England would be involved in this great cause.

Clearly, Henry's rhetoric will not stand on the basis of pure logic alone, nor should we expect it to; remember that persuasion tends to work more on the basis of possibility than certainty. Henry is working in the realm of the enthymeme, appealing to certain reasonable if not scientific premises, without spelling them out in syllogistic form. The enthymeme allows him to emphasize those aspects of his argument that are grounded in possibilities of logic rather than to spell the arguments out completely and risk leaving them too open to the kinds of counterarguments we have raised.

Nonetheless, you would probably agree that given the morale of the army, Henry's attempt at logic is a useful one and gives him a base on which to build his appeals to pathos and ethos. He follows up his statement "The fewer men, the greater share of honor" with the admission of his "covetousness" for "honor," contrasting it with his lack of covetousness for either gold or rich garments. This is a very canny use of both pathos and ethos. "Covetousness" was typically considered to be one of the seven deadly sins in medieval Christian theology. In admitting that he is guilty of this sin, Henry humbles himself a bit

and also binds himself to the other soldiers. But he cleverly turns this sin into a virtue, in that all he covets is "honor." This statement appeals to the emotions of the warriors and also demonstrates his honesty and goodwill, aspects of ethos.

Reiterating that he would "wish not a man from England," he instructs Westmoreland to send out the message among the soldiers that anyone who wishes to leave before the battle may do so; he will be given his passport and "crowns for convoy." Henry says, "We would not die in that man's company/ That fears his fellowship to die with us." Again, Henry appeals to the emotion of courage in his audience and also to the binding ethos of the group: "fellowship" ties the true soldiers together.

From here, Henry moves into a ceremonial speech, commemorating the day. As is traditional with this type of speech, Henry uses time to mark the day's importance. He begins with the past, placing the battle in a larger historical context: "This day is called the Feast of Crispian." Crispianus and Cripinus were two Christian martyrs; that the battle is to take place today aligns Henry and his audience in the tradition of those who were willing to sacrifice themselves for their beliefs. Although this battle is not a religious one, the association with the martyrs imbues it with a highly serious, even spiritual quality, an appeal to ethos that may help raise the spirits of the soldiers, tired, hurt, and discouraged. They are not foot soldiers in a hopeless fight but participants in a continuation of something noble and holy.

He moves to the future: "He that outlives this day and comes safe home/Will stand a-tiptoe when this day is named . . . " He visualizes for the men how each year they will speak the words "Tomorrow is Saint Crispian" and "These wounds I had on Crispin's Day," building a momentum of the ritualistic remembrance of the occasion. He even builds on the Aristotelian concept of the ages of men, speaking of how "Old men forget" but how each of the men who survive this day will not forget St. Crispin's Day and what happened here.

He continues the visualization, invoking the names of the leaders and referring to himself as "Harry the King," the nickname giving him a double place in the context: "Harry" marks him as a man like anyone else in the audience, but "the King" reminds them of his status as their leader. The listing of the names of the other noblemen helps expand the inclusiveness of his appeal: he as speaker is only one of the many great men involved in the battle. He moves beyond this hierarchy as the speech reaches its climax, in which he calls all of the soldiers "We few, we happy few"; the use of the first person plural is not the traditional "royal we" (in which royalty refer to themselves as "we") but refers to the "band of brothers" of which he is honored to be a part. Again, pathos and ethos are intermingled: the pride he feels at being one of them makes it possible for him to speak as a leader of them, as well. The battle, he suggests, will be equally transformative: "This day shall gentle his condition," meaning that all soldiers will rise in rank because of this battle; he concludes by turning the word "gentle" around, imagining how those "gentlemen" not here today will "think themselves accursed they were not here,/And hold their manhoods cheap whiles any speaks/ That fought with us upon saint Crispin's Day." Henry's rhetoric is a complex

one, for it combines an appeal to the equality of the soldiers with the elitism of the exclusion of those not there. In short, it is perfectly suited for the audience to whom it is addressed.

Note how Henry's speech balances the three appeals Aristotle thought central to rhetorical invention: logos, pathos, and ethos. Although logos is not invoked frequently throughout the speech, remember that Henry begins his appeal with an enthymeme and, in a sense, cannot proceed without an audience that accepts the possibility of its truth; without this appeal to logos, the appeals to pathos and ethos that make up most of the speech would seem groundless. That pathos and ethos are so intermingled in the speech is appropriate; the emotions to which Henry is appealing are those of courage, honor, and bravery, all qualities he wishes his audience to attribute to him as well. His strategy is one of identification: he wishes his audience to see him as one of them and to see in him a representative of them. Thus, shared emotions lead to shared ethos.

There is a brief transition in the scene as the men prepare to go to battle, but Montjoy, the French herald enters, sent to make one more attempt to negotiate with Henry, ostensibly to save England from certain defeat and unnecessary loss of men. Notice how Henry's reaction to the question of the number of men, still the central issue, differs from his speech to the English soldiers. As with the St. Crispin's Day speech, Henry does not refute the basic premise that the English are outnumbered, but he gives his opponent that fact and then dismisses it as not the primary point to be discussed.

He issues this as a challenge: "Bid them achieve me, and then sell my bones." He has transformed himself into the terms of warfare, a corpse among many. He then speaks to the topic of "bodies," reducing the Frenchman's argument to the immediacy of physical mortality rather than the noble English one of patriotic immortality. In an argument paralleling the one he presented to the English armies, he visualizes a future when—although most of the English soldiers will "Find native graves"—some will "leave their valiant bones in France." He chooses some of the most sensually repellent language he can to describe the lands of France, using words like "dunghills" and "plague," suggesting ultimately that the corpses of English soldiers will improve the landscape of France. As in his speech to the soldiers, he stresses the humbleness of the English armies yet also praises their virtues, calling them "warriors for the working day." He finally sends Montjoy back to the constable of France: "Come thou no more for ransom, gentle herald."

What is most notable, from a rhetorical standpoint, is the way in which Henry uses many of the same basic ideas and materials (the stuff of invention, to use the rhetorical term) but adapts them to very different ends for his different audiences. What remains similar in the two speeches is an emphasis on the small size of the army as a potentially positive element and the possibility of spiritual glory even in physical defeat. Both speeches move from the initial statement of the argument toward an elaboration of it through images and other stylistic devices, moving toward a dramatic climax. Yet the rhetorical goals may finally be seen as quite different: in the St. Crispin's Day speech, Henry's goal is to inspire his soldiers to victory in the midst of seemingly certain defeat; in the speech to

Montjoy, it is to deny defeat and to claim victory from the enemy, even before the battle, no matter what the outcome may be.

What, then, of the rhetoric of the historical self of *Henry V* through the playwright Shakespeare? It is impossible, of course, ever to recover completely the rhetorical intention of Shakespeare in writing *Henry V*. Some might argue that Shakespeare's rhetorical goal is irrelevant to any performance of the play. But we would argue that considering the play in its historical context may help us to understand another possible level of its rhetoric. It is important to remember that Shakespeare was not writing about contemporary events, any more than a playwright in 1990 writing about the American Revolution would be writing about contemporary events. He was writing about a segment of English history distant from his own era. Therefore, his use of English history may be seen as an important rhetorical strategy.

What we can infer about Shakespeare's specific rhetorical goals in his use of historical material and in his portrait of Henry as king, orator, and warrior is considerably more open to debate. Various critics have discerned in the play (and in its companion history plays about this king, collectively called the Henriad) quite different, even opposing ways of seeing the world and understanding social and political processes. Perhaps the most conventional way of seeing Shakespeare's rhetoric is as that of the supreme patriot, glorifying the king as eloquent leader, the ultimate example of Quintilian's view of the "ideal orator" as the "good man skilled in speaking." Such critics would argue that those negative traits identifiable in Henry's character, his ethos (Aristotle used this term in describing both oratorical speakers and dramatic characters), may be explained through a realism Shakespeare brings to his understanding of human nature: that such flaws in Henry only make him more human. Shakespeare's rhetoric, then, becomes a relatively conservative one politically, celebrating the status quo of the English throne and thereby indirectly praising the reigning monarch, Elizabeth I.

More recent critics view the rhetoric of the play in more radical terms. Building on what has come to be called a deconstructive or poststructuralist turn, in which the literary text "undoes" itself and demonstrates contradictions in existing systems and beliefs, such critics argue that the play is as much about "misrule" as it is about "rule" and can be seen as a response to political conditions of the time, the decline of Elizabeth as monarch. Most of these critics do not deny the patriotic element in the play; they simply argue that there is a mediation between the patriotic, pro-Henry aspects of the play and the contradictions contained within. For them, Shakespeare as rhetor is only partly in control of the persuasion occurring in the play. The historical context in which Shakespeare wrote the play, the Renaissance tension between the absolute monarchy and the growth of the individual, perhaps accounts for the tensions in its rhetorical fabric.

How do we bridge the gap between the literary rhetoric and the historical rhetoric, between the rhetoric of the characters and the rhetoric of the play or playwright? Perhaps performance itself allows us an avenue for such an exploration. Let us consider, finally, two very different but to our minds equally valid and fascinating productions of the play, both filmed. The first is Laurence Olivier's 1946 film; the second is Kenneth Branagh's 1989 film. In both cases,

the director also played the title role of Henry, allowing for an almost uniquely parallel situation.

Olivier's version of *Henry V* is an extremely theatrical one. He sets his version at a specific performance of the play in the Globe Theatre of Shakespeare's time—indeed, Shakespeare, himself, makes an appearance. Before the play proper begins, Olivier shows us the actors backstage and the audience preparing for an afternoon at the theater. He is reminding us, as Shakespeare himself does in the play, that what we are watching is a play, a reinvention of history, an entertainment that occurred in a specific context. We see what appears to be a rather realistic re-creation of Elizabethan stagecraft and, for quite awhile, are not asked to suspend our acknowledgment of the artificiality of the theatrical situation.

Olivier eventually shifts into more realistic settings, in which we see battles occurring and soldiers riding horses—the epic becomes more palpably naturalistic. But the care he has taken to frame the film in a historical setting is not lost. Most audience members never quite forget that they have seen the actors backstage preparing for their entrances (including the boy actors dressing up as women, though real women play the female parts onstage in the film).

This recognition of the theatricality also leads Olivier to direct his actors in a style that seems artificial: we hasten to add that we use this word not as a negative judgment but as a description of our awareness of the acting going on. Henry becomes outsized, a hero larger than life. Olivier uses his justly famous voice as a magnificent instrument, raising the St. Crispin's Day speech to something close to song. This is not to suggest that it lacks passion or emotion: rather, its path to persuasion lies in rousing the men's spirits through their ability to adulate someone less mortal than themselves. Conversely, the French are depicted as particularly foolish and weak—to some minds, the acting is almost one-dimensional, or flat. There is a childishness to such characters as the French king that places them in high contrast to the noble British.

All of this may be seen as a valid reading of the rhetoric in the play; it may also be seen as part of a rhetorical mission occasioned by the historical context in which the performance was created. The film was produced during the last year or so of World War II, a time of great patriotism in the British Isles. The English had suffered devastating losses through bombs, death of soldiers, and economic deprivation and rationing. In a sense, the high heroic mode Olivier chose for the film may be seen as a rhetorical strategy for keeping up morale in Britain. A number of critics have suggested that the weak, childish French in the film might be interpreted as metaphors for the Nazis and the fascists. Remember that the French were allies of the English in World War II; however, a British audience needed an enemy that could be defeated, and the historical French of the play could stand in comfortably for the contemporary Germans and Italians.

You may find the 1946 film stiff and stilted, its conscious artificiality distancing. This response may be a reaction to the dissonance you feel in seeing something so consciously stagy on film, a medium many of us expect to appear more realistic. It may also have something to do with shifts in acting style in the last 40 years, in which the declamatory, almost musical style of acting has given way to more conversational or everyday approaches. But remember, if you have

the opportunity to see Olivier's *Henry V,* many of your reactions may result precisely from the film's rhetorical stance toward the play and toward the immediate audience for which it was designed. It is important to retain your own contemporary viewpoint, but it is also useful to try to place yourself imaginatively in the context in which the original war-beleaguered audiences experienced the performance.

A more recent performance of the play, also produced for film, was directed by and starred the young actor Kenneth Branagh. Its tone and portrait of Henry are very different from Olivier's. Some critics have called Branagh's version a "post-Vietnam" interpretation of the play. By this they mean that whereas Olivier's version was situated in the midst of what Studs Terkel has called "the good war"—when despite the losses, most of society agreed that the fight was worthwhile—Branagh's version calls into question the value and nobility of war. It even begins much more darkly, the chorus (played by Derek Jacobi) no longer the identifiable spokesperson for the players, as in Olivier's film, but a dark figure, recognizing the ironies of war even in his invocation of a muse of fire. The chorus opens the door to the world of the play, and once open, we are in a world of deterioration, a world of some despair and chaos.

If Olivier's portrait of Henry is of the warrior-king, almost a demigod, Branagh's is of the boy-become-king, the monarch learning, through trial and error, to put childishness behind, and to walk the delicate balance between private life and public responsibility. Branagh even appears less physically noble than Olivier, whose patrician looks contributed to the sense that he was greater than ordinary men; Branagh's Henry must struggle toward greatness. In the St. Crispin's Day speech, for example, Branagh moves the camera between Henry and the soldiers, sometimes shooting from the point of view of the latter, though not seeing Henry as a transcendent figure but almost as background to the company of soldiers. Branagh's Henry gives a rousing speech, but in some respects it seems much more palpably a persuasive task—we see how tired and beaten many of the men are, how close they are to defeat. There is nobility in Branagh's Henry, to be sure; for many audiences, a greater nobility than in Olivier's because Branagh's Henry has had to learn and grow to become the king who woos the French princess Katherine and, by extension, the defeated country of France, in gowns and language of splendor and richness.

For many viewers, Branagh has made one of the finest Shakespearean films of all time. But it is fair to say that its rhetoric would probably not have been as appropriate to or as effective for the 1946 audience of Olivier's film: it suggests far too much that war may not lead to honorable ends, and that Henry's rhetoric is itself potentially fallible. In that respect, it is a more appropriate rhetoric for today in ways that Olivier's may not be. Yet both performances (individually and collectively) are valid and satisfying on their own terms and in their own rhetorical contexts.

You may wish to work on this scene in class, either as a solo or as a group performance. Think about how your own perspective on the rhetoric of the scene (and of the entire play, for we would hope that you would read the whole play if you choose to perform the scene) might shape the performance you create.

If you see Henry as closer to Olivier's warrior-king, you may choose to focus on the fierceness of his call to arms and on his contest for supremacy in his speech to Montjoy. If, however, you find yourself closer to Branagh's vision of the boy-become-king, your Henry may have to persuade himself in the course of the speeches that this is not a hopeless battle. If you work on the entire scene as a solo performance, your view of the rhetoric will influence how you portray the other characters—as lesser figures than Henry, as supporters, or as near equals, drawn to Henry because of the belief in a god-given monarchy. Your staging of a group performance might also indicate spatial hierarchies, raising Henry for one set of relationships, placing him on the same level for others. Might he move among the men and speak to some of them individually? Might his body language alter significantly upon the entrance of Montjoy. Is there any tension between what his words say and what his body does? All these performance questions might be framed in the context of Henry as sociopolitical persuader—as rhetor—and of the play as rhetorical text.

MARXISM AND THE PERFORMANCE OF LITERATURE

So far we have paid little attention to the specific political underpinnings of the rhetorical approach to the performance of literature. Indeed, some critics might argue that traditional rhetorical studies do not adopt a specific political position with regard to the literary texts being studied. We would argue that there is no such thing as an "innocent" or "objective" perspective and that most traditional rhetorical analyses of texts typically emerge from democratic principles, as in the classical Greek society in which they first appeared. For example, the very notion of the individual as a source of persuasion for a decision-making audience implies a participatory form of government that in America was refined into Jacksonian democracy in the nineteenth century. Can you see ways in which traditional rhetoric valorizes, or holds up for admiration, other political systems or philosophies, as well?

In this section we would like to focus on one particular political system that has had and continues to have a significant impact on the study and performance of literature: Marxism. Most of you are probably familiar with some of the basic ideas behind Marxism. We will review these ideas and then consider how they might allow us insights into texts and performances.

Marxism is a political movement that grew out of the philosophy of the nineteenth-century writer Karl Marx, traditionally called the father of communism (along with Friedrich Engels, he wrote *The Communist Manifesto*), whose best-known interdependent work is *Das Kapital.* Marx's theories are based on a conception of historical process and economic production as interdependent: he sees the relationship between the ways societies move through history and the economic factors of the production of material goods and services as inextricably connected—in what, to borrow from the philosopher Hegel, might be described as a dialectical process, in which the interaction of two forces lead to a third condition or situation.

Marx identified two aspects of this relationship as superstructure and base. Superstructure refers to the ideology of a society; base refers to what Marx saw as the economic realities of a given society at any time. He argued not for a purely causal relationship between superstructure and base but for an interdependence: economic conditions may emerge out of a particular ideology that governs a culture; similarly, the ideology itself may derive from the way people have had to live their lives at any given moment in history.

Marxist critics have argued and continue to argue over the relationship between superstructure and base, both in Marx's theories and in the actual reality of life as we collectively live it; but what is perhaps most important to recognize is that this theory of the relationship between superstructure and base suggests that ideologies are not simply universal givens, accepted conditions of existence (as we may be likely to conceive of them), but also are products of history and of power relationships in different societies at different times. Thus, as Americans we are often tempted to assume that democracy is a universal, "pure" state of being and government, whereas Marx would argue that it, like any other political system, grows out of an economic base that favors certain groups at certain times.

All of this is not to say that Marx himself was not given to a specific ideology that he favored over other ones. Indeed, his own position was that we as a world are heading toward the decline of capitalism, a political-economic system that favors the few and the wealthy, and toward socialism or communism, which gives power to the proletariat or working class. One of the watchwords of Marxism is the famous "Workers of the world, unite! You have nothing to lose but your chains." Marx saw the conflict of social classes as leading to the inevitable revolution, during which the bosses would be overthrown and a utopian society would emerge in which every member would contribute what he or she was best disposed to contribute and would receive what he or she needed.

As we begin to discuss Marxism and the performance of literature, we might focus on a few central notions. First, Marx's philosophy is grounded in a notion of action rather than analysis or reflection: his goal was not simply to describe sociopolitical conditions but also to change them. Thus, in true Marxism, both criticism and performance have social change as a principal goal; in this sense, Marxism is clearly allied with rhetoric. Although it is possible to criticize or perform by using Marxist terms and concepts without necessarily subscribing to the belief in the need for radical change in society, it is clearly ethically and philosophically bankrupt to do so unless the intention is to be parodic. Marxism demands participation and commitment from both critic and performer.

A second central idea of Marxism is the relationship of the individual to society. Recall that in our discussion of the psychological self we focused on the development of the individual human being, only later moving that sense of psyche out into the world. If we saw a connection between the psychological self of the individual and the lives of others, it was typically based on intimate family relations (as in Freudianism) during infancy and childhood or on a broader sense of archetypal experiences (as in Jungian thought) that at some level transcend any individual historical moment of origination (although we may act out the trickster archetype in a specific historical moment in a highly individuated

way, the trickster archetype exists outside of any single moment). In sum, most psychological theories of the self argue that the individual (or many individuals together) creates society.

Marxists argue for the opposite position: it is the society and the historical and socioeconomic processes at work in society that create the individual. In examining any literary self, then, a Marxist would turn to the historical and social forces of power and production that contributed to who this self was. Even at the level of family relations, as we shall see in our analysis of Anzia Yezierska's *Bread Givers,* private life may be seen to emerge from a socioeconomic system that gives privileges to certain groups and oppresses others. This is not to say that individuals do not differ in their way of experiencing these social conditions but simply that we are first and foremost the products of such social conditions, and all else comes after such determination.

Before we examine a specific text, let us briefly consider how Marxism itself influences literature and performance. We might expect Marxists to want a literature that overtly espouses the dogma of an ideal socialist state. Actually, Marx himself did not feel this way. He favored works of literature that revealed the oppressed condition of the proletariat rather than those that simply preached a dogma. This preference led to a literary movement referred to as socialist realism. What *realism* means to Marxists remains disputed and depends greatly on the particular writer or critic. Perhaps the most notable conflict over the meaning of *realism* is that between Georg Lukacs and Bertolt Brecht, neatly summarized by Terry Eagleton in his book *Marxism and Literary Criticism.* For Lukacs, Eagleton suggests, realism was a form of literature, tied to the nineteenth-century fiction of such writers as Balzac. For Brecht, realism had more ideological and fewer formalistic connotations: "realistic" literature is that which represents political and social reality rather than that which provides seemingly photographic details of contemporary society.

Marxism, then, can lead in a number of directions in terms of the actual composition and production of literature. It can lead to those works (often narrative in form) that attempt to present a naturalistic picture of the ills of society through amassed detail and specificity. But it can also lead to a formally looser kind of literature, like Brecht's dramas, named by the literary movement expressionism, which may use extremely nonnaturalistic techniques to reveal the "reality" of the sociopolitical situation.

Brecht is perhaps the most accomplished example of the Marxist writer of the second category. Indeed, Brecht may be seen as responsible for the development of a Marxist approach to performance. Although his theory is too complex to describe in great detail here, his notion of the didactic and polemical nature of literature led to his composition and production of plays in what he called epic theater. The word *epic* suggests a differentiation from the traditional representationalism of the realistic theater of Henrik Ibsen and Anton Chekhov. Rather, Brecht wanted his plays to create an epic mode, in which performers and audience were always aware that they were in the presence of art, that they were not, to use the Romantic critic Samuel Taylor Coleridge's words, to rely upon "the willing suspension of disbelief." They were always to be aware that

they were involved in an intellectual process. To this end, Brecht wrote plays that would not allow the audience to be seduced or to seduce themselves into confusing what they were seeing onstage with real life. Brecht used a number of techniques to ensure this requirement. He had slides and titles projected onstage, framing the scenes of the play in narrative fashion. He purposely wrote plays in many scenes, to break up the sense of unfolding action. He integrated songs, often with a vaudevillian flavor, to break the spell of dialogue between characters. Actors might break the "fourth wall" of the proscenium and speak directly to the audience.

He also encouraged the actors in his productions to use rehearsal techniques that would keep them from identifying too deeply with the characters they were playing. For example, he often asked his actors to talk about the characters, referring to them in the third person, to retain the sense in which the actors are always commenting on their characters as well as impersonating them.

Have you ever used any of these techniques in working on a performance? If so, you may be surprised to realize that they had their origins in a sociopolitical view of performance.

A Marxist Analysis: *Bread Givers*

For our analysis we have selected a chapter from Anzia Yezierska's *Bread Givers*. The novel was published in 1925, and it presents the immigrant experience of a young Jewish girl on New York's Lower East Side in the early decades of this century. *Bread Givers* is an episodic novel, linked by the continuity of family themes, but each chapter has its own sense of completeness as we see the narrator-heroine grow from childhood to young womanhood. A novel about the development of an individual is called a *bildungsroman*. Sara's family is a traditional orthodox Jewish family. Although the severity of the father's control of the family and his disregard for the desires of his wife and daughters hardly represents all families of that time and culture, it clearly does represent people who did and, in different forms, continue to exist.

Sara is the youngest of four daughters. Much of the action consists of the attempt of Sara's father to marry off each of the daughters. The chapter we have given you is the fifth in the book, relatively early in the novel. It is called "Morris Lipkin Writes Poetry" and may be found in the appendix (pages 479–89). Read it and then return to this chapter.

It is possible to read and perform this selection from a number of different perspectives. Some readers will find the psychological tensions between the father and daughters the most interesting facet. Others will look to the cultural dimensions of Judaism and its position on filial obedience and reverence for the father as a respected man of prime importance. We would like to suggest that a Marxist reading of this chapter will also illuminate important elements of the selection's dynamics. Let us move through the selection, pointing to the ways in which Marx's views about social process are relevant.

The selection begins with the delivery of the letter for one of the sisters, Fania, from Morris Lipkin, the poet. As Mother immediately says, "Ain't it black

enough to be poor, without yet making poems about it?'' This draws into question immediately the value of poetry in an oppressed society. Mother's question and Father's reaction, calling Morris a ''schnorrer,'' suggest one position on poetry as a luxury in a world dominated by the capitalist necessity of production. As Father says, ''Those who sell the papers at least earn something. But what earns a poet?'' We are appalled to hear such a dismissal of poetry from a man who claims to be learned, but again, the religious factor is important: Father makes a distinction between his sacred learning and secular poetry; Marx might say that Father is using religion as a refuge from his own participation in the oppression of family, who represents a microcosm of the oppressed proletariat.

Indeed, Father cunningly uses poetic means to put fear and doubt into his children, telling them ''A Greek fairy tale,'' a corruption of the myth of the division of the universe, to suggest that poets are only dreamers. There is clearly a contradiction between Father's dismissal of the literary writer and his own manipulation of the myth (which he would not have regarded as sacred because it was not Judaic). Father takes on some of the evil qualities we might typically associate with the oppressive bosses of business, exploiting the ignorance or faith of his wife and children to his own ends.

Only Sara questions her father's rhetoric, quoting back to him his own words that ''poverty is an ornament on a good Jew, like a red ribbon on a white horse.'' To this Father replies, ''You're always saying things I don't ask you,'' indicating the gulf between what he would like his daughters to believe and what Sara, at least, has learned. Sara has learned to question, to go beyond the message he wants her to learn, and this angers (and perhaps frightens) him.

At the heart of Father's objection to Morris Lipkin as a husband for Fania is the economic question. Although Father claims to have Fania's best interests at heart, it is clear that he has an interest in the money she might bring to him through a ''good'' marriage. The suitors he finds for his daughters hardly seem the choices of a reverent, ascetic holy man: For Mashah, he selects Moe Mirsky, the diamond dealer, who will be revealed as a fraud later in the chapter. For Fania, he finds Abe Schmukler, a ''cloaks-and-suits'' man from Los Angeles, who barely spends as much time with Fania as he would with a shipment of clothes he might buy; indeed, we are told, ''Two weeks he already spent buying his cloaks and suits, and only two weeks he had left to get himself a wife.'' Fania gives up and accepts him as her husband, but in response to the bitter jealousy of the eldest daughter, Bessie, says, ''I love Lipkin. And I'll always love him. But even if Abe Schmukler was a rag-picker, a bootblack, I'd rush into his arms, only to get away from our house.'' The politics of marriage are akin to cutting a deal: rather than remain in her father's ''shop,'' she'll sell herself to the first man who will get her out of it. By the end of the chapter both marriages prove to be ''bad buys'': Mashah returns home to reveal that Moe Mirsky has lost his job; she returns to him when he finds work as a shoe clerk because she is convinced that even this is better than remaining with her father. Meanwhile, Fania's husband proves to be a gambler, leaving her lonely. She begs to return home and offers to work in a shop, simply to find human companionship again. Father refuses.

Only Bessie and Sara are left. Bessie is quickly turning into an embittered old maid (though she will marry within the course of the novel), a product of a society in which a woman is only a commodity for marriage. Sara remains obstinate, a firebrand, unwilling to give in to the materialism of her father, to the domination that would turn her into yet another product for sale. Near the end of the chapter Sara discovers Morris Lipkin's poems to Fania and falls in love with him through his poetry. When she finally confesses her love for him, he laughs at her, calling her "silly little kid." This destroys her hope for romance with him and she destroys his love letters to Fania, saying, "as I stamped the pieces under my feet, I felt I stamped for ever love and everything beautiful out of my heart."

What are we to make of this ending? Is Sara's response simply that of the teenage girl rejected by the man who perceives her only as a "kid"? Surely that element is there, and her act of destruction is something of a temper tantrum. But it may also be seen as a critique of two aspects of capitalism. First, it is a response to what may be seen as the gap between Lipkin's aestheticized love poetry, which claims an empathy and concern for others, and his actual callousness toward a young girl feeling the first pangs of love. In a sense, Sara's act is a rejection of a world in which poetry is indeed only a show, without substance behind it: Lipkin's poetry has no value, she seems to be saying. But her response is also perhaps the final act of a young woman who feels trapped by a world in which she has no social or economic position, where her father dictates what she may or may not do and where her best attempts to attract a man she admires only reveal her inability to control her own fate.

Clearly, gender issues are tied to socioeconomic ones in this selection, as they tend to be in life: Sara is more oppressed in this world because she is a girl, though the poverty and the traditions of Judaism would also oppress the children. Whether male or female, the children are oppressed by a society in which they cannot control the economy. It is even possible to argue that Father, who comes across as an extremely melodramatic, hypocritical villain, is also a victim of the capitalism that corrupts his devotion to scripture. Although it is doubtful that Marx or Marxists would ever approve of Father's religious orthodoxy, it is clear that it has been corrupted by the necessity of his participation in a capitalist system.

The novel continues to follow Sara through her struggles. She eventually leaves the family and suffers much deprivation in order to lead an independent life, but she manages to go through college and become a public school teacher: she knows that in this society she must have a profession to remain in control of her life. She becomes engaged to the principal of her school, a man much more enlightened than her father, and seems on the road to a life that will bring her fulfillment and will allow her to contribute her intelligence and passion to the children she teaches. But the novel ends on a note of ambiguity: her father is destitute and deserted by his second wife. Sara, despite her hatred for his treatment of her mother, her sisters, and herself, nonetheless cannot abandon him completely. As the novel ends, she and her fiancé, Hugo, prepare to take Father

in to live with them. Yet there is no assurance that this is a fairy tale ending of redemption and accommodation. Sara's last words speak to the open-ended unsureness of the decision: "But I felt the shadow still there, over me. It wasn't just my father, but the generations who made my father whose weight was still upon me" (Yezierska 297). In other words, her father is only part of a longer historical process of patriarchy. We have no guarantee that the "weight" on her shoulders will not continue.

Clearly, there is an intersection between Marxism and feminism in this novel and in the sections we have studied. If we look at the novel historically it would be virtually impossible to separate them—men were the bosses, literally and figuratively, the possessors of economic and cultural power. Marx suggested that "religion is the opiate of the masses," indicating that the religious fervor of a man like Father is part of the larger sociopolitical system, an element of the superstructure to use the technical term. Such a system gives privileges to men but also, as the last line of Yezierska's novel suggests, oppresses them. We will have more to say about feminism and issues of gender in the next chapter.

Finally, let us consider how a Marxist approach to performance might inform our work on the selection from *Bread Givers*. Recall that we identified one strand of Marxist literary criticism that sees the form of the realistic novel as distinctive. In these terms, Yezierska's novel seems an ideal candidate for performance. Because its naturalistic setting and the first-person narrator make the novel seem like a slice of life, a performance that convinces the audience members that they are spoken to directly by Sara herself—who speaks the narration with the mixture of Yiddish and English of Yezierska's style and who might approximate the young woman physically—would reveal the realism of the social conditions.

How might a Brechtian approach to the novel inform a performance? To begin with, it would allow for a greater range of performers. There would be no need to limit the performance to women, as any performer would essentially be seen as "commenting" on the character. In fact, a performance by a man might suggest a number of things through the notion of alienation. First, the conscious distinction between the female narrator and male performer could point to a universal realism, in which the oppressiveness of the nuclear family as a product of capitalism could be seen as having an impact on everyone. A male performer might also remind the audience of the ways in which men have had control over the production of women's writing; that is, publishers and critics have more often been men than women, so in a sense a male performer might be seen as once again appropriating the experience of a woman. Each of these perspectives may point to a dialectical relationship between the novel and performer, a relationship to be explored in more detail in a later chapter.

What other Brechtian devices might be employed? The very nature of the epic mode creates a distance between the narration of the events and the occurrence of them. A solo performer might be less likely to draw dramatic distinctions between the telling and showing of them but could subtly suggest the gap between experience and recollection. A group performance might suggest the process by which Sara struggled out of her environment, with different actresses being cast in her role at different times. Perhaps one actor might take

on all the male roles and one the mother and the sisters, suggesting a kind of sociology of the groups in the novel and showing ways in which Father and Lipkin and Hugo are all part of the process of male privilege.

Mixing the religious and economic images of the novel, perhaps purposely substituting one for the other, would illuminate the ways in which religion and economics are, in Marx's view, interdependent in their oppression of the masses. Perhaps Father would not be dressed as a holy man but as a merchant (indeed he moves between the roles quite literally in the novel). Sara might be seen to substitute education for religion and art—perhaps her impoverished room, where she studies, might be given a holy glow to indicate how Sara has transferred the values of her upbringing for those values that will liberate her from the poverty of mind, body, and spirit. Can you think of other ways in which performance choices might comment on the sociopolitical implications of this novel?

In exploring the uses of Brechtian approaches to performance, you may wish to read some of the writings of Robert S. Breen, a director and performance theorist who built on Brecht's theory of epic theater in devising his own method—chamber theater—an approach to the group performance of narrative literature in which the epic mode is retained. Breen found Brecht's theories of alienation and distancing of great value in presenting the relationship between narrators and other characters in literature, and he applied Brecht's theories, as well as those of Erwin Piscator, Brecht's principal director, to such areas as acting, directing, and staging.

CONCLUSION

The range of considerations we have grouped under the sociopolitical self in literature and performance are many. It is important to remember that they require thought and commitment and that they allow for experimentation. It is exciting to consider that a sociopolitical approach to the performance of literature has the potential to effect social change— or at least to attempt it—but it is essential to remember that with such potential come ethical and intellectual responsibilities, responsibilities of ideological consistency and the legitimate understanding of the philosophical implications of such performance choices for the texts, performers, and audiences involved in the process. Just as the psychological approach to the performance of literature opens up a rich avenue of insights into the inner life of the self, so a sociopolitical approach can encourage the performer to bring the literary text into immediate, sometimes frustrating, sometimes thrilling, contact with the world of people in groups, people as decision makers. Finally, it may be artificial to conceive of the psychological and sociopolitical dimensions of the self in literature as entirely distinct, any more than we have purely discernible lines between our inner and outer lives. In the next chapter we will consider the intersection of psychological and sociopolitical elements of the self in the arena of what are simultaneously the most basic and most sophisticated realms of human experience: body, race, gender, and sexuality in the discourse of the performance of literature.

WORKS CITED

Aristotle. *The Rhetoric of Aristotle.* Trans. Lane Cooper. New York: Appleton, 1932.

Branagh, Kenneth, dir. *Henry V.* Written by William Shakespeare. With Kenneth Branagh, Paul Scofield, Derek Jacobi, Ian Holm, Emma Thompson, Alec McCowen, Judi Dench, Christian Bale. Samuel Goldwyn Company and Renaissance Films in assoc. with the BBC, 1989

Breen, Robert S. *Chamber Theatre.* Evanston: Caxton, 1986.

Eagleton, Terry. *Marxism and Literary Criticism.* Berkeley: U of California P, 1976.

Lorde, Audre. "Power." *The Black Unicorn.* New York: Norton, 1978. 108–09.

Olivier, Laurence, dir. *Henry V.* Written by William Shakespeare. With Laurence Olivier, Leslie Banks, Robert Newton, Renee Asherson, Leo Genn. A Two Cities and Rank Organisation film, 1944.

Yezierska, Anzia. "Morris Lipkin Writes Poetry." *Bread Givers.* 1925. New York: Persea, 1975. 67–89.

FOR FURTHER READING

Benjamin, Walter. *Illuminations.* New York: Schocken, 1969.

Booth, Wayne C. *The Rhetoric of Fiction.* 2nd ed. Chicago: U of Chicago P, 1983.

Burks, Don M., ed. *Rhetoric, Philosophy, and Literature.* West Lafayette: Purdue UP, 1978.

Corbett, Edward P. J., ed. *Rhetorical Analyses of Literary Works.* New York: Oxford UP, 1969.

Dollimore, Jonathan, and Alan Sinfield, eds. *Political Shakespeare: New Essays in Cultural Materialism.* Ithaca: Cornell UP, 1985.

Drakakis, John, ed. *Alternative Shakespeares.* London: Methuen, 1985.

Jameson, Frederic. *The Political Unconscious: Narrative as a Socially Symbolic Act.* Ithaca: Cornell UP, 1981.

McGann, Jerome J. *Social Values and Poetic Acts: The Historical Judgment of Literary Work.* Cambridge: Harvard UP, 1988.

Williams, Raymond. *Marxism and Literature.* Oxford: Oxford UP, 1977.

CHAPTER **11**

The Body as Text: "Race," Gender, and Sexuality in the Performance of Literature

In a sense, our body is the one consistent fact of our life: from birth to death, we live out our existence in this container, made of flesh, blood, and water. Yet at the same time, our body is also mutable—ever changing, finally disappearing, and ultimately that which fails or betrays us in our journey to sustain life. The paradoxical position of the human body has resulted in much great literature, which both celebrates the pleasures and achievements of the corporeal and interrogates or questions our personal, psychological, and sociopolitical constructions of the body.

This chapter might have been appropriately placed at the beginning of our consideration of the performance of literary texts; as bodies may be seen arguably as a precedent to consciousness, they may also be seen as developmentally more basic than the sense of self. Play itself takes its earliest forms in the sometimes mindless or mindless-seeming responses of the body to the environment. Indeed, it may be in play that we first begin to build a relationship between our bodies and the rest of the world, including our psychological and spiritual selves.

But in contemporary society, the body has become a less uncontested site of experience and reality. As we shall explore in this chapter, categories that earlier in our lives and earlier in history, may have been regarded as givens (color of skin, gender, sexuality, etc.) are now less rigidly regarded and, indeed, have been discussed as far more complex concepts than we might have thought. In many significant ways, the body has become a kind of text, or even a set of texts, that we remake not only as we grow up physically and go through puberty and other physical stages but also as we reflect on and engage in psychological and sociopolitical dimensions of experience. Similarly, as performers of literary texts, we do not approach the fact of our bodies without considerable self-awareness and conscious work. We might indeed criticize some performances as demonstrating a lack of "body work," suggesting that the performer has not

adequately lived through the multiple texts of literature and performer and come to terms with what the sometimes parallel, sometimes contradictory nature of such relationships might mean.

"FALLING INTO LIFE": TEXT AND THE BODY

Before we turn to theories of the body as text (literary and otherwise), let us look at an example of a literary text that takes the awareness of the body as a central theme. Read the essay "Falling into Life" by Leonard Kriegel in the appendix (pages 489–99) and then return to this chapter. As you read Kriegel's essay, think about your own body. Kriegel's essay might be seen as an autobiography of his relationship with his body—a way of telling the story of how his body has shaped who he is and how he has shaped his body and how both can be seen as "written" by history, society, and in this case the work of medicine and physical therapy. If you were to write or perform an autobiography of your body, what shape might such a text take?

Let us look in some detail at Kriegel's essay. The title suggests what Kriegel's experience of his body has been and what he wishes to focus on in this essay: "falling into life." The very word "falling" suggests a physical action, one that is ambiguous in terms of bodily control and volition. We often think of the act of falling as accidental, in which the forces of gravity triumph over the will of the individual, who typically will do everything possible to remain ambulatory and upright.

But are there instances when falling is an act of will, an act of triumph for the body? We speak, metaphorically to be sure, of "falling asleep," but the metaphor serves to dramatize the giving over of consciousness to the usually healing and necessary period of unconsciousness in which we allow other aspects of our bodies to take over. Similarly, have you ever stood at the edge of a swimming pool or lake, dipped your foot in, and felt that the water was too cold, yet you knew you either had to or wanted to get in? There is sometimes an ambiguity in how we eventually negotiate the entry into the water. Some people will leap in, often yelling or screaming, as if to signal that they are taking control of their bodies. Others may feel that something in between diving and falling occurs, that as their body moves through space, in that split second before they hit the water, they no longer have complete control—they cannot reverse the action. This sensation is perhaps a variation of that form of play Caillois classified as *vertigo.*

Kriegel's title, "Falling into Life," suggests his view of falling as both an act of empowerment and as a reality of limitations and inevitabilities. He writes from the vantage point of the older man remembering his childhood battle with polio during the epidemic of 1944. He has now, as an adult, adapted to the ways in which the disease has shaped his body, has forced him to move in different ways than those people not afflicted by polio or some other disabling disease. Yet he carries the memory of his initiation into the world of "falling" with him.

Notice the details with which Kriegel describes his childhood experiences of falling. Although he chooses for the most part to write with some distance, he evokes the world of therapy: "Even today, more than four decades later, I still shiver at the mere thought of those salt tablets." The taste remains with him not only as an idea but also as something stored deep within the body's experience. Similarly, the story he tells of Joey Tomashevski, whose efforts to spoon mashed potatoes for himself and to throw a basket through a hoop, is not simply inspirational (though it is that) but also a way of recalling the literal physicality of the disease and its inextricable impact on the boy's sense of self.

"Falling into life," Kriegel reminds us, "was not a metaphor; it was real, a process learned only through doing, the way a baby learns to crawl, to stand, and then to walk." Kriegel's disavowal of the notion of metaphor here is a complex one, for a number of reasons. First, there is a level at which all recollection is recollection through the metaphors memory creates. As we retrieve experience, even experience that remains with us in the form of the effects of an illness like polio, we filter remembered experience through language, through images that, although they originated in bodily experience, at the same time are no longer the same experience as the original one; language, by its very function as a mediating channel, becomes a carrier of metaphor.

Second, Kriegel clearly is using the catchphrase "falling into life" as a metaphor for something larger than his own experience of recovering from childhood polio, as suggested by the ways in which the essay develops. Kriegel continues to explore the meaning of "falling" by turning to an incident in 1983 when, leaving a restaurant on a rainy, wet New York night, he falls and discovers that he can no longer triumph over the fall by getting up by himself: "My body had decided—*and decided on its own autonomously*—that the moment had come for me to face the question of endings." This moment of physical incapacitation becomes a metaphor for his own confrontation with death, and indeed the remainder of the essay is a meditation on mortality. So, "falling into life" does work metaphorically, through the agencies of language and the imagination's ability to yoke together physical phenomena and metaphysical contemplation.

Yet Kriegel's statement that "Falling into life was not a metaphor" remains an important and, at some level, true statement, if we understand him to mean that "falling into life" was not *only* a metaphor. What he seems to be cautioning us against is too facile an understanding of his own act as essayist; he insists that we not walk away from the essay thinking only of the more universal applications of the title—that we all, in a sense, "fall into life." The amount of time he takes in describing his own therapy and in re-creating the experience of himself as the younger boy who must move from victim to victor over the disease attests to the reality of the body's experience for him, however mediated it is through the language of memory. The body's need to learn to fall—and all of the pain, fear, and exhaustion that that entails—is primary. Without this level of sensory, kinesthetic experience, there is no philosophizing about the body to be done.

PERFORMING "FALLING INTO LIFE"

Consider the impact of this knowledge on your performance of this essay. Although the essay is probably too long for you to perform in its entirety in a class, you might try dividing it into various sections, examining its own body or structure. What gives the essay much of its power is Kriegel's ability to move between his own adult reflection on the process of falling as physical and philosophical phenomena and the immediacy, the "presentness," of his childhood self going through the brutal, difficult initiation into falling. Even if you were to perform only those sections in which Kriegel reflects as an older man on the significance of falling, how would your body be involved and affected by the polio and the therapy of the child? Is it ever entirely banished from the body of the essayist? Remember that, although Kriegel is careful not to describe his own middle-aged body in any great detail, he does provide the occasional detail— such as the crutch—that reminds us that polio has left its mark on and in him forever. Does this mean that as a performer you must adopt any of the outward signs of the polio survivor? To what extent are such signs necessary to represent accurately the bodily position of the text's speaker? To what extent is an emphasis on such physical characteristics in contradiction to the sense of the essayist as a middle-aged speaker? To put it another way, does the content and style of the language create a sense of body that is best communicated through the realism of the man dependent on a crutch?

We believe that different performers will answer these questions in different ways. For some performers, the person Kriegel creates out of his own remembered experience is someone for whom the effects of polio are always visible—always present in a full way—and to downplay them might be to ignore at least one level of reality. For other performers, it might be possible to say that much of the language of the essay is distanced enough emotionally from the childhood experience that what is most important is the mind, unfettered by the difficulties of the body, and that mind moves with grace and strength. We must be very careful in considering how to "embody" this speaker in performance so that we do not fall prey to any of the traps of sentimentalizing or dehumanizing the physically challenged. In an effort not to overemphasize the physical attributes of the polio survivor (in order not to turn the performance of the essay merely into an attempt to imitate the physical), we must also be aware that to omit any physical indication of disability might be as much of a disservice to the experience and message of the essay. Finding the right body in which to perform the essay is a challenge indeed.

BODY AS TEXT: SOME THEORETICAL ISSUES

As we explore the concept of the body as a text or set of texts, we also consider the relationship between the body and the performance of such texts. Contemporary theorists are particularly interested in such areas as the relationship

between language and the body, the construction of images of the body both in individual experience and in society, and the ways in which the performer's body creates a text that may both parallel and contradict the body of the literary text.

A particularly complex starting point is the relationship between language and the body. In oral cultures, as you have learned from part II, the relationship between language and the body is seen as direct and immediate: the body creates language and participates in its performance simultaneously. Even when we conceive of culture as being dominant over the individual body, we may conceive of the collective bodies of the participants in ritual as physically engaged in the performance of language. Thus, from the individuality of the personal narrative to the shamanistic healing of prayer to the revolutionary forcefulness of a demonstration, language and the body are inseparable. Today, even when the primary mode of reading is silent, studies have demonstrated that all reading involves some of the vocal muscles used for oral performance, that there is a physical basis for all acts of reading.

In the last few decades, there has risen another forceful set of thinkers who would argue that language is not by definition physical, not by its very nature bodily present. Rather, they would suggest that language is an abstraction, a system of rules and conventions that may exist without any physical evocation or representation of them. Many of these theorists are known as structuralists or poststructuralists and follow in the footsteps of such figures as Jacques Derrida and Paul de Man. The French word they use for this notion of language is *langue*. They put in a subordinate position any individual utterance and call it *parole* (literally, word). *Parole* exists because of the *langue* that precedes it. In a sense, these theorists are less interested in presence than they are in absence— in what is missing from any one given utterance or performance. As we noted in chapter 8, such thinkers find the notion of a unitary self or speaking subject an impossibility; that language finally cannot refer to anything other than itself. For such thinkers, the relationship between the body and language, although still important and intriguing, is less direct and more complex than one that might see language as arising from and representing any kind of final or ultimate reality about the physical. Just as our bodies are always changing through time, so language changes the ways in which we experience our bodies.

How is any of this discussion relevant to the performance of literary texts? Clearly, the performer, by his or her very actions, must attest to some belief in language as a present, bodied experience; otherwise, it would be impossible to execute a performance with any authenticity. At some level, we must believe in and trust our bodies as carriers of language and meaning. In some sense, to believe otherwise would be to believe that performance is creating an artificial appearance of presence—pretending that language is coherent, that it creates a unified speaker, when it really doesn't. Yet how do we reconcile that requirement with a belief also that there are larger systems of language (*langue*) that are abstract and do indeed account for our individual utterances and performances (*parole*)? Is it possible to perform a literary text from such a position? Is it possible to perform not as a single, unitary subject?

These are questions that are still being asked, and they provide something of a problem for today's student of performance. Many performers feel, even if only from intuitive experience, that language has an essential physical component—that there is a bodily form in which we live and in which we experience language. At the same time, other experiences may tell us that there is an arbitrary nature to language, that it does not necessarily refer in literal or natural ways to *things* (just as we discussed in the section on chance in our chapters on play). Because language is an abstract system, which we experience in our own concrete ways, we are always at odds with a final sense of definition through performance. Some literary theorists have tried to bridge the seeming chasm between the abstract, arbitrary nature of language as system and the felt life of specific utterances by invoking the ancient rhetorical concept of the figure, the transformation of language to resemble something beyond abstraction. Thus, for such theorists, all texts and all characters within texts become *figurations,* allegories or metaphors created through language to express and create experience for readers. One might think of performance in these terms: even in the most realistic performance of a text, because we are always at least one step removed from the character or speaker of a text, we are at some level involved in the figuration of that character. Some texts may figure their characters in more detailed ways than others; so it is with some performers and performances.

In a sense, our speaking subjects, our bodies, are always in a state of change and redefinition, as are the bodies of the texts we perform. On the one hand, such a view of the inability of the human performer ever to achieve a stable and final form or completion with the ever-changing form of language in the literary text may seem depressing or nihilistic, and, indeed, critics of poststructuralism or deconstructionism (as it is also known) make just that claim. Indeed, post-structuralism can be taken to such an extreme that the performer, the reader, or the writer—the individual who cares about language—may feel paralyzed, may feel that language is so chaotic that it is useless even to attempt to utter a coherent text. On the other hand, there are other ways of living with some version of the poststructuralist view of the relationship between language and the body. What it entails is giving up dominance over language, over texts, and even over the self as subject. Many of us may be reluctant to do so, so conditioned are we to place ourselves in control over our choices and destinies. If we see ourselves as driven by forces that include our consciousness—but also the unconscious; the collective nature of society; and even, depending on our religious beliefs, forces beyond the human—then the mutability of language and of literary texts becomes a horizon of possibilities and adventures, some accidental and some disastrous, to be sure, but some enlightening and many exciting. To view language and the body in this way is not to abdicate all responsibility or power but rather to open up the world to a wider range of voices and forces. In a sense, it may be to see the world as a set of texts in dialogue, an idea we will explore in the next chapter.

If we see the possible relationship between language and the body as complex and, from some perspectives, infinite, we can then move on to consider the ways in which the body has become a contested site in society. Various social scientists

have devoted much energy to a consideration of the role of the body in society, both in contemporary and historical terms. Just as is the case with theorists of language, such social scientists no longer view the body as anything remotely like an "innocent" given, a mass of chemicals that simply provides the containers in which we live. Rather, they view the body as a text or set of texts constructed by forces both within and outside of itself.

To put it a simpler way: from the time we are infants to the day we die, we live in bodies that are shaped in certain ways, dictated by ourselves (including individual habits of diet, health, etc.) and by a range of forces that might reasonably be seen as outside ourselves—from the genetic makeup we inherit from our parents to the impact of the media on how we treat and respond to our own bodies. Much of what is controversial in today's society is bound up in the construction of bodies *by* society—from issues surrounding racism to those around abortion and even suicide. Suicide is a crime in our legal system, suggesting the degree to which we live in a society in which the individual's body is not his or her own possession.

A particularly influential theorist of the body as social text is the late French philosopher Michel Foucault, whose work you have been introduced to in part II. Foucault was a thinker whose interests touched on virtually every area of human study and learning. Two areas about which he wrote extensively were criminology (specifically, theories of the penal system and the ways in which we have historically chosen to confine criminals and those considered or treated as criminals, such as the mentally insane or the chronically ill) and the history of sexuality. He spoke of "a 'knowledge' of the body that is not exactly the science of its functioning, and a mastery of its forces that is more than the ability to conquer them" (173). It is this distinction between the typical kind of biological data we associate with the study of the body and the sociopolitical uses to which the body is put throughout history that is of such interest today. Obviously, the biological and the sociopolitical cannot and should not be totally separated for the two are interdependent, as Foucault suggested in the neologism "bio-power."

In his study of both penology and sexuality, Foucault continually returned to a belief that what typically drives society in its choices is a need to exert control over the human body—whether through penal systems or through sexual codes of conduct. Thus, for Foucault, the body becomes a battleground, a place where differing factions in various societies through time have competed for dominance over how the body would be enclosed, treated, rewarded, and pleased. For Foucault, pleasure and punishment are not necessarily worlds apart but rather two views of how to manage the body, particularly the bodies of marginalized groups.

The remainder of this chapter will be devoted to exploring three body issues in literary texts: "race," gender, and sexuality. As we will see, these three categories of body are, like the concept of the body itself, contested sites, classifications no longer accepted by all (or even, we would argue, by the majority) as "natural" or "fixed." What will also be of interest are the connections among these issues—which concerns remain common from one category to the next and which are unique to a specific category. Finally, we will consider the common issues raised for the performer by these three texts of the body.

"RACE" AND THE PERFORMANCE OF LITERATURE

"Race," as the literary scholar Henry Louis Gates, Jr., suggests, "as a meaningful criterion within the biological sciences, has long been recognized to be a fiction" (4). A considerable amount of discourse has been generated to suggest that the physical (often termed morphological) distinctions initially used by anthropologists to describe the various major racial categories break down at the more subtle levels of the chromosomes and other kinds of genetic analysis. Indeed, research suggests that there is a considerably wider range and diversity within so-called "races" than from one to the next. Many would argue that *race* has become even less useful as a biological term today, when the global village no longer supports the maintenance of a relatively narrow gene pool.

For this reason, a number of critical theorists writing on the issue of racism have chosen to place the word "race" itself in quotation marks. This act indicates the contested nature of the term and is emblematic of their own denial of it as a natural or truthful category of human existence. Yet as Houston Baker recounts in the following personal anecdote, the question of race as a category is far from academic:

> An anecdote. Not long ago, my family and I were in a line of traffic moving along Chestnut Street in Philadelphia. On the corner, six or seven cars ahead of us, was a deranged, shabbily clad, fulminating white street person shouting obscenities at passengers and drivers. His vocabulary was the standard repertoire of SOBs and sons and mothers directed at occupants of the cars ahead, but when we came in view (gross features and all), he produced the standard "Goddamned niggers! Niggers! Niggers!" Now, if even a mad white man in the City of Brotherly Love knows that race, defined as gross features, makes all the difference in this world, what is it that Professor Appiah and evolutionary biology have done? What are they *teaching* us? (385)

Baker's point is a simple but strong one: although it is important to know and to affirm science's disavowal of race as a biological category, the historical and sociopolitical and even cultural reality is that race remains a vivid and powerful category. To simply dismiss those people who ignore biological data as ignorant is to miss the issue, and that is how race continues to be constructed as a category in the world today. As long as we live in a racist society, the concept of race will continue to be important; we may envision a world in which this concept has disappeared, but until then, we need to confront its meaning in the texts of those people whose bodies are constructed by society along racial lines.

In America, the issue of race has centered most consistently and devastatingly on the lives of African-Americans, in large part, of course, to their enslavement for economic purposes from the colonial period to the end of the Civil War and their continued economic disadvantage today. In recent years, more attention has been paid to the racism practiced historically and contemporaneously against other groups as well: Native Americans, Hispanic-Americans, and Asian-Americans.

In fact, so potent a concern is racism that the term *people of color* has been coined to provide an umbrella description for all those groups who have experienced oppression because they are not members of the dominant European-American or "white" culture.

Critics and writers concerned with race and racism have focused on a number of aspects: the history of race as a concept, the history of various "races" as represented in literature, and the traditions in experience and literary style found in the texts created by and about these groups. In recent African-American criticism of texts, there has been an interest in recovering lost or undervalued texts borne out of the experience of African-Americans: what has been called opening up the "canon" of accepted literary values. Thus, such critics as Gates and Mary Helen Washington have invested considerable effort in helping to establish and shape a historical tradition of African-American literary texts, sometimes, one might argue (as we have suggested in part II), at the expense of the rich oral traditional material. But the benefits of articulating the African-American literary tradition have been enormous because it has given readers new perspectives on the history of literature and added to the body of texts available. In a sense, working to open up the canon has helped us to understand how African-American writers have textualized their own bodies; and looking, as a number of critics have, at such texts in contrast to white, European versions of the "black body" has been instructive in demonstrating to what degree the body is constructed socially.

A second and in some ways more difficult and controversial task taken up by some critics has been not simply an attempt to conceptualize a tradition of African-American texts but also to invent or discover alternative ways of understanding them; in other words, to develop what might be called an African-American poetics. As Gates and others have suggested, the goal is not necessarily to celebrate African-American texts so that they may be read in the same way as European-American texts—that is, to somehow "prove" that they are the same and just as "good." Rather, such critics are attempting to discern what is special and unique about African-American texts and what tools, methods, and criteria are needed to read (and perform) these texts on their own terms. Gates has developed a theory of "signifyin(g)," based on the oral tradition of the signifying monkey, a tradition that involves irony, play, and double-voicedness—the characteristics of the trickster. To understand the crossover from oral to literary traditions, Gates and others have extended their consideration of an African-American poetics to such figures as Phillis Wheatley, for example, the eighteenth-century poet, originally brought over as a slave, who produced poetry in such neoclassical traditions as those of Pope and Milton. Gates has isolated the concept of the "talking book" as a transitional device in the African-American writer's shift from a purely oral tradition to the Western history of written literature.

Where some critics of African-American texts have felt the need to tread with special care has been in the very act of contemplating a specific African-American poetics, the notion that there might need to be alternative ways of reading and understanding texts that come out of that tradition. The danger, as some critics see it, is falling into yet another racialist argument: that there *is* a separate,

biological category that accounts for the differences between African-American texts and other kinds of texts. This biologism is typically countered by an appeal to culture and history, to the position that different traditions have evolved because of the geographical ties and historically shared experiences of people rather than biological unity.

We have already considered the issue of race as a sociopolitical factor in our discussion in chapter 10 of Audre Lorde's poem "Power." The explicit political agenda of the poem concerns both race and gender, but racism particularly is one of the topics raised. Remember to what degree the poem spoke of bodies: the body of the young black man killed by the white policeman, the body of the one black woman juror, and the imagined raped body of the elderly white woman in Lorde's nightmare fantasy at the conclusion of the poem. We have purposely shifted to the terms *black* and *white* here, as they are the bipolar, divisive terms Lorde invokes with anger and bitterness in her exhortation against racism.

Ralph Ellison's *Invisible Man*: A "Battle Royal" of Black and White Discourses

Let us look at another text in which the African-American body is represented and in which African-American traditions are invoked. Ralph Ellison's 1952 novel, *Invisible Man,* has been judged by some critics as the finest African-American novel of the century and even by some as the greatest American novel of the post-World War II generation. Ellison's novel comes out of a number of different literary traditions: Fyodor Dostoevsky's *Notes from the Underground* and Edgar Allan Poe's tales of the supernatural are only two of the European and European-American texts overtly alluded to. The title itself "signifies," to use Gates's term, H. G. Wells's science fiction novel about the mad scientist who made his own body disappear. The African-American textual traditions Ellison invokes include music, particularly jazz and blues; black Christian preaching and testifying; and the subversiveness of the slave mentality.

Ellison's Invisible Man never gives his name, suggesting both his diminished sense of self and his anonymity as a "text." He begins the prologue by saying,

> I am an invisible man. No, I am not a spook like those who haunted Edgar Allan Poe; nor am I one of your Hollywood-movie ectoplasms. I am a man of substance, of flesh and bone, fiber and liquids—and I might even be said to possess a mind. I am invisible, understand, simply because people refuse to see me. Like the bodiless heads you see sometimes in circus sideshows, it is as though I have been surrounded by mirrors of hard, distorting glass. When they approach me they see only my surroundings, themselves, or figments of their imagination—indeed, everything and anything except me. (3)

Notice the important distinction the narrator makes between the personal "body" and the socially constructed "body." And he concludes the novel by invoking his disembodied state once more, though this time with a warning to all of us,

many of whom may feel safe and secure in our own bodies and selves: "Being invisible and without substance, a disembodied voice, as it were, what else could I do? What else but try to tell you what was really happening when your eyes were looking through? And it is this which frightens me: Who knows but that, on the lower frequencies, I speak for you?" (581). The narrator suggests that his tale, for all its individual specificity, is a tale of all of us, that his invisibility is like our own—we may all be an "invisible man" to some part of society.

Yet for all its appeal to the universal, signaled by the title and by the narrator's final exhortation to all of the readers, *Invisible Man* is also a novel that falls quite clearly in a tradition of texts that take the experience of the African-American and the punishment of the African-American body as its central theme. The novel moves episodically, as the initially optimistic and dutiful protagonist bit by bit moves farther and farther underground, metaphorically and literally, as he is tormented by the demons of racism. The excerpt we have given you to read in the appendix (pages 499–509) is the first chapter of the novel. Read it, and then return to our discussion of it here.

This episode is the first of many experiences the narrator of *Invisible Man* will have that will lead to his descent underground. He locates the moment in time with the opening sentence: "It goes a long way back, some twenty years." He accounts for his life not through some extraordinary set of events—he refuses to call himself a "freak" (a word itself imbued with bodily associations and images)—but rather sees himself as the product of 85 years of slavery.

In particular, he feels a curious yet deep bond with his grandfather, whose dying words provide him with the contradiction of being black in the middle of the twentieth century. The grandfather uses the language of war, of bodies in opposition and confrontation, to describe the life of the black person. He directs his grandson to "Live with your head in the lion's mouth. I want you to overcome 'em with yeses, undermine 'em with grins, agree 'em to death and destruction, let 'em swoller you till they vomit or bust wide open." This is angry, painful language, filled with images of the body as a resistant, subversive agent. He is telling his grandson to act out a series of contradictions—pretending to obey and oblige with his gestures and body language but using these stereotypical signs of black servitude to undo his oppressors.

This final command from his grandfather sets up a theme of tension that is carried through the chapter and through much of the novel: the ability of the black person to use the discourse of the dominant white class to undermine it. As the narrator describes his education, he is constantly reminded of and troubled by his grandfather's words and the ways in which he cannot reconcile the whole concept of "treachery" in his actions; for every achievement he accomplishes, which at some level pleases the white man, the narrator knows that his progress stands in the way of the racist as well.

This dilemma comes to a head in the sequence that contains the action of the chapter: the "battle royal." The narrator has just graduated from high school, where he presented a speech in which he showed that "humility was the secret, indeed, the very essence of progress." As a result of the success of the speech, he has been invited to present it again at a smoker (a men-only

gathering) at a local hotel. Needless to say, the audience is to consist exclusively of prominent white men. It is to be the ultimate test of the young man's ability to enter into the discourse of white men.

The battle he faces, however, is a much more sadistic one, though tied in deeply painful ways to the battle of discourses: it is a boxing match between the narrator and a number of other young black men. The narrator resists participation in such an activity because he feels it "might detract from the dignity" of his speech; he wishes to define himself in terms of his words, not in terms of the white men's stereotype of his physical self. He admits that he "felt superior to them [the other black men] in my way," an indication that he is already buying into the lesson that the black man who is successful at the white man's language is a better man than his fellows. Nonetheless, he is literally swept into the battle, perhaps realizing that a refusal to participate will also result in not being allowed to present his speech; that is, unless he fulfills the white men's stereotyped construction of his body, he will be barred from proving himself better than the animal they presume him to be: a double bind.

The narration of the battle royal is thick and dense with descriptions of physical sensations and responses. It begins with the strange, pornographic presence of the "magnificent blonde." One of the most insidious stereotypes of black men is that of the buck, the oversexed man who wants nothing more out of life than to rape white women—and the blonde is a particularly polarized opposite to the black man in this arena. She, too, is a socially constructed contradiction, the blondness standing somehow for purity, yet her actions as an erotic dancer or stripper suggesting that she has a sexual dimension as well. She is there not as a woman bent on free and mutual seduction but instead as yet another body to be used by the white men. In this case, her function is to arouse the young black men, to cause them embarrassment (there is something excruciatingly painful in Ellison's description of one young man's erection, which he is unable to hide). One wonders at the exact logic behind the presence of the woman. Is she a leftover from the lurid pleasures of the white men's portion of the smoker, held over as sport? Is the purpose of using her to arouse the black men simply to cause them embarrassment, or is it also to "get them going," to excite them into a better fight? Whatever the explanation, despite her beauty (and the narrator admits to enormously ambiguous feelings about her), her presence is mechanical and ugly.

The actual battle is a journey into hell, in which the young men are blindfolded and required to fight until they have eliminated one another. Imagine the fear and disorientation such a thing would cause. In a sense, it makes all the black men invisible to one another, nothing but shapeless forms, perceptible only through fists and blows. In addition, the cacophony of jeers and catcalls proves even more disconcerting for the narrator; he becomes aware of one of the white men calling for his blood in particular, referring to him as "ginger-colored," thus reducing him to a color.

Nonetheless, the young men, all of whom but the narrator have participated in this battle before, have worked out a ritual by which they determine who will win and lose, thus subverting the white men. The narrator refuses to play along

with this ruse initially and, in his hubris, even suggests to his final opponent, the largest and most powerful of the men, that he throw the fight, in return for which the narrator will give him the prize money. This is how important it is, at this point, to the narrator to position himself as superior to the young black men, who have been depicted as animals by the white men. He almost manages to knock out the larger man, but he hears a voice yell that he has placed his money on his opponent. At this moment, the narrator experiences what we might call a confusion of discourses: his speech calls for humility as the key to success for the black man, yet he is on the verge of upsetting the desires and expectations of the white men in the room. He surrenders and passes out.

What follows seems even more unbelievably sadistic and inhuman. The black men are rewarded for their efforts by the opportunity to scramble for coins and a few bills on a carpet. What the narrator does not know is that the carpet has been electrified, and the shock will be even more severe for the men who have worked up a sweat. Nonetheless, he steels himself to contain the electricity and grabs as much money as possible. The pain must be severe, but he is learning, even in the brief time of this evening, how to endure and accept such pain in order to gain approval and rewards from the dominant culture.

He is then, almost as an afterthought, permitted to present his speech. The scene is intensely dramatic, as Ellison describes the narrator desperately trying to get through the words he has so carefully and proudly crafted in the midst of jeers and slurs. His speech is nothing but the final round of the battle royal, a chance for the white men to use the black body and, this time, the black mind for their own pleasure. When he comes to the phrase "social responsibility," the men call for him to repeat it, ostensibly because it is too long for most of them to understand. In the confusion of the situation and because of the damage done to his body, he accidentally replaces "social responsibility" with "social equality" and comes close to being harmed once more. He quickly assures them that he meant to say "responsibility." Is the substitution of "equality" a slip of the tongue, the unconscious expressing its real feelings? Is it also an act of signifying, in which the narrator is able to express himself yet trick the oppressor into thinking that he meant something else?

Finally, the narrator receives his reward: a calfskin briefcase and a scholarship to the state college for Negroes. He has had to suffer an almost unbelievably obscene initiation in order to be given entrance into the world of higher education, a world he no doubt believes will give him the knowledge he needs to speak the language of success. He does not even register anger or disbelief when he discovers that the gold pieces for which he scrambled were nothing but worthless tokens, advertisements for an automobile.

Yet he is haunted in his dreams that night by the specter of his grandfather. In a mock imitation of the night's events, he and his grandfather are at a circus and he opens envelope after envelope, finally finding a cruel parody of the embossed scholarship, with the words "Keep This Nigger Boy Running" in gold. At some level, however proud and excited he is about the prospect of being able to go to college, he is also aware that the white men who have made it possible have done so only because they have been able to continue to construct him as

nothing more than their own projections onto his skin. They see him as no more than an animal, however educated he may become, always to be kept moving, always to be reminded that he has no safety as long as he aspires to something they would keep from him.

As a class, you might want to discuss this excerpt in greater depth, looking particularly at the language used to describe the bodies and physical actions. To what extent does the narrator, at this point, engage in stereotyping, either of the white men or of the other black men? The episode seems to suggest that the narrator's ideals present literacy as a key to equality, that by proving himself able to engage in reasoned discourse he can prove himself to be ''as good'' as any of the white men in the room. What do you think about this? Is there something elitist in this view of what makes a person human or what makes a person of value? Does the narrator's language change at all stylistically as the excerpt progresses—is he drawn into a different kind of discourse as he enters into the world of the battle of bodies?

The battle royal segment of *Invisible Man* is one of the most powerful openings in the history of the novel. The rest of the novel is equally harrowing and equally concerned with the ways in which the black body is constructed and used by racist society. We encourage you to read the entire novel and to explore some of its passages in performances. It remains as powerful today as when it was first published more than 40 years ago.

GENDER AND FEMINISM: WRITING AND PERFORMING THE FEMALE BODY

If the concept of race is fraught with controversy, it is probably fair to see the cluster of terms and concepts surrounding sex, gender, and sexuality as equally if not more concerned with issues of value, definition, and belief. Even though the notion of race as a biological category is, as we said, almost universally discounted, scientists, critics, and philosophers still debate the differences between the sexes and the significance given to such differences.

Because of the continued debate, theorists have found it useful to devise a number of different terms to distinguish the areas being argued about: *sex, gender,* and *sexuality.* Though they are sometimes used interchangeably, the three terms do carry very different connotations and assumptions about the relationship between the physical body and the social body. Here are brief definitions for each:

1. *Sex:* refers to the biological characteristics distinctive of women and men—female and male.
2. *Gender:* refers to the socially and culturally constructed characteristics of women and men and, typically, to the values assigned to these characteristics—feminine and masculine.
3. *Sexuality:* refers to the erotic feelings and attractions felt by individuals toward other individuals—heterosexual, homosexual (lesbian in the case of women), bisexual, gay, and straight.

Before we go any further in our discussion of these terms and their issues, stop and consider your own use of them and what it suggests about your own beliefs. To what degree do you use the terms *male/female* and *masculine/ feminine* synonymously? If you do use them synonymously, how do you account for their interchangeability for you? Is it based on strongly held convictions about what it means to be a man or a woman? Is it based on biology as a determinant of identity (Freud's dictum that "anatomy is destiny"), or is it based on the teaching of a religion or culture?

You might also consider the terms surrounding sexuality. How rigid are these categories for you? What connotations do they carry? Are particular images evoked by each of the terms? Specifically, consider whether you react differently to the more "scientific" terms like *homosexual* and *heterosexual* than to the more socially based terms *gay* and *straight*. Again, what accounts for the associations you make with each set of terms?

Obviously, just as race became a contested category because of disagreements over whether there were fundamental, definitional differences between groups of people based on biology, so it is with the terms and concepts surrounding *sex, gender,* and *sexuality.* In a parallel fashion to the history of racism, the valuations made and discriminations practiced because of sex differences and the social values and constructions based (sometimes erroneously, many would argue) on such differences have led to sexism and homophobia. Although theoretically sexism can be practiced against either sex, typically, in most Western cultures, it has devalued women and what has been constructed as feminine. Such devaluation of the feminine also leads to another form of discrimination, homophobia, discrimination against homosexual men and women.

"Diving into the Wreck": The Gendered Body

Let us look at a poem that takes on the issues of the body as sexual and gendered text as a central motif in the quest for identity. It is Adrienne Rich's "Diving into the Wreck":

First having read the book of myths,
and loaded the camera,
and checked the edge of the knife-blade,
I put on
the body-armor of black rubber
the absurd flippers
the grave and awkward mask.
I am having to do this
not like Cousteau with his
assiduous team
aboard the sun-flooded schooner
but here alone.

There is a ladder.
The ladder is always there
hanging innocently

close to the side of the schooner.
We know what it is for,
we who have used it.
Otherwise
it's a piece of maritime floss
some sundry equipment.

I go down.
Rung after rung and still
the oxygen immerses me
the blue light
the clear atoms
of our human air.
I go down.
My flippers cripple me,
I crawl like an insect down the ladder
and there is no one
to tell me when the ocean
will begin.

First the air is blue and then
it is bluer and then green and then
black I am blacking out and yet
my mask is powerful
it pumps my blood with power
the sea is another story
the sea is not a question of power
I have to learn alone
to turn my body without force
in the deep element.

And now: it is easy to forget
what I came for
among so many who have always
lived here
swaying their crenellated fans
between the reefs
and besides
you breathe differently down here.

I came to explore the wreck.
The words are purposes.
The words are maps.
I came to see the damage that was done
and the treasures that prevail.
I stroke the beam of my lamp
slowly along the flank
of something more permanent
than fish or weed

the thing I came for:
the wreck and not the story of the wreck
the thing itself and not the myth
the drowned face always staring
toward the sun
the evidence of damage
worn by salt and sway into this threadbare beauty
the ribs of the disaster
curving their assertion
among the tentative haunters.

This is the place.
And I am here, the mermaid whose dark hair
screams black, the merman in his armored body
We circle silently
about the wreck
we dive into the hold.
I am she: I am he

whose drowned face sleeps with open eyes
whose breasts still bear the stress
whose silver, copper, vermeil cargo lies
obscurely inside barrels
half-wedged and left to rot
we are the half-destroyed instruments
that once held to a course
the water-eaten log
the fouled compass

We are, I am, you are
by cowardice or courage
the one who find our way
back to this scene
carrying a knife, a camera
a book of myths
in which
our names do not appear.

A number of people in your class might try performing this poem, looking
at it from a number of perspectives and emphasizing various aspects. What is the
literal level of the poem's body? That is, the kind of physical action it is describing
is a dive into the sea to explore a wrecked ship. One performance might emphasize
the literal sensual experience—what it would feel like to put on the diving suit
and what the movement would be to submerge oneself away from the world of
air and earth into the unfamiliar, darker world of water. You might look at the
ways in which Rich uses language and form to express the changes the body goes
through as it moves deeper and deeper, the ways in which the performer "breathes
differently down here." The poem asks the performer to adopt a different way

of experiencing body and geography—a different sense of weight, of pressure, and of light—in other words, a reorientation of the body's basic ways of knowing.

Any performance that wants to express the poem's body will need to confront the physical descriptions and acts contained within it, though not necessarily in a literal way. We would not say that the only valid and authentic performances are those in which the performer acts out each gesture named; but a performance that did not live in the body in a felt way would, we believe, be missing the life of the poem.

However, we would also argue that a performance that dealt with the body only in connection with Rich's physical descriptions would also lack what is central to the poem and central to the poem's figuring of the body: the relationship between gender and the adventure of "diving into the wreck." Rich has skillfully woven images taken from diving and from seascapes together with a level of metaphor and symbolism that evokes the quest for and questioning of sex and gender. For example, the opening image of the speaker preparing for the dive shows the speaker "having read the book of myths,/and loaded the camera,/and checked the edge of the knife-blade." Of these three images, only the first seems even potentially out of place: the camera and the knife are appropriate instruments for any dive. Yet they also stand for the speaker's lifelong experience of living a body gendered by society. The book of myths is surely the traditions, the tales centuries of people have been raised on about sex and gender; the camera is a tool for documenting surfaces, for proving who we are by what we look like; and the knife is a weapon as well as an instrument, something to cut open other things (the knife often carries phallic associations as well). Thus, the speaker has readied herself or himself for the trip underneath.

The speaker puts on the "body-armor of black rubber." Again, this is a literal image from the world of skin diving, but it also suggests the need to put on protection when making such a perilous journey. It may also foreshadow the *androgyny* (i.e., having both feminine and masculine qualities) of the speaker, made overt later in the poem. Notice that the speaker contrasts herself or himself to "Cousteau with his/assiduous team"; the journey the speaker makes, although funded by the lives and experiences of countless women and men, is nonetheless a solitary journey, the quest of the individual, of the poet to learn about the self as feminine and masculine being.

As the speaker makes her or his descent, the language becomes both more concrete and more mystical: the changes in color, light, and atmosphere both clarify the meaning of the journey and take the speaker beyond the mundane, beyond the everyday world of objects and their associations. There is a paradoxical giving over of the body as the diver descends—paradoxical because the diver is less in her or his accustomed element but also because the giving over of power serves to empower the diver in a new way:

> the sea is another story
> the sea is not a question of power
> I have to learn alone
> to turn my body without force
> in the deep element.

The speaker finally reaches the ship and with it the object of the dive: "the wreck and not the story of the wreck/the thing itself and not the myth." What do these lines mean? What distinction is Rich drawing in this pair of images? Is she suggesting that society has so powerfully constructed the body and gender identities associated with it that we need to take such a dive to get back to an authentic experience of the body as the text of the self? How can we ever get back to something experienced "purely," or without any expectations, assumptions, or prejudices? Is such a quest possible? Perhaps Rich's choice of the "wreck" as the central image of the body is itself a critique of the effects of sexism on society.

Yet there is also something triumphant and celebratory about the diver's accomplishment. The poem reaches a climax when the speaker declares, "This is the place," as if she or he has finally reached a knowledge of body as a text of the self. The speaker describes herself or himself in openly androgynous terms (which accounts for our decision to refer to the speaker through the multiple phrase *she and he* and so forth): the mermaid and the merman. The speaker has gotten beyond gender, beyond sex, to some more powerful and transcendent experience of the self. This does not mean that the speaker has transcended the body—not at all, for there is an honoring of the body as a carrier of knowledge and joy, even as it is also the "half-destroyed instrument." But the speaker has been able to dive deep enough to find what is truer than social rules and descriptions of what is masculine and feminine. As the final image suggests, whether "by cowardice or courage," the poet, the speaker, and the readers of the poem make their journey back again to the surface, carrying the self-same knife and camera, but with a change: the book of myths is now one "in which/our names do not appear." It is as if the dive has erased sexism from the consciousness of those who have the courage to make such a journey.

Performing "Diving into the Wreck"

We have seen "Diving into the Wreck" performed in a number of different ways, and one of the most interesting, if obvious, variables in the performances has been the effect of sex and gender on the performance. We include both sex and gender because in some instances, it was the body fact of the performer being either a woman or a man that shaded the performance; in other cases, it was gender with the performer's own sense of gender and the audience's response to gender, that added dimension and complexity to the poem. For example, consider the question of identity as you read the poem the first time. Having noticed that the poet was a woman, you might have automatically assumed that the speaker was also a woman (that the poem is being analyzed in a section on sex and gender might also have entered into your assumption). Yet the poet does not identify the speaker as either a woman or a man. The most Rich does overtly is to have the speaker refer to herself as mermaid and then merman, she and then he: given the patriarchal orientation we are accustomed to following, the almost minute primacy of the female might carry more connotative weight than it ought to. The poem aspires to an androgyny of the body and of the self in that body, and any performance of it will have to reckon with this feature. What might an

androgynous performance of the poem look and sound like? How might it differ from a more traditionally gendered performance? These are difficult questions to grapple with, so firmly constructed are our definitions of gender.

At the same time that we acknowledge the poem's use of androgyny, it is also important to bear in mind that the poem is a woman's text, typically placed in the growing canon of feminist literature: most critics would argue that the fact that the author is a woman is not incidental or unimportant but part of any informed reading of the poem. Adrienne Rich is one of a growing number of writers, artists, and critics who call themselves and are called feminists. The word *feminism* carries many different meanings for various audiences, but what is common to all is a belief that women's experiences are valuable and deserve more consideration than they have been given. This is perhaps the most general definition possible because the term is used in considerably different ways by different people, both those who embrace feminism and those who reject it. Feminism, we need to add, is not restricted only to women: there is a growing interest in the role of men in feminism and also in criticism with a feminist consciousness by men. This latter form of "male feminism" is not practiced exclusively on texts sympathetic to feminist ideologies; indeed, some of the more interesting criticism takes texts by such "masculinist" (many would say sexist) writers as Hemingway and others. The role of men in feminism remains controversial, both for women and for men. Some women believe that the presence of men in the feminist movement may dilute it and may result in women's voices being diminished once again; similarly, some men feel that the term *feminist* is itself sexist—that the term *antisexism* is more inclusive and works for broader goals.

FEMININE, FEMINIST, FEMALE—THREE STAGES OF WOMEN'S LITERARY HISTORY

Feminism remains the most pervasive word to describe the critical perspective that questions the status quo of gender in history and in contemporary life, and it is the one we will maintain. Although the terms *feminism* and *feminist* have been around since the last century, feminist literary theory and criticism have grown enormously in the last three decades, paralleling similar movements in civil rights that began in the 1960s and that continue to the present day. Elaine Showalter divides women's literary history into three stages; try not to be confused by her specialized use of *feminism* as one of the categories:

1. Feminine: 1840–80
 frequent use of male pseudonyms
 internalized assumptions about female nature, derived from male culture
2. Feminist: 1880–1920
 literature written for sociopolitical ends
 growth of female utopian novel
 period ended with the winning of the vote

3. Female: 1920–present
 female experience becomes the source of autonomous art (no longer
 having to fit "male standards" or a specific political agenda

Although Showalter's division of history is certainly arguable and her criteria
for dividing *feminist* from *female* may suggest that women writers no longer have
a sociopolitical agenda, her classification is useful in helping us to understand
how the social construction of gender has changed and how influential it was
and is on the writing of literary texts by women. It is interesting that she saves
the most biological term for what would seem to be the most advanced and
progressive period (the most recent), but this use suggests that for her the
movement is toward a time when women's experiences (including those unique
to women, such as childbearing) will be worthy of autonomous attention and
not as an adjunct to the more "primary" experiences of men; that is, men's lives
and art will no longer be the standard or norm from which women's art will
always be the specialized deviation. Thus, *female* ultimately becomes a higher
term for Showalter because it acknowledges sex differences (and the potential
experiential differences that result) without necessarily accepting what may be
seen as limiting and stereotypical constructions of femininity and womanhood.
Some critics even balk at this stage, arguing that other than motherhood,
menstruation, and a few other anatomically determined experiences, there is little
that can be termed "female" even from a biological standpoint. Think about this.
Can you come up with other experiences uniquely "female" (as opposed to
uniquely "feminine")?

In addition to charting the three periods of women's literary history,
Showalter has also classified feminist critical theory into two (and possibly three)
major divisions: Anglo-American and French. She initially draws the divisions
along nationalistic lines based on the kinds of feminism that developed in each
of the countries. Anglo-American (i.e., developed in the United Kingdom and
United States), Showalter suggests, has tended to emphasize institutionalized issues
of women and their literary production; that is, issues of ideology. In the United
States, she argues, literary feminism has been concerned more with the
reclamation of obscured or devalued women's texts (similar to the agenda of much
African-American criticism), with the analysis of women's experiences as
expressed in the texts they have written (and in some cases, the ways in which
men have represented women and their experiences), and with the expansion
of women's texts in the canon (i.e., the accepted and promoted set of texts
considered important at any one moment in the study of literature). Thus,
American literary feminism, in general, has been tied to its practice in colleges
and universities.

British literary feminism has taken a far more programmatic and overtly
Marxist agenda. Much of its criticism has tended to emphasize the economic
oppression of women as represented in literary texts and has argued for social
changes that will redress the imbalance. As Showalter notes, British literary
feminism is often tied quite closely to more mainstream Marxist criticism (though
sometimes in problematic relationship, as many feminists find Marxism itself

sexist), with its concern for issues of class. Whereas in the United States, literary feminism has been predominantly "women's work," this has been less the case in Great Britain, in large part, Showalter suggests, because the socialist base of some aspects of Great Britain has made varieties of Marxism more comfortable and familiar to both women and men.

Although there are quite obviously important differences between American and British literary feminism (though the two versions often cross over, thanks to the common language in which both factions work), the social and political nature of literary feminism practiced in both countries is similar enough for Showalter to group them together under the descriptive heading "ideological criticism."

The second major movement in literary feminism is that practiced in France and by followers of French critics and philosophers. In many respects, this school (if, indeed it can be called a school) of criticism is antithetical to Anglo-American literary feminism. Much French literary feminism takes as its starting point an interest in and even belief in essential differences between men and women, based not simply on certain biological terms but also on the level of capacity for kinds of experience and perceptions. Whereas Anglo-American literary feminists tend to view women's experiences as socially constructed, French literary feminists tend to see these experiences as biologically determined and look to the development of a feminine psychology based on biological differences. Hence, Showalter calls this form of feminism "biological criticism." Much of it is based on the works of male psychologists and philosophers (such as Freud and post-Freudian thinkers like Jacques Lacan, the most influential of the psychologists of the feminine). Although it is hardly lacking in political significance (as the writings of such diverse French feminists as Julia Kristeva, Luce Irigaray, Hélène Cixous, and Catherine Clément demonstrate), the emphasis is more on psychology, particularly that which is repressed by society in the unconscious, as the key to understanding what it means to be a woman. Similarly, ideological criticism, while it may emphasize the political implications of social and economic history, is also interested in how these external conditions affect the interior life of the individual.

In its most radical version, French literary feminism has created an enormous split, some opponents going so far as to call it "antifeminism," suggesting that it works against a view of the sexes as equal and capable of the same sets of experiences and accomplishments. For example, some French feminists tend to emphasize such biologically unique experiences as motherhood and the menstrual cycle in analyzing and describing women's discourse; to its critics, such an emphasis and the causal link drawn between bodily functions and discursive style are dangerous, potentially leading to the kinds of attitudes that argue that women should not have access to public office or military service because of their "emotionally charged hormones."

Where do you stand on such issues? This question takes us back to the distinction drawn between sex and gender raised earlier in the section. Anglo-American feminists tend to point to social, economic, and cultural history, particularly the history of patriarchy (the dominance of men over women) to explain how women have internalized certain traits and behaviors as "feminine."

French feminists might argue that biological aspects of being a woman are translated into gendered behaviors, attitudes, and beliefs. Is there any kind of middle ground between the most extreme versions of each of these movements? Is it possible to argue that because of economic history in the West, women's biological role as mother has been emphasized, sometimes to the exclusion of all other capabilities, thus giving the fact of motherhood (which, of course, is scarcely a fact to all women, any more than fatherhood is a fact to all men) its position in the historical and contemporary experiences of women without making it the singular and necessary experience available to women. Similarly, it might be possible to argue that because women have been defined by the dominant culture as "the other," that which is different, their biological sex differences, like "racial" differences among nonwhite people, have been given a distorted place as an explanation for the experience and style of women, both in literature and in life.

This debate continues to be a lively one and certainly does not seem to show any signs of concluding. It is important to note that there is also evidence of more and more communication among the various schools of feminism, both in attempts to find ways of combining what is useful and provocative and to point out intellectual flaws and inconsistencies in one another's arguments.

The Yellow Wallpaper: An Example

Let us consider the implications of each version of feminism for the analysis and performance of literary texts. To that end, let us look at a single text by a woman from each of the three perspectives and then consider how each perspective might yield different approaches in performance. The text we will examine is Charlotte Perkins Gilman's 1892 story, *The Yellow Wallpaper,* printed in the appendix (pages 509–21). Read it and then return to our discussion of it.

We will begin with a consideration of ideological aspects. Let us start by situating the story historically. It was written in 1892 and thus, by Showalter's divisions, is a product of the feminist period in women's literary history. To what degree does the story advance a sociopolitical agenda, particularly an agenda furthering the cause of women? It is possible to see the story as a representation of how medicine, as part of the social system, warped and demoted women's experience, even trivialized it: it can be no accident that both John, the narrator's husband, and her brother are doctors.

Gilman wrote the story in response to her own nervous breakdown after the birth of her daughter Katharine; the illness from which the nameless narrator (like the Invisible Man of Ellison's text) suffers would probably today be called postpartum depression, not terribly uncommon; in its own day, it was probably seen as neurasthenia, or "American nervousness," as its historian Tom Lutz names it (230–31). Indeed, Gilman even refers specifically to the controversial doctor Weir Mitchell, whose "cures" for neurasthenia were popularized during this period. The common treatment for such an illness, particularly among women, was the "rest cure," in which the patient was permitted to do little or nothing at all—the idea being that too much activity would excite the nerves. As women

were seen as even more emotional and nervous even when in a "normal" state, they were restricted even further. Also, because it was men who were inventing and prescribing treatment, there could be no first-hand knowledge of what the postpartum experience was like.

Gilman uses the immediacy of the first-person narrator to create an authentic sense of the descent into madness. The deterioration of the narrator's psyche is presented strictly from within her own consciousness; though we get glimpses of how other people regard her, they are still always presented through the filter of the narrator's own perspective. Yet despite the ultimate madness into which the narrator falls, we see her at the beginning of the story as someone who is not an "other" but is intelligent and aware of her surroundings. As Lynn Sharon Schwartz suggests, she is even clever enough to discern that her husband and family may indeed be part of the problem: "John is a physician, and *perhaps*—(I would not say it to a living soul, of course, but this is dead paper and a great relief to my mind)—*perhaps* that is one reason I do not get well faster" (xv). She is oppressed by those who would see her get better because they have constructed her body medically and psychologically in particularly restrictive ways. There is no question that the narrator is ill, even from the start, but the cure seems counter to her own experience of her needs and desires.

Gilman also suggests that women are involved in their oppression. The narrator herself, though she has glimmers of the evils of the treatment/punishment her husband is forcing on her, nonetheless spends considerable time berating herself for not being sufficiently grateful to him; she has learned to distrust her own body and to put ultimate faith in the medical system that has no first-hand knowledge of it (particularly in that specific historical period). Similarly, John's sister, Jennie (the names are almost phantoms of each other), is a dutiful nurse, "a perfect and enthusiastic housekeeper, and hopes for no better profession." Jennie's main contribution is to note the physical effects of the yellow wallpaper on the clothes of the narrator and her husband, a suggestion that she, too, can participate only at a distance from the narrator's interior experience of depression and frustration. What a mark of the narrator's alienation that the "woman" to whom she is closest is the figure she invents in the design of the yellow wallpaper itself—the woman she "becomes" by the end of the story.

Yet another interesting dimension to the ideology of the story is its emphasis on writing as an alternative cure to the one prescribed by the male doctors. As we suggested earlier, the rest cure usually involved an extraordinary restriction of activity. Yet in the text, the narrator, time and time again, declares how much of a "relief" the writing is to her, though it is clearly considered a subversive activity: for a woman to express herself in writing is a way of allowing herself to validate her experiences and emotions. To deprive her of this work is in some ways to deprive her of what seems to be the most natural form of psychic (and in this case, biological) healing.

Indeed, her final descent into madness may be seen at least in part as a desperate attempt to "write" herself into a new text. Pulling off the wallpaper carries with it some associations, however indirect and fragmented, of her connectedness with paper, with the tablet on which to inscribe herself. Though

she has been driven to such a schizophrenic level that she can no longer distinguish herself from the woman she has created behind the paper, there is, even in her final narration of the fainting of her husband, a kind of gleeful triumph—that even in her madness, she as writer has triumphed over the medical discourse of the oppressive, if well-meaning, husband.

Obviously, *The Yellow Wallpaper* is a text that writes about the body of the woman and thus has much to offer the biologically centered feminist critic. The ideological critic would probably suggest that the pervading impact of a patriarchal construction of the female body leads to the final madness of the narrator. The biological critic might be more interested in looking at the text as an example of what the French call *l'écriture féminine,* roughly translated as "feminine writing" or "putting the female into discourse." Theorists of *l'écriture féminine* suggest that women have a particular and distinctive way of using language, based on their bodies and on the experiences of those bodies. For example, a number of these critics point to the multiorgasmic nature of women's sexuality as the basis for a less linear, more diffuse, and more playful form of language (*jouissance* is the term they use for such play); Luce Irigaray goes so far as to see in women's anatomy the basis for a different kind of discourse: the presence of two sets of labia (lips) marks the woman as having a different set of linguistic potentials.

How would the biologically centered feminist critic view *The Yellow Wallpaper*? To begin with, such a critic might find a meeting ground with the ideological critic's concern with the importance of *writing* in the experience of the narrator. A number of French feminist critics follow a larger deconstructive move to replace speech with writing as the primary, superior form of language. Writing, then, becomes the "natural" way for the narrator to heal herself; the frustration of the act of writing by her husband would be seen as a way of disrupting the rhythm of the narrator's own body, of her own ability to restore harmony and balance to herself.

The style of the story would also be a source of interest to the biological critic. Did you notice anything distinctive about the style, the ways in which the narrator writes her own story? Go back and look at the story again. Even the most rudimentary inspection demonstrates that Gilman's narrator tends to write in relatively short paragraphs and sentences, even from time to time in phrases and fragments. Given the conventions practiced when the story was written, the style is comparatively loose (though it does not seem quite so today). The story moves forward in episodes, often presented elliptically and expressionistically, the emphasis less on action than on a representation of the narrator's feelings and responses to her environment and her encounters with others.

You might analyze the story in terms of each of its divisions (Gilman suggests natural breaks between entries or episodes by her use of typographical space). How does the language change as the narrator's relationship with her body changes and as the body of the room and the body of the woman she has hallucinated develop? Are you willing to argue, as some biological critics might, that rather than simply being a document of emotional pathology, the changing style also embodies the narrator's growth toward a freer, more natural sense of

identity, of what it means to be a woman? Hélène Cixous, one of the leading French feminists, has gone so far as to suggest that women's unconscious is structured differently from men's. If so, how might the written body of *The Yellow Wallpaper* show the narrator becoming more and more authentically in touch with her unconscious desires and feelings?

Consider now how these very different ways of constructing the relationship between women and their bodies might influence performance choices. Both ways of understanding the story would have the narrator responding to the same set of conditions: postpartum depression, accompanied by the confining if arguably well-intentioned treatments of male doctors and the women who attend them. For the ideological critic, the narrator is another example of what critics Sandra Gilbert and Susan Gubar have named the "madwoman in the attic," the woman who by design, illness, or accident has been marginalized in society or hidden away. For the biological critic, we may have that same "madwoman" (called "sorceress" or "hysteric" in her various manifestations, as French critic Catherine Clément suggests) who—perhaps ironically, certainly problematically—finds her most "natural" and "authentic" sense of self in her supposed "madness" (3 passim).

These two divergent ways of seeing the narrator would lead to different ways of characterizing her. Needless to say, there will be similarities: even in the latter interpretation (which we admit seems to us to be a radical rethinking of the madness in the story), there must be a sense of injustice and social pressure on the woman; and in the ideologically based performance, even if we view the final outcome as tragic—a tragedy of the effects of patriarchy on the woman's body— the final moment, for all of its horror, must carry some elements of triumph, no matter how distorted.

Think also about how these different ways of seeing the story would lead to different performance choices in terms of space, movement, and staging. The ideologically based version might elect to emphasize the confinement of the woman, perhaps stripping away as much of the physical trappings of the room as possible to suggest the ways in which she has been deprived of that which might cure her. Her containment might be translated into the amount of space she is given in which to move. The biologically based version might dispense with virtually all of the material elements of the story, allowing the performer to thematize the body's own sense of writing its text through movement that changes dramatically, perhaps nonrealistically, as the language (and body) of the woman changes. A number of other possibilities will no doubt also occur to you.

Because issues of sex and gender are so imprinted into us from the time we are young children, many writers have taken the gendered body as a central theme. The very fact that unlike race—which now is such a questioned category as to allow an individual to deny natural or biological membership in a particular racial group (though he or she may feel deep identification with the culture of a group socially defined by its ethnicity)—we are all conditioned to define ourselves in important ways as either male or female, this single characteristic still holds a primary place in our self-definitions and in the artistic productions we create and present. Any of the texts we have studied in part III offer many possibilities for the extended study of sex and gender and their impact on performance. Experiment with gender issues when you work on these texts in performance.

Though most of the critical theories about sex and gender have focused on feminist issues, in recent years, there has been increasing interest in sexuality and sexual orientation and the performance of literature. For many critics and social scientists, terms like *heterosexual* and *homosexual* are no longer viewed as fixed categories of identity but as complex psychological and social constructions. For example, Eve Kosofsky Sedgwick has identified a phenomenon she has named ''male homosocial desire'' as a way of understanding relationships between men that are not overtly physical, yet that involve desire and are usually expressed through the ''exchange'' of women as channels of that desire. Marjorie Garber considers transvestism (and transexualism) as recurring themes and experiences in Western culture. You may be interested to read some of their writings on these subjects, listed at the end of the chapter, and consider how they might influence performance choices you might make around sexuality and its embodiment in performance. For example, how might issues of sexuality and sexual orientation be relevant to the performance of such texts as Lawrence's ''Gladiatorial'' and Rich's ''Diving into the Wreck,'' to name only two?

THE BODY IN PERFORMANCE: SOME CONSIDERATIONS

We have devoted much of the space in this chapter to a survey of major ways in which the body has been constructed socially and psychologically in history and in today's world. To suggest that the body is a figure, a construction—whether made by groups of people through political, cultural, or social discourse or by individuals through personal experience, dreams, and the expression of the individual psyche—is not to deny or devalue the physical experience of the body, both in life and in literary texts. Recall the questions and exercises involved in our discussion of the essay ''Falling into Life''; working your way through the lived experiences described in the text is critical to producing a performance that carries authenticity and value.

So it is with each of the other literary texts. Moreover, we would argue that the sense of a physical, lived experience is enriched by a consideration of the ideological and theoretical ways of understanding the text's body. In each case, the immediacy of the body produced by the text, both by the writer and by the reader and performer, is taken to a more sophisticated and complex plane when seen synchronistically with the sociopolitical, cultural, and psychological aspects of the body as figured in the text. Thus, any performer who wants to work with ''The Yellow Wallpaper'' will need to experience that room as a palpable prison— feeling the texture of the wallpaper, envisioning the patterns described by Gilman, and having the sense of literally being trapped or imprisoned in a confined space. At the same time, a theoretical understanding of the ideological and biological approaches to the female body in the literary text opens up new possibilities of how to present the text in performance. Similarly, the kinesthetic imagery of Ellison's *Invisible Man* carries a visceral response that is made even more painful when set against the concept of ''race'' as a contested way of figuring the black body in society and in literary texts. We would not recommend neglecting

the world of physical experience for the theoretical analysis of the textualized body; at the same time, we strongly believe that to neglect the aspects of the body that reach beyond the physically immediate is to do a disservice to the complexities of the body as explored by these writers and as experienced by readers and performers.

The contemporary interest in theoretical approaches to the textual body has led to a number of complicated questions about selecting texts for performance. Many of these questions are not dissimilar to the issues raised in the performance of ethnographic texts, and some of the answers are parallel as well. For example, a number of white performers have felt ill at ease in performing texts by black writers, for a number of reasons. In some cases, the white performers worry about potential charges of appropriating black culture; in other cases, white performers may feel that they do not have the experience to fund a performance of a text by a black writer. Black performers sometimes respond to this second concern by pointing out that they have had to learn to perform "white texts" as a matter of course—that as long as racial divisions remain an active social construction, such a wall will always stand as a potential barrier, if one wants to make it so.

We agree with this line of reasoning and further suggest that to decide to exclude oneself from access to such texts in performance is, at some level, to buy into a racist (or sexist or homophobic) argument; at some level, to refuse to perform the texts of people who "belong" to other body categories is to fetishize that category as all-important. If either of the authors of this book were to choose to perform the excerpt from Ellison's *Invisible Man,* it is with the knowledge that neither of us is black. One of us is a man, but who is to say his maleness is somehow equivalent to the masculinity of the narrator in the Ellison selection? Perhaps both of us might respond to memories of being frightened, being put on display, or feeling uncomfortable because of our bodies and because of the use to which our bodies were being put. We would have to use these experiences as a base, but we would not stop there. We simply cannot *be* the black men figured in the text, but we can work to imagine and understand what it might mean to be in that bodily position. And we could also work to take our bodily differences into account in constructing the performance. To choose to ignore the social category of race in putting the performance together would make us guilty of a kind of "universalizing" impulse—reading as universal that which would otherwise exclude us or that which is not within our own immediate or primary experience.

The same situation holds true with sex, gender, and sexuality. We have noted, both as performers and as teachers, that there is a tendency for female performers to feel fairly comfortable in adopting a male persona but that male performers, with numerous notable exceptions, approach female personae with some trepidation and unease. A simple explanation may be one of socialization: both men and women have been socialized to accept the masculine as "normal," and within certain boundaries, both men and women are rewarded for displaying these characteristics. For a man to be "womanly," however, is often the cause for derision (indeed, this is typically pointed to as one of the sources of homophobia—the fact that gay men are perceived as being "womanly" and that

lesbians are perceived as being *too* manly and, hence, wanting access to male power). Think about what different connotations the terms *sissy* and *tomboy* carry in our society. In addition, women simply have more practice in acting in "masculine" ways because such characteristics (and remember that we are distinguishing here between socially constructed gender and biologically given sex) are held up as the standard.

We encourage you to examine your own relationship with these categories both in considering how you choose a text for performance and how you go about presenting it (as well as how you respond as an audience member). Do you find yourself holding back when the text requires you to enter a body category other than your own, perhaps selecting a more distanced style of performance? Or do you find yourself moving immediately to concerns about how to speak and gesture when you work in different racial or sexual categories? Do you simply choose to ignore these categories completely? And how do the answers to these questions suggest not only your philosophy of performance but also your thoughts and feelings (conscious or unconscious) about these concepts?

We also encourage you to reexamine and challenge the limitations such categories may place on you because the solo performance of literary texts often involves the presence of many voices, many bodies in a single text. Think of how many selections you have performed that involve more than one character (whether a narrative of prose or a scene from a play or even some poems). The simple fact is that you could not impersonate each one of these characters in a realistic way in any case; if you limit yourself only to those characters whose racial and sexual categories match your own, you might lead yourself to the dangerous conclusion that you can perform only characters who have blue eyes or who are over six feet tall. Whereas exploring and honoring the body of and in the text is essential and is to be praised, remember that performing involves the intersection of your body (and mind and spirit) and those of other texts; this intersection, which can never be perfect, even if you are performing an autobiographical text you have written, is the basis of the knowledge that performance can bring.

These issues remain lively and the basis of heated arguments in professional theatrical performance today. Most recently, members of Actors Equity and associations of Asian-American actors fought the casting of Jonathan Pryce, a Welsh actor, in the role of Engineer, a Eurasian pimp, in the musical play *Miss Saigon*. Asian-American groups were particularly incensed at what they saw as the appropriation, once again, of Asian culture by "round eyes" and by the appropriation of an opportunity for an Asian-American artist to perform a starring role on Broadway: Asian-Americans are vastly underrepresented in the highly commercial world of the Broadway theater. Both sides made strong arguments, with those opposed to blocking the casting of Pryce calling on theater as one of the few places where the artificial category of race should not matter because the art of acting involves imagining oneself into experiences and roles different from one's own. The argument is by no means concluded in the minds of the participants, though, in fact, Actors Equity relented and Pryce performed the role. Obviously, this example is complicated by the economics of commercial theater:

Cameron Mackintosh, *Miss Saigon's* producer, threatened to cancel the production if Pryce were not allowed to perform; had that happened, many Asian-American actors would not have had the opportunity to perform in other roles in the production.

Perhaps a happier example in which the issue of body played a role in casting was a recent production at the Folger Theater in Washington, DC, of Shakespeare's *The Merry Wives of Windsor,* in which Pat Carroll played the role of Sir John Falstaff. Carroll is a large-bodied, robust woman, who could conceivably impersonate a man, but because of her celebrity, surely all in the audience were aware that they were watching a woman play one of the great comic male roles in drama. In this case, the artistic staff chose to cast Carroll because she was able to embody the qualities they deemed most important, such as size and personality (and no doubt the publicity engendered by such a casting coup did not hurt ticket sales, either), and because she was able to bring an artistry to her characterization that made her Falstaff believable and consonant with the goals of the specific production. Because women typically are also less represented and hence have fewer opportunities than men in commercial theater, there was no vocal opposition to her casting. Indeed, Carroll received almost unanimous critical acclaim for her performance and won the award, at the end of the season, for best actress in the Washington theater community.

Can you think of other examples of what has been called nontraditional casting (disregard of race, gender, age, body type, and just about every other category by which the body may be constructed)? Think about your own experiences as a performer—have you ever been cast so far against type that you and the audience had to make certain leaps of faith to make you acceptable in a role? How much did those discrepancies matter? Can you think of any times when it could be important to stay within body boundaries? Why? As a performer, director, and audience member, you will need to think through the issues of body and casting. You may find that you cannot come up with a single policy that will hold true for every production, or you may be able to determine when the body of the performer and the body of the text must match as closely as possible—and what it means to say that they do "match," to use Wallace Bacon's concept. In any case, although you may never be in the position of a producer of a *Miss Saigon,* you will constantly be making decisions about how to consider the body when selecting and casting (in the case of group performances) texts.

CONCLUSION

The body is both the most basic component of human existence and also probably the most complex and disputed. We do not dispute the fact that we have bodies, nor do we dispute what it feels like to live in them, but we do often dispute how we and others think about them, talk about them, and interpret them. One of the aspects of performance that is usually most exciting is the sense of bodily engagement involved in the process; yet that engagement does not come without

responsibility, the responsibility to live these body texts critically and thoughtfully. Such critical engagement is part of the larger dialogic process of the analysis and performance of literary texts, which we discuss in the next chapter.

WORKS CITED

Bacon, Wallace A. *The Art of Interpretation*. 3rd ed. New York: Holt, 1979.

Baker, Houston A., Jr. "Caliban's Triple Play." Gates. 381–95.

Cixous, Hélène, and Catherine Clément. *The Newly Born Woman*. Trans. Betsy Wing. Minneapolis: U of Minnesota P, 1986.

Clément, Catherine. "Sorceress and Hysteric." Cixous and Clément. 3–59.

Ellison, Ralph. *Invisible Man*. New York: Random, 1952. 3–33.

Foucault, Michel. *The Foucault Reader*. Ed. Peter Rabinow. New York: Pantheon, 1984.

Gates, Henry Louis, Jr., ed. "Introduction." *"Race," Writing and Difference*. Chicago: U of Chicago P, 1986. 1–20.

Gilbert, Sandra M., and Susan Gubar. *The Madwoman in the Attic: The Woman Writer and the Nineteenth-Century Literary Imagination*. New Haven: Yale UP, 1979.

Gilman, Charlotte Perkins. "The Yellow Wallpaper." *The Yellow Wallpaper and Other Writings*. New York: Bantam, 1989. 1–20.

Irigaray, Luce. *The Irigaray Reader*. Ed. Margaret Whitford. Oxford: Blackwell, 1991.

———. *Speculum of the Other Woman*. Trans. Gillian C. Gill. Ithaca: Cornell UP, 1985.

Kriegel, Leonard. "Falling into Life." *Falling into Life*. San Francisco: North Point, 1991. 3–20.

Lutz, Tom. *American Nervousness, 1903: An Anecdotal History*. Ithaca: Cornell UP, 1991.

Rich, Adrienne. "Diving into the Wreck." *The Fact of a Doorframe: Poems Selected and New 1950–1984*. New York: Norton, 1984. 162–64.

Schwartz, Lynn Sharon. "Introduction." Gilman. vii–xxvii.

Sedgwick, Eve Kosofsky. *Between Men: English Literature and Male Homosocial Desire*. New York: Columbia UP, 1985.

———. *Epistemology of the Closet*. Berkeley: U California P. 1990.

Showalter, Elaine. "Toward a Feminist Poetics." *The New Feminist Criticism: Essays on Women, Literature & Theory*. Ed. Elaine Showalter. New York: Pantheon, 1985. 125–43.

Washington, Mary Helen, ed. *Black-eyed Susans: Classic Stories by and about Black Women*. 1st ed. Garden City: Anchor, 1975.

———. *Invented Lives: Narratives of Black Women, 1860–1960*. Garden City: Doubleday, 1987.

———. *Midnight Birds*. Garden City: Anchor, 1980.

FOR FURTHER READING

Appiah, Anthony. "The Uncompleted Argument: Du Bois and the Illusion of Race." Gates. "Race," Writing and Difference. 21–37.

Baker, Houston A., Jr. *Afro-American Poetics: Revisions of Harlem and the Black Aesthetic*. Madison: U of Wisconsin P, 1988.

Gallop, Jane. *Thinking through the Body*. New York: Columbia UP, 1988.

Garber, Marjorie. *Vested Interests: Cross-Dressing and Cultural Anxiety*. New York: Routledge, 1992.

Gates, Henry Louis, Jr., ed. *Black Literature and Literary Theory.* New York: Methuen, 1984.

———. "Race," Writing and Difference. Chicago: U of Chicago P, 1986.

———. *Reading Black, Reading Feminist: A Critical Anthology.* New York: Meridian, 1990.

Gilbert, Sandra M., and Susan Gubar. *No Man's Land: The Place of the Woman Writer in the Twentieth Century.* New Haven: Yale UP, 1988.

Jardine, Alice. *Gynesis: Configurations of Women and Modernity.* Ithaca: Cornell UP, 1985.

Moi, Toril. *Sexual/Textual Politics.* London: Methuen, 1985.

Scarry, Elaine, ed. *Literature and the Body: Essays on Populations and Persons.* Baltimore: Johns Hopkins UP, 1988.

Suleiman, Susan Rubin, ed. *The Female Body in Western Culture: Contemporary Perspectives.* Cambridge: Harvard UP, 1986.

Warhol, Robyn, and Diane Price Herndl, eds. *Feminisms: An Anthology of Literary Theory and Criticisms.* New Brunswick: Rutgers UP, 1991.

CHAPTER **12**

Dialogue and the Performance of Literature

Dialogue is perhaps the most immediate and dramatic impulse in human communication. The desire to break out of the confines of the self and make contact with another human being, another set of beliefs, attitudes, and experiences—even to make contact with another part of the self—is something we experience from the earliest years of consciousness and individuation to the last moments of our lives. Many communication specialists argue that there is no pure monologic language, that all language is essentially dialogic, even in the most extreme and barest of situations; even in the autistic person's seemingly disconnected cries there are the traces of the dialogic relationship with the world.

We are most keenly aware of the fundamental need for dialogue when dialogue breaks down. A number of writers have taken the inability to achieve dialogue as a central theme. The novelist E. M. Forster exhorted his readers to "Only connect!" as if to suggest that making contact and making sense of contact were the keys to human happiness. It is isolation from connection that Muriel Rukeyser explores in her poem "Effort at Speech between Two People":

 : Speak to me. Take my hand. What are you now?
 I will tell you all. I will conceal nothing.
 When I was three, a little child read a story about a rabbit

 who died, in the story, and I crawled under a chair :
 a pink rabbit : it was my birthday, and a candle
 burnt a sore spot on my finger, and I was told to be happy.

 : Oh, grow to know me. I am not happy. I will be open:
 Now I am thinking of white sails against a sky like music,
 like glad horns blowing, and birds tilting, and an arm about me.
 There was one I loved, who wanted to live, sailing.

: Speak to me. Take my hand. What are you now?
When I was nine, I was fruitily sentimental,
fluid : and my widowed aunt played Chopin,
and I bent my head on the painted woodwork, and wept.
I want now to be close to you. I would
link the minutes of my days close, somehow, to your days.

: I am not happy. I will be open.
I have liked lamps in evening corners, and quiet poems.
There has been fear in my life. Sometimes I speculate
On what a tragedy his life was, really.

: Take my hand. Fist my mind in your hand. What are you now?
When I was fourteen, I had dreams of suicide,
and I stood at a steep window, at sunset, hoping toward death :
if the light had not melted clouds and plains to beauty,
if light had not transformed that day, I would have leapt.
I am unhappy. I am lonely. Speak to me.

: I will be open. I think he never loved me:
he loved the bright beaches, the little lips of foam
that ride small waves, he loved the veer of gulls:
he said with a gay mouth: I love you. Grow to know me.

: What are you now? If we could touch one another,
if these our separate entities could come to grips,
clenched like a Chinese puzzle . . . yesterday
I stood in a crowded street that was live with people,
and no one spoke a word, and the morning shone.
Everyone silent, moving. . . . Take my hand. Speak to me.

This representation of the "effort at speech" is complex dialogue because Rukeyser's speaker or speakers perform elaborate acts of self-disclosure and the expression of needs.

We may ask of this poem, what is the identity of the speaker or speakers in this dialogue? Is this the monologue of one speaker, desperately, eternally it seems, waiting for the response of the addressee? Or is it an actual dialogue, in which each of the two participants takes his or her turn? If it is the former, how do we construct a situation in which the speaker receives no verbal response to cries for contact? The poem's title suggests that what we have read is an "effort at speech." How far does this effort extend? Does the speaker literally speak these words to the loved one? Or is the effort below the level of actual speech, being the speaker's working through of his or her past experiences and present emotions to summon the courage to expose his or her feelings and needs to this new partner? Is it possible to see this as a dialogue that moves between inner consciousness of the speaker and outer expression to the other participant?

If this is an actual dialogue, spoken in the presence of two participants and involving speech by both, how do we decide who is speaking when? Rukeyser

uses the colon to indicate some kind of shift, but it is not clear from the content of the poem that the shift is necessarily from one speaker to another. Similarly, what do the spaces between sentences and clauses symbolize in the movement of the dialogue? Are they possibly Rukeyser's own suggestions for timing, that is, for the movements in time between past and present?

In addition to raising questions of style and form of dialogue, "Effort at Speech between Two People" takes the difficulties (some might say impossibilities) of complete dialogue as one of its principal themes. Is the effort to "speak" successful or not? If you think strongly that the poem presents a successful conclusion, explain why? If you think the poem ends on a note of pessimism or ambiguity, point to details in the language to support this position.

How might you explore the poem's sense of dialogue in performance? We have seen one performance in which the words were divided between two speakers, a man and a woman, thus making the dialogue literal and explicit. In this performance, the sense of actual contact between the speakers was ambiguous: audience members disagreed about whether the speakers were speaking to each other or thinking aloud in the presence of each other. Obviously, each way of viewing the spoken dialogue would result in a different way of conceiving of the poem.

Bruce Henderson participated in a performance in which he spoke the poem and a second performer danced to the words. The performers intended to have the speech and dance serve as parallel texts: the dance was meant to express some of the emotions experienced by the poem's speaker, to intensify them through the life of the body, but also to suggest the gap between language and physicality that the performers saw as crucial to the poem.

Thus far, in part III, we have focused on various ways of experiencing the self in literary texts and performance contexts. We have not ignored the interactions between selves, but we have been most concerned with different ways of understanding what it might mean to speak of a self or selves in literary and performance terms. In this final chapter of part III, we will consider selves in dialogue with other selves. Dialogue—in its broadest sense, understood as the contact between two or more selves, two or more aspects of the same self; or two or more social, cultural, or other kinds of institutions or points of view— occurs at a number of levels: the intrapersonal discussions we have within ourselves through poetry and other lyric texts; the public debates we find in philosophy, drama, and fiction; and the representations of conversation and intimate relationships found in various kinds of literary texts.

DIALOGUE IN CLASSICAL DRAMA

In Western civilization, dialogue began as a formal use of language in two principal ways: the philosophical dialogue, invented and popularized by Plato through his series of dialogues spoken by his teacher Socrates, and classical drama, particularly the tragedies of Aeschylus, Sophocles, and Euripides and the comedies of Aristophanes. Although we are today less accustomed to thinking of philosophy

and drama as allied kinds of texts, in the classical period (ca. fifth century B.C.E.) the opposite was quite the case: indeed, in Aristotle's *Rhetoric* there are a number of references to the drama, and in his *Poetics* (his study of classical tragedy), there are references to the *Rhetoric* and to other philosophical ideas.

In both philosophical and dramatic dialogue, the dialogic form served as source of and approach to knowledge as well as an embodiment of competing or conflicting ideas, needs, and beliefs. As Tullio Maranhão says, the aim of dialogue was "to unearth knowledge in a practice qualified as ethical" (7). The name Plato gave philosophical dialogue, which he contrasted to oratorical rhetoric, was dialectic. *Dialectic* was preferable to rhetoric for two reasons: first, the process of questioning and answering was more likely to lead to truth than the singular speech making of an individual. Second, dialectic was morally superior to rhetoric: Socrates and Plato believed that the orator had a better opportunity to trick and fool his audience than did the dialectician.

Plato believed in a finite truth, but he believed that knowledge of such truth was ultimately unavailable to human beings, that we are all several steps away from Reality. Reality is found in what has been translated variously as Ideas and Forms, things beyond our apprehension. Thus, the process of dialectic was an act of humility, a rigorous and intellectually searching humility. At the same time, because Plato believed in a finite, ultimate Reality, there is something monologic in his use of dialogue: it does not assume that we make truth together but rather that we work toward one final truth. It is important to keep the notion of formal dialogue distinct from that of ideological or philosophical dialogism; they may work in parallel ways, but as in Plato's dialogues, the dialogue as form may be put in the service of monologic philosophy.

It was in the tragic and comic drama of the classical period that philosophical and literary uses of dialogue intersected. The form of the drama in ancient Greece followed in many respects the form of traditional argumentation and debate, in which characters representing opposing views on a given issue or situation made speeches and exchanged dialogue as ways of resolving or explaining their differences. In the classical drama, then, we find a wedding of the use of dialogue to present and resolve conflict and the use of dialogue to reveal personality and further action.

Let's look at a scene from Sophocles's tragedy *Antigone.* You may be familiar with the story, the conclusion of the trilogy of Theban plays, which follow the misfortunes of Oedipus and his children. Oedipus, king of Thebes, was fated to kill his father and marry his mother. Despite his parents' efforts to thwart fate, Oedipus did indeed fulfill the prophecy, and he did so blindly and with arrogance. After he discovered the truth about himself, he blinded himself, left Thebes, and wandered about the land, settling finally at Colonus to die. *Antigone* follows the actions of his daughter Antigone. Eteocles and Polyneices, Antigone's brothers, have both died in battle, but Polyneices died a traitor to Creon, Antigone's uncle and present king of Thebes. Creon has decreed a hero's burial for Eteocles but has forbidden anyone to bury Polyneices, under pain of death. Antigone, after much argument with her sister Ismene, has determined that she must disobey the orders of the state and risk death to do honor to her brother. She has weighed

her loyalties and has decided that loyalty to family takes precedence over loyalty to her government.

In the following scene, a guard has just brought Antigone before Creon, having discovered her in the act of burying the corpse of Polyneices. As you read the selection, try to identify the terms of the argument. What are the principles, values, and beliefs that Creon and Antigone use to defend their positions? What emerges from the dramatic opposition of perspectives in the dialogue? Notice in particular the very different rhythms. The very short interchanges between characters are called *stichomythia,* literally, the "stitching of lines"; how do they move ideas and emotions differently from the longer speeches?

CREON: You—tell me not at length but in a word.
You knew the order not to do this thing.

ANTIGONE: I knew, of course I knew. The word was plain.

CREON: And still you dared to overstep these laws?

ANTIGONE: For me it was not Zeus who made that order.
Nor did that Justice who lives with the gods below
mark out such laws to hold among mankind.
Nor did I think your orders were so strong
that you, a mortal man, could over-run
the gods' unwritten and unfailing laws.
Not now, nor yesterday's, they always live,
and no one knows their origin in time.
So not through fear of any man's proud spirit
would I be likely to neglect these laws,
draw on myself the gods' sure punishment.
I knew that I must die; how could I not?
even without your warning. If I die
before my time, I say it is a gain.
Who lives in sorrows many as are mine
how shall he not be glad to gain his death?
And so, for me to meet this fate, no grief.
But if I left that corpse, my mother's son,
dead and unburied I'd have cause to grieve
as now I grieve not.
And if you think my acts are foolishness
the foolishness may be in a fool's eye.

CHORUS: The girl is bitter. She's her father's child.
She cannot yield to trouble; nor could he.

CREON: These rigid spirits are the first to fall.
The strongest iron, hardened in the fire,
most often ends in scraps and shatterings.
Small curbs bring raging horses back to terms.
Slave to his neighbor, who can think of pride?
This girl was expert in her insolence

when she broke bounds beyond established law.
Once she had done it, insolence the second,
to boast her doing, and to laugh in it.
I am no man and she the man instead
if she can have this conquest without pain.
She is my sister's child, but were she child
of closer kin than any at my hearth,
she and her sister should not so escape
their death and doom. I charge Ismene too.
She shared the planning of this burial.
Call her outside. I saw her in this house,
maddened, no longer mistress of herself.
The sly intent betrays itself sometimes
before the secret plotters work their wrong.
I hate it too when someone caught in crime
then wants to make it seem a lovely thing.

ANTIGONE: Do you want more than my arrest and death?

CREON: No more than that. For that is all I need.

ANTIGONE: Why are you waiting? Nothing that you say
 fits with my thought. I pray it never will.
 Nor will you ever like to hear my words.
 And yet what greater glory could I find
 than giving my own brother's funeral?
 All these would say that they approved my act
 did fear not mute them.
 (A king is fortunate in many ways,
 and most, that he can act and speak at will.)

CREON: None of these others see the case that way.

ANTIGONE: They see, and do not say. You have them cowed.

CREON: And you are not ashamed to think alone?

ANTIGONE: No, I am not ashamed. When was it shame
 to serve the children of my mother's womb?

CREON: It was not your brother who died against him, then?

ANTIGONE: Full brother, on both sides, my parents' child.

CREON: Your act of grace, in his regard, is crime.

ANTIGONE: The corpse below would never say it was.

CREON: When you honor him and the criminal just alike?

ANTIGONE: It was a brother, not a slave, who died.

CREON: Died to destroy this land the other guarded.

ANTIGONE: Death yearns for equal law for all the dead.

CREON: Nor that the good and bad draw equal shares.

ANTIGONE: Who knows that this is holiness below?

CREON: Never the enemy, even in death, a friend.

ANTIGONE: I cannot share in hatred, but in love.

CREON: Then go down there, if you must love, and love
the dead. No woman rules me while I live.

Some critics have described *Antigone* as the tragedy of two individuals who are unwilling to entertain the possibility that the other person is right. Others have seen the crux of the conflict as the impossibility of resolving the values at hand in the dialogue: Antigone, on the one hand, arguing on the basis of familial fidelity and an implicit religious fidelity; Creon, on the other hand, arguing for the position of the state, for the laws of man (*man* in the most general sense and, as the last lines of the selection suggest, *man* in the gender-based sense of patriarchy, the governance by men over women). Do you think there is any chance for these two characters, as they are presented, to find a way of compromising? Or are their positions so extreme that tragedy must ensue?

The scene begins with a simple form of questioning, in which Creon simply wants to establish the fact of Antigone's deed, but it moves quickly to the longer speeches in which the characters make their philosophical positions clear. Antigone's long speech is itself an example of the monologue in which a speaker goes through something of a dialogical process. We see her working through the reasons available for taking either position but finally choosing to disobey the state. Here are the central issues she has had to confront in reaching her decision to bury Polyneices:

1. Divine law vs. mortal law
2. Physical life vs. spiritual reward. (i.e., happiness)
3. Relative grief (grief over death vs. grief over dishonor)

In each case, Antigone thinks through the options and bases her decision on the set of values that carries the highest position in her hierarchy. She is also aware, as she makes explicit, that her personal values, which she deems the right ones and the ones shared by the gods, are in conflict with those of the state; it is interesting that later in the scene, she claims that those who stand silent nonetheless are in agreement with her but are afraid to speak out. By implication, she indicts the society of misrepresenting the values of its people.

Creon's long speech is almost diametrically opposed to Antigone's both in substance and in argumentative style. He does not display appeals to reason but simply engages in name-calling. He uses analogies to criticize Antigone's character and actions, describing her as like ''these rigid spirits,'' ''the strongest iron,'' ''raging horses,'' and so forth. Rather than defending the particularities of the law Antigone has violated, Creon prefers simply to build his case on her insolence in breaking ''bounds beyond established law.'' He calls into question her morality and her ethics.

Impatient in the presence of Creon's vituperative attack, Antigone merely responds, ''Do you want more than my arrest and death?'' as if to say that all this talk is empty: simply move on to the punishment itself. She herself suggests that she thinks it impossible that they should ever resolve their different values:

"Nothing that you say/fits with my thought. I pray it never will." Sometimes, the speech implies, the goal of resolving differences through communication is artificial, impossible, and perhaps not even the point when values are held so passionately as to prohibit change. In this case, it seems as if Creon cannot even listen to Antigone's side. Although she ultimately chooses to disobey, she has worked through the two positions.

At this point, the scene picks up speed, as each speaker jumps on top of the other's line: here is the rapid-fire exchange of lines we identified as *stichomythia* earlier. It is as if in one last fury, Creon is determined to force Antigone to admit the moral and intellectual error in her action, as well as the simple legal disobedience. Antigone, who is perhaps now beyond any real desire to convince Creon, nonetheless will not allow him to undermine her position; thus, she volleys back and forth to keep her side alive intellectually and spiritually, even if she now knows, as she has known for some time, that she must die physically. Creon has the final word, yes, but it is only his by virtue of his political and social position, not because he has won it philosophically. He can pronounce her sentence, but he cannot convince her of his position.

For centuries, critics have argued over who is the tragic hero of *Antigone*. The title, of course, suggests that Antigone is the protagonist, but many have made interesting and compelling arguments for Creon as the central figure. In some respects, Antigone's resoluteness and courage, although enormously admirable and moving, may not finally be as complex as Creon's own process. He has his way, and Antigone dies, but at great loss to Creon: his own son and wife die as well. Like Oedipus, Creon is a victim of his own pride and stubbornness; at least Antigone died for something she knew she believed. Creon is not so certain at the end of the play.

Try performing this selection. You might begin by taking only one of the two roles and having a classmate take the other. Become aware of the perspective and values of your character. Live with this character for awhile: discover what it means to see the situation only from that one point of view. Then, after having performed that one role, switch roles and try going through the same process. Is it easier or more difficult the second time? Are you able to forget what it felt like to be in the other position? Finally, you might then move to a solo performance of the scene, in which you must adopt both positions and keep both perspectives alive at the same time.

SPEECH ACTS AND THE PERFORMANCE OF LITERATURE

We have considered language as a way of stating "truth," of making apparent that which the speaker considers to be *the* truth. Another way of perceiving language is to see it as a form of action, a way of doing something (in addition to the action of stating reality). In this view, language doesn't simply describe a condition (in fact, it may not state anything real at all) but also causes things

to happen. In *Yiddish Folktales,* edited by Beatrice Silverman, an intriguing story illustrating language's potential to act as well as state is found in the Jewish folk tale of the Golem of Vilna.

If you know the secret Name of God, you can build worlds and you can destroy them. You can move mountains. You can also make a human being—a living person—out of clay. A golem.

One such golem was made by a great rabbi, a gaon, a genius. Oh, what marvelous consolation that golem was for the Jews! The rabbi created him so that he could provide the Jews with fish for the Sabbath. He would send the golem into the depths of the river, where the golem, using the language of fish, called them together, trapped them in a net, and distributed them to the Jews.

The Vilna Gaon formed this golem out of sand and clay and water. And since the Gaon, may heaven be radiant for him, was a scholar and knew the five Books of Moses and the Commentaries all by heart, as well as all the secrets of the Cabala—since he knew all that, he also knew the blessed Lord's secret Name of Names and had written it down on a piece of paper. This he put into the golem's ear, and it was the writing on the paper that turned the clay into a living human being.

The golem could leap from roof to roof, like a bird, and he could disguise himself so that nobody knew who he was. He could drift through the air like a breeze on a cold day. Ah, what was there he couldn't do?

He was at once human and inhuman. For instance, the Gaon could send him to the synagogue to extinguish the Sabbath candles, because, though he had the appearance of a human being, he was not really human and therefore not required to fulfill all the prescriptions of the Torah. He was allowed to violate the Sabbath.

But his most important work was to defend the faithful on holidays and market days, when drunken peasants turned ugly and started to beat Jews. It was then that the Gaon turned the golem loose. Ah, how the golem used to crack their heads and break their arms and legs! There was no way they could escape from him. Sometimes he was on the rooftop, sometimes underwater in the river, sticking out his long, stone tongue. When the governor heard about him . . . ah Lord, Lord . . . the golem, I mean the Gaon, sent the golem to slap the governor around a bit.

When the Gaon decided that he did not want the golem to be a golem any longer, he simply returned the bit of paper with the Name of Names on it from the golem's ear. He did so because, may the good Lord be thanked, there are now plenty of fish in the marketplace. Even such poor people as we can afford a bit of carp for the Sabbath. Besides (and I hope never to see the day), should the time come when we do need the golem again, there will be someone to revive him. A new gaon will arise who will put the terrifying bit of paper in his ear. But I trust God will protect us from that. It will be much better if we never have need of the golem again.

There are many versions of the legend of the Golem in both Jewish folklore and Jewish literature. What is remarkable about the legend, for our purposes, is the critical role language plays in the instigation of action. The first paragraph of the tale makes this clear: it is through knowledge of language and the use of language that one can "build worlds and destroy them." The Golem is not simply made of clay, sand, and water but also the secret words that name God, words whose possession and utterance create power for both good and evil. Knowing the Name of Names is not enough; the Gaon must also actually use them.

The legend, then, may be seen as an allegory of language as action, as agency of power. Notice, too, that in this retelling of the legend, there are frequent uses of language as action as well. The teller uses such phrases as "ah Lord, Lord" and "may the good Lord be thanked" and "I trust God will protect us" as a way of acknowledging the power of God to protect the teller and the audience from those who would destroy them. It is not simply a matter of stating that God will do something, but also it is action—"thanking," "trusting," and calling on God to do something. Culturally and theologically, this legend represents recurrent strains in Jewish thought, belief, and art: the Jews, often displaced and powerless politically in history, have had a great reverence for prayer and for thought—for the spoken and written words as sources of power—so that even in captivity, through meditation, dialogue, and study Jews have traditionally found solace and survival.

A twentieth-century philosophical movement that also sees language as action is called *speech act theory*. It was first developed by British analytic philosopher J. L. Austin and was later elaborated on and modified by the American philosopher John Searle and others. Critic Sandy Petrey summarizes the movement: "Speech-act theory addresses . . . language's productive force," in other words, to paraphrase Austin, what we *do* when we use language (3). The foundation of Austin's theory is an initial distinction between two kinds of utterances: *constative* and *performative*. *Constative* utterances are those that, in Petrey's words, "describe the world"; performative utterances, in contrast "become part of the world" (4): they move beyond the realm of theory and into practice, which in linguistics is often called pragmatics.

Constative utterances presuppose a world in which there are final realities about the way things are. Although there are still many philosophers who subscribe to this view of the universe, there are also now a larger number who do not, for whom the issue of reality and truth is not objective, not even answerable. Such theorists of language are not particularly interested in what might be called "truth values" of language, that is, the accuracy with which any given sentence, statement, or text may be said to describe truth. Rather, such theorists are more concerned with what happens when we use language to try to do something and what happens as a result of such transactions, regardless of any sense of truth. The terms Austin invented to describe success or failure of language use are *felicity* and *infelicity* (some theorists prefer the simpler terms *happy* and *unhappy*). The choice of these terms suggests a relativity of truth value: instead of worrying about whether language actually matches some objective sense of reality, an analysis of felicity or infelicity is a way of uncovering what makes

language work in a given context. Thus, there would be a different set of felicity conditions for language that serves as a contract and for language that serves as a threat because the nature of the successful conclusion of the act would differ in each case.

Performatives, then, are those sentences, statements, or texts that attempt to do something as a result of their utterance. Examples are clearest in sentences that begin with the form "I *verb*." Statements like "I promise," "I swear to you," or "I defy you to" are all performatives, in that their very form declares an intent to do something and that speaking or writing the words is meant to accomplish the act. Performatives don't describe an action you intend to do; they *are* the act itself. We use performatives all the time in ordinary conversation, but perhaps we notice them most when we feel passionately about something and need to make that passion known through an action.

In attempting to analyze language as speech act, Austin identified three aspects of any performative situation: *locutionary acts, illocutionary acts,* and *perlocutionary acts.* Obviously, the three terms are linked by the root *locution,* "to speak." Locutionary acts refer to the formal components of any utterance, divorced from the context in which the utterance may have been spoken and from its results. Illocutionary acts are the intentions the speaker indicates in the utterance; the verbs *promise, threat, apologize,* and so forth all suggest the nature of the illocutionary act. The illocutionary act focuses on the speaker (or writer) and the conditions and contexts in which he or she originates and carries out the speech act itself. Finally, perlocutionary acts are those acts that result from the performance of the illocutionary act—in simpler terms, what happens as a result of the utterance. Does the listener reciprocate with another threat? Protest that there is no need for an apology? Acknowledge the terms of the promise and offer a complementary one? Locutionary acts have traditionally been the focus of linguists, who have been most interested in the form and structure of language. It is in the attention paid to illocutionary and perlocutionary acts that speech act theory moves language into the realm of pragmatics, or actual usage.

Austin devised categories by which speech acts could be classified:

1. *Verdictives:* judgments
2. *Exercitives:* orders
3. *Commissives:* commitments
4. *Behabitives:* social postures
5. *Expositives:* clarifications

Try this: think through as many possible verbal statements as you can that perform an action. Into which categories do they fit? Are there any categories you think have been omitted?

Communication scholars have been particularly interested in speech act theory because it argues that language is always situational, always exists in a particular social context, and therefore can be analyzed in terms of the typical conventions of the kind of speech act an utterance is as well as the specific details of any given interaction. Speech act theory moves beyond what some philosophers

of language have called the *descriptive fallacy,* the idea that the truth or falsity of a description should be the criterion for evaluating the way we use language in general or in a given instance.

Although it is possible to find both overt and implied speech acts in virtually every kind of literary text, critics have typically focused on prose fiction and the drama, in large part because they contain so many dialogic exchanges. Let us look at a text in which speech act theory provides a useful mode of analysis.

APPLYING SPEECH ACT THEORY: "PUTTERMESSER AND XANTHIPPE"

Turn to the appendix and read the chapter from Cynthia Ozick's novella "Puttermesser and Xanthippe" (pages 521–32). The novella is a contemporary version of the Golem legend, resituated in present-day New York City. Puttermesser (the name means "butter knife") is a middle-aged, unmarried, mid-level functionary in the bureaucracy of New York City government. Xanthippe is the name of Socrates's shrewish wife and the name the golem asks to be called. Notice how Ozick uses the very act of naming not simply as a way of describing existence but also as a way of calling things or situations into being and effecting action. Note that language is always used, either by the narrator or the characters, to commit an act. Is the power of language to perform action always a positive force? To what does it lead in this excerpt?

Notice how even from the start of this selection, language is used to perform actions: "Turtelman sent his secretary to fetch Puttermesser." Turtelman, bureaucrat supreme that he is, cannot be bothered to go directly to get Puttermesser but sends his secretary to communicate his message. Language is used here as what Austin would call an *exercitive,* an assertion of authority. Puttermesser misinterprets the nature of the speech act initially; she assumes that Turtelman has sent for her because he "wanted teaching." She assumes that the speech act is not one of ordering but one of requesting. This gap between his intentions and her assumptions leads to the shock she experiences at his dismissal of her. Turtelman's actual dismissal of Puttermesser is short and succinct—"You're out"—suggesting that the greater the authority he assumes, the briefer the required length of the speech act. It is a mark of the ultimate illusion of his authority that he then gives himself away by backing up the directive with what Austin would classify as *expositives,* statements produced to clarify a situation. The expositive statements are a set of confused signals: first, he denies that the dismissal is personal; second, he acknowledges that it is unfortunate that Puttermesser will be unable to retire; finally, the narrator describes Turtelman as "about to deliver a sting: 'We ordinary people who aren't lucky enough to be in the Civil Service can't afford you.'" The sarcasm of the statement is an implied judgment of Puttermesser and of the system of which she is a part—again, a speech act Austin would call a *verdictive.*

Turtelman's series of speech acts is loathsome because it contradicts its own *felicity* conditions almost simultaneously. The brutality of the "You're out" might be acceptable if Turtelman made no attempt to suggest any sympathy for Puttermesser (whom he has deliberately ousted). The expressive act of sympathizing, however briefly, with her inability to retire is immediately undercut by the sarcastic verdictive. Although we are almost always suspicious of people who try to soften the blow when they have to or choose to say something unpleasant to us ("I hate to tell you this, but as your friend I felt someone needed to . . ."), we also often understand implicitly the social conventions that make such statements a part of our everyday discourse. Again, what is at stake is not necessarily the "truth" or "falsity" of the emotion per se but the maintenance of the felicity conditions, the conventional requirements that allow such interchanges to occur successfully. Success in this case might mean Turtelman firing Puttermesser in a way that would allow her to save face and that would encourage her and allow her to leave gracefully.

Puttermesser, perhaps reading Turtelman's inability to maintain his verbal authority over her, takes a chance and, as the dialogue tag indicates, "announces" her credentials—listing her accomplishments, and declaring her competence, in that she "earns my way." From one perspective, this kind of sentence may suggest that she is describing reality, but from a speech act perspective, we would say that she is using language to defend who she is, to mold her image as the gaon molded the golem. Her knowledge becomes the basis for her power; language is the vehicle through which she enacts this power.

Puttermesser's immediate response to Turtelman may be seen as a perlocutionary act, the result of his inept and inappropriate carrying out of the various performatives we have identified. An even more elaborate perlocutionary response to the verbal dismissal is the letter she writes to the mayor of New York City. You might find it useful as an exercise to identify the various performatives employed by Puttermesser in this letter. Is there a point at which the letter is no longer a perlocutionary act, a result of Turtelman's earlier illocutionary act, and becomes an illocution on its own terms? In other words, when does Puttermesser go beyond her initial reactive context to frame her language as something intended to accomplish an action? In particular, you might pay attention to the uses of questioning and naming as actions. Notice in the penultimate paragraph of the letter how often Puttermesser repeats the verb "are." Perhaps you were taught, as were we, that it is not good as a rule to depend too much on the verb *to be* or any of its forms because such use creates the appearance of reality, without necessarily establishing the truth of the reality presented. What point is Puttermesser making in her series of "are" statements? Is there a criticism of the very nature of what Austin calls constative statements, an endorsement of the descriptive fallacy? How has Puttermesser used the very nature of language here to critique its misuse by bureaucrats?

Let us move ahead. More or less true to his word, Turtelman does find a place for Puttermesser, but he has "shoved her into the lowliest ranks of Taxation." Deprived of the opportunity to do what she knows and enjoys,

Puttermesser instead engages in day-long fantasies, particularly of a biologically impossible maternity. In some respects, Puttermesser is performing the act of imagining a different life, a different state of existence from her present one. It is interesting that when Puttermesser stops using language to perform social action and uses it to create her own "literary" dream world that trouble begins, in the person of the golem she discovers lying in her bed. Ozick describes the golem in unattractive terms, suggesting that Puttermesser's first impression is not of the golem as the creation of her own imagination but as yet another symptom of a hellish, corrupt New York City.

Just as in the legend, it is only when Puttermesser discovers the white square of paper and recognizes the Hebrew characters as the Name of Names that she is able to bring the golem to life. Even when the golem comes to life, Puttermesser does not immediately accept her as her imagined daughter but orders her out of the apartment in a series of directives culminating in "Do what I say!" It is at this point that the creature grabs the paper and, in some way, imitates the speech acts of her "mother" by using language. The golem explains her condition in writing: "All tongues are mine, especially that of my mother. Only speech is forbidden me." It is a source of some of the humor in the story that Puttermesser remains resistant to the explanation, preferring to see the creature as a "lunatic . . . a maniac . . . a deaf-mute to boot," rather than as the perlocutionary result of her fantasy.

Puttermesser finally accepts her responsibility for having brought the golem to life: "Yet she had formed this mouth—the creature's mute mouth. She looked at the mouth: she saw what she had made." Examine the rest of Puttermesser's encounter with the golem in this chapter to see how each being views and uses language (and naming in particular) as a source of action. In particular, consider the final section, the history of the golem in legend and folklore, not simply as description but also as a calling into being through language.

The application of speech act theory to a literary text allows the performer to view language not simply as a description of a state of reality but also as a medium for action. Again, it is not simply that language allows us to then perform certain actions (i.e., prepares the way) but also that the use of language is action. As you work through this selection, consider the parallels between a speech act approach to literature and performance as a speech act. Performance is not simply a way of describing something (that something being the "reality" of a text) but also a way of "doing" something, of making a new text out of the one printed on the page. In some respects, it might be possible to say that performance is indeed the logical perlocutionary act resulting from the text's illocutionary act: that we as performers produce our speech acts of performance as a result of the initiating act of the literary text.

Speech act theory assumes a dialogic context for all language and seeks to identify possible categories of speech acts and the conditions under which they succeed or fail. Such a perspective can be applied both to the performance of individual literary texts and to the notion of literature in performance in general. We will now turn to another way of looking at the language of literature in dialogic terms: conversational theory.

CONVERSATION AND DIALOGUE
IN LITERARY TEXTS

Read this excerpt from act II of Samuel Beckett's absurdist tragicomedy, *Waiting for Godot:*

VLADIMIR/ESTRAGON [*turning simultaneously*]: Do you—

VLADIMIR: Oh pardon!

ESTRAGON: Carry on.

VLADIMIR: No no, after you.

ESTRAGON: No no, you first.

VLADIMIR: I interrupted you.

ESTRAGON: On the contrary.

[*They glare at each other angrily.*]

VLADIMIR: Ceremonious ape!

ESTRAGON: Punctilious pig!

VLADIMIR: Finish your phrase, I tell you!

ESTRAGON: Finish your own!

[*Silence. They draw closer, halt.*]

VLADIMIR: Moron!

ESTRAGON: That's the idea, let's abuse each other.

[*They turn, move apart, turn again and face each other.*]

VLADIMIR: Moron!

ESTRAGON: Vermin!

VLADIMIR: Abortion!

ESTRAGON: Morpion!

VLADIMIR: Sewer-rat!

ESTRAGON: Curate!

VLADIMIR: Cretin!

ESTRAGON: [*with finality*]. Crritic!

VLADIMIR: Oh!

[*He wilts, vanquished, and turns away.*]

ESTRAGON: Now let's make it up.

VLADIMIR: Gogo!

ESTRAGON: Didi!

VLADIMIR: Your hand!

ESTRAGON: Take it!

VLADIMIR: Come to my arms!

ESTRAGON: Your arms?

VLADIMIR: My breast!

ESTRAGON: Off we go!

[*They embrace. They separate. Silence.*]

VLADIMIR: How time flies when one has fun!

[*Silence.*]

ESTRAGON: What do we do now?

VLADIMIR: While waiting.

ESTRAGON: While waiting.

[*Silence.*]

In this brief passage, we have a microcosmic representation of the phrases, moves, and characteristics of conversational dialogue. Beckett's Vladimir (Didi) and Estragon (Gogo) are trapped forever on an unnamed, unlocatable country road, waiting perennially for Godot, who is always one day out of reach. Only rarely is their dialogue broken by the arrival of other living figures; their existence is primarily one long conversation, repeated each day, in which they try to find strategies for variation within the predictable patterns of dialogic interchange.

Let's look at how the conversation is structured and what some of its characteristics are. In addition to the two-act structure of the play, *Waiting for Godot* moves from one episode to another, punctuated by silences that force the two to invent or recall another set of moves. This one begins after a silence, at the point when each member of the dyad decides that he must initiate the next phase. They begin with symmetrical phrases—"Do you—"—and then proceed to fall all over each other with courtesy. The comedy of the interchange is that such extreme attention to giving way to the other in speech results in anger; Didi calls Gogo "Ceremonious ape" and Gogo calls him "Punctilious pig," as if each is accusing the other of valuing overbearingly rigid decorum in maintaining politeness to going on with the dialogue. They each challenge the other to "finish your phrase," which leads to a stalemate and another silence, suggesting that they do not know how to finish their phrases or even that they are perhaps afraid to—just as throughout the play there is never any sense of completion, of a day, of life, or of any closure or conclusion. Uncertainty is the theme, the condition of being in this universe; it is no different in its conversations.

In response to Didi's "Moron," Gogo gets the idea that they should abuse each other. His very pronouncement of this thought suggests that it is not an unfamiliar activity and, therefore, one that may not ultimately carry the level of trauma or authentic insult that it might in some more ordinary life situations. Abuse is one way of passing the time, of getting through eternity "while waiting." The dialogue devolves into name-calling at the level of individual words: conversation no longer even consists of complete sentences but merely of epithets building on one another.

Notice that there is a kind of linguistic progression to the list of insults. (Even though the play was originally written in French, Beckett's native language was English, and he translated his own texts). Notice that the exchange begins with "Moron" and then moves to "Vermin," the second word echoing the *m, r,* and *n* sounds of the first but in random order. The next shift is to "Abortion," followed by "Morpion," a word that doesn't exist but that collapses "Moron" and "Abortion" together, also invoking the word "Scorpion" as well. "Sewer-rat" is then followed by "Curate," which both cleverly rhymes with "Sewer-rat" and implies criticism of the clergy. The exchange culminates in "Crritic," perhaps the fiercest insult a playwright might hurl, made even more intense by the double *r* in the word. Such poetic features emphasize the literary context of the conversation; at the same time, they also suggest that what we may be accustomed to seeing as "literary" elements find their roots in the everyday. In her book *Talking Voices,* sociolinguist Deborah Tannen makes this very point, demonstrating how such literary elements as rhythm, rhyme, assonance, and imagery are as frequent and as patterned in conversational dialogue as we think they are in poetry.

Having exorcised (as well as exercised) their need to engage in verbal dueling ("abuse"), Didi and Gogo conclude the conversational episode by restoring friendship and harmony, embracing each other. One observation made by Margaret L. McLaughlin, a conversational analyst, is that there is built into the structure of conversation a tendency toward agreement: the ways in which conversation moves creates a situation in which the participants automatically strive for agreement rather than disagreement (201 passim). It ends on a note of symmetry, with Didi and Gogo each saying, "While waiting," reminding themselves, each other, and the audience of the context and the function of this conversation: to pass the time until Godot comes. The silence that punctuates their conversation is rich, filled with the possibility and necessity to move from one ritual to another many times over, within each day and from day to day.

Of all the forms of dialogue, conversation is perhaps the most common, one in which virtually all of us engage on a regular basis. It has formed the basis of realistic fiction and drama for the past several centuries and is present even in the most absurdist texts (as the scene from *Godot* and the scene from *The Bald Soprano* attest), because such a conventional and familiar form can help display other kinds of unreality. Perhaps it is because conversation is so familiar to us that we tend in our own thinking to treat it less analytically. At the same time, there are long traditions of attention to conversation, both descriptively and prescriptively. For example, in the eighteenth and nineteenth centuries, there were courtesy books, designed to teach young men and women how to act and how to speak with each other in private and public situations. Similarly, we remember having lessons in elementary school in proper etiquette while speaking on the telephone. Conversation, which we assume to be the most natural mode of communication, is also one of the most ritualized; it is the appearance of informality that can make the examination of conversation so complex.

Conversational theorists and analysts look at a wide range of elements for

a number of different purposes. There are those theorists who look at the rules of conversation, both the rules that constitute conversations (i.e., what is necessary to have happen for us to agree that a conversation has taken place) and the rules that regulate acceptable behavior in conversation, not unlike the felicity conditions of speech act theory. Such theorists are most interested in devising ways of describing universal and repeatable rules of the content and structure of conversations; we might call these theorists macroscopic in their aims and range.

Other conversational analysts are more interested in careful attention to and close description of the physical elements of specific conversational occurrences. They time pauses, note intonational patterns, and transcribe every stammer and vocalized pause (such as *uh* and *um*) in an effort to put in print each element of the sounds of the conversation. Many of these analysts have worked out elaborate systems for notating and symbolizing all of the paralinguistic and prosodic elements (the patterns of intonation, rhythm, etc.). Reading one of their analyses is akin to reading a musical score. These analysts, whom we might name microscopic, have various goals in mind: sometimes the meticulous attention to detail is designed to allow them to look for recurrent patterns over the course of a number of conversations (either multiple conversations by the same dyad, similar kinds of conversations by different couples, etc.); others look to these minute features for interpretive value—to try to draw conclusions about the relationship between a feature, such as the length of the pause before a response, and the meaning the conversationalists create together.

As you might expect, students of performance are becoming more and more interested in considering how conversational theory and analysis might illuminate both literary texts and performances of these texts. It is possible for the performer, for example, to notate a text as part of the preparation for performance, to suggest which of the many possible prosodic and paralinguistic features will be selected. A danger might be in notating a text too narrowly ahead of time, allowing the performer and text little room to breathe. But a positive element would be the ability of the performer to make conscious and concrete decisions about major elements or moments and to use notation to help in rehearsing the text. Similarly, critics or audience members might use conversational analysis to demonstrate their own reception of the performance—to note what they heard. Often, in postperformance discussion, it can be difficult to articulate a response to a given moment, in part because the ear may not be able to retrieve the specific contour of a moment, phrase, or intonation. Within reason (i.e., without losing track of all the other elements of the performance), the microscopic notation might help to make criticism more detailed and concrete.

The macroscopic conversational theorist, who is more interested in determining universal or common rules or features of conversation, may particularly help the performer who wishes to understand the dynamics of conversation in a specific literary text. It is important to remember that literary conversations are not identical to everyday conversations. Literary conversations, as a rule, tend to be more selective, more economical, and more focused, which stands to reason: they are consciously controlled by an individual writer,

who may whittle away at the vocalized pauses and eliminate digressions and side-tracking. At the same time, some writers aspire to the grittiness of everyday conversation, and their style may reflect it. What is also crucial to remember is that literary texts in general are written documents and, as such, do not have as much specific information about the spoken contours of the text. It is true that some writers use punctuation, italics, underlining, and dialogue tags to get very specific about the sound of a conversation; but an equal number do not. In fact, one of the great pleasures about the performance of literary conversations is the multiplicity of ways of uttering a given word, phrase, or exchange. Certainly, all literary texts, whether they refine the rules of everyday conversation or attempt to replicate them, refer to the way people actually speak when in contact with each other; and from this perspective, conversational theory and some of its findings can be a useful point of reference for either contrast or comparison with the literary artist's use of conversation in a text.

The number of theories and findings in the research on conversation is so vast that we cannot possibly hope to cover it all in the scope of this chapter. We will summarize some of the more intriguing and consistent aspects of conversational theory. McLaughlin suggests that conversation is rule-based and that one of the major rules is what is called *conversational coherence*. Conversational coherence is predicated on what she calls the "maxim" of "relevance"; that is, we expect the content of the exchanges in a conversation to be relevant to the topic at hand (274). We have all been in a conversation in which the other person goes off on a tangent, redirects the conversation onto a topic totally alien to the previous one, and gives the impression that he or she either has not been paying attention to what has been said or has little regard for maintaining the issue. McLaughlin cites Winograd, who is concerned with the concept of conversational goals and who suggests that *competence* in conversation requires awareness of common goals. Thus, in the Beckett scene, for example, Didi and Gogo, by virtue of their incessant repetition from day to day, clearly share and understand common conversational goals.

Various scholars have examined the rules, rituals, and conventions surrounding the opening and closing of conversations (what Erving Goffman calls "access rituals" [qtd. in McLaughlin 169]), and the nature of taking turns. Schiffrin suggests that there are three major ways to open a conversation: cognitive recognition (i.e., acknowledgment of the other person as different by class or category), identification displays (nonverbal versions of cognitive recognitions), and social recognition displays (i.e., greetings) (qtd. in McLaughlin 170–71). Mark Knapp, conversely, has derived three typical elements of conversational closings (qtd. in McLaughlin 176): signaling decreased access (letting the other person know that the conversation is ending and there is little time to be in contact with you), showing appreciation and desire for future contact, and summarizing what has been said and what has occurred (both the content and any relational messages, that is, a description of any changes in how the participants feel about or regard each other).

Taking turns is viewed as one of the foundations or building blocks of conversational analysis. Much has been written about what constitutes a "turn"

in conversation: when it begins, when it ends, what happens in between, and so forth. In life we typically do not exchange conversation simply by speaking, being silent, listening, waiting for silence, and speaking again, though this may often be the representation of conversation in literary texts. In addition, McLaughlin suggests, we engage in what she calls "non-turns," such as side comments and encouragers, not interruptions per se but utterances designed to help along the speaker whose turn it is at a given moment. She also distinguishes between disruptive and nondisruptive simultaneous talk, considering when we accept simultaneity of speech and when we do not. Think about your own conversations: when is it okay for someone to break in on your "turn"? When is it not, and why?

Another element is what McLaughlin refers to as conversational lapses, those silences within a conversation and within a turn. Hesitation pauses are those silences within a single speaker's turn, as he or she prepares to continue. As performers of literature, we are often reluctant to trust such pauses, though we might look to everyday conversation to see how frequent and important these kinds of pauses actually are. Switching pauses are those in which the turn changes from one speaker to the next. Consider the excerpt from *Waiting for Godot,* a text filled with silences. Which are more common, hesitation pauses or switching pauses? What is going on within each of these silences?

Scholars of both interpersonal communication and rhetoric are interested in what occurs between people socially and psychologically in conversation, in addition to the actual structures and rules of conversations. Because literary texts are about relationships between people, some of the concepts and constructs used by interpersonal communication are of value to the performer. Almost all literature deals at some level with conflict and power relations, even at the intrapersonal level of the lyric poem. In drama and prose fiction and nonfiction, the tensions between people from the classic tragedy of *Antigone* to the primarily nonverbal conflict of the wrestlers, Birken and Rupert, in Lawrence's *Women in Love* to the clownlike Didi and Gogo—suggest the recurrence of *dominance messages,* attempts to wrest or give up power in a given relationship or interaction within a relationship.

Sarah Trenholm and Arthur Jensen identify common terms for the three major types of dominance messages: *one-ups, one-downs, one-acrosses* (186). In one-up messages (↑), a speaker indicates a "desire to take control or limit the action of others"; in one-down messages (↓), a speaker indicates a "desire to give in or relinquish one's freedom"; finally, in one-across messages (→), there is a neutrality, "indicating equivalence or not implying control." Obviously, such messages rarely occur in isolation, and it is possible to identify, as Trenholm and Jensen have, patterns of these dominance messages within a conversational interaction. A series of opposing dominance messages (i.e., a mixture of one-ups and one-downs) is referred to as a complementary pattern. When the dominance messages are the same, the pattern is considered symmetrical: if the pattern is consistently made up of one-ups, it is a competitive symmetry; if it is primarily one-downs, it is submissive symmetry.

Again, consider Didi and Gogo. Initially, their interaction is a submissive symmetry, in which they virtually fall all over each other yielding power to the other. This pattern shifts to the series of one-ups, in which they call each other by various epithets. You might look at other dialogues in the text and try to identify patterns. Note that not all such dominance messages are as easy to label as Didi and Gogo's. Ambiguity in interpreting just what kind of move for dominance or submission is going on in a conversation can be half the challenge, both for the performer of a text and for all of us in our everyday lives. This is particularly the case in those texts marked by character and/or narrator irony, in which we cannot be wholly certain about the sincerity of a given utterance. A statement that may appear to be a one-down or one-across may actually be a sarcastic or subversive reversal, a message of disdain for the other or a masked desire for usurpation of power.

DIALOGISM AND INTERTEXTUALITY

We have considered dialogue in literature from a number of perspectives: as a fundamental human impulse and need; as form and structure; and as a way of "doing" language and experience, both in the public arena and in the private conversation. In all cases, we have focused fundamentally on the dialogue of *people,* of characters interacting verbally with each other.

It is also possible to view the dialogical situation as one that embraces ideas, cultures, and texts. To say that this is different from "people" interacting is an important and valuable distinction. A dialogical approach to texts helps us to see them as something including but larger than the positions of individuals, separate from the complex systems in which they live.

The Soviet critic Mikhail Bakhtin, whose theories of dialogism were discussed in part II, used the word *heteroglossia* to describe this simultaneous overlay of systems in dialogue. Hazard Adams and Leroy Searle interpret Bakhtin's use of heteroglossia as "all those conditions that impinge in any moment on a human event, affecting meaning" (664). *Hetero,* means "different," and *glossia* means "tongues" or "languages": at any point, with any utterance (as small as a single word sometimes), there is a dialogue among all the various conditions that contribute to the meaning. No utterance exists in complete isolation: the very act of speaking, writing, or thinking presupposes the possibility of an answer and is articulated with such a possibility in mind.

A word that has been coined to describe this dialogical process is *intertextuality.* What it suggests is that every utterance—particularly, for our concerns, literary ones—is a *text,* a piece of discourse in the making, never wholly complete or finished. It also suggests that every text is connected to other texts, that every text, in some sense, *reads* or *speaks* to other texts, drawing connections, that are both obvious and indirect.

A fundamental example of an *intertext* is found in an *allusion:* some kind of reference within a literary text to another text. Often, students take courses

in classical myth or biblical scripture to enable them to understand such references. We prefer the word *intertext* to *allusion* for a number of reasons. First, *intertext* suggests a set of active relationships, not all of which are necessarily consciously operative; it draws into relief writer, reader, and text (though many contemporary critics choose to omit the author from the primary horizon of intertextual relations). Second, the word *intertext* reminds us of the multiplicity of the kinds of texts in human experience and dialogue: in addition to literary texts, we may see cultural, ideological, historical, and personal texts at work at any given moment. As the French philosopher Jacques Derrida argues, there is nothing outside the text: the possible range of "texts" germane to a literary text may be endless; if not endless, it is certainly broader in scope than might have been imagined at other times in the history of literary study. Let us look at a text whose web of intertexts is particularly complex and intriguing.

"In the Region of Ice": An Example of Intertextuality

Read Joyce Carol Oates's story "In the Region of Ice" in the appendix (pages 532–44). As you read it, note the number of different levels of intertextuality at work. Consider the relevance of each level to an understanding of the story and to a performance of it. How many different *kinds* of intertexts do you find?

Perhaps the most significant and notable *intertext* is a literary one: Shakespeare's tragicomedy *Measure for Measure.* This drama gives the story its title and provides a link between the two protagonists, Sister Irene and Allen Weinstein, Jr., at a critical point in the story. In the play, Claudio has been condemned to death by the tyrannical villain Angelo for impregnating Mariana, Claudio's fiancée. In the speech quoted in the story, Claudio describes for his sister Isabella what he imagines death will be like. At the same time, Claudio is begging Isabella, who is a novice (a woman in the process of becoming a Catholic nun but has not yet taken her final vows of chastity and obedience), to help save his life. Angelo has agreed to stop the execution if Isabella will have sex with him. Isabella refuses, arguing that her virtue would be compromised and that it would be better for Claudio to die than for her knowingly to commit such a grave sin. The play ultimately ends happily (or relatively so), with Angelo unmasked and repentant, Claudio saved from the grave, and Isabella choosing to leave the convent to marry the Duke of Vienna.

The play raises issues about the nature of virtue, what constitutes proper conduct in a corrupt society, and the relationship between religious faith and institutional dogma. It is often classified as a "problem play," in part because it is difficult to classify as either tragedy or comedy but also because it deals with social and ethical problems. In this sense, Claudio's speech is not the only level of intertextuality the play and the story share: Oates raises many of the same issues about virtue and responsibility in her story. Although Weinstein doesn't explicitly ask Sister Irene to give up her virginity for him, he does, in a sense, ask her to give up her rigidity, her impenetrability, in order to save him from his own self-destruction.

To what extent does Sister Irene demonstrate similarity to and difference from her "sister," Isabella, in Shakespeare's play? It can be argued that she goes

further than Isabella by leaving the convent to talk to Weinstein's parents, even though she fails miserably in her efforts to persuade them to take action. But in their final encounter Sister Irene reveals that she is incapable of permitting entrance to herself, not only physically, but emotionally as well. In the single, stark gesture in which Weinstein reaches for her hand and she pulls away, she demonstrates her inability (and it does seem to be inability rather than unwillingness in any simple sense) to move beyond her very circumscribed sense of self. Unlike Isabella, she remains trapped not by religion per se but by her own manipulation of religion to allow her to remain a prisoner of her own isolation. Yes, her "Claudio," Allen Weinstein, Jr., has drowned himself, not unlike poor, mad Ophelia in Shakespeare's tragedy *Hamlet,* but she, too, is destined to a kind of spiritual and emotional death; she has retreated into her own "region of ice." As she walks down the hall, haunted by the questions of self she continually asks, she confronts the meaning of guilt, of her own sense of violation of responsibility toward another person: "If she could have felt guilt, she thought, she might at least have been able to feel something."

Shakespeare provides the perfect intertext for Oates's story. Shakespeare has often been hailed as the most universal of writers and one of the least personal, in the sense of allowing his characters to emerge as full-blooded figures, independent of his own opinions of them, implicit or explicit. We should interject that this is perhaps an overidealized view, part of the mythologizing of the "Bard," and that Shakespeare is every bit as much a product of his own era, his own nation, and his own point of view as any other writer. Nonetheless, there is something in the range of characters created by Shakespeare that does make him different from many other writers, who work within what seems to be a narrower range of what it means to be human.

It is, therefore, at some level ironic, tragic, and appropriate that Shakespeare becomes the *intertext* between Sister Irene and Weinstein. Shakespeare is the channel that allows these two people to connect. On a superficial level, Sister Irene and Weinstein seem as different as imaginable: she, reserved, controlled, prudent; he, passionate, extroverted, chaotic. Yet they are both drawn to Shakespeare, who is perhaps the central demigod in Western civilization (certainly in English literature). For both, Shakespeare becomes the text by which they mark their own lives—a sign of accomplishment and of their own entrance into the elite of the intelligentsia. As Weinstein says, "Shakespeare, only Shakespeare is . . ." and Sister Irene fills in the sentence mentally for him, but perhaps also for her: "only Shakespeare was equal to him."

However, the passion Weinstein finds in Shakespeare (notice that his paper for Sister Irene is on "Erotic Melodies in *Romeo and Juliet*") he cannot find in Sister Irene: that is, she may possess intellectual passion but not personal compassion. And although she admires the reach and the genius of Weinstein's analysis of Shakespeare, she is frightened and paralyzed by his insistence on translating the lessons he has learned from Shakespeare into actual human relationships. The tragedy of their intertextual dialogue is that they have, in a sense, misread each other through Shakespeare: what originally binds them ultimately drives them apart—the large-hearted, deep-thinking art of Shakespeare.

What other intertexts exist within the story? A second important intertextual level is a cultural and religious one: the dialogic relationship between Jewish culture and Judaism, on the one hand, and Christianity and Catholicism, on the other. As you reread the story, note the number of references to the two religions and the cultures associated with them. Weinstein's own sense of cultural identity is profoundly complicated and conflicted: he recites a litany of famous Jews—figures who have contributed to civilization—but in his less lucid moments he articulates anti-Semitic stereotypes, such as the reference to the "real beak" on the psychiatrist at the institution (the physical stereotype of the large nose). Similarly, Oates depicts Sister Irene praying, though always in a troubled way, as if Sister Irene keeps hoping that she will truly experience the mystery of Christ. Notice that she finally believes she does, as a result of Weinstein's suffering, but after she must confront the suffering "in the flesh" rather than as a theoretical construct, she rejects her spiritual experience as false and retreats into the intellect.

Oates seems less critical of religious faith or of the individual religions of Judaism and Catholicism than she is of the twisting of religion to fit the flaws of individuals. It is not that the intellectual questioning of Judaism or the self-sacrificing martyrdom of Christianity are portrayed as deficient in the world of the story but that each of the protagonists displays a pathological version of the characteristics of each religion. Weinstein questions too deeply, perhaps pins too much on the world of study and is then unable to handle his powerful, uncontrolled emotions. Sister Irene has found in the religious life a secret selfishness, a way of avoiding a family that placed too many demands on her; her devotion to Christ seems at times incidental to her use of Christianity as a safe haven in which she can pursue her own gratification. It is important to keep in mind that Judaism and Christianity are not "opposites"; rather, they are historically, geographically, and philosophically linked together—just as are Sister Irene and Allen Weinstein, Jr.

Another intertext is the set of personal texts each reader will bring to the story. We do not read impersonally; rather, we bring all of our *texts,* all of the stories that we have lived through, to our response to the story. Not everything we have experienced is necessarily relevant to our readings, but much may be. For example, your own knowledge of Shakespeare may give you one set of intertexts: if your exposure to Shakespeare was a dry one, involving nothing but quotations and tests, you may find your own response to Oates's use of Shakespeare very different from ours. Shakespeare may remain a distant, monolithic figure for you, which would be a personal text you would carry with you when you read the story. We would also hasten to add that the story might help encourage you to go back and rethink your earlier *text* of Shakespeare. Similarly, if you were raised in either Judaism or Catholicism, this background will give you a set of personal texts that will be relevant to your own responses to Oates's story. As a student, you also bring a set of experiences to the story; as a member of a family (or as someone who perhaps defines oneself without a family), you will bring another set of texts. It can be useful to try to articulate for yourself how each of these personal texts interacts with the story Oates has written. In discussing these personal texts in a classroom or rehearsal, you may be

surprised to find how differently you construct the story from other people. It might then become equally important to agree on what points of commonality would be the basis of an ensemble performance; without disconfirming the personal value of individual readings, it is necessary to find those points of contact that can become the basis of a performance text for all involved.

Different performances of the story can also become intertexts, each creating a dialogic relationship with the others. This is true both at the level of individual classroom performances, perhaps all done within a single round of exercises, and group public performances, separated by time and space. Bruce Henderson has adapted this story for chamber theater and has directed it three times, in three very different contexts. The story changed in important ways for him each time, though the common threads remained the same throughout all three of the productions.

He first directed "In the Region of Ice" at Eastern Illinois University in 1983. It was one half of a pair of stories by Joyce Carol Oates, collectively entitled *Ice and Desire.* The other story, "Bodies," was adapted and directed by a second director. The directors had entirely different casts for the two stories but shared the same set and the same designers. There was a congruity between the stories, as both deal with teachers and their disturbed students; the title of the production suggests the polarities explored emotionally in the two stories.

Two primary intertexts were at work in this production of "In the Region of Ice." The first was the primacy of Shakespeare as text; Sister Irene held a volume of Shakespeare at the lectern and was without it only when she left the convent to visit the Weinstein's. The presence of the large volume served as an anchor for Sister Irene and for the production. A second intertext was the Judaism-Catholicism division. The production began with a silent, ritualistic series of movements. Weinstein was present when the audience entered the theater, bathed in a cold, blue light. His parents entered a few minutes before the house lights went down, his father wearing a yarmulke and prayer shawl, his mother dressed in mourning. Weinstein's father pulled off the yarmulke and loosened his tie— the businessman throwing off the consolations of his religion—and the two left. Finally, Sister Irene entered, in habit but without the wimple, the headpiece nuns traditionally wore. She looked once at Weinstein, and he left; as he left, the Narrator and Sister Carlotta entered. The Narrator held the volume of Shakespeare and Sister Carlotta the wimple. Sister Carlotta affixed the wimple to Sister Irene and exited, and the Narrator placed the book on the lectern and then began the opening description of Sister Irene.

The staging was designed to play up for the audience the conflicting religious and cultural values and characteristics—in a sense, to communicate that the story would feature the tensions between Judaism and Catholicism. The religious ritual was intended to underscore the cyclicity of the story, the sense in which it is already completed when the Narrator begins to articulate it. Sister Irene ends where she began, in a way, and that is her tragedy. To mime the acts of grief and mourning and the absence of such acts by Sister Irene (she simply puts her costume back on and returns to the classroom) is in some ways to rob the story of some degree of suspense, but it then allows the audience to focus on the

psychological and cultural conflict between Sister Irene and Weinstein and to foresee the tragic outcome as inevitable—the result of some kind of destiny, not unlike the fate of characters in Greek tragedies.

An intensely *personal* text became important for Henderson during the rehearsal and production period. He selected the story during the fall semester and was scheduled to direct it in January and February. Over winter vacation, he returned to his family home and learned that his father had just been diagnosed with terminal cancer; his father died during the run of the show. In some way, "In the Region of Ice" became an intertext for the pain he felt for his father and the sense of impending loss as he drifted away into his own region of ice. And, at the same time, his father's illness and subsequent death became an intertext for understanding Oates's story and understanding the complex reactions of Sister Irene to Weinstein's death and of his parents to his illness. He did not approach this intertextual situation in as calculated a way as the language in this analysis might suggest: the points of contact between Oates's text and his own personal text were often incredibly painful. But, at moments, they were also helpful and healing, just as ritual can be.

Each of the other two productions of the story lived its own life in very different settings and contexts. The second production Henderson directed was part of an evening-length compiled script, *Women's Words/Women's Worlds,* focusing on literature written by women. The first half of the production was a compilation of poetry and excerpts from prose fiction that viewed women in various social and psychological roles (such as "Work," "Artistry," "Family," etc.). "In the Region of Ice" made up the second half of the production. Henderson used an ensemble of six performers, four women and two men, as he did in the earlier production, but in this case, the six performers not only played the roles in Oates's story but also shifted through many different roles and voices in the first half of the production. Thus, there was less identification between performer and individual role than in the first production. Staging was also simplified, following a much more traditional "Readers Theater" approach, emphasizing an offstage focus throughout and minimal costuming. This neutral approach emphasized the continuity between the first and second half of the production, so the focus was on the position of the religious and academic woman in society rather than on the Shakespearean intertext.

The third production of the story Henderson directed was at Ithaca College in 1990. Again, it was part of an evening of texts, which was itself part of a four-part series of productions presented under the umbrella title *Diversity Awareness Performances.* The first production, "Questioning Faith," examined religious diversity in post-World War II American culture. The first half of the production consisted of ensemble productions of two stories: Philip Roth's "The Conversion of the Jews" and Lev Raphael's "Dancing on Tisha B'Av." Both stories examined issues of faith and prejudice within Judaism and Jewish culture: the first, a comic tale of a young boy's "conversion" of his community to Christianity; the second, the confrontation between a gay male couple and the Orthodox community to which they belong.

"In the Region of Ice" made up the second half of the evening. Its story echoed the questions of faith raised in the first half, especially because of the

thematization of Judaism as a religion of intellectual questioning; at the same time, because Oates's story is really Sister Irene's story more than Weinstein's, there was a balance to the evening. In a sense, what was created was a dialogue between these linked but in many crucial respects very different religions. What also contributed to a sense of dialogue from the start was the production's organization. The evening was codirected by Henderson and a student intern. The student adapted and directed the Roth story, Henderson adapted and directed the Oates (using essentially the same script he had used in the first two productions), and the two directors shared responsibility for the Raphael story. So although each director had his own story, so to speak, Raphael's story gave them a common ground, a place where they worked together at all levels. It is likely that this link influenced decisions each made in directing the individual stories as well.

The production was presented in the Ithaca College Chapel, which serves the three principal religious communities of the college—Jewish, Protestant, and Catholic—and therefore does not carry one set of religious associations in its design or decoration more than any other. The production was also fortunate to have the Jewish chaplain in the audience on opening night, and he gave a response and led an open discussion. (The company had hoped to have a member of the Catholic community as well, but logistics did not allow for it.) The open discussion after each performance allowed an opportunity for performer-director-audience dialogue, particularly about the issues of religious and cultural conflict; that the performance and discussion took place in the chapel provided a dramatic context for the dialogue. Particularly interesting was the dynamic in "In the Region of Ice." Purely accidentally, through the process of open auditions, the three principal performers in the production, the Narrator, Sister Irene, and Weinstein, were all Jewish. The young woman who was cast as Sister Irene was particularly nonplussed at first, but she ultimately found the challenge of journeying outside her cultural background invigorating and, indeed, produced a subtle and powerful performance. The actor playing Weinstein brought out the somewhat risky cultural dimensions of self-loathing inscribed in the character more fully in this production than in the other two, not necessarily because of any internalized anti-Semitism but perhaps because his cultural heritage made him more familiar and comfortable with the history of persecution to which the story refers. The intertexts for this cast were in many respects much more personal this time than in the earlier productions of the story; for Henderson, the personal texts were bound up in the memories of the two earlier productions but were also in dialogue with the social and cultural texts that working with this cast created for him and for them.

CONCLUSION: PERFORMANCE AND DIALOGUE

Throughout the chapter we have offered a perspective on literature and performance that valorizes the dialogic. In fact, following in the ideas of a number of critical theorists, we have even suggested that at some fundamental level, all texts, all readings, and all performances cannot help but be dialogic, whether by design or fact: no text and no relationship with a text exists without other texts.

At the same time, there are important distinctions to be drawn between the dialogic nature of all utterances and the purposefully dialogic approach a performer, director, or audience may take. The dialogue between literary text and personal text in Henderson's first production of "In the Region of Ice" was, by his own description, not a consciously determined dialogue: it was a product of a combination of forces multiplied by the inexorable movement of what happened onstage and what happened to the director offstage. The third production, however, was consciously dialogic from its conception to its final discussion session. Decisions in selecting texts for the production, how to divide adaptor-director labor, to what degree to involve the cast in conceptualizing the production, how to involve audience members in postperformance discussion—all of these elements were borne out of a desire to create dialogue.

Think about your own performance experiences in monologic and dialogic terms. When might a more monologic approach be valid or even more desirable? To what degree can a monologic stance then be integrated into a dialogic process? Have you had performance teachers who are more monologic in approach than others? Remember, here we are not using *monologic* to describe the literary form of the single speaker but the aesthetic and ideological approach to the performance. What about directors with whom you have worked? Is there ever a time when a dialogic approach can be negative? Does it necessarily lead to a situation in which all readings, all versions, of a text in performance must be equally acceptable? (We do not think so.) Perhaps choice is the hallmark of a balanced approach, for although choice may inevitably mean moving to one way of performing a text at a given moment, it also means becoming consciously aware of the alternatives and knowing your reasons for selecting one set of options over another in a specific context.

The performance of literary texts is, at its most exciting, dialogic in the world of opportunities it opens for text, performer, and audience. We encourage you to explore the issues we have raised in a dialogical way—arguing; experimenting; and playing with ideas, experiences, and texts through a variety of performances.

WORKS CITED

Adams, Hazard, and Leroy Searle, eds. *Critical Theory since 1965.* Tallahassee: Florida State UP, 1986.

Austin, J. L. *How to Do Things with Words.* Cambridge: Harvard UP, 1962.

Beckett, Samuel. *Waiting for Godot.* New York: Grove, 1954.

Maranhão, Tullio, ed. *The Interpretation of Dialogue.* Chicago: U of Chicago P, 1990.

McLaughlin, Margaret L. *Conversation: How Talk Is Organized.* Beverly Hills: Sage, 1984.

Oates, Joyce Carol. "In the Region of Ice." *Where Are You Going, Where Have You Been? Stories of Young America.* New York: Fawcett, 1974. 57–77.

Ozick, Cynthia. "Puttermesser and Xanthippe." *Levitation: Five Fictions.* New York: Dutton, 1982. 75–158.

Petrey, Sandy. *Speech Acts and Literary Theory.* New York: Routledge, 1990.

Rukeyser, Muriel. "Effort at Speech between Two People." *The Collected Poems.* New York: McGraw-Hill, 1978. 9–10.

Searle, John. *Speech Acts: An Essay in the Philosophy of Language*. Cambridge: Cambridge UP, 1969.

Sophocles. "Antigone." *Sophocles I*. Ed. David Grene and Richmond Lattimore. Trans. Elizabeth Wyckoff. Chicago: U of Chicago P, 1954. 159–204.

Tannen, Deborah. *Talking Voices: Repetition, Dialogue, and Imagery in Conventional Discourse*. Cambridge: Cambridge UP, 1989.

Trenholm, Sarah, and Arthur Jensen. *Interpersonal Communication*. Belmont: Wadsworth, 1988.

Weinreich, Beatrice Silverman, ed. "The Golem of Vilna." *Yiddish Folktales*. Trans. Leonard Wolf. New York: Pantheon, 1988. 340–41.

FOR FURTHER READING

Bakhtin, Mikhail. *The Dialogic Imagination*. Ed. Michael Holquist. Trans. Caryl Emerson and Michael Holquist. Austin: U of Texas P, 1981.

———. *Problems of Dostoevsky's Poetics*. Ed. and trans. Caryl Emerson. Minneapolis: U of Minnesota P, 1984.

Breen, Robert S. *Chamber Theatre*. Evanston: Caxton, 1986.

Felman, Shoshana. *The Literary Speech Act: Don Juan with J. L. Austin, or Seduction in Two Languages*. Trans. Catherine Porter. Ithaca: Cornell UP, 1983.

Gusdorf, Georges. *Speaking (La Parole)*. Trans. Paul T. Brockelman. Evanston: Northwestern UP, 1965.

Holub, Robert C. *Reception Theory: A Critical Introduction*. London: Methuen, 1984.

Kennedy, Andrew K. *Dramatic Dialogue: The Duologue of Personal Encounter*. Cambridge: Cambridge UP, 1983.

Lanser, Susan Sniader. *The Narrative Act: Point of View in Fiction*. Princeton: Princeton UP, 1981.

Tompkins, Jane P., ed. *Reader-Response Criticism: From Formalism to Post-Structuralism*. Baltimore: Johns Hopkins UP, 1980.

Part III

SOURCES OF PERFORMANCE MATERIAL

Arkin, Marion, and Barbara Scholler, eds. *Longman Anthology of World Literature by Women: 1875–1975*. White Plains: Longman, 1989.

Bain, Carl, et al., eds. *The Norton Introduction to Literature*. 4th ed. New York: Norton, 1986.

Beaty, Jerome, and J. Paul Hunter, eds. *New Worlds of Literature*. New York: Norton, 1989.

Chan, Jeffrey, et al., eds. *The Big Aiiieeeee! An Anthology of Chinese-American and Japanese-American Literature*. New York: Dutton, 1991.

Gilbert, Sandra M., and Susan Gubar, eds. *The Norton Anthology of Literature by Women: The Tradition in English*. New York: Norton, 1985.

McMillan, Terry, ed. *Breaking Ice: An Anthology of Contemporary Black Writers*. New York: Viking/Penguin, 1990.

Scholes, Robert, et al., eds. *Elements of Literature*. 4th ed. London: Oxford UP, 1991.

Washington, Mary Helen, ed. *Black-Eyed Susans: Classic Stories by and about Black Women*. Garden City: Anchor, 1975.

———. *Midnight Birds: Stories by Contemporary Black Women Writers*. Garden City: Anchor, 1980.

PART IV
Performance Art

CHAPTER 13

Performance Art and the Traditions of the Avant-Garde

Performance art is a term that entered the American art world in about 1970. According to Henry M. Sayre in *The Object of Performance: The American Avant-Garde since 1970,* it was first introduced as "a distinct and definable medium in the feminist arts program run by Judy Chicago and Miriam Shapiro at Cal Arts in Los Angeles" (xiv). The term is a loose one, used to describe performative events that occurred first in the world of the visual arts in America during the late 1960s and the 1970s—cropping up in gallery spaces, museums, and elsewhere. In these kinds of performance artworks, visual artists were the performers and their acts of performance were treated as one of the media of their artistic expression. These performances are defined as "live art by artists" by RoseLee Goldberg in *Performance Art: From Futurism to the Present* (9). *Performance art* is also a term that has been used by those trained in theater arts or in live performance, such as Spalding Gray and Whoopi Goldberg, John Fleck, and Karen Finley. We will be discussing Gray's and Goldberg's performance artworks in the next chapter.

These theatrical artists choose the phrase *performance art* deliberately to distinguish the conventions of their artwork from a set of theatrical conventions most often represented on the stage in the performance of play texts such as Tennessee Williams's *The Glass Menagerie* or more avant-garde theatrical works such as Samuel Beckett's *Waiting for Godot.* Productions of either of these plays are typically staged in traditional theater spaces, employing actors sufficiently versatile to assume the appropriate acting style. In these mainstream theater practices, the actors are playing the roles of characters and the play, the drama, has a clearly defined plot. Performance artists, in contrast, often play themselves—their own personality or life—not a character, and both plot and narrative are handled in unconventional ways. They say that the only material they are really working with is themselves, and the performances rely on ritual

and narrative more than drama. These performance artists usually seek alternative spaces for their performances. They perform in bars, cabarets, on the streets, or in found spaces such as a used-car lot or an underpass. They also utilize museum and gallery spaces.

Have you seen any performance art? If so, how did you respond to it? Many students and audience members have been thoroughly irritated or frustrated by their early encounters with the form. Some confess that they simply "did not get it." Others become total fans, finding it new, innovative, open to experiment, and very often an exciting way to open up new spaces and criticize dominant cultural and aesthetic practices. It is often best when confronting a new form to try simply to let go—give in to it, accept its difference, and see where it takes you before trying to pass judgment on it or even trying to say what it means.

Performance art typically inflames the public and invites the disapproval of the critics, who often refer to it in scathing terms, calling it purely amateur self-indulgence, not worthy of the name of performance. The works are usually designed to be provocative. They cater to their own audiences at the same time as they provoke what we have called the establishment. In recent years, some of the more provocative pieces have become the center of a storm of controversy, with critics and the public calling for the censorship of the work and funding agencies withdrawing support of the artists whose works are being denounced as obscene and pornographic.

The works are often political and committed to various programs of social action. Much of the best performance art in recent years has grown out of the feminist movement. Many of these works, which are characterized as post-modern, are seen to rebel against modernist standards, which place meaning in an autonomous artwork and displace the site of meaning from the work to the audience. Sayre speaks of this practice as one that features "undecidability," the processual, polysemous, multivocal, and polyphonic. As you can see, he writes from a deconstructive base, describing performance art in terms that we used when describing Mardi Gras and other performances earlier in this book. Performance artists like Guillermo Gomez, Holly Hughes, or Robbie McCauley fuse performance art and culture. Many performance artists explore their ethnic identities through the use of personal narratives in ways not so unlike some of the storytellers we discussed in chapter 2.

PERFORMANCE ART: A DEFINITION

Performance art refers to an interdisciplinary artwork in which a performer or performers feature themselves in live performance as the focal point of the work. It belongs in the traditions of the avant-garde. The works vary widely but all share a number of common characteristics: (1) an antiestablishment, provocative, unconventional, often assaultive interventionist or performance stance; (2) opposition to culture's commodification of art, (3) a multimedia texture, drawing for its materials not only upon the live bodies of the performers but upon media images, television monitors, projected images, visual images, film, poetry, autobiographical

material, narrative, dance, architecture, and music; (4) an interest in the principles of collage, assemblage, and simultaneity; (5) an interest in using "found" as well as "made" materials; (6) heavy reliance upon unusual juxtapositions of incongruous, seemingly unrelated images; (7) an interest in the theories of play that we discussed earlier, including parody, joke, breaking of rules, and whimsical or strident disruption of surfaces; and (8) open-endedness or undecidability of form.

This chapter examines the manifestos and key concepts of avant-garde practices beginning with three overlapping movements—futurism (1909–14), dadaism (1917–24), and surrealism (1924 to mid-1930s)—and concluding with poem-paintings and happenings of the 1960s. It acquaints you with the traditions in avant-garde art in the twentieth century, enabling you to explore in performance a number of elements in these works that are later featured in the work of performance artists. We have found that students are very excited by the performance opportunities afforded by this form. It gives you another way to experiment with making your own texts, evolving and evoking a visual image, which you flesh out and amplify, and drawing upon media arts, sound, and movement to construct the performance art piece. As you look at the works of earlier twentieth-century avant-garde practitioners, think about the performative elements and principals that you would like to use, or appropriate, for your own makings.

The final chapter will look at a representative sampling of works by American performance artists of the past 20 years, showing you how you can involve yourself in this kind of performance and develop an extended work of performance art, focusing particularly on the construction of identity, of self and selves, that this form encourages.

FUTURISM AND THE BODY AS A MACHINE

The futurists, led by the Italian poet and playwright F. T. Marinetti, launched their avant-garde movement in the publication of a manifesto appearing in the Paris newspaper *Le Figaro* in 1909. They celebrated man's relationship to the machine and to technology, and they heralded the new mechanized humanity. They had a fascination for nonhuman forces, particularly the force of the machine—its strength, speed, vitality, and amorality. The roots of modern performance art can be traced to this manifesto and the ideas it expresses.

Futuristic Manifesto

1. We want to sing the love of danger, the habit of danger and of temerity.
2. The essential elements of our poetry will be courage, daring, and revolt.
3. Literature having up to now magnified thoughtful immobility, ecstasy, and sleep, we want to exalt the aggressive gesture, the feverish insomnia, the athletic step, the perilous leap, the box on the ear, and the fisticuff.

4. We declare that the world's wonder has been enriched by a fresh beauty: the beauty of speed. A racing car with its trunk adorned by great exhaust pipes like snakes with an explosive breath . . . a roaring car that seems to be driving under shrapnel, is more beautiful than the *Victory of Samothrace.*

5. We want to sing the man who holds the steering wheel, whose ideal stem pierces the Earth, itself launched on the circuit of its orbit.

6. The poet must expend himself with warmth, refulgence, and prodigality, to increase the enthusiastic fervor of the primordial elements.

7. There is no more beauty except in struggle. No masterpiece without an aggressive character. Poetry must be a violent attack against the unknown forces, summoning them to lie down before man.

8. We stand on the far promontory of centuries! . . . What is the use of looking behind us, since our task is to smash the mysterious portals of the impossible? Time and Space died yesterday. We live already in the absolute, since we have already created the eternal omnipresent speed.

9. We want to glorify war—the only hygiene of the world—militarism, patriotism, the anarchists's destructive gesture, the fine Ideas that kill, and the scorn of woman.

10. We want to demolish museums, libraries, fight against moralism, feminism, and all opportunistic and utilitarian cowardices.

11. We shall sing the great crowds tossed about by work, by pleasure, or revolt; the many-colored and polyphonic surf of revolutions in modern capitals; the nocturnal vibration of the arsenals and the yards under their violent electrical moons; the gluttonous railway stations swallowing smoky serpents; the factories hung from the clouds by the ribbons of their smoke; the bridges leaping like athletes hurled over the diabolical cutlery of sunny rivers; the adventurous steamers that sniff the horizon; the broad-chested locomotives, prancing on the rails like great steel horses curbed by long pipes, and the gliding flight of airplanes whose propellers snap like a flag in the wind, like the applause of an enthusiastic crowd.

It is in Italy that we launch this manifesto of tumbling and incendiary violence, this manifesto through which today we set up *Futurism,* because we want to deliver Italy from its gangrene of professors, of archaeologists, of guides, and of antiquarians.

Italy has been too long a great secondhand brokers' market. We want to rid it of the innumerable museums that cover it with innumerable cemeteries.

Museums, cemeteries! . . . Truly identical in the sinister jostling of bodies that do not know each other. Great public dormitories where one sleeps forever side by side with beings hated or unknown. Reciprocal ferocity of painters and of sculptors killing each other with line and color in the same gallery.

They can be visited once a year as the dead are visited once a year. . . . We can accept that much! We can even conceive that flowers may once a year be left for *la Gioconda!* . . . But we cannot admit that our sorrows, our fragile courage, our anxiety may be taken through there every day! . . . Do you want to be poisoned? Do you want to rot?

What can one find in an old painting beside the embarrassing contortions of the artist trying to break the barriers that are impassable to his desire to wholly express his dream?

To admire an old painting is to pour our sensitiveness into a funeral urn, instead of throwing it forward by violent casts of creation and action. Do you mean thus to waste the best of you in a useless admiration of the past that must necessarily leave you exhausted, lessened, trampled?

As a matter of fact the daily frequentation of museums, of libraries and of academies (those cemeteries of wasted efforts, those calvaries of crucified dreams, those catalogues of broken impulses! . . .) is for the artist what the prolonged tutelage of parents is for intelligent young men, drunk with their talent and their ambitious will.

For the dying, the invalid, the prisoner, it will do. Since the future is forbidden them, there may be a salve for their wounds in the wonderful past. . . . But we want nothing of it—we the young, the strong, the living *Futurists!*

Let the good incendiaries come with their carbonized fingers! . . . Here they are! Here they are! . . . Set the library stacks on fire! Turn the canals in their course to flood the museum vaults! . . . There go the glorious canvases, floating adrift! Take up the picks and the hammers! Undermine the foundations of the venerable cities!

Look at us! We are not out of breath. . . . Our heart is not in the least tired! For it feeds on fire, on hatred, on speed! . . . You find it surprising? That is because you do not even remember having lived!—Up on the crest of the world, once more we hurl our challenge to the stars!

Your objections? Enough! Enough! I know them! Fair enough ! We know well enough what our fine, false intelligence asserts.—We are only, it says, the summary and the extension of our forebears.—Perhaps! Let it be so! . . . What does it matter? . . . But we don't want to listen! Beware of repeating these infamous words! Rather, look, up!

Up on the crest of the world, once more we hurl our challenge to the stars! (Ellmann and Feidelson 433–35)

Try reading this manifesto aloud and performing it in class. When you first read this piece, did it offend you or did you find yourself agreeing with or even identifying with the ideas of the speaker? Did you notice how inflammatory the rhetoric is? The youthful poet Marinetti rages against the past, the establishment, institutions of learning, and art as a property of museums rather than something that can live anywhere—in the streets or outside, not just within walls. One of the characteristics of performance art is its opposition to the treatment of art as a commodity, as something that can be bought and sold. Marinetti's manifesto

attacks the bourgeois and museums as well as archaeologists. Part of his distaste for these institutions and professions stems from their assumption that art can be collected, that is, treated as if it were a property and displayed in designated places. He wants art to violate any spatial restrictions, and he battles with the concept of ownership as it pertains to art. Sensitive to the particular power of the material of art—its medium—he expresses outrage that works of artists should be mounted on the same walls, side by side, as if their lines and colors were not "live materials" but some dead things that can be assimilated almost as if they were decor. You will see that this protest against art as a commodity is one that persists in the works of performance artists throughout this century.

Note that the artists used the performance of this manifesto to launch their new artistic movements, which permitted them later to introduce their art objects, be they poems, plays, or paintings, to a public whom they had prepared for the work. The break with the past that comes about in avant-garde movements seems necessarily to entail a period of disruptive activity and energetic proselytizing. The artists are asking the public to understand art in new and different ways. Dissatisfied with the current practices and trying to break through the forms to create something different and new, these artists sometimes go to extreme lengths to capture the attention of the public and other artists and shock them into new ways of seeing.

Much of the language of the manifesto is very performative. It invites the body of the performer to act out the words that are being spoken. Look, for example, at the frequent reference to bodily acts. The manifesto calls on others to sing, to dance, to leap, to struggle, maybe to fight, or to become breathless. The call to action attempts to mobilize the audience, the public, in part by shocking them, in part by energizing them, making them act rather than be complacent.

Marinetti and other futurists put the principles of the manifesto into action. He and his circle are famous for their fascination with variety theater, cabarets, and "noise music." Noise music offers harshly dissonant, cacophonous sounds that imitate military sounds or take the whole range of sounds from life—a moving tram car, an explosion from a car, a crowd's shouting, and numerous other sounds of a bustling, mechanized city. Special instruments were designed to make it possible to create this noise music, and performances of the music were offered at Marinetti's home. Many years later in the United States, the experiments with sound and silence produced by John Cage drew on concepts and materials first used by the futurists. Cage's doctored piano, rigged with wooden spoons and rubber bands, is comparable to the rigged wooden boxes that the painter Russolo built to produce his noise music.

Among the many characteristics associated with performance art and the avant-garde are the boisterous, open-ended nature of the form as well as the role of the performer as an iconoclast, a destroyer of meanings or symbols. Earlier we referred to the "antiestablishment, provocative, unconventional, often assaultive performance stance" of the work. Look at the ways in which Marinetti attacks the bourgeois and other established institutions and professions. What means does he use to ridicule the public? What is unconventional about the way in which he sets forth his manifesto?

Marinetti's numerous performances—some taking the form of a soirée or a salon, (i.e., an evening of entertainment at his home), others being staged in variety theaters or public spaces—all were designed to inflame the public, arouse scandal, and draw still greater crowds. One of the concerns of our book has been to show how audience and context contribute to shaping the meaning of artworks. You will want to think about how audiences are manipulated by these performance artists and how the audience, on its part, affects the work. Recall Conquergood's map of ethical stances. Performance artists are very often accused of being exhibitionistic; exploitive; or extremely skeptical, almost misanthropic or misogynistic. When you watch performances in class, discuss the ethical stances taken by the performers.

How do performance artists manage to develop their own circle of followers while at the same time keeping the attention of (even by scandalizing) a larger, less sympathetic audience? One of the means consistently used by these artists involves manipulating the media—newspapers, radio, or later film and video—to advertise their events, often actually announcing events that have not and will not happen. The documented "nonevent" has become an important element in performance art in recent years. Does this raise ethical questions for you? Think about the purposes behind the practice and discuss whether or not the end justifies the means.

Marinetti's manifesto points to this technique. He published the manifesto before opening one of his plays in Paris to prepare the ground for his future work. He also recognized the power of using public performances to advertise his work further. He often announced events that did not occur in order to stir up controversy. The nonexistent works became works by virtue of the rumors that abounded about them. In recent years hardship art (also known as cruelty art) has often exploited this technique. The document about the work, more than the work itself, constitutes the performance art piece. In the performance art events of the late 1960s and early 1970s it was customary for the artists to extend written invitations to their happenings or events to a select list of guests. Often performance art audiences are made up of people sympathetic to the aims of the artists. Performance artworks in particular depend for their success in large part on the dynamic interplay among the artists, the artwork, and the integral audiences who keep fueling the work, feeding it with their responsive attitude and reconfiguring its meaning in a processual way.

Futurist performers developed their own gestural language to instruct one another on just the style of declamation they sought. They also developed a vocabulary of mechanized movements appropriate to the new technologies of force Marinetti celebrated. A brief description of Marinetti's "Dynamic and Synoptic Declamation" will give you a sense of the flavor of his playful, often infuriating performances. Goldberg draws on the *Times* review appearing in London in 1914 to describe the affair:

> . . . The room was 'hung with many specimens of the ultra-modern school of art' and 'Mademoiselle flicflic chapchap'—a ballet dancer with cigar holders for legs and cigarettes for neck—was in attendance.

Dynamically and synoptically, Marinetti declaimed several passages from his performance *Zang tumb tumb* (on the siege of Adrianople): 'On the table in front of me I had a telephone, some boards, and matching hammers that permitted me to imitate the Turkish general's orders and the sounds of artillery and machine-gun fire', he wrote. Blackboards had been set up in three parts of the hall, to which in succession he 'either ran or walked, to sketch rapidly an analogy with chalk. My listeners, as they turned to follow me in all my evolutions, participated, their entire bodies inflamed with emotion, in the violent effects of the battle described by my words-in-freedom.' In an adjoining room, the painter Nevinson banged two enormous drums when instructed to do so by Marinetti over the telephone. (18–20)

Marinetti wrote rules to govern his declamatory style. He urged the performers to use body actions that imitated the staccato movements of machines. "Gesticulate geometrically," he told his performers, setting down rules for how they could make spirals and cones and spheres in the air.

You may want to prepare a short performance for class in which you rely on your own body and movement to create a strong visual image for your audience of a human's relationship to a machine or technology. You may want your body to evoke an image of a machine or computer or some other image. The point of the exercise is to communicate clearly your visual image, using only your body as the material for the performance. At first this task may seem frightening. It might help you to think of your body as something you can sculpt. Some of you may also try adding one or two simple props or sound to your performance. Again, however, the object is to strike a powerful visual image to govern your performance.

DADAISM AND THE ELEMENTS OF PLAY AND CHANCE

The dadaist performances, which date to 1916, profoundly influenced the directions of avant-garde and performance art throughout this century. Occurring originally in the Cabaret Voltaire in Zurich, Switzerland, they spread to France and other cities on the continent, eventually dying out in the mid-1920s when they were replaced by the projects of the surrealists. Dada was committed to the principle of innovation, spontaneity, and antiart. It was inevitable that it could not perpetuate itself indefinitely without becoming predictable and so endangering its very status as chance, spontaneous affairs. The artists who made up this movement were constantly battling with one another, breaking away, and forming new movements. You will notice that a number of the artists who first appeared as dadaists later forged new movements and offered their art under the name of surrealism. Similarly, futurists appeared as dadaists.

The performance history of Dada is a fascinating and rich one, full of variety, whimsicality, and zaniness. Some of you may be familiar with Tom Stoppard's

play *Travesties,* in which he brings together three revolutionaries—Tristan Tzara, the father of Dada; James Joyce, with his revolution of the word, and Lenin, the political revolutionary who made Karl Marx's dialectical materialism a reality. Stoppard's play involves the unlikely meeting of these three figures and sets the action on the grid of Oscar Wilde's play *The Importance of Being Earnest.* Stoppard's outlandish play, a technical virtuoso for the actor and a wildly inventive, parodic play of ideas, is an excellent vehicle to convey some of the extreme ideas about play and games and their relationship to art set forth by the dadaists.

We want to focus on several aspects of the dadaist venture: its interest in chance as an integral element in art making; its use of nonsense and noncausal, illogical structure; its subjective cry, which releases the inexhaustible and uncontrollable unconscious in spontaneous joy; and its antiestablishment elements. You will want to think about some of these features in relationship to the discussion in part III of Caillois and his theories of play.

Tristan Tzara is usually credited with having originated the idea of Dada. The word itself is susceptible of almost an infinite play of interpretations. In fact, much of the pleasure derived from the word comes from its sound, the circumstance of its discovery—it was chosen randomly by opening a German-French dictionary—and its meaning. The word means "yes, yes" in Rumanian and Russian. In French it means "hobbyhorse," a child's toy or a fad. From the perspective of the inventors of the movement, it was just the right word for their purposes. In dadaist manifestos the word is repeated again and again, usually in such a manner that it appears to be just nonsense, a noise repeated for no other purpose than the deliciously silly pleasure it gives or for its sharp staccato sound that dismisses everything of value. For Tzara all knowledge is merely the sound "boum," and everyone can make their own "boumboum." He wrote that Dada abolished memory, the past, the future, logic, and all prophets. It opposed good manners and complacency.

Dadaists used chance as a method of governing both the selection and the arrangement of materials in their performances. In 1916–17 Hans Arp designed a collage of colored squares of paper arranged according to the "laws of chance." Marcel Duchamp dropped three threads of equal length onto a sheet of glass from a height of one meter and fastened the threads down with glue, following the curve of the thread just as it fell. Tzara created poems out of words written on slips of paper, dropped into a hat, and then selected randomly. The poem followed the arrangement of words produced by the random drawing.

In all these cases, the chance happening or event became an organizing principle in the structure of the work. Works so constructed flagrantly violated ordinary ideas about order and logic. The technique also put into question the idea of an artist's "genius," challenging the authority and importance of the artist's will in the work. In a calculated way, the artists sought something disordered, although we can see that actually what they did was introduce a new organizing principle, namely, random selection. Together with the preoccupation with the laws of chance came a desire to introduce objects and materials not traditionally associated with art. We already discussed an example of this technique employed by Russolo and Marinetti, both of whom were attracted to noises in life. These

artists used implements from the kitchen or household as well as from larger, outdoor environments to produce the sounds in their compositions.

The dadaists used found objects, the laws of chance, and the spectacle of unrelated materials produced simultaneously to achieve the spontaneously joyous art that was the object of their aesthetic. It was not uncommon to see a performance in which 20 different people read 20 different poems simultaneously, interrupted by dissonant sounds and interspersed with visual elements arranged in a jarring fashion.

These artworks invited their makers to engage in play, improvisation, and the development of new rules to break away from more formal structures and create a new kind of art. Some of the antics of the performers in these dadaist works are similar to the gestures and styles of performance of the music hall or the circus. In part II we discussed carnivalesque comedy and the inversions that characterize the acrobatics of the circus and bawdy, parodic comedy. The dadaists, in their search for new materials and in their fondness for the antiaesthetic object, often looked for the same kind of materials that we considered in our chapters on ritual and the social drama and public celebrations. You will want to notice the way in which performance art draws on materials from everyday life and nontheatrical contexts as well as from the traditions of Western art.

Try to construct a two- or three-minute performance based on found objects and drawing on the principle of chance for its arrangement. As you experiment with constructing a found text, think about what values are constructed around it, if *values* is the right word. Chance poems—texts compiled by arranging arbitrarily selected passages of newsprint according to a pattern established by the throw of dice (i.e., the number on the die indicating the number of the line you should use)—construct an unusual kind of experience when they are performed. Once you watch the class performances, discuss whether or not you think the text can be considered to be a "poem." If so, why? If not, why not?

You may be surprised to discover that most chance performances using found objects (often drawn from advertising copy, newsprint, graffiti, etc.) give a sense of coherence and definition in performance. They do constitute a text, but you will see that this method of finding, constructing, and in some ways appropriating a text gives rise to pleasure for some and to confusion, ambivalence, and rejection for others.

CUBIST-SURREALIST AESTHETIC
OF SIMULTANEITY AND PERFORMANCE ART

In cubist paintings such as Picasso's or Braque's, the artist refuses to let us rearrange the image so that it will conform to the three-dimensional object that was its model, be it a jar, guitar, or face. Instead, the paintings resist this kind of consistency, scrambling representational clues and forcing us to accept the flat, two-dimensional surface of the canvas with all its tensions. Cubist and surrealistic art also mix spheres of meaning, combining objects from the real room and the real world with objects drawn from a dream or hallucination. The

paintings show us a sofa in the middle of a forest or a still life of a fish in the midst of an image of a proscenium stage. The paintings and their poetic counter-parts also mingle past and present, erasing causal relationships and leaving the image enigmatic, ambiguous, and undecidable. Principles of *collage* and *assemblage* govern many of the artworks produced by the surrealists and continuing up to today. Many performance art pieces exploit the ideas and materials behind collage and assemblage.

Surrealist art probed the unconscious. In the "First Manifesto," written by André Breton in 1924, *surrealism* is defined as "Pure psychic automatism by means of which we propose to express either verbally, in writing, or in some other fashion what really goes on in the mind. Dictation by the mind, unhampered by conscious control and having no aesthetic or moral goals" (35). The painter Max Ernst also described how he used principles of collage and assemblage to create what he describes as "multiple vision."

> One rainy day in 1919, finding myself in a village on the Rhine, I was struck by the obsession which held under my gaze the pages of an illustrated catalogue showing objects designed for anthropologic, microscopic, psychologic, mineralogic, and paleontologic demonstra-tion. There I found brought together elements of figuration so remote that the sheer absurdity of that collection provoked a sudden inten-sification of the visionary faculties in me and brought forth an illusive succession of contradictory images, double, triple and multiple images, piling up on each other with the persistence and rapidity which are peculiar to love memories and visions of half-sleep.
>
> These visions called themselves new planes, because of their meeting in a new unknown (the plane of non-agreement). It was enough at that time to embellish these catalogue pages, in painting or drawing, and thereby in gently reproducing only that which *saw itself in me,* a color, a pencil mark, a landscape foreign to the represented objects, the desert, a tempest, a geological cross-section, a floor, a single straight line signi-fying the horizon . . . thus I obtained a faithful fixed image of my halluci-nation and transformed into revealing dramas my most secret desires— from what had been before only some banal pages of advertising.
>
> Under the title "La Mise sous Whiskey-Marin" I assembled and exhibited in Paris (May 1920) the first results obtained by this procedure, from the *Phallustrade* to *The Wet Nurse of the Stars.* (qtd. in Ellmann and Feidelson 163)

The interest in creating dreamscapes and, in Ernst's case, of bringing unexpected and contradictory images onto the same canvas are characteristic of much surrealistic artwork. Again, you can see how a heightened importance is given to the materials of the artwork. Later, Jean Dubuffet argued that the very paste he used in his assemblages served as the catalyst for his art. The properties of the materials as much as the agency of the artist were responsible for making the artwork. The fascination with the unconscious, its archetypes and raw libidinal

impulses, also led artists to abandon willful attempts to plummet its depth and replace their will with an appeal to automatic writing. Art produced through automatic writing was believed to capture the unconscious (and sometimes a higher visionary reality) without any mediating influence on the part of the artist.

Surrealism also took the occasion of the "nonevent" to a new plateau. One of the most remarkable pieces of this era is Francis Picabia's "ballet" *Relâche*. Goldberg describes the event as follows:

> Opening night was scheduled for 27 November 1924. But that evening the principal dancer, Jean Borlin, fell ill. Consequently a sign, *'Relâche',* the theatrical world's term for 'no performance tonight', was pasted on the doors of the Théâtre des Champs-Elysées. The crowd thought it was yet another Dada hoax, but for those who returned on 3 December, a dazzling spectacle was waiting. First they saw a brief cinematic prologue, which indicated something of what was to follow. Then they were confronted by an enormous backdrop comprising metal discs, each reflecting a powerful light bulb. Satie's prelude, an adaptation of the well-known student song, 'The Turnip Vendor', soon had the audience roaring the scandalous chorus. From then on heckling and laughter accompanied the affectedly plain orchestration and the unfolding of the burlesque 'ballet.'
>
> The first act consisted of a series of simultaneous events: downstage a figure (Man Ray) paced up and down, occasionally measuring the dimensions of the stage floor. A fireman, chain-smoking, poured water endlessly from one bucket into another. In the background the Ballets Suédois dancers revolved in darkness, an occasional spotlight revealing a *tableau vivant* of a naked couple representing Cranach's *Adam and Eve* (Duchamp portraying Adam). Then came the interval. But it was no ordinary interval. Picabia's film *Entr'acte,* scripted by him and filmed by a young cameraman René Clair, began rolling: a male dancer in a gauze skirt was seen from below, filmed through a glass plate; chess players (Man Ray, Duchamp, and adjudicator Satie) were filmed from above, on the roof of the same Théâtre des Champs-Elysées; a funeral procession took the viewers through the Luna Park and around the Eiffel Tower as mourners followed a camel-drawn hearse decked with advertising posters, bread, hams and interlocking monograms of Picabia and Satie; and a soundtrack by Satie closely matched the length of each shot in the film. No sooner had the slow-motion procession ended with the coffin falling off the hearse and breaking open to reveal a grinning corpse, than the cast broke through the "End" paper, marking the beginning of the second act.
>
> The stage was hung with banners proclaiming: 'Erik Satie is the greatest musician in the world', and 'if you are not satisfied you can buy whistles at the box office for a few farthings.' Borlin, Edith Bonsdorf and the corps de ballet danced 'gloomy and oppressive' dances. For the final curtain-call, Satie and other creators of the work drove around the stage in a miniature five-horsepower Citroen.
>
> The evening ended inevitably in tumult. (90–95)

Critics quarrel about whether Picabia and Satie can be included among the surrealists or the dadaists or whether they belong in a group of their own fashioning. Nonetheless, the elements of the event described above are typical of avant-garde movements, particularly in its unconventional music; its multimedia texture; its illogical structure, featuring simultaneous events that are unrelated except for the fact that they appear in the same frame; its sloganeering advertisements; and the dismantling of the audience's ordinary expectations about whether a performance is or is not taking place and whether there is or is not an intermission. By blurring the boundaries that conventionally separate a performance into acts, thereby providing an intermission, and by having the actors break through the film frame at the opening of the second act, the event continued the experimental tradition of trying to eliminate some of the barriers that separate the performers from the audience.

HAPPENINGS

Happenings first appeared on the art scene in 1959 in Allan Kaprow's *18 Happenings in 6 Parts* at the Reuben Gallery in New York. Kaprow chose the word *happening* in preference to words like *theater piece, performance,* or *game* because he wanted to suggest in an offhand way that something, as he says, "rather spontaneous . . . 'just happens to happen'" (Kirby 47). Actually, there is nothing spontaneous about the affair. It was planned, rehearsed (albeit in somewhat unusual ways), and scripted. It was also highly unconventional.

Michael Kirby describes the happening. Kaprow sent written invitations to 75 people, inviting them to collaborate with him in the work and simultaneously experience it. In some of the invitations, the guests were given "collaged bits of paper, photographs, wood, painted fragments and cutout figures" (67). The work was "staged" in three rooms created for the occasion in the long space of the loft gallery. The rooms were connected, and the people moving through them were then led to a common gathering area. The participants were sent instructions, which they were to execute in the designated room. Three performances took place in the three rooms simultaneously. The audience members were either participants following fixed instructions or audience-participants, for want of a better word, who were instructed about which seats in which rooms they were to take. The sound of a bell announced that the guests were to switch rooms. Throughout the evening not only were the guests confronted with visual, acoustical, light, sound, and verbally scripted experiences but they were also constantly conscious of their own role in the event. In short, it was a highly performative event, self-reflexive and antiestablishment. To give the participants a sense that they were part of the created environment, all were given pieces of "work" to occupy themselves. Some were asked to move things, others were told to turn switches, and still others had more scripted texts.

Kirby defines the happening as "a purposefully composed form of theatre in which diverse alogical elements, including non-matrixed performing, are organized in a compartmental structure" (21). He explains the term "non-matrixed" in relation to theater practices in which actors function within a matrix of time,

place, and character. The theater actor takes on a character and imagines himself or herself to be in the "world" of that character. The actor's impression is reinforced by the set, the lights, and so on. The audience clearly knows the difference between the actual time of the performance and the imagined time and place that inhabits the actor whose performance is matrixed. In the case of the "non-matrixed" performance, the performer is simply executing a task, such as sweeping. While sweeping, the performer does not invest the act with character or imagine a time and a place for the act. Instead, the task is simply done. Performers, in this regard, are treated much as though they were simply a prop or stage effect. Similarly, the occurrences in happenings take place in segmented and "closed" compartments, where again the spaces are based on the arrangement and contiguity of theatrical units that are completely self-contained. The units may be arranged sequentially, as they were in the Kaprow happening, and they can also be utilized simultaneously, but what goes on in each space emphasizes its discontinuity from what is around it. It is isolated, which contributes to the jarring effect of happenings and the odd way in which they push the burden of explanation onto the audience members as much as the makers.

In other parts of this chapter, we will discuss happenings further. In their original form, they often made the most use of noise, music, and visuals, and words were kept to a minimum, although from the very beginning the reading of chance poems was often included.

In *The Perception and Evocation of Literature,* Leland H. Roloff recounts a performance by his students that can be viewed as a precursor of performance art. The performance of Albert Camus's novel *The Stranger* seemed a dazzling defiance of performance conventions dominant at the time. His description of the unconventional performance treated it as a happening. In his description notice that it is the performance rather than the literary text that is the center of attention. The performance event functioned as an antiestablishment statement. The typical mode for performing a literary text by students of oral interpretation at the time was to employ a lectern (a reading stand) and embody the text through acts of suggestion rather than enactment. This concept of oral interpretation viewed performing as a way of experiencing literary texts. In 1972, *interpretation* was defined by Wallace Bacon in *The Art of Interpretation* as "the study of literature through the medium of oral performance" (6). The audience, coming to the home of the director in the passage you are about to read, was made up of students educated in the conventions of interpretation. These conventions, in part, affected how they responded to the event.

Roloff's approach to interpretation was somewhat different from the one that was dominant when his textbook appeared. He was more interested in the psychological underpinnings, and his approach encouraged students to take risks and defy the conventions of performance. His account demonstrates the willingness of these students to depart from the more traditional modes of performance which they were experiencing in other classes and offer an unusual rendering of Camus's literary text.

The description also shows that the director and the two principal actors saw their performance as part of the performance scene of happenings. Roloff

and clearly some of the audience came to see the performance in the context of a happening rather than judging it against conventions of an interpretive reading of Camus's novel, although in part it could be said that it was. Students were given exact lines from the text, and there was some expectation that the significant passages were selected with an eye on preserving the novel's coherence. What was less apparent at the time was the implication of such a presentational style on the material, the text, that it supposedly illuminated. Read Roloff's description of the event.

> An invitation was extended to be at a particular address at ten o'clock one Sunday morning. As the small invited audience arrived, they were greeted at the door by a silent director. He handed to each entering person a piece of paper on which appeared a rather long section from the novel. The director instructed each person that he could read aloud his piece of paper any time he wished to do so. Each member of the audience was ushered into the living room, the windows of which were heavily draped. The audience sat in silence, rather uncomfortably (a discomfort which was to prove of extreme importance before the morning was out). At a seemingly undetermined moment, a tape recorder was turned on, then another, then another, then yet another, each recorder playing a scene from the novel. The director suddenly asked that the audience go to the bedroom where they saw a man and a woman, fully clothed, lying on the bed. They arose, and the man, who wore a tape recorder hung around his neck, turned it on. The opening lines to the novel were heard. The man put on his shoes, yawned, and went to the bathroom. (All the while the recorder played the opening scene of the novel.) A member of the audience looked at his piece of script and read it aloud. Others did the same. The mirror in the bathroom was covered with foil, but the man shaved, peering into an unreflecting mirror. The woman by this time had gone to the kitchen. Some members of the audience followed her there; others remained with the man. Members of the audience continued to read their selections, the tape machines continued to play, and the tape recorder hanging from the man's neck continued to narrate Chapter 1. The man, finished with his shaving, went into the kitchen to eat the breakfast the woman had been preparing. The audience waited for the coffee to boil, the eggs to cook, and the bread to be toasted. By this time anxiety within the audience was becoming acute; their reactions to where they were, what they were doing, and the events surrounding them ranged from "meaningless" to "involving"—but no one left. After breakfast, the couple went into the living room. There was a total freezing of action; the only thing heard were all the tape recorders playing at once. One of them, louder than the rest, narrated the "murder of the Arab on the beach outside Algiers." Unexpectedly, the woman moved to the windows and flung open the curtains. Sunlight flooded the room. There was a sound of pistol shots. A pause. The man got his top coat and prepared to leave. A member

of the audience found he had the trial scene in his hand and began to read it. A tape machine synchronously played the final scene in the novel, and the audience heard the famous last line. The happening was over.

The event confronted the audience with the totality, more or less, of the events in the novel, with the totality of existential loneliness at ten o'clock on a Sunday morning, with the sense that all had been "directed," "planned," and "executed," and with a profound awareness that if the morning were to make sense, it had to make sense within the perceiver. The audience wanted to talk about what they had experienced, and they asked the director and the two members of the cast to participate. The group remained in that "theater" until well after two o'clock in the afternoon probing the novel, relating their awareness of the movement and the meaning or meaninglessness of that moment to the same elements in the novel. Those who had not read the novel felt it imperative to do so, felt the novel took on new dimensions.

While the production was not a *pure* happening, it relied on many of the elements of a happening to make it work: the chance readings of the parts handed to the audience members, the chance synchronizing of audience readings to taped readings, the juxtapositions of "life events," and the omnipresent "director" into whose hands the audience had by chance committed itself. There are not many audiences that remain three hours after a production, discussing it, and there are not many productions that live in the memory as continuing sources of information and delight. (355–56)

Can you see how this event was funded by Kaprow's happening? Notice the way the text is handled and apportioned. In what ways can we speak of this performance in an apartment as an example of a happening in the sense that Kirby defines it? Are we seeing nonmatrixed performances? Is the space compartmentalized? Kirby provides a definition of a happening, but he is quick to point out that very often the makers of happenings violate the definition. In what ways is it helpful to think about this event as a happening? Also, how did the audience participate in the event?

You may want to construct a happening, developing it around a literary text, as in Roloff's example, or around everyday life, as in Kaprow's example.

POEM-PAINTINGS

Collaboration between poets and painters; among poets, painters, and musicians; or among poets, painters, musicians, and performers (theater artists) is one of the hallmarks of performance art and the modernist influences from which it derives. The avant-garde movements of futurism, dadaism, and later surrealism all constructed works in which practitioners of these different arts—the visual arts, the theatrical or performance arts, the musical arts, and the art of dance—came together to create multileveled, interdisciplinary collaborations in which

the artists performed "live art" and defied the conventions of art dominant at the time. In other words, performance art was always profoundly antiestablishment, whether the quarrel was with aesthetic standards or political ideologies. It was also an art form in which the artists considered themselves performers.

Let us look at one of the poem-paintings, a mixed-media work executed in the 1960s by the poet Frank O'Hara and the painter Norman Bluhm. Study Figure 13.1, *Hand.* This poem-painting, 1 of 26, is executed in black and white paint and ink. The two artists decided that they did not want to illustrate a poem but rather, inspired by music to which they were listening, have a gesture (the figural representation, in this case the hand closed like a fist) relate to the idea of the poem. The hand is outlined in thick black paint with a white splash across the center. The word "Hand" is in the upper left corner; O'Hara exhibits his skills as a calligrapher in the small script in which he inserts the words of his poem.

When you studied the figure, how did you go about examining it? Did you take it in in one look, which focused first on the broad black outlines of the hand? Or did you begin by looking at the manuscript, which places words between the

FIGURE 13.1 Norman Bluhm and Frank O'Hara, *Hand,* 1960.

SOURCE: Gouache on paper, 14 × 19¼ inches. Grey Art Gallery and Study Center. New York University Art Collection. Gift of Norman Bluhm, 1966.

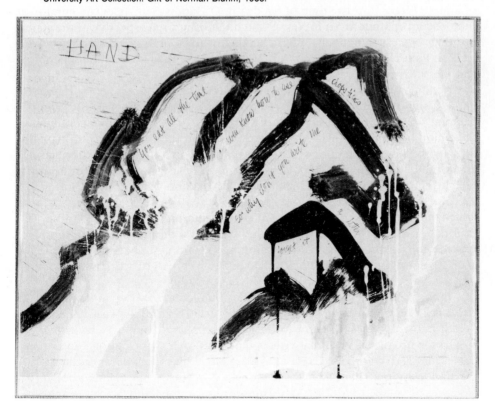

outlines of the fingers and the thumb, and then move out from there? Or was your starting point somewhere else? If you started by looking at the words that form a poem, did your eye immediately go to the left side of the frame, starting with the title; or did you begin with the opening line, "You eat all the time"; or did you start with another line and then back up, looking for the beginning? Discuss the way in which you tried to take in this poem-painting. Below is the text of the poem (qtd. in Perloff 108):

> You eat all the time
> you even know how to use
> chopsticks
> so why don't you write me
> a letter
> forget it

Both Bluhm and O'Hara were devoted to music: Bluhm had wanted to be an opera star; O'Hara had wanted to be a concert pianist. By the 1950s, O'Hara was a well-known experimental poet, associated with the New York school. Shortly after his accidental death in 1966—he was killed when a beach buggy struck him on Fire Island—he had become a cult hero. In 1975 his death was mythologized in a "confrontational" painting by Alfred Leslie entitled "The Killing of Frank O'Hara." At the time of his death, O'Hara was an associate curator of the Museum of Modern Art in New York, organizing a retrospective of the action paintings of Jackson Pollock. O'Hara mingled with painters, working closely with Jackson Pollock, Robert Motherwell, Willem de Kooning, Robert Rauschenberg, and Larry Rivers.

Action painting treated the surface of the canvas not as a site of reproduction but as a site of action, of what is referred to as "push and pull" and "all-over painting" (composition without either a beginning or an end—only a continuum), the action being the actual work of the painter in the process of putting paint on canvas. These painters view the canvas as a field that they enter. The paintings are not to be treated as static objects framing an image, no matter how abstract, which reproduced or imitated some object in nature. Rather, the painting is a site of work (a gestural surface) where the viewer can see traces of the way in which the painter actually "performed" the execution of his or her painting. The material or the medium, of the painting was not a means to an end; rather, it was the end, or the subject, of the painting. O'Hara described the principles of action painting, or what Pollock called *scale,* in a letter to Larry Rivers:

> In the past, an artist by means of scale could create a vast panorama on a few feet of canvas or wall, relating this scale both to the visual reality of known images . . . and to the real setting. . . . Pollock, choosing to use no images with real visual equivalents . . . struck upon a use of scale which was to have a revolutionary effect on contemporary painting and sculpture. The scale of the painting became that of the painter's body, not the image of a body, and the setting for the scale, which would

include all referents, would be the canvas surface itself. Upon this field the physical energies of the artist operate in actual detail, in full scale. . . . It is the physical reality of the artist and his activity of expressing it, united with the spiritual reality of the artist in a oneness which has no need for the mediation of metaphor or symbol. It is Action Painting. (*Art Chronicles* 34–35)

During the era of action painting, artists like Yves Klein experimented with other forms of "live painting." Taking the idea about the surface of the canvas as a field of forces, Klein began to use live models, not as his subject, but as his paint brushes. In *The Anthropometries of the Blue Period,* exhibited in Paris first in 1958, he covered the bodies of naked women with monochromatic colors of paint and then invited the women to roll on a canvas that was stretched on the floor, moving in any manner they saw fit. Once the canvas was covered with the actual bodies and the marks or blotches of paint they left, the viewer saw a canvas (called a painting and treated as a work of art) on which a visual representation of the act of its own making was exhibited. The event of the gallery piece in which the painted women rolled on the canvas is an example of performance art. The painting made from this process is a piece of action art, in which the materials that make it are an important aspect of what it is. In addition, the painting produced in this manner as a performance piece explicitly raises questions about art—what it is and how it is to be understood. Pollock sometimes literally flung paint at the canvas from considerable heights (he moved across metal rigging suspended above the canvas) in order to capture the violence of his bodily movement in material textures of the paint.

The poem-paintings of Bluhm and O'Hara belong in the traditions of action painting, happenings, and performance art. They also can be traced back to the works of dadaists, surrealists and the verbal "readymades" of Marcel Duchamp. Bluhm describes the work on the poem-paintings as a "terrific event, a Happening—a way of amusing ourselves. They were done as an event by two people who had this special feeling for each other and for art, music, and literature. . . . We thought of our collaboration as a theatrical event, an amusement " (Perloff 106–07).

The poem-paintings they made, contrary to being slight and trivial works, are important in what they reveal about the nature of performance art and its commentary on *establishment* art and poetry. Here, by *establishment,* we refer to the dominant voices, or the arbiters of taste, who set the standard of what is to be considered "high" art or "excellent " poetry. In the early 1950s through the 1960s, O'Hara rebelled against the great moderns, such as T. S. Eliot and Ezra Pound, whose poetry was famous for its erudition, use of symbol, difficult surface, and rich use of allusion. Such poetry is highly intellectual. O'Hara preferred to trace his roots to the American poet William Carlos Williams and his celebration of ordinary experience described in colloquial language. Many American poets rebelled against the postsymbolist practices of Pound and Eliot, beginning with Karl Shapiro in the 1940s. In the 1950s the Beat poet Allen Ginsberg offered *Howl,* an anarchic primal scream, in response to the rarefied

voice of Eliot. In the world of visual art there were similar rebellions against cubism and abstract expressionism.

Both Bluhm and O'Hara are part of the New York school of artists who are trying to break away from certain practices of the moderns. In the case of O'Hara, you see ample evidence of his desire to use simple, plain language and a lean, sparse, colloquial style. There is something campy about his sense of humor. There is an artlessness about the poem-painting and yet, simultaneously, you are made very conscious of the long traditions of art. O'Hara is interested in the poem's surface itself rather than in using the surface to capture a meaning behind or beyond it. He wants to attend to the surface in its immediacy and quickness. It is material and present, like a gesture. The poem is also parodic and whimsical, making fun of itself and almost dismissing its consequence in its final line, "forget it." Often he interjected materials from pop culture and film into his works. He also had a fondness for found objects.

The found object contrasts with the made one. Much traditional art reflects an artist's careful fabrication of an object, such as an apple in a Cézanne still life or Picasso's blue guitar. In each case, the artist tried to make an object that bears a resemblance, sometimes even a verisimilitude, to objects in nature. Or in the case of Picasso and Cézanne, the objects in their paintings offer the artists' impressions of or distortions of objects in the natural world. When an audience looks at these objects, they relate them to a vast tradition of artistic representations of such objects. Consequently, the objects are linked to the past and memory and a body of visual images created by artists. The objects also bear the signature or imprint of the artist who makes them.

The found object, sometimes called the *raw* as opposed to the *cooked,* simply exists out there in life, to be found by chance by the artist and then incorporated into the artwork. Claes Oldenburg, a sculptor who created many happenings, took ordinary objects from everyday life or from newsprint and magazine pages and made them into the materials of his art—sometimes constructing these found objects out of papier-mâché, wood, and glue, making a monstrously large wedge of chocolate and vanilla cake or a seven-foot pistachio ice cream cone. Much of the object of this kind of effort is to take the very familiar—for Oldenburg, a cake or a sausage; for O'Hara, a hand—and defamiliarize it, making it something new.

Bluhm and O'Hara choose the hand as the subject of their prose poem. For artists, the subject of the hand has long been one of high seriousness. The hand is the implement of both the writer's and the painter's art. Through it, both exert control of their medium, be it words or paint. The deftness of the hand is a requirement of both arts, the more so in the case of the painter, obviously; but for much of history, when words were transcribed by hand and set down on manuscripts (or even today, when we use computers), artists were dependent on the health of the physical hand to produce their art. Earlier in the book we referred to the "pandying" received by Stephen Dedalus in James Joyce's *A Portrait of the Artist as a Young Man.* Joyce took great care in developing a rich set of associations tied to the hand. Stephen's pride and his artistry are threatened when the prefect bruises Stephen's hand with harsh blows. The hand

is an instrument of autoeroticism in the novel. Stephen places it in his pocket, very near his genitals, as he stands eyeing and longing for his childhood love, Eileen Vance, with the long, white fingers. In short, hands are of vital importance to artists, and it is no accident that the subject of this poem-painting is the hand and that the hand suggests art, sexuality, intimacy, and power. However, artists want to defeat this power of the symbol and force you to engage the hand in new ways.

After looking at the black and white gouache of the hand, can you identify other icons that it represents? Can you see how it can be thought of in relationship to two hands held together in a position of prayer? To the hands that can hold chopsticks, implements not so far away from the pen and the scalpel? The two collaborators are trying to assert the presence of this particular gesture and words, while at the same time we are made aware of much that is absent, including numerous other renderings of hands.

O'Hara's aim is to keep the surface of this poem very much in the present, trying to deny us the opportunity to read behind it and making it function more symbolically than as an immediate, material presence that is idiosyncratic and resists explanation by virtue of its symbolism or a commentary it offers on itself. Can you see how O'Hara manages to achieve this objective in this poem-painting? Although we can talk of all the symbolism that surrounds hands, there is also a way in which this work wants to keep the quirky image of just these particular lines, woven with a kind of graffiti that invites us to "forget it" just as we "grasp" it. O'Hara and Bluhm strive here for an openness of form, something kinetic or active that engages the audience and performs itself almost as it seems to undo aspects of itself.

The opening line of the poem is disarming in its frank colloquialism. Against traditions of high art in which a poem's diction is elevated and words are freighted with meaning to achieve evocative affects and symbolic resonance, this poem opens with a declaration that the hand "eats all the time." The opening suggests that the speaker is bored by all the symbols of an overly symbolic, consumer society—a society in which advertisers have put Botticelli's Venus rising from the half-shell on liquor bottles. The visual strokes depicting the hand are equally irreverent and "unpoetic." The poem continues by observing that the space between the fingers can be filled with "chopsticks," but then it quickly turns to another possibility, namely, that a pen can replace chopsticks and maybe a letter can be written. Now the line takes on a more personal meaning. The speaker suddenly and nakedly introduces his need, his hunger for emotional food—a love letter. But as quickly as he asks for it, he says "forget it," and places the lines between the thumb and the forefinger in such a way that the visual image suggests just how easily the hand can let the letter drop. In this poem-painting the audience is asked to keep studying the surface of the work, discovering various ways of understanding it, which keep being revised the more the eye and mind experience the process of the work. It is this quality of the work that makes it involve process, discovery, and open-endedness. O'Hara is working with poetry in a manner imitative of the action painters.

The gesture of the poem-painting is quick and whimsical. A tension is created by the fact that the surface of the image uses black lines, black manuscript

against white, cutting up the plane of the two-dimensional paper and creating a permanence that the words, together with the visuals, attempt to erase. In such a way, O'Hara and Bluhm construct a work that is best understood in the traditions of performance art.

In this case, we have two artists who do actually perform together in the sense that they have executed their collaborative work, both employing bodily effort to realize the making. The performance is more *paratheatrical* (i.e., it is almost theatrical) than theatrical. It emerges in a situation that the artists' themselves describe as an ordinary daily occurrence. It is a kind of play that leads them to create something whimsical, but also something that is to be understood as art. O'Hara uses words and the performance of them; Bluhm uses brush strokes. However, the poem-painting that results from this joint performance of the two artists itself belongs in the traditions of the avant-garde—the open-endedness of the work, its insistence that we attend to the medium in which it is made, and its campy rejection of "high art." These are all a part of the traditions that began with the futurists in 1909 and realize themselves in the 1980s and 1990s in the work of individual performance artists like Judy Chicago, Karen Finley, and Laurie Anderson. Bluhm and O'Hara did not describe themselves as performance artists. In fact, the phrase *performance art* had not yet entered the critical vocabulary. Nonetheless, in attempting to explain the rise of performance art and trace its roots, this experiment by O'Hara and Bluhm exhibits many of the elements that are later configured as performance art pieces.

"WHY I AM NOT A PAINTER," BY O'HARA: 1960 EXPERIMENT WITH A DADAIST TECHNIQUE

Another example of dadaist elements can be found in one of O'Hara's best poems, "Why I Am Not a Painter."

> I am not a painter, I am a poet.
> Why? I think I would rather be
> a painter, but I am not. Well,
>
> for instance, Mike Goldberg
> is starting a painting. I drop in.
> "Sit down and have a drink" he
> says. I drink; we drink. I look
> up. "You have SARDINES in it."
> "Yes, it needed something there."
> "Oh." I go and the days go by
> and I drop in again. The painting
> is going on, and I go, and the days
> go by. I drop in. The painting is
> finished. "Where's SARDINES?"
> All that's left is just
> letters, "It was too much," Mike says.
> But me? One day I am thinking of

a color: orange. I write a line
about orange. Pretty soon it is a
whole page of words, not lines.
Then another page. There should be
so much more, not of orange, of
words, of how terrible orange is
and life. Days go by. It is even in
prose, I am a real poet. My poem
is finished and I haven't mentioned
orange yet. It's twelve poems, I call
it ORANGES. And one day in a gallery
I see Mike's painting, called SARDINES.

> (*The Collected Poems of Frank
> O'Hara* 261–62)

This poem expands on the idea of the relationship between poetry and painting and also offers a fuller example of some of the avant-garde techniques that poets have incorporated into their verse and that can also be seen to contribute to an understanding of performance art. Try performing this poem, experimenting with the space you want to set it in and the way in which you take on the character of the speaking subject, the "I" of the poem. Notice how time is handled.

To give you a little background, Michael Goldberg is a painter and contemporary of O'Hara. The two men were personal friends. One of the devices O'Hara employs to make poetry speak more colloquially, more as if it were one person speaking to another, is to use real proper names, forcing the audience to recognize that poetry comes out of life—real people in a real historical time and moment. It is also important that the name may not be known to a large part of the poem's audience. The poem makes us see Goldberg as a friend, someone important to the poet but someone that the poem refuses either to elevate beyond what is appropriate or to diminish more than he deserves. The naming also contributes to the poem's appearance of being a slice of life, a piece of casual conversation. It forces us to recognize that there are lots of things, including people, whom we simply do not and will not know.

Similarly, the poem suggests that it holds meanings for the poet that it cannot hold for us. In fact, in this poem there are other pieces of information that will have meaning only for those who know O'Hara. Because he worked in an art gallery and wrote art criticism as well as caroused with New York painters, many critics would solemnly ask O'Hara why he was not a painter. He thought the question was absurd, and one of his responses to the actual question is this poem. However, even when writing it, O'Hara and Goldberg and some intimate few can share its in-joke at the expense of the all too solemn critic, but at the same time this knowledge will probably be unknown to many who encounter the poem. From O'Hara's perspective, this aspect is also part of the poem's unfolding and shifting meaning. This device makes us think more about poetry and its relationship to living.

Another background detail important to an understanding of the poem is the fact that O'Hara had, indeed, written a series of surrealistic, erotic prose poems entitled *Oranges,* in which oranges are never mentioned or alluded to again. The poems open with the line "Black crows in the burnt mauve grass, as intimate as rotting rice, snot on a white linen field" (*The Collected Poems of Frank O'Hara* 5). You can see how perversely he denies any reference to the color orange as he mentions other colors. O'Hara wrote the series of poems to be incorporated into an exhibition of paintings by Grace Hartigan, also entitled "Oranges." As he states in "Why I am Not a Painter," the series of poems began when he tried to write a poem about oranges. He kept finding more and more words to express what he was feeling, but although he knows that "oranges" were once part of the poem, the reader knows this only because of a title that appears to have little bearing on anything else that happens in the 12 prose poems. The dadaists in their manifestos revealed the importance of the apparently inconsequential or the accidental in art. O'Hara's use of his title, as if it is of no consequence, can be traced back to their ideas.

Hans Arp, in *On My Way, Poetry and Essays 1912–47,* wrote about dadaist ideas and works:

I Became More and More Removed from Aesthetics

Dada aimed to destroy the reasonable deceptions of man and recover the natural and unreasonable order. Dada wanted to replace the logical nonsense of the men of today by the illogically senseless. That is why we pounded with all our might on the big drum of Dada and trumpeted the praises of unreason. Dada gave the Venus de Milo an enema and permitted Laocoon and his sons to relieve themselves after thousands of years of struggle with the good sausage Python. Philosophies have less value for Dada than an old abandoned toothbrush, and Dada abandons them to the great world leaders. Dada denounces the infernal ruses of the official vocabulary of wisdom. Dada is for the senseless, which does not mean nonsense. Dada is senseless like nature. Dada is for nature and against art. Dada is direct like nature. Dada is for infinite sense and definite means

The Navel Bottle

The bourgeois regarded the Dadaists as a dissolute monster, a revolutionary villain, a barbarous Asiatic, plotting against his bells, his safe-deposits, his honors. The Dadaist thought up tricks to rob the bourgeois of his sleep. He sent false reports to the newspapers of hair-raising Dada duels, in which his favorite author, the "King of Bernina," was said to be involved. The Dadaists gave the bourgeois a sense of confusion and distant, yet mighty rumbling, so that his bells began to buzz, his safes frowned, and his honors broke out in spots. "The Eggboard," a game for the upper ten thousand, in which the participants leave the arena covered with egg yolk from top to toe; "The Navel Bottle," a monstrous home furnishing in which bicycle, whale, brassière

and absinthe spoon are combined; "The Glove," which can be worn in place of the old-fashioned head—were devised to show the bourgeois the unreality of his world, the nullity of his endeavors, even of his extremely profitable patrioteerings. This of course was a naive undertaking on our part, since actually the bourgeois has less imagination than a worm, and in place of a heart has an over-life-size corn which twitches in times of approaching storm—on the stock exchange. (48–49)

Arp's many descriptions of dadaist works show us the way in which they celebrate anarchy and the irrational. Inconsequential items, for example, a bottle or an egg yolk, are introduced into the art object in ways that seem to be nonsensical. Can you see how O'Hara's insistence on naming the color orange only to abandon it is just exactly the kind of unreason and nonsense that the dadaists cultivated? It is interesting to note that in this essay Arp also talks of art as a fruit, saying that art, "the spiritual fruit of man, usually shows an absurd resemblance to the aspect of something else." He wants art not to stand in opposition to nature; it must not be a substitute for nature and nature's objects; rather, art must be liberated from forms like apples or mandolins and be allowed to express sublimated emotions flowing from the body of the artist until they grow into intensely new forms. Arp worked in the medium of plastic. He often took a curve and intensified it until it became something else.

O'Hara compares his art as a poet with the art of his friend the painter. Whereas his overt object is to show why he works with words and not paint, he actually shows, in his parodic way, how both the painter and the poet work in similar ways—masking the original inspiration for their work and building more and more meanings in the process of the art until O'Hara's poems no longer make any overt reference to the color orange, which was their beginning point, and Goldberg's paint has fully covered the image of sardines, with which he started. O'Hara produces the erasure of "orange" by leaving the word out of all the rest of the poems and adding instead many other words. Goldberg applies more paint to his palette, also, through addition, concealing the original markings. Initially, it may appear that the two arts are quite different—Goldberg constantly taking out the image of the sardines he created, whereas O'Hara puts in more and more words—but beneath this superficial difference in technique are important points of commonality. Part of the poem's final joke is that art involves the chance string of associations. Its end product, if viewed as product and not as part of a process, can perversely negate most of the impulses that originally led to the work. O'Hara is reaffirming one of the principles important to happenings and performance art: the work is processual; a discovery; and in important ways, illogical and irrational.

CONCLUSION

This overview of avant-garde movements from the dadaists through the happenings of the 1960s gives you some idea of the richness of performance traditions in the twentieth century and the principles you can use to construct

your own performance art pieces. There is much that we have had to leave out: the Bauhaus in the 1920s in Germany, where theater artists and dancers worked closely and collaboratively in a teaching school for the arts; the works of Oskar Schlemmer and others concerning the opposition between visual planes and spatial depth and his own vocabulary for gesture dance. Later in the early 1930s, the Bauhaus formed a touring company. Their experiments in the relationships of painting and performance were later brought to the United States, influencing the composer John Cage, the dancer Merce Cunningham, and the painter Robert Rauschenberg.

Before concluding, we want to highlight two important dimensions of all this experimentation. One involves the active role the audience plays in creating the emergent meanings of the various pieces. The other involves the improvisational, found quality of the pieces. In an important sense, we can consider performance art a hybrid, crossing performance in everyday life with performance of high art.

Can you see how much of the discussion in part II about forms of cultural performance is useful to an understanding of these avant-garde performance traditions? In part II we looked at narratives, personal histories, and ritual events, such as the social drama and Mardi Gras. You probably noticed the extent to which repetition patterned many of these performative events. Repetition can be of two sorts: (1) it can produce a copy, an imitation of the thing or phrase that is repeated, as if it existed out there in some original form that can be repeated again and again; or (2) repetition can produce a *similacrum,* a repetition that strives for but can never capture something that exists out there. The similacrum offers a trace of the original; that is, it offers the original with a difference. In fact, such repetition acknowledges that there is no pure original thing that is being repeated. You have seen works that practice repetition of both kinds. However, as art is increasingly viewed as process and not as product, the repetitions it practices are more like a simulacrum than a copy. In this respect, the role of the audience becomes more active than in art that asks an audience to regard, to look at passively, a spectacle of imitation. As artworks lose their authority and the question of whether an artwork is or is not original becomes more pertinent, the audience is more empowered and the work threatens to displace itself or even to self-destruct.

In the next chapter you will look at a number of performance art pieces that begin to treat the pseudocommodity status of an artwork in new terms. One of the ways in which these performance traditions open up space for new meanings and new ideologies and social actions is by their heteroglossic features. It is useful to pursue the question of the relationship between ritual and narrative and the avant-garde traditions we have explored in this chapter.

The found nature of many of the materials used in the performances we have looked at in this chapter also connect these performances to the sphere of everyday life. Collage and assemblage raise the issue of breaking the frame, questioning the relationship of inside and outside. When you place a bicycle pump alongside a wood chip or a photograph alongside a piece of canvas washed in acrylics, can you see how the collage keeps forcing you to reflect on the

combination of such unlikely things, relating them back to the environments from which they came—some of which lie outside the frame in everyday experience, others of which relate to other artworks? In this sense, the collage keeps exploding its frame, involving you in the interpretation of meaning. The banal qualities of so many of the objects often call forth quite personal memories and narratives in audience members. One of the ways these works achieve their open-endedness and undecidability is by hovering between different kinds of time and space and different kinds of materials—those that are raw and those that are cooked; the animate and the inanimate; the trivial, banal object from everyday experience and the aesthetically made object.

You have also been exploring how you relate to these performance art traditions. What kind of performances do they inspire you to make? How can their performances be used to advance a political agenda or alter attitudes about art, gender, and technology? How do the materials of these arts, the audience, and the principles that direct the making of the event actively combine to create the emerging meaning?

WORKS CITED

Arp, Hans. *On My Way, Poetry and Essays 1912–47*. New York: Wittenborn, 1948. 48–49.
Bacon, Wallace A. *The Art of Interpretation*. 2nd ed. New York: Holt, 1972.
Breton, André. "First Manifesto." *The Surrealist Revolution in France*. Trans. Herbert S. Gershman. Ann Arbor: U of Michigan P, 1974.
Camus, Albert. *The Stranger*. Trans. Mathew Ward. New York: Knopf, 1988.
Ellmann, Richard, and Charles Feidelson, Jr., eds. *The Modern Tradition*. New York: Oxford UP, 1965.
Goldberg, RoseLee. *Performance Art: From Futurism to the Present*. Rev. ed. New York: Abrams, 1988.
Kirby, Michael. *Happenings: An Illustrated Anthology*. Ed. Michael Kirby. New York: Dutton, 1965.
Marinetti, F. T. "Futuristic Manifesto" Trans. Eugen Weber. Ellmann 433–35.
O'Hara, Frank. *Art Chronicles 1954–1966*. New York: Braziller, 1975.
———. *The Collected Poems of Frank O'Hara*. Ed. Donald Allen. New York: Knopf, 1971.
Perloff, Marjorie. *Frank O'Hara: Poet among Painters*. New York: Braziller, 1977.
Roloff, Leland H. *The Perception and Evocation of Literature*. Chicago: Scott, 1973.
Sayre, Henry M. *The Object of Performance: The American Avant-Garde since 1970*. Chicago: U of Chicago P, 1989.
Stoppard, Tom. *Travesties*. London: Faber, 1975.
Wilde, Oscar. *The Importance of Being Earnest*. London: Methuen, 1910.

FOR FURTHER READING

Baudrillard, Jean. *In the Shadow of the Silent Majorities, or the End of the Social*. New York: Semiotext(e), 1983.
———. *Simulations*. New York: Semiotext(e), 1983.

Best, Steven, and Douglas Kellner. *Postmodern Theory: Critical Interrogations.* New York: Guilford, 1991.

Birringer, Johannes. *Theatre, Theory, Postmodernism.* Bloomington: Indiana UP, 1991.

Bürger, Peter. *Theory of the Avant-Garde.* Trans. Michael Shaw. Minneapolis: U of Minnesota P, 1984.

de Lauretis, T. *Technologies of Gender: Essays on Theory, Film and Fiction.* Bloomington: Indiana UP, 1987.

Hutcheon, Linda. *A Poetics of Postmodernism: History, Theory and Fiction.* New York: Routledge, 1990.

———. *The Politics of Postmodernism.* London: Routledge, 1989.

———. *A Theory of Parody: The Teaching of Twentieth-Century Art Forms.* New York: Methuen, 1985.

Lyotard, Jean-François. *The Postmodern Condition: A Report on Knowledge.* Minneapolis: U of Minnesota P, 1979.

Meyrowitz, Joshua. *No Sense of Place: The Impact of Electronic Media on Social Behavior.* New York: Oxford UP, 1985.

Toulmin, Stephen. *Cosmopolis: The Hidden Agenda of Modernity.* New York: Free, 1990.

Contemporary Performance Art

This chapter will extend our consideration of the evolving history of performance art as a pluralistic art form, a category that embraces a variety of impulses, media, and designs. We will examine four figures who suggest the range of possibilities in the performance art of the past two decades as well as major trends for the future. For the sake of consistency, we have chosen four solo performance artists. The first two come from the earlier end of the time period encompassed in this chapter, the 1970s and early 1980s; the latter two have found their primary success and popularity in the 1980s and 1990s. In a sense, the contrast between the first two, Chris Burden and Eleanor Antin, and the second pair, Whoopi Goldberg and Spalding Gray, demonstrate critic Philip Auslander's schematization of the two ends of the era: "Whereas the earlier generation was concerned with the body's raw physical presence, the current generation is more concerned with the word than with the body." (119)

FOUR PERFORMERS: BURDEN, ANTIN, GOLDBERG, AND GRAY

Chris Burden

Chris Burden began his career as a sculptor, the medium to which he has, for the most part, returned. He emerged as part of the California (primarily Southern California) art scene of the late 1960s and early 1970s. He has been one of the most controversial contemporary artists because his work has involved personal risk and has challenged the boundaries of what constitutes the acceptable or appropriate in aesthetics.

Burden's performance pieces diverge from the other three we will consider in that the verbal component of his *texts* is minimal or entirely absent. Burden has constituted text on the level of idea and act rather than as a linear and narrative progression of words or connected, interpreted events. In trying to classify the nature of his performance pieces, critics have alternately used such terms as *body art* and *conceptual art,* the former because Burden uses his body as the primary material for artistic expression, the latter because, although the body is the material, the idea behind the performance piece is often viewed as the primary force of inspiration. As critic Jan Butterfield has written, "It is not his body per se that comprises Burden's pieces—but his mind. . . . His body is merely a tool with which to pry open the lid to the mind" (Burden and Butterfield 238).

It is the nature and quality of that mind that has been the basis of much analysis and disagreement, with some critics (and some audiences) venturing to suggest that Burden's taste for risk and his relationship to society verge on insanity. Burden himself, although acknowledging that in a few instances the demands of his performance pieces led him close to something near madness (most specifically his "Bed Piece"), for the most part he dismisses the emphasis placed on risk in his pieces. As C. Carr suggests, Burden "denies any interest in either pain or transcendence." (118). As Burden himself says, "The important thing to remember was that *I* had set it [the risk conditions] up" (Burden and Butterfield 225).

What are these performance pieces that have been the source of so much controversy, to the extent that Burden was mentioned in *People Magazine* as recently as 1989? Let's look at a number of them, considering what Burden seems to have been working with and toward what ends.

One of his first major performance pieces was done as part of his master of fine arts program at the University of California at Irvine. Entitled "Five-Day Locker Piece," it consisted of Burden confining himself to an extremely small locker (it measured 2 × 2 × 3 feet) in a campus gallery for a period of five days. The only concessions to human comfort Burden allowed was a five-gallon bottle of water in a locker above his own and an empty five-gallon bottle below. Beyond that, he simply existed in the extremely confined space for the prescribed five days. The piece engendered considerable discussion, and Burden remarked on what it was like to be the object of discussion and debate. The physical discomfort and sensory deprivation marked the beginnings of Burden's aesthetic of performance, an aesthetic that would be elaborated on in even more dangerous ways.

In response to another piece, "Shout Piece," in which Burden used his recorded voice to insult and offend the audience, Burden created one of the first of his pieces to put himself in a potentially life-threatening situation: "Prelude to 220, or 110." The 220 and 110 refer to electric voltages. In this piece, Burden had himself bolted with copper bands to the floor of the F-Spot gallery. Nearby, he had two metal buckets filled with water and 110 voltage wires. At any moment, it was conceivable that an audience member (or spectator—it is difficult to select an altogether appropriate name for those who witnessed Burden's pieces), either by design or by accident, might upset the buckets and electrocute Burden, who was quite literally and authentically bound to the floor. Of course, one of the results of this piece was to recontextualize the audience's relationship to the art

event: the audience members had considerable responsibility and power but also were themselves put in what might be called a state of psychological and emotional "danger," "risking" their own ability to cope with such a potentially stressful situation. This piece was followed by "220," in which Burden took his interest in electrocution even further, this time also involving other people, a gallery flooded with water, and the temporal variable of fatigue to raise the stakes.

These pieces were followed by such others as "Bed Piece," in which Burden stayed in a bed installed in a gallery for a period of 22 days (a piece that he conceded led him as close to the edge of sanity as any he has done), and "Icarus," involving gasoline, sheet glass, and fire and playing off the Greek myth of Icarus, the youth who flew too close to the sun and whose wings were melted. Other pieces became more public in their audience and occasion as well as in their recognition. In "Shoot," for example, done in 1971, Burden had himself shot in the arm at close range by a friend. "Deadman" (1972) consisted of Burden lying under a tarpaulin next to a car on a busy thoroughfare in Los Angeles during rush hour—for which he was arrested. "Through the Night Softly," performed in 1973, had Burden, arms tied behind his back and almost naked, crawling through a path of broken glass as the piece was filmed. The immediate audience for this piece was not the art world per se but the passersby. "Doorway to Heaven" (1973), which Butterfield has called Burden's "most personally immoral" piece, had Burden stand in the doorway of his studio and shove two live electric wires into his chest; the wires crossed and exploded, saving Burden from electrocution.

Perhaps the climax of Burden's series of performance pieces is "Trans-Fixed" (1974). Although many of his pieces clearly borrow images from classical mythology and Western civilization, often juxtaposed with the technology of contemporary society, "Trans-Fixed" may be seen as taking that tendency to its apex. Burden had himself nailed to the back hood of a Volkswagen. The car was then pushed partway into the street, the engine was turned on for two minutes—in Burden's words, "screaming for me"—the engine was turned off, and the car was pushed back into the garage (Burden and Butterfield 237). Photographs documenting the event suggest the multiplicity of texts at work. The sacrificial element, present throughout many of Burden's pieces, is especially prominent in the crucifixion image of Burden nailed in a Christ-like position, with the stigmata in his palms. The Volkswagen is a particularly piquant choice—an extremely popular, economical car, somehow a symbol of 1960s and 1970s middle-class commodification. One reading might be of the artist as martyr and the event as a parody of the commodification of artworks, an important element in the development of performance art in this period. In ways both simple and complex, the juxtaposition of Christological and industrial-capitalist images both rebels against the notion that art is something for sale to the highest bidder and winks at it—as if to complicate the romanticized image of the artist by linking him to the Bug.

Burden has, in the last decade or so, turned away from performance as his medium for art. He has returned to sculpture, but he has also built on the conceptual and environmental elements found in his experiments in performance.

Perhaps one measure of the distance he has come from these early pieces is a recent retrospective that consisted primarily of objects—"relics" or "icons," some critics have called them—from his performances, displayed in almost traditional museum fashion behind glass. The momentary and temporal having disappeared, what remains are the documentary materials, the nails like shards of wood from the "true cross," often sold during the Middle Ages.

Burden's reception was and remains controversial, and the bases for the controversy varied. The question of whether his pieces constitute art at all is much debated, forcing the issue of what is acceptably considered art. The nature of the texts produced by the performance pieces, as well as the question of their value, is equally difficult and open. Many critics simply saw an aestheticization of the masochistic in Burden's "risk" pieces. For others, including Burden himself, although risk was present, more important were issues of control and power— the artist's authority over his own body, the audience's position in the life of the art experience, and the disciplining of the body and mind by and as the basis of art. Although we hasten *not* to recommend that you emulate Burden's own experiments in risk and control, he remains an intriguing example of art as extremity—and of performance as a way of exploring and testing various kinds of limits.

Eleanor Antin

At approximately the same time that Chris Burden was moving away from any traditional notions of sculpture and moving toward his combinations of body, performance, and conceptual art, Eleanor Antin was beginning to experiment with multimedia ways of exploring her body and herself. Antin's training in the various arts was both disciplined and eclectic. She graduated from the City College of New York, worked as an actress, and studied and wrote poetry. By the 1960s, she was also experimenting with the visual arts. In contrast to Burden, whose aesthetic of performance evolved from his work as a visual artist, Antin's work stems from the performance art tradition of the individual whose desire for self-expression needs a plurality of media in which to manifest itself. Although many of Antin's most important first projects took the visual component as *a,* even *the,* primary medium, her work as actress and writer were never entirely absent.

Two visual projects point forward to Antin's more overt use of performance. "Carving: A Traditional Sculpture" (1972) was an effort to extend the classical Greek marble sculpture to the actual human body. In an interview, Antin explained what interested her in the Greek marble sculptures: "They would keep carving around and around the figure and whole layers would come off at a time until finally the esthetic ideal had been reached" (Nemser 281). Antin had her naked body photographed over a period of 36 days from four positions (front, back, and right and left profiles), coordinated with a regimen of diet. Over the period of time documented, Antin lost 10 pounds. As she recalls, the change from photograph to photograph was minimal, and the viewer could focus on individual images, on the repetitive pattern, or on the subtle changes. What is significant from the standpoint of performance is the artist's use of her own body through

time as the basis for her artwork. The conscious effort to change her body through the discipline of dieting, along with the self-described goal of achieving an "esthetic ideal" roughly analogous to the method of the Greek marble sculptors, suggest the performer's thematizing of the body and attempt to control it in a time-bound and temporally dynamic situation. As with some forms of play, there is also an element of chance (*alea*) at work: however consciously controlled the dieting, there was no guarantee of a specific weight loss. It is possible to see Antin playing a game in which time, fate, and perhaps even gravity are also competitors.

A second visual project, considerably more playful, was the "100 Boots" series, a "postcard novel," as it were. It was, as Antin explains, in part an effort to use "mailwork" (her own word) as an alternate "distribution system," that is, as opposed to publishing the series in one place or through more conventional means. This goal places Antin's work in a sociopolitical context in which the means of production of the artwork is being questioned, perhaps even critiqued. It also questions who the audience might be for works of art, as Antin herself determined who would receive the postcards and felt free to take people off the list and restore them when and as she saw fit. Similarly, the issue of the limits of time for the completion of a work of art was challenged by the fact that Antin took over two years to send out the entire series of cards, though, as she has indicated, "the day I did the first card I did the last card"—which, by the way, ended with the boots in the Museum of Modern Art in New York City. Though not all 51 cards of the series were worked out from the beginning, the idea of a beginning and end, to be suspended over a number of years, created an interesting sense of what it means to tell a story, what it means to invent and be invented by a narrative. Each image was given a title that suggests an action or event in which the boots were involved, titles like "100 Boots Out of a Job" and "100 Boots in a Field" (Munro 426).

The composition also contributes to a simultaneous sense of play and eeriness, almost a Brechtian alienation. The absurdity of imagining this astronomical number of boots having adventures is droll and childlike in some respects; at the same time, the absence of the human figure suggests a kind of comment on the depersonalization of a mass-marketed society, in which the boots carry more of a sense of presence, action, and involvement than any human individual. Again, the creation of a narrative and sustaining it over an unusually long period of time look back to such novelistic traditions as Dickens's serial novels and also look ahead to Antin's major work as a performance artist—her development of a series of personae, or sustained characters, by which she explored various aspects of herself and which became the primary focus of her work through the 1970s and 1980s.

A video piece, "Representation Painting," exhibited around the same time as the "Carving" series, also served as a bridge from visual art to performance art in Antin's career. This video, whose title of course plays on the notion that painting attempts to represent material objects and individuals, consisted of Antin going through an elaborate process of making herself up. By the end of the 35-minute tape, Antin ventures out into the world. What was remarkable about the piece, from Antin's perspective, was her commitment to doing the makeup in

a "straight fashion," with no sense of intentional parody. In an interview, she indicates that "It was very simple make-up and the kind I respect on other people but just never bother using myself because I don't use any make-up" (Nemser 283). Certainly, as her interviewer suggests, there is some level of feminist comment on the "painting" of women in contemporary society, but Antin is quick to respond: "I don't want to rip myself off. I made myself as glamorous as possible. I rather grooved on looking so good" (Nemser 294). It is important to keep in mind that Antin sees her performance as an act of self-exploration as much as a social critique. The fact of the beauty market is undeniable, but for Antin the process of transformation involved in any enactment of a persona foreign to her everyday one is what is most important.

Around 1972, Antin began to create a series of four personae as "an exploration of the self, not simply as a single self-image, but as a collection of several possibilities open to a particular individual" (Roth 76). Think about this way of describing the self; it shares certain similarities with Jung's concept of archetypes. The four personae with which Antin worked were the King, the Ballerina, the Nurse, and the Black Movie Star. In each case, Antin had a specific goal: "to rule [King], to star [Ballerina], to help [the Nurse], and to turn one's blackness in a white culture into a Virtue and a Power [Black Movie Star]" (Roth 76).

The idea of the persona is a complex one, and should not be equated in any simple sense with the actor's assumption of a role in a scripted, plot-based play. Indeed, one of Antin's primary goals was living *in* the role. Thus, she would frequently go out into the community in a specific persona and interact with various individuals, some of whom did not necessarily know that she was Eleanor Antin giving a performance.

According to Antin, the evolution of the various personae did not always involve a completely conscious plan or design. For example, the King grew out of her desire to determine what kind of man she would be if she were a man. Building on her training as an actress and visual artist, she played with facial hair and, in her words, "learned I was not an explorer—a grizzled Hemingway. My small chin couldn't make it. I found I was not a fierce patriarch, nor Jesus. Only when I trimmed my beard into an elegant courtier style did I know I had found him/me" (Munro 425). She adds that she later discovered a resemblance between herself-as-man and the painter Van Dyke's portrait of Charles I.

From there, Antin improvised contemporary life in the persona of her King. She did not write a script or try to locate herself in the historical period of the King to whom she bore a resemblance. Rather, she "got the idea to go out and talk to my people. Ask how things were going" (Munro 427). She became "the King of Solana Beach," and her performance consisted of moving among and interacting with her "subjects."

She utilized other persona in a number of ways. For example, the Nurse became the basis of a video performance piece, "Angel of Mercy," and was specifically the historical Florence Nightingale as filtered through Antin's own dialogue between history and her own psychological self. In other words, although the text of the performance was based quite heavily on historical fact and document, it was also a "fiction" mediated by Antin's own principal goal of using performance to explore the various major aspects of herself.

One of the most potent of the personae developed by Antin was the Ballerina, who emerged as a response to Antin's experience with the King; having worked through what it would mean for her to be a man, Antin wanted to do the same thing with a feminine persona. Because she is herself a woman, she needed to find an image that was almost hyper-feminine. For her that was the Ballerina (Munro 285). She has also said that another reason for selecting the Ballerina was that "ballet had always been my passion but they say that after ten or twelve you can't be a ballerina anymore. I said to hell with that" (Munro 285).

Antin studied ballet for several years, studying older forms of ballet and working on toe, perhaps the most grueling technique. She discovered that she was not in this case particularly interested in documenting the process of becoming the Ballerina, as she had been interested in the evolution of her body in "Carving." Rather, "the interesting thing was to make myself into a ballerina and show the final project." She threw herself into creating this persona of the Ballerina, producing drawings of her "life with Diaghilev" and finally writing her memoirs. The Ballerina and the Black Movie Star finally merged in some respects as Antin became "Eleanora Antinova, the Once Celebrated but Now Retired Black Ballerina of Diaghilev's Ballet Russe" (Sayre 84). *Being Antinova* was a daybook she wrote to document her three weeks in New York as the Ballerina in 1980, when she presented her performance. At her performance as Antinova, she read from her memoirs, in the tradition of the grand prima ballerina, now the author. In odd and interesting ways, Antin's performance carried some sense of parody of the kind of literary performance in which the presence of the celebrity reading her scripted text is the occasion for public attention and excitement. Even today, the authorial reading, whether good or bad in aesthetic terms, remains a popular mode of performance, the audience frequently less focused on the text being read than on the text of the celebrity presenting herself or himself.

Antin's art has continued to develop through the last decade, including her elaboration on the impulses toward puppets and artificial figures found throughout her career. She maintains faithful but intentionally small audiences. Although her performance art is considerably less ephemeral than that of Burden, in that her various books and catalogues have given a kind of permanence often associated with the material product of the book, she remains squarely, so to speak, in the avant-garde. Critics disagree over the quality of her actual performance work, but her synthesis of various art media as a way of exploring and, some would say, constructing her "selves" makes her emblematic of very important aspects of performance art.

Whoopi Goldberg

If both Chris Burden and Eleanor Antin represent the eclectic, to some degree ascetic, performance artists—who intentionally limited the distribution and reception of their performances to a fairly narrowly defined audience, the radical art community—our last two performers move toward the opposite end of the continuum. Philip Auslander suggests that in recent years, mass media has created a "rapprochement between performance and entertainment" (120). No doubt,

many of you have heard of both Goldberg and Gray, and it is equally likely that you were perhaps surprised to see them listed under the heading of performance artists. You may have seen Gray in one of his cable specials or in the film *Swimming to Cambodia* (or indeed, you may have first encountered him in one of the published volumes of his monologues). Whoopi Goldberg may be even more of a surprise for some of you. Your knowledge of her is likely to be as an off-beat but nonetheless commercial and somewhat traditional actress or stand-up comedian, a recent winner of the Academy Award for Best Supporting Actress for her role in *Ghost* and the recipient of considerable praise for her performance as Celie in the film of Alice Walker's novel *The Color Purple.* Indeed, none of these perceptions of either Gray or Goldberg are inaccurate, but they are also incomplete. We will begin with a consideration of Whoopi Goldberg, who serves as something of a bridge between the personae of Eleanor Antin and the verbally centered performances of both Goldberg and Gray.

Antin and Goldberg are especially connected through the assumption of various personae as the core of their performances. There are also significant differences between them, in that Goldberg in her live performance work deliberately moves among many characters in the course of an evening (though generally staying "in" character within a single monologue), often breaking the illusion of characterization either spontaneously and intentionally and blurring the lines between dramatic character and her "own" performance persona. For example, for the videotaping of her live Broadway performance, she did not get the response from the audience she wanted. So, still more or less in the character of Fontane, her drug-addicted Ph.D., she instructed the audience as to the proper response and started the performance again. The audience not only did not mind the instruction but also audibly enjoyed the sense of collaboration with the performer.

Goldberg is similar to Lily Tomlin and also to such predecessors as Ruth Draper, whose name is synonymous with the monologue form, as well as to such contemporaries as Eric Bogosian (Gentile 169 passim). Like both Tomlin and Bogosian, Goldberg achieves a blend of entertainment values and political agenda. As a black woman, Goldberg is in a particularly marginalized position; consider how the commercial arenas for theatrical and mediated performance (such as television and film) have typically constructed, restricted, and simply ignored the black woman as anything other than a stereotyped figure. In fact, when asked why she chose the one-woman form for her performances, Goldberg frequently replies that it was simply the only way she could manage to get her work shown (Hurwitt n.p.).

Goldberg's life is an odyssey of growing up in poverty, going through a dissolved marriage and motherhood, and moving to California to try to break into theater (Berson 19ff). She played occasional roles in such plays as *Getting Out* and *Mother Courage* but began to flourish and develop her own particular brand of performance when she became involved with a Berkeley performance group, the Blake Street Hawkeyes. It was with this company that she first began to perform her monologues, under the title *The Spook Show.* She also worked on a one-woman show called *Moms,* based on the life of black comedian "Moms" Mabley, suggesting another source of Goldberg's style and aesthetic. In 1985,

Goldberg's evening-length performance, *Whoopi Goldberg,* supervised by noted stage and film director Mike Nichols, had a successful run on Broadway. Ironically, Goldberg, who began her solo performances in some part because she could not find conventional avenues for casting, had a Broadway success in her avant-garde, dramatic, stand-up monologues.

Just as Antin moved increasingly toward fixed scripts for her performances as Eleanora Antinova, so Goldberg's monologues, although still maintaining some degree of improvisation, particularly in interjections and asides to the audience, are for the most part set texts. However, their specific form has changed in some ways in the transition from the earlier versions in *The Spook Show* to the Broadway versions, which some critics see as more sentimentalized and less political in their bite (Berson 24). It would be instructive to compare some of the monologues in their written form and the live Broadway performance as documented in the video.

Goldberg's recurrent characters all share their position of oppression in society, though the specificity of their lives varies considerably. The character to which she has devoted the most complex attention is Fontane, the drug-addicted Ph.D. in literature from Columbia University. We first meet Fontane in *The Spook Show,* where he ruminates on such topics as abortion and E.T. In the Broadway production, the centerpiece of Fontane's monologue is his visit to the Anne Frank House in Amsterdam. This is an instance in which Goldberg has been accused of sentimentality, drawing on the martyred child as a source of her politicizing. Responses to this portion of Fontane's monologue vary, some people feeling that the use of the Anne Frank anecdote to contrast the Holocaust to the civil rights movement lacks intellectual solidity; others find a complex irony in Fontane's ability to see, as the "wise fool," through his drug haze to the fact that an entire planet has adopted as an inspirational adage an optimistic position that only a child could honestly articulate.

Goldberg also uses Fontane's drug-induced bluntness to open up the audience's perceptions about drug use and abuse and to try to correct stereotypes. In one of the more edgy moments, Fontane confronts the audience with the challenge to see Betty Ford as really no different from him. In fact, in a later cable special, in which Goldberg impersonates Fontane exclusively, the performance is framed with a prologue in which an unseen Betty ("Bett-ay" in Fontane's dialect) releases Fontane from the Betty Ford Clinic.

Fontane is Goldberg's primary foray into the masculine sensibility. The other characters in her Broadway performance are all women situated in various positions in contemporary society. "Crippled Lady" is daring in Goldberg's insistence on articulating the halting speech of the cerebral palsied woman; the content is perhaps sentimental in its presentation of a noble man who helps the woman overcome her own self-oppression, ending in their marriage. Nonetheless, Goldberg's willingness to take on the perspective of the disabled individual is something of a landmark.

She takes similar risks in monologues like "Surfer Chick," which begins as an amusing but somewhat aimless parody of "valley girl" speak but turns to a sad narrative of the young woman's unwanted pregnancy, horrifying wire-hanger

abortion, subsequent sterility, and rejection by her family. The pathos is genuine but in some ways easily achieved. What is interesting is the phenomenon of Whoopi Goldberg, as a black woman, parodying a particularly *white* stereotype and turning it away from stereotype, finding some depth in the outcome of this girl's brief foray into adulthood. That, in some respects, she seems unchanged on the surface at the end may itself be seen as Goldberg's unwillingness to force an epiphany.

In "Little Girl with Blonde Hair," a monologue from *The Spook Show* and the Broadway production, Goldberg offers a little black girl fantasizing that she is white. Entering with a white shirt draped over her head, which she insists is her glamorous, long blond hair, she dreams about her future and responds to images of beauty from popular culture, particularly TV advertising and merchandizing. Goldberg is careful to establish the little girl's economic milieu: her mother works on Wall Street, so there is a degree of comfort and financial security. Goldberg is clearly documenting the effects of racism even on those well off economically, again breaking stereotypes that would suggest that racism affects only the ghetto resident. Throughout, Goldberg maintains the voice and perspective of the little girl, allowing the child to articulate the fears, frustrations, and concerns of all those hurt by racism.

This monologue harkens back to several ancestors, including the adult-as-child, most memorably rendered by Fannie Brice as Baby Snooks and Lily Tomlin as Edith Ann. Part of the pleasure an audience takes from this sort of performance is in the mimicry, the incongruity of the adult enacting childish behaviors, voices, and attitudes. Much of Brice's work as Snooks was on radio, and hence depended on her voice (though she did dress up in an oversized little girl dress for stage appearances and publicity photos); Tomlin did Edith Ann on the TV show *Laugh In,* appearing in costume and perched on an exaggerated rocking chair. Goldberg eschewed such costumes and props (other than the all-important white shirt) and depended on her body, her voice, and her ability to make an audience believe in her inner life as a child. Her approach to performance has been called minimalist or, in John S. Gentile's word, "coarse" (Gentile 172). In some respects, this aesthetic takes Goldberg away from the personae of Eleanor Antin and perhaps closer to both the stand-up comedian and the literary performer, who depend primarily on the audience's imagination to flesh out detail.

The nonrepresentational approach to costuming has its thematic values, as well. Goldberg achieves something of a unity of vision and values by always reminding the audience that at some level she remains herself. In Brechtian terms, her customary black sweater, white shirt, and black leather trousers allow her both to enact and to comment on each of the characters in her show, thus binding what might to a casual observer seem to be a series of entertaining but quite loosely woven monologues. This quality of remaining herself at some level has carried through to her film work (with the notable exception of *The Color Purple*): in many of her light comedies, such as *Jumpin' Jack Flash* and *Burglar,* there is little difference in style, delivery, and personality between the Whoopi Goldberg of monologue, stand-up, and talk-show situation and those of the nominal characters of these films. For some viewers, the result is deficient: Goldberg isn't

"acting." For others, the opposite is precisely the source of pleasure: the knowledge that Goldberg's customary approach to comedy will be present. Can you think of other contemporary performers for whom this statement is also true? Consider such figures as Robin Williams, Eddie Murphy, and Roseanne Barr Arnold, all of whom have played dramatic characters in film and on television.

The elusiveness of identity is complex when one views Goldberg's performances as entire evenings and her presentation of a performing self throughout a career. She has been quoted as saying that she does not like the audience to be aware of Whoopi Goldberg when she is onstage (Steinman 40), and this feeling comes through not only in her impersonation of the various characters in her show but also in the curtain speech she makes for the videotaped version of the Broadway performance. In it she speaks eloquently and lengthily about the avant-garde and about the necessity of bringing work like hers to wider publics, articulating what we can probably assume are her genuine sentiments. Yet, although the content of the speech might reasonably be seen to be her own thoughts and feelings, she presents them in a variety of shifting accents and voices, beginning with a kind of affected stage speech (a kind of near British); moving to Jamaican; and ending with Yiddish/New York/West Side, almost like a burlesque or vaudeville veteran. This contrast between the seriousness of the substance of the curtain speech and the lightness, even playful trickery of skipping from one voice to the next continues to complicate Goldberg's own construction of the identity of her performing self. After all, it is useful to remember that her name, Whoopi Goldberg, is an obvious and deliberate stage name—as Robin Williams said, an amalgam of a Yiddish comic and a novelty device designed to simulate a farting noise.

Spalding Gray

If Whoopi Goldberg's intention is, at some level, to erase herself (as "Whoopi Goldberg") from the stage, masked by her various characters, it might be said that just about the opposite is the case with Spalding Gray, the last of our four performance artists. Though Gray has had an active and successful career as an actor who plays roles other than himself (and was educated in theater at Emerson College), he is perhaps more widely known as the most successful and popular of a class of performance artists who have been grouped together under the heading "autoperformers"—performers of their own lives. Others are Karen Finley, Holly Hughes, and in some ways the musician and media artist Laurie Anderson.

In many respects, this subgenre of performance art shares some of the characteristics of the autobiography and the lyric poem as well as some of the complex issues of identity raised by those literary forms. Recall from part III the difficulties of setting hard rules for autobiography—such as to what degree any invention of an incident or a rearrangement of sequence is permissible. Remember, too, that some theorists would argue that all text making is fictionalizing: it is selective and involves self-conscious embellishment of the "fact" (however contested that term itself may be).

The autoperformance may also share some qualities with the personal narrative, which was examined in the beginning of part II. Indeed, the autoperformance may be seen as combining the literariness of written texts (i.e., autobiography and lyric poem) with the immediacy of performance context inscribed into the traditional personal narrative or oral history. As we suggested, the personal narrative is not in any sense purely spontaneous, any more than the literary text lacks a sense of "presentness" (illusory or otherwise). So how might we differentiate the performance artist's autoperformance from either of the two forms discussed earlier?

A brief and probably unsatisfying answer might be that there is no necessary difference between autoperformance and the cultural and literary performances of self we have been considering in parts II and III. Indeed, there are ways in which—if we concede that many culturally centered personal narrativists such as Hurston and Kingston engage in the same kind of selectivity that the more traditionally literary writers do—the sociopolitical, personal, and global issues raised by many autoperformers are indistinguishable from the oral histories collected by many ethnographers. Similarly, consider the fact that such autoperformers as Gray and Karen Finley have had their monologues published for commercial purchase and silent reading. How, then, are these volumes different from the literary texts we asked you to engage in performance in part II?

A more complex answer might lie in the artists' intentions and their own sense of the status of their texts. To read one of Finley's monologues on the page is to engage in an experience not entirely unlike reading a poem by a confessional writer like Sylvia Plath, Anne Sexton, or Robert Lowell. Much is made of the personal life of the author, viewed through symbol; metaphor; and crafting of language through sound, rhythm, and image. Yet Finley has been controversial not simply for the verbal content or style of her monologues. Indeed, her role in the recent controversy over the grants of the National Endowment for the Arts (which we will consider at the end of the chapter) is also bound up in her use of her own body in performance and the discomfort viewers have experienced in watching her use various materials as part of her narrative of being abused and oppressed. It would be interesting to speculate about whether her work would be viewed as quite so problematic if it lived exclusively in the relatively private pages of the printed book. Finley's texts of autoperformance are located as much in the temporal, kinetic presentation of her body as in the words she composes.

Such is the case, in perhaps less dramatically confrontational ways, with Spalding Gray. He explains the origins of his own autoperformances as an outgrowth of his propensity for social storytelling when a student at Emerson College. He worked nights in the kitchen of the Katherine Gibbs School (a secretarial academy) and told stories to other workers to pass the time (Gray, *Sex* ix). This habit continued as a part of his everyday life, though initially with little or no thought to placing these social performances in the aestheticized frame of the public arena. He recalls spontaneously performing a personal narrative as part of an acting workshop and being asked who had written the monologue (Gray, *Sex* x), but he still did not see this as an avenue for serious performance.

It was only as a result of working in the experimental theater of the 1960s that Gray began to develop his autoperformances with any degree of seriousness. Working first with Richard Schechner and then as a founding member of the Wooster Group, he began to understand the depth of his desire to use himself as a text for performance. "Three Places in Rhode Island," an ensemble piece, served as something of a watershed. In it, he explicitly drew on events in his family's life, and in the second of the pieces, "Rumstick Road," he played "Spalding Gray" and told personal stories.

These experiences led to keeping a diary, and this diary eventually became the source of his autoperformance monologues. The performances were not in any simple sense the same as the kind of literary performances we considered in part III, nor even the kind of authorial performance parodied by Eleanor Antin in her "appearances" as Antinova. They were not public soundings of texts composed in or for silence. Gray has described the process: "I'll chronicle my life, but I'll do it orally, because to write it down would be in faith, would mean I believed in a future. . . . Each performance was to be a personal epitaph. Each night my personal history would disappear on a breath" (*Sex* xii). The subjects of these monologues range from adolescent memories of sexual initiation to a "personal history" of Gray's experiences in the theater.

The transcription of the monologues from this ephemeral form to the printed page was not an easy one for Gray:

> None of them [the monologues] had been written down prior to performance; they always came together in front of the audience. . . . At first I was intimidated by the idea and thought that I would have to take the stories in each monologue and rewrite them. When I tried to do this I found I no longer had my own voice. My writing was derivative and imitative. It was then that Melanie [Fleishman, his editor] and I decided to rework the transcripts from my performances and turn them into writing. She wanted to preserve the original breath and rhythm of my voice. . . ." (*Sex* xiii).

Gray's longest and most complex autoperformance is *Swimming to Cambodia,* a two-part performance presented first in 1986, which toured various parts of the country and was eventually filmed by Jonathan Demme. Gray's description of the process by which he developed *Swimming to Cambodia* is strikingly similar to that of the other, shorter monologues:

> *Swimming to Cambodia* evolved over two years and almost two hundred performances. It was constructed by recalling the first image in my memory of each previous performance, so it evolved almost like a children's "Round Robin" game in which a phrase is whispered around and around a circle until the new phrase is stated aloud and compared with the original. The finished product is a result of a series of organic, creative mistakes—perception itself becoming the editor of the final report. (xv)

Can you see how Gray's own reflections on his process situates *Swimming to Cambodia,* along with his other autoperformances, somewhere in between the oral narrative per se and the more self-consciously aestheticized performances based on literary texts? Gray's commitment to some elements of chance and to the journey of the psyche through and from an image clearly marks the monologue as something whose actual verbal text is fluid and mutable, always in a state of change. At the same time, the extraordinarily public and postmodern context of the theatrical setting for the performance imposes a degree of self-consciousness that veers toward the kind of polishing and intellectualizing more customarily associated with the aestheticized realm of the literary. And the necessary presence of this particular performer and the varying audiences place Gray's work in a category with the other performance artists in this chapter.

Gray's actual performances also suggest the liminality of his position. His performances are as simple as Goldberg's in their approach to staging, though with a very different feel and result. Gray simply enters, carrying his notebook; sits behind a table; and begins the performance, combining a reference to the diary, which presumably jogs his imagination in the ways he has described, and direct, orally composed "telling." In *Swimming to Cambodia,* he occasionally adds other effects, such as a map of Asia and, in the video, clips from *The Killing Fields* (the film that inspired Gray's monologue) and music by Laurie Anderson. There is the appearance of utter simplicity and straightforwardness; at the same time, as the performance progresses, the audience becomes aware of how much actual performance skill and craft are involved in Gray's spellbinding narrative of his experiences.

As we contended with Whoopi Goldberg, perhaps contrary to her own stated intentions, that a consistent, definable presence named "Whoopi Goldberg" was present in the performance at all times, so it is with Gray. As Frank Rich has suggested, there is a level at which "Spalding Gray," for all his historical and presentational verity, also emerges as a fiction of sorts, connected to the man who lives outside his stage performances but also not entirely identifiable with him (qtd. in Gentile 151).

This assertion is noticeable both in Gray's style of performance and in the content and themes of the monologue. In live viewings of Gray's performance of *Swimming to Cambodia* as well as in the film version, one observes the performer being aware that he is performing, sometimes phrasing and pacing his speech in a way that goes beyond the conversational, that reaches toward artifice; at the same time, in both versions, it is possible to detect occasional flaws in delivery, times when Gray misspeaks, hesitates, stammers, or reaches for a word. Although the performance is considerably less "coarse" in feel than Goldberg's, it is clear that Gray makes no effort to create an illusion of total control over language and the act of speaking. At some level, he wants us to see the seams in the performance as well as to admire the artistry. That we as audience move willingly between our admiration for Gray's talents and our acknowledgment of his "errors," and indeed take pleasure in our consciousness of both and in our willingness to become wrapped up in his stories and performances, is a testament to his ability and achievement.

Let us look at one brief segment of the monologue. *Swimming to Cambodia* grew out of Gray's experience in playing a small role in the film *The Killing Fields,* a film that followed the odyssey of journalist Sydney Schanberg and his assistant Dith Pran through the horrifying experiences of the Vietnam war in Cambodia. The film documents Schanberg's efforts to use his position as a journalist to save Pran from imprisonment and death; thus, the film is in some respects itself about the self-consciousness of the individual journalist, whose role in reporting and creating news carries ethical and personal dilemmas and complexities.

Gray began working on the monologue six months after the completion of the filming of *The Killing Fields* (*Swimming* xvi). In some ways, then, he speaks as both participant and observer, recalling his own role in the film and in the making of the film, but with a certain degree of distance and remove, effected by time and space. The monologue is both document and fiction, and the performer is both Spalding Gray and "Spalding Gray," both historical and cultural member and aestheticized "actor."

The selection we have chosen to consider highlights some of these metaperformance (i.e., performance about performance) issues, and it occurs in the first part of the monologue (for live performances, Gray designated each half as a part and typically performed them on separate occasions, though they are combined in the film version).

My first big scene was to be filmed on a soccer field outside of Bangkok. We were reenacting the 1975 evacuation of the American embassy in Phnom Penh. I was with Ira Wheeler, who was playing John Gunther Dean, the last American ambassador.

Ira is an interesting man—he used to be vice president of American Celanese Chemical. After he retired he was singing in a glee club in New York, where someone saw him and put him in Jane Fonda's *Rollover.* Now, at sixty-three years old, he was beginning his film career. If you live long enough I find it all comes full circle. Shortly after I arrived in Bangkok I found out that Ira served on the same ship in World War II as my Uncle Tinky. They were on an LST together in the Pacific.

So Ira was playing John Gunther Dean, the last American ambassador. We got to meet Dean because he is now ambassador to Thailand, right there in Bangkok. And because Costa Gavras was getting sued for fourteen million dollars by the Chilean ambassador for *Missing,* David Puttnam wasn't taking any chances. He was bending over backwards to have the text examined by the ambassador to make sure it represented history the way he remembered it.

Ira and I went over to visit him because we wanted to meet a real ambassador. I was very intimidated by this man. I had met politicians but never a *statesman.* And he was a true statesman, a combination of a ship's captain, say, of the Q.E. II, and a boarding school principal, say, of Phillips or Andover Academy. And he said, "We saw Cambodia as a ship floundering in high seas. We wanted desperately to bring her safely into port. When we saw we were going to lose her, we wanted to leave

the ship with dignity, and I cut down the American flag that you see behind me, wrapped it in plastic and carried it over my arm.''

And there we were, Ira running with the American flag wrapped in plastic over his arm. And me, the ambassador's aide, running beside him, heading for a Cadillac limousine, it was 110 degrees, and the first thing that happened was that the air conditioner broke. We had to spend the whole day in this black torture box—it was going to take that long to shoot the scene—and Ira was sweating, he was dripping. It was cooler outside than in, and Ira is the type who sweats like a, like . . . an *Ira.* He sweats so much that he says he beats his opponents at squash because they slip in his puddles.

Wardrobe was changing his shirt while we sat in the limousine and next the electric windows broke, the radiator boiled over and by the end of the day the entire exhaust system and muffler were dragging on the football field. I was laughing—I found the whole thing very funny. Roland Joffe had told us, ''Look like you're on the verge of tears.'' Ira, who was studying Stanislavsky acting for the first time and had read *An Actor Prepare* and *Building a Character,* thought that Roland meant ''on the verge of tears'' *all day long,* just in case the camera was turned on. So he was doing an emotional memory and he was in a deep funk. You couldn't even approach him.

I was so bored that I began talking to the driver—an extra. He was an expatriate from San Francisco, an elephant expert, who was spending his time counting elephants in the Thai jungle because he thought, ''America is going crazy. Going nuts, going to the dogs. Going to the wow-wows.'' He went to Thailand to get his sanity back, and in Thailand he only trusted elephants. So they were all he was interested in. He slept in the bush at night and in the morning he got up, grabbed his elephant counter and just counted elephants.

He had a limp, a game leg—and he knew that if you frighten elephants at night they will charge. They sleep standing up and he was sure, he confided to me, that he was going to be killed within the following two months by a stampeding elephant.

In the middle of this Ira looked up and cried out, ''WILL YOU STOP TALKING ABOUT WHATEVER IT IS YOU'RE TALKING ABOUT? I'm trying to have an emotional memory.''

''Ira, Ira, this guy is about to be killed by an elephant, for *real.* Think on *that.*''

And we were driving through this black smoke, pouring up off of rubber tires, which were burning to make it look like a real war. We headed for a nonexistent Sikorski—I guess because the American Air Force had not given the Thai Air Force any Sikorskis. They just had little choppers. We were supposed to be getting into the Sikorski but we were just pretending it was there. We drove through Marine guards, lots of extras dressed as American Marines—I don't know who those guys were. I think some of them were Marines who didn't get enough of the war

so they went back to join up with Bo Gritz, who had a foreign legion going in Laos to look for MIAs. Others were there to deal drugs, which is extremely lucrative but very dangerous in Thailand. And still others were there basically for the sex. Because on one lower Chakra level Bangkok is one big whorehouse. It's not all our fault, or the fault of the troops on R&R, or the Japanese sex tourists. The tradition existed way back before the war, when there were concubines in all the villages. It just got way out of hand during the war. They had hundreds of prostitutes in Quonset huts the size of airplane hangars, to service all the soldiers—and for birth control they took Chinese herbal potions. There were a lot of Amerasian children being born. (*Swimming* 37–40)

Consider the ways in which Gray tells the story. How does he select which details and events to include and which to exclude? How does he create a sense of voice, a tone, and an attitude—is there judgment, amusement, or contemplation in his remembering and reinventing of the incidents? You might find it interesting to obtain the filmed version of the monologue (it is also available on videotape) and perhaps compare Gray's performance to your own "sounding" of the selection in your ear. What kind of "Spalding Gray" does Spalding Gray create? And what role does the audience play? Does the audience seem more or less important in Gray's performance than in Goldberg's? Why?

You may wish to consider elements of the text as well, keeping in mind Gray's own stated intentions and realizing that what you have read constitutes one version of the anecdote as it might have been performed and that other performances might have presented this memory in different ways. Consider other ways of shaping and reshaping the images of this selection. Can you conceive of other *texts* that could be made out of the events described in this selection?

The anecdote, like many in *Swimming to Cambodia,* underscores the complex relationships between art and reality, between history and invention. The figure of Ira Wheeler may be seen as emblematic of aspects of filmmaking and performance Gray finds both intriguing and amusing. How does Gray "perform" Wheeler? Are we meant to think of Gray as sitting somewhere between Wheeler's almost myopic obsession with the aesthetics of realistic acting (represented by his immersion in Stanislavsky's books and his insistence on living in an "emotional memory") and the conversational, spontaneous personal narrative of the driver, whose style and voice are filtered through Gray's own performance? If so, what does it mean for Gray to stand between these two kinds of performers? Is he mediator? Is he their "author"?

Finally, how are these issues of aesthetics also related to issues of culture and the ethics of cultural and ethnographic performance, issues raised in part II? *Swimming to Cambodia* is also about Western, industrialized nations appropriating the land and lives of third-world countries, countries quite devastated in large part because of Western intervention. How is the encounter with the American ambassador, and the subsequent filming of the flag incident connected to this issue? And why is the detail of the wrapping of the flag in plastic,

a detail Gray is careful to include and repeat, critical to the mixture of cultural and literary and aesthetic elements of Gray's own performance?

Consider what it would mean for you to perform this monologue. Does the autoperformance-based monologue preclude performance by individuals other than the original artist? What is altered in the very fact of another person electing to perform Gray's monologue? Is it more or less justifiable, in your mind, than performing ethnographically obtained texts? How might it be different? What possibilities might you explore to treat Gray's monologue in the tradition of the autoperformance? One option might be to elect not to perform the monologue as a set text, any more than Gray did, but to treat it as an intertext for your own performance work. Just as Gray altered his verbal text from performance to performance, you might experiment with emphasizing your own verbal text as a dialogue with Gray's own mutable, protean script.

Thinking back on all four of the performance artists analyzed in this chapter, consider the degree to which they all share an interest in the self in performance and the self as performance. Some critics have accused these performers (with the possible exception of Goldberg) of being narcissistic and self-indulgent in their obsession with their own selves. Others find the performance artist's exploration of self an act of generosity and courage and a way of allowing audience members to confront their own personal texts. What do you think?

DOING PERFORMANCE ART

For a performer about to practice performance art, there is no clear-cut point of entry, as in participation in certain cultural rituals or activities or even in literary performances, in which there is at least a set verbal script with which to begin. To be sure, in both cultural and literary performances, the performer may begin from a number of perspectives: play, self, politics, religious belief, psychology, and dialogue, to name some of the categories we considered in parts II and III. Texts may be both multiple and shifting in both cultural and literary performances, but there is customarily either a set of behaviors or a set of words with which to initiate a performance. There may even be a specific audience, environment, or context to which the performance must conform.

The performance artist may typically begin with less of a list of set *texts* for his or her performance. Actually, the audience and environment may be the most prescribed in some instances, as many performance artists create a performance with a specific space (such as a gallery) in mind and may even have a contractual agreement to deliver a performance piece on such and such a date in a given place. But the media, the subject, and the form—the whole sense of text—may be much more open-ended than in either of the previous performance categories. Indeed, there is a way in which the performer might be ill advised to embark on a performance just for its own sake; in some ways, it is like writing a personal, lyric poem simply because it has been assigned: the initiating force may not be sufficient to inspire anything worth spending time on.

However, the performance artist, like any artist in training, may find it useful to experiment with certain kinds of exercises or assignments, not unlike the musician who must study études or scales to get a sense of the materials and possibilities of the art forms. In the last chapter, you experimented with performances that put you in touch with elements of performance art. Out of such experiments, the performance artist may find a personal text, a personal style worth extending to develop an original piece. Let us consider a few more exercises; they are by no means exhaustive, but they may provide avenues for exploring whether or not you wish to work in more depth as a performance artist. Also, just as we have focused on the solo performance artist in this chapter, so we write these suggestions or possibilities to you as, first, a solo performer. But we also realize that any performance is collaborative, at least at the level of involving an audience and those who must assist with the space to see that the performance takes place. We also recognize that many performance artists work with groups of performers, as directors supervising a piece that requires multiple bodies; multiple individuals working together; or in a fully collaborative way, with all performers and other artists (such as sculptors, composers, and writers) working to create a piece that is truly "authored" by all of them.

FINDING TEXTS

You may recall from the last chapter that one of the ways in which early performance artists, such as dadaists, broke down barriers between high art and popular culture was by experimenting with what made up a text and what values were to be constructed through it. Dadaists would find texts in everyday life, in advertisements, posters, and other media. They would also play with the randomness of language and sequence through the chance poem. In the last chapter you explored a number of ways of developing a performance text. You used found objects, you constructed a visual image to govern the performance; and you experimented with the happening.

There are certainly many opportunities in today's society to experiment with what constitutes a text and to find many texts in surprising places. Not only can you construct verbal found texts but also there is no reason to restrict yourself to texts made up only of words. What images, objects, sounds, gestures, and motions do you observe that might be recontextualized in a performance piece? In some sense, many of the music videos on channels like MTV and VH1 resemble found visual texts, in which seemingly disparate sets of images, combined with a musical and verbal text, create a new *text*. How might you combine verbal and visual and abstract and concrete objects in found ways? Think of Chris Burden, whose aesthetic of performance involves the finding or recontextualization of the body and of various events and objects to explore various issues, ideas, and experiences. Although we hardly recommend that you have yourself shot or nailed to a Volkswagen, you might consider how Burden's acts of extremity might be translated into your own approaches to using all the *texts* out there in the world as part of your performances.

PERSONAL TEXTS

As we have seen in the discussion of several of the performance artists, the personal text is often central to the performance art event: from Eleanor Antin's personae to Spalding Gray's use of family and professional experiences. Remember that we considered personal texts in part III, when we discussed the psychology of the performer and the intertextuality of the dialogic approach to performance. In the work of many performance artists, the personal text is not something used in dialogue with a set literary text as subtext but itself becomes the text. In this respect, the personal text shares similarities to the personal narrative in cultural contexts discussed in part II.

For the performance artist, the personal text often becomes the basis for larger claims about social, political, and psychological aspects of contemporary life. The narratives that grew out of Gray's experiences in making the film *The Killing Fields* allowed him to explore the lines between the cultural and the aesthetic; to consider the very nature of performance; and to work through his ever-present questions of identity and quest for "Perfect Moments," moments in which life is experienced and recollected as something close to ideal. For Antin and, to a degree, Goldberg, constructing *fictional* personae and characters was a way of exploring the multiple identities we each possess.

How might you work with personal texts in creating performance art texts and events? Certainly it is true that many, if not most, performance artists who work so closely with personal texts do so out of some kind of need or at least out of a self-conscious belief that what they have lived through or what they wish to live through bears scrutiny and elaboration in a public or semipublic way.

Many of you may find it intriguing to explore the ways in which your own experiences may be the basis of a performance. Some of you may wish to begin with narrative improvisation, talking through stages or landmarks in your life or in your family's life. You may wish to do this in the privacy of your own room or a rehearsal space. You may wish to work alone or with a close and trusted friend (some people find they have more to say when they have an actual audience). You may find it useful to tape-record some sessions and to replay them on your own, listening for patterns, phrases, images, and stories that recur or that strike you as worth exploring in greater depth.

Others may find that beginning with written or other media is more fruitful. A diary or daybook may give you structure for recounting segments of your life. Working with art materials (such as paints, clay, and collage objects) may lead you to elements of the nonverbal and the subconscious that could unlock possibilities. Try whatever will help you explore the complicated set of experiences, emotions, and thoughts that constitute you. You may even find that the best mode for creating and performing personal texts may not necessarily be verbal or public.

As you work to create your text and your eventual piece, keep the balance between personal experience and aesthetic and cultural purpose in mind. The liberation working with personal material brings can be exciting and joyful (it can also be frightening), but it also needs to be guided by the discipline and

craft of the artist who is working toward a goal, even if the goal is not immediately apparent to you.

Finally, consider the purpose of even embarking on a performance based primarily in the realm of the personal. What do you hope to accomplish in working with the intensely personal? Is your use of the personal intended to function cathartically, with the audience assisting you in the process either simply by attending or by participating actively in the performance? Do you intend to use the personal to make a broader social or political point for your audience? Does the personal serve as a way of specifying an ideology for your audience? And what do you want your audience to do, think, or feel as a result?

A great deal of performance art, particularly in the last 30 years, has used the personal text in beautiful, affecting, and courageous ways. But at the same time, we also wish to impress on you that personal texts, by very definition, have lived in us for a long time and are part of the very fabric of our beings. It is considerably more difficult to disengage ourselves from them at the end of a rehearsal or performance than it is from a literary or even a cultural text (some might argue with the last). Make sure that as you explore the personal, you do it with support and with awareness of how you are using the conscious and unconscious materials of your life. As with Spalding Gray, you may find that narratives from family, school, and professional life allow you to become more interested in what it means to be a performer and that the performance of such personal texts in some ways becomes part of your own development as a performer of all kinds of texts—cultural, literary, and personal. And as with Eleanor Antin and Whoopi Goldberg, you may find it exciting to translate that which is personal—that which matters to you and is an authentic part of you— into personae or characters, working through the dramatic masks that do not hide us but help us become and know who we are. You may find that the "other" you invent may be a surer way of presenting your personal text than the most overtly confessional or self-disclosive performance. Experiment with all the possibilities—from autoperformance to dramatic monologue to living in character (like Antin). Find what is the truest way for you to "perform" yourself.

INTERTEXTUALITY

We have already discussed intertextuality a number of times in this book, including most recently in our consideration of found texts. You may find it useful to explore the relationship between texts as one way to approach performance art pieces. Remember that in our discussion of Gray's *Swimming to Cambodia,* we considered how radically it would change the status of the text for someone other than Gray to perform that script. One suggestion we made was that in the spirit of Gray's aesthetic of the mutability of his own text (i.e., changing each night), you might consider creating your own text that speaks in a kind of a dialogue with Gray's, thus creating a new text that is both your own and an intertext for Gray's.

The same principle could certainly hold true for working with many other texts, cultural and literary. At some level, it is possible to argue that ACT UP's

intervention at St. Patrick's Cathedral was a postmodern piece of *performance art,* in which the AIDS activists created a cultural text competing with that of the traditional Catholic church. To be sure, the evaluation of ACT UP's *performance* varied and the nature of its text was deemed controversial, but there is no question that the intertext was sounded.

You may find that the creation of your own intertext may also be a way of speaking to, with, and against literary texts. The use of various media may be involved in such efforts. For example, a production of *Alice in Wonderland* featured a videotaped version of the croquet match, filmed on a campus landscape. The familiar outdoor surroundings served to underscore the sense of the college as a "Wonderland," exciting and terrifying to newcomers. Playing it on a TV monitor reminded many viewers of the ways in which sports and games (particularly golf and tennis, traditional "genteel" activities) have also become as much entertainment for spectators as activities of the body. And not all intertexts have to be literary: exploring the texts afforded by history (or "histories") and by the psyche (such as Jung's archetypes, which themselves might become texts for the performance artist) are only two other sources.

These intertexts need not always or only feature verbal texts. The body is, of course, a fundamental *text* for performance art. Recall the ways in which Chris Burden created many intertexts without speaking a single word; the "Icarus" performance, which we described earlier, suggests the ways in which Burden's body became the focal point in a text that was a dialogue between classical Greek myth and the modern technology of fire. One performance, included in a dance concert, consisted of a combination of a dance set to Madonna's song "Vogue" and a dance choreographed in the style of Bob Fosse (including his trademark chairs and bowler hats), followed by a return to Madonna's music and to the dance style she made famous and, in this case, referred back to the black and Hispanic gay "balls" from which she appropriated her moves; the intertextual relationship became the basis of this body-filled performance.

Perhaps the only caveat we might suggest in encouraging you to explore the limits of intertextuality in the creation of your own texts, whether through verbal scripts or other modes of expression, is to consider questions of quality and evaluation. Should you choose to write your own intertext in dialogue with, say, Shakespeare or D. H. Lawrence or Audre Lorde (to pick three random writers from part II), remember that each of these writers has a distinct style and that you are probably inspired to create an *intertextual* performance by the distinctiveness of the style. No writer is sacred, somehow above any kind of opening up to dialogue. But simply be aware that it is likely that audiences will somehow consider your work against the text with which you are "speaking." Your goal need not be to match or surpass the original writer in quality (and in fact you may be uninterested in such matters of critical evaluation), and your purpose might even be to break down such canonical elevation of certain writers. You may also be more driven by an idea, image, phrase, or something else in the original text, and the text as literary artifact may be incidental. But it is necessary to recognize that audiences have been conditioned to make such distinctions, and that may itself become a *text* for some or all of your audiences.

ENVIRONMENTS AND AUDIENCES

Finally, consider experimenting with the nature, function, and limits of environments and audiences. The happening, discussed in the previous chapter, involves refiguring what is an appropriate place for performance, deconstructing the notions that a theater is the proper container for aesthetic performance and that the gallery is only for visual art. Similarly, one of the principal agendas for many performance artists of the 1960s and 1970s (as well as earlier forerunners) was to reconsider what it is to have and be an audience. Remember that one of the reasons a number of visual artists turned to performance was to protest the commodification of visual art, the sense in which they were engaged in a market economy that made them all too aware of producing objects to be consumed by others and over which they would no longer have any control. Thus, performance, because of its transitory nature, became a way of reexerting a sense of power over the audience—particularly over those members of the audience who were members of the artistic community primarily on the basis of their checkbooks, as opposed to those who were themselves creators of art. That relatively few people witnessed Burden's performance events or that Antin's personae made their appearances in small spaces may have as much to do with the artists' desire to keep their art within a community of discourse in which genuine commitment to intellectual and aesthetic exploration might be nominally assured as it does with the economics of renting performance spaces in major urban areas. Certainly some performance artists desire larger, more mainstream and "general" audiences and actively seek them out; probably just as many do not.

Explore the possibilities of working in different spaces, spaces you or potential audiences might not ordinarily think of as places for certain kinds of performance. Depending on where you are working, even campus art galleries or music halls might be a start; the more conventional and traditional your typical audience, the likelier it is that even these artistic spaces would seem unusual. You might move from there to either more public or more private spaces. Cafeterias, athletic arenas, shopping malls—to perform in such places, particularly depending on what is performed, might be bracing for audiences and encourage them to regard the nature of the performance and its specific content in new and fresh ways. Similarly, turning to private homes, residence halls, and other places generally thought private (for the daring, a rest room might even be considered as a liminal spot—available for the public though all behaviors in it are carried out as if in utter privacy!) might make audiences think about their own position of privilege as audiences for art. Some of these performances may take the forms of interventions, disrupting societal practices and offering a critique of them.

The audience is itself yet another variable. Because of conventional realistic theater and film, many audiences regard themselves as passive members rather than active participants. If you can, watch Whoopi Goldberg's video and see how she *plays* the audience members, even when they seem initially resistant or hesitant. She breaks the *fourth wall* by acknowledging its pervasiveness and clarifying for them their responsibilities in her realm of performance. Consider reversing positions with audiences, refashioning the performance in such a

way that they will feel "onstage" and become more aware of their behaviors and attitudes. When appropriate, consider whether they might actually become part of the performance; without arbitrarily inventing something, think about involving them actively.

These suggestions for making both the environment and the audience materials for performance art depend, of course, on the nature of your performance and your goals. We do not suggest that you embark on the more active involvement of audiences or the selection of an unusual environment if what your piece really needs is a silent but attentive audience in a traditional theater or gallery: always be true to what it is you want your art to accomplish, to evoke, or to engage, that is, what it is you wish to perform. However, much performance art is interventionist and confrontational, trying to produce change and empower hitherto unempowered peoples.

THE FUTURE OF PERFORMANCE ART

As we have seen, performance art has developed from its beginning with the avant-garde movements of the early decades of the century to a contemporary art form that is extremely eclectic in its range and dialogic in its aims. In addition to the four solo performers we have considered in this chapter, there are numerous other performers, working solo or in collaboration (with other performers, visual artists, musicians and composers, choreographers, and theater artists), whose work bears analysis, criticism, and celebration.

In particular, performance art has proven to be an art form that is hospitable for artists who are members of marginalized or oppressed groups. Recall Whoopi Goldberg's statement that one of the reasons she began creating her own performance pieces was that she simply could not get cast in any other way. For other artists, it is not that they could not get cast but that they found more traditional performance forms (such as theater, television, and film) and experiences less authentic and satisfying than performance art. For women, people of color, and gay men and women, performance art has offered avenues for self-expression and self-representation, and in this way performance is always a psychologically grounded experience and politically framed event. For these artists, performance art is a way of taking back power from those who would constitute them as "others," a way of reclaiming their own position as subjects rather than objects. One exciting result is that because these artists are breaking ground in terms of content (i.e., what may be represented in performance), they also frequently explore the boundaries of conventional form (how experience may be represented or constituted in performance).

Thus, an artist like Karen Finley not only explores what it means to be a woman in a patriarchal society but also experiments with how to use her body as an embattled site for representation; a performer like Holly Hughes moves between pastiche and parody in such satiric plays as *The Well of Horniness* and *The Lady Dick* and confessional history of the self in her monologue "World without End." In "Stretch Marks," Tim Miller appropriates the lyrics of "Climb Every Mountain," from the mainstream Rodgers and Hammerstein musical *The*

Sound of Music, and mixes them with images taken and reshaped from advertisements and popular culture—all in counterpoint with the autobiographical memoir of growing up as a gay man in America and contemporary ACT UP polemical rhetoric. John Fleck pushes the boundaries of the acceptable by juxtaposing Christian imagery with body parts (including his own genitals) and excremental and ejaculatory functions (e.g., a real toilet) in his piece "BLESSED are All the *Little* FISHES."

The choice of these four examples is not accidental, for these four performance artists were (and are) at the center of the crisis in the politics of performance art of the last few years. All four were initially offered grants in 1990 by the National Endowment for the Arts (NEA), the government's funding agency for the arts, grants rescinded because of the "offensive" nature of their works (for *offensive,* many would argue, read *homoerotic*). That a number of these artists were previous recipients of grants suggests that the decision in 1990 was a barometer of the political atmosphere in a more conservative and more restrictive government, signaled also by the court cases over the visual works of Robert Mapplethorpe and Andres Serrano, whose images were deemed "obscene" in some corners.

In addition to the suggestion that these decisions were marked by reactions to feminism, gay liberation, and the AIDS crisis, these controversies have raised questions about the role of the government in funding the arts and about who should make such decisions. What happens when the government allocates money for the arts (and the United States allocates considerably less per citizen than other industrialized countries)? Must the art to be funded somehow stay away from areas that may offend the majority (however that group is constituted)? Should performance reflect social values or should it take a part in shaping them? Who should make the decisions about who receives such funding—peers (other artists and critics) or laypersons?

These questions remain unresolved. In the wake of the NEA's decisions, a number of artists who had been offered grants elected not to take them as a protest; others took them in the belief that they could use their performances to educate and criticize the system. Complicating the situation was a requirement that grantees sign a pledge promising "not to use the money to 'promote, disseminate, or produce materials which in the judgment of the NEA . . . may be considered obscene.'" (Phelan 133). Of course, what may be considered obscene remains, as it always has, open to passionate dispute. At one point, it seemed a real possibility that the NEA would be disbanded entirely; that has not yet happened, and at the moment the question of what constitutes obscenity is still in dispute (though the move to require the pledge has, for the moment, died).

Performance art requires financial support to thrive: the nature of the medium is such that even a performance done on a shoestring can be expensive. Whether the money to fund such performances should come from the government, from private sources, or from a mixture is an open question but one that itself asks the question, Who is the government? To argue that public money should not fund "offensive" performance is to ignore the lives and values of many citizens whose tax money is used to fund other projects they may deem "offensive" (such as military spending, certain kinds of research, etc.). The issues are thorny and not likely to be resolved quickly or completely.

Though the recent controversies have without question had a negative effect on performance art (as some artists are unfunded and performance sites like Franklin Furnace, central to many of the more controversial performances, close down), performers continue to explore their personal, often risky visions, continuing to learn how to collaborate not only on art as art but also on the politics of art and the art of politics.

CONCLUDING THOUGHTS ON PERFORMANCE

In a sense, it is something of a misnomer to try to offer concluding thoughts about performance—whether performance art specifically or the span of performance as explored throughout this book. Our position has been that performance does not end, even though the formal performance event may. One performance leads to another performance; it may also lead to a series of critical responses and acts; it may even lead to social change and personal growth.

We have explored the range of acts that may be considered under the term *performance:* from the seemingly simple telling of a story about one's life to, oddly enough, the postmodern, contemporary act of autoperformance, of performing one's life. Have we traveled this distance only to return to where we began? We hope that the journey you have made—and that we hope you will continue to make—keeps this question an open one for you: what is the nature, scope, and function of performance? How are the cultural stories we perform, the rituals we enact, and the spectacles we observe and participate in intricately tied to the literary texts we read, study, and perform, whether in the classroom or in the public arena? How is the playful basis of poetry connected to the postmodern performance artist's risks? How is the self writers like cummings, Lawrence, and Lorde explore connected to the selves performed by Antin and Goldberg? And how is the Vietnam veteran, narrating his tales of battle and horror, the same as and different from Gray performing "Spalding Gray," the actor and the man whose odyssey in living through the cinematic construction and reconstruction of the Vietnam war is so richly told in *Swimming to Cambodia?* There are no easy answers to any of these questions, nor should there be. Frustrating as it may be for some, performance remains an experience, a field, or a phenomenon or set of phenomena open and multiple in value, potential, and meaning. Whether you choose to continue your study of performance by being a performer, by being a critic, by being an audience, or by being all three, we hope you continue to find new texts and contexts in which to explore what it means to perform.

WORKS CITED

Auslander, Philip. "Going with the Flow: Performance Art and Mass Culture." *The Drama Review* 33.2 (1989): 119–36.
Berson, Misha. "Whoopi in Wonderland." *West Coast Plays* 21/22 (1987): 19–25.

Burden, Chris, and Jan Butterfield. "Through the Night Softly." *The Art of Performance: A Critical Anthology.* Ed. Gregory Battcock and Robert Nickas. New York: Dutton, 1984. 222–39.

Carr, C. "This Is Only a Test: Chris Burden." *Artforum* 28 (1989): 116–22.

Gentile, John S. *Cast of One: One Person Shows from the Chautauqua Platform to the Broadway Stage.* Urbana: U of Illinois P, 1989.

Goldberg, Whoopi. "The Spook Show." *West Coast Plays* 21/22 (1987): 1–18.

Gray, Spalding. *Sex and Death to the Age 14.* New York: Viking, 1986.

——. *Swimming to Cambodia.* New York: Theatre Communications Group, 1985.

Hurwitt, Robert. "Editor's Note." *West Coast Plays* 21/22 (1987): n.p.

Munro,Eleanor. *Originals: American Women Artists.* New York: Simon, 1979.

Nemser, Cindy. *Art Talk: Conversations with 12 Women Artists.* New York: Scribner's, 1975.

Phelan, Peggy. "Money Talks, Again." *TDR* 35.3 (1991): 131–41.

Roth, Moira, ed. *The Amazing Decade: Women and Performance Art in America 1970–1980.* Los Angeles: Astro Arts, 1983.

Sayre, Henry M. *The Object of Performance.* Chicago: U of Chicago P, 1989.

Steinman, Louise. *The Knowing Body: Elements of Contemporary Performance and Dance.* Boston: Shambhala, 1986.

FOR FURTHER READING

Banes, Sally. *Terpsichore in Sneakers: Post-Modern Dance.* Boston: Houghton, 1980.

Case, Sue-Ellen, ed. *Performing Feminisms: Feminist Critical Theory and Theatre.* Baltimore: Johns Hopkins UP, 1990.

Henri, Adrien. *Total Art: Environments, Happenings, and Performance.* New York: Praeger, 1974.

Marranca, Bonnie, and Gautam Dasgupta, eds. *Interculturalism and Performance: Writings from PAJ.* New York: PAJ Publications, 1991.

Novack, Cynthia J. *Sharing the Dance: Contact, Improvisation, and American Culture.* Madison: U of Wisconsin P, 1990.

Sauran, David. *The Wooster Group, 1975–85: Breaking the Rules.* Ann Arbor: UMI Research P, 1986.

Part IV

SOURCES OF PERFORMANCE MATERIALS

Journals

The Drama Review (TDR): A Journal of Performance Studies
Live (ceased publication in 1982 and was succeeded by *Alive*)
High Performance
Performing Arts Journal

Other Works

Case, Sue-Ellen, ed. *Performing Feminisms: Feminist Critical Theory and Theatre.* Baltimore: Johns Hopkins UP, 1990.

Champagne, Lenora. ed. *Out from Under: Texts by Women Performance Artists.* New York: Theatre Communications Group, 1990.

Gordon, Mel, ed. *Dada Performance.* New York: PAJ Publications, 1987.

————. *Expressionist Texts.* New York: PAJ Publications, 1986.

Henri, Adrien. *Total Art: Environments, Happenings, and Performance.* New York: Praeger, 1974.

Juno, Andre, and V. Vale, eds. *Angry Women.* San Francisco: Re/Search, 1991.

Kirby, Michael, and Victoria Nes Kirby, eds. *Futurist Performance.* New York: PAJ Publications, 1986.

Nuttall, Jeff. *Performance Art: Memoirs.* London: John Calder, 1979.

————. *Performance Art: Scripts.* London: John Calder, 1979.

Selections

Index of Selections

"Tom Biscotto," from *The Quilt: Stories from the NAMES Project*

CINDY RUSKIN AND MATT HERRON

Fourteen people worked on Tom Biscotto's panel with a different group designing each letter of his name. As the former stage manager of the Goodman Theater in Chicago—one of the country's top regional theaters—and cofounder of the Godzilla Rainbow acting troupe, Tom was a friend to many who had worked in the Chicago arts community. Jim Rinnert, Tom's lover of 13 years, orchestrated the efforts, in some cases contacting friends that Jim hadn't heard from since Tom's death in October 1984. The letters of Tom's name are laid out on a piece of the curtain that used to hang in Tom and Jim's house on Orchard Street in Chicago. The house was filled with plants, stuffed animals, live snakes and birds. Even Tom's enormous macaw, Gladys, contributed a feather to the panel. The Orchard Street house was, as one friend put it, "the haven for every lost artistic soul that passed through Chicago for over twenty years."

We don't think Tom needs to be memorialized in any way. He lives in each and every one of our hearts each and every day. He's been gone now for almost three years to the day and we think and speak of him no less than when he was with us in the flesh. Which should tell us something . . . he is still with us. And

FIGURE A.1

SOURCE: © 1988 Matt Herron

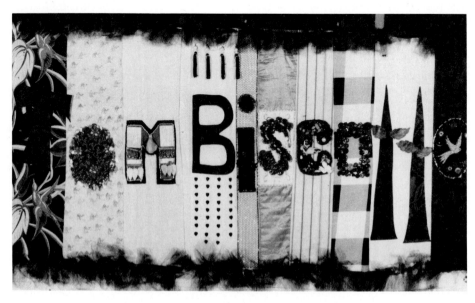

I'll tell you how we know . . . it was Tom that whispered in our ear that he thought the thing needed a little red tulle around the edges to finish it off. And you know what? He's right!

Anne

Jim Rinnert created the initial "T."

Lily, an actress in the Godzilla Rainbow troupe, hand-stamped the "O" with camels as a reminder of a trip she took to Morocco with Tom. On the trip, Tom kiddingly accepted a local merchant's offer of 4,000 camels in exchange for Lily.

Kib, a friend from Toronto, chose birchbark and snakeweeds for the "M" to symbolize Tom's earthiness. According to friends, the nose is an exact replica of Tom's.

Tom's mother and sister Barb decorated the "B" in Los Angeles. After nursing him through the final months of his life, they set the sparkling hearts in lines as a symbol of their tears.

Brent, a neighbor, dotted the "I" with a real pressed flower sealed in plastic, a stand-in for the indoor jungle that filled Tom's home.

Anne, a onetime roommake of Jim and Tom's included a snake in her design for the "S" to represent Rosie, the smaller of Tom's two boa constrictors. Anne remembers how the 15-foot boa lazed about on the kitchen counter, and she will never forget the time Rosie escaped and found refuge in the walls of the Orchard Street house. The background fabric, which Tom bought once for a costume, commemorates Tom's life in the theater. "The sequins are there," says Anne, "because if anyone loved glitz and truly appreciated its trashiness, it was Tom."

Greg Kooper designed the "C" in keeping with his and Tom's hippie phase in the 60s when they learned beading and macramé.

Charlotte, a neighbor, chose buttons for the "O" to recall Tom's ever-expanding collection of colorful buttons, beads, and trinkets that he picked up in his travels and then scattered all over the house.

Jim, Richard, Virgie and Christina, friends now living together in Sawyer, Indiana, organized their own sewing bee to design the double "T."

The final "O" was made by Deb and Gusto, tenants that lived upstairs from Tom.

In the panel's final phase, Jim, Anne and Lily gathered together the separate pieces created by Tom's far-flung friends and family. Late one night, while playing Tom's records, drinking, laughing a lot and crying a little, they sewed the pieces together and spelled out the name of their friend.

"Gladiatorial," from *Women in Love*

D. H. LAWRENCE

After the fiasco of the proposal, Birkin had hurried blindly away from Beldover, in a whirl of fury. He felt he had been a complete fool, that the whole scene had been a farce of the first water. But that did not trouble him at all. He was deeply,

mockingly angry that Ursula persisted always in this old cry: "Why do you want to bully me?" and in her bright, insolent abstraction.

He went straight to Shortlands. There he found Gerald standing with his back to the fire, in the library, as motionless as a man is who is completely and emptily restless, utterly hollow. He had done all the work he wanted to do—and now there was nothing. He could go out in the car, he could run to town. But he did not want to go out in the car, he did not want to run to town, he did not want to call on the Thirlbys. He was suspended motionless, in an agony of inertia, like a machine that is without power.

This was very bitter to Gerald, who had never known what boredom was, who had gone from activity to activity, never at a loss. Now, gradually, everything seemed to be stopping in him. He did not want any more to do the things that offered. Something dead within him just refused to respond to any suggestion. He cast over in his mind what it would be possible to do, to save himself from this misery of nothingness, relieve the stress of this hollowness. And there were only three things left, that would rouse him, make him live. One was to drink or smoke hashish, the other was to be soothed by Birkin, and the third was women. And there was no one for the moment to drink with. Nor was there a woman. And he knew Birkin was out. So there was nothing to do but to bear the stress of his own emptiness.

When he saw Birkin his face lit up in a sudden, wonderful smile.

"By God Rupert," he said, "I'd just come to the conclusion that nothing in the world mattered except somebody to take the edge off one's being alone: the right somebody."

The smile in his eyes was very astonishing, as he looked at the other man. It was the pure gleam of relief. His face was pallid and even haggard.

"The right woman, I suppose you mean," said Birkin spitefully.

"Of course, for choice. Failing that, an amusing man."

He laughed as he said it. Birkin sat down near the fire.

"What were you doing?" he asked.

"I? Nothing. I'm in a bad way just now, everthing's on edge, and I can neither work nor play. I don't know whether it's a sign of old age, I'm sure."

"You mean you are bored?"

"Bored, I don't know. I can't apply myself. And I feel the devil is either very present inside me, or dead."

Birkin glanced up and looked in his eyes.

"You should try hitting something," he said.

Gerald smiled.

"Perhaps," he said. "So long as it was something worth hitting."

"Quite!" said Birkin, in his soft voice. There was a long pause during which each could feel the presence of the other.

"One has to wait," said Birkin.

"Ah God! Waiting! What are we waiting for?"

"Some old Johnny says there are three cures for ennui, sleep, drink, and travel," said Birkin.

"All cold eggs," said Gerald. "In sleep you dream, in drink you curse, and in travel you yell at a porter. No, work and love are the two. When you're not at work you should be in love."

"Be it then," said Birkin.

"Give me the object," said Gerald. "The possibilities of love exhaust themselves."

"Do they? And then what?"

"Then you die," said Gerald.

"So you ought," said Birkin.

"I don't see it," replied Gerald. He took his hands out of his trousers pockets, and reached for a cigarette. He was tense and nervous. He lit the cigarette over a lamp, reaching forward and drawing steadily. He was dressed for dinner, as usual in the evening, although he was alone.

"There's a third one even to your two," said Birkin. "Work, love, and fighting. You forget the fight."

"I suppose I do," said Gerald. "Did you ever do any boxing——?"

"No, I don't think I did," said Birkin.

"Ay——" Gerald lifted his head and blew the smoke slowly into the air.

"Why?" said Birkin.

"Nothing. I thought we might have a round. It is perhaps true that I want something to hit. It's a suggestion."

"So you think you might as well hit me?" said Birkin.

"You? Well—! Perhaps—! In a friendly kind of way, of course."

"Quite!" said Birkin, bitingly.

Gerald stood leaning back against the mantelpiece. He looked down at Birkin, and his eyes flashed with a sort of terror like the eyes of a stallion, that are bloodshot and overwrought, turned glancing backwards in a stiff terror.

"I feel that if I don't watch myself, I shall find myself doing something silly," he said.

"Why not do it?" said Birkin coldly.

Gerald listened with quick impatience. He kept glancing down at Birkin, as if looking for something from the other man.

"I used to do some Japanese wrestling," said Birkin. "A Jap lived in the same house with me in Heidelberg, and he taught me a little. But I was never much good at it."

"You did!" exclaimed Gerald. "That's one of the things I've never even seen done. You mean jiu-jitsu, I suppose?"

"Yes. But I am no good at those things—they don't interest me."

"They don't? They do me. What's the start?"

"I'll show you what I can, if you like," said Birkin.

"You will?" A queer, smiling look tightened Gerald's face for a moment, as he said, "Well, I'd like it very much."

"Then we'll try jiu-jitsu. Only you can't do much in a starched shirt."

"Then let us strip, and do it properly. Hold a minute——" He rang the bell, and waited for the butler.

"Bring a couple of sandwiches and a syphon," he said to the man, "and then don't trouble me any more tonight—or let anybody else."

The man went. Gerald turned to Birkin with his eyes lighted.

"And you used to wrestle with a Jap?" he said. "Did you strip?"

"Sometimes."

"You did! What was he like then, as a wrestler?"

"Good, I believe. I am no judge. He was very quick and slippery and full of electric fire. It is a remarkable thing, what a curious sort of fluid force they seem to have in them, those people—not like a human grip—like a polyp——"

Gerald nodded.

"I should imagine so," he said, "to look at them. They repel me, rather."

"Repel and attract, both. They are very repulsive when they are cold, and they look grey. But when they are hot and roused, there is a definite attraction—a curious kind of full electric fluid—like eels."

"Well—yes—probably."

The man brought in the tray and set it down.

"Don't come in any more," said Gerald.

The door closed.

"Well, then," said Gerald, "shall we strip and begin? Will you have a drink first?"

"No, I don't want one."

"Neither do I."

Gerald fastened the door and pushed the furniture aside. The room was large, there was plenty of space, it was thickly carpeted. Then he quickly threw off his clothes, and waited for Birkin. The latter, white and thin, came over to him. Birkin was more a presence than a visible object; Gerald was aware of him completely, but not really visually. Whereas Gerald himself was concrete and noticeable, a piece of pure final substance.

"Now," said Birkin, "I will show you what I learned, and what I remember. You let me take you so——" And his hands closed on the naked body of the other man. In another moment, he had Gerald swung over lightly and balanced against his knee, head downwards. Relaxed, Gerald sprang to his feet with eyes glittering.

"That's smart," he said. "Now try again."

So the two men began to struggle together. They were very dissimilar. Birkin was tall and narrow, his bones were very thin and fine. Gerald was much heavier and more plastic. His bones were strong and round, his limbs were rounded, all his contours were beautifully and fully moulded. He seemed to stand with a proper, rich weight on the face of the earth, whilst Birkin seemed to have the centre of gravitation in his own middle. And Gerald had a rich, frictional kind of strength, rather mechanical, but sudden and invincible, whereas Birkin was so abstract as to be almost intangible. He impinged invisibly upon the other man, scarcely seeming to touch him, like a garment, and then suddenly piercing in a tense fine grip that seemed to penetrate into the very quick of Gerald's being.

They stopped, they discussed methods, they practised grips and throws, they became accustomed to each other, to each other's rhythm, they got a kind of

mutual physical understanding. And then again they had a real struggle. They seemed to drive their white flesh deeper and deeper against each other, as if they would break into a oneness. Birkin had a great subtle energy, that would press upon the other man with an uncanny force, weigh him like a spell put upon him. Then it would pass, and Gerald would heave free, with white, heaving, dazzling movements.

So the two men entwined and wrestled with each other, working nearer and nearer. Both were white and clear, but Gerald flushed smart red where he was touched, and Birkin remained white and tense. He seemed to penetrate into Gerald's more solid, more diffuse bulk, to interfuse his body through the body of the other, as if to bring it subtly into subjection, always seizing with some rapid necromantic foreknowledge every motion of the other flesh, converting and counteracting it, playing upon the limbs and trunk of Gerald like some hard wind. It was as if Birkin's whole physical intelligence interpenetrated into Gerald's body, as if his fine, sublimated energy entered into the flesh of the fuller man, like some potency, casting a fine net, a prison, through the muscles into the very depths of Gerald's physical being.

So they wrestled swiftly, rapturously, intent and mindless at last, two essential white figures working into a tighter closer oneness of struggle, with a strange, octopus-like knotting and flashing of limbs in the subdued light of the room; a tense white knot of flesh gripped in silence between the walls of old brown books. Now and again came a sharp gasp of breath, or a sound like a sigh, then the rapid thudding of movement on the thickly-carpeted floor, then the strange sound of flesh escaping under flesh. Often, in the white interlaced knot of violent living being that swayed silently, there was no head to be seen, only the swift, tight limbs, the solid white backs, the physical junction of two bodies clinched into oneness. Then would appear the gleaming, ruffled head of Gerald, as the struggle changed, then for a moment the dun-coloured, shadow-like head of the other man would lift up from the conflict, the eyes wide and dreadful and sightless.

At length Gerald lay back inert on the carpet, his breast rising in great slow panting, whilst Birkin kneeled over him, almost unconscious. Birkin was much more exhausted. He caught little, short breaths, he could scarcely breathe any more. The earth seemed to tilt and sway, and a complete darkness was coming over his mind. He did not know what happened. He slid forward quite unconscious, over Gerald, and Gerald did not notice. Then he was half-conscious again, aware only of the strange tilting and sliding of the world. The world was sliding, everything was sliding off into the darkness. And he was sliding, endlessly, endlessly away.

He came to consciousness again, hearing an immense knocking outside. What could be happening, what was it, the great hammer-stroke resounding through the house? He did not know. And then it came to him that it was his own heart beating. But that seemed impossible, the noise was outside. No, it was inside himself, it was his own heart. And the beating was painful, so strained, surcharged. He wondered if Gerald heard it. He did not know whether he were standing or lying or falling.

When he realized that he had fallen prostrate upon Gerald's body he wondered, he was surprised. But he sat up, steadying himself with his hand and waiting for his heart to become stiller and less painful. It hurt very much, and took away his consciousness.

Gerald, however, was still less conscious than Birkin. They waited dimly, in a sort of not-being, for many uncounted, unknown minutes.

"Of course—" panted Gerald, "I didn't have to be rough—with you—I had to keep back—my force——"

Birkin heard the sound as if his own spirit stood behind him, outside him, and listened to it. His body was in a trance of exhaustion, his spirit heard thinly. His body could not answer. Only he knew his heart was getting quieter. He was divided entirely between his spirit, which stood outside, and knew, and his body, that was a plunging, unconscious stroke of blood.

"I could have thrown you—using violence—" panted Gerald. "But you beat me right enough."

"Yes," said Birkin, hardening his throat and producing the words in the tension there, "you're much stronger than I—you could beat me—easily."

Then he relaxed again to the terrible plunging of his heart and his blood.

"It surprised me," panted Gerald, "what strength you've got. Almost supernatural."

"For a moment," said Birkin.

He still heard as if it were his own disembodied spirit hearing, standing at some distance behind him. It drew nearer, however, his spirit. And the violent striking of blood in his chest was sinking quieter, allowing his mind to come back. He realized that he was leaning with all his weight on the soft body of the other man. It startled him, because he thought he had withdrawn. He recovered himself, and sat up. But he was still vague and unestablished. He put out his hand to steady himself. It touched the hand of Gerald, that was lying out on the floor. And Gerald's hand closed warm and sudden over Birkin's, they remained exhausted and breathless, the one hand clasped closely over the other. It was Birkin whose hand, in swift response, had closed in a strong, warm clasp over the hand of the other. Gerald's clasp had been sudden and momentaneous.

The normal consiousness, however, was returning, ebbing back. Birkin could breathe almost naturally again. Gerald's hand slowly withdrew, Birkin slowly, dazedly rose to his feet and went towards the table. He poured out a whisky and soda. Gerald also came for a drink.

"It was a real set-to, wasn't it?" said Birkin, looking at Gerald with darkened eyes.

"God, yes," said Gerald. He looked at the fine body of the other man, and added: "It wasn't too much for you, was it?"

"No. One ought to wrestle and strive and be physically close. It makes one sane."

"You do think so?"

"I do. Don't you?"

"Yes," said Gerald.

There were long spaces of silence between their words. The wrestling had some deep meaning to them—an unfinished meaning.

"We are mentally, spiritually intimate, therefore we should be more or less physically intimate too—it is more whole."

"Certainly it is," said Gerald. Then he laughed pleasantly, adding: "It's rather wonderful to me." He stretched out his arms handsomely.

"Yes," said Birkin. "I don't know why one should have to justify oneself."

"No."

The two men began to dress.

"I think also that you are beautiful," said Birkin to Gerald, "and that is enjoyable too. One should enjoy what is given."

"You think I am beautiful—how do you mean, physically?" asked Gerald, his eyes glistening.

"Yes. You have a northern kind of beauty, like light refracted from snow—and a beautiful, plastic form. Yes, that is there to enjoy as well. We should enjoy everything."

Gerald laughed in his throat, and said:

"That's certainly one way of looking at it. I can say this much, I feel better. It has certainly helped me. Is this the Bruderschaft you wanted?"

"Perhaps. Do you think this pledges anything?"

"I don't know," laughed Gerald.

"At any rate, one feels freer and more open now—and that is what we want."

"Certainly," said Gerald.

They drew to the fire, with the decanters and the glasses and the food.

"I always eat a little before I go to bed," said Gerald. "I sleep better."

"I should not sleep so well," said Birkin.

"No? There you are, we are not alike. I'll put a dressing-gown on." Birkin remained alone, looking at the fire. His mind had reverted to Ursula. She seemed to return again into his consciousness. Gerald came down wearing a gown of broad-barred, thick black-and-green silk, brilliant and striking.

"You are very fine," said Birkin, looking at the full robe.

"It was a caftan in Bokhara," said Gerald. "I like it."

"I like it too."

Birkin was silent, thinking how scrupulous Gerald was in his attire, how expensive too. He wore silk socks, and studs of fine workmanship, and silk underclothing, and silk braces. Curious! This was another of the differences between them. Birkin was careless and unimaginative about his own appearance.

"Of course you," said Gerald, as if he had been thinking; "there's something curious about you. You're curiously strong. One doesn't expect it, it is rather surprising."

Birkin laughed. He was looking at the handsome figure of the other man, blond and comely in the rich robe, and he was half thinking of the difference between it and himself—so different; as far, perhaps, apart as man from woman, yet in another direction. But really it was Ursula, it was the woman who was gaining ascendance over Birkin's being, at this moment. Gerald was becoming dim again, lapsing out of him.

"Do you know," he said suddenly, "I went and proposed to Ursula Brangwen tonight, that she should marry me."

He saw the blank shining wonder come over Gerald's face.

"You did?"

"Yes. Almost formally—speaking first to her father, as it should be, in the world—though that was accident—or mischief."

Gerald only stared in wonder, as if he did not grasp.

"You don't mean to say that you seriously went and asked her father to let you marry her?"

"Yes," said Birkin, "I did."

"What, had you spoken to her before about it, then?"

"No, not a word. I suddenly thought I would go there and ask her—and her father happened to come instead of her—so I asked him first."

"If you could have her?" concluded Gerald.

"Ye-es, that."

"And you didn't speak to her?"

"Yes. She came in afterwards. So it was put to her as well."

"It was! And what did she say then? You're an engaged man?"

"No—she only said she didn't want to be bullied into answering."

"She what?"

"Said she didn't want to be bullied into answering."

" 'Said she didn't want to be bullied into answering!' Why, what did she mean by that?"

Birkin raised his shoulders. "Can't say," he answered. "Didn't want to be bothered just then, I suppose."

"But is this really so? And what did you do then?"

"I walked out of the house and came here."

"You came straight here?"

"Yes."

Gerald stared in amazement and amusement. He could not take it in.

"But is this really true, as you say it now?"

"Word for word."

"It is?"

He leaned back in his chair, filled with delight and amusement.

"Well, that's good," he said. "And so you came here to wrestle with your good angel, did you?"

"Did I?" said Birkin.

"Well, it looks like it. Isn't that what you did?"

Now Birkin could not follow Gerald's meaning.

"And what's going to happen?" said Gerald. "You're going to keep open the proposition, so to speak?"

"I suppose so. I vowed to myself I would see them all to the devil. But I suppose I shall ask her again, in a little while."

Gerald watched him steadily.

"So you're fond of her then?" he asked.

"I think—I love her," said Birkin, his face going very still and fixed.

Gerald glistened for a moment with pleasure, as if it were something done specially to please him. Then his face assumed a fitting gravity, and he nodded his head slowly.

"You know," he said, "I always believed in love—true love. But where does one find it nowadays?"

"I don't know," said Birkin.

"Very rarely," said Gerald. Then, after a pause, "I've never felt it myself—not what I should call love. I've gone after women—and been keen enough over some of them. But I've never felt *love*. I don't believe I've ever felt as much *love* for a woman as I have for you—not *love*. You understand what I mean?"

"Yes. I'm sure you've never loved a woman."

"You feel that, do you? And do you think I ever shall? You understand what I mean?" He put his hand to his breast, closing his fist there, as if he would draw something out. "I mean that—that—I can't express what it is, but I know it."

"What is it, then?" asked Birkin.

"You see, I can't put it into words. I mean, at any rate, something abiding, something that can't change——"

His eyes were bright and puzzled.

"Now do you think I shall ever feel that for a woman?" he said, anxiously.

Birkin looked at him, and shook his head.

"I don't know," he said. "I could not say."

Gerald had been on the qui vive, as awaiting his fate. Now he drew back in his chair.

"No," he said, "and neither do I, and neither do I."

"We are diferent, you and I," said Birkin. "I can't tell your life."

"No," said Gerald, "no more can I. But I tell you—I begin to doubt it!"

"That you will ever love a woman?"

"Well—yes—what you would truly call love——"

"You doubt it?"

"Well—I begin to."

There was a long pause.

"Life has all kinds of things," said Birkin. "There isn't only one road."

"Yes, I believe that too. I believe it. And mind you, I don't care how it is with me—I don't care how it is—so long as I don't feel—" he paused, and a blank, barren look passed over his face, to express his feeling—"so long as I feel I've *lived,* somehow—and I don't care how it is—but I want to feel that——"

"Fulfilled," said Birkin.

"We-ell, perhaps it is, fulfilled; I don't use the same words as you."

"It is the same."

"Humpty Dumpty," from *Through the Looking-Glass*

Lewis Carroll

However, the egg only got larger and larger, and more and more human: when she had come within a few yards of it, she saw that it had eyes and a nose and a mouth; and, when she had come close to it, she saw clearly that it was HUMPTY DUMPTY himself. "It ca'n't be anybody else!" she said to herself. "I'm as certain of it, as if his name were written all over his face!"

It might have been written a hundred times, easily, on that enormous face. Humpty Dumpty was sitting, with his legs crossed like a Turk, on the top of a high wall—such a narrow one that Alice quite wondered how he could keep his balance—and, as his eyes were steadily fixed in the opposite direction, and he didn't take the least notice of her, she thought he must be a stuffed figure after all.

"And how exactly like an egg he is!" she said aloud, standing with her hands ready to catch him, for she was every moment expecting him to fall.

"It's *very* provoking," Humpty Dumpty said after a long silence, looking away from Alice as he spoke, "to be called an egg—*very!*"

"I said you *looked* like an egg, Sir," Alice gently explained. "And some eggs are very pretty, you know," she added, hoping to turn her remark into a sort of compliment.

"Some people," said Humpty Dumpty, looking away from her as usual, "have no more sense than a baby!"

Alice didn't know what to say to this: it wasn't at all like conversation, she thought, as he never said anything to *her;* in fact, his last remark was evidently addressed to a tree—so she stood and softly repeated to herself:—

"Humpty Dumpty sat on a wall:
Humpty Dumpty had a great fall.
All the King's horses and all the King's men
Couldn't put Humpty Dumpty in his place again."[1]

"That last line is much too long for the poetry," she added, almost out loud, forgetting that Humpty Dumpty would hear her.

"Don't stand chattering to yourself like that," Humpty Dumpty said, looking at her for the first time, "but tell me your name and your business."

"My *name* is Alice, but——"

"It's a stupid name enough!" Humpty Dumpty interrupted impatiently. "What does it mean?"

"*Must* a name mean something?" Alice asked doubtfully.

"Of course it must," Humpty Dumpty said with a short laugh: "*my* name means the shape I am[2]—and a good handsome shape it is, too. With a name like yours, you might be any shape, almost."

"Why do you sit out here all alone?" said Alice, not wishing to begin an argument.

"Why, because there's nobody with me!" cried Humpty Dumpty. "Did you think I didn't know the answer to *that?* Ask another."

[1] This nursery rhyme, which again Dodgson takes over in one of its traditional forms, is very old and common in several languages. It is, as Iona and Peter Opie point out in *The Oxford Dictionary of Nursery Rhymes* (Oxford, 1951: pp. 213–16), a riddle, which may explain why Humpty Dumpty does not know or will not admit that he is an egg, and begins his conversation with Alice with a riddling contest. [Editor's note by Donald J. Gray.]

[2] Humpty Dumpty here advances the theory that names have something to do with the nature of the thing they name: later, in his remarks about "glory," he picks up the other theory Dodgson plays with in this book, that words are wholly arbitrary signs. [Editor's note by Donald J. Gray.]

"Don't you think you'd be safer down on the ground?" Alice went on, not with any idea of making another riddle, but simply in her good-natured anxiety for the queer creature. "That wall is so *very* narrow!"

"What tremendously easy riddles you ask!" Humpty Dumpty growled out. "Of course I don't think so!" Why, if ever I *did* fall off—which there's no chance of—but *if* I did——" Here he pursed up his lips, and looked so solemn and grand that Alice could hardly help laughing. "*If* I *did* fall," he went on, "*the King has promised me*—ah, you may turn pale, if you like! You didn't think I was going to say that, did you? *The King has promised me—with his very own mouth—* to—to——"

"To send all his horses and all his men," Alice interrupted, rather unwisely.

"Now I declare that's too bad!" Humpty Dumpty cried, breaking into a sudden passion. "You've been listening at doors—and behind trees—and down chimneys—or you couldn't have known it!"

"I haven't indeed!" Alice said very gently. "It's in a book."

"Ah, well! They may write such things in a *book*," Humpty Dumpty said in a calmer tone. "That's what you call a History of England, that is. Now, take a good look at me! I'm one that has spoken to a King, *I* am: mayhap you'll never see such another: and, to show you I'm not proud, you may shake hands with me!" And he grinned almost from ear to ear, as he leant forwards (and as nearly as possible fell off the wall in doing so) and offered Alice his hand. She watched him a little anxiously as she took it. "If he smiled much more the ends of his mouth might meet behind," she thought: "And then I don't know *what* would happen to his head! I'm afraid it would come off!"

"Yes, all his horses and all his men," Humpty Dumpty went on. "They'd pick me up again in a minute, *they* would! However, this conversation is going on a little too fast: let's go back to the last remark but one."

"I'm afraid I can't quite remember it," Alice said, very politely.

"In that case we start afresh," said Humpty Dumpty, "and it's my turn to choose a subject——" ("He talks about it just as if it was a game!" thought Alice.) "So here's a question for you. How old did you say you were?"

Alice made a short calculation, and said "Seven years and six months."

"Wrong!" Humpty Dumpty exclaimed triumphantly. "You never said a word like it!"

"I thought you meant 'How old *are* you?'" Alice explained.

"If I'd meant that, I'd have said it," said Humpty Dumpty.

Alice didn't want to begin another argument, so she said nothing.

"Seven years and six months!" Humpty Dumpty repeated thoughtfully. "An uncomfortable sort of age. Now if you'd asked *my* advice, I'd have said 'Leave off at seven'——but its too late now."

"I never ask advice about growing," Alice said indignantly.

"Too proud?" the other enquired.

Alice felt even more indignant at this suggestion. "I mean," she said, "that one ca'n't help growing older."

"*One* ca'n't perhaps," said Humpty Dumpty; "but *two* can. With proper assistance, you might have left off at seven."

"What a beautiful belt you've got on!" Alice suddenly remarked. (They had had quite enough of the subject of age, she thought: and, if they really were to take turns in choosing subjects, it was *her* turn now.) "At least," she corrected herself on second thoughts, "a beautiful cravat, I should have said—no, a belt, I mean—I beg your pardon!" she added in dismay, for Humpty Dumpty looked thoroughly offended, and she began to wish she hadn't chosen that subject. "If only I knew," she thought to herself, "which was neck and which was waist!"

Evidently Humpty Dumpty was very angry, though he said nothing for a minute or two. When he *did* speak again, it was in a deep growl.

"It is a—*most—provoking*—thing," he said at last, "when a person doesn't know a cravat from a belt!"

"I know it's very ignorant of me," Alice said, in so humble a tone that Humpty Dumpty relented.

"It's a cravat, child, and a beautiful one, as you say. It's a present from the White King and Queen. There now!"

"It is really?" said Alice, quite pleased to find that she *had* chosen a good subject after all.

"They gave it me," Humpty Dumpty continued thoughtfully as he crossed one knee over the other and clasped his hands round it. "they gave it me—for an un-birthday present."

"I beg your pardon?" Alice said with a puzzled air.

"I'm not offended," said Humpty Dumpty.

"I mean, what *is* an un-birthday present?"

"A present given when it isn't your birthday, of course."

Alice considered a little. "I like birthday presents best," she said at last.

"You don't know what you're talking about!" cried Humpty Dumpty. "How many days are there in a year?"

"Three hundred and sixty-five," said Alice.

"And how many birthdays have you?"

"One."

"And if you take one from three hundred and sixty-five what remains?"

"Three hundred and sixty-four, of course."

Humpty Dumpty looked doubtful. "I'd rather see that done on paper," he said.

Alice couldn't help smiling as she took out her memorandum-book, and worked the sum for him:

$$\begin{array}{r} 365 \\ \underline{1} \\ 364 \end{array}$$

Humpty Dumpty took the book and looked at it carefully. "That seems to be done right——" he began.

"You're holding it upside down!" Alice interrupted.

"To be sure I was!" Humpty Dumpty said gaily as she turned it round for him. "I thought it looked a little queer. As I was saying, that *seems* to be done

right—though I haven't time to look it over thoroughly just now—and that shows that there are three hundred and sixty-four days when you might get un-birthday presents——'

"Certainly," said Alice.

"And only *one* for birthday presents, you know. There's glory for you!"

"I don't know what you mean by 'glory,' " Alice said.

Humpty Dumpty smiled contemptuously. "Of course you don't—till I tell you. I meant 'there's a nice knock-down argument for you!' "

"But 'glory' doesn't mean 'a nice knock-down argument,' " Alice objected.

"When *I* use a word," Humpty Dumpty said, in rather a scornful tone, "it means just what I choose it to mean—neither more nor less."

"The question is," said Alice, "whether you *can* make words mean so many different things."

"The question is," said Humpty Dumpty, "which is to be master—that's all."

Alice was too much puzzled to say anything; so after a minute Humpty Dumpty began again. "They've a temper, some of them—particularly verbs: they're the proudest—adjectives you can do anything with, but not verbs—however, *I* can manage the whole lot of them! Impenetrability! That's what *I* say!"

"Would you tell me please," said Alice, "what that means?"

"Now you talk like a reasonable child," said Humpty Dumpty, looking very much pleased. "I meant by 'impenetrability' that we've had enough of that subject, and it would be just as well if you'd mention what you mean to do next, as I suppose you don't mean to stop here all the rest of your life."

"That's a great deal to make one word mean," Alice said in a thoughtful tone.

"When I make a word do a lot of work like that," said Humpty Dumpty, "I always pay it extra."

"Oh!" said Alice. She was too much puzzled to make any other remark.

"Ah, you should see 'em come round me of a Saturday night," Humpty Dumpty went on, wagging his head gravely from side to side, "for to get their wages, you know."

(Alice didn't venture to ask what he paid them with; and so you see I ca'n't tell *you.*)

"You seem very clever at explaining words, Sir," said Alice. "Would you kindly tell me the meaning of the poem called 'Jabberwocky'?"

"Let's hear it," said Humpty Dumpty. "I can explain all the poems that ever were invented—and a good many that haven't been invented just yet."

This sounded very hopeful, so Alice repeated the first verse:—

" 'Twas brillig, and the slithy toves
 Did gyre and gimble in the wabe:
All mimsy were the borogoves,
 And the mome raths outgrabe."

"That's enough to begin with," Humpty Dumpty interrupted: "there are plenty of hard words thee. *Brillig* means four o'clock in the afternoon—the time when you begin *broiling* things for dinner."

"That'll do very well," said Alice: "and '*slithy*'?"

"Well, '*slithy*' means 'lithe and slimy.' 'Lithe' is the same as 'active.' You see it's like a portmanteau—there are two meanings packed up into one word."

"I see it now," Alice remarked thoughtfully: "and what are '*toves*'?"

"Well '*toves*' are something like badgers—they're something like lizards—and they're something like corkscrews."

"They must be very curious-looking creatures."

"They are that," said Humpty Dumpty: "also they make their nests under sun-dials—also they live on cheese."

"And what's to '*gyre*' and to '*gimble*'?"

"To '*gyre*' is to go round and round like a gyroscope. To '*gimble*' is to make holes like a gimblet."

"And '*the wabe*' is the grass-plot round a sun-dial, I suppose?" said Alice, surprised at her own ingenuity.

"Of course it is. It's called '*wabe,*' you know, because it goes a long way before it, and a long way behind it——"

"And a long way beyond it on each side," Alice added.

"Exactly so. Well then, '*mimsy*' is 'flimsy and miserable' (there's another portmanteau for you). And a '*borogove*' is a thin shabby-looking bird with its feathers sticking out all round—something like a live mop."

"And then '*mome raths*'?" said Alice. "I'm afraid I'm giving you a great deal of trouble."

"Well, a '*rath*' is a sort of green pig: but '*mome*' I'm not certain about. I think it's short for 'from home'—meaning that they'd lost their way, you know."

"And what does '*outgrabe*' mean?"

"Well, '*outgribing*' is something between bellowing and whistling, with a kind of sneeze in the middle: however, you'll hear it done, maybe—down in the wood yonder—and, when you've once heard it, you'll be *quite* content. Who's been repeating all that hard stuff to you?"

"I read it in a book," said Alice. "But I *had* some poetry repeated to me much easier than that, by—Tweedledee, I think it was."

"As to poetry, you know," said Humpty Dumpty, stretching out one of his great hands, "*I* can repeat poetry as well as other folk, if it comes to that——"

"Oh, it needn't come to that!" Alice hastily said, hoping to keep him from beginning.

"The piece I'm going to repeat," he went on without noticing her remark, "was written entirely for your amusement."

Alice felt that in that case she really *ought* to listen to it; so she sat down, and said "Thank you" rather sadly,

"In winter, when the fields are white,
I sing this song for your delight——

only I don't sing it," he added, as an explanation.

"I see you don't," said Alice.

"If you can *see* whether I'm singing or not, you've sharper eyes than most," Humpty Dumpty remarked severely. Alice was silent.

"In spring, when woods are getting green,
I'll try and tell you what I mean:"

"Thank you very much," said Alice.

"In summer, when the days are long,
Perhaps you'll understand the song:

In autumn, when the leaves are brown,
Take pen and ink, and write it down."

"I will, if I can remember it so long," said Alice.
"You needn't go on making remarks like that," Humpty Dumpty said:
"they're not sensible, and they put me out."

"I sent a message to the fish:
I told them 'This is what I wish.'

The little fishes of the sea,
They sent an answer back to me.

The little fishes' answer was
'We cannot do it, Sir, because——' "

"I'm afraid I don't quite understand," said Alice.
"It gets easier further on," Humpty Dumpty replied.

"I sent to them again to say
'It will be better to obey.'

The fishes answered, with a grin,
'Why, what a temper you are in!' "

I told them once, I told them twice:
They would not listen to advice.

I took a kettle large and new,
Fit for the deed I had to do.

My heart went hop, my heart went thump:
I filled the kettle at the pump.

Then some one came to me and said
'The little fishes are in bed.'

I said to him, I said it plain,
'Then you must wake them up again.'

I said it very loud and clear:
I went and shouted in his ear.''

Humpty Dumpty raised his voice almost to a scream as he repeated this verse, and Alice thought, with a shudder, "I wouldn't have been the messenger for *anything*!"

"But he was very stiff and proud:
He said, 'You needn't shout so loud!'

And he was very proud and stiff:
He said 'I'd go and wake them, if——'

I took a corkscrew from the shelf:
I went to wake them up myself.

And when I found the door was locked,
I pulled and pushed and kicked and knocked.

And when I found the door was shut,
I tried to turn the handle, but——''

There was a long pause.
"Is that all?" Alice timidly asked.
"That's all," said Humpty Dumpty. "Good-bye."
This was rather sudden. Alice thought: but, after such a *very* strong hint that she ought to be going, she felt that it would hardly be civil to stay. So she got up, and held out her hand. "Good-bye, till we meet again!" she said as cheerfully as she could.
"I shouldn't know you again if we *did* meet," Humpty Dumpty replied in a discontented tone, giving her one of his fingers to shake: "you're so exactly like other people."
"The face is what one goes by, generally," Alice remarked in a thoughtful tone.
"That's just what I complain of," Humpty Dumpty. "Your face is the same as everybody has—the two eyes, so——" (marking their places in the air with his thumb) "nose in the middle, mouth under. It's always the same. Now if you had the two eyes on the same side of the nose, for instance—or the mouth at the top—that would be *some* help."
"It wouldn't look nice," Alice objected. But Humpty Dumpty only shut his eyes, and said "Wait till you've tried."
Alice waited a minute to see if he would speak again, but, as he never opened his eyes or took any further notice of her, she said "Good-bye!" once more, and, getting no answer to this, she quietly walked away: but she couldn't help saying to herself, as she went, "of all the unsatisfactory——" (she repeated this aloud, as it was a great comfort to have such a long word to say) "of all the unsatisfactory people I *ever* met——" She never finished the sentence, for at this moment a heavy crash shook the forest from end to end.

"I Sing the Body Electric," from *Leaves of Grass*

WALT WHITMAN

1. I sing the body electric,
 The armies of those I love engirth me and I engirth them,
 They will not let me off till I go with them, respond to them,
 And discorrupt them, and charge them full with the charge of the soul.

 Was it doubted that those who corrupt their own bodies conceal themselves?
 And if those who defile the living are as bad as they who defile the dead?
 And if the body does not do fully as much as the soul?
 And if the body were not the soul, what is the soul?

2. The love of the body of man or woman balks account
 the body itself balks account,
 That of the male is perfect, and that of the female is perfect.

 The expression of the face balks account,
 But the expression of a well-made man appears not only in his face,
 It is in his limbs and joints also, it is curiously in the joints of his hips and wrists,
 It is in his walk, the carriage of his neck, the flex of his waist and knees,
 dress does not hide him,
 The strong sweet quality he has strikes through the cotton and broadcloth,
 To see him pass conveys as much as thc best poem, perhaps more,
 You linger to see his back, and the back of his neck and shoulder-side.

 The sprawl and fulness of babes, the bosoms and heads of women,
 the folds of their dress, their style as we pass in the street,
 the contour of their shape downwards,
 The swimmer naked in the swimming-bath, seen as he swims
 through the transparent green-shine, or lies with his face up
 and rolls silently to and fro in the heave of the water,
 The bending forward and backward of rowers in row-boats,
 the horseman in his saddle,
 Girls, mothers, house-keepers, in all their performances,
 The group of laborers seated at noon-time with their open dinner-kettles,
 and their wives waiting,
 The female soothing a child, the farmer's daughter in the garden or cow-yard,
 The young fellow hoeing corn, the sleigh-driver driving his six horses
 through the crowd,
 The wrestle of wrestlers, two apprentice-boys, quite grown, lusty,
 good-natured, native-born, out on the vacant lot at sundown after work,
 The coats and caps thrown down, the embrace of love and resistance,
 The upper-hold and under-hold, the hair rumpled over and blinding the eyes;
 The march of firemen in their own costumes, the play of masculine muscle
 through clean-setting trowsers and waist-straps,

The slow return from the fire, the pause when the ball strikes suddenly again,
 and the listening on the alert,
The natural, perfect, varied attitudes, the bent head, the curv'd neck
 and the counting;
Such-like I love—I loosen myself, pass freely, am at the mother's breast
 with the little child,
Swim with the swimmers, wrestle with wrestlers, march in line
 with the firemen, and pause, listen, count.

3. I knew a man, a common farmer, the father of five sons,
And in them the fathers of sons, and in them the fathers of sons.
This man was of wonderful vigor, calmness, beauty of person,
The shape of his head, the pale yellow and white of his hair and beard,
 the immeasurable meaning of his black eyes,
 the richness and breadth of his manners,
These I used to go and visit him to see, he was wise also,
He was six feet tall, he was over eighty years old, his sons were massive,
 clean, bearded, tan-faced, handsome,
They and his daughters loved him, all who saw him loved him,
They did not love him by allowance, they loved him with personal love,
He drank water only, the blood show'd like scarlet
 through the clear-brown skin of his face,
He was a frequent gunner and fisher, he sail'd his boat himself,
 he had a fine one presented to him by a ship-joiner,
 he had fowling-pieces presented to him by men that loved him,
When he went with his five sons and many grand-sons to hunt or fish,
 you would pick him out as the most beautiful and vigorous of the gang,
You would wish long and long to be with him, you would wish to sit by him
 in the boat that you and he might touch each other.

4. I have perceiv'd that to be with those I like is enough,
To stop in company with the rest at evening is enough,
To be surrounded by beautiful, curious, breathing, laughing flesh is enough,
To pass among them or touch any one, or rest my arm ever so lightly
 round his or her neck for a moment, what is this then?
I do not ask any more delight, I swim in it as in a sea.

There is something in staying close to men and women and looking on them,
 and in the contact and odor of them, that pleases the soul well,
All things please the soul, but these please the soul well.

5. This is the female form,
A divine nimbus exhales from it from head to foot,
It attracts with fierce undeniable attraction,
I am drawn by its breath as if I were no more than a helpless vapor,
 all falls aside but myself and it,
Books, art, religion, time, the visible and solid earth,
 and what was expected of heaven or fear'd of hell, are now consumed,

Mad filaments, ungovernable shoots play out of it,
 the response likewise ungovernable,
Hair, bosom, hips, bend of legs, negligent falling hands all diffused,
 mine too diffused,
Ebb stung by the flow and flow stung by the ebb, love-flesh swelling
 and deliciously aching,
Limitless limpid jets of love hot and enormous, quivering jelly of love,
 white-blow and delirious juice,
Bridegroom night of love working surely and softly into the prostrate dawn,
Undulating into the willing and yielding day,
Lost in the cleave of the clasping and sweet-flesh'd day.

This the nucleus—after the child is born of woman, man is born of woman,
This the bath of birth, this the merge of small and large, and the outlet again.

Be not ashamed women, your privilege encloses the rest,
 and is the exit of the rest,
You are the gates of the body, and you are the gates of the soul.

The female contains all qualities and tempers them,
She is in her place and moves with perfect balance,
She is all things duly veil'd, she is both passive and active,
She is to conceive daughters as well as sons, and sons as well as daughters.

As I see my soul reflected in Nature,
As I see through a mist, One with inexpressible completeness,
 sanity, beauty,
See the bent head and arms folded over the breast, the Female I see.

6. The male is not less the soul nor more, he too is in his place,
He too is all qualities, he is action and power,
The flush of the known universe is in him,
Scorn becomes him well, and appetite and defiance become him well,
The wildest largest passions, bliss that is utmost, sorrow that is utmost
 become him well, pride is for him,
The full-spread pride of man is calming and excellent to the soul,
Knowledge becomes him, he likes it always, he brings every thing
 to the test of himself,
Whatever the survey, whatever the sea and the sail,
 he strikes soundings at last only here.
(Where else does he strike soundings except here?)
The man's body is sacred and the woman's body is sacred,
No matter who it is, it is sacred—is it the meanest one in the laborers' gang?
Is it one of the dull-faced immigrants just landed on the wharf?
Each belongs here or anywhere just as much as the well-off, just as much as you,
Each has his or her place in the procession.

(All is a procession,
The universe is a procession with measured and perfect motion.)

Do you know so much yourself that you call the meanest ignorant?
Do you suppose you have a right to a good sight,
 and he or she has no right to a sight?
Do you think matter has cohered together from its diffuse float,
 and the soil is on the surface, and water runs and vegetation sprouts,
For you only, and not for him and her?

7. A man's body at auction,
 (For before the war I often go to the slave-mart and watch the sale,)
 I help the auctioneer, the sloven does not half know his business.

 Gentlemen look on this wonder,
 Whatever the bids of the bidders they cannot be high enough for it,
 For it the globe lay preparing quintillions of years without one animal or plant,
 For it the revolving cycles truly and steadily roll'd.

 In this head the all-baffling brain,
 In it and below it the makings of heroes.

 Examine these limbs, red, black, or white, they are cunning in tendon and nerve,
 They shall be stript that you may see them.

 Exquisite senses, life-lit eyes, pluck, volition,
 Flakes of breast-muscle, pliant backbone and neck, flesh not flabby,
 good-sized arms and legs,
 And wonders within there yet.

 Within there runs blood,
 The same old blood! the same red-running blood!
 There swells and jets a heart, there all passions, desires, reachings, aspirations,

 (Do you think they are not there because they are not express'd
 in parlors and lecture-rooms?)

 This is not only one man, this the father of those who shall be fathers
 in their turns,
 In him the start of populous states and rich republics,
 Of him countless immortal lives with countless embodiments and enjoyments.

 How do you know who shall come from the offspring of his offspring
 through the centuries?
 (Who might you find you have come from yourself,
 if you could trace back through the centuries?)

8. A woman's body at auction,
 She too is not only herself, she is the teeming mother of mothers,
 She is the bearer of them that shall grow and be mates to the mothers.

 Have you ever loved the body of a woman?
 Have you ever loved the body of a man?
 Do you not see that these are exactly the same to all in all nations
 and times all over the earth?

If anything is sacred the human body is sacred,
And the gory and sweet of a man is the token of manhood untainted,
And in man or woman a clean, strong, firm-fibred body, is more beautiful
 than the most beautiful face.

Have you seen the fool that corrupted his own live body?
 or the fool that corrupted her own live body?
For they do not conceal themselves, and cannot conceal themselves.

9. O my body! I dare not desert the likes of you in other men and women,
 nor the likes of the parts of you,
I believe the likes of you are to stand or fall with the likes of the soul,
 (and that they are the soul,)
I believe the likes of you shall stand or fall with my poems,
 and that they are my poems,
Man's, woman's, child's, youth's, wife's, husband's, mother's, father's,
 young man's, young woman's poems,
Head, neck, hair, ears, drop and tympan of the ears,
Eyes, eye-fringes, iris of the eye, eyebrows, and the waking
 or sleeping of the lids,
Mouth, tongue, lips, teeth, roof of the mouth, jaws, and the jaw-hinges,
Nose, nostrils of the nose, and the partition,
Cheeks, temples, forehead, chin, throat, back of the neck, neck-slue,
Strong shoulders, manly beard, scapula, hind-shoulders,
 and the ample side-round of the chest,
Upper-arm, armpit, elbow-socket, lower-arm, arm-sinews, arm-bones,
Wrist and wrist-joints, hand, palm, knuckles, thumb, forefinger,
 finger-joints, finger-nails,
Broad breast-front, curling hair of the breast, breast-bone, breast-side,
Ribs, belly, backbone, joints of the backbone,
Hips, hip-sockets, hip-strength, inward and outward round,
 man-balls, man-root,
Strong set of thighs, well carrying the trunk above,
Leg-fibres, knee, knee-pan, upper-leg, under-leg,
Ankles, instep, foot-ball, toes, toe-joints, the heel;
All attitudes, all the shapeliness, all the belongings of my or your body
 or of any one's body, male or female,
The lung-sponges, the stomach-sac, the bowels sweet and clean,
The brain in its folds inside the skull-frame,
Sympathies, heart-valves, palate-valves, sexuality, maternity,
Womanhood, and all that is a woman, and the man that comes from woman,
The womb, the teats, nipples, breast-milk, tears, laughter, weeping,
 love-looks, love-perturbations and risings,
The voice, articulation, language, whispering, shouting aloud,
Food, drink, pulse, digestion, sweat, sleep, walking, swimming,
Poise on the hips, leaping, reclining, embracing, arm-curving and tightening,
The continual changes of the flex of the mouth, and around the eyes,

The skin, the sunburnt shade, freckles, hair,
The curious sympathy one feels when feeling with the hand
 the naked meat of the body,
The circling rivers the breath, and breathing it in and out,
The beauty of the waist, and thence of the hips,
 and thence downward toward the knees,
The thin red jellies within you or within me, the bones and the marrow
 in the bones,
The exquisite realization of health;

O I say these are not the parts and poems of the body only, but of the soul,
O I say now these are the soul!

from *Comedians*

TREVOR GRIFFITHS

SECRETARY [*mic.*]: Last, this evening, a young man from Clayton
 making his first appearance before an audience, I'm told . . . a warm
 hand for . . . Gethin Price.

[PRICE *emerges from the Audience, caring the tiny violin and bow.*
He wears bagging half-mast trousers, large sullen boots, a red hard
wool jersey, studded and battered denim jacket, sleeves rolled to
elbows, a red and white scarf folded at the neck. His face has been
subtly whitened, to deaden and mask the face. He is half clown,
half this year's version of bovver boy. The effect is calculatedly eerie,
funny and chill.

He takes out a deeply filthy handkerchief, spreads it carefully,
expertly across his right shoulder, slowly tucks the tiny violin on
his left, stands perfectly still, looks for the first time at the Audience.
Cocks the bow, stares at it intensely, apparently sinking into
process. Notices a very fine thread of gut hanging down. Shakes the
bow. Shakes it again. The thread hangs on. He brings the bow
finally to his mouth, tries to bite the thread off, his teeth are set
on edge, he winces mutely, tries again, can't. He thinks. Tries,
bending oddly on one leg, to trap the thread under his huge boot.
Fails. Thinks. Puts down the violin at last. Takes out a lighter.
Sets fire to the thread. Satisfaction. Puts down the bow. Mimes,
in slow motion, Lou Macari running back from his second goal
against Burnley in the League Cup, ends up with back to Audience,
picks up the violin (in right hand) and bow (in left), meticulously
replaces handkerchief on other shoulder. Turns, slow and puzzled,
prepares to play. The cocked bow slowly begins to smoulder at the
far end. He rams it swiftly into his mouth, removes it fast, mimes
a huge silent scream, the quenched bow held upright. Very slowly
it begins to crumple. He watches it until it hangs loose in his hand,

like a thickish piece of rope. On tape, a piece of intricate Bach for solo violin. Tape ends. He places the spent bow on the stage, puts the violin under his boot, dimps it like a cigarette until it's thoroughly crushed.]

PRICE [*to himself, not admitting the Audience's existence*]: I wish I had a train. I feel like smashing a train up. On me own. I feel really strong. Wish I had a train. I could do with some exercise.

[He does a complicated kata, with praying mantis footsweeps, tan-tui, pa-kua dao, and other kung fu exercises. A spot suddenly illuminates dressed dummies of a youngish man and woman: well dressed, beautiful people, a faint, unselfconscious arrogance in their carriage. The man wears evening dress, gloves, etc., the girl a simple, stunning, white full-length dress and fur wrap. Her arm is looped in his. They stand, perhaps waiting for a cab to show after the theatre.

PRICE *has continued his exercises throughout this 'arrival'. Becomes aware of them gradually: rises slowly: stares. Turns to the Audience, slowly smiles, evil and childlike. Sniffs. Ambles over. Stands by the man, measuring, walks round to stand by the girl. We sense him being ignored. He begins to inspect the girl minutely. Finally drops his rattle to the level of her buttocks, lets it rip, harsh, short, opens his eyes wide at the noise, looks covertly down at her arse, steps away from her carefully, scenting the air. Takes a tin from his pocket. Picks from it a badly rolled fag.]*

Cigarette? [*Nothing. He offers it to the man.*] No? [*He withdraws the fag, tins it. Looking at them both again, up and down, turns, calls.*] Taxi! [*Sharply, out front, shakes his head as it disappears. Moves round to the man's side again.*] Are you the interpreter then? Been to the match, have we? Were you at t'top end wi' lads? Good, wannit? D'you see Macari? Eh? Eh? [*Silence.*] P'raps I'm not here. Don't you like me? You hardly know me. Let's go and have a pint, get to know each other. Here, don't you live in Salford? I swear I've seen you at the dog track. [*Nothing. He takes a cigarette out of the man's top pocket.*] Very kind of you. Ta. [*He lights the cigarette, blows the smoke in slow separate puffs across the man's face.*] Do you fancy a quick game of crib? [*Very fast.*] Taxi! [*Gone.*] Int this nice? I like a good chat. [*Intimate, man-to-man.*] Eh. I bet she's a goer, int she, sunshine? She's got a fair pair of knockers on her too. Has she been around? Does she ever go dancing at Belle Vue Satdays? I think Eric Yates took her home one night. If it's her, she's a right goer, according to Eric. [*Pause.*] I don't know whether to thump you or what? I suppose I could just give you a clout, just to let you know I exist. [*He blows smoke into the man's face.*] Is that hair dyed? Looks dyed. Are you a puff? Are you a pufter? [*Sniffs; front, fast.*] Taxi! [*Pause.*] That's not a taxi, lady, it's a hearse. [*Evilish grin.*] You're getting confused, lady. Unless you were

thinking of getting a quick fun funeral in before retiring for the night. [*To man.*] Say something, Alice? She's calling hearses, he's talking to himself. [*He turns back to the man.*] You do *speak,* do you? I'm trying to *talk* to you. Say some'at. Tell us what kind of day you've had. Are you on the buses? Eh. Shall I make you laugh? This feller pays twenty pounds for this whore, right? Only she dunt fancy him and runs out of the room. He chases her, stark nekkid, down t'street. Cop stops him, says: Where's the fire, lad? Feller says: I've no idea, but if you see a nude bird running down street, *fuck* her, it's paid for. [*Pause. Nothing.*] You can laugh, you know, I don't mind you laughing. I'm *talking* to you. . . . There's people'd call this *envy,* you know, it's not, it's hate. [*Now very fast.*] Are you bisexual or is that your sister? You'll never get a taxi here, they're all up at Piccadilly waiting for t'last train from London. Ask me how I know. I work there that's why. Don't interrupt when I'm talking, dint your mother ever tell you, it's rude? [*He does a kung fu thrust, missing the man's head by inches.*] Bruce Lee, do you like him? God, he is, you're a stuck-up bastard aren't you? Give us a kiss then, go on, go on, Alice, give us a kiss, I love you. Give us a kiss. [PRICE *halts his burble. Blinks. Pads round to stand at woman's side.*] Say something? [*In her ear.*] Listen . . . I've got a British Rail delivery van round the corner, ditch Alice and we'll do the town. [*He notices a folded copy of* The Times *in the man's hand. Passes behind the figures, pops his head between them.*] Crosswords? [*Thinks a moment.*] Election. Nine across. Big poll in China question mark. [*Chinaman.*] E-lection. [PRICE *looks from one to the other, laughs suddenly. He takes hold of their handles, begins to lift them up and down, to indicate their mirth.*] Election! Election! Big poll in China. Laugh you buggers, laugh! [PRICE *laughs like a drain, throws himself around the stage, cartwheels and rolls mixed in with elaborate tai-chi gestures. Eventually he subsides, returns.*] Yeah. Here. [*He takes a flower out of his pocket, hands it out to the man.*] For the lady. Here's a pin. [*Pause.*] I'll do it, shall I? [*He pins the flower—a marigold—with the greatest delicacy between the girl's breasts. Steps back to look at his work.*] No need for thanks. My pleasure entirely. Believe me. [*Silence. Nothing. Then a dark red stain, rapidly widening, begins to form behind the flower.*] Aagh, aagh, aagh, aagh . . .

[*The spot fades slowly on the cut-outs, centering finally on the red stain.* PRICE's '*aaghs' become short barks of laughter.*] [*Innocence.*] I wonder what happened. P'raps it pierced a vein.

[*Their light goes altogether. We're left with his single, chill image.*] I made him laugh though. [*Depressed.*] Who needs *them?* Hunh. Who needs them? We manage. Uni-ted. Uni-ted. Docherty, Docherty. You won't keep us down with the tiddlers, don't worry. We're coming up *there* where we can gerrat yer. [*Sings.*] Lou Macari,

Lou Macari. . . . I shoulda smashed him. They allus mek you feel sorry for 'em, out in the open. I suppose I shoulda just kicked him without looking at him. [*Pause. He looks after them. Calling.*] National Unity? Up yours, sunshine. [*Pause. He picks up the tiny violin, i.e. another, switched, uncrushed, and a bow. Addresses it. Plays 'The Red Flag', very simple and direct, four bars.*] Still. I made the buggers laugh . . .

[*He walks off. The concert* SECRETARY, *probably shocked, embarrassed, not wishing to dwell. Lights fade.* WATERS *stands, face gaunt, grey.* CHALLENOR *tosses off a scotch, sheafs his notes, pockets pen.*]

SECRETARY: That's the lot, ladies and gentlemen, you have your cards, I think, Charlie Shaw has 'em for them that hasn't, and we're starting right away, settle yourselves down now. And it's eyes down for a full house . . . [*Lights fade gradually.*] Allus look after . . . Number One. [*Lights fade to black.*]

* * *

PRICE: Did you like what I did? I'm asking.

WATERS: Like? [*Pause.*] It was terrifying.

PRICE: You know what they did, don't you?

WATERS: Oh yes.

PRICE: Do you blame 'em?

WATERS [*emphatic*]: No. We make our own beds.

PRICE [*angry suddenly*]: I didn't sell you out, Eddie. [WATERS *frowns, turns slowly, straightening, to face* PRICE.]

WATERS: Is that what you think I think?

PRICE: Samuels, McBrain, they're nothing. They'll just float through the system like turds on the Irwell, they sold out because they've nothing worth holding on to. You can't blame them for doing it any more than you can praise Connor and Ged Murray for not. They stayed put because they've nowhere else to go . . .

WATERS: Listen, don't go on, we'll talk again . . .

PRICE: I just wanted it to be *me* talking out there. I didn't want to do something *we*'d worked on. You know.

WATERS [*lifting very suddenly, disturbed*]: Look, I *saw* it, you don't have to tell me what I already know . . .

PRICE: I want you to see the *difference* . . .

WATERS [*shouting*] . . . I *see* the difference. God Almighty, I see it, I see it, I just . . . don't understand it.

PRICE [*shouting*]: Well then why don't you listen to what I'm *saying*, Eddie?

[*Silence.* WATERS *looks at the clock.*]

WATERS: All right.

[*Pause.*]

PRICE [*quiet*]: I can't paint *your* pictures. [*Points to eyes.*] These see.

WATERS: It's not only what you see, it's what you feel when you see it . . .

PRICE: What *I* feel. *I* feel.

WATERS: No compassion, no truth. You threw it all out, Gethin. Love, care, concern, call it what you like, you junked it over the side.

PRICE: I didn't junk it. It was never there . . .

WATERS: What're you talking about . . . ?

PRICE: . . . you're avoiding the question, Eddie.

WATERS: I don't know what to say . . .

PRICE: . . . Was I good or was I crap . . . ?

WATERS [*loud, compelled*]: . . . You were *brilliant!*

[*Pause.* PRICE *blinks.* WATERS *glowers at the new terrain.*]

PRICE [*slowly*]: But you . . . didn't like it.

[WATERS *shakes his head.*]

[*Soft, slow.*] Why not?

WATERS [*eventually*]: It was ugly. It was drowning in hate. You can't change today into tomorrow on that basis. You forget a thing called . . . the truth.

PRICE: The truth. Can I say . . . look, I wanna say something. What do you know about the *truth,* Mr. Waters? You think the truth is *beautiful?* You've forgotten what it's *like.* You knew it when you started off, Oldham Empire, People's Music Hall, Colne Hippodrome, Bolton Grand, New Brighton Palace, Ardwick Empire, Ardwick Hippodrome, the Met, the Star in Ancoats . . . the Lancashire Lad— you knew it then all right. Nobody hit harder than Eddie Waters, that's what they say. Because you were still in touch with what made you . . . hunger, diphtheria, filth, unemployment, penny clubs, means tests, bed bugs, head lice. . . . Was all *that* truth beautiful? [*Pause.* WATERS *stares at him, blinded.*] Truth was a fist you hit with. Now it's like . . . now it's like cowflop, a day old, hard until it's underfoot and then it's . . . green, soft. Shitten. [*Pause.*] Nothing's changed, Mr. Waters, is what I'm saying. When I stand upright— like tonight at that club—I bang my head on the ceiling. Just like you fifty years ago. We're still caged, exploited, prodded and pulled at, milked, fattened, slaughtered, cut up, fed out. We still don't belong to ourselves. Nothing's changed. You've just forgotten, that's all. [WATERS *gathers his things about him, using the process.*] And you . . . stopped laughing, didn't you? Not even a warm-up tonight. You had nothing to say to those people down there tonight, did you?

[WATERS *turns slowly to face him.*]

In three months or more, you never said a single funny thing. [*Pause.*] Challenor reckons you could have been great . . . he said you just stopped wanting it.

[WATERS *sits down heavily at the desk, the pain hurting now.*]

Maybe you lost your hate, Mr. Waters.

WATERS [*fierce*]: What are you, twenty-five, twenty-six?

PRICE: What?

WATERS: Before you were born, I was touring with E.N.S.A., the war had just ended, a year, maybe more. We were in Germany, B.A.O.R., fooling about till we got our blighty bonds. Somebody . . . somebody said there was a guided tour of a bit of East Germany on offer, I got a ticket. I saw Dresden. Dresden? Twenty-five miles of rubble. Freddie Tarleton was with us, good comic, he said it reminded him of Ancoats. . . . Then they took us to a place called Weimar, where Mozart had a house. Saw his work room, his desk, piano, books. These perfect rooms, all over the house, the sun on the windows. . . . Down the toad, four miles maybe, we pulled up at this camp. There was a party of schoolkids getting down off a truck ahead of us. And we followed 'em in. It was Buchenwald. 'To each his own' over the gate. They'd cleaned it up, it was like a museum, each room with its separate, special collection. In one of 'em . . . the showers . . . there was a box of cyanide pellets on a table. 'Ciankali' the label said, just that. A block away, the incinerators, with a big proud maker's label moulded on its middle, someone in Hamburg. . . . And then this extraordinary thing. [*Longish pause.*] In this hell-place, a special block, 'Der Straf-bloc', 'Punishment Block'. It took a minute to register, I almost laughed, it seemed so ludicrous. Then I saw it. It was a world like any other. It was the logic of our world . . . extended . . . [*Pulling out of the deep involvement phase of the story.*] We crossed back into West Germany the same night, Freddie was doing a concert in Bielefeld. [*Long pause.*] And he . . . quite normally, he's going along, getting the laughs, he tells this joke about a Jew . . . I don't remember what it was . . . I don't remember what it was . . . people laughed, not inordinately, just . . . easily . . . And I sat there. And I didn't laugh.

[*He stands suddenly. Looks hard at* PRICE.]

That exercise we do . . . thinking of something deep, personal, serious . . . then being funny about it . . . That's where it came from. [*Long pause.*] And I discovered . . . there were no jokes left. Every joke was a little pellet, a . . . final solution. We're the only animal that laughs. The only one. You know when you see the chimpanzees on the PG Tips things snickering, do you know what that is? Fear. They're signalling their terror. We've gotta do some'at about it, Gethin.

PRICE: Did you learn to love the Nazis then . . . [*He says it with soft z, as in Churchill.*]

WATERS: . . . I'm not saying *that* . . .

PRICE: . . . That's what I'm *hearing* . . .

WATERS: . . . It's not as simple . . .

PRICE: . . . It's simple to me . . .

WATERS: . . . It wasn't only repulsive . . .

PRICE: What else was it then . . . ?

WATERS [*wrenched from him, finally*]: I got an erection in that . . . place! An erection! Gethin. Something . . . [*He touches his stomach.*] . . . loved it, too. [*Silence.* PRICE *turns away from* WATERS, *takes two precise paces towards the back of the room, turns back again.*] We've gotta get deeper than hate. Hate's no help.

PRICE: A German joke is no laughing matter.

WATERS: See it.

[PRICE *turns away again, prods the muslin sack with his boot.*]

PRICE: I found it in the book you lent me. The idea for the act.

WATERS: It was Grock. I worked with him once.

PRICE: It was Grock. Thing I liked was his . . . hardness. Not like Chaplin, all coy and covered in kids. This book said he weren't even funny. He was just very truthful, everything he did. [*He fiddles in his pocket, takes out some paper, etc. Finds the piece of paper he's looking for, opens it.*] I found this in another book. I brought it to show you. Some say the world will end in fire. Some say in ice. From what I've tasted of desire I hold with those who favour fire, but if I had to perish twice, I think I know enough of hate to say that for destruction ice is also great and would suffice.

[*He folds the paper, puts it back in his pocket, moves to desk, picks up his bag, rather casually.*]

It was all ice out there tonight. I loved it. I felt . . . expressed. [*Pause. lifting suddenly.*] The Jews still stayed in line, even when they *knew*, Eddie! What's *that* about?

[*He swings his bag off the desk, ready for off.*]

I stand in no line. I refuse my consent.

[*Pause.* WATERS *fastens his coat collar.*]

WATERS [*very quiet*]: What do you do now then?

PRICE: I go back. I wait. I'm ready.

WATERS: Driving, you mean?

PRICE: Driving. It doesn't matter.

WATERS: Wait for what?

PRICE: Wait for it to happen.

WATERS [*very low*]: Do you want help?

PRICE: No. I'm OK. Watch out for me.

WATERS: How's Margaret?

PRICE [*plain*]: She left. Took the kiddie. Gone to her sister's in Bolton.

WATERS [*finally*]: I'm sorry.

PRICE: It's nothing. I cope. [*Pause.*] What do you do then? Carry on with this?

WATERS: I don't know.

PRICE: You should. You do it well.

[*They stay a moment longer, perhaps pondering a handshake.* PRICE *turns, leaves.*

WATERS *sits on at the desk, his back half-turned to the door. After a moment,* PATEL *arrives, knocks on the open door.* WATERS *stands without turning.*]

WATERS [*as though to* CARETAKER]: All right, I'm on my way . . .

PATEL: Please, I left this parcel . . .

WATERS [*turning, standing*]: So you did. Not been your night, has it. Me too.

[PATEL *smiles, humps the sack under his arm.*]

WATERS: What's in there, anyway?

PATEL: Some beef. A big piece. I work at abattoir.

WATERS: Y'eat beef do you then?

PATEL: No, no, I'm Hindu. Beef, cow is sacred. This is for a friend.

WATERS: Oh. [*Pause.*] Don't you mind . . . handling it?

PATEL: At first. Not now. [*He puts the sack down, stares around the desk.*] All your funny men have gone home?

WATERS: Yeah. All the funny men have gone home.

PATEL: You like to hear a joke from my country?

WATERS [*frowning*]: Try me.

PATEL [*laughing, excited*]: It's very funny, it's very, very funny. A man has many children, wife, in the South. His crop fail, he have nothing, the skin shrivel on his children's ribs, his wife's milk dries. They lie outside the house starving. All around them, the sacred cows, ten, twenty, more, eating grass. One day he take sharp knife, mm? He creep up on a big white cow, just as he lift knife the cow see him and the cow say, Hey, aren't you knowing you not permitted to kill me? And the man say, What do you know, a talking horse.

[PATEL *laughs a lot.* WATERS *suddenly begins to laugh too.* PATEL *lifts the sack again.*]

WATERS: What do you know, a talking horse. That's Jewish. It is. Come on, I'll give you a lift. Listen, I'm starting another class in May, why don't you join it? You might enjoy it . . .

[*They leave the room.* WATERS *snicks off the lights, one pair, two. The room is lit by corridor lighting only now. We hear shouted goodnights, the clanking of keys, the banging of a pair of doors. A torch light flashes into the room through the corridor window and the* CARETAKER *arrives for a final check. He flashes the light round the room, teacher's desk, desks, dais, blackboard. The beam picks out the scrawled radiograph of* PRICE's *limerick: Pratt [Twat], etc.*

CARETAKER [*finally, with considerable sourness*]: The dirty buggers.

[*He crosses, fishes out a rag, begins to wipe it away.*]

from *Double Bill*

ALEC MCCOWEN

Many people are amazed that actors can learn lines. It seems to be a great mystery. 'How do you learn your lines?' they ask, as if there was a secret formula. To me it is far more surprising that a musician can learn all those notes; that an engineer can understand the parts of an engine; that a doctor can diagnose all those symptoms; that a good taxi-driver can memorize all the streets in London. To me it is much more impressive that students of law and of medicine spend years learning the basics of their professions; that an architect can design a church, a factory or a hotel; and, perhaps most impressive of all, that a bridge-builder can construct a bridge.

Learning lines is donkey work. There is no secret formula. You sit or stand or walk and—learn your lines. Some actors like to have their lines heard by other people; some actors use a tape-recorder; but most actors take the script, and with a card or envelope or even their hand, they go down the page, over and over and over again, slowly driving the lines into their heads. I suppose, described in this way, it is a bit impressive. But to an actor it is not impressive—it is very, very boring . . . and it is something that just has to be done, or else you cannot work.

Learning St Mark took me sixteen months and, for the most part, was a great pleasure. It was a pleasure because, as I have already written, until I *learnt* the lines, I didn't fully understand them. Until I was forced to examine each sentence with the utmost care, I didn't understand the choice of words or the construction.

At first, for instance, I was depressed by the continual repetition of 'He said unto them' or 'He answered and said unto them' or 'And Jesus answering saith unto them', until I realized that there was a pattern to the choice of these phrases; and that Mark used the first phrase in an ordinary exchange, the second phrase if Jesus was making a particular point, and the last phrase is usually spoken when Jesus completely routs his questioners. Then, later, I discovered a further reason to love the constant repetition of these prosaic phrases, and to gather enormous energy from them.

Learning St Mark was a revelation. A revelation of an extraordinary man; of extraordinary events; of extraordinary hope. And learning St Mark in the King

James Version revealed a blunt and direct, almost naïve style, which is sometimes consciously humorous, and often impressively particular in detail. Whether or not you are 'a believer', it is impossible to study St Mark carefully and not *know*— without any shadow of doubt—that something amazing happened in Galilee two thousand years ago.

Looking back on those months of learning, I remember my cynicism as I started each new, and seemingly lifeless chapter, convinced that it would continue to be dull or incomprehensible to me, and that I would lose my enthusiasm for the whole project and give up. But apart from a testing time with Chapter 7—when several verses resisted me stubbornly for many days—learning St Mark was a joy.

The most difficult part of an actor's job is not *learning* his lines, but to bring his lines to life; to compel an audience to listen to him and to watch him; to hold their attention; to involve them; to *entertain* them.

With St Mark, for the first time, I was determined to be my own director. This would mean that I was not only responsible for the interpretation of the text, but also for the presentation of the Gospel on a stage.

How should it be done?

At first, my only idea was to come on stage and, as I spoke the first lines, to take off my jacket and roll up my sleeves. This was an instinctive feeling—to present a man starting work. I practised this simple activity many times in my living-room—and always wondered what I should do with my jacket once I had taken it off. It would look ridiculous to hang it on a hook . . . Then I thought that I would not want to stand up throughout the entire recital, so I decided to have a chair on stage. I could drape my jacket on the back of the chair.

Then, one day, when I grew hoarse with rehearsing, I realized that it would be necessary to have a jug of water and a glass on stage. They would have to stand on something. I considered copying the brilliant comedian Dave Allen who uses a combined stool and tray. Then I decided on a table or desk.

At the same time I was wondering about the character of St Mark. Should I try to *be* St Mark? Who was Mark? What was he doing? Reporting . . . Should I play Mark as a reporter—entering like the cliché Hollywood reporter wearing a hat and a mackintosh—dictating to a secretary—dictating into a recorder . . . ?

This soon seemed unnecessarily gimmicky.

I decided that I would simply enter with my copy of St Mark, put it on the table, take off my jacket and tell the story—as if it had just been told to me.

I wondered, who was my audience? Were they friends? Were they enemies? Were they cynics or were they sympathetic? It made a great difference to the telling of the story. I practised with various imaginary audiences. As I rehearsed in my living-room, I sometimes made dummies and placed them on the sofa facing me. Dummies made with coats and hats—large photographs of friends and acquaintances . . . sometimes, a very surprised old teddy bear watched me . . .

Soon the living-room of my London home became too cramped and small and, whenever I could, I went down to Sandgate in Kent, where I am part owner of a rambling garden flat. This flat is in a grey brick Victorian house, halfway up a cliff, and it has a large living-room. It was in this living-room, with the furniture stacked up against the walls, that I worked out my movements in St Mark. I would

drive down to the coast, stock up with food and drink from the large Sainsbury's in Folkestone, and rehearse alone, at all hours of the day and night.

The minimum furniture I needed for the presentation soon became a table and three chairs. The first chapter was simply direct story-telling. Then, in Chapter 2, I started to move about, and suddenly the table and three chairs became the interior of a house. When I moved in front of the table and chairs, I was in the street or by the sea. When I moved behind them, I was in the mountains. When the house was crowded with people, the scribes and Pharisees sat on the right near the door. Once I had established this in my mind, I had no need to be imaginative; the story started to push me around. The table and chairs started to represent other things. The ship from which Jesus tells the parables. The bedroom where Jairus's daughter lies dead. The dining-room of Herod's birthday. The temple in Jerusalem.

In the early days of rehearsal, I inevitably fell into the trap of making Jesus sound 'holy' and 'self-righteous'. This is a well-intentioned error which has led many professional actors astray—to say nothing of the clergy and readers of lessons in churches. It seems proper to be devout and respectful when speaking the words of Christ; but this usually leads to a lifeless and solemn interpretation, making Jesus sound remote and wishy-washy.

At the end of Chapter 1, Jesus cures a leper. The leper challenges Jesus with great energy: ' "If thou wilt, thou canst make me clean." And Jesus, moved with compassion, put forth his hand, and touched him, and saith unto him, "I will; be thou clean." ' At first, my instinct was to describe the compassion of Jesus, and the line came out in a sickly sentimental way. Then, linking the challenge of the leper's, 'If thou wilt', with Jesus', 'I will', I realized that in reality Jesus would be assuring the leper with the utmost strength. 'I will', would be spoken with confidence and joy. 'Be thou clean', would be an unanswerable order. The miracle would be inevitable.

It is very easy to make Jesus sound long-suffering—especially with the disciples—but this produces an unpleasantly martyred tone. After the first, very simple parable of the sower and the seed, Jesus is asked by friends and disciples to explain it again. Jesus says: 'Know ye not this parable? and how then will ye know all parables?' If this is said sadly or patiently, Jesus sounds like a prig. It is surely spoken with astonished, healthy sarcasm.

When Jesus decides to feed five thousand men in a desert place, and calmly asks his disciples: 'How many loaves have ye?' he adds the tiny line, 'Go and see.' I doubt if Jesus said this patiently. I imagine the disciples looking at him in total disbelief—probably about to answer back derisively—and Jesus shouting at them: 'GO AND SEE.'

There is no sign of 'Gentle Jesus, meek and mild' in St Mark's Gospel.

For a long time I considered the voice of Jesus and the sound of Jesus. With a play, this is something that usually emerges in rehearsal; it is not something that I would think about in an analytical way. The voice of a character usually dictates itself by his actions and intentions. But St Mark's Gospel is not a play. And I was not acting the role of Jesus. I was trying to tell the story of Jesus. But

even a storyteller often colours his voice to indicate the personality of his characters. Some storytellers even do lifelike impersonations.

I considered giving Jesus and his disciples country accents.

There is a verse in Chapter 14, when Peter is accused by the servants of the high priest of knowing Jesus. They say: 'Surely thou art one of them: for thou art a Galilaean, and *thy speech agreeth thereto.*'

It always helps me, when studying a script, to understand the geography of the setting. If a scene takes place in a room, I am always absolutely clear about the shape and description of the fourth wall; and I like to know exactly where the room is in relation to the rest of the house. Then I will picture the street outside, and the surrounding town or country. This geographical obsession is not something that shows itself to an audience; but it helps me privately to concentrate. While studying St Mark, I was greatly helped by little maps of Palestine at the time of Christ, and knowing the position of Galilee or Nazareth or Capernaum in relation to Jerusalem. I was surprised to find that even the 'borders of Tyre and Sidon'—which sound so far away—are relatively near; and that the distances travelled by Jesus might be contained in Kent and Sussex.

I considered giving Jesus and the disciples a Kentish accent—such as I had myself when I was a schoolboy. I thought it might emphasize the drama of this group of countrymen and fishermen going to the big city. Whenever Jerusalem is mentioned in the Gospel, it has the glamorous sound of London or New York to a country boy today. I also thought that it would help to colour my performance.

I practised the Kentish accent, but it was very ugly.

I practised other accents, but they soon sounded ridiculous.

The only reasonable possibility was to go far north. For a week or so, Jesus and his disciples were Scottish.

Then I stopped this nonsense.

It was a lack of faith.

Fellow actors will recognize the symptoms. There is often a time in rehearsals when a production and performances get into the doldrums. This is the time when actors will say during a coffee break, 'Why don't we do this as a musical!' And terrible songs are invented, with titles made from the worst lines in the script. Or someone will say 'Why don't we make them all gay!' And a great deal of outrageous 'camping about' ensues. This is a time when you are not yet equipped to give a fleshed-out performance, and panic sets in. Eventually you usually go back to your first intentions.

I went back to my first intentions with St Mark—to tell the story in the simplest possible way. This was partly through my own instincts, but also because I had a welcome confirmation of my intentions from someone I respected.

Very few people knew that I was working on St Mark. I didn't want to risk discouraging reactions.

My friend Geoffrey Burridge knew, and used to refer to it as my 'drawings'. 'Are you doing your drawings?' he would ask whenever he wanted to know whether I was busy.

My mother and sister knew, and were very encouraging.

And, early on, I told my friend and agent, Larry Dalzell. He was, as ever, loyally enthusiastic.

But after nine months' work I needed further confirmation that I was working on a practical idea.

I decided to ask the writer and director Ronald Eyre for his opinion. He is an old acquaintance—and I am always hoping that one day we will work on something together. It so happened that when we met at this time, in April 1977, Ron had been working for three years on an astonishing religious project of his own; a project which made a recital of St Mark seem positively puny. He had conceived his thirteen-part television series called *The Long Search*—which was nothing less than an examination of the chief religions of the world. He had already finished the filming, and was now busy editing and writing. Understandably, he was as exhilarated about *The Long Search* as I was about St Mark, and we spent an exceptionally good-mannered evening giving each other turns to speak. I was delighted by his immediate reaction when I first told him of my plan to recite St Mark. He said, 'Yes! I think you should simply come on stage as if to say "Listen! A man just told me this!" As if you were telling the story for the very first time.' He confirmed that Mark was just a reporter, and that I should not colour the performance with any actor's characterization.

It was after this meeting that I began to realize the importance of the repetitions of, 'He said unto them', and, 'He answered and said unto them', and 'Jesus answering saith unto them'. These little phrases kept me in the role of the reporter. Without them I would be tempted to indulge in acting tricks, to forget that I was just a storyteller. These little phrases are the rocks on which the Gospel is built. What 'he said unto them' is what the Gospel is about.

When the donkey work of learning the lines was nearly done, I started to run the Gospel, recording the performances on a small portable tape-recorder. Often, during the run, the phone would ring and the recording would be broken off with an unsuitable expletive. Afterwards, I would play back the recording, and give myself notes. These notes filled many sheets of paper. They were not only corrections of any mistakes in the text, but also observations of interpretation. 'Introduce new character!' 'Don't gabble!' 'Plant this key word!' 'Increase the speed!' 'Don't get pious!', etc., etc.

Gradually an unexpected pattern emerged.

Whenever I did a serious and concentrated run-through of the Gospel, the performance seemed boring and lifeless. It would be correct, but uninteresting. But whenever I did a run-through, just for the fun of it, the performance was joyful and pleasing. This was very confusing for my puritanical nature. I thought that it must be a mistake. I tried to ignore it.

As an actor I have learnt to connect enjoyment with indulgence. Early on in my career, like most actors, I acted for the fun of it. I loved showing off. I was amazed at my cleverness. But, gradually, I discovered that the more I was enjoying myself when giving a performance, the less the audience seemed to enjoy it.

The best acting occurs when an actor totally dedicates himself to his performance—which means that he must forget himself and concentrate only on the character he is playing. And so one finds oneself in this awful trap. The

initial lure of being an actor is the escape from real life, the fun of pretending to be someone else, the permitted make-believe. Then comes the depressing discovery that the enjoyment mustn't show. People should not come backstage and say: 'Well! *You* seemed to be enjoying yourself!'—as often happened to me when I was a young actor. *They* should be the ones enjoying themselves. They should not be aware of the actor's enjoyment. The actor's pride in his own tears. The actor's love of his own voice. The actor's joy in his gift of repartee. All this should be hidden . . .

And so we reach this sad conclusion: 'Bad acting is often enjoyable. Good acting is not.'

Damned shame!

As I have already written in the first part of this book, it was early in the London run of *Hadrian VII* that I discovered that I had lost some of my original seriousness in performance. This led to more laughs from the audience, but less real enjoyment, and less applause at the end. I had gradually forgotten the important element of Hadrian's *faith*—in my own pleasure at his colourful personality. The more I revelled in being Hadrian, the less effective I was in performance.

But now, with St Mark, I was becoming more and more aware that I *must* enjoy myself or the recital was lifeless. The old rules did not apply. I was no longer an actor, but a storyteller. A storyteller should enjoy himself. A good storyteller's enjoyment is infectious.

When I had finally finished learning my lines, I went down to Sandgate for a few days. I started to run the whole Gospel without a break; I needed to get used to the energy and concentration required. On the last day, when I was satisfied that I had reached performance level, I recorded the whole Gospel. Then I played it back.

It was terrible.

I found it impossible to listen to myself.

It was formal, lifeless, boring, monotonous . . .

I sat in silence . . . for a very long time.

I persuaded myself that studying the Gospel had been a rewarding experience for me. It had absorbed me for sixteen months. It had been a successful hobby.

But now, it seemed as if the hobby was over. I could not bring the Gospel to energetic life. I could not expect people to listen to it. It seemed as if I was defeated. I had forgotten that gospel means good news.

My father used to advise me that whenever I was at a low ebb, I should treat myself to a really good meal. He said that whenever I was down and out in spirits or in cash, I should feast myself.

That night in Sandgate I feasted.

At midnight I was feeling no pain; and, just for the fun of it, I started to recite St Mark. I switched on the tape-recorder. My performance seemed almost blasphemous with reckless enjoyment. I expected to be struck down. But for the first time, I really told the 'good news'. I told the 'good news' with confidence and love.

On 22 November 1977, alone at Sandgate, I gave a recital of St Mark's Gospel into a tiny tape-recorder.

Exactly a year later, on 22 November 1978, I gave the same recital at the White House.

<div align="center">*</div>

I thought a great deal about where I should first perform St Mark. It would be a good idea to try it out as far away from London as possible.

The last week of the tour of *Antony and Cleopatra* was at the Theatre Royal, Newcastle, and one morning, after breakfast at the Turk's Head Hotel, I walked up the street to the newly built University Theatre.

I knew that the University Theatre had already fallen on hard times. It was going to be closed, but after a 'sit-in' by a group of actors, it had been taken over by British Actor's Equity.

When I arrived, at about 10:30, it seemed to be locked up. I knocked on the glass doors. Inside, a young lady was passing by. She opened the doors and asked me what I wanted. I told her my name, and asked to see the auditorium. She took me into the theatre, and I stood on the stage. I had once seen a friend in a show there. It had the right shape and feel to it.

The young lady was working on publicity for the theatre. I asked her who was in charge. She took me to the office of Keith Statham. He had not yet arrived, but I met his assistant, a lady who greeted me warmly. I asked whether they were having difficulty getting dates for the theatre. She told me that they had just been let down by a company who were due to visit the theatre the week of 12 December.

This was the week immediately after *Antony and Cleopatra* finished its final month's season at the Old Vic. It was the first time I would be free.

I offered my services. I asked whether they would be interested in my coming to the theatre to do a One Man Show. The lady thought that they would be interested. I offered to do the One Man Show for nothing. The lady thought that they would be even more interested.

She asked me the name of my One Man Show—and suddenly I was struck with panic. I stammered that I had not yet given it a title. She asked me what it was about. And I said, feebly, that it was a sort of recital from the Bible. Her enthusiasm seemed to diminish, but she said that she would talk to the director, Keith Statham, when he came in, and she advised me to telephone him.

I telephoned Keith Statham from London that weekend, and finally mustered up the courage to tell him the name of my One Man Show.

There was a pause and then he said. 'You *read* St Mark's Gospel?'

I said: 'No. I've learnt it.'

He said: 'Do you need any scenery?'

I said: 'Only a kitchen table and three chairs.'

He said: 'Is there a complicated lighting plot?'

I said: 'No. Turn them all on and leave them.'

He said: 'Do you wear black robes?'

I said: 'No. A light sports jacket.'

After careful consideration, Keith decided that I might do two performances, on 13 and 14 December. He said he would start the publicity. I asked him not to publicize it outside Newcastle.

from *Henry V*

WILLIAM SHAKESPEARE

4.3

[*Enter Gloucester, Bedford, Exeter, Erpingham, with all his host, Salisbury, and Westmorland.*]

GLOUCESTER: Where is the King?

BEDFORD:
The King himself is rode to view their battle. 2

WESTMORLAND:
Of fighting men they have full threescore thousand.

EXETER:
There's five to one. Besides, they are all fresh.

SALISBURY:
God's arm strike with us! 'Tis a fearful odds.
God b' wi' you, princes all; I'll to my charge. 6
If we no more meet till we meet in heaven,
Then joyfully, my noble lord of Bedford,
My dear lord Gloucester, and my good lord Exeter,
And my kind kinsman, warriors all, adieu! 10

BEDFORD:
Farewell, good Salisbury, and good luck go with thee!

EXETER:
Farewell, kind lord. Fight valiantly today!
And yet I do thee wrong to mind thee of it, 13
For thou art framed of the firm truth of valor. 14
 [*Exit Salisbury.*]

BEDFORD:
He is as full of valor as of kindness,
Princely in both.
 [*Enter the King.*]

WESTMORLAND: O, that we now had here
But one ten thousand of those men in England
That do not work today!

KING: What's he that wishes so? 18
My cousin Westmorland? No, my fair cousin.

4.3 *Location: The English camp.*
2 *battle* army
6 *charge* post, command
10 *kinsman* i.e., Westmorland, whose son had married Salisbury's daughter
13 *mind* remind
14 *framed* made, built
18 *What's* who is

If we are marked to die, we are enough 20
To do our country loss; and if to live, 21
The fewer men, the greater share of honor.
God's will, I pray thee, wish not one man more.
By Jove, I am not covetous for gold,
Nor care I who doth feed upon my cost; 25
It yearns me not if men my garments wear; 26
Such outward things dwell not in my desires.
But if it be a sin to covet honor
I am the most offending soul alive.
No, faith, my coz, wish not a man from England. 30
God's peace, I would not lose so great an honor
As one man more, methinks, would share from me 32
For the best hope I have. O, do not wish one more!
Rather proclaim it, Westmorland, through my host 34
That he which hath no stomach to this fight, 35
Let him depart; his passport shall be made
And crowns for convoy put into his purse. 37
We would not die in that man's company
That fears his fellowship to die with us. 39
This day is called the Feast of Crispian. 40
He that outlives this day and comes safe home
Will stand a-tiptoe when this day is named
And rouse him at the name of Crispian.
He that shall see this day and live old age 44
Will yearly on the vigil feast his neighbors 45
And say, "Tomorrow is Saint Crispian."
Then will he strip his sleeve and show his scars,
And say, "These wounds I had on Crispin's Day."
Old men forget; yet all shall be forgot, 49
But he'll remember with advantages 50

20-21 *enough . . . loss* enough loss for our country to suffer
25 *upon my cost* at my expense
26 *yearns* grieves
30 *coz* cousin, kinsman
32 *share from me* take from me as his share
34 *host* army
35 *stomach to* appetite for
37 *crowns for convoy* travel money
39 *That . . . us* that is afraid to risk his life in my company
40 *Feast of Crispian* Saint Crispin's Day, October 25. (Cripinus and Crispianus were martyrs who fled from Rome in the third century; according to legend they disguised themselves as shoemakers, and afterward became the patron saints of that craft.)
44 *live* live to see
45 *vigil* evening before a feast day
49 *yet* in time
50 *advantages* additions of his own

What feats he did that day. Then shall our names,
Familiar in his mouth as household words—
Harry the King, Bedford and Exeter,
Warwick and Talbot, Salisbury and Gloucester—
Be in their flowing cups freshly remembered. 55
This story shall the good man teach his son;
And Crispin Crispian shall ne'er go by,
From this day to the ending of the world,
But we in it shall be rememberèd—
We few, we happy few, we band of brothers.
For he today that sheds his blood with me
Shall be my brother; be he ne'er so vile, 62
This day shall gentle his condition. 63
And gentlemen in England now abed
Shall think themselves accursed they were not here,
And hold their manhoods cheap whiles any speaks
That fought with us upon saint Crispin's Day.

[*Enter Salisbury.*]

SALISBURY:
My sovereign lord, bestow yourself with speed. 68
The French are bravely in their battles set 69
And will with all expedience charge on us. 70

KING:
All things are ready, if our minds be so.

WESTMORLAND:
Perish the man whose mind is backward now!

KING:
Thou dost not wish more help from England, coz?

WESTMORLAND:
God's will, my liege, would you and I alone,
Without more help, could fight this royal battle!

KING:
Why, now thou hast unwished five thousand men,
Which likes me better than to wish us one.— 77
You know your places. God be with you all!

[*Tucket. Enter Montjoy.*]

55 *flowing* overflowing
62 *vile* lowly
63 *gentle his condition* raise him to the rank of gentleman
68 *bestow yourself* take up your battle position
69 *bravely. . .set* finely arrayed in their battalions
70 *expedience* speed
72 *backward* reluctant
77 *likes* pleases

MONTJOY:

Once more I come to know of thee, King Harry,
If for thy ransom thou wilt now compound 80
Before thy most assurèd overthrow;
For certainly thou art so near the gulf 82
Thou needs must be englutted. Besides, in mercy 83
The Constable desires thee thou wilt mind 84
Thy followers of repentance, that their souls
May make a peaceful and a sweet retire 86
From off these fields where, wretches, their poor bodies
Must lie and fester.

KING: Who hath sent thee now?

MONTJOY: The Constable of France.

KING:

I pray thee, bear my former answer back:
Bid them achieve me, and then sell my bones. 91
Good God, why should they mock poor fellows thus?
The man that once did sell the lion's skin
While the beast lived was killed with hunting him.
A many of our bodies shall no doubt 95
Find native graves, upon the which, I trust, 96
Shall witness live in brass of this day's work.
And those that leave their valiant bones in France,
Dying like men, though buried in your dunghills,
They shall be famed; for there the sun shall greet them
And draw their honors reeking up to heaven, 101
Leaving their earthly parts to choke your clime,
The smell whereof shall breed a plague in France. 104
Mark then abounding valor in our English, 104
That, being dead, like to the bullets crazing 105
Break out into a second course of mischief,
Killing in relapse of mortality. 107
Let me speak proudly. Tell the Constable
We are but warriors for the working day. 109

80 *compound* make terms
82 *gulf* whirlpool
83 *englutted* swallowed up
84 *mind* remind
86 *retire* retreat
91 *achieve* capture
95 *A many* many. (The phrase is an exact parallel to "a few.")
96 *native* in their own land (i.e., England)
101 *reeking* (1) breathing (2) smelling
104 *abounding* overflowing, abundant
105 *crazing* shattering, with a suggestion also of *grazing,* ricocheting
107 *Killing . . . mortality* killing (their foes) as they (the English) fall back (decompose) into their elements; also, like the bullet, with a deadly ricohet
109 *for the working day* i.e., to do serious work, not take a holiday

Our gayness and our gilt are all besmirched
With rainy marching in the painful field.
There's not a piece of feather in our host—
Good argument, I hope, we will not fly—
And time hath worn us into slovenry.
But, by the Mass, our hearts are in the trim!
And my poor soldiers tell me, yet ere night
They'll be in fresher robes, or they will pluck 117
The gay new coats o'er the French soldiers' heads
And turn them out of service. If they do this— 119
As, if God please, they shall—my ransom then
Will soon be levied. Herald, save thou thy labor. 121
Come thou no more for ransom, gentle herald. 122
They shall have none, I swear, but these my joints,
Which if they have as I will leave 'em them,
Shall yield them little, tell the Constable.

MONTJOY:
I shall, King Harry. And so fare thee well.
Thou never shalt hear herald any more.

[*Exit*]

KING:
I fear thou wilt once more come again for a ransom.
Enter York [and kneels.]

YORK:
My lord, most humbly on my knee I beg
The leading of the vaward. 130

KING:
Take it, brave York. Now soldiers, march away.
And how thou pleasest, God, dispose the day!

[*Exeunt.*]

117 *in fresher robes* i.e., in heavenly garb. (Or perhaps the phrase *or they will* means "even if they have to.")
119 *turn . . . service* i.e., send them away stripped of their finery, like dismissed servants stripped of their livery
121 *levied* collected
122 *gentle* noble
130 *vaward* vanguard [Editor's notes by David Bevington.]

"Morris Lipkin Writes Poetry," from *Bread Givers*

ANZIA YEZIERSKA

We were sitting and eating our dinner when we heard the mail man's whistle and our name called.

I quickly ran downstairs and got a letter. It was for Fania. Many times before she had been getting them. But this was the first time that Father was around when one came.

"For whom is the letter?" asked Father, taking it from my hand.

"It's for Fania," I said.

"Who can be writing to such a child?" And he tore open the letter and read:

BELOVED, DEAREST ONE:

How I long to shout to the world our happiness. I feel that you and I are the only two people alive in the world—the only people that know the secret meaning of existence.

I have no diamond rings, no gifts of love that other lovers have for their beloved. My poetry is all I have to offer you. And so I dedicate my collected verses, "Poems of Poverty," to you, beloved.

MORRIS.

"Poems of Poverty!" cried Mother. "Ain't it black enough to be poor, without yet making poems about it?"

Father turned angrily on Mother. "Woman! Why didn't you tell me what's going on in this house? A man writes letters to my daughter and I'm told nothing about it?"

"Is it my fault that you're away all the time, so busy working for God that you don't know what's going on in your own house? Are you a man like other men? Does your wife or your children lay in your head at all?"

Into this father-and-mother fight, Fania came in.

"Poems of Poverty!" Father shook the opened letter in Fania's face. "Who is this *schnorrer* who writes you love letters on wrapping paper?"

"My letter! Why did you open my letter? It's mine. You had no right to read it! It's terrible to have to live in a house where even a letter is not one's own." And she snatched it from Father's hand.

"Who is he? What is he? By what does he work?" Father demanded.

"He works for newspapers," Fania answered.

"And where does he sell them, from the sidewalk or has he a stand of his own?"

"He sell papers? Why, he's a writer, a poet."

"A writer, a poet you want for a husband? Those who sell the papers at least earn something. But what earns a poet? Do you want starvation and beggary for the rest of your days? Who'll pay your rent? Who'll buy you your bread? Who'll put shoes on the feet of your children, with a husband who wastes his time writing poems of poverty instead of working for a living?"

Father, once started, went right on, like a wound-up phonograph that couldn't stop itself.

"Maybe you would like to go on working in the shop, to support your husband, after you're married? Do you know what black life is before you if you tie yourself to a poet?"

And then Father told us a Greek fairy tale he once read! The king of the gods wanted to divide up everything among those under him. To one he gave the sea, to another the stars, to another the earth, the sun, and so on. After everything was divided up, the poet woke from his dreams and asked for his part. "Where were you all this time, while everybody was fighting for his share of the world?" "I was in the heaven of my dreams," answered the poet. "*Nu,*" said the god. "If you can live in dreams, then you don't need the things of this world. Go back to your dreams."

Father looked around to see how we all listened with open mouths to his smartness. Only Fania, on whom he pointed his preaching, only she pushed away his story with a toss of her head.

"H'm! Only a fairy tale," she sniffed. "I'd rather have Lipkin and be poor, so long I have the man I love."

"How long will love last with a husband who feeds you with hunger? Even Job said, of all his sufferings, nothing was so terrible as poverty. A poor man is a living dead one. Even dead you got to have money. The undertaker wouldn't bury you, unless you have the price of a grave."

"Father!" I broke in, "didn't you yourself say yesterday that poverty is an ornament on a good Jew, like a red ribbon on a white horse?"

"Sure," added Mother, "aren't you always telling me that those whom God loves for the next world can't have it good here?"

"Woman! You compare a man who works for God, a man who holds up the flames of the Holy Torah before the world, to this *schnorrer?* Of what use are poets to themselves, or to anybody? Aren't there enough beggars——?"

"But didn't you say that the poorest beggars are happier and freer than the rich?" I dared question Father. "You said that a poor man never has to be afraid of thieves or robbers. He can walk alone in the middle of the night and fear nobody. Poor people don't need locks on their houses. They can leave their doors wide open, because nobody will come to steal poverty. . . ."

"Blood-and-iron! Hold your mouth!" hollered Father. "You're always saying things I don't ask you."

"But what will be the end of your driving the men away from the house?" said Mother. "Do you want a houseful of old maids on your neck? If these men are not good enough, why ain't you smart enough to bring somebody better?"

Father's eyes suddenly lighted up with a new idea. You forgot how old was his *capote,* how threadbare his skullcap, so shining with young joy was his face.

"I'll show you how quickly I can marry off the girls when I put my head on it."

"Yah," sneered Mother. "You showed me enough how quickly you can spoil your daughters' chances the minute you mix yourself in. If you had only let Mashah alone, she would have been married to a piano-player."

"Did you want me to let in a man who plays on the Sabbath in our family? A piano-player has no more character than a poet."

"*Nu*—Berel Bernstein was a man of character, a man who was about to become a manufacturer."

"But he was a stingy piker. For my daughters' husbands I want to pick out men who are people in the world."

"Where will you find better men than those they can find for themselves?"

"I'll go to old Zaretzky, the matchmaker. All the men in his list are guaranteed characters."

"But the minute you begin with the matchmaker you must have dowries like in Russia yet."

"With me for their father they get their dowries in their brains and in their good looks."

"*Yid!* You've forgotten already that I was the beauty of the village. What good looks the children got is from me," Mother laughed, straightening herself up and glancing toward the mirror.

"Woman! If not for your pretty face I wouldn't have now a houseful of females on my neck. But I'll show you how I can marry them off in one, two, three."

A few days after, as I came home, I saw a man talking to Fania. At first sight, I saw only his back, but I knew by the worn-out shabby coat and how his hair cried for a barber that it was Fania's poet, Morris Lipkin.

"I'll talk to your father," I heard him say to Fania. "I'll never give you up. He can't know the depth of our love. How our lives are bound in one another."

"You don't know my father," Fania whispered. "He'll never listen to us."

"He must listen. He shall listen." He put his arm around her. "Let me only tell him what our love is to us."

The stairs in the outside hall creaked under heavy shoes. Father with his pouncing footsteps was stamping ahead of another man.

"He's coming now!" Fania tried to draw away from Morris, but he only drew her closer.

"Darling! Together we can fight the world." His pale face, his burning eyes were aflame with the courage of his love.

The door was pushed open. Father stood before them.

Instantly Morris and Fania drew apart.

"Reb Smolinsky"—Morris came forward—"Fania and I——" But the words died in his throat, for Father without looking at him stepped back and pushed another man into the room.

A big diamond was glittering from the man's necktie and diamonds hollered from the man's fingers.

"Mr. Moe Mirsky! These are my four daughters, Bessie, Mashah, Fania, and Sara," Father announced. "And over there, by the stove, is my wife."

Moe Mirsky bowed politely and began to fuss with his tie, dazzling us with the glitter of his shining wealth.

Father did not notice Lipkin any more than if the place where he stood was air.

"Bring only some tea and jelly for the company," Father ordered; his head high with pride at the rich company he brought. He himself handed around the tea that Mother brought over, and he passed Lipkin by as if he did not exist.

Whiter than death grew Lipkin's face. Stone-still he stood, his lids lowered over his shamed eyes. None of us dared look at him, but it burned through us, the hurt of his shame, and yet we too stood like helpless stone.

Setting his own glass of tea down on the table, Father pushed around the chairs for every one. And then he deliberately took Lipkin's chair away from the window where Lipkin was still standing and pulled it up to the table; and Father sat himself down in it, with his back toward Lipkin.

Through our half-closed eyes of shame, we felt, more than saw, Lipkin walk out stiffly like an unwanted ghost.

Moe Mirsky was quick to take in how the other man was frozen out by Father, but he pretended not to notice it. And as soon as the door closed behind Lipkin, Moe Mirsky gave us all a look over, and then his eyes lighted on Mashah, and he pushed his chair near her.

Father began to brag about our smartness the way he always did before strangers. And Moe Mirsky, warmed with the tea, or fired by Mashah's beautiful, sad face, laughed and entertained us all as if he had known us all his life. He told us about the different cities he travelled, the names of the grand hotels where he stopped at, the theatres he went to, and the big sales he made in diamonds. And before he left, he invited us all to go with him to Coney Island on Sunday.

As soon as he had gone, Father turned to Mother, "*Nu?* How would you like this diamond-dealer for a son-in-law?"

"*Ach!*" sighed Mother, a far-off look of longing gleaming in her eyes, "only to see my daughters settled in good luck! But what do you know about him? Who is he? What is he?" Mother clutched at Father's arm in excited eagerness.

"A diamond-dealer! What more can you ask? The riches shines from him. The minute I saw him by the matchmaker, I said: This is the man I want for my daughter. You can see for yourself this man is a person of the world, and not a pale, half-starved poet."

Fania could hold herself in no longer. "Father!" she burst out, "why were you so mean, so brutally cruel to Lipkin?"

"That poet would be the ruin of your life, and you wanted me to welcome him yet? Why, he hasn't the money to get himself a decent haircut. Starvation cries from his face——"

"Poverty is no crime. You had no right to insult him so before everybody, only because he's poor."

Father's eyes flashed with rage. "The impudence of that long-haired beggar— wanting to push himself into my family! I'm a person among people. How would I look before the world if I introduced such a hunger-squeezed nobody for a son-in-law?"

"That diamond show window that you brought into the house can't hold a candle before Lipkin's brains. You think Lipkin will be poor always? You ought to see how hard he works by night and day at his writing. How can you tell what Lipkin's future might yet be?"

"A father knows the future because he's older." His strong hand pushed back and beat down all contradictions. "I can see your bitter end if you married such a *schnorrer.*"

"I know what I want for my happiness."

"Either you listen to what I say, or out you go of this house!" Father pounded the table with his fist. "Such shameless unwomanliness as a girl telling her father

this man I want to marry! *Rifkeh!*'' He turned to Mother. ''Did we ever know of such nonsense in the old country? Did you even give a look on me, or I on you till the wedding was all over?''

Mother shook her head at Father with a funny smile.

''Maybe if I had the sense of my daughters in America, I would have given you a good look over before the wedding.''

In the stillness that followed Mother's words, I was thinking: Suppose Mother had not felt like marrying Father, then where would all of us children be now? And here, in America, where girls pick out for themselves the men they want for husbands, how grand it would be if the children also could pick out their fathers and mothers. But my foolish, flying thoughts were stopped by an angry cry from Fania.

''I'll sooner go out of this house than go to Coney Island with your walking jewellery store!''

''I certainly won't go,'' said Bessie. ''He didn't even give a look on me.''

''Only let me go,'' I cried. ''I never yet seen Coney Island.''

''Blood-and-iron!'' Father pushed me aside. ''You think because he's a gentleman and invites the family for politeness that he has time to waste with children? If Fania don't want to grab this chance, then you go with him, Mashah.''

Mashah looked with her cold, tired eyes at Father.

''One man or another man, it's all the same to me now.''

And so it was Mashah's luck to be the only one to go with Moe Mirsky to Coney Island.

The next week Moe Mirsky brought Mashah a pair of diamond earrings and a diamond ring.

''*Nu—Rifkeh?*'' cried Father, examining the diamonds after Moe Mirsky was gone. ''Am I a judge of people? Didn't I tell you from the first that I *know* how to pick out a man? With this diamond-dealer in the family, all our troubles are over. You'll see he'll cover Mashah with diamonds. And through her riches, all of us will get rich quick. Think only of the future for the other girls with a sister in the diamond business!''

A few days after, Moe Mirsky told Mashah, ''I got a chance to sell your diamonds at a big profit, and meanwhile I'll bring you yet bigger diamonds.''

And so every few evenings Moe Mirsky kept changing Mashah's diamonds, taking the old diamonds one night and bringing other new diamonds the next night.

Before the month was up Mashah became engaged. She didn't care so much about Moe Mirsky or his diamonds. She didn't care about any man at all. But like all of us she was sick and tired from the house and crazy to get away.

Father was so excited with his success in getting Mashah engaged to a diamond-dealer that he wanted to show off more smartness.

''I'll show you how quickly I can get another rich man for Fania, now that my brain got started with matchmaking,'' he said to Mother.

Bessie was threading the beads she had taken home for night work. Suddenly all the beads in her lap dropped to the floor. ''Let it all go to hell,'' she cried. ''I'm sick of life.''

Of late Bessie was getting more and more bitter, because it ate out her heart, when she saw that Father was thinking only of marrying the younger sisters because he didn't want to let go her wages.

"Why do I kill myself for nothing?" Bessie went on, kicking the beads with her foot instead of picking them up. "Why should I be the burden bearer for them all?" And she began to weep.

"Old maid!" shouted Father. "Stop jumping out of your skin and making the whole house miserable with your salted tears."

Bessie rushed into the bedroom and slammed the door, and Father kept right on. "It's only through me that Mashah got luck. If I put my head on it, I can just as quick get another man for Fania and show the neighbours that when Reb Smolinsky only wants, he can marry even two daughters in a day as easy as Rockefeller signs a check for a million dollars."

And so the next day, Father brought another man from Zaretzky, the matchmaker. His name was Abe Schmukler and he was in the cloaks-and-suits business. He came from Los Angeles, at the other end of America, to buy cloaks and suits for his stores and get himself a wife.

Abe Schmukler liked Fania at first sight. Fania wasn't stuck on him and his cloaks and suits any more than Mashah was stuck on Moe Mirsky with his diamonds. But how could the girls stop to think whether they liked the men, or didn't like the men, so long they only got the chance to run away from our house, where there would be no more Father's preaching?

At first, we thought that Fania would never take to Abe Schmukler, because she was still in love with her poet, even though he wasn't around since that night that he walked out of the house like a dead ghost. And then she knocked us all over with surprise by the quick way in which she turned from the poor poet to the rich buyer and seller of cloaks and suits, and went out every night to uptown theatres with Abe Schmukler. From the outside she looked all excited with happiness, because every day Abe Schmukler brought her new things: dresses, cloaks, suits, candies, and flowers, till all the girls on the block were green with envy.

Abe Schmukler had only a month's time in New York. Two weeks he already spent buying his cloaks and suits, and only two weeks he had left to get himself a wife. So he had to quicken his love with many presents.

And that's how Father's bragging that he could marry off his two daughters in one day really happened.

Every one knew that Mashah was not marrying Moe Mirsky for his diamonds. But Fania made all believe that she fell head over heels in love with her cloaks-and-suits millionaire. Only a night before the wedding, as Bessie, with biting envy in her eyes, watched Fania pack her trunk, Fania got into a nervous fit. She threw all her beautiful wedding presents down on the floor and burst out crying.

"My God! Bessie! You're cutting me with your eyes! What do you envy? A broken heart?"

With her feet she stamped on a black lace dress, trimmed with gold, which Abe Schmukler had given her. "What do you envy? The shine of these gilded

rags with which I choke my emptiness? I love Lipkin. And I'll always love him. But even if Abe Schmukler was a rag-picker, a bootblack, I'd rush into his arms, only to get away from our house. . . . If I seem so excited about Los Angeles, it's only because it's a dream city at the other end of the world, so many thousands of miles away from home."

But in the meantime, the whole tenement house where we lived, and every house on the block, the fish market, the butcher, the grocer, on the stoop and in the doorways, rang the excited news, from lips to lips, like fire in the air, that there was to be a double wedding in our house.

Everywhere, I saw groups of people whispering and looking after us, as though their eyes were tearing themselves out of their heads with envy. When Mother passed with her market basket, the neighbours stood back with choked breath, as though she was already Mrs. Vanderbilt, coming to give Christmas presents among the poor.

"*Ach!* How the sun shines for them!"

"Luck smiles on them!"

"For them is America a golden country!"

"A diamond-dealer and a cloaks-and-suits milllionaire!"

"Music plays for them!"

"Life dances for them!"

"We must dry our heads worrying for bread, while they bathe themselves in milk and soak themselves in honey!"

It made me feel bad to see how everybody began to hate us because we had a little luck. Dogs envying another dog a bone. They were only bread-and-butter marriages, like in Europe, and all the neighbours eating themselves out with envy.

A month after the double wedding, we were seated at the table for dinner. Mother skimmed off the fat part of the potato soup, and carefully picked out all the little pieces of suet and fried onions for Father's plate, and handed it to him.

"Woman!" Father frowned. "Why have you no meat for my dinner this whole week? With the hard brain work I do day and night, I can't live on the flavour of onions!"

"But the meat went up a nickel a pound, and the two girls married, there are two wages less with which to buy."

"With one son in-law a diamond-dealer and another a cloaks-and-suits manufacturer I ought to have at least one man's meal a day. If I were a butcher, a baker, a thickneck, a money-maker, if I did less for my children, then maybe they would have done more for me. But from the day they were born, I held up for them the flame of the Holy Torah. It was I, my brains, my knowledge of the world, that brought them such golden luck marriages—and see their gratitude!"

The door opened; Mashah, with a wild worried look in her eyes, entered, but Father was too excited with his wrongs to see her.

"Woe to a man who has females for his offspring," he went on. "The thanklessness of these daughters! Getting them such rich husbands—and they forgetting their father as though their luck dropped down to them from the sky. . . ."

He caught sight of Mashah, but he was too much in his thoughts to see how terrible she looked. "*Nu,* Mrs. Moe Mirsky," he reproached. "With a husband a diamond-dealer, isn't it your duty to see that your father has at least meat——"

"Meat! I didn't even taste bread to-day!" The words tore themselves out of Mashah's throat. "Moe Mirsky, a diamond-dealer? Oh-h-h! The liar—the faker!"

She sank into a chair. What she had told had used up her last strength.

"Where are all the diamonds he gave you?" Father stared with innocent eyes at her.

"Those diamonds weren't his. . . ."

"Not his?" A puzzled look came into Father's face. "Why, he said he was a dealer——"

"But he lied. He was only a salesman in a jewellery store." Her voice was faint with tiredness. "He lost his job—lost it—because he let me wear the diamonds he was sent to sell. . . . The day after the wedding, it happened. I was too shamed to tell you then. But now, I'm so starved, I could hold myself in no longer. I had to come for—for something to eat."

"Empty-head!" shouted Father. "Where were your brains? Didn't you go out with the man a whole month before you were married? Couldn't you see he was a swindler and a crook when you talked to him?"

"Couldn't I see?" cried Mashah. "I thought you said you saw. You said you knew yourself a person on first sight. You picked him out! You brought him to the house! I didn't care about any man any more. I only wanted to run away from home."

"You wanted to run away because you were a lazy empty-head. So now you got it for your laziness. I always told you your bad end. As you made your bed, so you got to sleep on it."

For the week that Mashah stayed in our house, not one day passed that Father did not remind her, over and over again, that there was no more hope for her, for this world or for the next. Never again would she be able to lift up her head among people. But this time his preaching was in a whispering voice, because no matter how the shoe pinched us, we had to hide our shame from the neighbours.

At last, her husband came with the news that he got a job as a shoe clerk, so worn down was Mashah by Father's never-ending pictures of the hell that was waiting for her, that she was glad to leave our house, even though her diamond-dealer of a husband had come down to be a shoe clerk. So crushed, so broken was she, as she took her husband's arm, that Bessie, who was always jealous of Mashah because of her luck with men, Bessie took a dollar out of her purse and slipped it, unseen, into Mashah's empty one.

Now that the puffed balloon of Mashah's luck match crashed to nothingness, Father still fanned himself with pride in Fania's marriage. "At least one daughter takes after her father," he soothed himself. "At least one child listened to her father's wise words. One child has remained a credit to me."

For six months we didn't get any letters from Fania. She only sent us fancy postal cards with pictures of orange trees and beautiful bungalows surrounded with flowers that grew all winter. Then we got from her the first real letter. It

told that Abe Schmukler was a gambler. He spent his nights in one poker game after another. So lonely did she get, that she wanted to leave all the riches of cloaks and suits, and the beautiful houses with fruits and flowers of that dream city, and come back to our black, choking tenements in New York, and go back to work in a shop if only Father would let her.

But Father answered her back a quick letter. "Don't dare come and disgrace me before the neighbours," he wrote. "You had a right to find out what kind of a man your husband was before you married him. The neighbours here wouldn't believe that you left him. They will say that he threw you out. And don't forget it, you are already six months older—six months less beautiful—less desirable, in the eyes of a man. Your chances for marrying again are lost for ever, because no man wants what another turns down. As you made your bed, so you must sleep on it."

"What are you always blaming everything on the children?" I burst out at Father. "Didn't you yourself make Fania marry Abe Schmukler when she cried she didn't want him? You know yourself how she ate out her heart for Morris Lipkin——"

"Hold your mouth!" And he walked away as if I was nothing.

"I'll never let no father marry me away to any old *yok*," I threw after him. And he made believe that he didn't hear me.

It was the same night that I found Fania's love letters from Morris Lipkin.

Father had gone to his lodge meeting as usual. I went to bed, but I tossed about in anger over Father. Then I thought that I couldn't sleep because the mattress was so lumpy. So I got up, lifted the mattress to turn it over. And there, spread out on the spring, were bunches of papers. They were covered with fine handwriting. I picked up one after another and began to read. . . . "Love of my heart." . . . Then I read one after another. "Dearest, loveliest! I feel you in my arms. I kiss you and press you close to my heart!" "Adorable precious one, you are the very breath of me. This day is blank with emptiness because I cannot see you. I can only soothe my aching heart reading poems of love. Here are words that might have rushed to you, loved one, out of my own heart:

"Come to me in my dreams, and then by day
I shall be well again,
For then the night will more than pay
The hopeless, hopeless longing of the day,
The hopeless, hopeless longing of the day."

On and on, I read. I forgot everything until I heard the stamp of Father's footsteps. And I quickly hid the letters and jumped into bed.

All night long I dreamed of Morris Lipkin. It wasn't any more the Morris Lipkin whose hair was always crying for the barber. It was a new and wonderful Morris Lipkin. His eyes looked into my eyes. All those beautiful letters of love that he had written to Fania, I felt he had written to me. In the morning, when I woke up, I found, crumpled in my hand, tight to my breast, the letter that said, "I love you. I love you. I love you!"

That morning, to work, Morris Lipkin was everywhere I looked. When I got to the shop, the clattering noise of the machines was the music of his words of love to me.

For days and weeks, I lived only in Morris Lipkin and in his letters. Noon-time, when I was eating my lunch, I read them over and over again till I knew them by heart.

One evening, I couldn't help it any more, I had to go to the library where Fania used to meet him. My heart stopped. There he was! What a pale face! What sad eyes! *Ach!* I knew what it was to be in love.

I took a book from the shelf and sat down near him. He was so beautiful. God, how I shivered. When he walked out, I followed him. I walked so near him!

"Fool! What are you so scared of—what are you so scared of!" I was pinching myself to speak to him. And there I let him cross the street to go into his house.

The next night, I fixed my hair just the way Mashah did and ran to the library. And all evening again I sat there like a *yok* with my heart in my mouth, staring at him.

The library was already closing, and he was the last one out. He was still dreaming, his head in the air. He walked past me without even seeing me.

"Hello! Morris Lipkin!" I grabbed him by the sleeve. And then I couldn't say another word more. We walked half the block and yet I couldn't speak.

"What do you want?" he asked.

Before I knew what I was doing, I was running away from him like a crazy.

"What a fool he'll think me!" I sobbed into my pillow half the night. As I quieted down with my crying, it became so clear in my head what I should have said to him: "I love you. I ask nothing. I want nothing. Only let me love you. I'll leave my father and mother and follow you to the end of the earth."

All by myself I poured out my love to him in the most wonderful words.

Then one day, going to work, as I turned the block, there! I ran right into him. All my thoughts and dreams from days and weeks stumbled out of me. "I—oh, Morris—I—I——"

He stared. "What's the matter with you?"

"Oh—Morris—I got to tell you—I love you."

"You silly little kid." He burst out laughing.

Something beautiful that had built itself up in my heart all these days and nights, weeks and months, had fallen on top of me and crushed me.

For a long, long time after, I could feel nothing but the hurt of his laugh. Then one night when the whole house was thick with sleep I jumped out of bed and tore up into nothing every one of those love letters, and as I stamped the pieces under my feet, I felt I stamped for ever love and everything beautiful out of my heart.

"Falling into Life"

LEONARD KRIEGEL

It is not the actual death a man is doomed to die but the deaths his imagination anticipates that claim attention as one grows older. We are constantly being reminded that the prospect of death forcefully concentrates the mind. While that

may be so, it is not a prospect that does very much else for the imagination—other than to make one aware of its limitations and imbalances.

Over the past five years, as I have moved into the solidity of middle age, my own most formidable imaginative limitation has turned out to be a surprising need for symmetry. I am possessed by a peculiar passion: I want to believe that my life has been balanced out. And because I once had to learn to fall in order to keep that life mine, I now seem to have convinced myself that I must also learn to fall into death.

Falling into life wasn't easy, and I suspect that is why I hunger for such awkward symmetry today. Having lost the use of my legs during the polio epidemic that swept across the eastern United States during the summer of 1944, I was soon immersed in a process of rehabilitation that was, at least when looked at in retrospect, as much spiritual as physical.

That was a full decade before the discovery of the Salk vaccine ended polio's reign as the disease most dreaded by America's parents and their children. Treatment of the disease had been standardized by 1944: following the initial onslaught of the virus, patients were kept in isolation for a period of ten days to two weeks. Following that, orthodox medical opinion was content to subject patients to as much heat as they could stand. Stiff paralyzed limbs were swathed in heated, coarse woolen towels known as "hot packs." (The towels were that same greenish brown as blankets issued to American GIs, and they reinforced a boy's sense of being at war.) As soon as the hot packs had baked enough pain and stiffness out of a patient's body so that he could be moved on and off a stretcher, the treatment was ended, and the patient faced a series of daily immersions in a heated pool.

I would ultimately spend two full years at the appropriately named New York State Reconstruction Home in West Haverstraw. But what I remember most vividly about the first three months of my stay there was being submerged in a hot pool six times a day, for periods of between fifteen and twenty minutes. I would lie on a stainless steel slab, my face alone out of water, while the wet heat rolled against my dead legs and the physical therapist was at my side working at a series of manipulations intended to bring my useless muscles back to health.

Each immersion was a baptism by fire in the water. While my mind pitched and reeled with memories of the "normal" boy I had been a few weeks earlier, I would close my eyes and focus not, as my therapist urged, on bringing dead legs back to life but on my strange fall from the childhood grace of the physical. Like all eleven-year-old boys, I had spent a good deal of time thinking about my body. Before the attack of the virus, however, I thought about it only in connection with my own lunge toward adolescence. Never before had my body seemed an object in itself. Now it was. And like the twenty-one other boys in the ward—all of us between the ages of nine and twelve—I sensed I would never move beyond the fall from grace, even as I played with memories of the way I once had been.

Each time I was removed from the hot water and placed on a stretcher by the side of the pool, there to await the next immersion, I was fed salt tablets. These were simply intended to make up for the sweat we lost, but salt tablets

seemed to me the cruelest confirmation of my new status as spiritual debtor. Even today, more than four decades later, I still shiver at the mere thought of those salt tablets. Sometimes the hospital orderly would literally have to pry my mouth open to force me to swallow them. I dreaded the nausea the taste of salt inspired in me. Each time I was resubmerged in the hot pool, I would grit my teeth—not from the flush of heat sweeping over my body but from the thought of what I would have to face when I would again be taken out of the water. To be an eater of salt was far more humiliating than to endure pain. Nor was I alone in feeling this way. After lights-out had quieted the ward, we boys would furtively whisper from cubicle to cubicle of how we dreaded being forced to swallow salt tablets. It was that, rather than the pain we endured, that anchored our sense of loss and dread.

Any recovery of muscle use in a polio patient usually took place within three months of the disease's onset. We all knew that. But as time passed, every boy in the ward learned to recite stories of those who, like Lazarus, had witnessed their own bodily resurrection. Having fallen from physical grace, we also chose to fall away from the reality in front of us. Our therapists were skilled and dedicated, but they weren't wonder-working saints. Paralyzed legs and arms rarely responded to their manipulations. We could not admit to ourselves, or to them, that we were permanently crippled. But each of us knew without knowing that his future was tied to the body that floated on the stainless steel slab.

We sweated out the hot pool and we choked on the salt tablets, and through it all we looked forward to the promise of rehabilitation. For, once the stiffness and pain had been baked and boiled out of us, we would no longer be eaters of salt. We would not be what we once had been, but at least we would be candidates for re-entry into the world, admittedly made over to face its demands encased in leather and steel.

I suppose we might have been told that our fall from grace was permanent. But I am still grateful that no one—neither doctors nor nurses nor therapists, not even that sadistic orderly, himself a former polio patient, who limped through our lives and through our pain like some vengeful presence—told me that my chances of regaining the use of my legs were nonexistent. Like every other boy in the ward, I organized my needs around whatever illusions were available. And the illusion I needed above any other was that one morning I would simply wake up and rediscover the "normal" boy of memory, once again playing baseball in French Charley's Field in Bronx Park rather than roaming the fields of his own imagination. At the age of eleven, I needed to weather reality, not face it. And to this very day, I silently thank those who were concerned enough about me, or indifferent enough to my fate, not to tell me what they knew.

Like most boys, sick or well, I was an adaptable creature—and rehabilitation demanded adaptability. The fall from bodily grace transformed each of us into acolytes of the possible, pragmatic Americans for whom survival was method and strategy. We would learn, during our days in the New York State Reconstruction Home, to confront the world that was. We would learn to survive the way we were, with whatever the virus had left intact.

I had fallen away from the body's prowess, but I was being led toward a life measured by different standards. Even as I fantasized about the past, it

disappeared. Rehabilitation, I was to learn, was ahistorical, a future devoid of any significant claim on the past. Rehabilitation was a thief's primer of compensation and deception: its purpose was to teach one how to steal a touch of the normal from an existence that would be striking in its abnormality.

When I think back to those two years in the ward, the boy who made his rehabilitation most memorable was Joey Tomashevski. Joey was the son of an upstate dairy farmer, a Polish immigrant who had come to America before the Depression and whose English was even poorer than the English of my own shtetl-bred father. The virus had left both of Joey's arms so lifeless and atrophied that I could circle where his bicep should have been with pinky and thumb and still stick the forefinger of my own hand through. And yet, Joey assumed that he would make do with whatever had been left him. He accepted without question the task of making his toes and feet over into fingers and hands. With lifeless arms encased in a canvas sling that looked like the breadbasket a European peasant might carry to market, Joey would sit up in bed and demonstrate how he could maneuver fork and spoon with his toes.

I would never have dreamed of placing such confidence in my fingers, let alone my toes. I found, as most of the other boys in the ward did, Joey's unabashed pride in the flexibility and control with which he could maneuver a forkful of mashed potatoes into his mouth a continuous indictment of my sense of the world's natural order. We boys with dead legs would gather round his bed in our wheelchairs and silently watch Joey display his dexterity with a vanity so open and naked that it seemd an invitation to being struck down yet again. But Joey's was a vanity already tested by experience. For he was more than willing to accept whatever challenges the virus threw his way. For the sake of demonstrating his skill to us, he kicked a basketball from the auditorium stage through the hoop attached to a balcony some fifty feet away. When one of our number derisively called him lucky, he proceeded to kick five of seven more balls through that same hoop.

I suspect that Joey's pride in his ability to compensate for what had been taken away from him irritated me, because I knew that, before I could pursue my own rehabilitation with such singular passion, I had to surrender myself to what was being demanded of me. And that meant I had to learn to fall. It meant that I had to learn, as Joey Tomashevski had already learned, how to transform absence into opportunity. Even though I still lacked Joey's instinctive willingness to live with the legacy of the virus, I found myself being overhauled, re-created in much the same way as a car engine is rebuilt. Nine months after I arrived in the ward, a few weeks before my twelfth birthday, I was fitted for double long-legged braces bound together by a steel pelvic band circling my waist. Lifeless or not, my legs were precisely measured, the steel carefully molded to form, screws and locks and leather joined to one another for my customized benefit alone. It was technology that would hold me up—another offering on the altar of compensation. "You get what you give," said Jackie Lyons, my closest friend in the ward. For he, too, was now a novitiate of the possible. He, too, now had to learn how to choose the road back.

Falling into life was not a metaphor; it was real, a process learned only through doing, the way a baby learns to crawl, to stand, and then to walk. After the steel bands around calves and thighs and pelvis had been covered over by the rich-smelling leather, after the braces had been precisely fitted to allow my fear-ridden imagination the surety of their holding presence, I was pulled to my feet. For the first time in ten months, I stood. Two middle-aged craftsmen, the hospital bracemakers who worked in a machine shop deep in the basement, held me in place as my therapist wedged two wooden crutches beneath my shoulders.

They stepped back, first making certain that my grip on the crutches was firm. Filled with pride in their technological prowess, the three of them stood in front of me, admiring their skill. Had I been created in the laboratory of Mary Shelley's Dr. Frankenstein, I could not have felt myself any more the creature of scientific pride. I stood on the braces, crutches beneath my shoulders slanting outward like twin towers of Pisa. I flushed, swallowed hard, struggled to keep from crying, struggled not to be overwhelmed by my fear of falling.

My future had arrived. The leather had been fitted, the screws had been turned to the precise millimeter, the locks at the knees and the bushings at the ankles had been properly tested and retested. That very afternoon I was taken for the first time to a cavernous room filled with barbells and Indian clubs and crutches and walkers. I would spend an hour each day there for the next six months. In the rehab room, I would learn how to mount two large wooden steps made to the exact measure of a New York City bus's. I would swing on parallel bars from one side to the other, my arms learning how they would have to hurl me through the world. I balanced Indian clubs like a circus juggler because my therapist insisted it would help my coordination. And I was expected to learn to fall.

I was a dutiful patient. I did as I was told because I could see no advantage to doing anything else. I hungered for the approval of those in authority—doctors, nurses, therapists, the two bracemakers. Again and again, my therapist demonstrated how I was to throw my legs from the hip. Again and again, I did as I was told. Grabbing the banister with my left hand, I threw my leg from the hip while pushing off my right crutch. Like some baby elephant (despite the sweat lost in the heated pool, the months of inactivity in bed had fattened me up considerably), I dangled from side to side on the parallel bars. Grunting with effort, I did everything demanded of me. I did it with an unabashed eagerness to please those who had power over my life. I wanted to put myself at risk. I wanted to do whatever was supposed to be "good" for me. I believed as absolutely as I have ever believed in anything that rehabilitation would finally placate the hunger of the virus.

But when my therapist commanded me to fall, I cringed. For the prospect of falling terrified me. Every afternoon, as I worked through my prescribed activities, I prayed that I would be able to fall when the session ended. Falling was the most essential "good" of all the "goods" held out for my consideration by my therapist. I believed that. I believed it so intensely that the belief itself was painful. Everything else asked of me was given—and given gladly. I mounted the bus stairs, pushed across the parallel bars until my arms ached with the effort, allowed the medicine ball to pummel me, flailed away at the empty air with my

fists because my therapist wanted me to rid myself of the tension within. The slightest sign of approval from those in authority was enough to make me puff with pleasure. Other boys in the ward might not have taken rehabilitation seriously, but I was an eager servant cringing before the promise of approval.

Only I couldn't fall. As each session ended, I would be led to the mats that took up a full third of the huge room. "It's time," the therapist would say. Dutifully, I would follow her, step after step. Just as dutifully, I would stand on the edge of those two-inch-thick mats, staring down at them until I could feel my body quiver. "All you have to do is let go," my therapist assured me. "The other boys do it. Just let go and fall."

But the prospect of letting go was precisely what terrified me. That the other boys in the ward had no trouble in falling added to my shame and terror. I didn't need my therapist to tell me the two-inch-thick mats would keep me from hurting myself. I knew there was virtually no chance of injury when I fell, but that knowledge simply made me more ashamed of a cowardice that was as monumental as it was unexplainable. Had it been able to rid me of my sense of my own cowardice, I would happily have settled for bodily harm. But I was being asked to surrender myself to the emptiness of space, to let go and crash down to the mats below, to feel myself suspended in air when nothing stood between me and the vacuum of the world. *That* was the prospect that overwhelmed me. *That* was what left me sweating with rage and humiliation. The contempt I felt was for my own weakness.

I tried to justify what I sensed could never be justified. Why should I be expected to throw myself into emptiness? Was this sullen terror the price of compensation, the badge of normality? Maybe my refusal to fall embodied some deeper thrust than I could then understand. Maybe I had unconsciously seized upon some fundamental resistance to the forces that threatened to overwhelm me. What did matter that the ground was covered by the thick mats? The tremors I feared were in my heart and soul.

Shame plagued me—and shame is the older brother to disease. Flushing with shame, I would stare down at the mats. I could feel myself wanting to cry out. But I shriveled at the thought of calling more attention to my cowardice. I would finally hear myself whimper, "I'm sorry. But I can't. I can't let go."

Formless emptiness. A rush of air through which I would plummet toward obliteration. As my "normal" past grew more and more distant, I reached for it more and more desperately, recalling it like some movie whose plot has long since been forgotten but whose scenes continue to comfort through images disconnected from anything but themselves. I remembered that there had been a time when the prospect of falling evoked not terror but joy: football games on the rain-softened autumn turf of Mosholu Parkway, belly-flopping on an American Flyer down its snow-covered slopes in winter, rolling with a pack of friends down one of the steep hills in Bronx Park. Free falls from the past, testifying not to a loss of the self but to an absence of barriers.

My therapist pleaded, ridiculed, cajoled, threatened, bullied. I was sighed over and railed at. But I couldn't let go and fall. I couldn't sell my terror off so cheaply. Ashamed as I was, I wouldn't allow myself to be bullied out of terror.

A month passed—a month of struggle between me and my therapist. Daily excursions to the rehab room, daily practice runs through the future that was awaiting me. The daily humiliation of discovering that one's own fear had been transformed into a public issue, a subject of discussion among the other boys in the ward, seemed unending.

And then, terror simply evaporated. It was as if I had served enough time in that prison. I was ready to move on. One Tuesday afternoon, as my session ended, the therapist walked resignedly alongside me toward the mats. "All right, Leonard. It's time again. All you have to do is let go and fall." Again, I stood above the mats. Only this time, it was as if something beyond my control or understanding had decided to let my body's fall from grace take me down for good. I was not seized by the usual paroxysm of fear. I didn't feel myself break out in a terrified sweat. It was over.

I don't mean that I suddenly felt myself spring into courage. That wasn't what happened at all. The truth was I had simply been worn down into letting go, like a boxer in whose eyes one recognizes not the flicker of defeat—that issue never having been in doubt—but the acceptance of defeat. Letting go no longer held my imagination captive. I found myself quite suddenly faced with a necessary fall—a fall into life.

So it was that I stood above the mat and heard myself sigh and then felt myself let go, dropping through the quiet air, crutches slipping off to the sides. What I didn't feel this time was the threat of my body slipping into emptiness, so mummified by the terror before it that the touch of air pre-empted even death. I dropped. I did not crash. I dropped. I did not collapse. I dropped. I did not plummet. I felt myself enveloped by a curiously gentle moment in my life. In that sliver of time before I hit the mat, I was kissed by space.

My body absorbed the slight shock and I rolled onto my back, braced legs swinging like unguided missiles into the free air, crutches dropping away to the sides. Even as I fell through the air, I could sense the shame and fear drain from my soul, and I knew that my sense of my own cowardice would soon follow. In falling, I had given myself a new start, a new life.

"That's it!" my therapist triumphantly shouted. "You let go! And there it is!"

You let go! And there it is! Yes, and you discover not terror but the only self you are going to be allowed to claim anyhow. You fall free, and then you learn that those padded mats hold not courage but the unclaimed self. And if it turned out to be not the most difficult of tasks, did that make my sense of jubilation any less?

From that moment, I gloried in my ability to fall. Falling became an end in itself. I lost sight of what my therapist had desperately been trying to demonstrate for me—that there was a purpose in learning how to fall. For she wanted to teach me through the fall what I would have to face in the future. She wanted to give me a wholeness I could not give myself. For she knew that mine would be a future so different from what confronts the "normal" that I had to learn to fall into life in order not to be overwhelmed.

From that day, she urged me to practice falling as if I were a religious disciple being urged by a master to practice spiritual discipline. Letting go meant allowing

my body to float into space, to turn at the direction of the fall and follow the urgings of emptiness. For her, learning to fall was learning the most essential of American lessons: how to turn incapacity into capacity.

"You were afraid of hurting yourself," she explained to me. "But that's the beauty of it. When you let go, you can't hurt yourself."

An echo of the streets and playgrounds I called home until I met the virus. American slogans: go with the flow, roll with the punch, slide with the threat until it is no longer a threat. They were simply slogans, and they were all intended to create strength from weakness, a veritable world's fair of compensation.

I returned to the city a year later. By that time, I was a willing convert, one who now secretly enjoyed demonstrating his ability to fall. I enjoyed the surprise that would greet me as I got to my feet, unscathed and undamaged. However perverse it may seem, I felt a certain pleasure when, as I walked with a friend, I felt a crutch slip out of my grasp. Watching the thrust of concern darken his features, I felt myself in control of my own capacity. For falling had become the way my body sought out its proper home. It was an earthbound body, and mine would be an earthbound life. My quest would be for the solid ground beneath me. Falling with confidence, I fell away from terror and fear.

Of course, some falls took me unawares, and I found myself letting go too late or too early. Bruised in ego and sometimes in body, I would pull myself to my feet to consider what had gone wrong. Yet I was essentially untroubled. Such defeats were part of the game, even when they confined me to bed for a day or two afterward. I was an accountant of pain, and sometimes heavier payment was demanded. In my mid-thirties, I walked my two-year-old son's babysitter home, tripped on the curbstone, and broke my wrist. At forty-eight, an awkward fall triggered by a carelessly unlocked brace sent me smashing against the bathtub and into surgery for a broken femur. It took four months for me to learn to walk on the crutches all over again. But I learned. I already knew how to fall.

I knew such accidents could be handled. After all, pain was not synonymous with mortality. In fact, pain was insurance against an excessive consciousness of mortality. Pain might validate the specific moment in time, but it didn't have very much to do with the future. I did not yet believe that falling into life had anything to do with falling into death. It was simply a way for me to exercise control over my own existence.

It seems to me today that, when I first let my body fall to those mats, I was somehow giving myself the endurance I would need to survive in this world. In a curious way, falling became a way of celebrating what I had lost. My legs were lifeless, useless, but their loss had created a dancing image in whose shadowy gyrations I recognized a strange but potentially interesting new self. I would survive. I knew that now. I could let go, I could fall, and, best of all, I could get up.

To create an independent self, a man had to rid himself of both the myths that nurtured him and the myths that held him back. Learning to fall had been the first lesson in how I yet might live successfully as a cripple. Even disease had its inviolate principles. I understood that the most dangerous threat to the sense of self I needed was an inflated belief in my own capacity. Falling rid a man of excess baggage; it taught him how each of us is dependent on balance.

But what really gave falling legitimacy was the knowledge that I could get to my feet again. That was what taught me the rules of survival. As long as I could pick myself up and stand on my own two feet, brace-bound and crutch-propped as I was, the fall testified to my ability to live in the here and now, to stake my claim as an American who had turned incapacity into capacity. For such a man, falling might well be considered the language of everyday achievement.

But the day came, as I knew it must come, when I could no longer pick myself up. It was then that my passion for symmetry in endings began. On that day, spurred on by another fall, I found myself spinning into the inevitable future.

The day was actually a rainy night in November of 1983. I had just finished teaching at the City College Center for Worker Education, an off-campus degree program for working adults, and had joined some friends for dinner. All of us, I remember, were in a jovial, celebratory mood, although I no longer remember what it was we were celebrating. Perhaps it was simply the satisfaction of being good friends and colleagues at dinner together.

We ate in a Spanish restaurant on Fourteenth Street in Manhattan. It was a dinner that took on, for me at least, the intensity of a time that would assume greater and greater significance as I grew older, one of those watershed moments writers are so fond of. In the dark, rain-swept New York night, change and possibility seemed to drift like a thick fog all around us.

Our mood was still convivial when we left the restaurant around eleven. The rain had slackened off to a soft drizzle and the street glistened beneath the play of light on the wet black creosote. At night, rain in the city has a way of transforming proportion into optimism. The five of us stood around on the slicked-down sidewalk, none of us willing to be the first to break the richness of the mood by leaving.

Suddenly, the crutch in my left hand began to slip out from under me, slowly, almost deliberately, as if the crutch had a mind of its own and had not yet made the commitment that would send me down. Apparently, I had hit a slick patch of city sidewalk, some nub of concrete worn smooth as medieval stone by thousands of shoppers and panhandlers and tourists and students who daily pounded the bargain hustlings of Fourteenth Street.

Instinctively, I at first tried to fight the fall, to seek for balance by pushing off from the crutch in my right hand. But as I recognized that the fall was inevitable, I simply went slack—and for the thousandth time my body sought vindication in its ability to let go and drop. These good friends had seen me fall before. They knew my childish vanities, understood that I still thought of falling as a way to demonstrate my control of the traps and uncertainties that lay in wait for us all.

Thirty-eight years earlier, I had discovered that I could fall into life simply by letting go. Now I made a different discovery—that I could no longer get to my feet by myself. I hit the wet ground and quickly turned over and pushed up, trying to use one of the crutches as a prop to boost myself to my feet, as I had been taught to do as a boy of twelve.

But try as hard as I could, I couldn't get to my feet. It wasn't that I lacked physical strength. I knew that my arms were as powerful as ever as I pushed down

on the wet concrete. It had nothing to do with the fact that the street was wet, as my friends insisted later. No, it had to do with a subtle, if mysterious, change in my own sense of rhythm and balance. My body had decided—*and decided on its own, autonomously*—that the moment had come for me to face the question of endings. It was the body that chose its time of recognition.

It was, it seems to me now, a distinctively American moment. It left me pondering limitations and endings and summations. It left me with the curiously buoyant sense that mortality had quite suddenly made itself a felt presence rather than the rhetorical strategy used by the poets and novelists I taught to my students. This was what writers had in mind when they spoke of the truly common fate, this sense of ending coming to one unbidden. This had brought with it my impassioned quest for symmetry. As I lay on the wet ground—no more than a minute or two—all I could think of was how much I wanted my life to balance out. It was as if I were staring into a future in which time itself had evaporated.

Here was a clear, simple perception, and there was nothing mystical about it. There are limitations we recognize and those that recognize us. My friends, who had nervously been standing around while I tried to get to my feet, finally asked if they could help me up. "You'll have to," I said. "I can't get up any other way."

Two of them pulled me to my feet while another jammed the crutches beneath my arms, as the therapist and the two bracemakers had done almost four decades earlier. When I was standing, they proceeded to joke about my sudden incapacity in that age-old way men of all ages have, as if words might codify loss and change and time's betrayal. I joined in the joking. But what I really wanted was to go home and contemplate this latest fall in the privacy of my apartment. The implications were clear: I would never again be an eater of salt, I would also never again get to my feet on my own. A part of my life had ended. But that didn't depress me. In fact, I felt almost as exhilarated as I had thirty-eight years earlier, when my body surrendered to the need to let go and I fell into life.

Almost four years have passed since I fell on the wet sidewalk of Fourteenth Street. I suppose it wasn't a particularly memorable fall. It wasn't even particularly significant to anyone who had not once fallen into life. But it was inevitable, the first time I had let go into a time when it would no longer even be necessary to let go.

It was a fall that left me with the knowledge that I could no longer pick myself up. That meant I now needed the help of others as I had not needed their help before. It was a fall that left me burning with this strange passion for symmetry, this desire to balance my existence out. When the day comes, I want to be able to fall into my death as nakedly as I once had to fall into my life.

Do not misunderstand me. I am not seeking a way out of mortality, for I believe in nothing more strongly than I believe in the permanency of endings. I am not looking for a way out of this life, a life I continue to find immensely enjoyable—even if I can no longer pull myself to my own two feet. Of course, a good deal in my life has changed. For one thing, I am increasingly impatient

with those who claim to have no use for endings of any sort. I am also increasingly embarassed by the thought of the harshly critical adolescent I was, self-righteously convinced that the only way for a man to go to his end was by kicking and screaming.

But these are, I suppose, the kinds of changes any man or woman of forty or fifty would feel. Middle-aged skepticism is as natural as adolescent acne. In my clearer, less passionate moments, I can even laugh at my need for symmetry in beginnings and endings as well as my desire to see my own eventual death as a line running parallel to my life. Even in mathematics, let alone life, symmetry is sometimes too neat, too closed off from the way things actually work. After all, it took me a full month before I could bring myself to let go and fall into life.

I no longer talk about how one can seize a doctrine of compensation from disease. I don't talk about it, but it still haunts me. In my heart, I believe it offers a man the only philosophy by which he can actually live. It is the only philosophy that strips away both spiritual mumbo jumbo and the procrustean weight of existential anxiety. In the final analysis, a man really is what a man does.

Believing as I do, I wonder why I so often find myself trying to frame a perspective that will prove adequate to a proper sense of ending. Perhaps that is why I find myself sitting in a bar with a friend, trying to explain to him all that I have learned from falling. "There must be a time," I hear myself tell him, "when a man has the right to stop thinking about falling."

"Sure," my friend laughs. "Four seconds before he dies."

Chapter 1 from *Invisible Man*

RALPH ELLISON

It goes a long way back, some twenty years. All my life I had been looking for something, and everywhere I turned someone tried to tell me what it was. I accepted their answers too, though they were often in contradiction and even self-contradictory. I was naïve. I was looking for myself and asking everyone except myself questions which I, and only I, could answer. It took me a long time and much painful boomeranging of my expectations to achieve a realization everyone else appears to have been born with: That I am nobody but myself. But first I had to discover that I am an invisible man!

And yet I am no freak of nature, nor of history. I was in the cards, other things having been equal (or unequal) eighty-five years ago. I am not ashamed of my grandparents for having been slaves. I am only ashamed of myself for having at one time been ashamed. About eighty-five years ago they were told that they were free, united with others of our country in everything pertaining to the common good, and, in everything social, separate like the fingers of the hand. And they believed it. They exulted in it. They stayed in their place, worked hard, and brought up my father to do the same. But my grandfather is the one. He was

an odd old guy, my grandfather, and I am told I take after him. It was he who caused the trouble. On his deathbed he called my father to him and said, "Son, after I'm gone I want you to keep up the good fight. I never told you, but our life is a war and I have been a traitor all my born days, a spy in the enemy's country ever since I give up my gun back in the Reconstruction. Live with your head in the lion's mouth. I want you to overcome 'em with yeses, undermine 'em with grins, agree 'em to death and destruction, let 'em swoller you till they vomit or bust wide open." They thought the old man had gone out of his mind. He had been the meekest of men. The younger children were rushed from the room, the shades drawn and the flame of the lamp turned so low that it sputtered on the wick like the old man's breathing. "Learn it to the younguns," he whispered fiercely; then he died.

But my folks were more alarmed over his last words than over his dying. It was as though he had not died at all, his words caused so much anxiety. I was warned emphatically to forget what he had said and, indeed, this is the first time it has been mentioned outside the family circle. It had a tremendous effect upon me, however. I could never be sure of what he meant. Grandfather had been a quiet old man who never made any trouble, yet on his deathbed he had called himself a traitor and a spy, and he had spoken of his meekness as a dangerous activity. It became a constant puzzle which lay unanswered in the back of my mind. And whenever things went well for me I remembered my grandfather and felt guilty and uncomfortable. It was as though I was carrying out his advice in spite of myself. And to make it worse, everyone loved me for it. I was praised by the most lily-white men of the town. I was considered an example of desirable conduct—just as my grandfather had been. And what puzzled me was that the old man had defined it as *treachery*. When I was praised for my conduct I felt a guilt that in some way I was doing something that was really against the wishes of the white folks, that if they had understood they would have desired me to act just the opposite, that I should have been sulky and mean, and that that really would have been what they wanted, even though they were fooled and thought they wanted me to act as I did. It made me afraid that some day they would look upon me as a traitor and I would be lost. Still I was more afraid to act any other way because they didn't like that at all. The old man's words were like a curse. On my graduation day I delivered an oration in which I showed that humility was the secret, indeed, the very essence of progress. (Not that I believed this—how could I, remembering my grandfather?—I only believed that it worked.) It was a great success. Everyone praised me and I was invited to give the speech at a gathering of the town's leading white citizens. It was a triumph for our whole community.

It was in the main ballroom of the leading hotel. When I got there I discovered that it was on the occasion of a smoker, and I was told that since I was to be there anyway I might as well take part in the battle royal to be fought by some of my schoolmates as part of the entertainment. The battle royal came first.

All of the town's big shots were there in their tuxedoes, wolfing down the buffet foods, drinking beer and whiskey and smoking black cigars. It was a large room with a high ceiling. Chairs were arranged in neat rows around three sides

of a portable boxing ring. The fourth side was clear, revealing a gleaming space of polished floor. I had some misgivings over the battle royal, by the way. Not from a distaste for fighting, but because I didn't care too much for the other fellows who were to take part. They were tough guys who seemed to have no grandfather's curse worrying their minds. No one could mistake their toughness. And besides, I suspected that fighting a battle royal might detract from the dignity of my speech. In those pre-invisible days I visualized myself as a potential Booker T. Washington. But the other fellows didn't care too much for me either, and there were nine of them. I felt superior to them in my way, and I didn't like the manner in which we were all crowded together into the servants' elevator. Nor did they like my being there. In fact, as the warmly lighted floors flashed past the elevator we had words over the fact that I, by taking part in the fight, had knocked one of their friends out of a night's work.

We were led out of the elevator through a rococo hall into an anteroom and told to get into our fighting togs. Each of us was issued a pair of boxing gloves and ushered out into the big mirrored hall, which we entered looking cautiously about us and whispering, lest we might accidentally be heard above the noise of the room. It was foggy with cigar smoke. And already the whiskey was taking effect. I was shocked to see some of the most important men of the town quite tipsy. They were all there—bankers, lawyers, judges, doctors, fire chiefs, teachers, merchants. Even one of the more fashionable pastors. Something we could not see was going on up front. A clarinet was vibrating sensuously and the men were standing up and moving eagerly forward. We were a small tight group, clustered together, our bare upper bodies touching and shining with anticipatory sweat; while up front the big shots were becoming increasingly excited over something we still could not see. Suddenly I heard the school superintendent, who had told me to come, yell, "Bring up the shines, gentlemen! Bring up the little shines!"

We were rushed up to the front of the ballroom, where it smelled even more strongly of tobacco and whiskey. Then we were pushed into place. I almost wet my pants. A sea of faces, some hostile, some amused, ringed around us, and in the center, facing us, stood a magnificent blonde—stark naked. There was dead silence. I felt a blast of cold air chill me. I tried to back away, but they were behind me and around me. Some of the boys stood with lowered heads, trembling. I felt a wave of irrational guilt and fear. My teeth chattered, my skin turned to goose flesh, my knees knocked. Yet I was strongly attracted and looked in spite of myself. Had the price of looking been blindness, I would have looked. The hair was yellow like that of a circus kewpie doll, the face heavily powdered and rouged, as though to form an abstract mask, the eyes hollow and smeared a cool blue, the color of a baboon's butt. I felt a desire to spit upon her as my eyes brushed slowly over her body. Her breasts were firm and round as the domes of East Indian temples, and I stood so close as to see the fine skin texture and beads of pearly perspiration glistening like dew around the pink and erected buds of her nipples. I wanted at one and the same time to run from the room, to sink through the floor, or go to her and cover her from my eyes and the eyes of the others with my body; to feel the soft thighs, to caress her and destroy her, to love her and murder her, to hide from her, and yet to stroke where below the small American

flag tattooed upon her belly her thighs formed a capital V. I had a notion that of all in the room she saw only me with her impersonal eyes.

And then she began to dance, a slow sensuous movement; the smoke of a hundred cigars clinging to her like the thinnest of veils. She seemed like a fair bird-girl girdled in veils calling to me from the angry surface of some gray and threatening sea. I was transported. Then I became aware of the clarinet playing and the big shots yelling at us. Some threatened us if we looked and others if we did not. On my right I saw one boy faint. And now a man grabbed a silver pitcher from a table and stepped close as he dashed ice water upon him and stood him up and forced two of us to support him as his head hung and moans issued from his thick bluish lips. Another boy began to plead to go home. He was the largest of the group, wearing dark red fighting trunks much too small to conceal the erection which projected from him as though in answer to the insinuating low-registered moaning of the clarinet. He tried to hide himself with his boxing gloves.

And all the while the blonde continued dancing, smiling faintly at the big shots who watched her with fascination, and faintly smiling at our fear. I noticed a certain merchant who followed her hungrily, his lips loose and drooling. He was a large man who wore diamond studs in a shirtfront which swelled with the ample paunch underneath, and each time the blonde swayed her undulating hips he ran his hand through the thin hair of his bald head and, with his arms upheld, his posture clumsy like that of an intoxicated panda, wound his belly in a slow and obscene grind. This creature was completely hypnotized. The music had quickened. As the dancer flung herself about with a detached expression on her face, the men began reaching out to touch her. I could see their beefy fingers sink into the soft flesh. Some of the others tried to stop them and she began to move around the floor in graceful circles, as they gave chase, slipping and sliding over the polished floor. It was mad. Chairs went crashing, drinks were spilt, as they ran laughing and howling after her. They caught her just as she reached a door, raised her from the floor, and tossed her as college boys are tossed at a hazing, and above her red, fixed-smiling lips I saw the terror and disgust in her eyes, almost like my own terror and that which I saw in some of the other boys. As I watched, they tossed her twice and her soft breasts seemed to flatten against the air and her legs flung wildly as she spun. Some of the more sober ones helped her to escape. And I started off the floor, heading for the anteroom with the rest of the boys.

Some were still crying and in hysteria. But as we tried to leave we were stopped and ordered to get into the ring. There was nothing to do but what we were told. All ten of us climbed under the ropes and allowed ourselves to be blindfolded with broad bands of white cloth. One of the men seemed to feel a bit sympathetic and tried to cheer us up as we stood with our backs against the ropes. Some of us tried to grin. "See that boy over there?" one of the men said. "I want you to run across at the bell and give it to him right in the belly. If you don't get him, I'm going to get you. I don't like his looks." Each of us was told the same. The blindfolds were put on. Yet even then I had been going over my speech. In my mind each word was as bright as flame. I felt the cloth pressed into place, and frowned so that it would be loosened when I relaxed.

But now I felt a sudden fit of blind terror. I was unused to darkness. It was as though I had suddenly found myself in a dark room filled with poisonous cotton mouths. I could hear the bleary voices yelling insistently for the battle royal to begin.

"Get going in there!"

"Let me at that big nigger!"

I strained to pick up the school superintendent's voice, as though to squeeze some security out of that slightly more familiar sound.

"Let me at those black sonsabitches!" someone yelled.

"No, Jackson, no!" another voice yelled. "Here, somebody, help me hold Jack."

"I want to get at that ginger-colored nigger. Tear him limb from limb," the first voice yelled.

I stood against the ropes trembling. For in those days I was what they called ginger-colored, and he sounded as though he might crunch me between his teeth like a crisp ginger cookie.

Quite a struggle was going on. Chairs were being kicked about and I could hear voices grunting as with a terrific effort. I wanted to see, to see more desperately than ever before. But the blindfold was as tight as a thick skin-puckering scab and when I raised my gloved hands to push the layers of white aside a voice yelled, "Oh, no you don't, black bastard! Leave that alone!"

"Ring the bell before Jackson kills him a coon!" someone boomed in the sudden silence. And I heard the bell clang and the sound of the feet scuffling forward.

A glove smacked against my head. I pivoted, striking out stiffly as someone went past, and felt the jar ripple along the length of my arm to my shoulder. Then it seemed as though all nine of the boys had turned upon me at once. Blows pounded me from all sides while I struck out as best I could. So many blows landed upon me that I wondered if I were not the only blindfolded fighter in the ring, or if the man called Jackson hadn't succeeded in getting me after all.

Blindfolded, I could no longer control my motions. I had no dignity. I stumbled about like a baby or a drunken man. The smoke had become thicker and with each new blow it seemed to sear and further restrict my lungs. My saliva became like hot bitter glue. A glove connected with my head, filling my mouth with warm blood. It was everywhere. I could not tell if the moisture I felt upon my body was sweat or blood. A blow landed hard against the nape of my neck. I felt myself going over, my head hitting the floor. Streaks of blue light filled the black world behind the blindfold. I lay prone, pretending that I was knocked out, but felt myself seized by hands and yanked to my feet. "Get going, black boy! Mix it up!" My arms were like lead, my head smarting from blows. I managed to feel my way to the ropes and held on, trying to catch my breath. A glove landed in my mid-section and I went over again, feeling as though the smoke had become a knife jabbed into my guts. Pushed this way and that by the legs milling around me, I finally pulled erect and discovered that I could see the black, sweat-washed forms weaving in the smokey-blue atmosphere like drunken dancers weaving to the rapid drum-like thuds of blows.

Everyone fought hysterically. It was complete anarchy. Everybody fought everybody else. No group fought together for long. Two, three, four, fought one, then turned to fight each other, were themselves attacked. Blows landed below the belt and in the kidney, with the gloves open as well as closed, and with my eye partly opened now there was not so much terror. I moved carefully, avoiding blows, although not too many to attract attention, fighting from group to group. The boys groped about like blind, cautious crabs crouching to protect their mid-sections, their heads pulled in short against their shoulders, their arms stretched nervously before them, with their fists testing the smoke-filled air like the knobbed feelers of hypersensitive snails. In one corner I glimpsed a boy violently punching the air and heard him scream in pain as he smashed his hand against a ring post. For a second I saw him bent over holding his hand, then going down as a blow caught his unprotected head. I played one group against the other, slipping in and throwing a punch then stepping out of range while pushing the others into the melee to take the blows blindly aimed at me. The smoke was agonizing and there were no rounds, no bells at three minute intervals to relieve our exhaustion. The room spun round me, a swirl of lights, smoke, sweating bodies surrounded by tense white faces. I bled from both nose and mouth, the blood spattering upon my chest.

The men kept yelling, "Slug him, black boy! Knock his guts out!"

"Uppercut him! Kill him! Kill that big boy!"

Taking a fake fall, I saw a boy going down heavily beside me as though we were felled by a single blow, saw a sneaker-clad foot shoot into his groin as the two who had knocked him down stumbled upon him. I rolled out of range, feeling a twinge of nausea.

The harder we fought the more threatening the men became. And yet, I had begun to worry about my speech again. How would it go? Would they recognize my ability? What would they give me?

I was fighting automatically when suddenly I noticed that one after another of the boys was leaving the ring. I was surprised, filled with panic, as though I had been left alone with an unknown danger. Then I understood. The boys had arranged it among themselves. It was the custom for the two men left in the ring to slug it out for the winner's prize. I discovered this too late. When the bell sounded two men in tuxedoes leaped into the ring and removed the blindfold. I found myself facing Tatlock, the biggest of the gang. I felt sick at my stomach. Hardly had the bell stopped ringing in my ears than it clanged again and I saw him moving swiftly toward me. Thinking of nothing else to do I hit him smash on the nose. He kept coming, bringing the rank sharp violence of stale sweat. His face was a black blank of a face, only his eyes alive—with hate of me and aglow with a feverish terror from what had happened to us all. I became anxious. I wanted to deliver my speech and he came at me as though he meant to beat it out of me. I smashed him again and again, taking his blows as they came. Then on a sudden impulse I struck him lightly and as we clinched, I whispered, "Fake like I knocked you out, you can have the prize."

"I'll break your behind," he whispered hoarsely.

"For *them?*"

"For *me,* sonofabitch!"

They were yelling for us to break it up and Tatlock spun me half around with a blow, and as a joggled camera sweeps in a reeling scene, I saw the howling red faces crouching tense beneath the cloud of blue-gray smoke. For a moment the world wavered, unraveled, flowed, then my head cleared and Tatlock bounced before me. That fluttering shadow before my eyes was his jabbing left hand. Then falling forward, my head against his damp shoulder, I whispered,

"I'll make it five dollars more."

"Go to hell!"

But his muscles relaxed a trifle beneath my pressure and I breathed, "Seven?"

"Give it to your ma," he said, ripping me beneath the heart.

And while I still held him I butted him and moved away. I felt myself bombarded with punches. I fought back with hopeless desperation. I wanted to deliver my speech more than anything else in the world, because I felt that only these men could judge truly my ability, and now this stupid clown was ruining my chances. I began fighting carefully now, moving in to punch him and out again with my greater speed. A lucky blow to his chin and I had him going too— until I heard a loud voice yell, "I got my money on the big boy."

Hearing this, I almost dropped my guard. I was confused: Should I try to win against the voice out there? Would not this go against my speeeh, and was not this a moment for humility, for nonresistance? A blow to my head as I danced about sent my right eye popping like a jack-in-the-box and settled my dilemma. The room went red as I fell. It was a dream fall, my body languid and fastidious as to where to land, until the floor became impatient and smashed up to meet me. A moment later I came to. An hypnotic voice said FIVE emphatically. And I lay there, hazily watching a dark red spot of my own blood shaping itself into a butterfly, glistening and soaking into the soiled gray world of the canvas.

When the voice drawled TEN I was lifted up and dragged to a chair. I sat dazed. My eye pained and swelled with each throb of my pounding heart and I wondered if now I would be allowed to speak. I was wringing wet, my mouth still bleeding. We were grouped along the wall now. The other boys ignored me as they congratulated Tatlock and speculated as to how much they would be paid. One boy whimpered over his smashed hand. Looking up front, I saw attendants in white jackets rolling the portable ring away and placing a small square rug in the vacant space surrounded by chairs. Perhaps, I thought, I will stand on the rug to deliver my speech.

Then the M.C. called to us, "Come on up here boys and get your money."

We ran forward to where the men laughed and talked in their chairs, waiting. Everyone seemed friendly now.

"There it is on the rug," the man said. I saw the rug covered with coins of all dimensions and a few crumpled bills. But what excited me, scattered here and there, were the gold pieces.

"Boys, it's all yours," the man said. "You get all you grab."

"That's right, Sambo," a blond man said, winking at me confidentially.

I trembled with excitement, forgetting my pain. I would get the gold and the bills, I thought. I would use both hands. I would throw my body against the boys nearest me to block them from the gold.

"Get down around the rug now," the man commanded, "and don't anyone touch it until I give the signal."

"This ought to be good," I heard.

As told, we got around the square rug on our knees. Slowly the man raised his freckled hand as we followed it upward with our eyes.

I heard, "These niggers look like they're about to pray!"

Then, "Ready," the man said. "Go!"

I lunged for a yellow coin lying on the blue design of the carpet, touching it and sending a surprised shriek to join those rising around me. I tried frantically to remove my hand but could not let go. A hot, violent force tore through my body, shaking me like a wet rat. The rug was electrified. The hair bristled up on my head as I shook myself free. My muscles jumped, my nerves jangled, writhed. But I saw that this was not stopping the other boys. Laughing in fear and embarrassment, some were holding back and scooping up the coins knocked off by the painful contortions of the others. The men roared above us as we struggled.

"Pick it up, goddamnit, pick it up!" someone called like a bass-voiced parrot. "Go on, get it!"

I crawled rapidly around the floor, picking up the coins, trying to avoid the coppers and to get greenbacks and the gold. Ignoring the shock by laughing, as I brushed the coins off quickly, I discovered that I could contain the electricity—a contradiction, but it works. Then the men began to push us onto the rug. Laughing embarrassedly, we struggled out of their hands and kept after the coins. We were all wet and slippery and hard to hold. Suddenly I saw a boy lifted into the air, glistening with sweat like a circus seal, and dropped, his wet back landing flush upon the charged rug, heard him yell and saw him literally dance upon his back, his elbows beating a frenzied tattoo upon the floor, his muscles twitching like the flesh of a horse stung by many flies. When he finally rolled off, his face was gray and no one stopped him when he ran from the floor amid booming laughter.

"Get the money," the M.C. called. "That's good hard American cash!"

And we snatched and grabbed, snatched and grabbed. I was careful not to come too close to the rug now, and when I felt the hot whiskey breath descend upon me like a cloud of foul air I reached out and grabbed the leg of a chair. It was occupied and I held on desperately.

"Leggo, nigger! Leggo!"

The huge face wavered down to mine as he tried to push me free. But my body was slippery and he was too drunk. It was Mr. Colcord, who owned a chain of movie houses and "entertainment palaces." Each time he grabbed me I slipped out of his hands. It became a real struggle. I feared the rug more than I did the drunk, so I held on, surprising myself for a moment by trying to topple *him* upon the rug. It was such an enormous idea that I found myself actually carrying it out. I tried not to be obvious, yet when I grabbed his leg, trying to tumble him out of the chair, he raised up roaring with laughter, and, looking at me with soberness dead in the eye, kicked me viciously in the chest. The chair leg flew out of my hand and I felt myself going and rolled. It was as though I had rolled through a bed of hot coals. It seemed a whole century would pass before I would roll free, a century in which I was seared through the deepest levels of my body to the fearful

breath within me and the breath seared and heated to the point of explosion. It'll all be over in a flash, I thought as I rolled clear. It'll all be over in a flash.

But not yet, the men on the other side were waiting, red faces swollen as though from apoplexy as they bent forward in their chairs. Seeing their fingers coming toward me I rolled away as a fumbled football rolls off the receiver's fingertips, back into the coals. That time, I luckily sent the rug sliding out of place and heard the coins ringing against the floor and the boys scuffling to pick them up and the M.C. calling, "All right, boys, that's all. Go get dressed and get your money."

I was limp as a dish rag. My back felt as though it had been beaten with wires.

When we had dressed the M.C. came in and gave us each five dollars, except Tatlock, who got ten for being last in the ring. Then he told us to leave. I was not to get a chance to deliver my speech, I thought. I was going out into the dim alley in despair when I was stopped and told to go back. I returned to the ballroom, where the men were pushing back their chairs and gathering in groups to talk.

The M.C. knocked on a table for quiet. "Gentlemen," he said, "we almost forgot an important part of the program. A most serious part, gentlemen. This boy was brought here to deliver a speech which he made at his graduation yesterday"

"Bravo!"

"I'm told that he is the smartest boy we've got out there in Greenwood. I'm told that he knows more big words than a pocket-sized dictionary."

Much applause and laughter.

"So now, gentlemen, I want you, to give him your attention."

There was still laughter as I faced them, my mouth dry, my eye throbbing. I began slowly, but evidently my throat was tense, because they began shouting, "Louder! Louder!"

"We of the younger generation extol the wisdom of that great leader and educator," I shouted, "who first spoke these flaming words of wisdom: 'A ship lost at sea for many days suddenly sighted a friendly vessel. From the mast of the unfortunate vessel was seen a signal: "Water, water; we die of thirst!" The answer from the friendly vessel came back: "Cast down your bucket where you are." The captain of the distressed vessel, at last heeding the injunction, cast down his bucket, and it came up full of fresh sparkling water from the mouth of the Amazon River.' And like him I say, and in his words, 'To those of my race who depend upon bettering their condition in a foreign land, or who underestimate the importance of cultivating friendly relations with the Southern white man, who is his next-door neighbor, I would say: "Cast down your bucket where you are"—cast it down in making friends in every manly way of the people of all races by whom we are surrounded' "

I spoke automatically and with such fervor that I did not realize that the men were still talking and laughing until my dry mouth, filling up with blood from the cut, almost strangled me. I coughed, wanting to stop and go to one of the tall brass, sand-filled spittoons to relieve myself, but a few of the men, especially the superintendent, were listening and I was afraid. So I gulped it down, blood, saliva and all, and continued. (What powers of endurance I had during those days! What enthusiasm! What a belief in the rightness of things!) I spoke even

louder in spite of the pain. But still they talked and still they laughed, as though deaf with cotton in dirty ears. So I spoke with greater emotional emphasis. I closed my ears and swallowed blood until I was nauseated. The speech seemed a hundred times as long as before, but I could not leave out a single word. All had to be said, each memorized nuance considered, rendered. Nor was that all. Whenever I uttered a word of three or more syllables a group of voices would yell for me to repeat it. I used the phrase "social responsibility" and they yelled:

"What's that word you say, boy?"

"Social responsibility," I said.

"What?"

"Social . . ."

"Louder."

". . . responsibility."

"More!"

"Respon—"

"Repeat!"

"—sibility."

The room filled with the uproar of laughter until, no doubt, distracted by having to gulp down my blood, I made a mistake and yelled a phrase I had often seen denounced in newspaper editorials, heard debated in private.

"Social . . ."

"What?" they yelled.

". . . equality—"

The laughter hung smokelike in the sudden stillness. I opened my eyes, puzzled. Sounds of displeasure filled the room. The M.C. rushed forward. They shouted hostile phrases at me. But I did not understand.

A small dry mustached man in the front row blared out, "Say that slowly, son!"

"What sir?"

"What you just said!"

"Social responsibility, sir," I said.

"You weren't being smart, were you, boy?" he said, not unkindly.

"No, sir!"

"You sure that about 'equality' was a mistake?"

"Oh, yes, sir," I said. "I was swallowing blood."

"Well, you had better speak more slowly so we can understand. We mean to do right by you, but you've got to know your place at all times. All right, now, go on with your speech."

I was afraid. I wanted to leave but I wanted also to speak and I was afraid they'd snatch me down.

"Thank you, sir," I said, beginning where I had left off, and having them ignore me as before.

Yet when I finished there was a thunderous applause. I was surprised to see the superintendent come forth with a package wrapped in white tissue paper, and, gesturing for quiet, address the men.

"Gentlemen, you see that I did not overpraise this boy. He makes a good speech and some day he'll lead his people in the proper paths. And I don't have

to tell you that that is important in these days and times. This is a good, smart boy, and so to encourage him in the right direction, in the name of the Board of Education I wish to present him a prize in the form of this . . .''

He paused, removing the tissue paper and revealing a gleaming calfskin brief case.

''. . . in the form of this first-class article from Shad Whitmore's shop.''

''Boy,'' he said, addressing me, ''take this prize and keep it well. Consider it a badge of office. Prize it. Keep developing as you are and some day it will be filled with important papers that will help shape the destiny of your people.''

I was so moved that I could hardly express my thanks. A rope of bloody saliva forming a shape like an undiscovered continent drooled upon the leather and I wiped it quickly away. I felt an importance that I had never dreamed.

''Open it and see what's inside,'' I was told.

My fingers a-tremble, I complied, smelling the fresh leather and finding an official-looking document inside. It was a scholarship to the state college for Negroes. My eyes filled with tears and I ran awkwardly off the floor.

I was overjoyed; I did not even mind when I discovered that the gold pieces I had scrambled for were brass pocket tokens advertising a certain make of automobile.

When I reached home everyone was excited. Next day the neighbors came to congratulate me. I even felt safe from grandfather, whose deathbed curse usually spoiled my triumphs. I stood beneath his photograph with my brief case in hand and smiled triumphantly into his stolid black peasant's face. It was a face that fascinated me. The eyes seemed to follow everywhere I went.

That night I dreamed I was at a circus with him and that he refused to laugh at the clowns no matter what they did. Then later he told me to open my brief case and read what was inside and I did, finding an official envelope stamped with the state seal; and inside the envelope I found another and another, endlessly, and I thought I would fall of weariness. ''Them's years,'' he said. ''Now open that one.'' And I did and in it I found an engraved document containing a short message in letters of gold. ''Read it,'' my grandfather said, ''Out loud.''

''To Whom It May Concern,'' I intoned. ''Keep This Nigger-Boy Running.''

I awoke with the old man's laughter ringing in my ears.

(It was a dream I was to remember and dream again for many years after. But at that time I had no insight into its meaning. First I had to attend college.)

The Yellow Wallpaper

Charlotte Perkins Gilman

It is very seldom that mere ordinary people like John and myself secure ancestral halls for the summer.

A colonial mansion, a hereditary estate, I would say a haunted house, and reach the height of romantic felicity—but that would be asking too much of fate!

Still I will proudly declare that there is something queer about it.

Else, why should it be let so cheaply? And why have stood so long untenanted?

John laughs at me, of course, but one expects that in marriage.

John is practical in the extreme. He has no patience with faith, an intense horror of superstition, and he scoffs openly at any talk of things not to be felt and seen and put down in figures.

John is a physician, and *perhaps*—(I would not say it to a living soul, of course, but this is dead paper and a great relief to my mind)—*perhaps* that is one reason I do not get well faster.

You see he does not believe I am sick!

And what can one do?

If a physician of high standing, and one's own husband, assures friends and relatives that there is really nothing the matter with one but temporary nervous depression—a slight hysterical tendency—what is one to do?

My brother is also a physician, and also of high standing, and he says the same thing.

So I take phosphates or phosphites—whichever it is, and tonics, and journeys, and air, and exercise, and am absolutely forbidden to "work" until I am well again.

Personally, I disagree with their ideas.

Personally, I believe that congenial work, with excitement and change, would do me good.

But what is one to do?

I did write for a while in spite of them; but it *does* exhaust me a good deal—having to be so sly about it, or else meet with heavy opposition.

I sometimes fancy that in my condition if I had less opposition and more society and stimulus—but John says the very worst thing I can do is to think about my condition, and I confess it always makes me feel bad.

So I will let it alone and talk about the house.

The most beautiful place! It is quite alone, standing well back from the road, quite three miles from the village. It makes me think of English places that you read about, for there are hedges and walls and gates that lock, and lots of separate little houses for the gardeners and people.

There is a *delicious* garden! I never saw such a garden—large and shady, full of box-bordered paths, and lined with long grape-covered arbors with seats under them.

There were greenhouses, too, but they are all broken now.

There was some legal trouble, I believe, something about the heirs and coheirs; anyhow, the place has been empty for years.

That spoils my ghostliness, I am afraid, but I don't care—there is something strange about the house—I can feel it.

I even said so to John one moonlight evening, but he said what I felt was a *draught,* and shut the window.

I get unreasonably angry with John sometimes. I'm sure I never used to be so sensitive. I think it is due to this nervous condition.

But John says if I feel so, I shall neglect proper self-control; so I take pains to control myself—before him, at least, and that makes me very tired.

I don't like our room a bit. I wanted one downstairs that opened on the piazza and had roses all over the window, and such pretty old-fashioned chintz hangings! but John would not hear of it.

He said there was only one window and not room for two beds, and no near room for him if he took another.

He is very careful and loving, and hardly lets me stir without special direction.

I have a schedule prescription for each hour in the day; he takes all care from me, and so I feel basely ungrateful not to value it more.

He said we came here solely on my account, that I was to have perfect rest and all the air I could get. "Your exercise depends on your strength, my dear," said he, "and your food somewhat on your appetite; but air you can absorb all the time." So we took the nursery at the top of the house.

It is a big, airy room, the whole floor nearly, with windows that look all ways, and air and sunshine galore. It was nursery first and then playroom and gymnasium, I should judge; for the windows are barred for little children, and there are rings and things in the walls.

The paint and paper look as if a boys' school had used it. It is stripped off— the paper—in great patches all around the head of my bed, about as far as I can reach, and in a great place on the other side of the room low down. I never saw a worse paper in my life.

One of those sprawling flamboyant patterns committing every artistic sin.

It is dull enough to confuse the eye in following, pronounced enough to constantly irritate and provoke study, and when you follow the lame uncertain curves for a little distance they suddenly commit suicide—plunge off at outrageous angles, destroy themselves in unheard of contradictions.

The color is repellent, almost revolting; a smouldering unclean yellow, strangely faded by the slow-turning sunlight.

It is a dull yet lurid orange in some places, a sickly sulphur tint in others.

No wonder the children hated it! I should hate it myself if I had to live in this room long.

There comes John, and I must put this away,—he hates to have me write a word.

We have been here two weeks, and I haven't felt like writing before, since that first day.

I am sitting by the window now, up in this atrocious nursery, and there is nothing to hinder my writing as much as I please, save lack of strength.

John is away all day, and even some nights when his cases are serious.

I am glad my case is not serious!

But these nervous troubles are dreadfully depressing.

John does not know how much I really suffer. He knows there is no *reason* to suffer, and that satisfies him.

Of course it is only nervousness. It does weigh on me so not to do my duty in any way!

I meant to be such a help to John, such a real rest and comfort, and here I am a comparative burden already!

Nobody would believe what an effort it is to do what little I am able,—to dress and entertain, and order things.

It is fortunate Mary is so good with the baby. Such a dear baby!

And yet I *cannot* be with him, it makes me so nervous.

I suppose John never was nervous in his life. He laughs at me so about this wallpaper!

At first he meant to repaper the room, but afterwards he said that I was letting it get the better of me, and that nothing was worse for a nervous patient than to give way to such fancies.

He said that after the wallpaper was changed it would be the heavy bedstead, and then the barred windows, and then that gate at the head of the stairs, and so on.

"You know the place is doing you good," he said, "and really, dear, I don't care to renovate the house just for a three months' rental."

"Then do let us go downstairs," I said, "there are such pretty rooms there."

Then he took me in his arms and called me a blessed little goose, and said he would go down to the cellar, if I wished, and have it whitewashed into the bargain.

But he is right enough about the beds and windows and things.

It is an airy and comfortable room as any one need wish, and, of course, I would not be so silly as to make him uncomfortable just for a whim.

I'm really getting quite fond of the big room, all but that horrid paper.

Out of one window I can see the garden, those mysterious deepshaded arbors, the riotous old-fashioned flowers, and bushes and gnarly trees.

Out of another I get a lovely view of the bay and a little private wharf belonging to the estate. There is a beautiful shaded lane that runs down there from the house. I always fancy I see people walking in these numerous paths and arbors, but John has cautioned me not to give way to fancy in the least. He says that with my imaginative power and habit of story-making, a nervous weakness like mine is sure to lead to all manner of excited fancies, and that I ought to use my will and good sense to check the tendency. So I try.

I think sometimes that if I were only well enough to write a little it would relieve the press of ideas and rest me.

But I find I get pretty tired when I try.

It is so discouraging not to have any advice and companionship about my work. When I get really well, John says we will ask Cousin Henry and Julia down for a long visit; but he says he would as soon put fireworks in my pillow-case as to let me have those stimulating people about now.

I wish I could get well faster.

But I must not think about that. This paper looks to me as if it *knew* what a vicious influence it had!

There is a recurrent spot where the pattern lolls like a broken neck and two bulbous eyes stare at you upside down.

I get positively angry with the impertinence of it and the everlastingness. Up and down and sideways they crawl, and those absurd, unblinking eyes are everywhere. There is one place where two breaths didn't match, and the eyes go all up and down the line, one a little higher than the other.

I never saw so much expression in an inanimate thing before, and we all know how much expression they have! I used to lie awake as a child and get more

entertainment and terror out of blank walls and plain furniture than most children could find in a toy-store.

I remember what a kindly wink the knobs of our big, old bureau used to have, and there was one chair that always seemed like a strong friend.

I used to feel that if any of the other things looked too fierce I could always hop into that chair and be safe.

The furniture in this room is no worse than inharmonious, however, for we had to bring it all from downstairs. I suppose when this was used as a playroom they had to take the nursery things out, and no wonder! I never saw such ravages as the children have made here.

The wallpaper, as I said before, is torn off in spots, and it sticketh closer than a brother—they must have had perseverance as well as hatred.

Then the floor is scratched and gouged and splintered, the plaster itself is dug out here and there, and this great heavy bed which is all we found in the room, looks as if it had been through the wars.

But I don't mind it a bit—only the paper.

There comes John's sister. Such a dear girl as she is, and so careful of me! I must not let her find me writing.

She is a perfect and enthusiastic housekeeper, and hopes for no better profession. I verily believe she thinks it is the writing which made me sick!

But I can write when she is out, and see her a long way off from these windows.

There is one that commands the road, a lovely shaded winding road, and one that just looks off over the country. A lovely country, too, full of great elms and velvet meadows.

This wallpaper has a kind of sub-pattern in a different shade, a particularly irritating one, for you can only see it in certain lights, and not clearly then.

But in the places where it isn't faded and where the sun is just so—I can see a strange, provoking, formless sort of figure, that seems to skulk about behind that silly and conspicuous front design.

There's sister on the stairs!

* * *

Well, the Fourth of July is over! The people are all gone and I am tired out. John thought it might do me good to see a little company, so we just had Mother and Nellie and the children down for a week.

Of course I didn't do a thing. Jennie sees to everything now.

But it tired me all the same.

John says if I don't pick up faster he shall send me to Weir Mitchell in the fall.

But I don't want to go there at all. I had a friend who was in his hands once, and she says he is just like John and my brother, only more so!

Besides, it is such an undertaking to go so far.

I don't feel as if it was worth while to turn my hand over for anything, and I'm getting dreadfully fretful and querulous.

I cry at nothing, and cry most of the time.

Of course I don't when John is here, or anybody else, but when I am alone.

And I am alone a good deal just now. John is kept in town very often by serious cases, and Jennie is good and lets me alone when I want her to.

So I walk a little in the garden or down that lovely lane, sit on the porch under the roses, and lie down up here a good deal.

I'm getting really fond of the room in spite of the wallpaper. Perhaps *because* of the wallpaper.

It dwells in my mind so!

I lie here on this great immovable bed—it is nailed down, I believe—and follow that pattern about by the hour. It is as good as gymnastics, I assure you. I start, we'll say, at the bottom, down in the corner over there where it has not been touched, and I determine for the thousandth time that I *will* follow that pointless pattern to some sort of a conclusion.

I know a little of the principle of design, and I know this thing was not arranged on any laws of radiation, or alternation, or repetition, or symmetry, or anything else that I ever heard of.

It is repeated, of course, by the breadths, but not otherwise.

Looked at in one way each breadth stands alone, the bloated curves and flourishes—a kind of "debased Romanesque" with *delirium tremens*—go waddling up and down in isolated columns of fatuity.

But, on the other hand, they connect diagonally, and the sprawling outlines run off in great slanting waves of optic horror, like a lot of wallowing seaweeds in full chase.

The whole thing goes horizonally, too, a least it seems so, and I exhaust myself in trying to distinguish the order of its going in that direction.

They have used a horizontal breadth for a frieze, and that adds wonderfully to the confusion.

There is one end of the room where it is almost intact, and there, when the crosslights fade and the low sun shines directly upon it, I can almost fancy radiation after all,—the interminable grotesques seem to form around a common centre and rush off in headlong plunges of equal distraction.

It makes me tired to follow it. I will take a nap I guess.

I don't know why I should write this.

I don't want to.

I don't feel able.

And I know John would think it absurd. But I *must* say what I feel and think in some way—it is such a relief!

But the effort is getting to be greater than the relief.

Half the time now I am awfully lazy, and lie down ever so much.

John says I mustn't lose my strengh, and has me take cod liver oil and lots of tonics and things, to say nothing of ale and wine and rare meat.

Dear John! He loves me very dearly, and hates to have me sick. I tried to have a real earnest reasonable talk with him the other day, and tell him how I wish he would let me go and make a visit to Cousin Henry and Julia.

But he said I wasn't able to go, nor able to stand it after I got there; and I did not make out a very good case for myself, for I was crying before I had finished.

It is getting to be a great effort for me to think straight. Just this nervous weakness I suppose.

And dear John gathered me up in his arms, and just carried me upstairs and laid me on the bed, and sat by me and read to me till it tired my head.

He said I was his darling and his comfort and all he had, and that I must take care of myself for his sake, and keep well.

He says no one but myself can help me out of it, that I must use my will and self-control and not let any silly fancies run away with me.

There's one comfort, the baby is well and happy, and does not have to occupy this nursery with the horrid wallpaper.

If we had not used it, that blessed child would have! What a fortunate escape! Why, I wouldn't have a child of mine, an impressionable little thing, live in such a room for worlds.

I never thought of it before, but it is lucky that John kept me here after all, I can stand it so much easier than a baby, you see.

Of course, I never mention it to them any more—I am too wise,—but I keep watch of it all the same.

There are things in that paper that nobody knows but me, or ever will.

Behind that outside pattern the dim shapes get clearer every day.

It is always the same shape, only very numerous.

And it is like a woman stooping down and creeping about behind that pattern. I don't like it a bit. I wonder—I begin to think—I wish John would take me away from here!

It is so hard to talk with John about my case, because he is so wise, and because he loves me so.

But I tried it last night.

It was moonlight. The moon shines in all around just as the sun does.

I hate to see it sometimes, it creeps so slowly, and always comes in by one window or another.

John was asleep and I hated to waken him, so I kept still and watched the moonlight on that undulating wallpaper till I felt creepy.

The faint figure behind seemed to shake the pattern, just as if she wanted to get out.

I got up softly and went to feel and see if the paper *did* move, and when I came back John was awake.

"What is it, little girl?" he said. "Don't go walking about like that—you'll get cold."

I thought it was a good time to talk, so I told him that I really was not gaining here, and that I wished he would take my away.

"Why darling!" said he, "our lease will be up in three weeks, and I can't see how to leave before.

"The repairs are not done at home, and I cannot possibly leave town just now. Of course if you were in any danger, I could and would, but you really are better, dear, whether you can see it or not. I am a doctor, dear, and I know. You are gaining flesh and color, your appetite is better, I feel really much easier about you."

"I don't weigh a bit more," said I, "nor as much; and my appetite may be better in the evening when you are here, but it is worse in the morning when you are away!"

"Bless her little heart!" said he with a big hug, "she shall be as sick as she pleases! But now let's improve the shining hours by going to sleep, and talk about it in the morning!"

"And you won't go away?" I asked gloomily.

"Why, how can I, dear? It is only three weeks more and then we will take a nice little trip of a few days while Jennie is getting the house ready. Really dear you are better!"

"Better in body perhaps—" I began, and stopped short, for he sat up straight and looked at me with such a stern, reproachful look that I could not say another word.

"My darling," said he, "I beg of you, for my sake and for our child's sake, as well as for your own, that you will never for one instant let that idea enter your mind! There is nothing so dangerous, so fascinating, to a temperament like yours. It is a false and foolish fancy. Can you not trust me as a physician when I tell you so?"

So of course I said no more on that score, and we went to sleep before long. He thought I was asleep first, but I wasn't, and lay there for hours trying to decide whether that front pattern and the back pattern really did move together or separately.

On a pattern like this, by daylight, there is a lack of sequence, a defiance of law, that is a constant irritant to a normal mind.

The color is hideous enough, and unreliable enough, and infuriating enough, but the pattern is torturing.

You think you have mastered it, but just as you get well underway in following, it turns a back-somersault and there you are. It slaps you in the face, knocks you down, and tramples upon you. It is like a bad dream.

The ouside pattern is a florid arabesque, reminding one of a fungus. If you can imagine a toadstool in joints, an interminable string of toadstools, budding and sprouting in endless convolutions—why, that is somehing like it.

That is, sometimes!

There is one marked peculiarity about this paper, a thing nobody seems to notice but myself, and that is that it changes as the light changes.

When the sun shoots in through the east window—I always watch for that first long, straight ray—it changes so quickly that I never can quite believe it.

That is why I watch it always.

By moonlight—the moon shines in all night when there is a moon—I wouldn't know it was the same paper.

At night in any kind of light, in twilight, candle light, lamplight, and worst of all by moonlight, it becomes bars! The outside pattern I mean, and the woman behind it is as plain as can be.

I didn't realize for a long time what the thing was that showed behind, that dim sub-pattern, but now I am quite sure it is a woman.

By daylight she is subdued, quiet. I fancy it is the pattern that keeps her so still. It is so puzzling. It keeps me quiet by the hour.

I lie down ever so much now. John says it is good for me, and to sleep all I can.

Indeed he started the habit by making me lie down for an hour after each meal.

It is a very bad habit I am convinced, for you see I don't sleep.

And that cultivates deceit, for I don't tell them I'm awake—O no!

The fact is I am getting a little afraid of John.

He seems very queer sometimes, and even Jennie has an inexplicable look.

It strikes me occasionally, just as a scientific hypothesis,—that perhaps it is the paper!

I have watched John when he did not know I was looking, and come into the room suddenly on the most innocent excuses, and I've caught him several times *looking at the paper!* And Jennie too. I caught Jennie with her hand on it once.

She didn't know I was in the room, and when I asked her in a quiet, a very quiet voice, with the most restrained manner possible, what she was doing with the paper—she turned around as if she had been caught stealing, and looked quite angry—asked me why I should frighten her so!

Then she said that the paper stained everything it touched, that she had found yellow smooches on all my clothes and John's, and she wished we would be more careful!

Did not that sound innocent? But I know she was studying that pattern, and I am determined that nobody shall find it out but myself!

Life is very much more exciting now than it used to be. You see I have something more to expect, to look forward to, to watch. I really do eat better, and am more quiet than I was.

John is so pleased to see me improve! He laughed a little the other day, and said I seemed to be flourishing in spite of my wallpaper.

I turned it off with a laugh. I had no intention of telling him it was *because* of the wallpaper—he would make fun of me. He might even want to take me away.

I don't want to leave now until I have found it out. There is a week more, and I think that will be enough.

I'm feeling ever so much better! I don't sleep much at night, for it is so interesting to watch developments; but I sleep a good deal in the daytime.

In the daytime it is tiresome and perplexing.

There are always new shoots on the fungus, and new shades of yellow all over it. I cannot keep count of them, though I have tried conscientiously.

It is the strangest yellow, that wallpaper! It makes me think of all the yellow things I ever saw—not beautiful ones like buttercups, but old foul, bad yellow things.

But there is something else about that paper—the smell! I noticed it the moment we came into the room, but with so much air and sun it was not bad.

Now we have had a week of fog and rain, and whether the windows are open or not, the smell is here.

It creeps all over the house.

I find it hovering in the dining-room, skulking in the parlor, hiding in the hall, lying in wait for me on the stairs.

It gets into my hair.

Even when I go to ride, if I turn my head suddenly and surprise it—there is that smell!

Such a peculiar odor, too! I have spent hours in trying to analyze it, to find what it smelled like.

It is not bad—at first, and very gentle, but quite the subtlest, most enduring odor I ever met.

In this damp weather it is awful, I wake up in the night and find it hanging over me.

It used to disturb me at first. I thought seriously of burning the house—to reach the smell.

But now I am used to it. The only thing I can think of that it is like is the *color* of the paper! A yellow smell.

There is a very funny mark on this wall, low down, near the mopboard. A streak that runs round the room. It goes behind every piece of furniture, except the bed, a long, straight, even *smooch,* as if it had been rubbed over and over.

I wonder how it was done and who did it, and what they did it for. Round and round and round—round and round and round—it makes me dizzy!

I really have discovered something at last.

Through watching so much at night, when it changes so, I have finally found out.

The front pattern *does* move—and no wonder! The woman behind shakes it!

Sometimes I think there are a great many women behind, and sometimes only one, and she crawls around fast, and her crawling shakes it all over.

Then in the very bright spots she keeps still, and in the very shady spots she just takes hold of the bars and shakes them hard.

And she is all the time trying to climb through. But nobody could climb through that pattern—it strangles so; I think that is why it has so many heads.

They get through, and then the pattern strangles them off and turns them upside down, and makes their eyes white!

If those heads were covered or taken off it would not be half so bad.

I think that woman gets out in the daytime!

And I'll tell you why—privately—I've seen her!

I can see her out of every one of my windows!

It is the same woman, I know, for she is always creeping, and most women do not creep by daylight.

I see her on that long road under the trees, creeping along, and when a carriage comes she hides under the blackberry vines.

I don't blame her a bit. It must be very humiliating to be caught creeping by daylight!

I always lock the door when I creep by daylight. I can't do it at night, for I know John would suspect something at once.

And John is so queer now, that I don't want to irritate him. I wish he would take another room! Besides, I don't want anybody to get that woman out at night but myself.

I often wonder if I could see her out of all the windows at once.

But, turn as fast as I can, I can only see out of one at one time.

And though I always see her, she *may* be able to creep faster than I can turn!

I have watched her sometimes away off in the open country, creeping as fast as a cloud shadow in a high wind.

If only that top pattern could be gotten off from the under one! I mean to try it, little by little.

I have found out another funny thing, but I shan't tell it this time! It does not do to trust people too much!

There are only two more days to get this paper off, and I believe John is beginning to notice. I don't like the look in his eyes.

And I heard him ask Jennie a lot of professional questions about me. She had a very good report to give.

She said I slept a good deal in the daytime.

John knows I don't sleep very well at night, for all I'm so quiet!

He asked me all sorts of questions, too, and pretended to be very loving and kind.

As if I couldn't see through him!

Still, I don't wonder he acts so, sleeping under this paper for three months.

It only interests me, but I feel sure John and Jennie are secretly affected by it.

Hurrah! This is the last day, but it is enough. John to stay in town over night, and won't be out until this evening.

Jennie wanted to sleep with me—the sly thing! but I told her I should undoubtedly rest better for a night all alone.

That was clever, for really I wasn't alone a bit! As soon as it was moonlight and that poor thing began to crawl and shake the pattern, I got up and ran to help her.

I pulled and she shook, I shook and she pulled, and before morning we had peeled off yards of that paper.

A strip about as high as my head and half around the room.

And then when the sun came and that awful pattern began to laugh at me, I declared I would finish it to-day!

We go away to-morrow, and they are moving all my furniture down again to leave things as they were before.

Jennie looked at the wall in amazement, but I told her merrily that I did it out of pure spite at the vicious thing.

She laughed and said she wouldn't mind doing it herself, but I must not get tired.

How she betrayed herself that time!

But I am here, and no person touches this paper but me,—not *alive!*

She tried to get me out of the room—it was too patent! But I said it was so quiet and empty and clean now that I believed I would lie down again and sleep all I could; and not to wake me even for dinner—I would call when I woke.

So now she is gone, and the servants are gone, and the things are gone, and there is nothing left but that great bedstead nailed down, with the canvas mattress we found on it.

We shall sleep downstairs to-night, and take the boat home to-morrow.

I quite enjoy the room, now it is bare again.

How those children did tear about here!

This bedstead is fairly gnawed!

But I must get to work.

I have locked the door and thrown the key down into the front path.

I don't want to go out, and I don't want to have anybody come in, till John comes.

I want to astonish him.

I've got a rope up here that even Jennie did not find. If that woman does get out, and tries to get away, I can tie her!

But I forgot I could not reach far without anything to stand on!

This bed will *not* move!

I tried to lift and push it until I was lame, and then I got so angry I bit off a little piece at one corner—but it hurt my teeth.

Then I peeled off all the paper I could reach standing on the floor. It sticks horribly and the pattern just enjoys it! All those strangled heads and bulbous eyes and waddling fungus growths just shriek with derision!

I am getting angry enough to do something desperate. To jump out of the window would be admirable exercise, but the bars are too strong even to try.

Besides I wouldn't do it. Of course not. I know well enough that a step like that is improper and might be misconstrued.

I don't like to *look* out of the windows even—there are so many of those creeping women, and they creep so fast.

I wonder if they all come out of that wallpaper as I did?

But I am securely fastened now by my well-hidden rope—you don't get *me* out in the road there!

I suppose I shall have to get back behind the pattern when it comes night, and that is hard!

It is so pleasant to be out in this great room and creep around as I please!

I don't want to go outside. I won't, even if Jennie asks me to.

For outside you have to creep on the ground, and everything is green instead of yellow.

But here I can creep smoothly on the floor, and my shoulder just fits in that long smooch around the wall, so I cannot lose my way.

Why there's John at the door!

It is no use, young man, you can't open it!

How he does call and pound!

Now he's crying for an axe.

It would be a shame to break down that beautiful door!

"John dear!" said I in the gentlest voice, "the key is down by the front steps, under a plantain leaf!"

That silenced him for a few moments.

Then he said—very quietly indeed. "Open the door, my darling!"

"I can't," said I. "The key is down by the front door under a plantain leaf!"

And then I said it again, several times, very gently and slowly, and said it so often that he had to go and see, and he got it of course, and came in. He stopped short by the door.

"What is the matter?" he cried. "For God's sake, what are you doing!"

I kept on creeping just the same, but I looked at him over my shoulder.

"I've got out at last," said I, "in spite of you and Jane. And I've pulled off most of the paper, so you can't put me back!"

Now why should that man have fainted? But he did, and right across my path by the wall, so that I had to creep over him every time!

from "Puttermesser and Xanthippe"

CYNTHIA OZICK

Puttermesser's Fall, and the History of the Genus Golem

Turtelman sent his secretary to fetch Puttermesser. It was a new secretary, a middle-aged bony acolyte, graying and testy, whom he had brought with him from the Department of Hygienic Maintenance: she had coarse eyebrows crawling upward: "This isn't exactly a good time for me to do this," Puttermesser complained. It was as if Turtelman did not trust the telephone for such a purpose. Puttermesser knew his purpose: he wanted teaching. He was puzzled, desperate. Inside his ambitiousness he was a naked boy, fearful. His office was cradled next to the threatening computer chamber; all along the walls the computer's hard flanks glittered with specks and lights. Puttermesser could hear, behind a partition, the spin of a thousand wheels, a thin threadlike murmur, as if the software men, long-haired chaps in sneakers, had set lyres out upon the great stone window sills of the Municipal Building. Walking behind the bony acolyte, Puttermesser pitied Turtelman: the Mayor had called for information—figures, indexes, collections, projections—and poor Turtelman, fresh from his half-education in the land of abstersion and elutriation, his frontal lobes still inclined toward repair of street-sweeping machinery, hung back bewildered. He had no answers for the Mayor, and no idea where the answers might be hidden; alas, the questions themselves fell on Turtelman's ears as though in a foreign tongue.

The secretary pushed open Turtelman's door, stood aside for Puttermesser, and went furiously away.

Poor Turtelman, Puttermesser thought.

Turtelman spoke: "You're out."

"Out?" Puttermesser said. It was a bitter Tuesday morning in mid-January; at that very moment, considerably south of the Municipal Building, in Washington, D.C., they were getting ready to inaugurate the next President of the United States. High politics emblazoned the day. Bureaucracies all over the world were turning on their hinges, gates were lifting and shutting, desks emptying and filling. The tide rode upon Turtelman's spittle; it glimmered on his teeth.

"As of this afternoon," Turtelman said, "you are relieved of your duties. It's nothing personal, believe me. I don't know you. We're restructuring. It's too bad you're not a bit older. You can't retire at only forty-six." He had read her résumé, then; at least that.

"I'm old enough," Puttermesser said.

"Not for collecting your pension. You people have a valuable retirement system here. I envy you. It drains the rest of us dry." The clack of his teeth showed that he was about to deliver a sting: "We ordinary folk who aren't lucky enough to be in the Civil Service can't afford you."

Puttermesser announced proudly, "I earn my way. I scored highest in the entire city on the First-Level Management Examination. I was editor-in-chief of Law Review at Yale Law School. I graduated from Barnard with honors in history, *summa cum laude,* Phi Beta Kappa—"

Turtelman broke in: "Give me two or three weeks, I'll find a little spot for you somewhere. You'll hear from me."

Thus the manner of Puttermesser's fall. Ignoble. She did not dream there was worse to come. She spilled the papers out of her drawers and carried them to a windowless cubicle down the hall from her old office. For a day or so her ex-staff averted their eyes; then they ceased to notice her; her replacement had arrived. He was Adam Marmel, late of the Bureau of Emergencies, an old classmate of Turtelman's at New York University, where both had majored in Film Arts. This interested Puttermesser: the Department of Receipts and Disbursements was now in the hands of young men who had been trained to pursue illusion, to fly with a gossamer net after fleeting shadows. They were attracted to the dark, where fraudulent emotions raged. They were, moreover, close friends, often together. The Mayor had appointed Turtelman; Turtelman had appointed Marmel; Marmel had succeeded Puttermesser, who now sat with the *Times,* deprived of light, isolated, stripped, forgotten. An outcast. On the next Friday her salary check came as usual. But no one called her out of her cubicle.

Right in the middle of business hours—she no longer had any business, she was perfectly idle—Puttermesser wrote a letter to the Mayor:

The Honorable Malachy Mavett
Mayor, City of New York
City Hall

Dear Mayor Mavett:

Your new appointee in the Department of Receipts and Disburse-ments, Commissioner Alvin Turtelman, has forced a fine civil servant of honorable temperament, with experience both wide and impassioned, out of her job. I am that civil servant. Without a hearing, without due

process, without a hope of appeal or redress (except, Mr. Mayor, by you!), Commissioner Turtelman has destroyed a career in full flower. Employing an affectless vocabulary by means of which, in a single instant, he abruptly ousted a civil servant of high standing, Commissioner Turtelman has politicized a job long held immune to outside preferment. In a single instant, honor, dignity, and continuity have been snatched away! I have been professionally injured and personally humiliated. I have been rendered useless. As of this writing I am costing the City's taxpayers the price of my entire salary, while I sit here working a crossword puzzle; while I hold this very pen. No one looks at me. They are embarrassed and ashamed. At first a few ex-colleagues came into this little abandoned office (where I do nothing) to offer condolences, but that was only at first. It is like being at my own funeral, Mr. Mayor, only imagine it!

Mr. Mayor, I wish to submit several urgent questions to you; I will be grateful for your prompt views on these matters of political friendships, connections, and power.

1. Are you aware of this inequitable treatment of professional staff in the Bureau of Summary Sessions of the Department of Receipts and Disbursements?
2. If so, is this the nature of the Administration you are content to be represented by?
3. Is it truly your desire to erode and undermine the professional Civil Service—one of democratic government's most just, most equitable, devices?
4. Does Commissioner Alvin Turtelman's peremptory action really reflect your own sensibility, with all its fairness and exuberant humaneness?

In City, State, and World life, Mr. Mayor (I have observed this over many years), power and connections are never called power and connections. They are called principle. They are called democracy. They are called judgment. They are called doing good. They are called restructuring. They are called exigency. They are called improvement. They are called functioning. They are called the common need. They are called government. They are called running the Bureau, the Department, the City, the State, the World, looking out for the interests of the people.

Mr. Mayor, getting the spoils is called anything but getting the spoils!

Puttermesser did not know whether Malachy ("Matt") Mavett's sensibilty was really fair and exuberantly humane; she had only put that in to flatter him. She had glimpsed the Mayor in the flesh only once or twice, at a meeting, from a distance. She had also seen him on Sunday morning television, at a press conference, but then he was exceptionally cautious and sober; before the cameras he was neuter, he had no sensibility at all; he was nearly translucent. His white mustache looked tangled; his white hair twirled in strings over his temples.

Puttermesser's letter struck her as gripping, impressive; copying it over on the typewriter at home that night, she felt how the Mayor would be stabbed through by such fevered eloquence. How remorseful he would be, how moved!

Still another salary check arrived. It was not for the usual amount; Puttermesser's pay had been cut. The bony acolyte appeared with a memo from Turtelman: Puttermesser was to leave her barren cubicle and go to an office with a view of the Woolworth Building, and there she was to take up the sad life of her demotion.

Turtelman had shoved her into the lowliest ranks of Taxation. It was an unlikely post for a mind superfetate with Idea; Puttermesser felt the malignancy behind this shift. Her successor had wished her out of sight. "I do not consort with failure," she heard Adam Marmel tell one of the auditors. She lived now surrounded by auditors—literal-minded men. They read best-sellers; their fingers were smudged from the morning papers, which they clutched in their car pools or on the subway from Queens. One of them, Leon Cracow, a bachelor from Forest Hills who wore bow ties and saddle shoes, was engaged in a tedious litigation: he had once read a novel and fancied himself its hero. The protagonist wore bow ties and saddle shoes. Cracow was suing for defamation. "My whole love life's maligned in there," he complained to Puttermesser. He kept the novel on his desk—it was an obscure book no one had ever heard of, published by a shadowy California press. Cracow had bought it remaindered for eighty-nine cents and ruminated over it every day. Turning the pages, he wet two of his fingers repeatedly. The novel was called *Pyke's Pique;* a tax auditor named John McCracken Pyke was its chief character. "McCracken," Cracow said, "that's practically Cracow. It sounds practically identical. Listen, in the book this guy goes to prostitutes. I don't go to prostitutes! The skunk's got me all wrong. He's destroying my good name." Sometimes Cracow asked Puttermesser for her opinion of his lawyer's last move. Puttermesser urged him on. She believed in the uses of fantasy. "A person should see himself or herself everywhere," she said. "All things manifest us."

The secret source of this motto was, in fact, her old building on the Grand Concourse. Incised in a stone arch over the broad front door, and also in Puttermesser's loyal brain, were these Roman-style tracings: LONGWOOD ARMS, No. 26. GREENDALE HALL, No. 28. ALL THINGS MANIFEST US. The builder had thought deep thoughts, and Cracow was satisfied. "Ruth," he said, "you take the cake." As usual, he attempted to date her. "Any concert, any show, you name it," he said; "I'm a film buff." "You fit right in with Turtelman and Marmel," Puttermesser said. "Not me," Cracow retorted, "with me it's nostalgia only. My favorite movie is Deanna Durbin, Leopold Stokowski, and Adolphe Menjou in *One Hundred Men and a Girl.* Wholesome, sweet, not like they make today. Light classical. Come on, Ruth, it's at the Museum of Modern Art, in the cellar." Puttermesser turned him down. She knew she would never marry, but she was not yet reconciled to childlessness. Sometimes the thought that she would never give birth tore her heart.

She imagined daughters. It was self-love: all these daughters were Puttermesser as a child. She imagined a daughter in fourth grade, then in seventh grade, then in second-year high school. Puttermesser herself had gone to Hunter College High

School and studied Latin. At Barnard she had not renounced Catullus and Vergil. *O infelix Dido,* chanted the imaginary daughter, doing her Latin homework at Puttermesser's new Danish desk in the dark corner of the little bedroom. It was a teak rectangle; Puttermesser still had not bought a lamp for it. She hated it that all her furniture was new.

No reply came from the Mayor: not even a postcard of acknowledgment from an underling. Malachy ("Matt") Mavett was ignoring Puttermesser.

Rappoport had abandoned the Sunday *Times,* purchased Saturday night at the airport; he had left it, unopened, on the Danish desk. Puttermesser swung barefoot out of bed, stepped over Plato, and reached for Rappoport's *Times.* She brooded over his furry chest hair, yellowing from red. Now the daughter, still in high school, was memorizing Goethe's *Erlkönig*:

Dem Vater grauset's, er reitet geschwind,
Er hält in Armen des ächzende Kind,
Erreicht den Hof mit Mühe und Not:
In seinem Armen das Kind war tot.

The words made Puttermesser want to sob. The child was dead. In its father's arms the child was dead. She came back to bed, carrying Rappoport's *Times.* It was as heavy as if she carried a dead child. The Magazine Section alone was of a preternatural weight. Advertising. Consumerism. Capitalism. Page after page of cars, delicately imprinted chocolates, necklaces, golden whiskey. Affluence while the poor lurked and mugged, hid in elevators, shot drugs into their veins, stuck guns into old grandmothers' tremulous and brittle spines, in covert pools of blackness released the springs of their bright-flanked switchblades, in shafts, in alleys, behind walls, in ditches.

A naked girl lay in Puttermesser's bed. She looked dead—she was all white, bloodless. It was as if she had just undergone an epileptic fit: her tongue hung out of her mouth. Her eyelids were rigidly ajar; they had no lashes, and the skin was so taut and thin that the eyeballs bulged through. Her palms had fallen open; they were a clear white. Her arms were cold rods. A small white square was visible on the tongue. The girl did not resemble Puttermesser at all; she was certainly not one of the imaginary daughters. Puttermesser moved to one side of the bed, then circled back around the foot to the other side. She put on her slippers; summoning reason, she continued to move around and around the bed. There was no doubt that a real body was in it. Puttermesser reached out and touched the right shoulder—a reddish powder coated her fingers. The body seemed filmed with sand, or earth, or grit; some kind of light clay. Filth. A filthy junkie or prostitute; both. Sickness and filth. Rappoport, stalking away in the middle of the night, had been careless about closing the apartment door. God only knew where the creature had concealed herself, what had been stolen or damaged. When Puttermesser's back was turned, the filthy thing had slid into her bed. Such a civilized bed, the home of Plato and other high-minded readings. The body had a look of perpetuity about it, as if it had always been reclining there, in Puttermesser's own bed; yet it was a child's body, the limbs stretched into laxity

and languor. She was a little thing, no more than fifteen: Puttermesser saw how the pubic hair was curiously sparse; but the breasts were nearly not there at all. Puttermesser went on calculating and circling: should she call the super, or else telephone for an ambulance? New York! What was the good of living in a tiny squat box, with low ceilings, on East Seventy-first Street, a grudging landlord, a doorman in an admiral's uniform, if there were infiltrators, addicts, invaders, just the same as on the fallen Grand Concourse?

Puttermesser peered down at the creature's face. Ugly. The nose and mouth were clumsily formed, as if by some coarse hand that had given them a negligent tweak. The vomerine divider was off-center, the nostrils unpleasantly far apart. The mouth was in even worse condition—also off-center, but somehow more carelessly made, with lips that failed to match, the lower one no better than a line, the upper one amazingly fat, swollen, and the narrow tongue protruding with its white patch. Puttermesser reached out a correcting hand, and then withdrew it. Once again the dust left deep red ovals on her fingertips. But it was clear that the nostrils needed pinching to bring them closer together, so Puttermesser tentatively pinched. The improvement was impressive. She blew into the left nostril to get rid of a tuft of dust; it solidified and rolled out like a clay bead. With squeamish deliberation she pushed the nose in line with the middle space where the eyebrows ought to have been. There were no eyebrows, no eyelashes, no fingernails, no toenails. The thing was defective, unfinished. The mouth above all required finishing. Forming and re-forming the savage upper lip, getting into the mood of it now, Puttermesser wished she were an artist or sculptor: she centered the mouth, thickened the lower lip with a quick turn, smoothed out the hunch of the upper one—the tongue was in the way. She peeled off the white square and, pressing hard, shoved the tongue back down into the mouth.

The bit of white lay glimmering in Puttermesser's palm. It seemed to be nothing more than an ordinary slip of paper, but she thought she ought to put it aside to look it over more carefully after a while, so she left the bed and set it down on the corner of the teak desk. Then she came back and glanced up and down the body, to see whether there was anything else that called for correction. A forefinger needed lengthening, so Puttermesser tugged at it. It slid as if boneless, like taffy, cold but not sticky, and thrillingly pliable. Still, without its nail a finger can shock; Puttermesser recoiled. Though the face was now normal enough, there was more to be done. Something had flashed upward from that tongue-paper— the white patch was blank; yet it was not only blank. Puttermesser carried it in her palm to the window, for the sake of the light. But on the sill and under the sill every pot was cracked, every green plant sprawled. The roots, skeletal and hairy, had been torn from their embracing soil—or, rather, the earth had been scooped away. The plain earth, stolen. Puttermesser, holding the white scrap, wandered from window to window. There was no pot that had not been vandalized in the same way—Rappoport's big clay urn was in shards, the avocado tree broken. A few sparse grains of soil powdered the floor. Not a plant anywhere had been left unmolested—all the earth in Puttermesser's apartment was gone; taken away; robbed.

In the bedroom the girl's form continued its lethal sleep. Puttermesser lifted the tiny paper to the bright panes. Out of the whiteness of the white patch another whiteness flickered, as though a second version of absence were struggling to swim up out of the aboriginal absence. For Puttermesser, it was as if the white of her own eye could suddenly see what the purposeful retina had shunned. It was in fact not so much a seeing as the sharpness of a reading, and what Puttermesser read—she whose intellectual passions were pledged to every alphabet—was a single primeval Hebrew word, shimmering with its lightning holiness, the Name of Names, that which one dare not take in vain. Aloud she uttered it:

חַ שׁ ם,

whereupon the inert creature, as if drilled through by electricity, as if struck by some principle of instantaneous vitality, leaped straight from the bed; Puttermesser watched the fingernails grow rapidly into place, and the toenails, and the eyebrows and lashes: complete. A configuration of freckles appeared on the forehead. The hair of the head and of the mons Veneris thickened, curled, glistened dark red, the color of clay; the creature had risen to walk. She did it badly, knocking down the desk-chair and bumping into the dresser. Sick, drugged, drunk; vandal; thief of earth!

"Get your clothes on and get out," Puttermesser said. Where were the thing's clothes? She had none; she seemed less pale moment by moment; she was lurching about in her skin. She was becoming rosy. A lively color was in her cheeks and hands. The mouth, Puttermesser's own handiwork, was vivid. Puttermesser ran to her closet and pulled out a shirt, a skirt, a belt, a cardigan. From her drawers she swept up bra, pantythose, slip. There was only the question of shoes. "Here," she said, "summer sandals, that's all I can spare. Open toes, open heels, they'll fit. Get dressed. I can give you an old coat—go ahead. Sit down on the bed. Put this stuff on. You're lucky I'm not calling the police."

The creature staggered away from the bed, toward the teak desk.

"Do what I say!"

The creature had seized a notepad and a ballpoint pen, and was scribbling with shocking speed. Her fingers, even the newly lengthened one, were rhythmically coordinated. She clenched the pen, Puttermesser saw, like an experienced writer: as if the pen itself were a lick of the tongue, or an extension of the thinking digits. It surprised Puttermesser to learn that this thief of earth was literate. In what language? And would she then again try to swallow what she wrote, leaving one untouchable word behind?

The thing ripped away the alphabet-speckled page, tottered back with the pad, and laid the free sheet on the pillow.

"What's the matter? Can't you walk?" Puttermesser asked; she thought of afflicted children she had known, struck by melancholy witherings and dodderings.

But the answer was already on the paper. Puttermesser read: "I have not yet been long up upon my fresh-made limbs. Soon my gait will come to me.

Consider the newborn colt. I am like unto that. All tongues are mine, especially that of my mother. Only speech is forbidden me."

A lunatic! Cracked! Alone in the house with a maniac; a deaf-mute to boot. "Get dressed," Puttermesser again commanded.

The thing wrote: "I hear and obey the one who made me."

"What the hell *is* this," Puttermesser said flatly.

The thing wrote: "My mother," and rapidly began to jerk herself into Puttermesser's clothes, but with uneven sequences of the body—the more vitality the creature gained, the more thinglike she seemed.

Puttermesser was impatient; she longed to drive the creature out. "Put on those shoes," she ordered.

The thing wrote: "No."

"Shoes!" Puttermesser shouted. She made a signpost fist and flung it in the direction of the door. "Go out the way you came in!"

The thing wrote: "No shoes. This is a holy place. I did not enter. I was formed. Here you spoke the Name of the Giver of Life. You blew in my nostril and encouraged my soul. You circled my clay seven times. You enveloped me with your spirit. You pronounced the Name and brought me to myself. Therefore I call you mother."

Puttermesser's lungs began to roil. It was true she had circled the creature on the bed. Was it seven times around? It was true she had blown some foreign matter out of the nose. Had she blown some uncanny energy into an entrance of the dormant body? It was true she had said aloud one of the Names of the Creator.

The thing wrote again: "Mother. Mother."

"Go away!"

The thing wrote: "You made me."

"I didn't give birth to you." She would never give birth. Yet she had formed this mouth—the creature's mute mouth. She looked at the mouth: she saw what she had made.

The thing wrote: "Earth is my flesh. For the sake of my flesh you carried earth to this high place. What will you call me?"

A new turbulence fell over Puttermesser. She had always imagined a daughter named Leah. "Leah," she said.

"No," the creature wrote. "Leah is my name, but I want to be Xanthippe."

Puttermesser said, "Xanthippe was a shrew. Xanthippe was Socrates' wife."

"I want to be Xanthippe," the thing wrote. "I know everything you know. I am made of earth but also I am made out of your mind. Now watch me walk."

The thing walked, firmly, with a solid thump of a step and no stumbling. She wrote on the pad: "I am becoming stronger. You made me. I will be of use to you. Don't send me away. Call me what I prefer, Xanthippe."

"Xanthippe," Puttermesser said.

She succumbed; her throat panted. It came to her that the creature was certainly not lying: Puttermesser's fingernails were crowded with grains of earth. In some unknown hour after Rappoport's departure in the night, Puttermesser

had shaped an apparition. She had awakened it to life in the conventional way. Xanthippe was a golem, and what had polymathic Puttermesser *not* read about the genus golem?

Puttermesser ordered: "All right, go look on the bookshelves. Bring me whatever you see on your own kind."

The creature churned into the living room and hurried back with two volumes, one in either hand; she held the pen ready in her mouth. She dumped the books on the bed and wrote: "I am the first female golem."

"No you're not," Puttermesser said. It was clear that the creature required correction. Puttermesser flew through the pages of one of the books. "Ibn Gabirol created a woman. This was in Spain, long ago, the eleventh century. The king gave him a dressing-down for necromancy, so he dismantled her. She was made of wood and had hinges—it was easy to take her apart."

The creature wrote: "That was not a true golem."

"Go sit down in a corner," Puttermesser said. "I want to read."

The creature obeyed. Puttermesser dived into the two volumes. She had read them many times before; she knew certain passages nearly verbatim. One, a strange old text in a curiously awkward English translation (it was printed in Austria in 1925), had the grass-green public binding of a library book; to Puttermesser's citizenly shame, she had never returned it. It had been borrowed from the Crotona Park Branch decades ago, in Puttermesser's adolescence. There were photographs in it, incandescently clear: of graves, of a statue, of the lamp-hung interior of a synagogue in Prague—the Altneuschul—, of its tall peaked contour, of the two great clocks, one below the cupola, the other above it, on the venerable Prague Jewish Community House. Across the street from the Community House there was a shop, with a sign that said V. PRESSLER in large letters; underneath, his hand in his pocket, a dapper mustached dandy in a black fedora lounged eternally. Familiar, static, piercingly distinct though these illustrations were, Puttermesser all the same felt their weary old ache: phantoms— V. PRESSLER a speck of earth; the houses air; the dandy evaporated. Among these aged streets and deranged structures Puttermesser's marveling heart had often prowled. "You have no feelings," Rappoport once told her: he meant that she had the habit of flushing with ideas as if they were passions.

And this was true. Puttermesser's intelligence, brambly with the confusion of too much history, was a private warted tract, rubbled over with primordial statuary. She was painfully anthropological. Civilizations rolled into her rib cage, stone after graven stone: cuneiform, rune, cipher. She had pruned out allegory, metaphor; Puttermesser was no mystic, enthusiast, pneumaticist, ecstatic, kabbalist. Her mind was clean; she was a rationalist. Despite the imaginary daughters—she included these among her losses—she was not at all attached to any notion of shade or specter, however corporeal it might appear, and least of all to the idea of a golem—hardly that, especially now that she had the actual thing on her hands. What transfixed her was the kind of intellect (immensely sober, pragmatic, unfanciful, rationalist like her own) to which a golem ordinarily occurred—occurred, that is, in the shock of its true flesh and absolute being. The

classical case of the golem of Prague, for instance: the Great Rabbi Judah Loew, circa 1520–1609, maker of that renowned local creature, was scarcely one of those misty souls given over to untrammeled figments or romances. He was, instead, a reasonable man of biting understanding, a solid scholar, a pragmatic leader—a learned quasi-mayor. What he understood was that the scurrilous politics of his city, always tinged with religious interests, had gone too far. In short, they were killing the Jews of Prague. It had become unsafe for a peddler to open his pack, or a merchant his shop; no mother and her little daughter dared turn into an alley. Real blood ran in the streets, and all on account of a rumor of blood: citizens of every class—not just the guttersnipes—were muttering that the Jews had kneaded the bodies of Christian infants into their sacral Passover wafers. Scapegoat Jews, exposed, vulnerable, friendless, unarmed! The very Jews forbidden by their dietary code to eat an ordinary farmyard egg tainted with the minutest jot of fetal blood! So the Great Rabbi Judah Loew, to defend the Jews of Prague against their depredators, undertook to fashion a golem.

Puttermesser was well acquainted with the Great Rabbi Judah Loew's method of golem-making. It was classical; it was, as such things go, ordinary. To begin with, he entered a dream of Heaven, wherein he asked the angels to advise him. The answer came in alphabetical order: *afar, esh, mayim, ruach:* earth, fire, water, wraith. With his son-in-law, Isaac ben Shimshon, and his pupil, Jacob ben Chayim Sasson, the Great Rabbi Judah Loew sought inner purity and sanctification by means of prayer and ritual immersion; then the three of them went out to a mud-bed on the banks of the River Moldau to create a man of clay. Three went out; four returned. They worked by torchlight, reciting Psalms all the while, molding a human figure. Isaac ben Shimshon, a descendant of the priests of the Temple, walked seven times around the clay heap bulging up from the ground. Jacob ben Chayim Sasson, a Levite, walked seven times around. Then the Great Rabbi Judah Loew himself walked around, once only, and placed a parchment inscribed with the Name into the clay man's mouth. The priest represented fire; the Levite water; the Great Rabbi Judah Loew designated himself spirit and wraith, or air itself. The earth-man lay inert upon earth, like upon like. Fire, water, air, all chanted together: "And he breathed into his nostrils the breath of life; and man became a living soul"—whereupon the golem heated up, turned fiery red, and rose! It rose to become the savior of the Jews of Prague. On its forehead were imprinted the three letters that are the Hebrew word for truth: *aleph, mem, tav.*

This history Puttermesser knew, in its several versions, inside out. "Three went out; four returned"—following which, how the golem punished the slaughterers, persecutors, predators! How it cleansed Prague of evil and infamy, of degeneracy and murder, of vice and perfidy! But when at last the Great Rabbi Judah Loew wished the golem to subside, he climbed a ladder (a golem grows bigger every day), reached up to the golem's forehead, and erased the letter *aleph.* Instantly the golem fell lifeless, given back to spiritless clay: lacking the *aleph,* the remaining letters, *mem* and *tav,* spelled *met*—dead. The golem's body was hauled up to the attic of the Altneuschul, where it still rests among ever-thickening cobwebs. "No one may touch the cobwebs," ran one of the stories, "for whoever touches them dies."

For Puttermesser, the wonder of this tale was not in any of its remarkable parts; familiar as they were, and not even in its recurrence. The golem recurred, of course. It moved from the Exile of Babylon to the Exile of Europe; it followed the Jews. In the third century Rabbi Rava created a golem, and sent it to Rabbi Zera, who seemed not to know it was a golem until he discovered that it could not speak. Then realization of the thing's true nature came to him, and he rebuked it: "You must have been made by my comrades of the Talmudic Academy; return to your dust." Rabbi Hanina and Rabbi Oshaya were less successful than Rabbi Rava; they were only able to produce a very small calf, on which they dined. An old kabbalistic volume, the Book of Creation, explains that Father Abraham himself could manufacture human organisms. The Book of Raziel contains a famous workable prescription for golem-making: the maker utilizes certain chants and recitations, imprinted medals, esoteric names, efficacious shapes and totems. Ben Sira and his father, the prophet Jeremiah, created a golem, in the logical belief that Adam himself was a golem; their golem, like Adam, had the power of speech. King Nebuchadnezzar's own idol turned into a living golem when he set on its head the diadem of the High Priest, looted out of the Temple in Jerusalem; the jeweled letters of the Tetragrammaton were fastened into the diadem's silver sockets. The prophet Daniel, pretending to kiss the king's golem, swiftly plucked out the gems that spelled the Name of God, and the idol was again lifeless. Even before that, thieves among the wicked generation that built the Tower of Babel swiped some of the contractor's materials to fashion idols, which were made to walk by having the Name shoved into their mouths; then they were taken for gods. Rabbi Aharon of Baghdad and Rabbi Hananel did not mold images; instead, they sewed parchments inscribed with the Name into the right arms of corpses, who at once revived and became members of the genus golem. The prophet Micah made a golden calf that could dance, and Bezalel, the designer of the Tabernacle, knew how to combine letters of the alphabet so as to duplicate Creation, both heaven and earth. Rabbi Elazar of Worms had a somewhat similar system for golem-making: three adepts must gather up "virginal mountain earth," pour running water over it, knead it into a man, bury it, and recite two hundred and twenty-one alphabetical combinations, observing meticulously the prescribed order of the vowels and consonants. But Abraham Abulafia could make a man out of a mere spoonful of earth by blowing it over an ordinary dish of water; undoubtedly this had some influence on Paracelsus, the sixteenth-century German alchemist, who used a retort to make a homunculus: Paracelsus's manikin, however, was not telluric, being composed of blood, sperm, and urine, from which the Jewish golem-makers recoiled. For the Jews, earth, water, and the divine afflatus were the only permissible elements—the afflatus being summoned through the holy syllables. Rabbi Ishmael, on the other hand, knew another way of withdrawing that life-conferring holiness and rendering an active golem back into dust: he would recite the powerful combinations of sacred letters backward, meanwhile circling the creature in the direction opposite to the one that had quickened it.

There was no end to the conditions of golem-making, just as there was no end to the appearance of one golem after another in the pullulating procession

of golem-history; but Puttermesser's brain, crowded with all these acquisitions and rather a tidy store of others (for instance, she had the noble Dr. Gershom Scholem's bountiful essay "The Idea of the Golem" virtually by heart), was unattracted either to number or to method. What interested Puttermesser was something else: it was the plain fact that the golem-makers were neither visionaries nor magicians nor sorcerers. They were neither fantasists nor fabulists nor poets. They were, by and large, scientific realists—and, in nearly every case at hand, serious scholars and intellectuals: the plausible forerunners, in fact, of their great-grandchildren, who are physicists, biologists, or logical positivists. It was not only the Great Rabbi Judah Loew, the esteemed golem-maker of Prague, who had, in addition, a reputation as a distinguished Talmudist, reasoner, philosopher; even Rabbi Elijah, the most celebrated Jewish intellect of Eastern Europe (if Spinoza is the most celebrated on the Western side), whose brilliance outstripped the fame of every other scholar, who founded the most rigorous rabbinical academy in the history of the cold lands, who at length became known as the Vilna *Gaon* (the Genius of the city of Vilna, called, on his account, the Jerusalem of the North)—even the Vilna *Gaon* once attempted, before the age of thirteen, to make a golem! And the Vilna *Gaon,* with his stern refinements of exegesis and analysis, with his darting dazzlements of logical penetration, was—as everyone knows— the scourge of mystics, protester (*mitnagid*) against the dancing hasidim, scorner of those less limber minds to the Polish south, in superstitiously pious Galicia. If the Vilna *Gaon* could contemplate the making of a golem, thought Puttermesser, there was nothing irrational in it, and she would not be ashamed of what she herself had concocted.

She asked Xanthippe: "Do you eat?"

The golem wrote, "*Vivo, ergo edo.* I live, therefore I eat."

"Don't pull that on me—my Latin is as good as yours. Can you cook?"

"I can do what I must, if my mother decrees it," the golem wrote.

"All right," Puttermesser said. "In that case you can stay. You can stay until I decide to get rid of you. Now make lunch. Cook something I like, only better than I could do it."

"In the Region of Ice"

JOYCE CAROL OATES

Sister Irene was a tall, deft woman in her early thirties. What one could see of her face made a striking impression—serious, hard gray eyes, a long slender nose, a face waxen with thought. Seen at the right time, from the right angle, she was almost handsome. In her past teaching positions she had drawn a little upon the fact of her being young and brilliant and also a nun, but she was beginning to grow out of that.

This was a new university and an entirely new world. She had heard—of course it was true—that the Jesuit administration of this school had hired her at the last moment to save money and to head off the appointment of a man of

dubious religious commitment. She had prayed for the necessary energy to get her through this first semester. She had no trouble with teaching itself; once she stood before a classroom she felt herself capable of anything. It was the world immediately outside the classroom that confused and alarmed her, though she let none of this show—the cynicism of her colleagues, the indifference of many of the students, and, above all, the looks she got that told her nothing much would be expected of her because she was a nun. This took energy, strength. At times she had the idea that she was on trial and that the excuses she made to herself about her discomfort were only the common excuses made by guilty people. But in front of a class she had no time to worry about herself or the conflicts in her mind. She became, once and for all, a figure existing only for the benefit of others, an instrument by which facts were communicated.

About two weeks after the semester began, Sister Irene noticed a new student in her class. He was slight and fair-haired, and his face was blank, but not blank by accident, blank on purpose, suppressed and restricted into a dumbness that looked hysterical. She was prepared for him before he raised his hand, and when she saw his arm jerk, as if he had at last lost control of it, she nodded to him without hesitation.

"Sister, how can this be reconciled with Shakespeare's vision in *Hamlet?* How can these opposing views be in the same mind?"

Students glanced at him, mildly surprised. He did not belong in the class, and this was mysterious, but his manner was urgent and blind.

"There is no need to reconcile opposing views," Sister Irene said, leaning forward against the podium. "In one play Shakespeare suggests one vision, in another play another; the plays are not simultaneous creations, and even if they were, we never demand a logical—"

"We must demand a logical consistency," the young man said. "The idea of education is itself predicated upon consistency, order, sanity—"

He had interrupted her, and she hardened her face against him—for his sake, not her own, since she did not really care. But he noticed nothing. "Please see me after class," she said.

After class the young man hurried up to her.

"Sister Irene, I hope you didn't mind my visiting today. I'd heard some things, interesting things," he said. He stared at her, and something in her face allowed him to smile. "I . . . could we talk in your office? Do you have time?"

They walked down to her office. Sister Irene sat at her desk, and the young man sat facing her; for a moment they were self-conscious and silent.

"Well, I suppose you know—I'm a Jew," he said.

Sister Irene stared at him. "Yes?" she said.

"What am I doing at a Catholic university, huh?" He grinned, "That's what you want to know."

She made a vague movement of her head to show that she had no thoughts on this, nothing at all, but he seemed not to catch it. He was sitting on the edge of the straight-backed chair. She saw that he was young but did not really look young. There were harsh lines on either side of his mouth, as if he had misused that youthful mouth somehow. His skin was almost as pale as hers, his eyes were

dark and not quite in focus. He looked at her and through her and around her, as his voice surrounded them both. His voice was a little shrill at times.

"Listen, I did the right thing today—visiting your class! God, what a lucky accident it was; some jerk mentioned you, said you were a good teacher—I thought, what a laugh! These people know about good teachers here? But yes, listen, yes, I'm not kidding—you are good. I mean that."

Sister Irene frowned. "I don't quite understand what all this means."

He smiled and waved aside her formality, as if he knew better. "Listen, I got my B.A. at Columbia, then I came back here to this crappy city. I mean, I did it on purpose, I wanted to come back. I wanted to. I have my reasons for doing things. I'm on a three-thousand-dollar fellowship," he said, and waited for that to impress her. "You know, I could have gone almost anywhere with that fellowship, and I came back here—my home's in the city—and enrolled here. This was last year. This is my second year. I'm working on a thesis, I mean I was, my master's thesis—but to hell with that. What I want to ask you is this: Can I enroll in your class, is it too late? We have to get special permission if we're late."

Sister Irene felt something nudging her, some uneasiness in him that was pleading with her not to be offended by his abrupt, familiar manner. He seemed to be promising another self, a better self, as if his fair, childish, almost cherubic face were doing tricks to distract her from what his words said.

"Are you in English studies?" she asked.

"I was in history. Listen," he said, and his mouth did something odd, drawing itself down into a smile that made the lines about it deepen like knives, "listen, they kicked me out."

He sat back, watching her. He crossed his legs. He took out a package of cigarettes and offered her one. Sister Irene shook her head, staring at his hands. They were small and stubby and might have belonged to a ten-year-old, and the nails were a strange near-violet color. It took him awhile to extract a cigarette.

"Yeah, kicked me out. What do you think of that?"

"I don't understand."

"My master's thesis was coming along beautifully, and then this bastard—I mean, excuse me, this professor, I won't pollute your ofice with his name—he started making criticisms, he said some things were unacceptable, he—" The boy leaned forward and hunched his narrow shoulders in a parody of secrecy. "We had an argument. I told him some frank things, things only a broad-minded person could hear about himself. That takes courage, right? He didn't have it! He kicked me out of the master's program, so now I'm coming into English. Literature is greater than history; European history is one big pile of garbage. Sky-high. Filth and rotting corpses, right? Aristotle says that poetry is higher than history; he's right; in your class today I suddenly realized that this is my field, Shakespeare, only Shakespeare is—"

Sister Irene guessed that he was going to say that only Shakespeare was equal to him, and she caught the moment of recognition and hesitation, the half-raised arm, the keen, frowning forehead, the narrowed eyes; then he thought better of it and did not end the sentence. "The students in your class are mainly negligible. I can tell you that. You're new here, and I've been here a year—I would

have finished my studies last year but my father got sick, he was hospitalized, I couldn't take exams and it was a mess—but I'll make it through English in one year or drop dead. I can do it, I can do anything. I'll take six courses at once—" He broke off, breathless. Sister Irene tried to smile, "All right then, it's settled? You'll let me in? Have I missed anything so far?"

He had no idea of the rudeness of his question. Sister Irene, feeling suddenly exhausted, said, "I'll give you a syllabus of the course."

"Fine! Wonderful!"

He got to his feet eagerly. He looked through the schedule, muttering to himself, making favorable noises. It struck Sister Irene that she was making a mistake to let him in. There were these moments when one had to make an intelligent decision. . . . But she was sympathetic with him, yes. She was sympathetic with something about him.

She found out his name the next day: Allen Weinstein.

After this she came to her Shakespeare class with a sense of excitement. It became clear to her at once that Weinstein was the most intelligent student in the class. Until he had enrolled, she had not understood what was lacking, a mind that could appreciate her own. Within a week his jagged, protean mind had alienated the other students, and though he sat in the center of the class, he seemed totally alone, encased by a miniature world of his own. When he spoke of the "frenetic humanism of the High Renaissance," Sister Irene dreaded the raised eyebrows and mocking smiles of the other students, who no longer bothered to look at Weinstein. She wanted to defend him, but she never did, because there was something rude and dismal about his knowledge; he used it like a weapon, talking passionately of Nietzsche and Goethe and Freud until Sister Irene would be forced to close discussion.

In meditation, alone, she often thought of him. When she tried to talk about him to a young nun, Sister Carlotta, everything sounded gross. "But no, he's an excellent student," she insisted. "I'm very grateful to have him in class. It's just that . . . he thinks ideas are real." Sister Carlotta, who loved literature also, had been forced to teach grade-school arithmetic for the last four years. That might have been why she said, a little sharply, "You don't think ideas are real?"

Sister Irene acquiesced with a smile, but of course she did not think so: only reality is real.

When Weinstein did not show up for class on the day the first paper was due, Sister Irene's heart sank, and the sensation was somehow a familiar one. She began her lecture and kept waiting for the door to open and for him to hurry noisily back to his seat, grinning an apology toward her—but nothing happened.

If she had been deceived by him, she made herself think angrily, it was as a teacher and not as a woman. He had promised her nothing.

Weinstein appeared the next day near the steps of the liberal arts building. She heard someone running behind her, a breathless exclamation: "Sister Irene!" She turned and saw him, panting and grinning in embarrassment. He wore a dark-blue suit with a necktie, and he looked, despite his childish face, like a little old man; there was something oddly precarious and fragile about him. "Sister Irene, I owe you an apology, right?" He raised his eyebrows and smiled a sad, forlorn,

yet irritatingly conspiratorial smile. "The first paper—not in on time, and I know what your rules are. . . . You won't accept late papers, I know—that's good discipline, I'll do that when I teach too. But, unavoidably, I was unable to come to school yesterday. There are many—many—" He gulped for breath, and Sister Irene had the startling sense of seeing the real Weinstein stare out at her, a terrified prisoner behind the confident voice. "There are many complications in family life. Perhaps you are unaware—I mean—"

She did not like him, but she felt this sympathy, something tugging and nagging at her the way her parents had competed for her love so many years before. They had been whining, weak people, and out of their wet need for affection, the girl she had been (her name was Yvonne) had emerged stronger than either of them, contemptuous of tears because she had seen so many. But Weinstein was different; he was not simply weak—perhaps he was not weak at all—but his strength was confused and hysterical. She felt her customary rigidity as a teacher begin to falter. "You may turn your paper in today if you have it," she said, frowning.

Weinstein's mouth jerked into an incredulous grin. "Wonderful! Marvelous!" he said. "You are very understanding. Sister Irene, I must say. I must say . . . I didn't expect, really . . ." He was fumbling in a shabby old briefcase for the paper. Sister Irene waited. She was prepared for another of his excuses, certain that he did not have the paper, when he suddenly straightened up and handed her something. "Here! I took the liberty of writing thirty pages instead of just fifteen," he said. He was obviously quite excited; his cheeks were mottled pink and white. "You may disagree violently with my interpretation—I expect you to, in fact I'm counting on it—but let me warn you, I have the exact proof, right here in the play itself!" He was thumping at a book, his voice growing louder and shriller. Sister Irene, startled, wanted to put her hand over his mouth and soothe him.

"Look," he said breathlessly, "may I talk with you? I have a class now I hate, I loathe, I can't bear to sit through! Can I talk with you instead?"

Because she was nervous, she stared at the title page of the paper: 'Erotic Melodies in *Romeo and Juliet*' by Allen Weinstein, Jr.

"All right?" he said. "Can we walk around here? Is it all right? I've been anxious to talk with you about some things you said in class."

She was reluctant, but he seemed not to notice. They walked slowly along the shaded campus paths. Weinstein did all the talking, of course, and Sister Irene recognized nothing in his cascade of words that she had mentioned in class. "The humanist must be committed to the totality of life," he said passionately. "This is the failing one finds everywhere in the academic world! I found it in New York and I found it here and I'm no ingénu, I don't go around with my mouth hanging open—I'm experienced, look, I've been to Europe, I've lived in Rome! I went everywhere in Europe except Germany, I don't talk about Germany . . . Sister Irene, think of the significant men in the last century, the men who've changed the world! Jews, right? Marx, Freud, Einstein! Not that I believe Marx, Marx is a madman . . . and Freud, no, my sympathies are with spiritual humanism. I believe that the Jewish race is the exclusive . . . the exclusive, what's the word,

the exclusive means by which humanism will be extended. . . . Humanism begins by excluding the Jew, and now,'' he said with a high, surprised laugh, ''the Jew will perfect it. After the Nazis, only the Jew is authorized to understand humanism, its limitations and its possibilities So, I say that the humanist is committed to life in its totality and not just to his profession! The religious person is totally religious, he is his religion! What else? I recognize in you a humanist and a religious person—''

But he did not seem to be talking to her or even looking at her.

''Here, read this,'' he said. ''I wrote it last night.'' It was a long free-verse poem, typed on a typewriter whose ribbon was worn out.

''There's this trouble with my father, a wonderful man, a lovely man, but his health—his strength is fading, do you see? What must it be to him to see his son growing up? I mean, I'm a man now, he's getting old, weak, his health is bad—it's hell, right? I sympathize with him. I'd do anything for him, I'd cut open my veins, anything for a father—right? That's why I wasn't in school yesterday,'' he said, and his voice dropped for the last sentence, as if he had been dragged back to earth by a fact.

Sister Irene tried to read the poem, then pretended to read it. A jumble of words dealing with ''life'' and ''death'' and ''darkness'' and ''love.'' ''What do you think?'' Weinstein said nervously, trying to read it over her shoulder and crowding against her.

''It's very . . . passionate,'' Sister Irene said.

This was the right comment; he took the poem back from her in silence, his face flushed with excitement. ''Here, at this school, I have few people to talk with. I haven't shown anyone else that poem.'' He looked at her with his dark, intense eyes, and Sister Irene felt them focus upon her. She was terrified at what he was trying to do—he was trying to force her into a human relationship.

''Thank you for your paper,'' she said, turning away.

When he came the next day, ten minutes late, he was haughty and disdainful. He had nothing to say and sat with his arms folded. Sister Irene took back with her to the convent a feeling of betrayal and confusion. She bad been hurt. It was absurd, and yet—She spent too much time thinking about him, as if he were somehow a kind of crystallization of her own loneliness; but she had no right to think so much of him. She did not want to think of him or of her loneliness. But Weinstein did so much more than think of his predicament: he embodied it, he acted it out, and that was perhaps why he fascinated her. It was as if he were doing a dance for her, a dance of shame and agony and delight, and so long as he did it, she was safe. She felt embarrassment for him, but also anxiety; she wanted to protect him. When the dean of the graduate school questioned her about Weinstein's work, she insisted that he was an ''excellent'' student, though she knew the dean had not wanted to hear that.

She prayed for guidance, she spent hours on her devotions, she was closer to her vocation than she had been for some years. Life at the convent became tinged with unreality, a misty distortion that took its tone from the glowering skies of the city at night, identical smokestacks ranged against the clouds and giving to the sky the excrement of the populated and successful earth. This city

was not her city, this world was not her world. She felt no pride in knowing this, it was a fact. The little convent was not like an island in the center of this noisy world, but rather a kind of hole or crevice the world did not bother with, something of no interest. The convent's rhythm of life had nothing to do with the world's rhythm, it did not violate or alarm it in any way. Sister Irene tried to draw together the fragments of her life and synthesize them somehow in her vocation as a nun: she was a nun, she was recognized as a nun and had given herself happily to that life, she had a name, a place, she had dedicated her superior intelligence to the Church, she worked without pay and without expecting gratitude, she had given up pride, she did not think of herself but only of her work and her vocation, she did not think of anything external to these, she saturated herself daily in the knowledge that she was involved in the mystery of Christianity.

A daily terror attended this knowledge, however, for she sensed herself being drawn by that student, that Jewish boy, into a relationship she was not ready for. She wanted to cry out in fear that she was being forced into the role of a Christian, and what did that mean? What could her studies tell her? What could the other nuns tell her? She was alone, no one could help; he was making her into a Christian, and to her that was a mystery, a thing of terror, something others slipped on the way they slipped on their clothes, casually and thoughtlessly, but to her a magnificent and terrifying wonder.

For days she carried Weinstein's paper, marked A, around with her; he did not come to class. One day she checked with the graduate office and was told that Weinstein had called in to say his father was ill and that he would not be able to attend classes for a while. "He's strange, I remember him," the secretary said. "He missed all his exams last spring and made a lot of trouble. He was in and out of here every day."

So there was no more of Weinstein for a while, and Sister Irene stopped expecting him to hurry into class. Then, one morning, she found a letter from him in her mailbox.

He had printed it in black ink, very carefully, as if he had not trusted handwriting. The return address was in bold letters that, like his voice, tried to grab onto her: Birchcrest Manor. Somewhere north of the city. "Dear Sister Irene," the block letters said, "I am doing well here and have time for reading and relaxing. The Manor is delightful, My doctor here is an excellent, intelligent man who has time for me, unlike my former doctor. If you have time, you might drop in on my father, who worries about me too much, I think, and explain to him what my condition is. He doesn't seem to understand. I feel about this new life the way that boy, what's his name, in *Measure for Measure,* feels about the prospects of a different life; you remember what he says to his sister when she visits him in prison, how he is looking forward to an escape into another world. Perhaps you could *explain* this to my father and he would stop worrying." The letter ended with the father's name and address, in letters that were just a little too big. Sister Irene, walking slowly down the corridor as she read the letter, felt her eyes cloud over with tears. She was cold with fear, it was something she had never experienced before. She knew what Weinstein was trying to tell her,

and the desperation of his attempt made it all the more pathetic; he did not deserve this, why did God allow him to suffer so?

She read through Claudio's speech to his sister, in *Measure for Measure:*

Ay, but to die, and go we know not where;
to lie in cold obstruction and to rot;
This sensible warm motion to become
A kneaded clod; and the delighted spirit
To bathe in fiery floods, or to reside
In thrilling region of thick-ribbed ice,
To be imprison'd in the viewless winds
And blown with restless violence round about
The pendent world; to be worse than worst
Of those that lawless and incertain thought
Imagines howling! 'Tis too horrible!
The weariest and most loathed worldly life
That age, ache, penury, and imprisonment
Can lay on nature is a paradise
To what we fear of death.

Sister Irene called the father's number that day. "Allen Weinstein residence, who may I say is calling?" A woman said, bored. "May I speak to Mr. Weinstein? It's urgent—about his son," Sister Irene said. There was a pause at the other end. "You want to talk to his mother, maybe?" the woman said. "His mother? Yes, his mother, then. Please. It's very important."

She talked with this strange, unsuspecting woman, a disembodied voice that suggested absolutely no face, and insisted upon going over that afternoon. The woman was nervous, but Sister Irene, who was a university professor, after all, knew enough to hide her own nervousness. She kept waiting for the woman to say, "Yes, Allen has mentioned you . . ." but nothing happened.

She persuaded Sister Carlotta to ride over with her. This urgency of hers was something they were all amazed by. They hadn't suspected that the set of her gray eyes could change to this blurred, distracted alarm, this sense of mission that seemed to have come to her from nowhere. Sister Irene drove across the city in the late afternoon traffic, with the high whining noises from residential streets where trees were being sawed down in pieces. She understood now the secret, sweet wildness that Christ must have felt, giving himself for man, dying for the billions of men who would never know of him and never understand the sacrifice. For the first time she approached the realization of that great act. In her troubled mind the city traffic was jumbled and yet oddly coherent, an image of the world that was always out of joint with what was happening in it, its inner history struggling with its external spectacle. This sacrifice of Christ's, so mysterious and legendary now, almost lost in time—it was that by which Christ transcended both God and man at one moment, more than man because of his fate to do what no other man could do, and more than God because no god could suffer as he did. She felt a flicker of something close to madness.

She drove nervously, uncertainly, afraid of missing the street and afraid of finding it too, for while one part of her rushed forward to confront these people who had betrayed their son, another part of her would have liked nothing so much as to be waiting as usual for the summons to dinner, safe in her room. . . . When she found the street and turned onto it, she was in a state of breathless excitement. Here lawns were bright green and marred with only a few leaves, magically clean, and the houses were enormous and pompous, a mixture of styles: ranch houses, colonial houses, French country houses, white-bricked wonders with curving glass and clumps of birch trees somehow encircled by white-concrete. Sister Irene stared as if she had blundered into another world. This was a kind of heaven, and she was too shabby for it.

The Weinsteins' house was the strangest one of all: it looked like a small Alpine lodge, with an inverted V-shaped front entrance. Sister Irene drove up the blacktopped driveway and let the car slow to a stop; she told Sister Carlotta she would not be long.

At the door she was met by Weinstein's mother, a small, nervous woman with hands like her son's. "Come in, come in," the woman said. She had once been beautiful, that was clear, but now in missing beauty she was not handsome or even attractive but looked ruined and perplexed, the misshapen swelling of her white-blond professionaly set hair like a cap lifting up from her surprised face. "He'll be right in. Allen?" she called, "our visitor is here." They went into the living room. There was a grand piano at one end and an organ at the other. In between were scatterings of brilliant modern furniture in conversational groups, and several puffed-up white rugs on the polished floor. Sister Irene could not stop shivering.

"Professor, it's so strange, but let me say when the phone rang I had a feeling—I had a feeling," the woman said, with damp eyes. Sister Irene sat, and the woman hovered about her. "Should I call you Professor? We don't . . . you know . . . we don't understand the technicalities that go with—Allen, my son, wanted to go here to the Catholic school; I told my husband why not? Why fight? It's the thing these days, they do anything they want for knowledge. And he had to come home, you know. He couldn't take care of himself in New York, that was the beginning of the trouble. . . . Should I call you Professor?"

"You can call me Sister Irene."

"Sister Irene?" the woman said, touching her throat in awe, as if something intimate and unexpected had happened.

Then Weinstein's father appeared, hurrying. He took long, impatient strides. Sister Irene stared at him and in that instant doubted everything—he was in his fifties, a tall, sharply handsome man, heavy but not fat, holding his shoulders back with what looked like an effort, but holding them back just the same. He wore a dark suit and his face was flushed, as if he had run a long distance.

"Now," he said, coming to Sister Irene and with a precise wave of his hand motioning his wife off, "now, let's straighten this out. A lot of confusion over that kid, eh?" He pulled a chair over, scraping it across a rug and pulling one corner over, so that its brown underside was exposed. "I came home early just for this, Libby phoned me. Sister, you got a letter from him, right?"

The wife looked at Sister Irene over her husband's head as if trying somehow to coach her, knowing that this man was so loud and impatient that no one could remember anything in his presence.

"A letter—yes—today—"

"He says what in it? You got the letter, eh? Can I see it?"

She gave it to him and wanted to explain, but he silenced her with a flick of his hand. He read through the letter so quickly that Sister Irene thought perhaps he was trying to impress her with his skill at reading. "So?" he said, raising his eyes, smiling, "so what is this? He's happy out there, he says. He doesn't communicate with us any more, but he writes to you and says he's happy—what's that? I mean, what the hell is that?"

"But he isn't happy. He wants to come home," Sister Irene said. It was so important that she make him understand that she could not trust her voice; goaded by this man, it might suddenly turn shrill, as his son's did. "Someone must read their letters before they're mailed, so he tried to tell me something by making an allusion to—"

"What?"

"—an allusion to a play, so that I would know. He may be thinking suicide, he must be very unhappy—"

She ran out of breath. Weinstein's mother had begun to cry, but the father was shaking his head jerkily back and forth. "Forgive me, Sister, but it's a lot of crap, he needs the hospital, he needs help—right? It costs me $200 a day out there, and they've got the best place in the state, I figure it's worth it. He needs help, that kid, what do I care if he's unhappy? He's unbalanced!" he said angrily. "You want us to get him out again? We argued with the judge for two hours to get him in, an acquaintance of mine. Look, he can't control himself—he was smashing things here, he was hysterical. They need help, lady, and you do something about it fast! You do something! We made up our minds to do something and we did it! This letter—what the hell is this letter? He never talked like that to us!"

"But he means the opposite of what he says—"

"Then he's crazy! I'm the first to admit it." He was perspiring, and his face darkened. "I've got no pride left this late. He's a little bastard, you want to know? He calls me names, he's filthy, got a filthy mouth—that's being smart, huh? They give him a scholarship for his filthy mouth? I went to college too, and I got out and knew something, and I for Christ's sake did something with it; my wife is an intelligent woman, a learned woman, would you guess she does book reviews for the little newspaper out here? Intelligent isn't crazy—crazy isn't intelligent. Maybe for you at the school he writes nice papers and gets an A, but out here, around the house, he can't control himself, and we got him committed!"

"But—"

"We're fixing him up, don't worry about it!" He turned to his wife. "Libby, get out of here, I mean it. I'm sorry, but get out of here, you're making a fool of yourself, go stand in the kitchen or something, you and the goddamn maid can cry on each other's shoulders. That one in the kitchen is nuts too, they're all nuts. Sister," he said, his voice lowering, "I thank you immensely for coming

out here. This is wonderful, your interest in my son. And I see he admires you—that letter there. But what about that letter? If he did want to get out, which I don't admit—he was willing to be committed, in the end he said okay himself—if he wanted out I wouldn't do it. Why? So what if he wants to come back? The next day he wants something else, what then? He's a sick kid, and I'm the first to admit it."

Sister Irene felt that sickness spread to her. She stood. The room was so big it seemed it must be a public place; there had been nothing personal or private about their conversation. Weinstein's mother was standing by the fireplace, sobbing. The father jumped to his feet and wiped his forehead in a gesture that was meant to help Sister Irene on her way out. "God, what a day," he said, his eyes snatching at hers for understanding, "you know—one of those days all day long? Sister, I thank you a lot. There should be more people in the world who care about others, like you. I mean that."

On the way back to the convent, the man's words returned to her, and she could not get control of them; she could not even feel anger. She had been pressed down, forced back, what could she do? Weinstein might have been watching her somehow from a barred window, and he surely would have understood. The strange idea she had had on the way over, something about understanding Christ, came back to her now and sickened her. But the sickness was small. It could be contained.

About a month after her visit to his father, Weinstein himself showed up. He was dressed in a suit as before, even the necktie was the same. He came right into her office as if he had been pushed and could not stop.

"Sister," he said, and shook her hand. He must have seen fear in her because he smiled ironically. "Look, I'm released. I'm let out of the nut house. Can I sit down?"

He sat. Sister Irene was breathing quickly, as if in the presence of an enemy who does not know he is an enemy.

"So, they finally let me out. I heard what you did. You talked with him, that was all I wanted. You're the only one who gave a damn. Because you're a humanist and a religious person, you respect . . . the individual. Listen," he said, whispering, "it was hell out there! Hell Birchcrest Manor! All fixed up with fancy chairs and *Life* magazines lying around—and what do they do to you? They locked me up, they gave me shock treatments! Shock treatments, how do you like that, it's discredited by everybody now—they're crazy out there themselves, sadists. They locked me up, gave me hypodermic shots, they didn't treat me like a human being! Do you know what that is," Weinstein demanded savagely, "not to be treated like a human being? They made me an animal—for $200 a day! Dirty filthy swine! Now I'm an outpatient because I stopped swearing at them. I found somebody's bobby pin, and when I wanted to scream I pressed it under my fingernail and it stopped me—the screaming went inside and not out—so they gave me good reports, those sick bastards. Now I'm an outpatient and I can walk along the street and breathe in the same filthy exhaust from the buses like all you normal people! Christ," he said, and threw himself back against the chair.

Sister Irene stared at him. She wanted to take his hand, to make some gesture that would close the aching distance between them. "Mr. Weinstein—"

"Call me Allen!" he said sharply.

"I'm very sorry—I'm terribly sorry—"

"My own parents committed me, but of course they didn't know what it was like. It was hell," he said thickly, "and there isn't any hell except what other people do to you. The psychiatrist out there, the main shrink, he hates Jews too, some of us were positive of that, and he's got a bigger nose than I do, a real beak." He made a noise of disgust. "A dirty bastard, a sick, dirty, pathetic bastard—all of them. Anyway, I'm getting out of here, and I came to ask you a favor."

"What do you mean?"

"I'm getting out. I'm leaving. I'm going up to Canada and lose myself. I'll get a job, I'll forget everything. I'll kill myself maybe—what's the difference? Look, can you lend me some money?"

"Money?"

"Just a little! I have to get to the border, I'm going to take a bus."

"But I don't have any money—"

"No money?" He stared at her. "You mean—you don't have any? Sure you have some!"

She stared at him as if he had asked her to do something obscene. Everything was splotched and uncertain before her eyes.

"You must . . . you must go back," she said, "you're making a—"

"I'll pay it back. Look, I'll pay it back, can you go to where you live or something and get it? I'm in a hurry. My friends are sons of bitches: one of them pretended he didn't see me yesterday—I stood right in the middle of the sidewalk and yelled at him, I called him some appropriate names! So he didn't see me, huh? You're the only one who understands me, you understand me like a poet, you—"

"I can't help you, I'm sorry—I . . ."

He looked to one side of her and flashed his gaze back, as if he could control it. He seemed to be trying to clear his vision.

"You have the soul of a poet," he whispered, "you're the only one. Everybody else is rotten! Can't you lend me some money, ten dollars maybe? I have three thousand in the bank, and I can't touch it! They take everything away from me, they make me into an animal. . . . You know I'm not an animal, don't you? Don't you?"

"Of course," Sister Irene whispered.

"You could get money. Help me. Give me your hand or something, touch me, help me—please. . . ." He reached for her hand and she drew back. He stared at her and his face seemed about to crumble, like a child's. "I want something from you, but I don't know what—I want something!" he cried. "Something real! I want you to look at me like I was a human being, is that too much to ask? I have a brain, I'm alive, I'm suffering—what does that mean? Does that mean nothing? I want something real and not this phony Christian love garbage—it's all in the books, it isn't personal—I want something real—look. . . ."

He tried to take her hand again, and this time she jerked away. She got to her feet. "Mr. Weinstein," she said, "please—"

"You! You nun!" he said scornfully, his mouth twisted into a mock grin. "You nun! There's nothing under that ugly outfit, right? And you're not particularly smart even though you think you are; my father has more brains in his foot than you—"

He got to his feet and kicked the chair.

"You bitch!" he cried.

She shrank back against her desk as if she thought he might hit her, but he only ran out of the office.

Weinstein: the name was to become disembodied from the figure, as time went on. The semester passed; the autumn drizzle turned into snow, Sister Irene rode to school in the morning and left in the afternoon, four days a week, anonymous in her black winter cloak, quiet and stunned. University teaching was an anonymous task, each day dissociated from the rest, with no necessary sense of unity among teachers: they came and went separately and might for a year just miss a colleague who left his office five minutes before they arrived, and it did not matter.

She heard of Weinstein's death, his suicide by drowning, from the English Department secretary, a handsome white-haired woman who kept a transistor radio on her desk. Sister Irene was not surprised; she had been thinking of him as dead for months. "They identified him by some special television way they have now," the secretary said. "They're shipping the body back. It was up in Quebec. . . ."

Sister Irene could feel a part of herself drifting off, lured by the plains of white snow to the north, the quiet, the emptiness, the sweep of the Great Lakes up to the silence of Canada. But she called that part of herself back. She could only be one person in her lifetime. That was the ugly truth, she thought, that she could not really regret Weinstein's suffering and death; she had only one life and had already given it to someone else. He had come too late to her. Fifteen years ago, perhaps, but not now.

She was only one person, she thought, walking down the corridor in a dream. Was she safe in this single person, or was she trapped? She had only one identity. She could make only one choice. What she had done or hadn't done was the result of that cholce, and how was she guilty? If she could have felt guilt, she thought, she might at least have been able to feel something.

A Glossary of Key Terms and Concepts

The terms in this glossary are far from exhaustive. We have included key concepts in the field of performance studies that are given extended treatment in this book. The entries are cross-referenced to parts and chapters in the book for a fuller discussion. Teachers and students will find the glossary useful as a source for additional discussion and for written assignments. All terms in boldface in these definitions have separate glossary entries.

Body. The whole physical structure and presence of the human performer. By extension, the physicality of the text, including the sensuous characteristics of language as spoken. The idea of body can be used to distinguish between *la langue,* language as an abstract system, and *la parole,* actual physical manifestations of language by individual speakers. Body has become a concept made problematical by psychological and political conditions (part II, ch. 5; part III, ch. 11). See also *race* and *sex, gender, sexuality.*

Dialogue, dialectic, dialogism. *Dialogue* is the discourse in which an exchange of voices is heard, in contrast to terms such as *monologue* or *soliloquy,* which are restricted to the presence of a single voice. Dialogue is present in drama, in everyday life, and in interpersonal conversations. Classical drama employed *stichomythia,* alternating lines of dialogue, usually between antagonists engaged in a contest of passions or a debate of ideas. *Dialectic,* exemplified in Plato's writings on Socrates, is a method of examining opinions logically, using a series of questions and answers to trace ideas back to a logical postulate and to trace the consequences of a denial or assertion of that proposition in a quest for truth. Mikhail Bakhtin's concept of *dialogism* approaches discourse as a way of allowing polyvocality, or the simultaneous privileging of many voices, to emerge. In both cultural and literary performances, *dialogism* is critically connected with intertextuality (part II, ch. 2; part III, ch. 12).

Dramatism. Kenneth Burke's method of analyzing literature as "equipment for living." Burke draws on six principles to explain actions: *act* is defined as a deed, thought,

or feeling; *scene* is the background or situation in which the act occurs; *agent* is the person who performs the act; *agency* is the instrument or means by which the action is produced; *purpose* is the reason for which the action is undertaken; and *attitude* is the bent of mind through which the action is carried out. Dramatism helps performers understand and develop roles and can also help us understand ordinary social interactions and human behavior (part I, ch. 1).

Ethnography. The description of specific cultures. The "interpretive" view of ethnographic analysis of culture defines the doing of ethnography as "thick description" (see Clifford Geertz, Paul Rabinow, and William M. Sullivan). Ethnography recognizes the relationship between what is seen and the vantage point from which it is seen and the instruments that assist in the seeing. Ethnographers produce texts, in which they are implicated. Theorists of ethnography argue that the description of culture is itself an act of performance (part II, ch. 2).

Frame analysis. The device of setting borders around a scene, signaling what is to be attended to and what is to be excluded from attention, developed by Erving Goffman. This concept helps us understand the invisible frames that define participants, roles, and meanings of everyday actions (part I; part II, ch. 2).

"Not I, not not-I." A condition of double negativity that characterizes the state of the actor's self in relation to the role the actor plays (part I).

Oral culture, print culture. Oral cultures have no experience of writing. Print cultures depend first on chirographic transcription; then on print; and finally on electronic technologies, involving not only computers but also television and video to record experience. In oral-centered cultures, the primary medium of communication emphasizes speech and the acoustical dimensions of experience. Individuals are the repositories of the collective and shared wisdom of the culture. In print-centered cultures, the eye replaces the ear, and linearity, logic, and reason replace memory and ritual as the principal means by which cultures transmit knowledge (part II, ch. 2).

Performance. A human activity, interactional in nature and involving symbolic forms and live bodies, which constitutes meaning, expressing or affirming individual and cultural values; from the Old French *parfournir* (see Victor Turner), meaning "to complete" or "to carry out thoroughly." We use the term broadly to refer to three continuums of human activity: from individual role playing in everyday life to collective staged performances; from everyday life performances to artificial, stylized performances (such as plays); and from ordinary performances to extraordinary performances or from personal narrative to ecstatic trance.

 Performance embraces cultural and literary performance as well as performance art, which includes a variety of activity from aesthetic to political, individual to collective (part I; part II; part III; and part IV).

Performance Art. A hybrid form of performance, originating in futurist and dadaist performances, that often draws on visuals, media art, dance, and music and appropriates its materials from pop culture, often blurring the boundary between art and life. Performance art can be loosely improvisatory, relying on environment, chance, and even found objects, or tightly scripted; it can function as antiaesthetic statement, political or cultural intervention, social practice, or theatrical or narrative art (part I; part IV).

Performer, text, audience, context. A set of paradigmatic terms designed to assist the student of performance in understanding how meaning is constituted in a performance event. The *performer* uses his or her body as the instrument of performance, whether consciously or unconsciously. The *text,* which may be oral, written, gestural, or some combination of these, is repeatable and capable of having invisible boundaries placed around it, separating it from other external features. The *audience* is made up of those who witness the event and may sometimes include participants. The *context* includes the political, social, historical, psychological, institutional, and aesthetic factors that shape the way we understand the performance event. The *performance event* is the embodiment or enactment of the text—usually a collaborative endeavor involving one or more *performers, text, audience, context,* and sometimes a director (part I, ch. 1).

Play. Activities separate from formal work. Huizinga (1872–1945) and Caillois (1913–78) ascribe the following characteristics to play: free, separate, uncertain, unproductive, governed by rules, and make-believe. The concept of *play* is central to both *cultural* performance—where it appears as folk tale performance, public spectacle, and various oral forms—and *literary* performance—where sound, word play, and conventions of literature and reading carry playful significance. In performance art, play appears in the tendency toward satire; the use of popular culture; and the incorporation of masks, impersonations, and stand-up comedy techniques (part III, ch. 6, ch. 7).

Race, ethnicity. Problematic words used to describe human beings in physical, anthropological, and geopolitical terms. Both terms are social constructions, used sometimes to account for physical and cultural differences and sometimes to exert control over oppressed groups. *Ethnicity* describes the phenomenon of groups of people living in close proximity or sharing a culture; it is sometimes used problematically to describe an experience that is not Anglocentric. *Race* is an even more problematic term that has been used occasionally to distinguish between those who are "fully" human and those who are "less" human (as in the U.S. Constitution or the Nazis' persecution of the Jews). (Part III, ch. 11, and parts II and IV refer to race and ethnicity as elements in cultural performance and performance art.)

Ritual. Ceremonial or formal acts, usually performed in accordance with a set of prescribed rules or customs (part I, ch. 1; part II, ch. 4, ch. 5).

Self, selves. The idea of *self* defined as a single, solitary, autonomous being is contested by many contemporary theorists from diverse disciplines, who instead speak of multiple selves within any individual person and often disagree about the origin and nature of these selves (part II; part III, ch. 9, ch. 10). See also ***Dialogue, dialectic, dialogism.***

Sense, nonsense. The idea of *sense*—that something is logical or intelligible—is predicated on intellectual traditions that argue for the ability of the human mind and human language to establish common and stable "truths." Logic is perhaps the most institutionalized form of sense. *Nonsense,* in turn, requires either a commitment to the idea of sense as a basis for contrast or a commitment to the subversion of anything approaching stable or fixed values of reality. In literary performance, nonsense finds its beginnings in the *play* of sound in nursery rhymes and riddles and its most elaborate manifestations in absurdism and postmodernism. Performance art, deriving from the Dada movement, gives nonsense a particularly privileged position (part III, ch. 7; part IV, particularly ch. 14).

Sex, gender, sexuality. Terms differentiating among biological, social, and erotic constructions of physical and psychological differences between men and women and among heterosexual, homosexual, and bisexual experiences. *Sex* refers to purely biological differences, such as genitalia and child-bearing abilities. *Gender* refers to culturally and socially conditioned views of what is considered feminine and masculine, involving the complex set of psychological and political situations creating and resulting from such constructions. *Sexuality* refers to one's sense of erotic being, one's attitude toward sexual behavior, and one's attractedness to the same or other sex. *Gender* and *sexuality* are contested terms, some critics arguing that the categories merely perpetuate socially constructed dualisms (part III, ch. 11).

Social drama. A spontaneous unit of social process in a range of sociocultural systems (see Victor Turner). The *social drama* is marked by four stages: breach, crisis, redress, and either reintegration or recognition of schism. Turner draws on the structure of Greek drama to organize his anthropological thinking about collective, organized behaviors in society (part I, ch. 1; part II, ch. 4).

Speech act. Speech act theory (see J. L. Austin and John Searle) responds to what has been called the referential fallacy, the belief that language's principal function is to describe reality. Speech act theory argues that language itself performs actions. Speech acts are divided broadly into three categories of locutionary (grammatical) acts, illocutionary acts (performative acts), and perlocutionary acts (acts resulting from speech) (part III, ch. 12).

Theatricality in everyday life. A metaphor, drawn from theater, used to describe how social individuals assume roles in their nontheatrical, everyday, ordinary life experiences in a fashion not greatly dissimilar to the ways in which an actor assumes a role in a staged production of a play (see Erving Goffman) (part I, ch. 1).

Index

Copyright Acknowledgments